Designing Emerging Markets

Giaime Botti

Designing Emerging Markets

A Quantitative History of Architectural Globalisation

Giaime Botti
Department of Architecture and Built
Environment
University of Nottingham Ningbo China
Ningbo, Zhejiang, China

ISBN 978-981-99-1551-4 ISBN 978-981-99-1552-1 (eBook)
https://doi.org/10.1007/978-981-99-1552-1

© The Editor(s) (if applicable) and The Author(s), under exclusive license to Springer Nature
Singapore Pte Ltd. 2023
This work is subject to copyright. All rights are solely and exclusively licensed by the Publisher, whether
the whole or part of the material is concerned, specifically the rights of translation, reprinting, reuse
of illustrations, recitation, broadcasting, reproduction on microfilms or in any other physical way, and
transmission or information storage and retrieval, electronic adaptation, computer software, or by similar
or dissimilar methodology now known or hereafter developed.
The use of general descriptive names, registered names, trademarks, service marks, etc. in this publication
does not imply, even in the absence of a specific statement, that such names are exempt from the relevant
protective laws and regulations and therefore free for general use.
The publisher, the authors, and the editors are safe to assume that the advice and information in this book
are believed to be true and accurate at the date of publication. Neither the publisher nor the authors or
the editors give a warranty, expressed or implied, with respect to the material contained herein or for any
errors or omissions that may have been made. The publisher remains neutral with regard to jurisdictional
claims in published maps and institutional affiliations.

This Springer imprint is published by the registered company Springer Nature Singapore Pte Ltd.
The registered company address is: 152 Beach Road, #21-01/04 Gateway East, Singapore 189721,
Singapore

To Roberta, who gave me life.
To Roberta, with whom I share my life.

Preface

This book emerged from a series of interests and intellectual anxieties about the forms and scope that writing architectural history could assume nowadays. At the same time, it approaches a specific problem that was fascinating to me: architectural globalisation. It comes at a moment when globalisation appears to many different observers in retreat for the first time in decades. Some political events and then the COVID-19 pandemic, sealed borders and disrupted supply chains have produced a more closed and less connected world in these last few years. During this time, this book was conceived and developed. I started the tedious work of data collection during the first lockdown in Italy in 2020 and continued and expanded it in the following year while I was stuck in China. Had I not lived, researched, and worked in Europe, Colombia, and especially China over the past ten years, I would not have felt the need to undertake such a geographically wide-ranging investigation nor the urgency to study the phenomenon of globalisation. The result is an up-to-date and data-driven study of 30 years of architecture produced by overseas design firms in emerging markets problematised through the lenses of the globalisation of the architectural profession and its market expansion worldwide.

For the development of this book, beyond valuable feedback received by reviewers, I want to thank several colleagues and friends who read part of this text, discussed it with me, and provided much-appreciated criticism, suggestions, and comments. Daniele Pisani introduced me to the work of Franco Moretti, provided me with several more suggestions and was available for stimulating discussions from which this book greatly benefitted since the beginning. Andreas Guidi signalled some theoretical questions related to global history. More inputs and feedback came from Eugenio Mangi, Hiroyuki Shinohara, Andrea Palmioli, and Vuk Radovic, while Simone Noja and Daniele Garrisi kindly dispelled some mathematical doubts. Ali Cheshmehzangi and the Department of Architecture and Built Environment and Wu Deng and the SBE Research Group at the University of Nottingham Ningbo China always supported my activity. My thanks also go to the Springer team, especially Lydia Wang and Sivananth S. Siva Chandran. Marco E. Riva helped me with some last-minute research on magazines.

Finally, in my continuous attempt to cross-check information and fill the gaps I found, I could rely on the kindness of many architects that answered my inquiries. In this regard, special thanks go to Fanny Hoffmann from GMP (Shanghai), Ben Somner and Yvonne Wang from Chapman Taylor (Shanghai), Luca Frassanito from Hydea (Beijing), Francesca Lombardo from RMJM, Tom Westberg from Arquitectonica, Xin Huang from AIA Life Designer (China), and Yifan Huang from Benoy (China). Helpful information was also kindly provided by ADP Architecture (New Delhi), ANMA, Creneau International (Dubai), DBI, CEBRA (Abu Dhabi), Buchan Group (Shanghai), EDI International, EMBT (Shanghai), Ennead (Shanghai), Ferrier Marchetti (Shanghai), Foster + Partners (Abu Dhabi), Goettsch Partners (Abu Dhabi), GRAFT Architects, Hassel, Nikken Sekkei, Nickl & Partners, Pelli Clarke Pelli Architects (Shenzhen), PLP Architecture, Sasaki (Shanghai), Powerhouse Company, Ryder Architecture (Hong Kong), Safdie Architects, Saraiva+Associados (Mexico), Stantec, and Steven Holl (Beijing).

As writing this book has occupied a significant share of my time during the last few years that could have been spent otherwise, it is dedicated to the memory of Roberta, my mother, and to Roberta, my wife.

Ningbo, China
Giaime Botti

Contents

1 Introduction ... 1
 1.1 How to Measure Globalisation? 2
 1.2 Contemporary Architecture and Its Geographies 6
 1.3 Beginning with the End: Our Conclusions for a Multi-layer
 History of Architecture 8
 References .. 14

Part I Gauging Architectural Globalisation

2 Towards a Quantitative Turn: Frontiers of Architectural
 Historiography .. 19
 2.1 World History, Globalisation, and Architectural
 Historiography ... 20
 2.2 Architectural Historiographies and Globalisation: Still
 Grasping the Surface? 24
 2.3 Architectural Modes of Production in the Age
 of Globalisation: Sociology and Ethnography of Practice 29
 2.4 Towards a Quantitative and Cross-Disciplinary Approach:
 From Serial History to the Digital Humanities 35
 2.5 Gauging 1000+ Architectural Firms: A Representative
 Sample ... 39
 2.6 Conclusions .. 46
 References .. 47

3 A Globalising Practice: From European Colonialism
 to the Global Age of Architecture, 1400–1989 55
 3.1 Across Lands and Seas: Colonial Empires and Royal
 Patronage During the "Long Sixteenth Century" 57
 3.2 Expanding Empires, Expanding Opportunities: Nineteenth
 and Early Twentieth Century 60

3.3	Cold War, Tropical Modernism, and the Globalisation of Modernism in a Decolonising World: 1945–70s	67
3.4	The Side of the Oil Crisis from the Middle East Boom to the "End of History:" 1970–90s	84
3.5	Conclusions	100
References		102

4 Architecture in Emerging Markets: A "Distant Reading" 111

4.1	BRICS and Other Emerging Markets: Defining the Scope of This Study	112
4.2	A Broad, But Still Incomplete, Picture: Globalisation Versus Mondialisation	118
4.3	The Globalisation of the Architectural Practice: Building in Emerging Markets	121
4.4	The Aeroplane and the Internet: Towards a 24 h Working day with CAAD	133
4.5	"Boots on the Ground": Office Branches	136
4.6	Successful Export and Unaccomplished Ambitions: Europe Versus the USA Versus the Asia–Pacific	145
4.7	Conclusions	154
References		155

Part II Architectural Geographies of Globalisation

5 The Skyscraper: Go East, Go High, Go Hybrid 163

5.1	A Changing Geography, a Changing Typology: Asian and Hybrid	164
5.2	At the Top (the Largest Number): China	167
5.3	At the Top (the Tallest): The Middle East	189
5.4	Unsatisfied Global Aspirations and Regionalist Reactions: South and South-East Asia	208
5.5	The Oil and Gas Boost: Russia	218
5.6	A Different Chronology? Latin America	223
5.7	Innovation, Technology Transfer, and Experimental Conditions: Tall, Anti, and Hyper	232
5.8	Entangled Debates: The (Un)ethics of the Skyscraper	237
5.9	Conclusions	242
References		244

6 Art and Culture: Global Icons for the Starchitects 249

6.1	The Museum Boom: China	250
6.2	Emerging Cultural Hubs? Museum Franchises and Cultural Clusters in the Persian Gulf	263
6.3	Opera and Theatres: China, Again	268
6.4	Temples of Knowledge in the Age of Information: Libraries	276

6.5	Marginal Geographies and Import Substitution Architecture: From Africa to Latin America	281
6.6	Conclusions	288
	References	290

7 Megaevents: Dubious Legacies and Empty Shells ... 293

7.1	The Rise of Global China: Beijing 2008 Summer Olympic Games and Expo 2010 Shanghai	295
7.2	The Brazilian Bet: Brazil 2014 FIFA World Cup and Rio de Janeiro 2016 Summer Olympic Games	304
7.3	Beyond Oil? National Monuments and Economic Diversification in Astana 2017 and Dubai 2020	309
7.4	FIFArchitecture: South Africa 2010, Russia 2018, and Qatar 2022	316
7.5	Conclusions	324
	References	325

8 Dwelling: New Forms of Housing, New Forms of City ... 331

8.1	Supertall Residential: Living the Sky from Australia to New York	332
8.2	Concrete or Terracotta Dragon? China's Real Estate	339
8.3	Signature Housing for an Emerging Middle-Class: A Global Picture	347
8.4	Villa No More: Housing Communities and the End of Privacy	353
8.5	New Experiments in Mass Housing: Dwellings for the Well-Off?	357
8.6	Pieces of a New, Hybrid City: Mixed-Use Developments and Real Estate Developers	363
8.7	The New Town in the Twenty-First Century: From Shanghai "One City and Nine Towns" to Masdar	370
8.8	Conclusions	379
	References	380

9 Workplace: The Office and Beyond the Office ... 383

9.1	Global Cities and Multinational Companies: The Office is Dead; Long Live the Office	385
9.2	The Typology of the Office Building and the New City: Low-Versus High-Rise, Monofunctional Versus Mixed-Use	394
9.3	New Islands of Knowledge Production: Science and Technology Parks	406
9.4	A New City of Knowledge: Qatar Education City	411
9.5	From Nation-Building to Market-Competition: The Architecture of Higher Education	415
9.6	Between Private Demand and Good Intentions: School Architecture	424

9.7	Room for Machines: Data Centres and Factory Plants	427
9.8	Healthy and Long Lives: The High-Tech Hospital	433
9.9	Conclusions	436
	References	438

10 Architecture for Leisure: Living the "Generic City" 443

10.1	City Gates in Search of Place: Airports and Railway Stations	444
10.2	Hotel Design and Globalisation: Opening, Diversifying, and Crafting Identities	454
10.3	Hospitality Design and its Firms: When the Hyper-Local is Hyper-Global	458
10.4	International Chains, International Architects: China's Booming Hotel Market	474
10.5	Spending Time and Money: From the Shopping Mall to the Leisure Centre	487
10.6	The City of Leisure and History: Theme Parks and Disneyfied Heritage	494
10.7	Megaboxes Since 1851: Conference and Fair Centres	500
10.8	Conclusions	506
	References	507

Appendix A: Emerging Markets: Surveyed Regions 511

Appendix B: Surveyed Firms by Country 517

Chapter 1
Introduction

Globalisation has been the word used and abused during the last few decades to talk about a series of economic, political, social, and cultural phenomena shaping our present. From the perspective of many Marxian scholars, globalisation is the world becoming one, unified, by the expansion of the capitalist world-system (Wallerstein 1974). As Eric Hobsbawm (1975) put it, the pre-nineteenth century world was a disconnected one, where what happened in a continent was not only unknown in the others but also barely mattered. Nevertheless, such a Western-centric position, the periodisation it entails, and the limited scope of its analysis are by now challenged by a myriad of studies that we will concisely present. Having done so, we will be able to discuss the real problem at the centre of this book: the globalisation of *architectural markets*.

Our italic is to emphasise one first and crucial fact. We are not interested in mapping the n-fold processes, events, and stories that, since antiquity, have shaped architecture as technical and artistic activity rarely insensible to the happenings of distant regions. To give some examples of what we are not interested in, let us think about how the classical Greek Doric capital evolved from Egyptian prototypes like those found in the Mortuary Temple of Hatshepsut; how Arab architecture influenced design in Spanish and Portuguese colonies in America; how the Beaux-Arts became an 'international style' before the "International Style" thanks to the influence of a few architecture schools from Paris to Philadelphia that trained professionals from across the world. To all this, and much more that we will trace in Chap. 3, this book is not dedicated. Paolo Tombesi (2001) correctly distinguished between the "globalisation of architectural markets" from that of the "design production," considering the latter as a system to exploit the international division of labour. In this book, we are interested in the former aspect. And for a few good reasons.

First, we still rely on limited knowledge about if, how, when, and to which extent the architecture market has become one. Secondly, the exploitation of an international division of labour in architecture appears to be a less-significant aspect compared to

© The Author(s), under exclusive license to Springer Nature Singapore Pte Ltd. 2023
G. Botti, *Designing Emerging Markets*,
https://doi.org/10.1007/978-981-99-1552-1_1

other changes in the profession. The emergence of new markets has wholly transformed the scope of design firms—whether small, medium or big—and partly modified the modes of production of contemporary architecture. In the first pages of a milestone book of the 1990s, *S, M, L, XL*, a graph showed OMA's financial turnover (Office for Metropolitan Architecture, Koolhaas, and Mau, 1995, ii–iii). Amidst fluctuations, was visible the importance of France, Germany and The Netherlands, and the minor relevance of some other countries, including Japan. The same graph today would show a completely different reality. We would undoubtedly see many more countries, starting from the USA. And we would notice China and Qatar, for instance. In other words, OMA's financial geography would be highly dissimilar, broader, indeed. And this is not only because OMA is today a much larger and more successful firm than thirty-eight years ago. This is because the architectural profession and its scope have profoundly changed globally.

1.1 How to Measure Globalisation?

As stated, we are interested in the process of globalisation of architectural production and its market expansion, i.e., our investigation focuses on architecture (projects and buildings) produced by architects (and their firms) with the support of multiple consultants on behalf of a client. This is to make clear that, in many ways, we are staying in the tradition of architectural historiography as a research activity concerned with selected pieces and their authors. To free the ground of any possible misunderstanding, this is not a history of popular architectural expressions or the informal city. On the contrary, it is a history of very formal, highly planned cities; it is a history that, even when the word "vernacular" comes to the stage, does not refer to an "architecture without architects" (Rudofsky 1964) but instead to one highly mediated by professionals. This is a history of the contemporary profession, its geography, outcomes, and modes of production.

Let us proceed by order. After this introduction, the reader will enter the first part of this book, which examines the meaning of globalisation from the perspective of the architectural profession. To do so, we first question the historiographic *status quo* on architecture. Such a theoretical task moves us towards two diverging directions. One leads us to discuss what architectural historiography is today, given for granted that we cannot consider any longer this discipline as a branch of art history that selectively focuses on a few canonical authors and buildings. In this sense, we highlight the limits and frontiers for architectural history, cross-fertilising our theoretical framework with the perspectives and the scales of the world and global history, economic history, and environmental history, but also crossing disciplinary boundaries towards sociology and the so-called ethnography of practice to investigate how architects work. Should one be the conceptual and methodological keyword we want to emphasise, this would be *quantity*. Indeed, one of the essential novelties of this book is that we want to measure architectural globalisation. The aim is to question the foundations of a discipline, architectural historiography, that has always been primarily qualitative.

1.1 How to Measure Globalisation?

For this reason, we look back at the tradition of serial history (Furet 1971) and get to the present time with the literary theories of Franco Moretti's (2005a) "distant reading." In this light, besides a rich set of images, the book features a vast set of tables, graphs, and maps to visualise quantitative data better.

Moreover, following Moretti, we assume that distant reading is a different and complementary form of knowledge. We move back and forth from different scales: the building, the city, the world. The history of architecture should first and foremost be *history*, and certain phenomena cannot be explained by and through a single building. A crucial concept in quantitative history is "series," as put forward by François Furet. Some of the objects we study are, indeed, series of buildings rather than individual pieces of architecture. For example, while we may focus here and there on individual projects by a firm like Skidmore, Owings & Merrill (SOM), we will more often consider its production in terms of a series of buildings, like the nine supertall skyscrapers completed in China. On the other hand, a significant series can be identified by looking at some cities, or even some sectors of them, where we find an extraordinary concentration of works produced by overseas firms: Shanghai and Dubai, or Kuala Lumpur City Centre (KLCC) and Moscow International Business Centre (MIBC). Hence, this is a history of architectural globalisation and, with some ambitions, a history of contemporary architecture because a large swath of contemporary production has been designed overseas by US, European, Japanese and Australian firms, especially in what we call emerging markets. If we agree with Kenneth Frampton's claim that architecture is the less autonomous of the disciplines, we should more deeply explore economic conditions and the agency of other actors when we write its history. The emergence of real estate developers like SOHO China, Emaar Properties, and CapitaLand, for example, had played a fundamental role in promoting large-scale operations involving renowned architects that have been crucial drivers of architectural globalisation. Similarly, we should approach the scale of the city and the territory together with that of the building. The quantitative or distant approach is helpful to do so. It allows us to explain the significance of a piece of architecture—the reasons we include it in our narrative among the hundreds we have already pre-selected—by understanding it as a part of a series.

Chapter 2 discusses globalisation as a general phenomenon and then focuses on how architectural historiography has dealt with it. Indeed, while globalisation itself is a debated issue, architectural globalisation seems to remain, in many cases, a kind of a nuisance for historians who would instead focus on the architecture that resists such a phenomenon (Frampton 1983; 2020). That said, the problem has not been avoided (Adam 2012; Ponzini 2020). While some authors have explored the phenomenon by analysing changes in the profession (McNeill 2009; Raisbeck 2020) and in the modes of production (Tombesi 2001), others have focused on the connection between the neoliberal order, global elites, and architecture (King 2004; Spencer 2016), with a particular interest in the problem of iconic buildings (Sklair 2017). Others have seen in the works of architects like Frank O. Gehry, Richard Rogers, and Norman Fosters the emergence of a new "global style" like Le Corbusier's, Walter Gropius', and Ludwig

Mies van der Rohe's works embodied the "International Style" (Foster 2011). Globalisation has been at the core of studies focusing on areas where it has apparently been felt more, like China (Ren 2011) and the Persian Gulf (Fraser and Golzari 2013). Given this theoretical background, the chapter finally explains the quantitative methodology used to collect data for this research. To operate our analysis, we elaborated a database of 1,025 design firms from twenty countries from the Global North (all part of what during the Cold War was the Capitalistic Bloc), mapping their work in selected overseas markets since the 1990s. This database reflects the different weights of these countries in terms of dimension and 'architectural influence' and includes firms of different sizes and typologies. The methodological aspects of the survey and its potential flaws are thoroughly discussed in the chapter, while at the end of the book, an Appendix provides further data.

Chapter 3 can be read as an outline of globalisation in architectural history since 1400 and up to 1990 based on an extensive literature review. Rejecting the idea that globalisation has always existed in the past, this part of the book aligns with current literature on globalisation, economic history (Flynn and Giráldez 1995; de Zwart and van Zanden 2018), and environmental history (Richards 2003) that agree on interpreting the fifteenth century, with its travels, discoveries, and new commercial and economic links, as a turning moment in human history. The different sections thus explore architectural globalisation in the colonial and imperial eras (from a Western perspective, the "long sixteenth century" and the "long nineteenth century"), discussing colonisation, migrations, and knowledge exchange processes. We then observe the acceleration after World War II of Western architects' mobility in a decolonising world as well as the rise of the first global architects. They were not only what we call today 'archistars,' like Le Corbusier, but also figures presenting themselves as reliable experts, like Constantinos Doxiadis or Michel Écochard. We then close the chapter by examining the period between the 1973 Oil Crisis and the fall of the Berlin Wall, together with the collapse of the Soviet Union. This post-1973 world saw the rise of a new, extraordinary market for Western architects: the oil-rich Middle East. Such a rise provided a further push to architectural globalisation, which in many ways anticipated what would happen in the 1990s. One of the takeaways of this book is that architectural globalisation, or better, the globalisation of the architectural profession through the markets' expansion of the last thirty years, is different from the pre-1990s (or perhaps slightly earlier in regions like the Middle East). It is different qualitatively and quantitatively. This is what the next chapter examines.

Chapter 4 opens with the definition of emerging markets, a concept that partially overlaps with that of emerging economies, starting from the so-called BRICS countries (Brazil, Russia, India, China, and South Africa), but that also encompasses wealthy countries like some Persian Gulf states that, for the global architectural profession, have constituted an 'emerging' market. Specifically, the surveyed countries include China (mainland) and India; Indonesia, Malaysia and Vietnam in South-East Asia; Oman, Qatar, Saudi Arabia and the United Arab Emirates in the Middle East; Angola, Ghana, Ivory Coast, Kenya, Nigeria, South Africa for sub-Saharan Africa; Russia and Kazakhstan for Eurasia; Brazil, Colombia and Mexico for Latin

1.1 How to Measure Globalisation?

America. With this, we find a second delimitation of this study, which is geographical but, in a way, also conceptual. As said, we mapped the work of 1,025 firms from twenty developed, Western or Western-aligned countries in twenty emerging markets representative of different continents and, together, of approximately 56% of the world population and 30% of its GDP. Therefore, although the sample of countries is representative, we left a big part of the story outside our research.

The scope of this book, indeed, may appear as much narrowed down as to consider globalisation as a Western-led phenomenon. We did not explore, in terms of architectural production, the broader phenomenon of *mondialisation* as theorised by Nancy (2007); we did not study the many "globalisations" that exist (Pieterse 2004) and that allow Chinese firms to work in Africa and Europe, or Arab firms to work across the whole Middle East transcending national boundaries. For what concerns architecture, this has been thoroughly and pioneeringly reviewed by Stanek (2012; 2015) with regard to the agency of Eastern European architects in Africa and the Middle East during the Cold War, while Xue and Ding (2022) have led research on the export of Chinese architecture and engineering services since the 1970s. And many more cases, starting from the intra-regional flows and exchanges in the Middle East, would deserve new studies. With all this in mind, including the awareness of the limits of the present work, this chapter continues with the display of some data elaborated from our database (which includes 5,955 projects, nearly half of which were built) complemented with qualitative considerations. Figures show the increasing involvement of international firms in emerging markets, showing staggering growth in all regions since the early 2000s. At the same time, they allow us to distinguish and evaluate the different weights these markets have had for the global architectural profession. One case stands out among all: China and India have a similar size in terms of population (although quite different GDPs), but when it comes to the involvement of foreign architects, the distance between the countries exacerbates, with the former resulting the most important emerging market for international architects and the latter an almost insignificant one. And this is only a foretaste of what the reader will find in this chapter.

Indeed, the text will also focus on qualitative changes in the architectural modes of production brought about by advancements in transportation and communication technologies and by the digitalisation of the design process, as well as on the importance of having "boots on the ground" through office branches located in emerging markets. Before concluding with a comparative discussion of the performance of design firms from different countries, these two sections of the chapter will also highlight the traits of continuity and discontinuity between the pre and post-1990s world, once again to stress how the globalisation of architecture of the last three decades is inherently different from the past much like today's globalisation is different from the pre-1990s (Baldwin 2016; also Friedman 2008).

1.2 Contemporary Architecture and Its Geographies

The second part of this book could be read as a thematic history of contemporary architecture since the 1990s within determined geographic boundaries: the emerging markets, especially the twenty countries we surveyed. The five chapters display and discuss how architectural globalisation materialises in concrete buildings. Compared to many histories, this is broader, to the extent that it sometimes may the defined as encyclopaedic. We defend such a choice as being motivated by the will to display and discuss the quantitative dimension of contemporary production. The numbers involved are relatively big (five, a dozen, two dozen buildings for one firm) compared to the standard focus of architectural histories (one, two, or three buildings for most of them) but actually small for the creation of many significant statistics. For this reason, we make ample use of tables to display and understand the series. Again, the reader may find all this tedious, but we believe it necessary. In the second place, this history is thematic, organised into five chapters touching on five broad topics that allow us to cover most of the typologies on which design firms work. By doing so, we examine different geographies, problems, and responses. The question of authoriality, individual poetics and formal expressions shifts to the background of our narrative while production, outputs, quantities, and connections become central. Still, we never abandon the close reading, the comparative perspective, the theoretical debate, and the formal analysis typical of architectural historiography.

More in detail, Chap. 5 deals with the skyscraper, perhaps the best symbol of architectural globalisation, the one that perfectly materialises the image of global cities (Sassen 1991) and the aspirations of the "globalising" ones (Rennie-Short 2004, 3). Our extensive mapping starts with China, the country where most skyscrapers have been built, and the Middle East, the region where we find the tallest standing building. Several statistics are provided to understand trends and identify the key players, while the close reading remains limited to mega and supertall buildings and signature skyscrapers. The chapter then touches on Asia's many aspiring global cities—discussing their often-frustrated ambitions and the meaning of megaprojects in which the scale of the global and the local collides—but also Moscow and some Latin American centres. Finally, we discuss the experimental character, in terms of technology, typology, and form, of a few high-rise projects that fully exploited the opportunities provided by emerging markets: weaker regulatory frameworks, lower level of engagement and power of the public opinion, urban *tabula rasa*, capital availability, and desire to impress. Here, architects have found the conditions for the realisation of innovative buildings that would have barely been possible in the West. One paradigmatic case we will mention several times in this book is that of the CCTV tower designed by OMA in Beijing at the beginning of the twenty-first century. With this, more problems come under our lenses. They could be summarised as the (un)ethics of the skyscraper, allowing us to start a discussion about the ethical dimension in architectural practice, whether it regards politics, form, or the environment. One of the themes of this book, indeed, is how much the globalisation of the practice, together with making possible experimental buildings otherwise hardly

1.2 Contemporary Architecture and Its Geographies

buildable in European or US cities, has also fostered a wide-ranging debate on the ethics of architecture a couple of decades after the oblivion of the moral dimension of design promoted by postmodern theorists.

Chapter 6 investigates the architecture of art and culture, examining those iconic buildings that have multiplied worldwide with more and more cities competing to become the new Bilbao following the illusion of the replicability of the "Guggenheim effect." The boom in the construction of new museums in China, and the overall development of its cultural infrastructure of theatres, libraries and art centres, have been, in this regard, one of the drivers of the increase in the overseas demand for architectural services, especially for European and Japanese boutique architects. In the last decade, the Middle East has also provided fundamental opportunities with a few buildings extremely relevant from a qualitative standpoint. At the same time, for different reasons, other emerging markets had minimal quantitative relevance. Much like in the previous chapter, we can understand most of these projects according to the reality of competing cities, especially in Asia (Ong 2011). Chapter 7 explores a series of megaevents, from the Summer Olympic Games to International Expos, that, from China to Kazakhstan, from Brazil to the United Arab Emirates, attracted foreign architects. Overall, their broader legacies have been dubious from many perspectives and architectural outcomes relatively ordinary. Still, in addition to displaying the ability of some firms to deliver multiple projects (Populous' and GMP's impressive series of stadiums and sports facilities, for instance), these megaevents also represented catalysers for the debate on the ethics of the profession. The visibility they gave to architects came with the price of increased scrutiny by public opinion, NGOs, and some governments on human and labour rights and on the role that architects can and should play in improving them.

With Chap. 8, we delve into housing projects, from the new global typology of the residential supertall to gated communities of villas. By doing so, we focus on the housing market in China, a strength and, at the same time, an Achilles' heel of the Chinese economy, and explore how the problem of housing, from a key preoccupation and duty for modernist architects, has been transformed into a lucrative market for contemporary firms. In other words, the architecture of globalisation shows us the shift from housing as a moral duty for the profession to housing as a real estate product for an emerging global middle-class willing to live in deluxe buildings 'signed' by renowned architects. At the same time, the architecture of globalisation has also made possible the construction of extended mixed-use developments, which are relevant for the scale they allowed architects to work on and for materialising new pieces of the city, often of higher quality than their surroundings.

Chapter 9 explores the architecture of the workplace, starting from the office building, whose design still constitutes an essential source of work for several international firms that are well positioned for the delivery of projects characterised by efficiency and high environmental performances or a strong visual identity needed to communicate the company's values through architecture. Significant projects of office buildings also display the evolution of the typology along different paths, from the high-rise to the campus cluster and the single horizontal building. Horizontality, indeed, is the keyword of new organisational work patterns that emerged from Silicon

Valley and were adopted in many innovative companies. With obvious reflections on workplace design, such needs were best addressed by some North American firms. However, this chapter analyses a diverse set of typologies and programmes beyond the office building. A special place, for example, is devoted to what we call the new 'islands of knowledge production,' meaning morpho-typologically autonomous, sometimes enclosed, areas like the science and technology parks and university campuses. Among them, we primarily focused on Qatar Education City, a megaproject boasting an exemplary series of buildings designed by leading international architects. The chapter also includes an overview of industrial buildings and other facilities that generally escape from historical narratives for their limited aesthetic qualities, from data centres to hospitals.

By focusing on the architecture of leisure and tourism, the tenth and last chapter deals primarily with typologies that are also customarily neglected for their triviality, like shopping malls and theme parks. From our perspective, however, malls deserve more scrutiny, not only because overseas firms have delivered many projects in emerging markets but also for the role of this typology in creating centralities and what could be considered public space (although privately owned) in many cities of the Global South. With an eye on texts like Koolhaas' "The Generic City" (1995) and "Junkspace" (2004), the chapter delves into several more typologies related to tourism and leisure, starting from transportation infrastructures, primarily airports, to end with facilities related to business travels like the conference and exhibition centres. In the middle, an essential part of our analysis and reflections is concerned with hospitality architecture, discussing the relevance of the hotel typology for architectural globalisation, the role of certain firms dominating this sub-market, and the weight of China in it. By doing all this, we touch on themes related to local identities through architecture similar to those we discussed in Chap. 5.

1.3 Beginning with the End: Our Conclusions for a Multi-layer History of Architecture

The result of this book is a data-driven, multi-layer history of the architectural profession and its outcomes in our contemporary times, touching on multiple themes within precise geographies. It is undoubtedly a history of individual authors and extraordinarily unique architectural pieces. But it is also a history of corporate production and relatively anonymous buildings; it is a history of numbers and quantities that matter beyond quality. It is a history of the different modes of production of architecture and how they changed. It is a history of flows and exchanges (people, capital, services, knowledge). It is a history of cities and countries, their urban development and architecture. It is a selective history as much as it focuses on the work of firms from the Global North in emerging markets. Therefore, it excludes the work of these very firms within the territory of their home countries by not looking at what is done in Europe, Canada and the USA, Japan and South Korea, or Australia and New

1.3 Beginning with the End: Our Conclusions for a Multi-layer History …

Zealand. It neither investigates the architecture produced by designers from emerging countries in emerging countries. Nonetheless, it does not mean this book is entirely blind in this regard, as significant works produced in the West or those designed by architects from the Global South are often mentioned. Finally, this book does not touch on other fundamental aspects to investigate globalisation: academic networks, transnational research and education institutions, or travels.

The choice of buildings and cities we explore and analyse in these pages makes this book a journey in and a history of global and globalising cities, and many generic cities, too (sometimes they overlap). Ours, therefore, is a study of the architecture of many of these cities, from those more successful, like Shanghai or Dubai, to others struggling to actually rise on the global stage despite the presence of impressive skylines, like Moscow or Jakarta. And within them, it is also an investigation of specific parts of these cities, of certain districts and neighbourhoods: Shanghai Lujiazui, Beijing Chaoyang CBD, Kuala Lumpur City Centre, Doha Corniche, Dubai Downtown, Moscow IBC, Polanco neighbourhood in Mexico City. These are some of the places where globalisation materialised for (and was materialised by) design firms from the Global North. And to these places, we could add dozens of Chinese cities, the island of Bali in Indonesia, the Olympic Park of Rio de Janeiro, or an isolated gated community for expat workers in Angola.

As the book features partial conclusions at the end of every chapter, our general remarks are presented here instead of at the end of the book. The first set of reflections is about the globalisation of architectural markets. By the turn of this century, the whole world had become a potential market for design firms willing to engage with it. With the fall of the Soviet Union, a new immense territory opened to Western business. China's extraordinary growth and urbanisation and its access to the World Trade Organisation were up to creating the largest market on earth, including for the export of design services. Some Middle Eastern countries were on the rise, again, thanks to the increasing oil price, with centres like Dubai ready to become global cities. The BRICS, although quite ephemerally, seemed to anticipate the emergence of a new bloc in a multi-polar world. Several megaevents like the Summer Olympic Games, the FIFA World Cup, and International Expos were held in these emerging economies for the first time. As Richard Baldwin recognised a new phase in the process of globalisation from the 1990s, with this book, we argue about how different today's architectural globalisation is from that of a century ago or even post-World War II.

First of all, since the 1990s, and especially from the first decade of the new century, the output of firms from the USA, Europe, and the Asia–Pacific (Japan, South Korea, Australia) in emerging markets has surged, with China outweighing every other country and region in the import of architectural services. From our mapping, we counted 11 completed projects in 2000; 111 in 2010; 152 in 2019. Our sample of firms was responsible for the successful design of 3.5 million square metres of GFA in the triennium 1997–99 in China and the surveyed countries of the Middle East; it soared to 34 million in 2015–17 (Sect. 4.3). Such figures display a trend that clearly differentiates, in quantitative terms, the present condition from that of the past century. As Knox and Taylor (2005) explained, by the early 2000s,

the architectural practice had "a truly global" dimension, although different from other advanced business services. Above all, as they suggested, the globalisation of architectural practice was "at a relatively early stage." As McNeill (2009, 9) noted a decade ago, many large firms mostly rely on their domestic markets, and "the architectural world is still noticeably regionalised." In this regard, the 1990s can be seen as a transition period, in many ways still bound to the reality of the 1970-1980s. Despite geopolitical upheavals, the decade could be read as a sort of continuum from the 1970s, with the early 2000s as the actual moment in which the scale of the phenomenon dramatically changed. This is true quantitatively if we look at the outputs in emerging markets.

Nonetheless, for what concerns the modes of production, the 1990s marked a turning point that, again, consolidated in the following decade. The internet and digital technologies displaced architectural production, but not in the direction that Tombesi (2001) explained. Or better, we believe that the outsourcing of drafting and other services (including, more recently, rendering and visualisation) to lower-wage countries, as explained by Tombesi, has been less impactful than other factors, namely the geographical expansion of office branches, a phenomenon that has less to do with lowering costs (an expat architect can be rather expansive) and more with being in touch with the local market, client, and other actors, following the design and construction process, and procuring new commissions. As we thoroughly analyse in Chap. 4, at the end of the 1980s, some US megafirms opened their first overseas branch offices in London and Tokyo. Of course, they were not the first cases, but, again, quantitatively, what happened after 2000 is different, as our data and maps in Sect. 4.5 explain. As a result, since the 2000s, the activity of architectural firms has been spread across multiple office branches, primarily located in China and the Middle East, and, to a lesser extent, South-East Asia and India.

Together with connectedness (and the fact that multiple globalisations exist), however, we also want to highlight disconnectedness to not read this process as a unified and inexorable reality from which no swath of land escapes. Our data show that the African countries we surveyed were barely touched on by the activity of overseas architects (at least by those we mapped). More than this, we could notice pockets of globalisation within territories untouched by it. The internal geographies (internal to regions and nation-states) are diverse and divided. In China, the activity of overseas architects concentrated initially in Hong Kong, then Beijing and Shanghai, and by the 2000s to many more second and third-level cities (or tier, to use a common albeit unofficial category). Still today, we notice a pretty obvious concentration of projects in coastal China compared to the interior. In other countries, however, this divide is even more evident. In Malaysia, 77% of the built projects we mapped are located in Kuala Lumpur (84%, including those in nearby Putrajaya, the planned administrative and judicial capital of the country). It appears that the only globalised reality in Malaysia, when it comes to architecture, is Kuala Lumpur. In fact, the reality of the Malaysian economy and how its territory is exploited tell otherwise. Almost every piece of land is wholly integrated into the global economy, as evident from the over-extended plantations of palm trees and natural rubber and the industrial plants to process them for export. In Indonesia, a country of 273 million

1.3 Beginning with the End: Our Conclusions for a Multi-layer History …

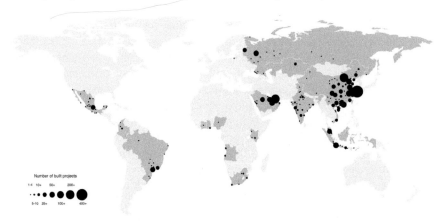

Fig. 1.1 Designing emerging markets, 1990–2020. A map with the location of built projects by surveyed firms overseas (surveyed emerging markets only). Copyright Giaime Botti

inhabitants extended over 17,000 islands, 60% of the projects are in Jakarta and 19% on the island of Bali. Overall, 71% of the projects are located in Java, which alone accounts for more than 50% of the Indonesian GDP. In this light, architectural globalisation is perhaps less pervasive than other forms of globalisation. Works by international architects concentrate within major urban centres and a few other locations (Fig. 1.1): these are where governments invest in grand public projects (museums, libraries, theatres) and real estate developers in office buildings, hotels, and signature housing. All in all, this concentration of imported design projects in specific regions of some emerging markets is in line with the idea that the current phase of globalisation should rather be defined as "regionalisation" (O'Neil 2022).

The second aspect related to this has to do with architectural culture. Along the book, we often suggest that the minimal involvement of overseas architects in Latin America, beyond macroeconomic reasons, may be due to the strength of the local architectural scene, intended as both the recognised quality of Latin American architects and their ability, through professional associations, to protect their prerogatives over foreign professionals. On the contrary, if we look at China in the early 2000s, we may wonder whether local architects could have taken over a variety of projects for which, either for technical know-how or formal creativity, overseas architects seemed better suited. Indeed, at that time, there was also a need to engage with the world and create the image of a new global China through architecture, something well visible in the changes recorded in magazines and other platforms (Botti 2022). Some processes appear as self-fulfilling. For instance, a major international recognition for a local architect through a consistent featuring in influential publications or the award of an important prize may push a developer or a potential client to choose that local firm rather than a foreign one. On the opposite side of the spectrum, public authorities can turn their eye inwards or outwards, especially for high-profile commissions in national capitals. Given its weight, what a country like China will do in the following decades will fundamentally affect the global architectural market.

About half of our 1,025 surveyed firms had some sort of overseas involvement in our selection of emerging markets (some had in other countries we did not map). Of these, a few dozen completed projects that we see as significant. There are a few hundred buildings whose visibility, due to location, typology, or media coverage, defined our perception of an architecturally globalised world. Again, this was due to both quality (in a neutral sense) and quantity (series, clusters). This leads us to some last remarks. According to common criticism, the architecture of globalisation is an architecture of homogenisation or sameness. In Sect. 2.4, we borrow from and adapt another text by Moretti (2005b, 221) to discuss the sameness of global architecture as a consequence of a process of diffusion from a core. Ponzini explains the processes of "transfer" and "decontextualisation" and their role in producing urban homogenisation. At the same time, Ponzini (2020, 259) also highlights the multiple urban nodes through which design solutions are further hybridised and re-circulated, making the process less Western-centric than normally assumed. Indeed, the circulation of projects is multi-directional. Solutions are exported from the cores, but often they return after multiple experimentations, which, for instance, allow to master the extra-large scale better. The case of KPF's mixed-use skyscrapers and complexes is emblematic. The megafirm itself explains how the massive 1.2-million-square-metre Hudson Yard re-development in New York that it master-planned—and the buildings it designed, including three skyscrapers and a commercial podium—was possible thanks to a three-decade-long experience initiated in Chicago with the 900th North Michigan Avenue tower and continued in Asia, first in Japan with the JR Central Towers & Station in Nagoya, and then in Tokyo, Shanghai (Plaza 66 and Kerry Centre; Sects. 5.1 and 9.2), and Hong Kong, before returning to the USA (KPF 2022). This leads to further reflections.

The architecture of globalisation is a mirror to look at the 'metropolis' and to reconsider problems that have long been neglected. The export of design services, especially in sectors in which some countries dominate the markets, unveils the sought-after identity of architecture. In this sense, as we see in Chap. 5, the fact that today the largest number of skyscrapers is no longer built in the USA but rather in Asia does not really put in doubt the primacy of the USA in this market. Yes, there are now more skyscrapers in Shanghai than in New York; yes, the tallest one is in Dubai and not in Chicago. But which firms have the know-how to dominate this market worldwide? Which firms have designed the tallest buildings? The projects for eight of the ten tallest towers were indeed elaborated by US firms: three by SOM and three by KPF alone. Furthermore, the overseas agency of architects has stimulated the debate on the ethics of the practice since the 1990s (Chaps. 5–7). The multiplications of commissions in countries with poor records on human and labour rights, the social consequences of megaevents on local communities, and the insensibility to the context of some works produced a new awareness within the whole ecology of the profession.

Working across continents made the present and future challenges of climate change more evident to architects. More than that, globalisation produces the absurdity of an urbanscape dominated by fully glazed skyscrapers in the desert. There are even buildings that, just to cool down, need ancillary multi-storey structures located

a few hundred metres away; a building purely serving another. Globalisation also reveals this. And it promotes an architecture that needs to face this reality due to its location: as Koolhaas (1995, 1262) stated, "the generic city is in a warmer than usual climate." We may even cynically see current high-performance buildings in the Middle East as experiments soon to be re-proposed in Southern Europe or the USA. All this happens amidst a multiplication of appeals for architects (Smith and RIBA 2021) to take climate action seriously. Calder (2023) has recently stressed that the real and only battle in contemporary architecture has nothing to do with style (classical versus modernist) but only with the environment: architecture that is dependent on fossil fuels and architecture that is not. Indeed, most of the architecture we see in this book is reliant on fossil fuels insofar as it was made possible by the wealth coming from their extraction. The architecture of globalisation is, in many ways, the architecture built when oil (the Middle East) or manufacturing (China) money meets with governments' (local and national) ambitions and an increasingly financialised real estate. Not by chance, a critical historical moment that we analyse in Sect. 3.4 is the 1973 Oil Crisis. A crisis for the West that was actually a boom for many Middle Eastern countries.

Finally, globalisation set the conditions (financial, regulatory, formal) for an experimental architecture barely possible outside emerging markets. The case of the Persian Gulf, where money is abundant, regulations are weak, and labour is cheap and disciplined (Molotch and Ponzini 2019), is the most extreme and the one producing some of the most stunning outcomes. No more exact words than those of Ching et al. (2017, 791) can be said: "The global commodification of prestige buildings should not lead us to dismiss the potential importance of these buildings in the history of architecture, for they are places where architects can experiment not only with new technologies but also with new ideas about program and function." While overseas work for architects like Le Corbusier, Alvar Aalto, Louis Khan, or Paul Rudolph in the past arrived at the climax of their career or in their mature, even declining phase, for many contemporary celebrities, it came in an earlier stage. In many cases, it was overseas work, especially in emerging markets, that offered opportunities still unavailable in Europe to architects and firms like Snøhetta with the Bibliotheca Alexandrina or in moments when their career was at the turning point like for Zaha Hadid with the Guangzhou Opera House, OMA with the CCTV, and Herzog & De Meuron with the "Bird's Nest" Stadium. Emerging markets provided the ground for experimentation and legitimisation for many "boutique" or "idea firms" that would soon transform into "celebrities." On the contrary, for megafirms, overseas projects, especially in emerging markets, represented more the consequence of expansion and geographical diversification.

In the end, despite the criticism it may engender, constructing an eight-hundred-metre-tall skyscraper like the Burj Khalifa represented an extraordinary technological enterprise. OMA's CCTV tower embodied not only a challenging and bold structural concept but also a formal and typological novelty, perhaps only equalled by Moshe Safdie's works in which horizontal volumes connected multiple skyscrapers, like in the Marina Bay in Singapore and the Raffles City in Chongqing, the closest materialisation of OMA's vision of the Hyperbuilding (Chap. 5). Mixed-use skyscrapers

are now a consolidated reality after two decades of experimentations in Asia. "Vertical urbanism" is a new keyword (Gensler n.d.; Tickle n.d.). The dense urban block typology has been questioned and challenged by Steven Holl's Linked Hybrid in Beijing (Sect. 8.6); middle-class mass housing by OMA's Interlace in Singapore (Sect. 8.5); the corporate office building by Holl's Vanke Horizontal Skyscraper in Shenzhen (Sect. 9.2). Museums of extraordinary formal complexity and visual qualities like Jean Nouvel's Louvre Abu Dhabi and Qatar National Museum (Sect. 6.2) have been used to replicate the Guggenheim effect at nth power. Whether this will happen, they set a new standard for cultural buildings. In this light, rather than on the architecture of resistance to globalisation, we want to stress the creative and experimental character of the architecture of globalisation. An architecture that was possible thanks to the formal and financial freedom that emerging markets and their wealthy patrons granted. All this, without ever forgetting its many dark sides.

References

Adam, Robert. 2012. *The Globalisation of Modern Architecture: The Impact of Politics, Economics and Social Change on Architecture and Urban Design since 1990*. Newcastle-upon-Tyne: Cambridge Scholars Publishing.

Baldwin, Richard. 2016. *The Great Convergence. Information Technology and the New Globalization*. Cambridge, MA; London: The Belknap Press of Harvard University Press.

Botti, Giaime. 2022. "Changing Narratives: China in Western Architecture Media." In China's International Communication and Relationship Building, edited by Xiaoling Zhang and Corey Schultz, 199-215. London: Routledge.

Calder, Barnabas. 2023. *Both sides in the style wars are equally wrong*. Dezeen, Jan 12. https://www.dezeen.com/2023/01/12/architectural-styles-classical-georgian-modernism-climate-eme rgency-barnabas-calder-opinion/?utm_source=linkedin&utm_medium=linkedin&utm_cam paign=register&utm_content=ap_ho3fu263u8. Accessed 25 Jan 2023.

Ching, Francis D.K., Mark M. Jarzombek, and Vikram Prakash. 2017. *A Global History of Architecture*, 3rd ed. Hoboken: Wiley.

de Zwart, Pim, and Jan Luiten van Zanden. 2018. *The Origins of Globalization. World Trade in the Making of the Global Economy, 1500–1800*. Cambridge: Cambridge University Press.

Flynn, Dennis O., and Arturo Giráldez. 1995. Born with a 'silver spoon:' The origin of world trade in 1571. *Journal of World History* 6 (2): 201–221.

Foster, Hal. 2011. *The Art-Architecture Complex*. London: Verso.

Friedman, Thomas L. 2008. The World Is Flat: A Brief History of the Twenty-First Century 2Nd rev. and expanded ed. New York N.Y: Farrar Straus and Giroux.

Frampton, Kenneth. 1983. Towards a critical regionalism: Six points for an architecture of resistance. In *The Anti-Aesthetic. Essays on Postmodern Culture*, ed. Hal Foster, 16–30. Port Townsend, WA: Bay Press.

Frampton, Kenneth. 2020. *Modern Architecture: A Critical History*, 5th ed. London: Thames & Hudson.

Fraser, Murray, and Nasser Golzari, eds. 2013. *Architecture and Globalisation in the Persian Gulf Region*. Farnham: Ashgate.

Furet, François. 1971. Quantitative history. *Daedalus* 100 (1): 151–167.

Gensler. n.d. *Vertical urbanism and the livable cities of tomorrow*. Gensler. https://www.gensler.com/blog/vertical-urbanism. Accessed 17 Jan 2023.

Hobsbawm, Eric J. 1975. *The Age of Capital, 1848–1875*. London: Weidenfeld and Nicolson.

References

King, Anthony D. 2004. *Spaces of Global Cultures: Architecture, Urbanism, Identity.* London, New York: Routledge.

Knox, Paul L., and Peter J. Taylor. 2005. Toward a geography of the globalization of architecture office networks. *Journal of Architectural Education* 58 (3): 23–32.

Koolhaas, Rem. 1995. The generic city. In *S, M, L, XL*, ed. Office for Metropolitan Architecture, Rem Koolhaas and Bruce Mau, 1238–1267. New York, NY: The Monacelli Press.

Koolhaas, Rem. 2004. Junkspace. In *Content*, ed. Rem Koolhaas, Brendan McGetrick and Simon Brown, 162–171. Cologne: Taschen.

KPF. 2022. *Under one roof. The evolution of the mixed-use building.* KPF, July 21. https://www.kpf.com/story/mixed-use. Accessed 5 Sept 2022.

McNeill, Donald. 2009. *The Global Architect: Firms, Fame and Urban Form.* New York, NY: Routledge.

Molotch, Harvey, and Davide Ponzini, eds. 2019. *The New Arab Urban. Gulf Cities of Wealth, Ambition and Distress.* New York, NY: New York University Press.

Moretti, Franco. 2005a. *Graphs, Maps, Trees: Abstract Models for Literary History.* London: Verso.

Moretti, Franco. 2005b. World-systems analysis, evolutionary theory, 'Weltliteratur.' *Review (Fernand Braudel Center)* 28 (3): 217–228.

Nancy, Jean-Luc. 2007. *The Creation of the World, or Globalization.* Albany, NY: State University of New York Press.

Office for Metropolitan Architecture, Rem Koolhaas, and Bruce Mau (eds.). 1995. *S, M, L, XL.* New York, NY: The Monacelli Press.

O'Neil, Shannon K. 2022. *The Globalization Myth: Why Regions Matter.* New Haven: Yale University Press.

Ong, Aihwa. 2011. Introduction worlding cities, or the art of being global. In *Worlding Cities: Asian Experiments and the Art of Being Global*, edited by Ananya Roy and Aihwa Ong, 1–26. Chichester; Malden, MA: Wiley-Blackwell.

Pieterse, Jan Nederveen. 2004. *Globalization or Empire?* New York, NY: Routledge.

Ponzini, Davide. 2020. *Transnational Architecture and Urbanism. Rethinking How Cities Plan, Transform, and Learn.* London: Routledge.

Raisbeck, Peter. 2020. *Architecture as a Global System: Scavengers, Tribes, Warlords and Megafirm.* Bingley: Emerald Publishing.

Ren, Xuefei. 2011. *Building Globalization. Transnational Architecture Production in Urban China.* Chicago: The University of Chicago Press.

Rennie-Short, John. 2004. *Global Metropolitan: Globalizing Cities in a Capitalist World.* London, New York, NY: Routledge.

Richards, John F. 2003. *The Unending Frontier. An Environmental History of the Early Modern World.* Berkeley, CA: University of California Press.

Rudofsky, Bernard. 1964. *Architecture Without Architects: A Short Introduction to Non-Pedigreed Architecture.* New York, NY: MoMA.

Sassen, Saskia. 1991. *The Global City: New York, London, Tokyo.* Princeton, NJ: Princeton University Press.

Sklair, Leslie. 2017. *The Icon Project: Architecture, Cities and Capitalist Globalization.* New York, NY: Oxford University Press.

Smith, Maria, and RIBA (eds.). 2021. *Built for the environment. Addressing the climate and biodiversity emergency with a fair and sustainable built environment.* RIBA.

Spencer, Douglas. 2016. *The Architecture of Neoliberalism: How Contemporary Architecture Became an Instrument of Control and Compliance.* London: Bloomsbury.

Stanek, Łukasz. 2012. Miastoprojekt goes abroad: The transfer of architectural labour from socialist Poland to Iraq (1958–1989). *The Journal of Architecture* 17 (3): 361–386.

Stanek, Łukasz. 2015. Architects from socialist countries in Ghana (1957–67): Modern architecture and mondialisation. *Journal of the Society of Architectural Historians* 74 (4): 416–442.

Tickle, David. n.d. Superdensity: A new model for vertical urbanism. *Hassell.* https://www.hasselstudio.com/uploads/RP_170329_UrbanFutures_Superdensity_e.pdf. Accessed 17 Jan 2023.

Tombesi, Paolo. 2001. A true south for design? The new international division of labour in architecture. *Arq: Architectural Research Quarterly* 5 (2): 171–179.

Wallerstein, Immanuel. 1974. *The Modern World-System: Capitalist Agriculture and the Origins of the European World Economy in the Sixteenth Century*, vol. 1. San Diego, CA: Academic Press.

Xue, Charlie Q.L., and Guanghui Ding. 2022. *Exporting Chinese Architecture—History, Issues and One Belt One Road*. Singapore: Springer.

Part I
Gauging Architectural Globalisation

Chapter 2
Towards a Quantitative Turn: Frontiers of Architectural Historiography

How to write a history of contemporary architecture challenging consolidated practices, specifically focusing on the architectural modes of production and addressing the problem of globalisation is one of the questions behind this book. In the present chapter, we present the theoretical foundations of our work and approach. In the following pages, therefore, we first discuss the most updated historiographic trends that embrace history as a global problem, defining an overall framework to investigate the specificities of architectural historiography in the age of globalisation. As architecture transforms into an increasingly global phenomenon, new issues arise, and new methodologies are required, not least to question traditional historiographic paths aimed at establishing a selected canon of authors and works representative of a historical period and, very often, of a nation. The new modes of production that reshuffled the organisation of the architectural profession have been investigated by a growing scholarship. Examining and gauging an expanding transnational architectural production is one of the current challenges for the historian.

In this light, the methodological proposal of this book borrows from the tradition of serial history as well as from recent works in literary studies to enrich and diversify the tools in the hands of the architectural historian. Indeed, this study advances a methodology rooted in quantitative analysis and data visualisation as a strategy to investigate the architecture of globalisation. At the same time, it never disregards a "close reading" of works and the emphasis on their significance typical of the tradition derived from art history. In the final part of this chapter, we will then present the rationale behind the construction of the sample of architectural firms on which this research is based: a selection of over one thousand architectural firms of different business typologies, based in twenty countries of Europe, North America, and the Asia-Pacific region. As a result, this study represents the most up-to-date and comprehensive work on architectural globalisation today available. Still, this awareness comes together with the frank acknowledgement of potential flaws and limits in our methodology.

© The Author(s), under exclusive license to Springer Nature Singapore Pte Ltd. 2023 19
G. Botti, *Designing Emerging Markets*,
https://doi.org/10.1007/978-981-99-1552-1_2

2.1 World History, Globalisation, and Architectural Historiography

Since the publication of *The Outline of History* (1901) by Herbert G. Wells, the twentieth century has constantly developed a historiographic scholarship free of the blinders imposed by national historiographies. Early works by Spengler (1922) and Toynbee (1934–1961) overcame the national boundaries to focus on "civilisations" or "societies" as the basic units of historical development, showing the path for McNeill's (1963) *The Rise of the West*. This was later followed by Wallerstein (1974), whose politico-economical approach introduced the paradigm of the "world-system". Such scholarship, and several other works whose detailed discussion would exceed the scope of this brief review, increasingly challenged not only the idea of considering the state-nation as the basic unit on which history is constructed but also, although timidly, the central position given to Europe in history. It will be, in fact, with the end of the twentieth century, not least after the emergence of postcolonial and feminist thoughts, that these approaches will consolidate in the current paradigms of "world history" (Manning 2003) and "global history" (Mazlish and Buultjens 1993; Conrad 2016). The former consists in "the story of connections within the global human community" (Manning 2003, 3), while the latter, beyond producing an all-encompassing history and studying exchanges and connections, proposes a narrower approach that focuses on "global integration," recognising that "there have always been cross-border exchanges, but their operation and impact depended on the degree of systemic integration on a global scale" (Conrad 2016, 10).

Today, these approaches are facilitated by the availability of new insights into global linkages that materialised in several ways, from trade, as in the trans-Atlantic slave networks (Curtin 1969), to the spread of diseases (Crosby 1972; Diamond 1997). It is, therefore, up to the historian, "like an electrician," to connect the threads, encompassing both the local and regional scale on the one hand and the supra-regional and the global on the other, as proposed by Sanjay Subrahmanyam (1999). Given this ample and diverse framework, the next step is to position the historiography of architecture within this debate. Indeed, while the debate about "world" and "global" history continues (Mazlish 1998), sometimes in a relatively unproductive and nominalist fashion, not alien to—ironically!—national and linguistic controversies, the most critical point is understanding that "world" and "global" refer to scales and scopes that not only transcend national political boundaries (the world as the object of research) but also involve a cross-disciplinary approach that relies on multiple perspectives, as well evident in environmental history, which could not exist without contributions from geography, climatology, biology and so on (Douki and Minard 2007).

Hence, as we are not trying to evade the definition of the keyword of this book, 'globalisation,' we must now delve deeper into its meaning. Globalisation can be defined as the growing transnational interdependency and integration in every sector of human life. Globalisation is, therefore, a multi-faceted phenomenon. In economic terms, it is visible not only in the growth of international trade but also in the creation

2.1 World History, Globalisation, and Architectural Historiography

of truly global value chains, on which virtually every complex industrial product relies, from a smartphone to an aeroplane. Compared to previous globalisation (pre-1990s), today, intra-factory flows of goods, ideas, know-how, and investments have been replaced by international flows that have de-nationalised competitive advantages and shifted values towards services (Baldwin 2016, 144). Globalisation is also a political phenomenon, with tangible aspects in the gradual loss of sovereignty by the nation-state in favour of supranational entities (Hardt and Negri 2000), whether the United Nations or the European Union. Not least, globalisation is a social and cultural phenomenon (Castells 2010), tangible in the massive migrations undergoing across the planet or in the ubiquity of consumerism, with the same fashion brands worn all over the globe, or the presence of Coca-Cola bottles and McDonald's restaurant from the Brazilian Amazon to Chinese mountains. Still, McDonald's itself is becoming increasingly transnational, part of a culture that is neither local nor imported (Watson 1997). Furthermore, beyond 'Americanisation' (David 1993) and the power of the "irresistible empire" (De Grazia 2006), we acknowledge the existence of a multiplicity of globalisations. As Pieterse (2004, 38) writes, "contemporary globalization means not just Westernization but also Easternization, as in the influence of Japanese and East Asian forms of capitalism. Besides, 'the West' is not unified." Furthermore, we could add Chinese-led globalisation, too.

The concept of *mondialisation* as expressed by Lefebvre (2009) and Nancy (2007), explains the emergence of a world horizon in which the global (or the world making itself "worldly") is not only the result of the outreach of multinational corporations or US imperialism but of a multiplicity of actors that "experience" the new world dimension through urban protests, cultural revolutions, ecological disasters. Moreover, in recent times, not only globalisation as a process has been fought and questioned (from Brexit to "America first"), but the role of global history has been critically reassessed by its leading figures. As Adelman (2017) pointed out, cheering globalism also produced monsters and today the historian should better emphasise how together with integration and connections also come disintegration and disconnections. The Global Dis:Connect Research Centre at the Ludwig Maximilian University of Munich, for instance, "focuses on the deep significance of the interstices that emerge from the simultaneity and co-constitution of integrative and disintegrative elements," because "each process of integration bears elements of disintegration and disconnection within it" (gd:c n.d.). Sebastian Conrad (2016, 210) explains the critical relationship between the rise of global history and globalisation and the risks of a "collusion" of the former with the latter, exactly like national history emerged together with the nation-state. Such a critical stance, indeed, will hopefully emerge also from this book, despite its inherent interest in processes and phenomena of integration and exchange.

At this point, a typical question arises: when did globalisation emerge in history? In this regard, the debate is intense, and positions are distant. Some scholars see globalisation as if it has always existed since the antiquity (Held et al. 1999), while others believe it is a more recent phenomenon, dating back to the nineteenth century (O'Rourke and Williamson 2002). According to Richard Baldwin, the nineteenth century and the "steam revolution" unleashed a chain of transformation that, across

one century and a half, and with a setback between 1914 and 1945, created what we call modern globalisation. In the middle, many consider it a phenomenon of the early modernity (de Zwart and van Zanden 2018), intrinsically connected with the colonisation of the Americas. Moreover, the foundation of Manila in 1571 by establishing a "direct trade link" between the Americas and Asia, created the conditions for the rise of a true world market based on silver, mined in America and exported to Asia and China by Europeans through both Oceans (Flynn and Giráldez 1995). Environmental history also identifies such a threshold in early modernity since Alfred W. Crosby's milestone *The Columbian Exchange* (1972), which shed light on the exchange of plants, animals, and diseases across the Atlantic and the Pacific Ocean after the colonisation of America. In early modern times, the "global scale and impact of human intervention in the natural environment" assumed an "unprecedented" dimension. The access to previously unused and unknown natural resources paired with the increased efficiency in maritime connections generated growing outputs able to meet rising demand, while ecosystems around the globe were transformed at an unprecedented depth and pace (Richards 2003, 58–76). In the end, globalisation is a debated problem, especially when it comes to its periodisation. In this regard, one of the most critical tasks is exactly to "circumvent the false conundrum" between those who see globalisation as "a recent phenomenon and a feature of the modern era" and those who believe that "men, goods, and ideas have always circulated, and that the phenomenon is nothing new" and "identify periods of expansion and regression, of opening and closing" in order to periodise and historicise globalisation (Douki and Minard 2007). Globalisation, indeed, is not "an irreversible movement" in one direction (Bairoch 1996, 190).

This concise introduction to globalisation and historiographic approaches dealing not only with the global scale but also with a renewed way of investigating our past should serve to jump to the younger and less-mature discipline of architectural historiography. On the one hand, its youth has hindered it from fully acknowledging specific paths undertaken by general historiography already decades ago. Architectural history originated as a branch of art history during the nineteenth century (Crinson and Williams 2019). For these reasons, too, it has struggled to get rid of several limitations due to its origin, from the insistence on authorship and creation by few, which reminds us of the history of 'heroes' that the Annalist tradition eradicated, to the sustained need of constructing national canons representing the values and essential features of the architectural production of a country. Still, under the deforming lenses of imperial times, architectural historiography has nonetheless embraced a global dimension since the end of the nineteenth century. Even before this moment, architectural treatises have begun to display extra-European buildings on their plates, with Johann Bernhard Fischer von Erlach's *Entwurff Einer Historischen Architektur* (1721) likely standing as the first treatise to reach as far as China and Japan. Then, by the late nineteenth century, the first global historical accounts were produced: Fletcher's (1896) *A History of Architecture on the Comparative Method* and Choisy's (1899) *Histoire de l'architecture*. Later on, the emergence of the so-called "Modern Movement" and its historiography (Hitchcock and Johnson 1932; Pevsner 1936; Giedion 1941) that in the following decades "canonised" its production

(Scalvini and Sandri 1984; Tournikiotis 2001) affirmed that modern architecture was "international" (Gropius 1925; Hilberseimer 1928; Hitchcock and Johnson 1932). By doing so, however, historiography also affirmed that it was Western.

To explain this, we need to look at the following generations of historians. We could use a quotation from Curtis' (2000, 491) *Modern Architecture Since 1900*, as Hernández's (2021) did in a recent insightful article: "the modern movement in architecture was the intellectual property of certain countries in Western Europe, of the United States and some parts of the Soviet Union." As Hernández continued to explain, the "relationship of dependency" (Hernández 2021) of non-Euro-Atlantic modernism resulted in "transformations, deviations and devaluations of modern architecture" according to Curtis (2000, 491). In this framework, the presence and appreciation, or lack of it, of Latin American modernism within histories of modern architecture represents an excellent example of how narrow has remained the scope of mainstream narratives during decades. Re-reading Liernur's (2008) essay "It's the Viewpoint, Stupid!" is a good exercise to bring into focus the problem of the construction of canons—a vital issue discussed further below—in terms of geographic amplitude. That means understanding the (un)balance of power within historiographic scholarship between Euro-Atlantic centres and global peripheries. Moreover, Latin America does not represent the only significant case, as more studies are emerging from and on other regions of the Global South (Lu 2011). Specific gaps and unbalances are evident along more extended chronologies. For instance, Lara (2021) analysed and measured the presence of America—North and South—in architectural historiography since Banister Fletcher's text and up to the present most diffused books. The result is that there is barely any. However, as pointed out by Lara, the scholarship is changing, and a few general histories (Ching et al. 2017; James-Chakraborty 2014; Ingersoll and Kostof 2018; Fazio et al. 2003) now feature a genuinely global outlook.

Such a preamble may sound contradictory given the scope of this book, which in fact, analyses the architectural production from Western or Western-aligned, high-income countries in emerging markets, most of which are part of the so-called Global South. Someone may see this history as the history of a renewed process of colonisation, no longer based on the need to export the industrial surplus in exchange for raw materials, but of accommodating an over-supply of expertise in the contemporary service economy. Is this not the case if we think that Spain and Italy alone have more architects than the whole of China? However, there are other crucial issues at stake. This book primarily deals with the process of globalisation of the architectural practice seen through the perspective of the involvement of overseas firms in a selected but broad and representative sample of emerging markets (Sect. 4.1). Accordingly, one of the aims is gauging architectural globalisation and its historical evolution during the last three decades while understanding what has changed compared to fifty, eighty, or a hundred years ago. To do so, the proposed approach is based on a mix of quantitative and qualitative analysis. Such an outlook not only provides new and insightful data that produce an original perspective but also helps reshuffle the construction of current architectural canons. In other words, it helps write a distinct history of architecture of the recent past compared to consolidated narratives. The rest of this

chapter, therefore, will be dedicated to the discussion of these intermingled issues, which concern architectural historiography and the problem of globalisation, and the need to innovate our research methodologies, crossing the boundaries of disciplines and embracing a quantitative approach also in writing the history of architecture.

2.2 Architectural Historiographies and Globalisation: Still Grasping the Surface?

The globalisation of architecture has been, explicitly or implicitly, discussed by several authors in the last decade. One of the first and most comprehensive books, Adam's (2012) *The Globalisation of Modern Architecture*, provided an overview of architectural globalisation that highlighted the importance of geopolitical and economic changes that occurred since the 1990s and touched on several intermingled themes related to the profession and its celebrities, cities competing on the global stage through iconic buildings, and reactions to these trends. On the other hand, several authors have primarily focused on the phenomenon from the point of view of the architectural modes of production and work organisational patterns. In this regard, McNeill's (2009) *The Global Architect* offered an early account of the split at the top of the professional 'food chain' between large firms ("megapractices") and architectural "celebrities" for the design of cultural icon and landmark skyscrapers across the world. Along this line, more studies have followed. A recent book by Raisbeck (2020), *Architecture as a Global System*, unlike McNeill's text, stresses the full participation in the global architectural market also of actors located at a lower level of the professional ladder. Ponzini's (2020) *Transnational Architecture and Urbanism* deeply explores mechanisms of transnational design in which firms working across multiple locations provide an almost standardised set of solutions to legitimise urban operations that, in any case, adapt as they respond to the local context, with its actors and regulations. Such a transnational production relied on a "personification" strategy based on the idea that the architect's expertise and fame— and the same extends to urban experts, notes Ponzini—can successfully produce the transformation so keenly sought after. The Barcelona model, so successfully exported worldwide, especially in Latin America, is a very good example (Silvestre and Jajamovich 2022). Indeed, with a more limited scope, other authors had already delved into the emergence of new geographies of production (Knox and Taylor 2005) and forms of the international division of labour in architecture (Tombesi 2001; Tombesi et al. 2003), while a longer timeframe within a more limited focus has been adopted by Cody (2003) in a pioneering study on the export of design and engineering services by US professionals across the world.

Assuming different approaches, other authors have also dealt with the problem of (architectural) globalisation focusing more on its ideological, political, and social aspects. Anthony D. King, in his *Spaces of Global Cultures* explored, through a

2.2 Architectural Historiographies and Globalisation: Still Grasping …

variety of case studies (not limited to the last decades) and a multiplicity of lenses, how "architectural and building cultures […] are affected by transnational processes," investigating the cultural effects of transplanting architecture, the "larger political, social and economic forces" behind, and how such practices are "accepted, resisted, rejected, indigenized and hybridized" (King 2004, xvi). The transnational dimension of urban megaprojects across the Pacific Rim has been previously examined by Olds (2002), who illustrated how flows of capital, images, and property development expertise reshaped cities. New "spatial products" well beyond the standard typologies of architecture have been recognised as the global outputs of an architect- "orgman" (William H. Whyte's "organisation man" as nicknamed by Harold Rosenberg) that "derives a pioneering sense of creation from matching a labor cost, a time zone, and a desire to generate distinct forms of urban space, even distinct species of a global city" (Easterling, 2008, 2). More recently, Douglas Spencer (2016), with *The Architecture of Neoliberalism*, has exposed the contradiction of a "friction-free space supposed to liberate the subject from the strictures of both modernism and modernity, to reunite it with nature, to liberate its nomadic, social and creative dispositions, to re-enchant its sensory experience of the world" that characterises contemporary architecture and the current neoliberal order, of which architecture becomes the "scenography." In this light, such a "shared understanding of subjectivity has furnished architecture with the opportunity to design and build for the continued expansion of neoliberalism into the worlds of work, education, culture and consumption, both in the West and beyond, within the territories latterly exposed to its influence" (Spencer 2016, 1–2). The link between contemporary architecture and international capital has been highlighted by British sociologist Sklair (2005, 2006, 2017), according to whom the construction of iconic buildings designed by celebrated architects is today driven by the needs of a transnational capitalist class rather than those in control of the state (or religion) as in the pre-global era. Sklair thus connects iconic architecture to a specific form of globalisation, contemporary "capitalist globalisation," and to a transnational capitalist class composed of overlapping categories like the "corporate fraction" of prominent architecture firms and starchitects, a "state fraction" of politicians and bureaucrats, a "technical fraction" that also includes academics, and a "consumerist fraction" of the media and marketing world. In the end, not surprisingly, themes such as the tall building or the iconic museum return across all these texts, and in the present book too, as they emerge not only as a consequence of globalisation, with cities competing in the world arena to attract highly mobile capitals, but also as products of an increasingly globalised architectural practice.

However, dealing with the history of architectural globalisation does not mean taking a snapshot of the present but also understanding how we got there. At the same time, it means more than simply expanding the geographical scope of the survey in order to present a truly global, geographically all-encompassing overview of contemporary architectural production. In other words, it is not just a question of expanding the canon. What is at stake is the need to establish a different narrative, which assumes the contemporary modes of production and the unique conditions that globalisation provides as a point of departure. The following section will discuss how architectural practice has changed its business and organisation models. How

different the globalisation of architectural practice has been before and after the 1990s will be explored in Chap. 3 and the rest of the book. That said, the key point to highlight here is that the architecture of globalisation exploits a precise condition, and as such, it should be investigated. Some of the most remarkable buildings of the new century have been designed by architects based in Europe, the USA, or Japan but have been built in countries that we define here as emerging markets (Sect. 4.1). This fact cannot be overlooked as a banality because it likely represents one of the most notable conditions of contemporary architectural production. In this regard, we want to stress that the architecture of globalisation is not the one that some authors have pointed out by highlighting new formal trends emerging at the global scale in the last few decades (Ibelings 1998; Migayrou and Brayer 2003). It does not matter at all if the architecture of Frank Gehry, Richard Rogers, and Norman Fosters embodies a new "global style" replacing the "International Style" of Le Corbusier's, Walter Gropius', and Ludwig Mies van der Rohe (Foster 2011). Following the limited perspective of form, architecture has always been globalised. In fact, we want to explore buildings and their production beyond (although not excluding) forms.

In the introduction, we mentioned OMA's CCTV building in Beijing as a significant case for understanding architecture's new and unique condition in the age of globalisation. More on the project will come further ahead (Sect. 5.7), but one issue must be highlighted for the moment. The CCTV is the perfect example of why the architecture of globalisation represents a phenomenon that requires its own historiographic lenses. Such a project was conceived by a team led by one of the most clever and sophisticated thinkers in the architectural realm, Rem Koolhaas. The project, somehow, was the final product of ideas that Koolhaas started elaborating in the 1970s and that, before materialising in a building, were explored in theoretical texts like *Delirious New York* (1978) and "Bigness, or the Problem of Large" (Koolhaas 1995). On the other hand, the project, which took more than a decade to be completed, was developed by OMA's partner Ole Scheeren from the Beijing office branch, which was set during the process (2002–2012). Nevertheless, that project, although somehow "theoretically" proceeding from reflections originated in the encounter of European and North American architectural culture (Koolhaas' biography is well-known), would never have been possible either in Europe or the USA. China, like many other countries, most of which are included in this book, offered Western architects new and extraordinary opportunities, unseen in the West since the post-World War II reconstruction, to experiment in scale, form, and typology. Accordingly, the history of contemporary architecture, meaning that of the last thirty-forty years, is, to a large extent, the history of these new opportunities. Or at least, it should be.

Major works of Western historiography have sometimes assumed a rather critical and negative position or a pretty hurried one. Looking at Frampton's (2020) new and updated edition (5th) of his milestone *Modern Architecture: A Critical History*, it appears clear that the contemporary production worth mentioning is, in fact, the one opposing globalisation. Thus, the history of architecture has been turned into a history of the "resistance" to globalisation. For Frampton, "critical regionalism" became a

2.2 Architectural Historiographies and Globalisation: Still Grasping ...

crucial category in the architectural debate and a legitimising category for the productions of architects escaping from the logic of globalisation in both the developed and the developing world. This successful category—because relatively flexible, among other things—was originally put forward by Tzonis and Lefaivre (1981), then championed and made famous by Frampton (1983), and quickly appropriated in different contexts, especially in Latin America, where "critical regionalism", although rejected as such (Segawa 2005; Zambrano Torres 2015), was actually further re-elaborated as "appropriated" (Fernández Cox 1987), or "other modernity" (Browne 1988), with an unequivocal political stance in front of the forces of globalisation, from which Latin American architecture was "diverging" (Waisman 1987) rather than (passively) resisting as claimed by Frampton. Thus, his book ends with a chapter on "Architecture in the age of globalization" that somehow encompasses everything but the authors and works carefully selected as representatives of the many countries studied in this new edition. That extended part (Frampton 2020, 366–616), which follows the chapter on critical regionalism, is, in fact, used to highlight practices that are critical and regionalist in their essence (Frampton 2020, 368).

Other books end with longer or shorter chapters on globalisation, too.[1] Ching et al.'s (2017) *A Global History of Architecture* concludes with a chapter ("Globalization Today") in which the authors identify seven current trends, starting from the anonymous architecture of real estate and engineering firms as well as of megafirms to that of the archistars, from the work of NGOs to that of small, local firms. In the background is the awareness that some of the "small firms" cited, from EMBT to Atelier Bow-Wow, work globally (EMBT even has a branch office in Shanghai). Furthermore, Cohen (2012, 469) recognises how also medium- and small-size firms now work at a "transcontinental scale to survive," but the conclusive part of his *A Future of Architecture: Since 1889* is too rushed to engage with the problem of globalisation deeply. Similarly, James-Chakraborty's (2014, 472–488) *Architecture Since 1400* ends with a chapter on globalisation dedicated to Chinese global cities. As relevant as the case is, and undoubtedly is, such a treatment of the problem is not satisfying. Fazio et al. (2003, 564) also conclude their *A World History of Architecture* with a paragraph on "Architects working in China" after having defined a section (organised by architects as the whole last part of the book) "Form-making elsewhere" (548), suggesting, but not actually explaining, the rise of transnational architectural production. Finally, Ingersoll and Kostof (2018, 918), in the last part of *World Architecture: A Cross-Cultural History*, propose some reflections on the role of multinational architecture firms and star architects designing museums, seen by authors as sort of contemporary "cathedrals."

On the other hand, non-Western scholarship focused on specific regions (having thus the opportunity of going deeper compared to general histories) has dealt with

[1] That is not the case in Watkin's (2005) *A History of Western Architecture*, in which, except for some mentions of Japanese architects and SOM's Hajj Terminal of the King Abdulaziz International Airport in Jeddah, does not engage with architecture outside of the West, in agreement with its title. Indeed, at the end of the book, Watkin recognises that in the twenty-first century, "leading architects work in all countries, breaking down national barriers, so that is no longer possible in a book of this kind to divide the sections by country or nation" (685).

the problem of globalisation more productively. Drawing upon postcolonial theories, scholars have displayed architectural entanglements across the globe. Zhu (2009, 129–198), for instance, has highlighted the theoretical exchanges between China and the West that happened during the 1990s and early 2000s, when Chinese architects assumed western "criticality" while influence from Asia through figures like Koolhaas has supported "post-criticality" in the West. Indeed, globalisation has been too much of an issue to escape narratives in several architectural histories of contemporary China. In addition to the work of Zhu, we find the focus on the "impact" of overseas design in China in the studies of Xue (2006, 30–48; Xue and Li 2008; Xue et al. 2021), or the concerns (although not profoundly explored) recognised by Han (2019, 23–41) with the distinction between "Chinese architecture" and "China's architecture". The work of Ren (2011) represents one of the most valuable examples of how we can learn from sociology to investigate contemporary architectural production and globalisation. Continuing to glance at the relationship between one major global consumer of architectural services—China—and one of the key centres of their production and delivery—The Netherlands—another text can be analysed. In Haddad and Rifkind's (2014) *A Critical History of Contemporary Architecture: 1960–2010*, certain limits emerge. The organisation of the narrative by nation-states is undoubtedly logical, clear, and intuitive[2]; at the same time, it perhaps makes us neglect a part of the story. For instance, the chapter on China (Zhu 2014) only briefly touches on the contribution of foreign architects and the one on Dutch architecture remains focused on projects primarily located in The Netherlands (Hsu 2014). The result is that little comes to the surface about the agency of Dutch firms like MVRDV, OMA, or UN Studio—certainly among the most global and influential—in the world scenario. Little emerges about the role that non-Western markets, and China especially, had in allowing these firms to grow, experiment, and eventually complete projects that could have been barely done in the West or that could have been proposed, but only after that these firms have gained, through successful projects in the emerging markets, the professional legitimisation needed for such enterprises. In this regard, another region that allowed architects to almost experiment with their visions freely has been the Middle East, and Dubai and Abu Dhabi in particular. It is, therefore, not surprising to find in the literature dealing with the region a deeper interest in the problem of globalisation (Fraser and Golzari 2013; Molotch and Ponzini 2019).

[2] And of course, there are plenty of good reasons to organise a book as such, even more in the case of edited works collecting texts from different authors.

2.3 Architectural Modes of Production in the Age of Globalisation: Sociology and Ethnography of Practice

Every architectural historian writing a 'history' faces at a particular moment a question: Whom should the architectural historian write about? This decision, based on several factors—not least, the historian's bias towards certain regions, periods, architectural languages, theoretical positions, or even individual architects—will define a canon. In this framework, using quantitative methods allows one to question established narratives exclusively based on qualitative assumptions and expand their scope. Before doing so and discussing the methodological framework of this book, however, the previous question has yet to be answered. This is undoubtedly a complex task as it implies manifold reflections, going deep into the essence of architecture and its contemporary modes of production. The long-lasting problem of distinguishing between 'architecture' and simple 'building' is an excellent example of how the scope of any research could be broadly expanded or relatively restricted. In his history of Italian architecture, Manfredo Tafuri (Tafuri 1986, 123) highlighted that his narrative was devoted to a selected group of Italian architects whose work *de facto* represented a small proportion of the already small number of cubic metres every year built in Italy following an architect's plan.[3] Florent Champy (2001) described a very similar phenomenon in France, with architects not only by now responsible for less than one-third of the total volumes of construction but also subject to increasing competition from other professions (engineers, façade specialists, landscape designers) boosted by a growing division of labour. And this is not all.

The transmission between high and low profession and the appropriation of the architects' formal vocabulary by a larger public of builders have been documented, for example, in Brazil, where it originated a sort of "popular" modernism, according to Lara (2008). This case represents an example of a phenomenon that would usually escape from historiography based on selected great names. It has been argued (Lara 2018) that such popular involvement somehow defined a unique feature of Brazilian modernism, which is different from the uniqueness typically explained as the diffusion of a certain formal repertoire in the profession (Goodwin 1943; Mindlin 1956). As Elleh (2014, 22–23) reminds us, there are two different histories of (modern) architecture. The first one, "which is the reigning voice on modern and contemporary architecture—is the elitist version of architectural history. It depends on glorifying the works produced by trained architects, the cognoscenti;" the second one "is completely ignored in existing architectural history textbooks. The most rigorous debates on the topic sidelined the parallel realities that the project conceived and built by the urban poor were contemporaneous with the celebrated architectural objects in our history books." Let us think about who actually built Chandigarh or Brasilia, besides and outside their great modern monuments and master plans, Elleh

[3] In the country, *geometri* (professional figures with high-school degree comparable to surveyors) and civil engineers too can sign off building plans.

continues. Following this path, how not to mention the interest in the vernacular, the "architecture without architects" that Rudofsky (1964) celebrated in the 1960s. More recently, and not without some polemics (Hancox 2014), architectural scholarship has engaged with the issue of informality and what it could teach to professionals from Latin America (Hernández et al. 2010; Gyger 2009; McGuirk 2014) to Africa (Koolhaas and Cleijne 2008; Heisel and Kifle 2016).

These cases explain the urgency of considering more broadly the actors involved in the construction of the built environment. In this sense, again, we would have to assume a wide-angle lens. Political decision-makers, real estate developers, final users, and people affected by projects but with little power are all potential stakeholders whose position, interests, and agency would deserve larger space in our histories. This is what, for example, Kathleen James-Chakraborty (2014, xviii) does, emphasising the importance of multiple actors (clients, patrons, builders, users) sharing "responsibility for the creation and maintenance of buildings." In this book, our primary focus will remain on the architects, in the broadest sense, thus including, for example, large EAC (Architecture, Engineering & Construction) firms, but from time to time, we will not avoid considering the role of other actors, starting from consultancy firms and real estate developers. In order to do so, we need to learn from other disciplines, starting from the economy, sociology, and even ethnography. Although we have not undertaken any ethnographic investigation here, we rely on the literature that has explored the modes of production of contemporary architecture through the lenses of sociology and the ethnography of practice. Studies in this area date back to the 1980s, when Blau (1984) published *Architects and Firms*, based on a survey of over 400 firms in New York. Although they remain overall limited, we can mention Gutman's (1988) *Architectural Practice: A Critical View*, Cuff's (1992) *Architecture: The Story of Practice*, and the essays collected by Saunders (1996) in *Reflections on Architectural Practices in the Nineties*. More recently, Yaneva (2009) published *Made by the Office for Metropolitan Architecture: An Ethnography of Design* and Houdart and Chichiro (2009) *Kuma Kengo: An Unconventional Monograph*.

In this light, the first point to consider is that of authoriality in a profession where the architect as a sole practitioner, or leading figure of a small atelier, is no longer the main and only form of work organisation. On the contrary, the profession is now dominated by large integrated architecture, engineering, planning, and construction firms, with multiple partners relying on a broad range of external consultants. Therefore, while architectural histories traditionally focus on 'authors', a growing scholarship has been engaging with the current modes of production, dealing, for example, with large integrated companies, or "corporate architecture" (Kubo 2014), also labelled as "megapractices" (McNeill 2009) or "megafirms" (Raisbeck 2020). This opposition reminds us of the famous dichotomy presented in the late 1940s by Hitchcock (1947), who recognised the necessity of not limiting the historian's outlook to the architecture of the "genius" but also to that of "bureaucracy." Similarly, it may be argued that the current architectural system splits at the top level between the "celebrities" (McNeill 2009), "archistars" (Lo Ricco and Micheli 2003), or "warlords" (Raisbeck 2020), and the work of megafirms. If the former deal with authorship and values of artistic

2.3 Architectural Modes of Production in the Age of Globalisation: …

creation, the latter rely on a greater degree of anonymity, something that architectural histories generally dislike (except for Giedion 1948). Other authors (Coxe et al. 1986) have described architecture firms in relation to their delivery process as "strong-idea," "strong-service," and "strong-delivery." It is easy to recognise the professional 'stars' in the first category, whose product is "singular expertise or innovation on unique projects." The second and the third one can be both assimilated to the typology of the megafirms. "Strong-service" firms sell their "experience and reliability, especially on complex assignments." If we identify them with the megafirm, we agree with the authors on the comprehensiveness of their services. Still, we argue that such comprehensiveness is based on the work of specialised departments able to deal with the planning, design and construction phases (and not on simple projects teams). The "strong-delivery" type, finally, according to the authors provides "highly efficient service on similar or more-routine assignments, often to clients who seek more of a product than a service." In our view, it can also be identified with a megapractice, but one with a less cutting-edge approach and more routine and serial outputs (malls, housing, industrial buildings, prisons, military facilities) that rarely come to the attention of the architecture media and academic circles.

Beyond (and below) these two poles, however, the largest share of the profession is made by several more architects. Looking at them, Peter Raisbeck has identified other two categories of significant actors in the global "ecology of practice:" "scavengers" and "tribes." The first ones are the solo practitioners (usually white men) driven by the pursuit of fame but busy with a day-to-day fight for professional survival amid the volatility of the macroeconomy (Raisbeck 2020, 23–38). Tribes, instead, consist of networks of medium size firms (5 to 50 employees) that produce architectural knowledge and innovations from their work across communities and from collaborative practices (Raisbeck 2020, 39–64). In many ways, they also represent what other authors have identified as "boutique" firms (Larson 1993), medium size practices of some significance within the architectural system, also defined as "idea firms" in the USA by the end of the 1960s. They may be identified by browsing selected architectural magazines (and websites) and gauging the consistency of their featuring (Ren 2011). The result would be a list of small-to-medium size firms (although with exceptions) often led by internationally acclaimed architects, including Pritzker Prize winners, but also emerging firms led by young architects as well as small practices that have been on the scene for decades. Regardless of the nomenclature, it is essential to remember that even minor actors have been involved in the logic of architectural globalisation, sometimes getting their small slice of the cake.

As a large share of the projects mapped in this book have been produced by megafirms, we need to understand better what they are. To do so, rankings of firms by size constructed upon data on employees and fee income[4] provide us with helpful information. In the US, the first-ranked Gensler had U$1.19 billion in fee incomes in 2017, followed by Perkins & Will with U$551 million and HKS with U$410 million.

[4] Different rankings provide figures referring to slightly different indicators, being fee incomes and turnover the most common ones. In the text, we will thus use these different measures according to the available data.

At the bottom (149th), Kostow Greenwood Architects gained 1.5 million US\$ (BD+C 2018). In the UK, the highest-ranked firm, Foster + Partners, gained £164 million in fees in 2018, Atkins 109, Grimshaw 64, and companies in the 50th percentile about 8 million (Architects' Journal 2018). In Italy, the top-two firms, Lombardini22 and One Works, had a turnover of about €15 million, followed by RPBW with approximately 13; companies in the 50th percentile did not exceed 2 million (Norsa 2019). In France, AREP leads with a turnover of €63.5 million in 2017, followed by RPBW with 44,[5] and Valode & Pistre with 35.2; companies around the 50th position boast revenues of about €6 million (Dá Magazine 2019). Two graphs help visualise such information. The first one (Fig. 2.1) compares revenues from the top hundred US firms with fee incomes from the UK's top hundred.[6] In the first graph, we notice the huge gap between the first ranked and the following ones for the USA, but also how the top-three players in the USA had much higher revenues than their British counterparts. A consistent gap also remains in the top-ten firms, while from the 20th percentile, the gap starts closing at first sight. However, when we look at the 50th-ranked firms, we notice that the American one had revenues of U\$34 million against U\$10.8 million of the British one, meaning three times more. The same gap remains at the 100th position, where we find a U\$13.9 million to U\$3.8 million.

If we analyse the same indicators but referring to the UK, France, and Italy (Fig. 2.2), we notice that the first-ranked British firm earned three times as much as the first from France, which in turn earned 3.8 times as much as the highest-ranked Italian company. At the 25th percentile, a French company earns twice as much as an Italian one and half as much as a British company. At the 50th percentile, the gap between British and French firms is much smaller (10.8–7.3 million U\$), while Italian firms are well behind (2.8 million U\$). At the 75th percentile, the gap between British and French firms is almost closed (6.6 million U\$ against 5.5), with Italian firms still lagging (1.7 million U\$). In the 100th place, a French firm earns more than a British one. In the end, these two graphs display some interesting clues. They clearly show how much bigger a US firm is (or how much more it earns) compared to a European one, even if from the UK. More importantly, data show the current polarisation of the architecture market. In many ways, we got used to reading in the press about the top 1%, that small group of lucky people owning impressive wealth. It has been calculated that the top 10% in Europe and the USA own respectively 35 and 50% of all income (from both labour and capital), with the top 1% alone owning 10

[5] To be noted that RBBW, like other firms with a transnational structure, is present in both Italian and French rankings. We can also see that, depending on the firm's corporate structure, revenues can be calculated differently in relation to their origin. In the case of RPBW, it seems that the Italian rank only considers the turnover of the Italian branch based in Genova (but not necessarily only from projects in Italy), while the French one either considers the overall turnover of the firm or the one of the Paris branch, which is larger than the Italian one.

[6] In Figs. 2.1 and 2.2, data refer to different indicators: revenues for the USA, fees incomes for the UK, and turnover for France and Italy. Despite these differences, the comparison is meaningful to understand the variable size of these firms' businesses. All data are in US Dollars (U\$); for values in British Sterling Pound (£) and Euro (€), we operated a conversion at the average exchange rate of 2018 (2017 for France, as data refers to that year).

2.3 Architectural Modes of Production in the Age of Globalisation: ...

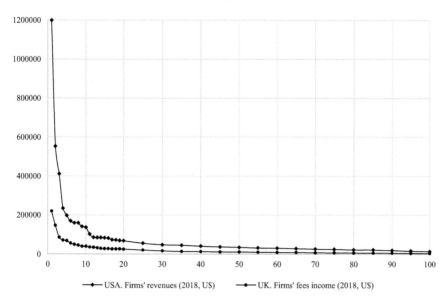

Fig. 2.1 Revenues/fee incomes by top US and British firms in 2018 (x values refer to the position in the ranking, with values expressed for the first ten firms ranked and then for those in every five percentiles; y values refer to revenues/fee incomes in U$)

and 20% of the total (Piketty 2014, 311). Should someone be not convinced by the parallel with individual wealth, consider that in 2017 the five biggest IT companies listed on the Nasdaq made up about 40% of the index's capitalisation (Sen 2017). Thus, it would not be strange at all to detect a similar concentration of income also for large architecture firms.

Hence, we can see in parallel how polarised the architecture market is today. To make the revenues of the top-three US firms, for example, more than the sum of the revenues of the following sixteen firms in the ranking is needed. To make the fee incomes of the top-three British firms, we need the next nine in the ranking. In other words, few are able to get a disproportionate share of the cake, while many have to compete for the remaining. As Raisbeck (2020, 26–27) pointed out, the Great Financial Crisis of 2007–08 and the Great Recession that followed were not felt in the same way by all. Overall, "scavengers" are the most subject to macroeconomic volatility, while megafirms and starchitects have been able not only to navigate the tricky waters of economic downturns but also to expand their market share. The polarisation of the architecture market in terms of income is also visible in some more data from an AIA report cited by Raisbeck: even though some eight years after the crisis the majority of American firms have returned to profitability, most of them have only "modestly" increased their income.[7] In this regard, Raisbeck also refers to the findings of Cuff (2014, 93), who explained that American "architecture practice

[7] Some evidence shows that, in the context of growing financial pressure on professionals, including architects, there is "no direct correlation between professional accomplishment and income" and

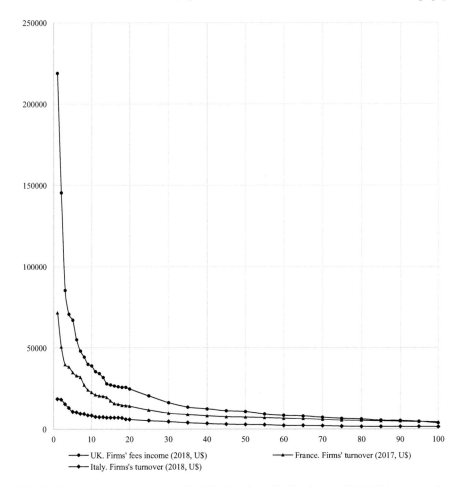

Fig. 2.2 Fee incomes/turnover by top British, French, and Italian firms in 2017–18 (x values refer to the position in the ranking, with values expressed for the first ten firms ranked and then for those in every five percentiles; y values refer to fee incomes/turnover in U$)

shrank and consolidated into the very largest firms" while the overall number of individual practices declined.

Polarisation, therefore, manifests itself in different ways across the profession. However, there is no automatism, as architects, especially the ones with a specific positional power, can still make choices. The diverging trajectories of different Pritzker-laureate architects can be used as an example. Foster + Partners developed into a megafirm more than a decade ago, as already McNeill (2009) recognised, while Zaha Hadid Architects, with a 400-people staff, could also be considered one; OMA is moving in this direction too, with 275 employees and five offices. Renzo

for architects, professional values still matter, making them identify more with the profession (and its ethics) than with entrepreneurial activity (Ötsch 2015, 169).

Piano's RPBW, on the contrary, did undoubtedly grow over the years, but the current employment of about 150 people suggests a clear choice in terms of self-imposed limits. And then, we find Pritzker winners that worked as solo practitioners like Paulo Mendes da Rocha and Glenn Murcutt or in small ateliers like Peter Zumthor. It is also interesting to note that only a few architecture firms have gone public and are currently listed in any major stock index. Regretfully, there is not much data on this, nor studies. Raisbeck (2020, 122), for example, quickly mentions the case of AECOM and Sweco. Indeed, looking at the first twenty US and Canadian firms ranked in 2020, only AECOM, Stantec, and IBI Group are publicly traded (while Callison RTKL is a subsidiary of the Dutch Arcadis NV, which is publicly traded at Euronext NV). The majority, instead, are private companies with a traditional governance structure composed of a partnership board and a hierarchy of partners and associates (Raisbeck 2020, 122), some are employee-owned companies. With this in mind, we can now discuss the theoretical and methodological approach of this book.

2.4 Towards a Quantitative and Cross-Disciplinary Approach: From Serial History to the Digital Humanities

By promoting a quantitative approach to architectural history, this book turns away from the traditional historiographic approach of constructing a representative canon based on the selection of some buildings and authors in a broader professional panorama. The methodological proposal underpinning the present work moves away from the close focus on great personalities or single architectural pieces in order to investigate something broader. This, of course, does not mean that the whole built production should assume the same value for the eyes of the historian, nor it implies a loss of criticality in the analysis. On the contrary, it means adopting a new methodological framework. One of the reasons behind this choice is that the very conditions of architectural production have irremediably changed, and the output of today's design firms is growing fast. This is not necessarily a new problem, as prolific architects have always existed. Half a century ago, at his death, Le Corbusier had completed 79 buildings in eleven countries and drawn a further 215 proposals. Frank Lloyd Wright, an extraordinarily prolific professional, had likely completed more than four hundred buildings, mainly in the USA. On the other hand, another master of the "Modern Movement", Ludwig Mies van der Rohe, completed a handful of works between Europe and the USA, plus one in Mexico. In our present, contemporary firms' output keeps growing in numerical terms and geographically expanding. Since 1978, OMA has produced 530 designs (by the end of 2022). However, if in the mid-1990s, the average output was less than seven projects per year, by now, it has more than doubled. To provide other figures, Skidmore, Owings & Merrill's website lists over 452 projects and Gensler's 585 under the categories of architecture and

urban design services. Willy-nilly, the theme of quantity and how to gauge, grasp and evaluate it can no longer escape from the historian's sight.

To address these and other issues, our proposal borrows from different disciplines. For instance, the word 'canon' is repeated several times in this text. Canon is a crucial concept in literary studies, as it originates as a representative selection of written texts aimed at setting a standard (*kanón* in ancient Greek). Therefore, it may be constructive the proposal of turning an eye towards this field. More specifically, the enlightening work of Moretti (1998) on the European novel and world literature becomes an unmissable point of departure. Moretti (2005a, 3–4) criticises scholars' literary knowledge based on a minimal number of books, often accounting for small percentages of national literature. In other words, he questions the canons on which literary scholarship is commonly built. According to him, such knowledge, by focusing on individual cases, does not allow us to grasp "the collective system [...] as a whole." Hence, the proposal of shifting from a "close" to a "distant reading" as a "specific form of knowledge." Following these suggestions means abandoning a traditional approach based on the highly detailed reading of a small sample of strictly selected works and initiating the investigation of large samples in quantitative terms, exploiting all the available instruments, including the computational ones. Furthermore, Moretti proposes using graphs (3–33), maps (35–64) and other diagrams to understand and visualise data. This a suggestion that we will follow in the present study: while maps establish a link with geography—and globalisation cannot be understood without geography–, graphs connect to quantitative history, a key methodological reference for this book.

In this regard, a quantitative approach does not represent a novelty in historiography, having been intensively discussed since the late 1960s (Erickson 1975) and then somehow abandoned, as Piketty (2014, 576) noted with regret discussing the legacy of French historian François Furet. At that time, without computers, Piketty reminded us, data were more difficult to collect and, above all, to process. As a result, much effort was put into collecting and sorting data rather than into its historical interpretation. On the contrary, today, a simple excel spreadsheet may save work hours, while artificial intelligence may soon replace the researcher in the tedious work of collecting data. In this perspective, it is essential to present "serial history" as a fundamental methodological reference. Back in the 1970s, Furet explained how the historian could use series that are not "structurally numerical" in a quantitative fashion (Furet 1971, 159):

> But the data of quantitative history refer not to some external, vaguely outlined "fact" but to internal criteria of consistency. A fact is no longer an event selected because it marks a high spot in a history whose meaning has been predetermined, but a phenomenon chosen and sometimes constructed by reason of the recurrence which makes it comparable with others in terms of some unit of time (Furet 1971, 155).

In addition, Furet foresaw how the digital revolution accompanied this process and could help its development. This theme allows bridging our approach with current trends in the digital humanities, of which the work of Moretti is a fundamental point of departure.

2.4 Towards a Quantitative and Cross-Disciplinary Approach: From Serial … 37

Indeed, while our data have been tediously and manually collected, digital worksheets have allowed quicker management of numerical results that are also presented through multiple graphs scattered across the book. While the methodology adopted to collect data and quantitatively study the architecture of globalisation will be discussed in the next section, its results will be presented in Chap. 4. There, we will operate a distant reading of the contemporary architectural production in emerging markets, to continue throughout the second part of this book with a blending of close and distant reading. In this regard, we believe that architectural historiography should never abandon the close reading of works. Moretti (2022) himself, by recently doing a balance of a decade of quantitative studies in the (digital) humanities, has shown a critical appraisal of the results, highlighting, for example, the void analysis of contents that characterises some studies or how anomalies escape quantitative research. With this in mind and a certain ambition, as briefly mentioned in our introduction, our work intends to challenge architectural historiography's limits and frontiers, proposing a narrative that distances itself from traditional studies. At the same time, we will 'traditionally' stick to the idea of writing a history of architecture, i.e., of significant buildings (we will get back on this very soon) within a historical and geographical—and so cultural, economic, social, and environmental—context.

Conjugating close and distant reading means bringing some scientific rigour from, for example, economic and environmental history—two among the historiographies that rely on hard data—into architectural historiography. Gordon (2016), to explain the change in the standard of living of American households during the "special century" (1870–1970), hinted at the need to introduce qualitative indicators (in any case measurable) to better reflect improvements that would otherwise escape statistics. On our side, we tried to add reliable quantitative indicators to investigate a qualitative problem such as architectural globalisation. In this regard, architectural historiography is today adopting new methodologies and exploring previously unknown territories. Several authors, for example, have proposed 'environmental histories' of architecture. Drawing on a tradition that goes back to Banham's (1969) *The Architecture of the Well-Tempered Environment*, authors like Overy (2008) with *Light, Air and Openness: Modern Architecture Between the Wars*, Fernández-Galiano's (2000) *Fire and Memory: On Architecture and Energy*, Prieto (2019) with *Historia medioambiental de la arquitectura* and Barber (2020) with *Modern Architecture and Climate: Designing Before Air Conditioning* have proposed new general narratives about architecture or modern architecture framed through the lenses of the thermodynamic and material exchange between architecture and the environment. Along similar lines, other authors have gone even further in questioning how we should today investigate the material production of architecture. In an inspiring text, Ockman (2022) defined this approach as the "political ecology of architecture." In practical terms, following one of the cases cited in the article, this entails questioning how the Guggenheim Bilbao, rather than only originating from a sketch on a napkin by a genius architect, an operation of a museum franchise, and the ambitions of a Spanish city, arose from the combination of all these together with the presence of some Russian titanium on the market. Some titanium that was later shipped to the USA to be chemically

treated and laminated and then to Spain, where an Italian-Spanish contractor digitally cut it before it was assembled in Bilbao. This type of perspective in these last years has been used to study one of the greatest masterpieces of modernism, Mies van der Rohe's Seagram Building. The New York skyscraper became the object of a healthy form of historical revisionism under which it was investigated to point out its immensely energy-intensive functioning (Calder and Urban 2022) and the extent, carefully documented and measured, of the "terrestrial" exchange—rooted in global asymmetries between developed and developing world—at the material and thermodynamic level that was embodied in its construction (Moe 2020).

As for the 'significance' of buildings, here lies one remarkable difference with a historiographic tradition of architecture fully engaged with a close reading of the architects' work. Of course, our intention is not to write about everything creating an impossible encyclopaedia of globalisation, nor to give the same weight to every architect and firm regardless of the quality of their work. What we do stress, instead, is the idea that we can study a particular aspect, even the significance of certain buildings, through the investigations of series. As a result, while certain buildings represent relevant examples that would have anyway deserved the honour of a close reading due to many possible reasons, starting from formal ones, others become relevant insofar as they are elements of a series. A series of buildings scattered across the world designed by a firm (the more than forty built supertalls designed by SOM); a series of buildings concentrated in an area of a city like a CBD or a waterfront, designed by a bunch of firms (Moscow International Business Centre, Kuala Lumpur City Centre, Downtown Dubai). This is the distant reading, the "specific form of knowledge" that Franco Moretti envisions. Moreover, it is surprising how world-system theory applied to literature can help us reflect on architecture-related problems. For Moretti (2005b, 221), according to the world-system analysis, "the world becomes *one*, and unequal: one because capitalism constrains production everywhere on the planted; and unequal, because its network of exchanges requires, and reinforces, a marked power unevenness among the three areas [core, semi-periphery, periphery]." Moretti follows by explaining how world literature is a system "unified but unequal," with a system of "diffusion" from the core to the periphery imposing "a stunning *sameness* to the literary system." Should we change the word 'literature' with 'architecture,' we would have an astonishing match in many of the issues we often hear about when it comes to the architecture of globalisation, starting from the 'sameness' of design throughout the world (according to processes of "transfer" and "decontextualisation" mentioned by Ponzini 2020). Nonetheless, there is also something in which we detect a different reality. Speaking about the "asymmetry" of this literary system, Moretti states that "powerful literatures from the core 'interfere' all the time with the trajectory of peripheral ones, whereas the reverse almost never happens, making the inequality of the system grow over time" (221). Indeed, despite an undeniable asymmetry between cores and peripheries in contemporary architecture, the "interference" also from the periphery is undeniable today. Moreover, it is an essential element in the logic of architectural globalisation insofar as the experimental conditions enjoyed in the emerging markets immensely contributed to many architects' professional success and legitimisation.

2.5 Gauging 1000+ Architectural Firms: A Representative Sample

The present chapter represents the most appropriate place to discuss the rationale behind the construction of the statistical sample that provides the quantitative foundation of this study. As mentioned in the Introduction, our research is primarily based on the quantitative analysis of the work of 1,025 firms of different business models and positions based in twenty countries. The survey covers practices from North America (Canada and the USA), fourteen European countries (Austria, Belgium, Denmark, Finland, France, Germany, Italy, Norway, Portugal, Spain, Sweden, Switzerland, The Netherlands, and the UK), and the Asia Pacific Region (Japan and South Korea, Australia and New Zealand). In other words, this study involves architectural firms based in high-income countries. With just 12.5% of the world population (952.9 million inhabitants), their total GDP (U\$48.3 trillion) accounts for 55% of the global output. From a historical perspective, these countries represent the so-called "First World" for their level of economic development and their position during the Cold War within the Western Capitalistic Bloc.

Then, the number of surveyed firms varies by country to provide statistical value to our findings. The size of every sample changes primarily according to the country's population, with a ratio of one company surveyed per one million inhabitants. However, a series of correctives have been added to this primary ratio. For instance, the number of firms has been weighted to account for more companies for smaller countries and less for bigger ones.[8] This allowed to enlarge the sample's size for small but influential-in-the-field nations, like Denmark, Portugal or The Netherlands, and to decrease it in highly populated ones. A positive weighting factor has also been introduced to reflect differences within the professional environment. Specifically, a 0.1 factor has been used, also cumulatively, each time a country meets one of the following conditions: (1) The presence of a higher-than-average number of architects[9]; (2) The presence of at least two Pritzker Prize winners between 1990 and 2020; (3) The presence of more than ten companies in the world top hundred rankings (Table 2.1).

[8] The range of population has been divided in three intervals (N = 1, N = 2, N = 3), with N = 1 for <20 million inhabitants, N = 2 for 20–100 million and N = 3 for > 100 million. The scaling factor obeys a simple inverse arithmetic progression: namely, the number of firms is equal to the million inhabitants of the country under consideration multiplied by 3/(N + 1).

[9] This has been calculated on the average architects-population ratio among 18 European countries, which is currently 1.11. We chose to use this value as a benchmark because European firms represent the largest batch and because of the completeness and consistency of the available data (Architecture Council of Europe 2018). Statistics on the countries have also been collected and refer to different years of the 2010s decade. For the USA, data referring to 2014 have been retrieved from (National Council of Architectural Registration Boards 2014); for Australia (Architects Accreditation Council of Australia 2018). Other data derives from the famous *Monditalia* exhibition curated by Rem Koolhaas at the Venice Architecture Biennale of 2014 (Quirk 2014), while for Japan, we referred to another source (Braw 2014).

Table 2.1 Number of surveyed architectural firms per country

	Population (in millions)	N. of architects (2018)	Architects-population ratio	Basic n. of surveyed firms	Population multiplier	Architects-population ratio multiplier	>2 Pritzker (1990–2020)	>10 Top100 firms (2013)	Final multiplier	Final n. of surveyed firms
Australia	24.98	13,567	0.54	25	1				1	**25**
Austria	8.84	5,400	0.6	9	1.5				1.5	**14**
Belgium	11.42	14,800	1.28	12	1.5	0.1			1.6	**19**
Canada	37.06	15,000	0.4	38	1				1	**38**
Denmark	5.79	10,300	1.8	6	1.5	0.1			1.6	**10**
Finland	5.51	3,600	0.65	6	1.5				1.5	**9**
France	67.1	30,000	0.46	67	1		0.1		1.1	**74**
Germany	82.90	112,200	1.33	83	1	0.1			1.1	**91**
Italy	60.42	160,000	2.64	60	1	0.1	0.1		1.2	**72**
Japan	126.81	300,000	2.37	127	0.75	0.1	0.1		0.95	**120**
The Netherlands	17.23	10,600	0.61	17	1.5				1.5	**26**
New Zealand	4.90	2,111	0.43	5	1.5				1.5	**8**
Norway	5.31	3,825	0.7	5	1.5				1.5	**8**
Portugal	10.28	23,000	2.27	10	1.5	0.1	0.1		1.7	**17**
South Korea	51.08	N.A.	N.A.	52	1				1	**52**
Spain	46.79	55,700	1.19	47	1	0.1	0.1		1.2	**56**
Sweden	10.17	6,750	0.67	10	1.5				1.5	**15**

(continued)

2.5 Gauging 1000+ Architectural Firms: A Representative Sample

Table 2.1 (continued)

	Population (in millions)	N. of architects (2018)	Architects-population ratio	Basic n. of surveyed firms	Population multiplier	Architects-population ratio multiplier	>2 Pritzker (1990–2020)	>10 Top100 firms (2013)	Final multiplier	Final n. of surveyed firms
Switzerland	8.51	7,400	0.86	9	1.5		0.1		1.6	**14**
UK	66.46	41,000	0.6	66	1		0.1	0.1	1.2	**79**
USA	326.83	141,700	0.43	327	0.75			0.1	0.85	**278**

As for the composition of our dataset, it has been constructed to encompass different forms of practice and to be as representative as possible of a global and diverse architectural market. It results from cross-checking multiple sources, ranging from global and national rankings by revenues, used to identify the largest architectural companies, to international-prizes winners, up to watch list on the internet (from websites and platforms like *Archdaily/Plataforma Arquitectura, Dezeen, Divisare*). Our dataset thus includes almost all the firms from our sample of surveyed countries (78 on 80) listed in the world's top hundred EC companies ranking elaborated by *BD* in 2013 (Pastorelli 2013). This ranking thus spans from AECOM (1,370 architects employed, >U$400 million in fee incomes) at the top, followed by Gensler (1,346, >U$400 million) and IBI Group (1,129, U$160–169 million), to Diamond Smith Architects (96, U$20–29 million) at the bottom. Looking at this side of the practice, we can notice that megafirms are concentrated in the USA and the UK, which boast 40% of the world's top hundred architectural companies in size. In comparison, Japan and South Korea account for 11%, the other European countries together (excluding the UK) for another 18%, with the rest scattered in Singapore, India, UAE, and China (Hong Kong especially). In this regard, it is interesting to note that by 2020 the average size of these megafirms has considerably grown (Building Design 2020). Gensler, now ranked first, has 2,817 employees, Nikken Sekkei, now second up from the fourth position of 2013, passed from 1,109 to 1,910 employees, and its fee incomes increased from the range of U$400–499 million to U$500–599. Another novelty is the growing number of firms from the Chinese mainland now ranked.

Our dataset, however, is much broader than this. Referring to the year 2018, it includes, for example, almost 90% (138 on 149) of the top-hundred-and-fifty US Architecture firms (BD+C 2018); 96% of the top-fifty British firms (Architects' Journal 2018); 90% of the first fifty firms ranked in Italy (Norsa 2019); the 80% of the French (Dá Magazine 2019). For Germany, rather than a ranking based on size, we started from the one elaborated every bimester by the platform *BauNetz* measuring the influence of architecture firms.[10] Thus, our sample includes 41 of the top fifty firms of 2019 (BauNetz 2019a).[11] From the international ranking elaborated by *BauNetz*, we have included 53 of the first 100 firms (BauNetz 2019b). Working on this type of list, on the one hand, is helpful because it provides a sample not based on size but rather (at least this is the idea of such a ranking) on quality; on the other, it is clear that firms from Germany, Austria, and Switzerland are over-represented. For the rest, in terms of professional influence, it has been easy to identify other significant players of the field: Pritzker Prize winners since 1990 and EU Mies van der Rohe Prize-awarded architects have been included, too. Regarding the Pritzker-awarded architects, all the winners based in the twenty surveyed countries have been

[10] The methodology used by BauNetz is clearly explained. Its German ranking is based on six German magazines, while the international one is on two German and six international magazines, with also different weighting factors (BauNetz No Year).

[11] This low number is due to the fact that *BauNetz*'s top hundred includes firms from all over the world and not only from the countries we surveyed (even though it remains rather Eurocentric overall).

2.5 Gauging 1000+ Architectural Firms: A Representative Sample

included, except for, going backwards in time, Frei Otto, Jørn Utzon, Sverre Fehn, Robert Venturi, Aldo Rossi, and James Stirling. All in all, the multiple sources used to create our dataset ensure a wide representativity for our sample, which includes all the top global players for size (top hundred megafirms) or influence (Pritzker-awarded architects), but also several more megafirms as well as many small-to-medium-size practices and "boutique" firms.

We must also acknowledge that firms are dynamic entities in their very structure insofar as they grow and shrink, merge and split, and get sold and purchased. Our selection mostly reflects a snapshot of the present, although we have also tried to consider past events of this type. For instance, Paul Andreu was considered together with ADPI Ingénierie (until 2003) and his own Agence Paul Andreu (2004–09), while after 2009 (until he died in 2018), his work was part of another firm, Richez Associés. Danish firm Schmidt Hammer Lassen was acquired by US megafirm Perkins & Will in 2018 but maintained its corporate identity. However, as projects of the two firms are featured on both websites, we counted them only once according to the period of development, assigning the post-2018 ones to Perkins & Will. This case is also interesting because it allows us to reflect on the theme of the nationality of a company. We counted Schmidt Hammer Lassen as a Danish firm, despite being owned by an American one. Nevertheless, Perkins & Will itself, a practice established in 1935 in Chicago, is actually a subsidiary of Lebanese multinational Dar Al-Handasah since 1986. Callison (established in 1975 in Seattle, WA) and RTKL (established in 1946 in Annapolis, MD) merged in 2015[12] after being acquired by Arcadis NV, respectively, in 2014 and 2017. In 2022, Arcadis NV acquired Canadian megafirm IBI Group, one the largest in the world. Since 2000, IBI Group itself has grown consistently through multiple operations of mergers and acquisitions of Canadian, US and British design and engineering firms. Once again, as no right or wrong answers exist on this, we worked on our database with a grain of salt. César Pelli was an Argentinian who moved to the USA for his studies, acquired US nationality and established Pelli Clarke Pelli Architects there. Diébédo Francis Kéré is a Burkinabé-German architect, and we counted his firm as a German one since it was established in Berlin, where Kéré has been living since his studies. LAVA—Laboratory for Visionary Architecture is a tri-cephalous firm established in 2007 as a network with offices in Sydney, Berlin, and Stuttgart. However, as the director of LAVA Asia Pacific, Chris Bosse, is based in Sydney (while Tobias Wallisser and Alexander Rieck, based in Berlin and Stuttgart, respectively, have the role of co-directors), we counted the firm as an Australian one. Could we have done differently? Of course, yes, but in the economy of our statistics and text, it would not have mattered much.

With the presentation of our methodological framework, we should not refrain from discussing the potential limits of our data collection. The first one regards the number of surveyed firms. Overall, the sample appears significant and statistically sound, with data from over one thousand companies. No other available research features anything comparable to what we have done here. For instance, the sample

[12] We counted Callison RTKL as a single company also for works previous to the merger as no possibility of distinguishing the authorship was given with the sources we used.

used by Ren (2011) in *Building Globalization* is ten times smaller, and more than 70% of the 100 firms mapped there are included here too. Alternatively, to provide another benchmark from literature, among the 104 projects of grand theatres listed at the end of Xue's (2019, Appendix A) *Grand Theater Urbanism*, 28 have been designed by foreign firms we surveyed, and only 12 by seven overseas firms not included in our sample. On the other hand, there may be problems in terms of statistical significance when comparisons are suggested among the countries in which our firms are based. Despite the use of weighting factors, numbers referring to certain countries remain small. For this reason, we have generally refrained from considering statistical findings concerning the internal market of smaller European countries, Australia, and New Zealand. As an example of such limits, we can point out the little soundness of a comparison between British and Swiss firms' involvement in a specific market because, while the sample referring to the UK is quite ample (82 companies), the one of Switzerland is somewhat limited (just 14).

A second potential issue to be considered is the sample selection in relation to the historical period under scrutiny. As a matter of fact, data may result chronologically biased due to the main sources on which this study relies.[13] Architectural practices active twenty or thirty years ago may have disappeared from the scene and, for this reason, been neglected in this study,[14] especially smaller and lesser-known ones. However, the timeframe involved—thirty years—is short enough to ensure a certain continuity in the professional field: many large companies were established over a century ago, while starchitects and many influential practitioners of the 1980–90s have been included. Overall, our statistics appear sound also in this perspective. A recent article (Xue et al. 2021) identified 58 projects built in China between 1990 and 2000 by foreign architects, half of which were designed by US architects. From our sample, we identified 20 projects in the same time frame, about 30% designed by US architects. The key point to stress, therefore, is that while seeking to identify each and every project may be a reasonable path to study transnational architecture in twentieth-century China, such a method becomes unfeasible after 2000, forcing us to explore other solutions.

Finally, another limit to highlight regards the quality of our data. The data collection was primarily based on information provided by architectural firms on their official websites. In this regard, we know that in addition to highly visible and mediatic 'flagship projects,' there might be many 'ghost projects' that are almost impossible to identify: it is the case of 'cash projects' of lower design quality that firms accept to undertake purely for profit but that are not featured in architecture media, or of works on which the involvement of the firm is limited or interrupted (more or less consensually) sometimes during the design or construction phase. This means that the

[13] For chronological data, we always try to provide the year of launch (year of the first competition, direct commission, or proposal by the architect) and completion of a built project; for the unbuilt ones, we only provide the year of launch.

[14] Or they may not list older projects on their website. RMJM, for instance, has been active in Africa and Pakistan since the 1960s, but projects belonging to that period and up to the 1990s are not featured. That said, these cases are limited, and projects of that period can be identified through other sources.

present study relies on the completeness and truthfulness of such information, which for a quantitative survey involving 1,025 firms and almost six thousand projects, cannot always be individually cross-checked. From this perspective, data quality and completeness sensibly vary from firm to firm. There are companies with rich and tidy websites, where all important information (including status, year of beginning and conclusion of the project, GFA—Gross Floor Area) is handily provided. However, many firms publish limited, confused, or incomplete data. To name the most common issues, it is not rare to find projects presented without any chronological reference or data about their size (GFA in m^2/ft^2). Above all, in many cases, it is difficult to understand the status of a project,[15] especially when indications like "in progress" or "ongoing" refer to designs dating back a few years.[16] In order to face all these problems, information has been cross-checked with other sources as much as possible, including using other internet websites (architecture platforms and magazines, news, etc.), publications (architectural journals, magazines, and books), and directly contacting some firms.

As a result, on 2,671 built projects surveyed, data about GFA is available on 56% of the total. However, this percentage varies by region, being the highest for China (78%), the lowest for Africa (43%), and about 50% for the rest of the countries. Information about the year of completion is overall available for 68% of the built projects, again with 80% for China and the Middle East, 77% for Eurasia, 73% for South-East Asia, 62% for Latin America, and just 56 and 50% for India and Africa respectively. Projects of uncertain status (classified as "unknown") account for just 15% of the total sample, being less than one thousand. In this regard, one last point deserves discussion. Saying that two firms have completed a similar number of projects in a region may have little significance if we do not know the size of these projects. To provide a concrete example, Italian firm Area 17 has completed at least 54 projects in China for a total GFA of almost 45,000 m^2. A single mixed-use project completed by KPF could span between 300,000 and 600,000 m^2 or even more. In other cases, the problem arises from how a project is counted. For instance, does a project composed of several buildings count as a single one, or should we count every building as an individual project? For Msheireb Downtown in Doha (Sect. 8.6), Allies and Morrison designed about thirty buildings; how to count them? For the CMSB China Mobile South Base in Guangzhou, GMP designed several buildings in different phases; how to count them? Indeed, having one single answer appears beyond our capacities. We generally relied on the designers' perspective, which

[15] Projects have been here classified into two main categories for statistical purposes: completed and unbuilt. Completed projects include built ones, projects under construction and completed master plan. Unbuilt projects are all those that remained in the design phase (for instance, the competition entries) or those whose status is ongoing/on hold/unknown.

[16] In this regard, one tricky typology of projects is the master plan. Understanding its status can be difficult as a master plan project can be successfully delivered by a firm but eventually not materialise later. In addition, the GFA that a master plan envisions cannot be counted as a built GFA for the firm drafting it. Hence, for a master plan project, even when we considered it as successful (status "built"), we did not include the GFA or any other surface measurement in the firm's statistics, unless the same firm then also developed an architectural project on the master plan's site.

sometimes disaggregates bigger projects into individual ones, if they are phased along more extended periods or typologically different, and sometimes present the work as one. In any case, these are also some of the reasons why we always provide the GFA of the projects we mention (when known) and why, in Chap. 4, we provided data referring as much as possible to both the number of projects and the GFA.

2.6 Conclusions

The problem of globalisation has entered architectural scholarship in different ways, and today we can rely on a growing literature investigating the modes of production of contemporary architecture. While some works had the ambition of studying this phenomenon comprehensively, most of the literature focuses either on some regions significantly affected by the phenomenon or assumes an explicit politico-ideological framework that brings the study away from the investigation of architectural production. At the same time, many authors remain concerned with the less-interesting problem of the emergence or less of a global architectural language. In addition, the main historiographic narratives do not offer enough insight into the phenomenon. On the contrary, in some cases, they focus on the architecture that, especially from the global peripheries, tries to resist globalisation. One crucial issue that appears often overlooked is the importance of globalisation, through access to new resourceful markets, in providing the conditions for developing an experimental architecture that could not otherwise exist.

To all this, we can add a second and equally crucial problem that this book addresses. How can we periodise and recognise changes in the globalisation of architecture? How can we measure them? These are vital questions that we answer in Chaps. 3 and 4. As we have already mentioned, to understand this phenomenon, we should be able to also count on some quantitative indicators instead of simply relying on our qualitative impressions. This is the lesson we can draw from economic and environmental history (today more and more integrated into architectural research in the form of political ecology and terrestrial exchanges), for example, and from sociology. Indeed, this is also what we borrow from a specific approach to the history of literature which appears to us extremely promising and well-suited to be applied in our field. Embracing Franco Moretti's "distant reading" means rethinking the paradigms of writing architectural history. Should we still approach it as a branch of art history, focusing on the individuality of each author and the uniqueness of each project? Or may we look at specific phenomena, including the globalisation of the architectural agency, from a different, more distant perspective? One that is able to grasp series and numbers that assume their meaning exactly when read as part of a broader picture.

These are some of the ambitions of this book, which neither avoids the in-depth exploration of relevant case studies nor forgets the different weights that different actors have in the global architectural system. Still, with the work of over one thousand architecture firms mapped, this investigation represents the most comprehensive

and wide-ranging examination of the agency of design firms from the Global North in emerging markets (a term that we prefer to Global South as it also includes countries with extremely high income per capita, like Qatar or Saudi Arabia). Despite its limitations in breadth (Sect. 4.2), this overview allows us to understand how the scope of the profession in geographical terms and the modes of production have changed in the last few decades and how architecture has evolved with it.

References

Adam, Robert. 2012. *The Globalisation of Modern Architecture: The Impact of Politics, Economics and Social Change on Architecture and Urban Design Since 1990.* Newcastle-upon-Tyne: Cambridge Scholars Publishing.

Adelman, Jeremy. 2017. What is global history now? *aeon,* Mar 2. https://aeon.co/essays/is-global-history-still-possible-or-has-it-had-its-moment. Accessed 7 Oct 2022.

Architects' Journal. 2018. AJ100. *Architects' Journal.* https://aj100.architectsjournal.co.uk/view/overview/2018/view.aspx. Accessed 20 June 2020.

Architects Accreditation Council of Australia. 2018. Industry profile. The profession of architecture in Australia, Feb 2018. https://www.aaca.org.au/wp-content/uploads/Industry-Profile.pdf. Accessed 20 June 2020.

Architecture Council of Europe. 2018. The architectural profession in Europe 2018. A sector study. https://www.ace-cae.eu/fileadmin/New_Upload/7._Publications/Sector_Study/2018/2018__ACE_Report_EN_FN.pdf. Accessed June 2020.

Bairoch, Paul. 1996. Globalization myths and realities: One century of external trade and foreign investment. In *States Against Markets: The Limits of Globalization,* ed. Robert Boyer and Daniel Drache, 173–192. London: Routledge.

Baldwin, Richard. 2016. *The Great Convergence: Information Technology and the New Globalization.* Cambridge, MA; London: The Belknap Press of Harvard University Press.

Banham, Reyner. 1969. *The Architecture of the Well-Tempered Environment.* London: Architectural Press.

Barber, Daniel A. 2020. *Modern Architecture and Climate: Designing Before Air Conditioning.* Princeton, NJ; Oxford: Princeton University Press.

BauNetz. 2019a. Ranking list. National. July/August 2019a. *BauNetz.* https://www.baunetz.de/ranking/?area=ranking&type=nat&date=1561932000. Accessed 30 June 2022.

BauNetz. 2019b. Ranking list. International. July/August 2019b. *BauNetz.* https://www.baunetz.de/ranking/?area=ranking&type=nat&area=ranking&type=int&page=. Accessed 30 June 2022.

BauNetz. No Year. Procedure rules. *BauNetz.* https://www.baunetz.de/ranking/?area=info&type=verfahren. Accessed 1 Oct 2022.

BD+C. 2018. Giant 300 report. *BD+C.* https://www.bdcnetwork.com/sites/bdc/files/Giants2018Master.pdf. Accessed 20 Aug 2020.

Blau, Judith R. 1984. *Architects and Firms: A Sociological Perspective on Architectural Practice.* Cambridge, MA: The MIT Press.

Braw, Elisabeth. 2014. Japan's disposable home culture is an environmental and financial headache. *The Guardian,* May 2. https://www.theguardian.com/sustainable-business/disposable-homes-japan-environment-lifespan-sustainability#:~:text=According%20to%20the%20International%20Union,residents%20and%20Canada%20has%200.22%25. Accessed 10 June 2020.

Browne, Enrique. 1988. *Otra arquitectura en America Latina.* Mexico City: Gustavo Gili.

Building Design. 2020. WA100 2020: The big list. *Building Design.* https://www.bdonline.co.uk/wa100-2020-the-big-list/5103321.article. Accessed 12 May 2022.

Calder, Barnabas, and Florian Urban. 2022. It is time no longer to praise the seagram building, but to bury it. *Architect's Journal*, Nov 10. https://www.architectsjournal.co.uk/buildings/it-is-time-no-longer-to-praise-the-seagram-building-but-to-bury-it. Accessed 12 Nov 2022.

Castells, Manuel. 2010. *End of Millennium: The Information Age. Economy, Society, and Culture.* Hoboken, NJ: Wiley.

Champy, Florent. 2001. *Sociologie de l'architecture.* Paris: La Découverte.

Ching, Francis D.K., Mark M. Jarzombek, and Vikram Prakash. 2017. *A Global History of Architecture*, 3rd ed. Hoboken, NJ: John Wiley & Sons.

Choisy, Auguste. 1899. *Histoire de l'architecture*, 2 vols. Paris: Gauthier-Villars.

Cody, Jeffrey W. 2003. *Exporting American Architecture, 1870–2000.* Abingdon: Routledge.

Cohen, Jean-Louis. 2012. *A Future of Architecture: Since 1889.* London and New York, NY: Phaidon.

Conrad, Sebastian. 2016. *What Is Global History? Princeton, NJ.* Oxford: Princeton University Press.

Coxe, Weld, Nina F. Hartung, Hugh H. Hochberg, Brian J. Lewis, David H. Maister, Robert F. Mattox, and Peter A. Piven. 1986. Charting your course. Master strategies for organizing and managing architecture firms. *Architectural Technology* 5: 52–58.

Crinson, Mark, and Richard J. Williams. 2019. *The Architecture of Art History: A Historiography.* London: Bloomsbury.

Crosby, Alfred W. 1972. *The Columbian Exchange: Biological and Cultural Consequences of 1492.* Westport, CT: Greenwood Press.

Cuff, Dana. 1992. *Architecture: The Story of Practice.* Cambridge, MA: The MIT Press.

Cuff, Dana. 2014. Architecture's undisciplined urban desire. *Architectural Theory Review* 19 (1): 92–97.

Curtin, Philip D. 1969. *The Atlantic Slave Trade: A Census.* Madison, WI: The University of Wisconsin Press.

Curtis, William J.R. 2000. *Modern Architecture Since 1900.* London: Phaidon.

Dá Magazine. 2019. Classement 2018 des 400 agences d'architecture par chiffres d'affaires. *Dá Magazine.* https://www.darchitectures.com/classement-architectes/2018/index.html#p=1. Accessed 20 June 2020.

David, Rieff. 1993. A global culture? *World Policy Journal* 10 (4): 73–81.

De Grazia, Victoria. 2006. *Irresistible Empire: America's Advance through Twentieth-Century Europe.* Cambridge, MA; London: Belknap Press of Harvard University Press.

de Zwart, Pim, and Jan Luiten van Zanden. 2018. *The Origins of Globalization: World Trade in the Making of the Global Economy, 1500–1800.* Cambridge: Cambridge University Press.

Diamond, Jared. 1997. *Guns, Germs and Steel: The Fates of Human Societies.* New York, NY: Norton.

Douki, Caroline, and Philippe Minard. 2007. Histoire globale, histoires connectées: Un changement d'échelle historiographique? Introduction. *Revue D'histoire Moderne & Contemporaine* 54–4 (5): 7–21.

Elleh, Nnamdi. 2014. Introduction. Keeping the mission of modern architecture in focus. In *Reading the Architecture of the Underprivileged Classes*, ed. Nnamdi Elleh, 20–31. Abingdon: Routledge.

Erickson, Charlotte. 1975. Quantitative history. *The American Historical Review* 80 (2): 351–365.

Easterling, Keller. 2008. *Enduring Innocence: Global Architecture and Its Political Masquerades.* Cambridge, MA: The MIT Press.

Fazio, Michael W., Marian Moffett, and Lawrence Wodehouse. 2003. *A World History of Architecture.* London: Laurence King Publishing.

Fernández Cox, C. 1987. Hacia una modernidad apropiada: factores y desafíos internos. *Summa* 241: 30–33.

Fernández-Galiano, Luis. 2000. *Fire and Memory: On Architecture and Energy.* Cambridge, MA: MIT Press.

Fischer von Erlach, Johann Bernhard. 1721. *Entwurff Einer Historischen Architektur.* Vienna.

References

Fletcher, Banister. 1896. *A History of Architecture on the Comparative Method*. London: Athlone Press, University of London.

Flynn, Dennis O., and Arturo Giráldez. 1995. Born with a 'silver spoon': The origin of world trade in 1571. *Journal of World History* 6 (2): 201–221.

Foster, Hal. 2011. *The Art-Architecture Complex*. London: Verso.

Frampton, Kenneth. 1983. Towards a critical regionalism: Six points for an architecture of resistance. In *The Anti-Aesthetic. Essays on Postmodern Culture*, ed. Hal Foster, 16–30. Port Townsend, WA: Bay Press.

Frampton, Kenneth. 2020. *Modern Architecture: A Critical History*, 5th ed. London: Thames & Hudson.

Fraser, Murray, and Nasser Golzari. 2013. *Architecture and Globalisation in the Persian Gulf Region*. Farnham: Ashgate.

Furet, François. 1971. Quantitative history. *Daedalus* 100 (1): 151–167.

gd:c. n.d. dis:connectivity. *Global dis:connect*. https://www.globaldisconnect.org/forschung/diskon nektivitat/. Accessed 10 Jan 2022.

Giedion, Sigfried. 1941. *Space, Time and Architecture: The Growth of a New Tradition*. Cambridge, MA: Harvard University Press.

Giedion, Sigfried. 1948. *Mechanization Takes Command: A Contribution to Anonymous History*. Oxford: Oxford University Press.

Goodwin, Philip L. 1943. *Brazil Builds: Architecture New and Old 1652–1942*. New York, NY: The Museum of Modern Art.

Gordon, Robert J. 2016. *The Rise and Fall of American Growth: The U.S. Standard of Living since the Civil War*. Princeton, NJ: Princeton University Press.

Gropius, Walter. 1925. *Internationale Architektur*. Munich: Albert Lange.

Gutman, Robert. 1988. *Architectural Practice: A Critical View*. New York, NY: Princeton Architectural Press.

Gyger, Helen. 2009. *Improvised Cities: Architecture, Urbanization, and Innovation in Peru*. Pittsburgh, PA: University of Pittsburgh Press.

Haddad, Elie, and David Rifkind. 2014. *A Critical History of Contemporary Architecture: 1960–2010*. Surrey: Ashgate.

Han, Jiawen. 2019. *China's Architecture in a Globalizing World: Between Socialism and the Market*. London: Routledge.

Hancox, Dan. 2014. Enough slum porn: The global north's fetishisation of poverty architecture must end. *Architectural Review*, Aug 12. https://www.architectural-review.com/essays/enough-slum-porn-the-global-norths-fetishisation-of-poverty-architecture-must-end. Accessed 20 June 2021.

Hardt, Michael, and Antonio Negri. 2000. *Empire*. Cumberland: Harvard University Press.

Heisel, Felix, and Bisrat Kifle. 2016. *Lessons of Informality: Architecture and Urban Planning for Emerging Territories*. Basel: Birkhäuser.

Held, David, Anthony G. McGrew, David Goldblatt, and Jonathan Perrathon. 1999. *Global Transformations. Politics, Economics and Culture*. Stanford, CA: Stanford University Press.

Hernández, Felipe. 2021. Modern Fetishes, Southern Thoughts. *Dearq* 29: 40–53.

Hernández, Felipe, Peter Kellett, and Lea K. Allen. 2010. *Rethinking the Informal City: Critical Perspectives from Latin America*. Oxford: Berghahn Books.

Hilberseimer, Ludwig. 1928. *Internationale Neue Baukunst*. Stuttgart: Julius Hoffmann.

Hitchcock, Henry-Russell. 1947. The architecture of bureaucracy & the architecture of genius. *Architectural Review* 601 (101): 3–6.

Hitchcock, Henry-Russell, and Philip Johnson. 1932. *The International Style: Architecture Since 1922*. New York, NY: Museum of Modern Art.

Houdart, Sophie, and Minato Chichiro. 2009. *Kuma Kengo: An unconventional Monograph*. Paris: Éditions Donner Lieu.

Hsu, Frances. 2014. Dutch modern architecture: From an architecture of consensus to the culture of congestion. In *A Critical History of Contemporary Architecture, 1960–2010*, ed. Elie Haddad and David Rifkind, 207–224. Surrey: Ashgate.

Ibelings, Hans. 1998. *Supermodernism: Architecture in the Age of Globalization*. Rotterdam: NAi Publishers.

Ingersoll, Richard, and Spiro Kostof. 2018. *World Architecture: A Cross-Cultural History*. New York, NY: Oxford University Press.

James-Chakraborty, Kathleen. 2014. *Architecture Since 1400*. Minneapolis, MN: University of Minnesota Press.

King, Anthony D. 2004. *Spaces of Global Cultures: Architecture, Urbanism, Identity*. London; New York, NY: Routledge.

Knox, Paul L., and Peter J. Taylor. 2005. Toward a geography of the globalization of architecture office networks. *Journal of Architectural Education* 58 (3): 23–32.

Koolhaas, Rem. 1978. *Delirious New York: A Retroactive Manifesto for Manhattan*. New York, NY: Oxford University Press.

Koolhaas, Rem. 1995. Bigness, or the problem of Large. In *S, M, L, XL*, ed. OMA, Rem Koolhaas and Bruce Mau, 494–517. New York, NY: The Monacelli Press.

Koolhaas, Rem, and Edgar Cleijne. 2008. *Lagos: How It Works*. Zurich: Lars Müller.

Kubo, Michael. 2014. The concept of the architectural corporation. In *Office US Agenda*, ed. Eva Franch i Gilabert, Amanda Reeser Lawrence, Ana Miljački and Ashley Schafer, 37–45. Zurich: Lars Müller.

Lara, Fernando Luiz. 2008. *The Rise of Popular Modernist Architecture in Brazil*. Gainesville, FL: University Press of Florida.

Lara, Fernando Luiz. 2018. *Excepcionalidade do modernismo brasileiro*. São Paulo: Romano Guerra.

Lara, Fernando Luiz. 2021. El otro del otro. *Anales Del Instituto De Arte Americano E Investigaciones Estéticas 'Mario J. Buschiazzo* 51 (1): 1–14.

Larson, Magali Sarfatti. 1993. *Behind the Postmodern Façade: Architectural Change in Late Twentieth-Century America*. Berkeley, CA: University of California Press.

Lefebvre, Henri. 2009. The worldwide experience (1978). In *State, Space, World: Selected Essays*, ed. Neil Brenner and Stuart Elden [Translated by Gerald Moore, Neil Brenner and Stuart Elden], 274–289. Minneapolis, MN: University of Minnesota Press.

Liernur, Jorge Francisco. 2008. It's the viewpoint, stupid! Nine points on positions. *Positions* 62–71.

Lo Ricco, Gabriella, and Silvia Micheli. 2003. *Lo spettacolo dell'architettura: profilo dell'archistar*. Milano: Bruno Mondadori.

Lu, Duanfang. 2011. Introduction: Architecture, modernity and identity in the third world. In *Third World Modernism: Architecture, Development and Identity*, ed. D. Lu, 1–28. Abingdon: Routledge.

Manning, Peter. 2003. *Navigating World History: Historians Create a Global Past*. New York, NY: Palgrave MacMillan.

Mazlish, Bruce, and Ralph Buultjens. 1993. *Conceptualizing Global History*. Boulder, CO: Westview Press.

Mazlish, Bruno. 1998. comparing global history to world history. *Journal of Interdisciplinary History* 28 (3): 385–395.

McGuirk, Justin. 2014. *Radical Cities: Across Latin America in Search of a New Architecture*. London: Verso.

McNeill, Donald. 2009. *The Global Architect: Firms, Fame and Urban Form*. New York, NY: Routledge.

McNeill, William H. 1963. *The Rise of the West: A History of the Human Community*. Chicago, IL: University of Chicago Press.

Migayrou, Frederic, and Marie-Ange. Brayer. 2003. *Archilab: Radical Experiments in Global Architecture*. London: Thames and Hudson.

References

Mindlin, Henrique E. 1956. *Modern Architecture In Brazil*. New York, NY: Reinhold Publishing Corporation.

Moe, Kiel. 2020. *Unless*. New York, NY: Actar Publishers.

Molotch, Harvey, and Davide Ponzini, eds. 2019. *The New Arab Urban. Gulf Cities of Wealth, Ambition and Distress*. New York, NY: New York University Press.

Moretti, Franco. 1998. *Atlas of the European Novel 1800–1900*. London: Verso.

Moretti, Franco. 2005a. *Graphs, Maps, Trees: Abstract Models for Literary History*. London: Verso.

Moretti, Franco. 2005b. World-systems analysis, evolutionary theory, 'Weltliteratur.' *Review* (Fernand Braudel Center) 28 (3): 217–228.

Moretti, Franco. 2022. *Falso movimento. La svolta quantitativa nello studio della letteratura*. Milano: Nottetempo.

Nancy, Jean-Luc. 2007. *The Creation of the World, or Globalization*. Albany, NY: State University of New York Press.

National Council of Architectural Registration Boards. 2014. *NCARB releases 2014 survey of architectural registration boards*, Nov 20. https://www.ncarb.org/press/ncarb-releases-2014-survey-of-architectural-registration-boards. Accessed 20 June 2020.

Norsa, Aldo. 2019. Report 2018. Update version on the Italian construction, architecture and engineering industry. *Guamari*. https://www.guamari.it/pubblicazioni. Accessed 20 June 2020.

O'Rourke, Kevin H., and Jeffrey G. Williamson. 2002. When did globalisation begin? *European Review of Economic History* 6: 23–50.

Ockman, Joan. 2022. Toward a political ecology of architecture. *Places Journal*.

Olds, Kris. 2002. *Globalization and Urban Change Capital, Culture and Pacific Rim Mega-Projects*. Oxford: Oxford University Press.

Ötsch, Silke. 2015. The architect: A disappearing species in a financialized space? In *Economy and Architecture*, ed. Juliet Odgers, Mhairi McVicar, and Stephen Kite, 162–174. Abingdon; New York, NY.

Overy, Paul. 2008. *Light, Air and Openness: Modern Architecture Between the Wars*. London: Thames & Hudson.

Pastorelli, Giuliano. 2013. Las 100 oficinas de arquitectura más grandes del mundo en 2013'. *Plataforma Arquitectura*, Feb 13. https://www.archdaily.cl/cl/02-236027/las-100-oficinas-de-arquitectura-mas-grandes-del-mundo. Accessed June 20, 2020.

Pevsner, Nikolaus. 1936. *Pioneers of the Modern Movement from William Morris to Walter Gropius*. London: Faber & Faber.

Pieterse, Jan Nederveen. 2004. *Globalization or Empire?* New York, NY: Routledge.

Piketty, Thomas. 2014. *Capital in the Twenty-First Century* [Translated by Arthur Goldhammer]. Cambridge, MA: Harvard University Press.

Ponzini, Davide. 2020. *Transnational Architecture and Urbanism: Rethinking How Cities Plan, Transform, and Learn*. London: Routledge.

Prieto, Eduardo. 2019. *Historia medioambiental de la arquitectura*. Madrid: Ediciones Cátedra.

Quirk, Vanessa. 2014. Does Italy have way too many architects? (The ratio of architects to inhabitants around the world). *Dezeen*, Apr 29. https://www.archdaily.com/501477/does-italy-have-way-too-many-architects-the-ratio-of-architects-to-inhabitants-around-the-world. Accessed 10 June 2020.

Raisbeck, Peter. 2020. *Architecture as a Global System: Scavengers, Tribes, Warlords and Megafirm*. Bingley: Emerald Publishing.

Ren, Xuefei. 2011. *Building Globalization: Transnational Architecture Production in Urban China*. Chicago, IL: The University of Chicago Press.

Richards, John F. 2003. *The Unending Frontier: An Environmental History of the Early Modern World*. Berkeley, CA: University of California Press.

Rudofsky, Bernard. 1964. *Architecture Without Architects: A Short Introduction to Non-Pedigreed Architecture*. New York, NY: MoMA.

Saunders, William S., ed. 1996. *Reflections on Architectural Practices in the Nineties*. New York, NY: Princeton Architectural Press.

Scalvini, Maria Luisa, and Maria Grazia Sandri. 1984. *L'immagine storiografica dell'architettura contemporanea da Platz a Giedion*. Roma: Officina Edizioni.

Segawa, Hugo. 2005. *Arquitectura latinoamericana contemporánea*. Barcelona: Gustavo Gili.

Sen, Conor. 2017. The 'big five' could destroy the tech ecosystem. *Bloomberg*, Nov 15. https://www.bloomberg.com/opinion/articles/2017-11-15/the-big-five-could-destroy-the-tech-eco system. Accessed 25 Sept 2022.

Silvestre, Gabriel, and Guillermo Jajamovich. 2022. The dialogic constitution of model cities: The circulation, encounters and critiques of the Barcelona model in Latin America. *Planning Perspectives* [vol. ahead of print].

Sklair, Leslie. 2005. The transnational capitalist class and contemporary architecture in globalizing cities. *International Journal of Urban and Regional Research* 29 (3): 485–500.

Sklair, Leslie. 2006. Iconic Architecture and Capitalist Globalization. *City* 10 (1): 21–47.

Sklair, Leslie. 2017. *The Icon Project: Architecture, Cities and Capitalist Globalization*. New York, NY: Oxford University Press.

Spencer, Douglas. 2016. *The Architecture of Neoliberalism: How Contemporary Architecture Became an Instrument of Control and Compliance*. London: Bloomsbury.

Spengler, Oswald. 1922. *The Decline of the West*. [Translated by C.F. Atkinson], 2 vols. New York: Alfred A. Knopf.

Subrahmanyam, Sanjay. 1999. Connected histories: Notes towards a reconfiguration of early modern Eurasia. In *Beyond Binary Histories: Re-imagining Eurasia to c.1830*, ed. Victor Lieberman, 289–316. Ann Arbor, MI: The University of Michigan Press.

Tafuri, Manfredo. 1986. *Storia dell'architettura italiana, 1944–1985*. Torino: Einaudi.

Tombesi, Paolo. 2001. A true south for design? The new international division of labour in architecture. *arq: Architectural Research Quarterly* 5 (2): 171–179.

Tombesi, Paolo, Bharat Dave, and Peter Scriver. 2003. Routine production or symbolic analysis? India and the globalization of architectural services. *Journal of Architecture* 8 (1): 63–94.

Tournikiotis, Panayotis. 2001. *The Historiography of Modern Architecture*. Cambridge, MA: MIT Press.

Toynbee, Arnold J. 1934–1961. *A Study of History*, 12 vols. Oxford: Oxford University Press.

Tzonis, Alexander, and Liane Lefaivre. 1981. The grid and the pathway: An introduction to the work of Dimitris and Suzana Antonakakis. *Architecture in Greece* 15: 164–178.

Waisman, Marina. 1987. Posmodernismo arquitectónico y cultura posmoderna. *Revista Summarios* 112: 13.

Wallerstein, Immanuel. 1974. *The Modern World-System: Capitalist Agriculture and the Origins of the European World Economy in the Sixteenth Century*, vol. 1. San Diego, CA: Academic.

Watkin, David. 2005. *A History of Western Architecture*. New York, NY: Watson-Guptill Publications.

Watson, James L. 1997. *Golden Arches East: McDonald's in East Asia*. Stanford, CA: Stanford University Press.

Wells, Herbert George. 1901. *The Outline of History: Being a Plain History of Life and Mankind*. New York, NY: Macmillan Company.

Xue, Charlie Q.L. 2006. *Building a Revolution: Chinese Architecture Since 1980*. Hong Kong: Hong Kong University Press.

Xue, Charlie Q.L., ed. 2019. *Grand Theater Urbanism. Chinese Cities in the 21st Century*. Singapore: Springer.

Xue, Charlie Q.L., and Yingchun Li. 2008. Importing American architecture to China: The practice of John Portman & associates in Shanghai. *The Journal of Architecture* 13 (3): 317–333.

Xue, Charlie Q.L., Guanghui Ding, and Yingting Chen. 2021. Overseas architectural design in China: A review of 40 years. *Architectural Practice* 29: 8–21.

Yaneva, Albena. 2009. *Made by the Office for Metropolitan Architecture: An Ethnography of Design*. Rotterdam: 010 Publishers.

Zambrano Torres, and María Rosa. 2015. Corrientes posmodernas vistas desde América Latina. La arquitectura 'latinoamericana' en la crítica arquitectónica de Marina Waisman. *rita_* 4: 152–159.

References

Zhu, Jianfei. 2009. *Architecture of Modern China: A Historical Critique.* London; New York, NY: Routledge.

Zhu, Tao. 2014. Architecture in China in the reform era: 1978–2010. In *A Critical History of Contemporary Architecture: 1960–2010*, ed. Elie Haddad and David Rifkind, 401–417. Surrey: Ashgate.

Chapter 3
A Globalising Practice: From European Colonialism to the Global Age of Architecture, 1400–1989

In the previous chapter, we have introduced the problem of globalisation, also discussing how both general historiography and architectural historiography have dealt with it. We understand that globalisation is a debated problem and that it is essential, rather than looking for origins, to "identify periods of expansion and regression" and periodise accordingly (Douki and Minard 2007). In this regard, when we look at the architectural profession and its market, we recognise a change taking strength in the early 2000s that, with some delay, reflected the new phase of globalisation that occurred since the 1990s, when knowledge flows accompanied North–South offshoring, leading to a period of growing economic convergence (Baldwin 2016, 79–110). Still, for us, the focus and the objectives remain clear. While discussing how architecture, as an economic and cultural activity, has not escaped the logic of globalisation, we want to explore how globalisation has changed the architectural profession and discipline and when this has happened.

Assuming that the emergence of globalisation coincided with that of modernity during what Immanuel Wallerstein (1974) called the "long sixteenth century", what happened in the architectural field is our main concern. If globalisation is a long-term phenomenon, its reflections should not be new also for architecture. Thus, with some ambition and a rather synthetic approach, this chapter retraces the most significant episodes for the process of architectural globalisation since the rise of the European empires in the "long sixteenth century" up to the 1990s, with the awareness that common periodisations in architectural history do not coincide with more general historiographic periodisations. And in this case, neither common architectural periodisations overlap with what is proposed in this chapter. As a matter of fact, the exploration of the process of globalisation only marginally considers formal and stylistic issues—which, despite all, still represent the primary concern for architectural historians—while it focuses on the architects' agency and the architectural modes of production. This chapter, therefore, will necessarily explore the circulation of formal repertoires and imaginaries, their adoption and hybridisation, the diffusion of ideas and theories, and the dissemination of technical knowledge, as well as

© The Author(s), under exclusive license to Springer Nature Singapore Pte Ltd. 2023
G. Botti, *Designing Emerging Markets*,
https://doi.org/10.1007/978-981-99-1552-1_3

stories of professional migration—undoubtedly fundamental for the history of architecture and of paramount importance in the transnational circulation of imaginaries, ideas, and know-how. By doing so, however, it will also reveal the differences with what today we can call the globalisation of the architectural practice; differences that strongly emerged after the 1970s. Our mapping mainly highlights episodes of transnational, distant work between Euro-Atlantic regions and the rest of the globe, again intending to display the shift in scale and depth that has occurred since the end of the twentieth century in the geographic scope of the architectural profession. By doing so, this chapter provides a framework to understand the traits of continuity in this process, but also and foremost, the shifts and immense acceleration that occurred in the last few decades, on which this book properly focuses.

What is here recognised are three phases in the process of architectural globalisation. The first one dates to early modernity and mainly relates to the circulation of architects and military engineers within colonial empires. As James-Chakraborty (2014, xvii-xviii) recognises, "the extent of contact and interaction between geographically disparate cultures quickened" in the fifteenth century compared to the centuries before, and "new, too, was the scale of the distances across which architectural ideas travelled with increasing speed." We, therefore, set a first period that coincides with the rise of two different phenomena: in terms of general history, the beginning of globalisation in the early modern period; in the history of architecture, the emergence of the figure of the architect as an intellectual producing a design as theorised by Leon Battista Alberti in the Renaissance. Regarding the scope of this book, we stress that similar conditions in terms of the mode of architectural production lasted until the nineteenth century. Then, globalisation as a phenomenon related to the economy and trade accelerated. While international freight rates "collapsed" and prices of basic goods started to converge across the world (O'Rourke and Williamson 2002), the geography of the architectural profession changed in two ways for the West. On the one hand, more and more professionals, including in the field of urbanism, moved for work around colonial empires; on the other, mass emigration from Europe towards North and South America also brought many architects to the new world. In addition, between the end of the nineteenth and the early twentieth century, pushed by the growing opportunities offered by international competitions, the number of circulating projects—meaning architectural plans usually designed in major European and US centres and mailed to distant places—increased. The rise of totalitarian regimes in Europe spurred the migration of scientists, intellectuals, artists, and architects during the 1930s, mainly towards North America. Then, in the new global order that emerged after World War II, the globalisation of architectural practice further accelerated, and remote design became an everyday practice. Le Corbusier planned the new city of Chandigarh, India, from his Paris atelier, and Jørn Utzon designed, in the first phase of the project, the Sydney Opera House from Copenhagen, just to name two significant examples that explain the transformation underway between the 1950s and the 1970s. The Opera House, indeed, is often seen as a representative case of the paradigm change in the architectural profession that brought architects to "infiltrate the global economy" with their design and make high-profile buildings "readily used in tourist brochures" (Ching et al. 2017, 791),

or, in other words, icons. Then, the final shift occurred primarily in the post-1973 Middle East, South-East Asia during the 1980s, and China in the 1990s. By the early 2000s, with most of the world easily accessible for Western architectural firms, including all the former states of the Soviet Union, the globalisation of architectural practice reached its highest point. While the book overall focuses on globalisation as a Western-led phenomenon, not least because it takes into consideration the work of firms from Western and Western-aligned developed countries, in this chapter, there will be room to engage with the broader framework of the *mondialisation* (Lefebvre 2009; Nancy 2007; Chap. 4.2), limitedly for what concerns the history of architecture.

3.1 Across Lands and Seas: Colonial Empires and Royal Patronage During the "Long Sixteenth Century"

Between 1492, when Columbus touched land in then-thought-to-be India, and 1571, when Spaniards established the first trans-Pacific stable commercial route after founding the city of Manila, Philippines, the world became truly global (Flynn and Giráldez 1995). With the process of colonisation of the Americas by the Spanish, as well as of many coastal areas in America, Africa, and Asia by the Portuguese, the expertise of military architects and engineers was immediately requested in these territories, fostering a now really global circulation of people and knowledge. And all this was happening while other significant transformations proper to architectural history were taking place. Indeed, early modernity also represents the period in which the figure of the architect and its profession emerged. The publication of Leon Battista Alberti's *De Re Aedificatoria*, written between 1443 and 1452 and printed in 1485, "provided the ideal model for the Renaissance architect" (*architectus*) as an intellectual figure inherently different from medieval construction masters (*maestro, magister*) or supervisors (*provveditore, capomastro*), pursuing fame and individual recognition as author (Merrill 2017). Although there was no architecture profession in the modern sense, at least until the eighteenth century (lacking institutions to provide a degree, accreditation boards to overview, and any requirement of a license for practice), architects have been increasingly professing themselves as such since the Renaissance. At the same time, military architects and engineers have distinguished their work from that of the civil architect (Merrill 2017).

As modernity cannot be disjoined by coloniality (Mignolo 2005), to understand globalisation, we need to start from the directions towards which the world was expanding during the fifteenth and sixteenth century, the Americas, and briefly examine the transplant of European architecture on the other side of Atlantic following Spanish and Portuguese colonisation. A transplant that occurred over the long term through 'travelling' plans brought to the Americas and the intermingled work of architects and engineers, but also master builders, simple colonisers, and slaves. Above all, what was transplanted was already hybrid in nature and will be

further hybridised. In the post-*Reconquista* Iberian Peninsula, Renaissance architecture incorporated a variety of elements, decorative patterns, and artisanal know-how from the Islamic tradition that afterwards crossed the Ocean together with the colonisers, manifesting itself in the Americas in multiple ways (Wolf and Nespral 2022). The use and the continuous reinterpretation of the *mashrabiya* in Spanish and Portuguese colonies, to mention one of the most relevant cases, continued until twentieth-century modernist architecture and to the present day. In the Americas, everything was further hybridised through encounters with local cultures and material traditions. Local workers used their know-how and techniques to erect buildings 'conceived' (the word 'designed' intending as if the building had a formalised project on drawings may still be misleading for the time) by the colonisers. Churches and other religious buildings would be the best examples to explain this hybridisation process, which also involved decorative aspects, architectural elements, and the definition of the urban space around them (James-Chakraborty 2014, 75–91). Then, we have the movements of professionals at the Crown's service. In the early 1580s, Battista Antonelli, brother of the better-known Giovanni Battista, moved from Spain, where his brother had been working for more than a decade, to America, taking care of the fortifications of the city of Cartagena de Indias (nowadays Colombia), Panamá, and Havana (Cuba), and later on in present-day Santo Domingo, Puerto Rico, and Florida. His nephew, Cristoforo Roda Antonelli, was also collaborating with him in designing Veracruz fortifications, to later move to other cities all over the Caribbean (Bertacchi 2012). That of the Antonelli family, including the other nephews Cristoforo and Francesco Garavelli, represents just one of the many histories of professionals travelling across the new Spanish colonial empire at the early age of colonial empires (Lucena Giraldo and Fernández-Armesto 2022; Niglio and Hernández Molina 2016).

Within Europe, during the fifteenth and sixteenth century, artists circulated unaffected by national (a rather inexistent concept at the time) boundaries under the protection of royals, popes, and cardinals. While Leonardo da Vinci entered the service of King Francis I of France in 1516, leaving Milan until his death, the young Philbert de l'Orme moved to Rome in 1530 to study the city's antiquities, bringing back to France his knowledge of Roman and Renaissance architecture. Far from being isolated cases, these movements represented a typical condition of early modernity (and even of the Late Middle Ages) that contributed to the diffusion of Renaissance culture from the Italian Peninsula to the rest of Europe (Burke 1998). At the same time, such a diffusion was hindered by a widespread "resistance" north of the Alps along all the sixteenth-century (James-Chakraborty 2014, 75–91), an opposition—not an outright rejection– that can be interpreted as a form of resistance to globalising forces from the centre to the peripheries. Though, under the same circulation patterns, many notable experiences occurred in the seventeenth century. Indeed, when in 1664, the French First Minister of State, Jean-Baptiste Colbert, invited French and Roman architects, including Pietro da Cortona and Gian Lorenzo Bernini, to submit plans for the East Wing of the Louvre Palace, and, one year later, Bernini to come to Paris for a few months (Zarucchi 2006), such a call represented a normal event in the logic of royal patronage for famed artists. Filippo Juvarra's invitation to Torino in 1714

3.1 Across Lands and Seas: Colonial Empires and Royal Patronage During … 59

by Victor Amadeus II of Savoy to become the "first civil architect" of the Kingdom, and his later invitations to Portugal in 1718, do highlight once again the mobility of famous architects in the early modernity. These and many other stories depict a context in which artists whose fame travelled across more or less distant territories moved for shorter or longer periods under the patronage of significant political and religious figures. Francesco Bartolomeo Rastrelli, of Florentine origins but born in Paris, moved to Saint Petersburg with his father in 1716, later becoming one the major figures on the local architectural scene, now regarded as a critical agent for the introduction of *rococo* taste in the Russian Empire. After that, however, a more classical aesthetic was favoured by the Tzars, and the French architect Jean-Baptiste-Michel Vallin de la Mothe was invited to build the Academy of Fine Arts according to a project elaborated by **Jean-François** Blondel and later several more projects inspired by Andrea Palladio and Jacques-Ange Gabriel (Watkin 2005, 420).

Jumping again on the other side of the Atlantic, the French presence in North America and the Caribbean since the mid-seventeenth century, similar to what we have seen for the case of Spanish and Portuguese colonies, produced other forms of hybridised architecture that were not the result of the pure infusion and adaptation of French construction traditions to the tropics. The evolution of architectural forms and techniques in Cap François in Saint Domingue (today's Haiti) is an excellent example of this process (Edwards 2006). Until the beginning of the eighteenth century, houses mainly were earthfast with thatched or shingle roofs, but after several fires, by the third decade of the eighteenth century, new constructions were erected in masonry and plaster. Neoclassical motives, in the form of simplified Tuscanic columns and pilasters, were adopted, while with more resources available, tiles from Normandy were imported; after destructions in 1842, houses were rebuilt with buttressed foundations. In the meantime, typical plans from the previous Spanish presence were adopted, as well as the gallery, which by the eighteenth century had also become popular. Evolving from the loggia, the Spanish gallery was derived from Guinea vernacular architecture, further showing the hybridisation of models at play. Studies have for a long time stressed the idea that the use of the gallery spread from the French territories of the Saint Lawrence River (today's Canada) down south to Louisiana along the Mississippi River while the French colonial house elevated and surrounded by galleries in fact derived from Caribbean models (Edwards 2006). These and other stories well describe the hybrid character of "creole" architecture and its multiple genealogies.

French colonisation in North America relied on the control of strategic fluvial and maritime passages through the establishment of fortified military outposts, from Québec in the north to Mobile in the south. In this context, the work of military engineers became essential and frequently transcended the purely military dimensions. In the first two decades of the eighteenth century, engineers like Adrien de Pauger and Pierre Le Blonde de La Tour were not only busy with the construction of forts across French territories of Louisiana but also on churches and other civil buildings (Robinson 1971; Wilson 1973). The plan of New Orleans, as that of other first and cities, re-proposed the grid system imposed by the Spanish throughout the whole continent according to the so-called *Ley de Indias* ("Indian Laws"), the legislative

apparatus issued in 1553 by Philip II of Spain to regulate the process of colonisation including the foundation of new settlements. A few decades later, the United States had become an independent nation requiring the construction of a new, monumental capital city. A French military engineer who had joined the American rebels during the War of Independence (1775–83) from the British Empire, Pierre Charles L'Enfant, in 1791, received from George Washington the commission to design the capital of the United States of America: Washington, DC. This project will develop into one of the most influential city-plan in history.

As we approach the nineteenth century, colonial enterprises expanded in scope and depth, with coastal commercial settlements asserting their control over the inland, and colonial territories transforming from areas controlled by private companies like the East India Company into integral parts of the empire. By the mid-nineteenth century, the British Empire was the largest on earth, French Second Empire was on the rise, and the Dutch were consolidating positions in South-East Asia and the Caribbean. In the meantime, the Spanish Empire was in demise: by the 1830s, most Latin American countries were independent, and with the defeat in the 1899 Spanish-American War, Cuba and the Philippines were lost. Brazil also gained its independence from Portugal in 1822, but unlike any other case, it was the very Prince Regent of Portugal, Dom Pedro, to declare it. This will be the context from which the next section of the present chapter begins. As we will see, there will be no significant qualitative change until the post-World War II period, as far as the process of globalisation of the architectural profession is concerned. There will be, instead, an increased circulation of architects, planners, engineers, contractors, and entrepreneurs able to exploit the opportunities offered by the imperial networks.

3.2 Expanding Empires, Expanding Opportunities: Nineteenth and Early Twentieth Century

By the early nineteenth century, globalisation had reached another stage, a "second era" in which, instead of limiting long-distance trade to non-competing goods, we saw "the rise of trade in 'basic' competing goods" during a century that recorded "spectacular transport cost declines and commodity price convergence," when "price gaps between trading partners fell sharply and when globalisation forces had a big income distribution impact on long-distance trading partners" (O'Rourke and Williamson 2002). This was the "Age of Empire" for Eric Hobsbawm, the last stage of the "long nineteenth century." And in this period, globalisation in the architectural field took a further step. While some European architects and engineers had already moved to the Americas in the centuries before, with the mass migrations that took place between 1850 and 1930, about forty million Europeans reached the Americas and Australia, with the USA alone receiving almost two-thirds of the total (Hatton and Williamson 1994). In such a context, the number of architects and construction professionals circulating across the globe significantly increased, especially within

the colonial territories of the British (Metcalf 1989; Crinson 1996; Bremner 2016) and the French empire (Culot and Thieveaud 1992), as well as in the German and Dutch ones, within Italian colonies, or inside the American "informal empire."

For US entrepreneurs and consultants, the isolated overseas adventures of the beginning of the nineteenth century became more consistent by the end of the century, as the potential of exporting know-how and construction materials or prefabricated components appeared more evident. While the Chicago Columbian Exposition of 1893 displayed to foreign visitors the impressive achievements of modern US industry, the economic depression of the period pushed American entrepreneurs to look for fortune in the international market (Cody 2003, 1–3). The expanding US "informal empire" (Ricard 1990) offered new profitable markets to architects, planners, engineers, entrepreneurs, and contractors. This marked a difference from the previous decades when US architects had travelled to Europe and vice-versa. Already in the 1860s, in addition, timber prefabricated structures like barracks for enslaved people working in the plantations were exported to the West Indies (Cody 2003, 4–5). Soon, US engineering and construction companies outbid British competitors in the construction of steel bridges in Africa. At the same time, some firms were able to exploit their technical know-how in steel-framing structures. One of the most interesting cases was that of the Milliken Brothers Company, a firm specialising in bridges and high-rise projects that became one of the first multinational construction companies, with office branches in London, Mexico City, La Habana, Cape Town, Johannesburg, and Sydney. A second case, also described by Cody (2003, 15–19), was that of Alfred Zucker, a German-American architect who, in 1904, emigrated to Buenos Aires, where he designed some of the first high-rise buildings using US-imported steel structures. In the same period, we find similar stories of European construction companies working across the British and French empires in the Mediterranean and the Middle East. The extended presence of French contractors in Algeria and Egypt and from there in other territories of North and Sub-Saharan Africa and the rest of the Arab world have been mapped (Barjot 2012), including some of the most remarkable experiences like those of François Hennbique and the Perret brothers. The former pioneered the use of reinforced concrete, patenting a system that became widespread all over the world. From his headquarter in Paris, Hennebique established a commercial empire relying on a network of agents and contractors scattered across the globe. In 1893, his firm already had agencies in Switzerland, Naples, and Algiers; by 1898, it had reached Cairo and Istanbul (Frapier and Vaillant 2012). The other case is that of Perret Frères, a rare firm providing services of both design and construction, with unique know-how on reinforced concrete, which had a subsidiary in Morocco during the 1910s, a branch office in Algiers in the 1930s, and projects across the whole Mediterranean rim (Peyceré 2012). These and other stories thus reflect the growing globalised character of the construction sector during the nineteenth century. Still, unlike what we will see in the late twentieth century, they are either stories of migration (the case of Zucker), or they involve engineering and construction companies (like the Milliken Brothers Company) rather than architecture firms (although Perret Frères was at all the effects an AEC company).

In the field of urban planning—at that time rather known as *urbanisme* in France, *Städtebau* in Austria and Germany, town or city planning in English-speaking countries—milestone projects, fundamental case studies, and patterns of knowledge transfer and circulation from these last decades of the nineteenth century have been intensely studied and revealed. The spread of Western planning ideas through the agency of mostly European professionals in the imperial world has been extensively mapped by Ward (2010), to whom these paragraphs are highly indebted in terms of cited literature. The geography of Western-based planning practices spanned all over the world. In Morocco, a French protectorate, already in 1913, a planning law started a national programme later applied in the rest of the French Empire (Wright 1991). Similarly, within the British Empire, town planning ideas were applied across the colonial territories, from India to Nigeria and Northern Rhodesia, from Malaya to Transjordan (Home 1997). No colonial power, indeed, left its territories untouched across Asia (Victoir and Zatsepine 2013). Modern planning projects were undertaken and practices based on national laws implemented as far as in Indonesia, then the Dutch East Indies (Van der Heiden 1990, van Roosmalen 2015), or in Chinese Treaty Port cities like Tianjin (Rogaski 1999) or Qingdao (Mühlhahn 2013). In the Philippines, Daniel Burnham designed a master plan for Manila in 1905 (Hines 1974). In this scenario, two urban projects stood out: the planning of the new Australian capital, Canberra, and India's New Delhi.

Canberra—initially not named as such—was built after an international design competition was called in 1911. More than one hundred entries were received, including from well-known professionals like Eliel Saarinen and Alfred Agache, whose proposals ranked second and third, respectively. The victory, however, went to Chicago-based architects Walter Burley Griffin and Marion Mahony Griffin. Still, the project was not entirely accepted, and modifications were introduced based on other awarded entries. In any case, the Griffins remained in charge of the project; in 1913, Walter moved to Australia to be reached by his wife the following year. Canberra was thus built according to a master plan that well-embodied the values and the forms promoted by the City Beautiful movement: a series of radial urban nuclei connected by major avenues all radiating from the city core, where the Capitol aligns in a monumental esplanade to the House of Parliament and the main government buildings (Mumford 2018, 76–77). In the following years, the American couple established a successful practice in Melbourne and Sydney, and in 1935 opened an office in India to oversee the large number of projects they were awarded after winning a competition for the library of the University of Lucknow. In 1937, Walter died, and Marion moved back to the USA. In the meantime, in India, still a British colony, unlike Australia, which had gained its independence in 1901, the construction of New Delhi had already begun in the 1910s. By 1915, Edward Lutyens, helped by Herbert Baker, had completed the design of a Beaux-Arts master plan centred on a monumental mall where major governmental buildings and monuments were aligned, from the India Gate to the Viceroy's House through the Parliament House (Irving 1981; Metcalf 1989). The master plan and its architecture have received different critical evaluations, from praise (Ridley 1998) to disdain (King 1976), but it seems anyway remarkable its attempt to blend European classicism with Mogul forms.

3.2 Expanding Empires, Expanding Opportunities: Nineteenth and Early ...

These planning experiences within the territories of various European empires, of the Japanese one, and in lands controlled by the USA were the result of the work of architects and planners either moving to these locations for medium-to-long periods or, in fewer cases, working from a distance. In the meantime, international expertise was keenly sought after in Latin America during the nineteenth and early twentieth century, in the field of urban planning and for the design of major public buildings. These decades were marked by an extraordinary urban development of major cities, both in qualitative—expansion plans and opening of monumental new "arteries"—and quantitative terms (Arango 2012, 94–116; Almondoz 2013). Buenos Aires grew from 950,000 inhabitants in 1904 to 1.5 million in 1914; Rio de Janeiro from 811,000 in 1900 to 1.1 million in 1920. And many other cities experienced similar trends. In this context, European architects and planners enjoyed plenty of professional opportunities in a moment in which the notion of planning was highly debated in the continent, with European urban theories flowing there together with their promoters (Hardoy 1988; Almandoz 2006). At that time, a significant number of Latin American professionals moved to Europe, especially to the Institut d'Urbanisme in Paris (Ávila-Gómez 2019), for specialised training in urbanism, while experienced European planners got involved in major projects, often commissioned following either short trips or long-term relocations.

Alfred Agache was invited in 1926 to Rio de Janeiro to develop the city master plan, a paradigmatic example of Beaux-Art planning to beautify the capital city and elevate it to the ranks of an international metropolis, but also the result of a comprehensive vision, grounded in statistical data and based on modern technical solutions (Underwood 1991). Austrian urbanist Karl Brunner travelled to Santiago de Chile in 1929, beginning two years of intense travelling within Latin America, and back and forth to the USA and Europe. Then, in 1933 he moved to Bogotá, where he lived until 1948. At that time, Brunner was one of the most influential figures in the field, responsible not only for the plan of Bogotá of 1938 as well as for that of many more cities across Chile and Colombia, but also an established theorist, writer and academic (Hofer 2003). Jean-Claude Nicholas Forestier, between 1923 and 1924, developed a plan for Buenos Aires after a four-week visit to the city, and another for La Habana in eighty-two days between 1925 and 1926, after having travelled to Cuba (Arango 2012, 166–169). To Caracas, instead, Jacques Lambert and Maurice Rotival were briefly dispatched by Henri Prost in 1939 to support the draft of the new master plan (Hein 2002). To all this, we need to add Le Corbusier's trips of 1929 and 1936 (on which we will return shortly) and many other cases of professionals who travelled for conferences and consultancies, like Léon Jaussely to Montevideo in 1926 and Werner Hegemann to Buenos Aires in 1931 (Almandoz 2006).

European architects had experienced this same fertile ground since the beginning of the century when multiple international design competitions across Latin American main cities sparked a considerable professional interest. As a result, buildings representing political power, such as national parliaments and presidential palaces, and cultural ones, like opera theatres, were designed by European architects who had either immigrated to these countries or, more interestingly, sent their plans directly from Europe. However, these stories are varied and more blurred, as often winning

an international competition represented a first and fundamental step for moving to the new world, temporarily or for good. The competition for the Mexican Legislative Palace, for instance, was advertised overseas through diplomatic channels and received fifty-seven entries in 1897; still, it was finally directly assigned by the government to the French architect Émile Bénard (Checa-Artasu 2021). In Colombia, important public roles were entrusted to foreign architects, like the French Gastón Lelarge in Bogotá, where he lived most of his life, or the Belgian Agustín Goovaerts in Medellín, who stayed in the country for almost a decade between 1920 and 1928 (Botti 2021). In Argentina, several major buildings were designed by Italian architects, whose presence was particularly significant. Some of them spent most of their lives in Argentina and died there, as in the case of Vittorio Meano, who designed the Legislative Palace of Argentina in Buenos Aires and of Uruguay in Montevideo, or Francesco Tamburini, who drafted the first project for the Colón Theatre in the Argentinian capital and many others, including the final intervention on the Presidential Palace (Casa Rosada). Others, instead, remained for shorter periods: Milanese architect Gaetano Moretti, after winning the competition for the celebratory monument to the Argentinian Republic in 1907, travelled to Buenos Aires. In the Rio de la Plata region, he was later entrusted with several projects—including the finalisation of the works of the Uruguayan Legislative Palace—and in 1923 also completed the Museum of Italian Art in Lima, Peru. For these reasons, Moretti spent long periods in Latin America for more than a decade without leaving his academic post in Milan. In the same period, another Milanese architect close to Moretti, Sebastiano Locati, travelled on several occasions to Argentina between 1908 and 1909 after providing the plans for a pavilion for the 1910 Argentinian Centennial International Exhibition (Exposición Internacional del Centenario) and participating in the design competitions for the Faculty of Science and the San Martín hospital (Liernur 2001; Niglio and Checa-Artasu 2021; D'Amia 2022).

Stories of professional migration were frequently intertwined with those of financial capital movements. When the First Bank of Boston decided to erect a new building in Buenos Aires, the work was handed over to Thomas & Chambers, a flourishing design partnership that had completed several projects for the British-owned railway company Ferrocarril del Sur since its establishment more than a decade before by the US architect Louis Newbery Thomas, raised in Buenos Aires, and the British architect Paul Bell Chambers, who had emigrated in 1896. The famous Banco de Boston building erected in 1921–24 in Neo-Hispanic fashion was thus the result of a project designed by Thomas & Chambers with the collaboration of the US-based firm Edward York & Philip Sawyer, which had just designed the bank's new headquarters in Boston, and Stone & Webster, another US construction consultancy, while the steel-structure and most of the technical equipment was shipped from the USA (Ramón and Tartarini 1996; Cody 2003, 63–72). All these cases, and many more that cannot be listed for the sake of the narration, display how, since the last decade of the nineteenth century, architecture was becoming an increasingly globalised profession. This happened not only because an unprecedented number of academics and practitioners, following general migration flows, moved from Europe to different parts of the world, with a remarkable impact in the architectural field of

their place of destination, but also because of a growing number of works that were assigned to foreign architects via international competitions or direct appointments by governments. In other words, now more than ever, architectural plans started travelling long distances, sometimes accompanied by their creators, occasionally alone. Still, as Cody (2003, 59) pointed out in the case of the USA, in the decade between World War I and the Great Depression, US architects did not engage with foreign markets as much as engineers, building contractors, and exporters, and just a few of them practised outside the USA.

While grand historical periodisations like the one proposed by Hobsbawm (1995) deem World War I as a watershed moment for the Western hemisphere, architectural historiography has traditionally presented the image of a more continuous flow of events that, between the 1910s and 1920s, consolidated into the new architecture of the "Modern Movement". By the second decade of the century, following the lesson of figures like Peter Behrens and Hendrik Petrus Berlage, a new generation of European architects represented by Walter Gropius, Le Corbusier, Ludwig Mies van der Rohe, Jacobus Johannes Pieter Oud, and many others emerged alongside a new architecture. The foundation of the Bauhaus school in Weimar in 1919, the publication of Le Corbusier's seminal book *Vers une Architecture* in 1923, the Weissenhof exhibition in Stuttgart in 1927, and the foundation of the International Congresses of Modern Architecture (CIAM) the following year represented some of the key events commonly associated by canonical historiography to the rise of the "Modern Movement." Discussing the limits of this historiographic construction is of no interest here, while referring to it is necessary for another reason. While architectural culture underwent such a dramatic evolution, the process of architectural globalisation did not record any significant change.

Projects continued to circulate across distant regions during the 1920s as a few landmark architectural competitions were launched in the decade, often involving architects from both sides of the Atlantic. Historiography has often highlighted these events as paradigmatic of the struggle between modernist architects (usually defeated), on the one side, and academicist and historicist ones, on the other. The competition for the Chicago Tribune office tower in 1922, to which many European architects, including Gropius, Adolf Loos, Bruno Taut, and Eliel Saarinen participated, was won by the neo-Gothic proposal of John Mead Howells and Raymond Hood. Similarly, in 1927 the project for the Palace of Nations in Geneve was awarded to Henri Paul Nénot and others after they infamously defeated the modernist proposal of Le Corbusier and Pierre Jeanneret in a crucial moment in the history of the "Modern Movement" as narrated by Siegfried Giedion (1941, 519–527). The four rounds of competition for the Palace of the Soviet (1931–34) in Moscow attracted not only European modernist architects, starting from Le Corbusier, but also American professionals. Indeed, British-born New York-based Hector Hamilton won the second phase of the competition. After that moment, although he was later dismissed, Soviet delegations travelled to the USA seeking technical expertise in different areas and signed a contract with foundations engineering company Moran & Proctor (Zubovich 2021, 28–56). Not forgetting that, already in 1929—and lasting until 1932—Kahn Associates, the firm of Ford's principal architect Albert Kahn, opened an office branch

in Moscow directed by his brother Moritz (Zimmerman 2019). In this same period (1928–30), another international competition displayed the level of interconnection that the architectural system had achieved across the Atlantic. The Columbus Lighthouse (Faro de Colón) competition in Santo Domingo recorded an astonishing number of expressions of interest from sixty-five countries, and a few hundred entries at the end, evaluated by a jury composed of Raymond Hood, Eliel Saarinen, Horacio Acosta y Lara, and Frank Lloyd Wright (González 2007). One of the most significant encounters, then, occurred in 1929, when Le Corbusier undertook his first trip to Latin America (Pérez Oyarzún 1991). Invited for some lectures in Buenos Aires—later published in *Précision* (Le Corbusier 1930)—Le Corbusier spent almost four months between Argentina, Brazil, Uruguay, and Paraguay, sketching several architectural and urban projects that never became a reality but that fostered architects' imagination for decades. Soon after, in the north of the continent, another seminal event prepared the rise of modernism in the USA: the exhibition *Modern Architecture. International Exhibition* curated by Hitchcock and Johnson (1932) at the Museum of Modern Art of New York.

Modernist rhetoric has emphasised the inherently international character of the new architecture. However, long before it, architectural trends have spread across borders, from Gothic in the Middle Age to the Beaux-Arts at the turn of the twentieth century. Indeed, the latter not only represented an *ante litteram* "international style" but also relied on a transnational network of educational institutions and architects based in multiple centres, from Paris and its École des Beaux-Arts to Philadelphia or Chicago in the USA, from the influential Liverpool University to British colonies. In a way, an "Angloworld" with a "degree of continuity" in the built environment was shaped in the first decades of the twentieth century not only across the Atlantic but as far as in Australia and New Zealand (Joyce 2021). Even China was touched during the Republican period (1911–49), when a handful of students travelled to the USA to study architecture, most of them under Paul Cret's guidance at the University of Pennsylvania, and then returned to the country. This originated a transplant of design forms, ideas, methodologies, and pedagogies that produced a transformation in the national professional and educational environment that is surprising considering the small number of architects involved (Xing 2002, Cody et al. 2011). In the same period, work for US architects was growing in the Chinese market. The case of Murphy & Dana is by far the most interesting one: starting from 1914, the firm designed several high-profile projects, including university campuses—a new typology in China–, six branches of the International Banking Corporation, and other buildings. To deal with projects in Japan and China, not only Murphy & Dana's office had an "Oriental Department", where many young Chinese architects trained in US universities worked, but they also considered the opening of a branch in Shanghai. After Richard Dana left the firm in 1921, the firm continued as Murphy, McGill, & Hamlin, until Henry Killam Murphy started his practice and, after having already travelled several times to China, moved to Nanjing in the late 1920s. There, Murphy worked directly for Chiang Kai-shek, elaborating the new master plan for Nanjing and designing Memorial Hall for Revolutionary Martyrs. In 1935 he returned to the USA (Cody 2003, 63–72 and 117–119). In the same decades, more and more

architects from Latin America moved to Europe or the USA to study architecture in universities still dominated by Beaux-Arts pedagogic models.

By the mid-1930s, even though transnational and transcontinental opportunities were growing in the architectural field, the world was becoming increasingly dangerous and less open, eventually falling into the unprecedented drama of World War II. In this context, modernist architecture was in retreat from Nazi Germany to the Soviet Union. Adolf Hitler's takeover spurred a massive migration of modernist architects towards the UK, the USA, the Soviet Union, and Latin America. Following these events, years of dialogues between the European—especially German—artistic and architectural avant-garde and the USA (Kentgens-Craig 1999) eventually produced the transplant of European modernist culture into the US academy, with Walter Gropius at Harvard and Mies van der Rohe at the Armour Collage, soon to be renamed Illinois Institute of Technology, in Chicago (Pearlman 2007; Alofsin 2012; Ockman and Sachs 2012). From 1936, the Spanish Civil War and Francisco Franco's victory in 1939 produced a similar migration among Spanish progressive architects, mostly heading for Latin America (Álvarez Prozorovich and Garrido 2007). Still, the movement of architects and projects did not stop. In British colonies, for instance, many architects got acquainted with tropical regions during World War II and set the basis for their practice in the post-War. On the opposite side of the front, Axis countries—Germany, Italy, and Japan—exported their architectural and urban expertise in more or less recently subjugated territories (Mumford 2018, 193–198). Cities in the Italian colonies of Albania, Libya, and East Africa (Fuller 2006) were the object of intense urban transformations, while Japanese occupations forces in China (Buck 1999) and Korea experimented with planning ideas resulting from exchanges with the West, in particular with Germany during the 1930s (Tucker 2003; Hein 2003). Indeed, World War II did not stop architects' movements, although it reduced them to a circulation primarily within the territories controlled by one of the two fronts, except for those who fled the countries of the Axis.

3.3 Cold War, Tropical Modernism, and the Globalisation of Modernism in a Decolonising World: 1945–70s

Within the new global order emerging after World War II and the re-opening of most of the world, transnational work intensified, and the geographical outreach of some famous architects gained a new dimension. According to Hobsbawm (1995), the forty-five years between the launch of the two atomic bombs on Hiroshima and Nagasaki and the end of the Soviet Union in 1991 did not represent a unitary period, despite the constant state of confrontation between the USA and the USSR known as the Cold War. For the British historian, those decades can be split into two parts, with the mid-1970s as the watershed. Partly for the same reasons, partly for different ones, the 1970s represented a turning point also in our narrative. Before getting to that, however, we need to present the post-World War II context.

The end of the hostilities between April and September 1945 brought to light a new global order already foreseen at the Yalta Conference in February of the same year. The northern hemisphere was now divided into two spheres of influence and separated by what Winston Churchill called in 1946 an "Iron Curtain," with European countries falling under either the umbrella of NATO (1949) or the Warsaw Pact (1955). By the end of 1945, the United Nations was established as an intergovernmental organisation aimed at maintaining international peace and security, developing friendly relations among states, achieving cooperation to solve global problems, and harmonising the actions of nations towards these ends. Fifty-one countries were represented, including the five permanent members of the Security Council. A new financial and trade order for the Western Bloc was also on the rise, based on the agreements achieved at the 1944 Bretton Woods Conference (formally known as the United Nations Monetary and Financial Conference) that established a monetary order based on the acceptance of the US Dollar as a reserve currency. With that, the International Monetary Fund (IMF) and the International Bank for Reconstruction and Development (IBRD), later renamed World Bank, were also founded. In the meantime, six European countries created the European Coal and Steel Community (ECSC) in 1951, which in many ways represented a first step towards the establishment of the European Economic Community (EEC) in 1957. What finally emerged from these years was a world divided into three Blocs, or "Worlds." The "First World" was the Western capitalist one, led by the USA and reaching as far as South Korea, Japan, Australia, and New Zealand in the Asia–Pacific. The "Second World" was led by the USSR and included the countries under the Warsaw Pact, China and a few more allies, like Cuba, after the 1959 Revolution. Then, a "Third World", in the words of the French demographer and anthropologist Alfred Sauvy, included all the countries outside of and politically not aligned with either of the two Blocs. Most of these countries formalised such a geopolitical position at the Asian-African Bandung conference in 1955 and then by establishing the Non-Aligned Movement in Belgrade in 1961. Together with Yugoslav President Josip Broz Tito, who had by then already broken away from Soviet political control, the prominent leaders of the movement were the head of states of recently independent countries like India (independence in 1947) with Jawaharlal Nehru, Egypt (1945) with Gamal Abdel Nasser, Ghana (1957) with Kwame Nkrumah, and Indonesia (1949) with Sukarno. By the 1970s, most of Africa and Asia was finally independent; the British and the French empires were over.

While the end of the European colonial empires severed specific ties between former metropolis and colonies, this did not necessarily happen everywhere, and many architects and planners that used to work in the colonies, sometimes even directly for the colonial governments, remained in the newly independent countries or maintained links with local professionals and authorities. Overall, the presence of Western architects in the post-colonial world of the 1960–70s did not diminish, although these considerations are more qualitative than quantitative, especially if we consider a few influential professionals who displayed an unstoppable will to travel across the globe. They include architects that today we would call celebrities, like Le Corbusier and Alvar Aalto, or later Kenzo Tange, Oscar Niemeyer and Jørn Utzon (Fig. 3.1), as well as others that were engaged, often within programmes of

3.3 Cold War, Tropical Modernism, and the Globalisation of Modernism …

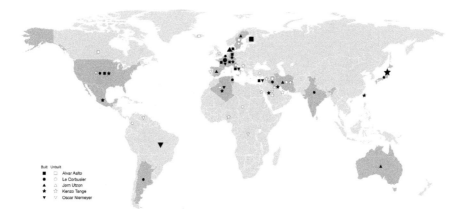

Fig. 3.1 The modernist masters, 1945–1970s. A map of countries with projects (built and unbuilt) by Alvar Aalto, Le Corbusier, Jørn Utzon, Kenzo Tange, and Oscar Niemeyer. Copyright Giaime Botti

technical aid for development by international organisations, as "technical experts" (Liernur 2004), like Maxwell Fry and Jane Drew, Gérald Hanning, Michel Écochard, or Constantinos Doxiadis (Fig. 3.2). Moreover, some less-personalised medium and large AEC firms were slowly engaging with the post-colonial world (Fig. 3.3). At the same time, with the Cold War, opportunities in some markets vanished for Western architects. While the Soviet Union was already of little interest, the establishment of the People's Republic of China in 1949 closed to European and US architects a market that had shown promising characteristics in the decades before World War II. It will remain closed until the 1980s, to transform itself into the most important international market for Western architects by the early 2000s (Sect. 4.3).

More in general, the whole Soviet Bloc lost appeal and professional opportunities for Western architects were minimum across the Soviet Union and Eastern European countries. This does not mean that forms of architectural globalisation did not take place within the "Second World" and between the "Second" and the "Third World." This appeals to the broader concept of the *mondialisation* (Lefebvre 2009; Nancy 2007) and to forms of transnational architectural collaboration that connected, for example, East Europe with Africa (Stanek 2019), the Middle East (Stanek 2021), or Mongolia (Stanek and Erofeev 2021). Still, in the 1970s, new markets were emerging, especially in oil-rich countries in the Middle East. Some will boom at the end of the century, becoming among the most attractive ones for foreign architects; others, like Iran, after enjoying a few decades of growing attractiveness, will be almost off-limits due to the political changes. In the meantime, Latin America offered fertile ground for European and US architects, especially during the promising 1950s, even though different reasons, including protectionist measures promoted by professional associations and much stronger competition from local architects compared to other contexts, limited the penetration of foreign professionals. The case of the design competition for the master plan of the new capital city of Brazil, compared to similar

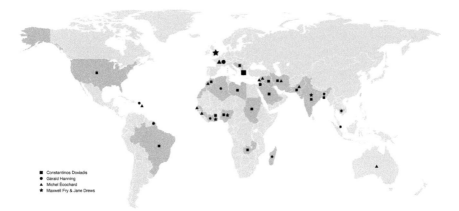

Fig. 3.2 The technical experts, 1945–1970s. A map of countries with projects (built or unbuilt) by Constantinos Doxiadis, Gérald Hanning, Michel Écochard, and Maxwell Fry and Jane Drew. Copyright Giaime Botti

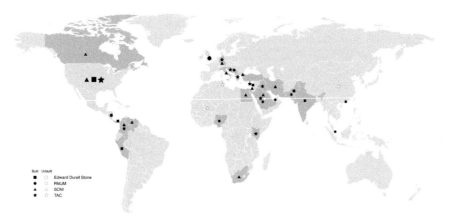

Fig. 3.3 The architecture of bureaucracy, 1945–1970s. A map of countries with projects (built and unbuilt) by Edward Durell Stone, RMJM, SOM, and TAC. Copyright Giaime Botti

cases in India and Pakistan, will make this difference clear. Lastly, the world that emerged from the ruins of World War II saw an increase in people's mobility and faster and cheaper communications due to a series of advancements that spanned from the jetliner to the telephone (Sect. 4.4).

If modernism was "international" by definition (Gropius 1925; Hilberseimer 1928; Hitchcock and Johnson 1932), it was not genuinely global until the post-War. However, by the 1950s, the geopolitical context of the Cold War boosted transnational cooperation in the field of architecture and planning and the circulation of Western architects and designs. Le Corbusier's frantic activity in the aftermath of the War

represents a clear example of how the agency of Western architects expanded globally. After the failure of the Saint Dié-des-Vosges proposal, only partially compensated by the approval and construction of the first Unité d'Habitation in Marseille, Le Corbusier in 1947 was busy with the—also failed—project for the United Nations Headquarters in New York. There, he was contacted by Colombian emissaries and invited to Bogotá. In the following years, he will be in charge of the Pilot Plan of the city (O'Byrne Orozco 2010), later developed as Regulatory Plan by the Town Planning Associates (TPA), Josep Lluís Sert's and Paul Lester Wiener's firm (Hernández Rodríguez 2004). The firm had already been active in Latin America since 1943 when Sert and Wiener drafted the master plan for the new industrial settlement of Cidade dos Motores in Brazil (de Filgueiras Gomes and Huapaya Espinoza 2009). After that, the duo developed a master plan for Chimbote, Peru, was consulted for the reconstruction of Tumaco, Colombia, and elaborated the regulatory plans of Medellín (Schnitter Castellanos 2007) and Cali (Vásquez Benítez 2001) and several plans in Cuba, including in 1955 the Havana Pilot Plan (Deupi and Lejeune 2021, 94–135). By the 1950s, Latin America represented a fertile land for modern architecture and the place where one of the most celebrated (and at the same criticised; Holston 1984) epopee of modernism took place: the construction of the new capital of Brazil, Brasilia. Around its master plan, envisioned by Lucio Costa in 1957, and the many monumental buildings designed by Niemeyer, many pages have been written (Farès 2005). We do not want here to add more. What we do like to highlight, instead, is the unique fact that Brasilia, thanks to the pressure from Brazilian architects and the presence of such a solid modernist tradition in the country, epitomised by Niemeyer himself—who according to his colleague and mentor Costa embodied the "national personality" of Brazil (Piccarolo 2020)—no foreign architects were involved in this grandiose project.

Brasilia, whose construction continued for decades after its inauguration in 1961, represented the climax of Brazilian modernism and developmentalist policies. For architecture, in many ways, it closed a period begun about two decades earlier when in the early 1940s, the young generation of architects led by Niemeyer started receiving growing recognition from the international architectural system. For this, the milestones event was the exhibition organised at the MoMA by Philip L. Goodwin (1943). After that moment, the work of Oscar Niemeyer, Affonso Eduardo Reidy, and many other talented architects started enjoying international appraisal, somehow becoming a representative of the whole Latin American architectural production (del Real 2012). Although seen as formally exuberant because of Brazil's Baroque heritage and tropical climate, this architecture was accepted and praised as a necessary evolution of a by-now sclerotised European rationalism. As Giedion (1954, 9) noted, "the contemporary movement spread out, during this difficult decade with which we are concerned, to the very fringes of our civilisation in the north and in the south. The contributions that come from the soil of Finland and of Brazil are not frontier of enterprise or provincialism but works of inspiration and of new discovery." Ties between Latin American architects and the CIAM, led by Sert since 1947, intensified in the period. The regional architectural production from Mexico to Argentina was finally acknowledged through another landmark exhibition curated

by Hitchcock (1955) at the MoMA: *Latin American Architecture: Since 1945*. These intense exchanges between North and South America and Europe resulted from policies that commenced at the beginning of Franklin D. Roosevelt's presidency, further reinforced during World War II and again with the heightening of Cold War tensions. Influential architects like Marcel Breuer and Walter Gropius, both based at Harvard, and Richard Neutra (Ettinger 2018), who had settled on the West Coast, were constantly in contact with their Latin American friends—many of whom were trained in US architecture schools (for Colombia, Botti 2017)—and often invited to collaborate at local projects, although generally with little success.

Colombia, during the 1950s and 1960s, besides the involvement of Le Corbusier, Sert and Wiener for urban master plans, received a limited inflow of projects designed by foreign architects (excluding those stably living in the country). Then, the stronger ties were with the United States: Lathrop Douglass, who had designed several office buildings for the Standard Oil Company in the USA, completed the Esso (Standard Oil) Building in Bogotá in 1957, not far from the Tequendama Hotel designed by Holabird, Root & Burgee in 1953. SOM also completed an office building modelled after the Lever House, the Bank of Bogotá (1956–59), while their proposal for the new National Administrative Centre (1957) during the years of Gustavo Rojas Pinilla's dictatorship was unsuccessful. Still, none of these projects, usually developed with the collaboration of Colombian firms, did add much to the local scene, where modern office buildings were routinely designed by mostly US-trained Colombian architects working in local AEC firms (Botti 2021). Bordering Venezuela, which during the 1950s was experiencing an economic boom thanks to its oil industry, represented a more attractive market for foreign architects. Indeed, while international architectural magazines featured the impressive achievements in public housing of the Banco Obrero led by Carlos Raúl Villanueva and his magnificent university buildings in Caracas (Blackmore 2017), opportunities were available for all types of projects. The country attracted migrating architects, including from Colombia, and many famous international figures. Gio Ponti, the founder of the Italian magazine *Domus*, designed Villa Planchart (1953–57), Richard Neutra the González Gorrondona House (1963–65), Marcel Breuer—invited by local architects Ernesto Fuenmayor Nava and Manuel Sayago—El Recreo Urban Centre (1959), while Oscar Niemeyer's daring design for a Museum of Modern Art in Caracas (1955) remained on paper.

As the country's wealth came from oil and mining, the work for architects and planners arrived from companies involved in these sectors. Holabird, Root & Burgee completed in 1953 the Hotel Lago in the coastal oil hub of Maracaibo and the Hotel Tamanaco in Caracas, part of a broader scheme funded by the Export–Import Bank of Washington, DC, backed by the US Government, and the Intercontinental Hotel Corporation (Architectural Record 1953). Lathrop Douglass designed in Caracas the Creole Building (1947–49), a modern office block for the Creole Company, owned by Standard Oil; New York-based architects Clarence Badgeley & Charles Bradbury the Shell Building (1946–50) in the same city. In the late 1950s, the Standard Oil-Creole started the development of the city of Judibana according to a "watered-down" version of a project initially delivered by SOM in 1948 (Correa 2021, 74–86). Extractivism was the underlying economic philosophy guiding development

efforts during those decades and pushing many more architectural and urban projects ahead. The most important of which was undoubtedly Ciudad Guayana, a city of new foundation developed in the 1960s in a mining region of southern Venezuela by a team from MIT led by Lloyd Rodwin (Correa 2021, 89–110), by no means the only international high-level urban consultant active in the country. By the mid-1950s, the Comisión Nacional de Urbanismo (National Commission of Planning) was counting on the collaboration of Sert, Robert Moses, Francis Violich and Maurice Rotival, who had returned to Venezuela in 1946 (Almandoz 2006).

All in all, Latin America between 1950 and 1953 received more than one-third of all US private investments abroad, while US agencies and international institutions were funding different types of projects in the region, too. The World Bank financed several hydropower projects following the model of the Tennessee Valley Authority (TVA), and the Export–Import Bank did the same with the Volta Redonda steel mill, the railway, and the whole new model community. At the same time, Nelson Rockefeller's International Basic Economy Corporation (IBEC), for instance, was deeply involved in Brazil and Venezuela (Cody 2003, 141–144). As a result, AEC companies from the USA were very active in the region, although most were involved in infrastructural rather than architectural projects. Of the seventeen AEC firms that Cody (2003, 145) listed as operating in Latin America in 1955, for example, just five (Edward Durell Stone & A. L. Aydelott; George Dudley, Edward Echevarria, architects & Robert Burlingham, a planner with IBEC; Holabird, Root & Burgee; SOM; Welton Becket) can be fully categorised as architecture firms, while in other cases there might have been a design department but within companies like General Motors, Ford Motor Company, or Chrysler. In addition, the type of work listed is often in the realm of pure engineering, like highway construction, power plants, and mining. These figures are important to measure the changing involvement of design firms overseas along different historical periods and better understand the quantitative shift towards a more globalised profession that occurred in the last three decades.

During the 1950–60s, modernist European and US architects, now presenting themselves as "technical experts" rather than radical avant-gardes (Liernur 2004), together with AEC firms, provided their (often faulty) solutions to developing countries. This happened in a general ideological framework, according to which the technical know-how from the First World was a crucial factor in promoting the development of countries that could otherwise steer towards Communism, as the case of Cuba showed. This was the key idea at the base of an influential book published by US economist Walt W. Rostow (Rostow 1960): *The Stages of Economic Growth: A Non-Communist Manifesto*. The idea of development, and the ideology of developmentalism, thus produced the perfect framework for the activity of international architects across (in today's language) the Global South. Their agency materialised along different paths: some worked for multinational companies; others were involved in big public projects or provided their expertise through international aid and cooperation programmes. The globalisation of modernism, by that time, was becoming part of the history of the Cold War, as explicitly told in a well-known book about the architecture of the Hilton hotels chain (Wharton 2001). A Hilton Hotel, whether

in Athens, Cairo, London, or Istanbul, was a recognisable building standing out from a low-rise old urban fabric, representing, or better reproducing, the comfort of American hospitality for business and leisure travellers. It was a symbol of the "free world." Several grand hotels of the US chain aimed at projecting an aura of modernity and openness were designed by Edward Durell Stone between the 1940s and 1970s: El Panama Hotel (1964), the Phoenicia InterContinental in Beirut (1954–56), the Sheraton in Lima, Peru (1970), or the Babin Kuk in Dubrovnik, Yugoslavia (1972). Of a neat, although often tropicalised, modernism were the US embassy building scattered around the globe, all of them designed in a few years by prominent modernist architects to promote a vision of an "open" America (Loeffler 1998): Rio de Janeiro (1952) and La Habana (1953) by Harrison & Abramovitz, Accra by Harry Weese (1958), New Delhi by Edward Durell Stone (1954–59), who also designed another Office Building for the US Government (1962), Karachi (1960) by Richard Neutra, Baghdad (1961) by Josep Lluís Sert, and a few other in Europe, including in The Hague (1960) by Breuer, Athens (1961) by Gropius' TAC, Oslo (1957) and London by Eero Saarinen. These and many other buildings consolidated a post-War international style with a tropicalised twist (Liernur 2015).

After 1945, economic entanglements and architectural networks within the former French and British empires survived the very end of these empires and the process of decolonisation while new forms of transnational collaboration and aid took steam. French colonies in North Africa had offered since the 1930s a fertile terrain for urban and architectural experimentation that Le Corbusier (at least in his drawings) exploited with the radical project of a city-viaduct with Plan Obus (1930). In the post-War, the African branch of the ATAB (Atelier des Bâtisseurs) led by Vladimir Bodiansky, Georges Candilis, Gérald Hanning, and Gyoji Banshoya developed influential studies on the problem of the *habitat pour le plus grand nombre* (housing for the greatest number), leading to the definition of a planning method defined as *habitat évolutif* (evolutionary housing). ATBAT's research and projects on *bidonville* and traditional dwellings, together with those of the CIAM-Algiers, soon became a reference within the CIAM network, setting the agenda for the 1953 Aix-en-Provence IX CIAM (Matsubara 2020). These approaches, indeed, had been influential over a long period and across long distances: from the PREVI-Lima in Peru in 1969 (see ahead) up to today's incremental solutions of Alejandro Aravena's Elemental (Mota 2021). The work of Candilis with Alexis Josic and Shadrach Woods in Morocco before returning to France was equally crucial in the growth of a less orthodox, more culturally and environmentally situated modernism, visible in projects like the Sémirarmis and the Nid d'Abeilles in early 1950s Casablanca (Avermaete 2005; Avermaete et al. 2010).

While many of these French architects and planners left Morocco before or immediately after its independence, the same did not happen in Algeria, where a long bloody war delayed its independence until 1962. The most remarkable projects are perhaps those left by Fernand Pouillon, especially the three housing estates Diar es-Saada (1953–54) exclusively for Europeans, Diar el-Mahsul (1954–55) for both Europeans and Muslims, and the Climat de France (1955–59) for Muslims only. The latter one, well known for its monumental scheme based on a rectangular block

3.3 Cold War, Tropical Modernism, and the Globalisation of Modernism … 75

surrounding a central 235 by 40 metres courtyard, embodied all the inherent contradictions of architects working for the French colonial regime. Pouillon, himself anti-colonialist, led the efforts to solve the housing shortage problem in Algeria, in a way missing the link between modernisation and oppression. The immense square carved inside the Climat de France became an ideal space to enhance surveillance, control, and repression by the French military and police (Utting and Jacobs 2022). Despite all, Pouillon will complete dozens of projects in post-independence Algeria, mostly hotels, tourist developments, and housing (Caruso and Thomas 2013). Bernard Zehrfuss worked in Tunisia from 1943 to 1946 as the national Chief Architect for the reconstruction, then produced several more projects in Algeria and Tunisia in the early 1950s before the latter country's independence and after it in the 1960–70s (Desmoulins 2015). In Algeria, however, another well-known architect, Oscar Niemeyer, a self-proclaimed communist and thus anti-colonialist, was commissioned several projects by Algeria's second president, Houari Boumédiène. While most of them remained unbuilt, the Brazilian architect—who had a unique role in shaping Brasilia and, with it, the very image of Brazil as a modern nation—completed the campus of the University of Constantine (1969–72) and the University of Science and Technology Houari Boumédiène in the 1970s (Oddy 2019).

As we have previously pointed out, a few European architects emerged as truly global practitioners in the post-World War II scenario. Perhaps our reader would expect us to refer to the masters of the "Modern Movement," Le Corbusier *in primis*. We are about to present other key figures generally overlooked or quickly mentioned in broad historiographic narratives like those of Curtis (2000) or Frampton (2020). Their activity, geographically speaking, usually spanned multiple countries and continents and profoundly impacted the architectural and planning profession, especially in setting the agenda of what, since the 1970s, will be called sustainability. Another characteristic of their activity was that it often began during colonial times but also continued in the post-colonial world of the 1960–70s, when these architects, who had previously worked for the colonial authorities, now either engaged with the governments or with international organisations like the various agencies of the United Nations.

Among French architects, the most striking case was that of Michel Écochard. At work in pre-independence Syria, where in 1936 designed the National Museum in Damascus and was later appointed Head of the Planning Administration; in 1941 he was sent to Lebanon, where he drafted the Development Plan of Beirut. After World War II, Écochard moved to Morocco, then a French Protectorate, where he was appointed Head of the Planning Department. There, he also collaborated with the Groupe des Architectes Modernes Marocains (GAMMA, Group of Modern Moroccan Architects), including Candilis, Josic and Woods, the *de facto* CIAM branch of Morocco (Cohen and Eleb 1998). Since the mid of the 1950s, then, Écochard, who had formed a private practice based in Paris, returned to Lebanon and Syria. His work displays the continuity with "former colonial initiatives" in post-colonial contexts. At the same time, he played a significant role in establishing new planning laws as well as in setting an updated urban agenda (Verdeil 2012). His work in this period included the master plans for Saida (1956–58), Jounieh and Jbeil

(1959–60) in Lebanon, and Damascus (1946–68), plus other plans in Iran (Tabriz, 1967; Meshed, 1971; Teheran, 1978), Guinea (Sabandé new town, 1956–58), and Senegal (Dakar, 1963–67). He also designed several schools, universities, and hospitals in Lebanon, Pakistan, Kuwait, Ivory Coast, Congo, Cameroon, and Bahrein. Some of these projects also revealed the international aid networks funding them, as in the case of the University Centre for Health Sciences (1970s) of Yaoundé, Cameroon, which the World Health Organisation established with the support of French cooperation and USAID. Besides Écochard, other French architects were active in Africa. In Ghana, Pierre Dufau designed the airport of Accra in the 1960s under a French government scheme (Stanek 2015a, b). In Guinea, Marcel Lods, Rémi Le Caisnem, and Vladimir Bodiansky completed residential and commercial buildings in Conakry in 1952, where also a French Hotel was built the following year by the Atelier LWD (Guy Lagneau, Michel Weill, and Jean Dimitrijevic) in collaboration with Jean Prouvé and Charlotte Perriand for the engineering and furniture respectively. As highlighted by Roskam (2015), Guinea, like Ghana and Nigeria for Maxwell Fry and Jane Drews, on which we will comment shortly, represented an essential location for "experimentation with prefabrication and climate control techniques."

Within British colonial territories, in the meantime, the planning and architectural expertise of professionals from the motherland was keenly promoted. With a "shrinking domestic market" in the field, increasingly in governmental hands, the Town Planning Institute advertised overseas the qualities of British planners (Ward 2010). In his late career, for example, Patrick Abercrombie was involved in projects in Malta, Cyprus, Ethiopia, and Ceylon, whereas Max Lock in Jordan (1954–55), Iraq (1954–56), and Nigeria (1965–677 and 1972–88). Meanwhile, in British West Africa, since the years of World War II, architects like Maxwell Fry and Jane Drew (Liscombe 2006) were busy designing modern schools and university buildings, up to the construction of the campuses of Ibadan and Kumasi in the late 1950s (Jackson and Holland 2014), and the plan, together with Lindsey Drake and Denys Lasdun, of the fishing village of Tema Manhean (Mumford 2018, 318). The independence of the Gold Coast, then Ghana, in 1957, and Nigeria in 1960, did not stop the work of these and other British professionals like the Architects' Co-Partnership, which opened an office in Lagos in 1954 (Tyack 2005, 27); Alan Vaughan-Richards, who settled in Lagos in 1955; James Cubitt, who, after building several schools and colleges in today's Ghana, was commissioned to plan the University of Nigeria at Nsukka and moved his office to Lagos in 1958; John Lloyd, sent by Otto H. Königsberger to lead the Faculty of Architecture of the Kwame Nkrumah University in Kumasi in 1963 up to 1966. A German *émigré*, Königsberger had previously reached London from India, taking in 1954 the direction of the newly established Department of Tropical Architecture at the Architectural Association (Le Roux 2004), one of the key centres for the consolidation of a tropicalised version of modernism and the research on climate responsive design (Baweja 2011). British firm RMJM—founded in the 1950s by modernist architects Robert Matthew and Johnson Marshall—developed a standardised design of school buildings for the Nigerian government to construct about one hundred schools. Planning ventures in post-independence Ghana included

3.3 Cold War, Tropical Modernism, and the Globalisation of Modernism ...

the Accra-Tema master plan by Doxiadis Associates in 1961 (d'Auria 2010). The military regimes that overthrew the governments that had led Ghana and Nigeria to independence pushed many foreign architects outside the countries. However, this did not stop other international enterprises, the most notable of which was the development of the new Nigerian capital, Abuja. This Brasilia-inspired master plan was designed by Wallace, Roberts, McHarg, and Todd (WRMT) and Archisystem International and later detailed by Kenzo Tange (Elleh 2001, 2016). Indeed, during the 1960s, we find Canadian firm PPAL delivering the master plan of Dar es Salaam in 1965 and Dodoma in 1975 (Ward 2010), and William Pereira designing the Hotel Ivoire in Abidjan, Ivory Coast in 1965, to mention two North American firms. Many more projects designed by local and foreign architects during the post-independence period of several countries would deserve further room for their design quality and relevance in displaying the relationship between modern architecture and nation-building in the post-colonial context (Herz et al. 2015).

Across India and South-East Asia, the very same architects were again the protagonists during the same decades. Exiled from Nazi Germany, Königsberger had arrived in India in 1939, soon becoming the Government Architect of Mysore State while also establishing an important link with Tata & Sons industrial group that led to the construction of several buildings at the Indian Institute of Science in Bangalore, plus the Tata Institute of Fundamental Research in Bombay, and the Jamshedpur Development Plan for Tata & Sons, and the master plan of the new capital of Orissa, Bhubaneswar. Before leaving India in 1951, Königsberger was also appointed Director of Housing in the Ministry of Health, for which he produced a model of low-cost prefabricated houses (Lee 2012; Baweja 2015). However, Königsberger resided in India throughout the whole period, making his case less of interest for the logic of this book. On the contrary, Le Corbusier's involvement in the design of the new capital of Punjab and Haryana states, Chandigarh, constituted a case of remote work. Indian Prime Minister Jawaharlal Nehru initially assigned the commission to US Architects Albert Mayer and Matthew Nowicki. At the latter's sudden death in 1950, Mayer abandoned the project and Le Corbusier, then working on the Bogotá Pilot Plan, received the commission. Over the next decade, the master plan was implemented, and Le Corbusier assigned the design of major institutional buildings like the Assembly, the Secretariat, and the High Court. They were all completed by the 1960s, standing out as the most consistent set of works embodying Le Corbusier's post-War new formal ethos. The new capital of Punjab was indeed conceived, in Nehru's eyes, as a symbol of modern, industrial India (Kalia 2006) and Le Corbusier's architecture, unlike Lutyens before, did achieve monumentality without a direct reference to Western classicism but rather appropriating the traditional "parasol" of Fatehpur Sikri "as a monumental coding device" (Frampton 2020, 261–262). In the meantime, Pierre Jeanneret, Fry, and Drews developed different typologies of residential units for the city (Prakash 2002; Bauchet-Cauquil et al. 2014; Jackson and Holland 2014).

The involvement in South Asia of another great master, Louis Khan, did neither escape from a developmentalist agenda in the logic of the Cold War. His famous project for the Indian Institute of Management (1962–74) in Ahmedabad was sponsored by the Ford Foundation to spread the ideals of American capitalism in a country

that was economically steering toward socialist models even though it remained Non-Aligned (James-Chakraborty 2013). Indeed, Kahn's project came while he was already working on the design of the Sher-e-Bangla Nagar (National Assembly of East Pakistan, now Bangladesh, 1962–83), invited by Muzharul Islam, an architect trained at the AA School of Tropical Architecture and later at Yale under Paul Rudolph that will emerge as the master of Bengali modernism. While Islam also invited Rudolph and Stanley Tigerman to the country, Khan was then involved in other projects: the National Institute of Cardiovascular Diseases and the Shaheed Suhrawardy Medical College, both in Dhaka. By that time, however, Kahn had also lost the commission for the Presidential Estate (1963) in West Pakistan, assigned to Edward Durell Stone, whose activity in the region further signalled the tightening of USA-Pakistan relations during the Cold War (James-Chakraborty 2008). Over a decade, Stone designed several important buildings: the Hotel InterContinental in Karachi (1956) and the Offices for Pakistan International Airlines in Lahore (1962) were not built, while the WAPDA House in Lahore (1962), the Pakistani National Shipping Corporation Building in Karachi (1967), and, in Islamabad, the Radio Pakistan (1969), and the Aiwan-e-Sadr, the Presidential Palace (1970) were all completed. Moreover, by 1965 the Pakistan Institute of Nuclear Science and Technology, the cradle of the Pakistani nuclear programme under US tutorship, was completed according to Stone's design.

Looking back at the late 1950s, in East Pakistan, we also find at work British planners like Anthony Minoprio, Hugh Spencely, and Peter Macfarlane, who in 1959 were commissioned the master plan of Dhaka, the future capital of Bangladesh, and in 1962 for the port of Chittagong (Ward 2010). In the 1960s also began the project of Islamabad, the new capital of (West) Pakistan, whose design by Doxiadis Associates also involved RMJM and the local engineering company Osmani (acquired in 2010 by the British firm). As for Doxiadis Associates, by that time, it had already designed the master plan for the new campus of the Punjab University at Lahore (1959–73) and several buildings inside it. The story of Doxiadis is, in this regard, remarkable. The Greek architect landed in Pakistan in 1954 as a member of the Harvard Advisory Group supported by the Ford Foundation. Doxiadis, as pointed out, was "unique in his global 'reach'" (Ward 2010, 61), with works spanning from Ghana to India and Pakistan, from Jordan, Lebanon, Iraq, and Syria to Venezuela and Brazil. Many of his projects were financed by American (USAID, for example) and international agencies (UN, IBRD, and Inter-American Development Bank) as well as by private actors like the Ford Foundation (Bromley 2003; Ward 2010, 60).

How the work of "experts" like Doxiadis and others was requested during the 1950s in the framework of development policies promoted and supported by the USA and the West is also well visible in the Middle East. Iraq during the 1950s represented one of the most paradigmatic cases. The dreams of modernisation of the young King Faisal II, supported by oil money, led to a frenzy of international activity (Bernhardsson 2008). Doxiadis Associates was assigned the master plan of Baghdad in 1955 (Pyla 2008), while soon after, Frank Lloyd Wright worked on the Greater Baghdad master plan and on the design of a few buildings that were never carried out because of the overthrowing of the Hashemite monarchy in 1958 (Kubo 2021). Walter

Gropius-led The Architects Collaborative's plan for the University of Baghdad of 1957, instead, survived the regime change, although its completion a decade later did not adhere to the original forms. The architectural proposal elaborated by TAC also offered an excellent example of the post-War concerns for defining spatial strategies and articulating a modernist vocabulary reflecting the growing interest in adapting to tropical climates (hot-dry in this case). The other aspect to highlight about this experience is that TAC established an office in Rome to manage this and other projects in the Middle East. In the meantime, the involvement of top modernist architects in Iraq included Le Corbusier for the project of the Baghdad Gymnasium (1956, completed in 1980), and Gio Ponti for a reinforced concrete Office Building (1955–57), while a few projects by Alvar Aalto—Fine Art Museum, Post and Telegraph Office (1957), and others—remained unbuilt, like Willem Marinus Dudok's Justice Palace, which was also to be located in the new Civic Centre. This last urban project was designed by the British firm Minoprio, Spencely & Macfarlane, which in 1951 had already designed the master plan of Kuwait City. The political changes of the 1960s, however, transformed Iraqi international relations, and new 'architectural geopolitics' emerged, as proved by the increasing engagement of Polish architects, planners, and specialised workers in the country. The Miastoprojekt-Kraków, a Polish state-owned firm, delivered two master plans for Baghdad in 1967 and 1973 and the General Housing Programme in 1976 (Stanek 2012).

In neighbouring Kuwait, in the meantime, the discovery of oil in the 1930s and the beginning of its exploitation on a commercial scale after World War II had prompted the development of its capital city, that by 1950 had reached 150,000 inhabitants and suffered from traffic congestion problems. As Ward (2010) explained, British planners at that moment were able to capitalise on their reputation for new town master plans and traffic planning. Hence, it should not surprise that in 1951 the Kuwaiti government commissioned the master plan of its capital city to Minoprio, Spencely & Macfarlane, which they delivered by copy-pasting what they had just done in Crawley, UK. The result of implementing this master plan was felt for the years to come, not least in terms of the loss of traditional urban fabric and urban identity of the city. In 1968, a new plan was prepared by Kuwaiti architects who could also rely on Colin Buchanan and Partners as consultants and on an advisory committee formed by Leslie Martin, Franco Albini, and the representative of the UN on Middle Eastern planning affairs. The result was not an attempt to recreate the historical city but at least to preserve what had escaped from destruction (Al-Ragam 2015). To gain further expertise, the municipal government invited a small group of well-respected European architects—Alison and Peter Smithson (Al-Ragam 2015), Reima and Raili Pietilä (Botz-Bornstein 2015), Georges Candilis (Al-Ragam 2017), and the B(B)PR from Italy—to make proposals for the improvement of the old town; the competition had no winner, but they were all asked further to study four different parts of the ancient city.

Of all, only Reima and Raili Pietilä did successfully develop a few projects in the following years: the extension of the New Sief Palace replicated the historicist language adopted by Pearce, Hubbard and Partners' 1963 Clock Tower extension and the original early-1900 building, while the Ministry Building of the 1980s proposed

a new vocabulary of forms, elements, details, and decorations based on (more or less) local building traditions and references (Botz-Bornstein 2015). This central area will undergo a profound transformation in the 1970s with the construction of important buildings like Jørn Utzon's National Assembly and Michel Écochard's National Museum. Being a small country in which barely half of the population was made of nationals, Kuwait had to rely heavily on different forms of foreign expertise in the field of architecture. It has been noted that in Iraq, at the end of the 1970s, 90% of architects were trained at the University of Baghdad, the first faculty of architecture in the Arab and Persian Gulf, and that its graduates "populated" the new departments of engineering and architecture of the region, including the college of engineering at Kuwait University, established in 1966 (Kubo 2021), but in any case, in the 1980s Kuwait was still counting on foreign expertise (AMO, Reisz and Ota 2007, 90). Back in the 1950–60s, several European architects were already active in the country: John R. Harris completed the Building Research Laboratories (1952) and the Sulaibikhat Hospital (1969) before turning his focus on Dubai; Arne Jacobsen successfully designed the Central Bank of Kuwait (1966–76), a prismatic bunker-like building protected by a wall like a fortress that still stands today, although altered in its appearance by the opening of large, unprotected windows of dubious taste. Finally, it is pertinent to recall a very interesting competition that happened in 1968. Aiming to host the Pan Arab Games, the Kuwaiti government launched an invited competition to design a large Sports Centre. Kenzo Tange with Frei Otto won, but the complex was never built. However, the event brought together some of the most creative architect-engineers of the time who had recently completed important sports venues: Félix Candela, Pier Luigi Nervi, Lloyd, Morgan & Jones (Marisela and Cresciani 2013).

Other Gulf countries, especially Qatar and the United Arab Emirates (still British colonies at the time), emerged only after the 1970s as key markets for architectural services. Nonetheless, they were already known to some European architects, especially British ones. John R. Harris, in 1949, had designed the Al Maktoum Hospital in Dubai; later, he completed the project for the Grindlays Bank (1957–67) in Abu Dhabi, where he also envisioned a master plan for the palace and the government centre (1962). The future capital of the UAE, in fact, started developing in the 1960s after its first oil export, when a municipal department was established with the responsibility for improving living conditions by providing drinkable water and accessible health services. At that moment, Halcrow & Company was appointed to draft a first master plan (Duncan and Tomic 2013). In the meantime, Harris had also worked in Doha, a city that only in the 1950s, and at a relatively slow pace, started developing into a centre with modern facilities thanks to the oil revenues (Adam 2013). Here, in 1957 Harris designed the Finance Ministry building and the Qatar State Hospital (today Rumailah Hospital), awarded through a RIBA-organised competition. The same year, Harris opened its first branch office in Tehran, Iran (AMO, Reisz and Ota 2007, 154). This was because Iran under the Pahlavi dynasty (1925–79) was becoming an increasingly attractive market for Western architects. Jørn Utzon completed the Bank Melli building in 1960, while Fernand Pouillon, during the 1950s, was involved in a certain number of projects, including the train stations of

3.3 Cold War, Tropical Modernism, and the Globalisation of Modernism …

Tabriz and Mashhad in collaboration with Heydar Ghiai, one of the most prominent Iranian modernist architects, trained at the École des Beaux-Arts. American architect William Pereira, famous for the iconic Transamerica Pyramid (1969–72, 260 m) in San Francisco, delivered during the 1970s the designs for the Tehran International Airport, the Imperial Medical Centre (1976), and Bell Operations Training Facility. In 1975, SOM was awarded the planning of two new towns, Ahvaz and Shaphur (Cody 2003, 154), to deal with which they opened an office in Teheran in 1975 (McNeill 2009, 119), while in the same year was initiated the construction of a monumental civic centre master-planned by Llewelyn-Davies International, which was preferred over a previous design by Kenzo Tange and Louis Khan (Emami 2014). However, the project was blocked by the rising political tensions that eventually led to the Islamic Revolution of 1978–79, an event that completely changed Iran's working conditions and led to Western architects abandoning this market.

Therefore, while for European architects the great changes brought by decolonisation did not halt their overseas professional adventures, other political upheavals did have a much different effect. With the Civil War outbreak in 1975, Lebanon became a dangerous workplace. Iran, as just observed, closed off in 1979. And it was not the only case. Back thirty years, with the establishment of the People's Republic of China in 1949, almost all ties with the West were cut. By the early 1950s, Soviet architects and planners had become the only international advisors, exercising a strong influence on local professional (Lu 2006). However, this inflow of foreign ideas did not last long, as the Cultural Revolution (1966–76) further severed links with the exterior, albeit ideas and models from the USA continued to circulate among Chinese architects even during the 1970s, exercising a relevant influence on them (Song and Zhu 2016). Far from the pre-World War II era when Albert Kahn had designed over 500 factories in the Soviet Union through an office established in Moscow in 1929 that trained over 4,000 architects and engineers (Melnikova-Raich 2010), Le Corbusier had designed the Tsentrosoyuz (1928–33), and CIAM architects maintained strong links with their Soviet friends, during the Cold War US and European architects had little opportunities to work in the USSR and the Eastern European countries. In Latin America, the success of the Cuban Revolution of 1959 terminated all business connections with the USA. Architecturally speaking, the best-known consequence was that Mies van der Rohe's design for the Bacardí HQ in Santiago de Cuba (1957) was not built but later became the Neue Nationalgalerie (1968) of West Berlin. On the other hand, another office building for the Bacardí was finally built in 1962 on the outskirt of México City, in a plant that became a showcase of modern architecture thanks also to Félix Candela's thin concrete shell roofing of the bottling plant (O'Rourke 2012).

On the other hand, new opportunities arose for architects and engineers from countries of the Soviet Bloc. To remain in Latin America, a significant case, albeit more related to the export of technology rather than on the circulation of professionals, was represented by the export from the Soviet Union to Cuba in the 1960s, and Salvador Allende's Chile, before the 1973 *coup*, of the KPD system ("large panel construction") for heavy prefabrication for housing construction similar to the Camus model (Alonso and Hugo 2012). In Asia, Soviet planners were not only

active in China in the 1950s, but also in Vietnam (Logan 1995; Schwenkel 2014) during the 1960–70s, when two master plans for Hanoi were elaborated. However, it was in Africa that the presence of Soviet and Eastern European architects produced the most remarkable architectural outcomes, extensively mapped by Łukasz Stanek (2019). To understand the dimension of this presence, some figures may help: Ghana received 102 Polish specialists in 1965, Nigeria 94 in 1971, and Algeria 91 (Stanek 2015a, b). In the Middle East, from Iraq and Kuwait to Syria, the presence of architects from the Soviet Bloc was significant, and more details will be provided in the next section. Finally, the People's Republic of China also emerged as an important actor providing technical support through architects and engineers, especially across Africa. A mapping of Chinese architects' work overseas has been recently published (Xue and Ding 2022), and here we can just remind of a few cases. Chinese architects, for example, were active in Ghana and in Guinea, where they designed the National Assembly Building (completed in 1967) in Conakry (Roskam 2015), while in Zanzibar, during the early 1980s they elaborated a master plan for Stone Town (Folkers 2014).

Indeed, development aid was not a binary option either from Western capitalistic or Socialist countries. Western but neutral countries and Non-Aligned ones were also in the game. Swiss planner Werner Moser prepared the master plan for Kalyani, in West Bengal, in 1947, while Sweden, which in the 1950s had not established a clear foreign aid policy yet, initiated programmes of technical training in Ethiopia, which led to the establishment of the Ethio-Swedish Building College, an educational and research offering a four-year programme in engineering and other types of technical training. As Levin (2022, 183–185) has investigated, Israel was also a very active actor in Ethiopia. While Sweden encouraged forms of self-help relying on local labour and materials (not conditioning aids to the purchase of its products) and focusing on rural communities, architectural education promoted at the Israeli-backed College of Engineering "focused on high-profile building projects" and the popularisation of engineering. Israeli aid promoted self-help solutions but emphasising the role of "industry over vernacular forms of production." And this was not an isolated case, as between 1958 and 1973, the "golden age" of Israeli-African relationships, Israel emerged as an important actor for technical aids in the field of architecture and construction in Ethiopia, Nigeria and Sierra Leone; an actor sought after by African elites that often preferred development aids from countries other than former colonial powers (Levin 2022, 1–3). A completely different experience, but very relevant for its visibility at the time and legacy today, was the one of PREVI (Proyecto Experimental de Vivienda; Experimental Housing Project) in Peru. Initiated in 1968 by the reformist president and architect himself, Fernando Belaúnde Terry (although a Pilot Plan by British architects Peter Land was already launched in 1965) and continued by the military government of Juan Velasco, who took over that same year, PREVI brought together some of the best architects of the period with the technical support of the United Nations. With two competitions held in 1969, thirteen Peruvian and thirteen foreign architects—including Aldo Van Eyck, Charles Correa, James Stirling, Kisho Kurokawa and Fumiko Maki, and Candilis, Josic and Woods–were selected to design 1,500 housing organised in low-rise neighbourhoods

provided with schools and commerce. The project represented an alternative to the then-dominant isolated high- and mid-rise typology for social housing, and the units were conceived to facilitate future expansion by the owners, a legacy that lasted, as Alejandro Aravena's celebrated Elemental houses exactly derive from this (Carranza and Lara 2015, 262–265).

To conclude this section, we point out again the expanding geographical scope of the architectural profession in the post-War. Unlike in the previous decades, when migration was the dominating phenomenon behind the overseas work of architects, with advancements in intercontinental transportation and communication, the possibility of delivering projects from a few centres in Europe, the USA, and Japan to the rest of the world dramatically increased. The celebrities of the time, from Le Corbusier to Alvar Aalto, from Jørn Utzon to Oscar Niemeyer, from Kenzo Tange to Louis Kahn, took the opportunities. At the same time, some larger firms like RMJM or SOM started working in new strategic markets in the Middle East and South Asia, where some office branches were opened. In addition, architects and planners able to capitalise on their colonial-era experiences and networks worked across the developing world, sometimes backed by private or multinational organisations. Although influential in several ways, all these different experiences remained quantitatively limited. In this regard, some additional data can help understand how, compared to this period, the situation will have changed by the 1990s and even more after the 2000s. Thanks to Jeffrey Cody's (2003, 130–142) extensive mapping of US companies' overseas operations, we know that in 1953 there were six US AEC companies active in the UK, nine in Italy, and five in Greece. None of them produced any work in architecture, as they were involved in building and rebuilding highways, ports, power plants, or refineries. Of ten firms active across Africa in the same year, just two or three (including SOM together with Porter & Urquhart) qualify as architectural firms. Of fifteen operating in Turkey in 1955, just SOM qualifies as an architectural firm and delivered architectural projects (a hotel design), while most of the remaining ones were involved in mining and other engineering enterprises. Of the other seventeen companies operating across the Middle East, only three—Edward Durell Stone, Edmund J. Whiting, and Chauncey Riley—were led by architects. And for India and the Far East, it was the same. Indeed, getting closer to the 1970s, the situation gradually changed, and with the 1973 Oil Crisis, we immediately appreciate its consequences in the global architectural profession. For many Middle Eastern countries, the oil shock in Europe represented a boom. This opened a period that, in our narrative, will close with 1989–91. As far as architectural globalisation is concerned, this period can be read as a transition to the present market conditions. A transition that, like any other process of change involving multiple regions, had different timings.

3.4 The Side of the Oil Crisis from the Middle East Boom to the "End of History:" 1970–90s

Despite the difficulties in providing periodisations valid for different historical problems and across geographical regions, as far as architectural globalisation is concerned, we propose to look at the decades between 1973 and the mid-1990s as a period with loose chronological boundaries but marked by important historical events with consequential repercussions on the architectural profession. In this regard, during these three decades, we find a reasonable degree of continuity with the previous period, slow transformations that will mature only later, and some more abrupt changes. Rather obviously, these decades marked the transition in the architectural profession between the post-World War II years and the last three decades.

For Hobsbawm's (1995, 403), the 1970s represent a watershed moment: the end of the post-World War II "golden age" and the beginning of a period of uncertainties— "a world which lost its bearings and slid into instability and crisis"—with Western countries experiencing economic downturns for the first time since the end of the War, growing unemployment and inflationary pressure. In the 1980s, advanced economies were generally more prosperous overall, while developing countries struggled during the decade, in many cases falling into a debt crisis. Still, many things have changed, not only in people's perceptions. Income inequalities in developed countries have started rising again since the 1970s, achieving an early twentieth-century level by the 2000s (Piketty 2014, 19), while the welfare state built during the "golden age" was partly dismantled following the now dominant neoliberal ideology. However, the most significant transformation was in the diminished power of the nation-state in controlling an increasingly transnational global economy. This "landslide," as Hobsbawm calls it, was triggered by a series of events in the early 1970s, from the dismantling of the Bretton Woods system culminating with the cancellation of the convertibility of the US Dollar into gold in 1971, to the oil shock of 1973, triggered by the Yom Kippur War between Israel, on one side, and a coalition of Arab countries, on the other. As a repercussion, Arab members (OAPEC) of the Organization of the Petroleum Exporting Countries (OPEC) established an oil embargo towards the USA and The Netherlands, while OPEC seized the opportunity to raise prices. The consequences on the economies of oil-consumer countries were harsh, but for the oil-producer ones, the "shock translated into an unprecedented control over their energy resources and completed the process of decolonisation, leading to a profound redefinition of international relations" (Bini et al. 2016, 1–2). As a result, the inflow of capital towards oil-producing regions after the mid-1970s became the great engine behind the growth of several countries, especially in the Middle East, which was transformed into one of the most attractive markets for European, US, and Japanese architects.

Although not the primary concern of this book, changes in the architectural discourse were significant in the 1970s, too. Once again, searching for watershed events would bring us to choose the demolition of the Pruitt-Igoe Apartment complex

3.4 The Side of the Oil Crisis from the Middle East Boom to the "End … 85

in Saint Louis, Missouri, as the one. As Jencks (2002, 9) wrote, with the demolition in 1977 of this high-density, modernist public housing estate designed by Minoru Yamasaki not even twenty years before, modern architecture was declared "dead". Whether modern architecture died that day or at any other moment, architectural culture underwent a transformative period. While the great masters of the "Modern Movement" were passing away one after the other—Wright in 1959, Le Corbusier in 1965, Gropius and Mies in 1969–, the new generation of modernist architects gathered in Team X had already brought the CIAM experience to an end in with the Otterlo meeting of 1959. And even before the rise of what Jencks called post-modern architecture epitomised by Robert Venturi's, Michael Graves', Charles Moore's, James Stirling's and others' buildings, the disciplinary discourse was shaken by a series of books that since 1960 had been destroying all the certainties of the previous decades and prepared for the next paradigm shift of post-modernism. The sequence, in many ways, was impressive: *The Image of the City* by Lynch (1960), *L'architettura della città* by Rossi (1966), *Complexity and Contradiction in Architecture* by Venturi (1966), *Los Angeles: The Architecture of Four Ecologies* by Banham (1971), and *Learning from Las Vegas* by Venturi et al. (1972). But the transformative power of the 1970s was not limited to the architecture form and theoretical discourse, as a new concern was getting a foothold: the awareness of resource scarcity, human impact on the environment (the ozone depletion was acknowledged in the 1970s and CFCs gradually phased out from the following decade, for example), and the rise of the new concept of sustainable development.

Commissioned by the Club of Rome, the milestone report *The Limits to Growth* (Meadows et al. 1972) was published in 1972. Based on innovative computer simulations, it warned about the devastating path towards the exhaustion of natural resources that humanity has undertaken. The word 'sustainable' made at that time its appearance to consolidate thirty years into the concept of sustainable development as expressed in the United Nations' Rio Declaration on Environment and Development of 1992. As for architecture, after the radical proposals of the 1960–70s counterculture epitomised by Paolo Soleri's community of Arcosanti, Arizona, and Olgyay's (1963) pioneering studies on bio-climatic architecture, by the 1970s in the United States a passive and active solar architecture was emerging, boosted by new legislations and by the consequences of the oil embargo (Tabb 2014). Indeed, this represented a turnaround for a profession that, despite the focus of institutions like the AA School of Tropical Architecture, had overall seen climate responsiveness as "redundant" given the advancements in mechanical equipment and the availability of cheap energy (Baweja 2011, 236). Since then, and especially from the 1990s onwards, 'green' or 'sustainable architecture' has become one of the "gospels" of the profession (Raisbeck 2020, 11), a dominant trend that several historians (Frampton 2020, 361; Fazio et al. 2003, 560; Ching et al. 2017, 797) recognise in the architecture of the new millennium, further strengthening both internationalist high-tech and low-tech regionalist trends of the 1980–90s, exemplified by the works of architects like Norman Foster and Renzo Piano for the former, and Glenn Murcutt for the latter.

In this light, if the key objective of this book is to study the process of globalisation of the architectural practice, the key region to look at during the 1970–80s is the

Middle East and its oil-richest countries in particular. As pointed out, even though the area was a dynamic market already in the 1960s, it was after the 1973 oil crisis that "the region's impact on architectural practice reached a global scale" (Hinchcliffe 2013). Of course, other regions started carrying weight too, like, for example, China in the 1980s, when, following its economic opening, it began to attract foreign investments and (although very limitedly) overseas architects. In the meantime, cities like Singapore and Hong Kong also captured the interest of Western, Japanese, and Australian architects, together with some urban centres in Malaysia, Indonesia, Thailand, and South Korea, which gradually emerged as important markets. On the other hand, Russia was still a closed reality for architects, albeit this does not mean that Soviet architects did not look at and know the state of the art of architecture in Europe and the USA (Yakushenko 2021). By that moment, Africa had lost much of the appeal it had in the 1960s when colonial links were still strong, and the newly independent countries were undergoing a sweeping modernisation attempt. In addition, its largest economy, South Africa, has been under international sanctions since 1962 due to the apartheid system, albeit only in the 1980s, they started really biting (Jones 2015, 52–92). Lebanon Civil War from 1975 and the Islamic Revolution in Iran in 1979 closed off these countries. In the meantime, Latin America during the 1980s was going through its *década perdida* ("lost decade"), a period characterised by low growth, high inflation, and sovereign debt defaults, which made the countries of the region not particularly attractive for investments.

Links between Europe and Japan, and between the USA, Japan and South Korea, were also intensifying during the 1970–80s. The first projects of Kenzo Tange in Europe and the USA date back to this period: Bologna Fiera (1971–75) and Naples Administration Centre ("Centro Direzionale", 1980s) in Italy, the unbuilt Baltimore Inner Harbour Master Plan (1973), and the completed Minneapolis Art Complex (1964, 45,500 m^2) and the Japanese Embassy in Mexico (1976, 3,656 m^2). Another case is Kisho Kurokawa's Japan-German Centre (1985–88, 8,467 m^2) in Berlin, a work to be inscribed in a broader framework of the Japanese diplomatic efforts of the time, comparable to the contemporaneous Chinese-Japanese Youth Centre (1987–90) also designed by Kurokawa. Indeed, some Japanese architects, especially those related to the Metabolist group, broadly expanded the geographical scope of their work in the 1970s towards the Middle East, and in the 1980s towards South-East Asia (Fig. 3.4), as thoroughly mapped in Rem Koolhaas and Hans Ulrich Obrist's *Project Japan* (2011). During the 1970s, Japan became the biggest exporter of goods to the region, with its architects following the wave (Koolhaas and Obrist 2011, 601–602). In the same decades, also some US architects that we could regard as celebrities were expanding their agency across the globe along a similar geographic pattern (Fig. 3.5), looking for opportunities no longer available in the oil-shocked West.

Given this context, the reasons for starting this section from the Middle East look obvious. And for its size and strategic importance, the Kingdom of Saudi Arabia is undoubtedly the place to begin with. By 1970, overcoming Venezuela, it had become the third largest world oil producer after the USA and the USSR. The Kingdom was already in the spotlight for foreign architects and contractors at that time. And the next five-year plans of 1970, 1975, and 1980 were up to pour hundreds of billions

3.4 The Side of the Oil Crisis from the Middle East Boom to the "End ...

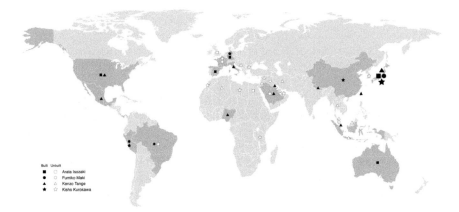

Fig. 3.4 The Japanese celebrities, 1965–1989. A map of countries with projects (built and unbuilt) by Arata Isozaki, Fumiko Maki, Kenzo Tange, and Kisho Kurokawa. Copyright Giaime Botti

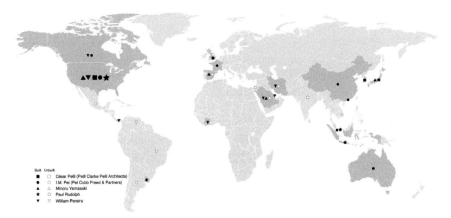

Fig. 3.5 The US celebrities, 1965–1989. A map of countries with projects (built and unbuilt) by César Pelli (Pelli Clarke Pelli Architects), I. M. Pei (Pei, Cobb, Freed & Partners), Minoru Yamasaki, Paul Rudolph, and William Pereira. Copyright Giaime Botti

of US Dollars into the construction sector. Riyadh was "the largest building site in the world in the mid-1970s, issuing an average of seventy permits each day" (Wright 2008, 234), and it has been claimed that, in 1985, a quarter of all the world architectural activities outside the Soviet Bloc was taking place there (Kultermann 1985). According to another article (Sennewald 1989), in 1978, more than half of New York-based firms had at least one ongoing project in the Middle East. Whether these data were correct or inflated, there is little doubt about the role that the KSA, and the region in general, started playing for Western and Japanese architects. Cities were undertaking incredible transformations, often resulting in significant losses of their historical fabric, something that had happened, for example, in Kuwait City during

the 1950s while whole new towns were built. With money and commissions flowing at this scale, foreign planners were busy elaborating general master plans for several cities. Doxiadis Associates prepared in 1972 the master plan for Riyadh (Mumford 2018, 318–319), RMJM those for Jeddah, Medina, Tabuk, Taif, and Yanbu (1970–73), while Candilis, who was no longer in partnership with Josic and Woods and was during the 1970s very active in Saudi Arabia and the rest of the Gulf, drafted the master plans for Al Ahsa, Al Jubayl Al Khobar, Dammam, and Qatif. In the meantime, The Architects Collaborative designed three new military cities (Kamis Mushayt, Quaysumah, Tabuk) that were completed around 1973, while another US firm, Brown and Daltas, the octagonal-shaped King Khalid Military Town. As international expertise was sought after by the Kingdom for a variety of projects, from grand public buildings to airports, from hotels to housing communities, opportunities flocked (Kultermann 1985).

The development of transportation infrastructures like airports was impressive in the decade following the 1973 oil crisis, which was not a crisis at all for Saudi Arabia. Minoru Yamasaki had in 1959–61 designed the Dhahran International Airport, a beautiful and celebrated example that "reintroduced the Islamic vocabulary in modern materials and technologies" through a modern interpretation of latticework ornamentation and pointed arches. The airport soon became a symbol of modern Arabia, even deserving a place in the Saudi Riyal banknote (Alkhabbaz 2017). Yamasaki also successfully designed the Royal Reception Pavilion at Jeddah International Airport (1974–79) and the Eastern Province Airport in Dammam (1975–90). By the 1980s, SOM had also completed the Hajj Terminal of the King Abdulaziz International Airport in Jeddah (1981), an impressive 260,000-square-metre naturally ventilated space covered by a light Teflon-coated fibreglass roof. On the contrary, HOK's King Khalid International Airport in Riyadh, which opened in 1984, was roofed with concrete vaults. The whole complex, which included a large mosque at the centre, was based on a triangular geometry that, through the use of vaults and arches, reminded of traditional Islamic architecture (Kultermann 1985). In a way, these works pioneered that blend of modernity with elements inspired by the local tradition—in the form of structural and roof elements or decorative patterns sometimes justified by functional reasons (sun-shading, for example)—used by foreign architects to regionalise their work. It is what we will see in several buildings developed since the 1990s across many emerging markets, from skyscrapers (Sect. 5.4) to airports (Sect. 10.1). The concrete vaults used by Foster and Partners for the Queen Alia International Airport (2005–12) in Amman represent just one example of this.

In the epoch, the re-shaping of Saudi Arabia's image as a modern kingdom was pursued by means of architecture, touching deep into the very core of its institutions: the King and the government. Kenzo Tange was selected to design both the Royal State Palace (1977–82, 14,000 m^2) and the Royal Palace for H.R.M. the King (1977, 11,000 m^2) in Jeddah. The two expansive buildings extend horizontally with articulated but enclosed forms and grand interiors. In two phases (1976–82, 70,190 m^2; 1984, 32,000 m^2), Tange also completed the King Faisal Foundation Headquarters Complex in Riyadh. The first part consisted of two office towers with a triangular floorplan backed by a low-rise complex, all organised along a central axis running

3.4 The Side of the Oil Crisis from the Middle East Boom to the "End ... 89

through an elongated courtyard. The symmetrical layout and the presence of colonnades, arcades, and majestic staircases delivered an image of *grandeur* that was not replicated in the second building, a sloping office block. In the meantime, several government buildings were designed by foreign architects: the Ministry of Foreign Affairs in Riyadh (1984, 85,000 m^2) was awarded to Henning Larsen after a competition that saw the participation of Arata Isozaki, Trevor Danatt, Frei Otto and Rolf Gutbrod, Ricardo Bofill, and Tange. The result was a fortress-like triangular building inspired by traditional geometric patterns and architecture. In addition, Frei Otto and Rolf Gutbrod, who delivered several projects in the country, designed the Royal Palace King's Office and Council of Ministers (1978), Kramer, Sieverts and Partners (KSP) the Ministry of Public Works and Housing (1982–85), Gollins, Melvin and Ward (GMW) the Ministry of Information, and Arthur Erickson the Ministry of Foreign Affairs International HQ. As noted (Kultermann 1985), only one Arab firm, Zuhair Hamid Fayez, was involved in this programme, with the project for the Ministry of Labour and Social Affairs (1984).

New university buildings and whole campuses were also built according to projects designed by foreign architects. The first enterprise in this field was the University of Petroleum and Minerals, designed by Caudill, Rowlett and Scott in 1964–71 and extended in 1982, while the largest was the King Saud University (1985) by HOK and GMW in Riyadh, a campus for over 20,000 students. As noted (Wright 1991, 232), "both campuses featured 'Islamic' ornament, colonnaded arcades, and pointed arches," while, for example, MIT-trained Ahmed Farid Moustapha "allowed no such historicist references for Riyadh University and the King Faisal University in Dammam." For King Abdulaziz University in Jeddah, Frei Otto and Rolf Gutbrod designed the Sports Hall (1981) with a lightweight tensile structure. The two Germans had entered this market in 1966 when they won the competition for a Hotel and Conference Centre, whose site was later changed to a mountainous area near Mecca. The complex, completed in 1974, featured an interesting organic layout where the two main buildings created semi-enclosed courtyards partially shaded by tensile structures. Indeed, Saudi Arabia became a fertile terrain of experimentation for lightweight tensile structures, as visible in SOM's Hajj Terminal or in Ian Fraser, John Roberts + Partners' King Fahd International Stadium (1980) in Riyadh. As the climate of the Arabian desert makes imperative the design of shaded and ventilated spaces, such kind of light solutions to cover huge areas became popular in the country during the same decades in which they were experimented in the West, like in Otto's German Pavilion at Montreal Expo 1967 and in the cover of the Olympic Stadium of Munich in 1972. Indeed, these tensile structures were much more successful in such a hot and dry context than in Europe or North America; in addition, they seemed a perfect solution for the deployment of temporary shelters to the millions of pilgrims the country received every year for the *Hajj*. With these numbers, accommodations and other facilities cannot be conceived as normal, air-conditioned buildings. As a result, in 1997, the German firm SL Rasch, led by Otto's former collaborator Bodo Rasch Jr, designed the High-Tech Tent City in Mecca, an impressive 2.4 million-square-metre system of temporary accommodations for pilgrims under a modular

lightweight structure. This is to mention one of the many projects that this firm has completed in the country.

And the list could go on, with more projects by SOM or The Architects Collaborative, and others by HPP Architekten, André Wogenscky, or Italian architects like Franco Albini, Paolo Ghera, and Pier Luigi Nervi. The number of projects developed by foreign architects far exceeds the possibility of individual coverage on these pages. Accordingly, we want to mention that, excluding master plans, and including the projects we already discussed, about four dozen of built projects by Western and Japanese architects have been identified from the end of the 1960s and 1980s (Table 3.1), while also some Australian firms were active in region (Saniga 2012, 251). To this, we should also add the work of Arab architects from other countries engaged in Saudi Arabia and a small number of local architects usually trained in Europe and the USA (Kultermann 1985).

Beyond Saudi Arabia, and before Dubai reached its apogee in the twenty-first century, other cities in the Gulf area used to attract overseas architects to promote their development. Kuwait City, as seen, was a fast-growing centre that by 1970 had reached over 700,000 inhabitants, of which less than half were Kuwaiti. Then, a new master plan was produced by Colin Buchanan and Partners, a British firm, but the result was a failure. Western consultants elaborated more master plans in the following years, specifically in 1977, 1983, and 2003 (Jones 2013). Indeed, the 1970s saw a boom of iconic architecture delivered by foreign professionals and a layer of more anonymous architecture designed by foreign and local architects. One of the landmark projects developed during these years in the capital city of this small and wealthy country was the National Assembly, designed by Jørn Utzon in 1972 (completed in 1982) after an invited competition overseen by Leslie Martin that involved a few other high-profile architects, including Balkrishna V. Doshi. The building is a simple rectangular volume cut by a monumental hallway that asymmetrically divides it into two parts, each internally organised along a grid with clusters of office rooms surrounding internal courtyards. This relatively simple scheme is enriched by the presence of the assembly hall, covered by a thick but apparently weightless concrete roof reminding of a Bedouin tent, and by the same type of roof running along the main front above a monumental arcade. In 1979, Tange designed the new Kuwait City Airport (67,046 m^2) shaped like an aeroplane in concrete, while Écochard designed the Museum for the Kuwait Arab World (now National Museum, 1976–83). Another French architect, Jacques Satour, produced the project for the Ministry of Education in the same decade: a glass box wrapped by thin vertical mullions culminating in pointed arches slightly distanced from the curtain wall.

The most iconic project of the period was the Kuwait Towers (1972–79), a group of three water towers designed by Malene Bjørn for VBB (that in the 1990s became Sweco) and his husband Sune Lindström, who directed the works. The couple also completed other mushroom-shaped water towers in the country, which were also awarded the Aga Khan prize. Modernised versions of the *suq* appeared with SOM' Suq Al-Kuwait (with SSH, 1975) and TAC's Souq Al-Manakh (1973–75) with PACE (Pan Arab Consultant Engineers). TAC also completed the Kuwait Foundation for the Advancement of Sciences (1982–86), a solid cuboid with a big square opening

3.4 The Side of the Oil Crisis from the Middle East Boom to the "End ... 91

Table 3.1 Built projects in Saudi Arabia by international architects, 1970–80s

Designer	Projects
André Wogenscky	Office building (Riyadh, 1979–81); Hospital and sport-medical centre (Riyadh, 1980–84)
Caudill, Rowlett and Scott (CRS)	University of Petroleum and Mineral (1964–71 + extension 1982) Dhahran; Housing projects in Abquaiq and Dhahran; Housing for the Ministry of Foreign Affairs employee in Abquaiq
Devecon	Dammam Girls College (1984)
Frei Otto + Rolf Gutbrod	Hotel and Conference Centre (Mecca, 1966–74); Royal Palace. Kings office and Council of Ministers (Riyadh, 1978); Sport Hall for King Abdulaziz University (Jeddah, 1981) (with Ove Arup)
Henning Larsen*	Ministry of Foreign Affairs (Riyadh, 1984)
HOK*	King Khalid International Airport (Riyadh, 1984); King Saud University (Riyadh, 1985) (with GMW)
HPP (Hentrich and Petschnigg)*	Marriott Hotel Jeddah (1977–81); Forum Hotel Mecca (1980–83); Hilton Hotel Jeddah; Sharaco Hotel Riyadh
Ian Fraser, John Roberts + Partners	King Fahd International Stadium (Riyadh, 1980)
McDonald and Yakeley	Riyadh Additional Water Supply (Riyadh, 1976)
Kramer, Sieverts and Partners*	Ministry of Public Works and Housing (1982–85)
Minoru Yamasaki	Royal Reception Pavilion at Jeddah International Airport (Jeddah, 1974–79); Saudi Arabia MonetaryAgency (Riyadh, 1973–85); Eastern Province Airport (Dammam, 1975–90)
Paolo Ghera	Central Market (Riyadh, 1977)
Peri Luigi Nervi	Management and staff housing (Dammam, 1977–78)
Rader Mileto Associates	Equestrian Club (Riyadh, 1977); Méridien Hotel (Jeddah 1975) (with Samir Khairallah)
Richard England	Villas (Jeddah, 1980s)
SOM*	King Abdulaziz International Airport, Hajj Terminal (Jeddah, 1981); National Commercial Bank (Jeddah, 1983); Hyatt Hotel Jeddah
Studio Franco Albini	Qasr-El-Hokm (Riyadh, 1974–78)
Tange Associates*	King Faisal Foundation Headquarters Complex Phase I (Riyadh, 1976–82); Royal Palace for H.R.M. the King (Jeddah, 1977); Royal State Palace (Jeddah, 1977–82); King Faisal Foundation Phase II (Riyadh, 1984); Japanese Embassy and Chancellery in Saudi Arabia (Riyadh, 1985)
The Architects Co-Partnership	8 hospitals
The Architects Collaborative (TAC)	Rayethon Compound (Jeddah, 1972) (with Metcalf and Eddy); Hospitals (Mushayt and Tabuk)
The Eggers Group	Dammam Residential Towers (1977–79)

(continued)

Table 3.1 (continued)

Designer	Projects
Trevor Dannatt	Hotel and Conference Centre (Riyadh, 1973)
Warner, Burns, Toan and Lunde	Hilton Riyadh (1976–79)

* Firms included in our survey

on one façade and a few others of smaller size that shed light on the central atrium. On the contrary, I. M. Pei had less luck in the country despite drafting two projects for residential buildings and one for a hotel. Once again, the involvement of Western architects only represented one side of the story, as in Kuwait, a small elite of Arab architects was also active, as well as Eastern European architects, especially Polish, who had reached the country and joined local firms in an open but highly competitive context in the second half of the 1970s disillusioned by the professional conditions in their homeland (Stanek 2015a, b). Iraq's 1990 invasion of Kuwait and the subsequent first Gulf War drove foreign architects out of the country, with many relocating to Dubai and Abu Dhabi. The aggression also marked the end of Iraq's attractiveness for Western architects like Denise Scott Brown, Robert Venturi, Arthur Erickson, and Ricardo Bofill, who in the 1980s had not avoided the country despite Saddam Hussein's presence (Stanek 2015a, b).

The 1970s were a significant moment also for the United Arab Emirates, which did actually form a unified and independent country at that moment, after that the British withdrawal in 1968 left the former Trucial States (the sheikdoms of Abu Dhabi, Ajman, Dubai, Fujairah, Sharjah, Umm Al Quwain, and Ras Al Khaimah) devoid of the protection they had enjoyed since 1892. It was, therefore, in 1971 that, under the guidance of Abu Dhabi's ruler, Sheikh Zayed bin Sultan Al Nahyan, the United Arab Emirates was established, with Abu Dhabi as its capital. Its master plan elaborated by Halcrow had been under revision by Egyptian engineer Abdul Rahman Makhlouf since 1968 when he was appointed as Director of the Town Planning Department of the Abu Dhabi Emirate. The plan was based on imported Western principles, with a layout favouring "wide grid-pattern streets with their emphasis on vehicle connectivity" and "high-density tower blocks." Despite the city's astonishing growth—from 17,000 inhabitants in 1966 to 70,000 in 1976 to about 1.4 million today—its approach to urban expansion has been "more conservative" compared to Dubai (Duncan and Tomic 2013), as also shown by the lower number of skyscrapers built (Sect. 5.3). As the city grew, so it did the involvement of foreign architects, who since the late 1970s have designed several projects.

The ever-present John Harris designed both the British (1972) and the US Embassy Ambassador's Residence (1977); another British firm, Fitzroy Robinson Partnership, was responsible for the BCCI-Emirates Bank (1970s), a prismatic building with a clear tripartition between an arched ground floor, a glazed main body interrupted by vertical white-concrete elements, and heavier crowning elements. Hotel buildings like the InterContinental Abu Dhabi (1981) and later the International Rotana Inn (1980s) were designed respectively by Boston-based Benjamin Thompson and

3.4 The Side of the Oil Crisis from the Middle East Boom to the "End ... 93

Associates and Greek firm Alexandros N. Tombazis & Associates. Another Greek architect, Constantine D. Kapsambelis & Associates, completed the crescent-shaped ADNOC (Abu Dhabi National Oil Company) residential building (1977), for many years a landmark of modern Abu Dhabi, now regretfully demolished (Sosa and Ahmad 2022). Other major commissions included the Zayed Sports City Stadium (1974–80) by Henri Colboc, Pierre Dalidet and George Philippe, and the Abu Dhabi Library (1973–81) by TAC, a cultural complex including an archive and conference centre, somewhat monumental and conservative in its architectural image. As for transportation, the period saw the completion of the New Abu Dhabi International Airport (1980), designed by French airport specialist Paul Andreu—ADP Ingénierie (with some involvement of Takenaka Corporation), and the Abu Dhabi Bus Terminal (1989) by Bulgaproject. In addition, some unbuilt projects are also revealing. In 1975, Kisho Kurokawa won the first prize in the international competition for the National University campus, which was never built as such, while a few years later, Oscar Niemeyer sketched a master plan for a leisure island (1981) and a circular conference centre (1982) surmounted by a triple parabolic arch. These projects confirm the international role and fame of architects like Kurokawa and Niemeyer in the 1980s and somehow anticipate the arrival of architects from the international star system, rather than by large AEC firms, that will mark the last two decades of Abu Dhabi's development.

While by the 1960s, Abu Dhabi was already exploiting its oil resources, Dubai was then emerging as a duty-free port, also thanks to the dredging and widening of the Dubai Creek in the 1950s. In 1966, however, oil was discovered offshore, spurring a development that made Dubai's population grow from about 59,000 inhabitants in 1968 to 183,000 in 1975. In 1959, John Harris, who already had a multi-year experience in the Gulf, elaborated the first master plan of Dubai, which he updated again in 1971 and 1976. One of the most interesting aspects of Harris' plan was the respect for existing houses and the old town, limiting the car penetration in the dense fabric of the centre (AMO, Reisz and Ota 2007; Alkoud 2017). In 1968, Harris also designed its first architectural project in Dubai, the expansion of Al Maktoum Hospital, followed the next year by the Rashid Hospital, and two office buildings for the National Bank of Dubai, one of which, with its seven storeys, was the tallest in the city. In a way, Harris had an unprecedented power in shaping the modernist urban image of the city (Alkoud 2017), which became visible with high-profile projects, from hotels like the Dubai Metropolitan (1976) and the Dubai Hilton (1979; Sect. 10.3) to the Dubai World Trade Centre (1975–79), a 39-storey concrete tower reaching 149 m. One of his last projects, won through a design competition launched in 1984, was the *Diwan* ("ruler's court") for H.H. the Ruler. This monumental building, white painted to stand out against the backdrop of the old Bastakiya district, incorporated traditional elements like the *barajeel* (wind tower) as decorative devices to cover HVAC and other mechanical systems. Such a response was actually in line with the competition brief, which explicitly named the wind tower as an example of "local Islamic Architectural features" requested for a building that, on the other end, also had to present itself as a symbol of "modern Dubai" (Reisz 2021, 321–332). Another firm active in Dubai was Page & Broughton, which

designed the international airport (opened in 1971) and a few other projects (banks, office buildings, BP and Shell petrol stations), with the two partners working one from Kuwait first, and Nicosia (Cyprus) later, and the other from the Dubai office. Notably, some of the first office branches of foreign design firms opened in the city in this period (Sect. 4.5): John R. Harris & Partners in 1962 and RMJM in 1971.

Last but not least in this overview comes Qatar. The newly independent country withdrew from the process of formation of what would become the United Arab Emirates in 1971. Soon after, with the 1973 oil crisis, its economy started to boom, making Qatar the second country in the world for GDP per capita. By 1977, all its oil production was nationalised under the control of the Qatar General Petroleum Corporation, while the country's population between 1971 and 1985 had soared from over 100,000 to more than 300,000 (Adam 2013). Sheikh Khalifa bin Hamad Al Thani's dreams of modernisation were concretely developed with the re-planning of Doha by British firms Llewelyn-Davies along the previously established pattern of the Corniche and the ring roads, and from 1975 with the involvement of William Pereira. By increasing the land reclamation area in its plan, the US architect created the West Bay area as the culminating point of the Corniche. Here, he designed the pyramidal Sheraton Hotel, the first architectural landmark of Doha. By the mid-1980s, Doha was a fully equipped capital city, with new ministry buildings and cultural and educational facilities (Adam 2013). And major projects, once again, involved foreign architects. The Ministry of Information and National Theatre (1980), designed by James Connell, was entirely original in its programmatic mix, while in terms of language reflected a trend of the period towards the abandonment of modernism in favour of a vague return to tradition, here visible in the arcades, arched windows, and some details. The National Museum—today replaced by Jean Nouvel's new building inspired by the desert rose (Sect. 6.2)—was designed with the consultancy of London-based Michael Rice & Co and integrated the old Amiri palace in a walled precinct with also a small lagoon and few other new buildings. Another leisure infrastructure was the Doha Zoo (1982), featuring an extended modular canopy designed by another British firm very active in Qatar as well as in Kuwait and the UAE, John S. Bonnington.

Still, the most remarkable project of the decade was the University of Qatar (1985) by Egyptian architect Kamal el Kafrawi with the collaboration of Arup. The complex, based on a modular prefabricated octagonal concrete structure, recalled the 1960–70s experiments of architects like Candilis-Josic-Woods or Safdie, while it also addressed the problem of natural cooling through the use of structures similar to wind-towers that not only bring cool air and reduce humidity but also create a recognisable image of the roofs with the interplay of the lower and the upper volumes, which perhaps was not unknown to I.M Pei at the time he designed the Museum of Islamic Art (Sect. 6.2). Then, oil prices in the mid-1980s dropped, pushing Qatar towards a decade-long economic stagnation, and new projects were significantly reduced until the economy started booming again after the first shipments of Liquified Natural Gas (Adam 2013). By the 2000s, the new construction frenzy was becoming evident in the growing skyline of Doha, especially in the West Bay area (Sect. 5.3).

3.4 The Side of the Oil Crisis from the Middle East Boom to the "End …

Before moving to other regions, one last aspect emerging from our overview of the Middle East deserves to be emphasised. Some authors have pointed out that from the 1970s, the "reference to an often-unspecified 'Islamic tradition' was becoming a standard requirement" in governmental commissions (Stanek 2015a, b, 65). There are examples of bank buildings by Fitzroy Robinson Partnership in Dubai, Abu Dhabi, and Muscat designed in a "generic modern idiom" whereas the Ministry of Foreign Affairs in Muscat had a "vernacular appearance;" or the project of the Kuwait Law Courts by Basil Spence Partnership was transformed " to accommodate stylistic recommendations and the sequence of its seven façade variants shows a transformation from the abstract grid of the competition project into a display of 'familiar elements of Islamic geometry and decoration'" (Stanek 2015a, b, 66–67). In this regard, it is also interesting to note that not only the distinction between a governmental and a private building could entail different 'stylistic' approaches but also that sometimes—and many examples we have seen in the previous paragraphs confirm it—Western architects seemed more concerned about the formal contextualisation of their projects rather than their Arab colleagues. The contrast we have seen between the University of Petroleum and Minerals and the King Saud University in Riyadh, both designed by US firms, and the King Faisal University in Dammam by Egyptian architect Ahmed Farid Moustapha, was, in this sense, emblematic. The just mentioned University of Qatar would be another example of this mature experimentation opposed to the borrowing of Islamic traditions as different as the Mughal in India and the Nasrid in Andalusia that professionals as diverse as the architects at SOM and Albini proposed in Saudi Arabia, for example (Wright 2008, 236). As a matter of fact, by the 1980s, internationalised design of buildings with clear lines and façade of minimal articulation, usually in the form of glazed curtain-walls, started incorporating a "superficial application of generic ornamentation without proper referencing of Arabic arts-and-crafts traditions" according to a logic defined as "contextual globalism" (Duncan and Tomic 2013, 144). Some of these same problems, and relative design responses, emerged during this period from other regions that is now time to explore.

The 1980s recorded the emergence of new markets in Asia, where the "Four Asian Tigers" (Hong Kong, Singapore, South Korea, and Taiwan) were on the rise. China, instead, had then just begun a process of economic opening and, for the first time in decades, it started receiving visits from US and Japanese architects who got gradually involved in hospitality projects (Sect. 10.4). The number of works produced until 1989, however, remained extremely limited: just twenty-two have been identified (Xue et al. 2021). Thus, while mainland China initiated its gradual opening, Hong Kong was booming, also thanks to this proximity, and architects did not miss the opportunity. After the end of World War II, Hong Kong was in dire straits. Japanese occupiers had demolished a large number of buildings, while the Allied had also bombed the city. Reconstruction was slow due to the high costs, while the housing shortage was exacerbated by the inflow of hundreds of thousands of migrants. Hong Kong's population grew by one million in about a year, soaring to 1.6 million by 1946. In this context, the colonial government invited Patrick Abercrombie to the city, which he visited for over a month in 1947. The result of his

engagement was a comprehensive 10-year plan. In 1950, the Hong Kong Preliminary Planning Report was reviewed and approved, and, despite the restraints caused by the Korean War, its implementation started in 1953. The plan greatly influenced the city's urban development in the following decades in terms of planning policies and directions (Xue 2016, 3–9). During the 1960–70s, Hong Kong became laboratory of social housing, which was built at an unprecedented pace—25,000 units per year from 1964 to 1970—with the involvement of many local top architects and firms, from Eric Cumine to Palmer & Turner (P&T), from Wai Szeto to Leigh & Orange (Xue 2016, 21–54). Still, as the focus of this book lies on the globalisation of the architectural profession, in this perspective, the turning point can be easily identified at the beginning of the 1980s. At that moment, following the Chinese opening, Hong Kong's economy ballooned, and the city was transformed from a modest industrial centre into a key node of the global economy. Its urban images changed accordingly, and the architectural scene too. Rather than relying on local firms established in Hong Kong and generally dealing only with local projects, clients sought international designers (Xue 2016, 194–195).

In the city were active a few large firms established at the turn of the century either in Hong Kong, like Leigh & Orange (1874) and Palmer & Turner (P&T; established in 1868), or Shanghai, like Spence & Robinson (1904), together with others born in the 1950–60s: Wong & Ouyang, Ronald Lu & Partners. In addition to several Chinese architects from Shanghai who arrived in Hong Kong after the proclamation of the PRC, of which Eric Cumine was one of the most important ones, there was now a new generation of capable professionals, either trained at Hong Kong University or overseas: Chung Wah-nan, Anthony Ng, Rocco Yim, to name a few (Xue 2016, Chaps. 3 and 8). Then, during the 1980s, the activity of foreign architects recorded a significant quantitative and qualitative increase. The most outstanding project of the decade was, without a doubt, the Hong Kong and Shanghai Bank Corporation (HSBC) Headquarters (1979–86, 99,000 m^2) designed by Foster + Partners after winning a competition that also involved Palmer & Turner, SOM, Hugh Stubbins and Associates, Yuncken Freeman H. K. (the local branch of Australian firm Denton Corker Marshall), and modernist Australian architect Harry Seidler. The building is regarded as a masterpiece of a new "era" (Curtis 2000) and as a paradigmatic piece of what Frampton (2020, 339–340) calls the "productivist approach". The 183-m skyscraper stands out for its visible external structure made of monumental trusses on which multi-floor blocks are hung. As in the contemporary Llyod's Building (1978–86) in London by Richard Rogers, structure and services were displaced to the perimeter of the building, freeing the interior from such elements. Just a few hundred metres away from the HSBC, the Bank of China tower (1982–89, 130,000 m^2) by Pei & Partners soared as an architectural and symbolic counterpoint, displaying the power of the growing Chinese financial capitalism. This 367-m tower, for quite a long time the tallest in the city, displays a precise geometry based on triangular prisms; while raising, it gradually reduces its volume, as it starts on the ground with a square plan, which is then halved in a triangle, then split again in a smaller one.

Another US architect involved in the region was Paul Rudolph, who had completed projects in Hong Kong and Singapore. In the former, his most relevant work, and the only one actually built, was the Bond Centre (now Lippo Centre; 110,500 m^2, 186 and 172 m) with Wong & Ouyang, a complex composed of two glazed towers made of different interlocking sections cantilevering from the core and raising above a common multi-level podium, connecting to the MTR line, thus integrating into that urban system of sky bridges, underground passages, and malls that run through all central Hong Kong in the first floors above and below ground (Frampton et al. 2012). His oldest project in the then-British colony dates to 1980 and consists of the unbuilt design for a group of villas on a sloping panoramic terrain for the Hong Fok Investment Holdings Private Ltd, which had already commissioned Rudolph a few works in Singapore; the most ambitious ones, instead, was the Sino Tower (1989), a 110-floor mixed-use skyscraper composed of different sections separated by an empty floor. As said, more projects were successfully carried out in Singapore. Independent since 1965, the city-state was by the 1980s a florid outpost of modernisation, with a GDP per capita closer to European countries than to any neighbouring ones. A city that, as Rem Koolhaas chanted, features a condition of *tabula rasa* where— pardoning the exaggeration—"almost all [...] is less than 30 years old" (Koolhaas 1995, 1011). Since the 1960s, local architects were able to "savagely syntheti[se]" the lesson of Le Corbusier, Team X, and Japanese metabolism (Koolhaas 1995, 1073), as evident in mega-structural projects like the Golden Mile Complex (completed in 1973) by DP Architects. Thus, looking back at Rudolph's proposals like the Lower Manhattan Expressway (1972), there should be no surprise about his interest in Singapore. For Hong Fok Investment, his first project was the Marina Centre Development (1979), in a competition won by Pei & Partners, whose recommendations were partially implemented. After another couple of unsuccessful projects for the same client, Rudolph finally completed the Colonnade Condominiums (1980–86), a double residential tower with a shared core originally thought to be built with prefabricated units (finally constructed in-site) within a structural framework resulting in a building conceptually comparable to Moshe Safdie's experiments like Habitat 67 in Montreal (Sect. 8.5). In the following year, more projects remained on paper, until the completion of a villa, the Keung Residence (1986), and of The Concourse (1981–94), a mixed-used complex made of an office tower and a multi-story commercial podium.

Since activities in Singapore have not been comprehensively mapped for this book, we can only provide a partial and quick overview. That said, it is evident from some cases that since the 1980s, the involvement of foreign architects has become significant. Kenzo Tange, for example, completed in 1986 the Nanyang Technological Institute (240,000 m^2), the City Telecommunication Centre tower (35,000 m^2), and the GB Building (1986, 21,261 m^2, 116 m). After that, commissions for the Japanese architect have copiously flocked during the 1990s—United Overseas Bank Plaza Tower 2 (1995, 131,887 m^2, 280 m) and renovation of Tower 1 built in the 1970s—and the 2000s, with a long list of residential and office high-rises. Pei,

Cobb, Freed & Partners completed the OCBC-Overseas Chinese Banking Corporation Centre (1970–76, 197 m) and the Raffles City (1969–86), a 370,000-square-metre mixed-use development. Since the 2000s, many more international firms have delivered successful projects, mostly high-rise residential and office buildings. Still, by the end of the 1980s, there were already a bunch of tall buildings completed in the city, in addition to Pei, Cobb, Freed & Partners' Swissotel The Stamford Tower (200 m), part of the Raffles City development, and the OCBC. They included the DBS Tower 1 (1975, 201 m) and the International Plaza (1976, 190 m) by Ang Kheng Leng and Partners, the Singapore Land Tower (1980, 190 m) by Hong Kong firm P&T, and the AXA Tower (1982–86, 234 m) by Hugh Stubbins and Associates and Boston-based LeMessurier Associates. Such a skyline represented a clear indicator of the dynamicity of a market where local and foreign firms, not only from the West and Japan but also from Hong Kong, could compete.

South-East and East Asia were in the 1980s increasingly attractive places for overseas architects, as cities competed to get "the stamp" of Western and Japanese architects (Shannon 2014, 369). This is true for highly developed countries, which was already an exporter of architectural services, like Japan, and to a lesser extent South Korea, but also other fast-growing economies of the region, especially Malaysia. While international modernism represented a dominant trend in urban centres, an agenda of hybridisation of universal modernism and tropical conditions emerged, especially from key figures like Tay Kheng Soon (one of the founders of The Design Partnership, or DP Architects) in Singapore and Ken Yeang in Malaysia. At the same time, by the 1980s, also a form of "tropical regionalism" arose for luxury houses and tourist resorts (Shannon 2014, 362–365), usually shaped as clusters of permeable pavilions with "exquisite detailing, creating a resurgence in local craft traditions and a boom in local materials. It produced high standards of design unaffordable to local clients" (Pieris 2005, 31, cited in Shannon 2014, 362–365). Australian architects like Peter Muller and Kerry Hill, or Ed Tuttle, emerged as leading figures in the region, defining with their work the characters of the so-called "Bali Style" (Scriver and Srivastava 2019; Sect. 10.2). All these trends can be identified in the creations of Australian, US, Japanese, and South Korean architects not based in the region, whose outreach was geographically expanding during the 1980s.

Australian engagement with the region has been strong since the 1980s as a consequence of the pivot in foreign relations exercised by Gough Whitlam's government the decade before, when the country's foreign policy embraced Asia at the expanse of the UK and Europe. The design of some embassy budlings across Asia became an occasion for Australian landscape architects to get familiar with these markets and later consolidate their presence, starting from Hong Kong (Bull 2018). Looking at our sample of firms, we find projects like the Kuching Indoor Stadium—Stadium Perpaduan (1985–88, 4,000 seats) and the Malaysia Sarawak Main Stadium (1989, 48,000 m^2, 40,000 seats) by Beyond Space—Ryu Choon-soo. In 1977 Maki and Associates had also worked on a Sports Complex and Park in Kota Kinabalu, but it was never built, while RMJM completed the local airport in 1985. A fascinating example of design in line with hybrid experimentations is Paul Rudolph's Wisma Dharmala Sakti Office Headquarters (1982) in Jakarta, the first of a series of projects

(mostly unbuilt) for the Indonesian industrial conglomerate Dharmala.[1] Drawing from empirical observations more than any scholarly approach, this office building was conceived as an "explicit response to local climate and to traditional Indonesian architecture," especially by the "consistency in the shapes of the overhanging roofs." The result was a 24-storey building designed to shade the main spaces and facilitate hot air flow. "Rudolph abstracted the roof forms and combined them with his own interest in rotated geometry and the interplay between supporting elements and building perimeter," with overhangs protecting the windows and creating terraces that made the building "a kind of hanging garden, with trees and bushes planted in the terraces and vines cascading down the side" suggesting "his ideas about the way architecture and landscape can merge" (Bruegmann 2010). As for the "tropical regionalist" trend, in 1981, we find the Tanjong Jara Resort in Kuala Terengganu by WATG, a typical example of a lavish pavilion-type hotel inspired by seventeenth-century Malay palaces built with local wood, bamboo, and stone, or, likely in the following decade, RMJM's Royal Méridien Baan Taling in Koh Samui, Thailand (more hotel projects will be discussed in Sect. 10.3).

In the meantime, during the 1980s, the export of American architecture through the construction of new embassy buildings or the renovation of old ones was spurred by a series of tragic events. The Beirut and Kuwait City bombs against US diplomatic posts in 1983 and 1984 led to a review of security standards according to the findings of the Inman Report, named after Admiral Bobby Ray Inman, who recommended various security changes and improvements for embassies and consulates. As a result, while several facilities worldwide were renewed, others were built anew, often in more isolated locations away from congested city centres. These isolated, massive, fortified buildings surrounded by walls left little room for designers, who, between the 1980s and 1990s, produced a new wave of projects with a very distinct aspect compared to those of the 1950–60s. The main examples included the Embassy in Muscat (1981–89) by James Stewart Polshek, Manama (1981–90) by ROMA, Cairo (1982–89) by William Metcalf, Santiago (1987–94) by Leonard Parker Associates, Bogotá (1987–96) by Integrus, Caracas (1991–95) by Gunnar Birkerts, Lima (1992–96) by Arquitectonica, Bangkok (1994–97) by Kallmann, McKinnel & Wood, and Singapore (1994–97) by King Stubbies (Loeffler 1998). Indeed, the Inman Report was never fully implemented, and the Nairobi and Dar es Salaam bombings of 1998, once again directed against US embassies, showed the vulnerabilities of buildings that need to strike a difficult balance between "security" and "openness" (Loeffler 2005). All in all, these buildings had also lost a lot of the architectural meaning their 1950–60s counterparts had. In those decades, modernist embassy buildings, like hotels from American chains like the Hilton, emerged in developing countries as a showcase of the modern, prosperous, free world they were supposed to aim at. Now, not only the global political and economic situation had changed entirely, but

[1] The Surabaya Hotel and Office Building for The Dharmala Group were completed in 1997, while the Cikini Office Building and the Gatot Subroto Office Building both designed in 1990 were never built. The same fate befell the master plan for a New Town for 250,000 People in Pantai Timur Surabaya Town (1990) for Dharmala, and another master plan of an urban development in Jakarta (1990), as well as a university building (1995).

above all, modernist architecture in the West was dead. And in any case, in many parts of the world (Middle East, South-East Asia), there was a growing presence of foreign architects that made these buildings designed by foreign professionals less an exception.

Beyond the regions we have focused on, the rest of today's emerging markets (both those extensively mapped in this book and many others not studied in depth) were marginal before the 1990s. The Soviet Union was on the brink of collapse; Africa was struggling with negative GDP growth and debt issues, while Latin America was going through the so-called "lost decade." In the meantime, another country was taking-off: China. Still, what would become the biggest market in the world at the beginning of the 2000s for any type of firm interested in exporting architectural services, in the 1980s was just starting to attract foreign architects, primarily Japanese and American, plus some firms from Hong Kong. At the same time, looking at the 1970–80s, we can observe similar patterns of geographical expansion in the design profession that will consolidate and become common in the following two decades (Sect. 4.5). The increasingly globalised agency of Japanese architects, especially in South-East Asia and the Middle East, and the growing involvement of US architects in these same two regions, although with a preponderance for the latter, is noteworthy. In these regions, we see at work large firms like SOM and once famous but now declining professionals like Paul Rudolph, as well as architects with a certain global outreach like William Pereira (Pereira & Luckman until 1959, then William L. Pereira & Associates), who designed buildings in Brazil, Ivory Coast, and Thailand in the 1960s, Venezuela, Nigeria, Iran, Iraq, and Thailand in the 1970s, Saudi Arabia and Qatar in the 1980s.

3.5 Conclusions

This chapter ends with the turning of a decade that, in many ways, anticipated the actual end of the century. The end of the "short twentieth century" (Hobsbawm 1995) drove the world into a new historical phase, although not to "the end of history" (Fukuyama 1992). Regardless of these periodisations, substantial changes were underway in the architectural profession. According to what we have seen in the present chapter, the nineteenth century marked the first turning point for architects. For about four centuries, some architects and engineers belonging to professions still undergoing a slow process of consolidation and institutionalisation had travelled between European nation-states and across the Atlantic Ocean to satisfy the requests of royal families and lay and religious aristocracy. Others were embedded in the army or religious orders. In the nineteenth century, not only did migratory movements bring trained professionals to North and South America, but above all, the expansion of colonial empires required the mobilisation of technical know-how to expand the bureaucratic and industrial infrastructure of the colonies. In this light, we can understand the largest share of the overseas work of European and, later on, also Japanese architects. Devoid of the support of a formal empire, US architects found, in any case, their way through many territories, anticipated by engineers and

3.5 Conclusions

contractors. Albeit by the end of the nineteenth century, some design competitions started receiving entries from distant countries, and plans of buildings began travelling long distances, such opportunities usually represented a chance to undertake a shorter or longer stay overseas rather than the commencement of some form of remote work: Frank Lloyd Wright spent almost three years in Japan between 1917 and 1922 to complete the project of the New Imperial Hotel and then returned to the USA.

The rise of the "Modern Movement" during the first two decades of the twentieth century, even though it marked a watershed in the history of architecture, changed little in the architectural modes of production. Neither the advent of totalitarian regimes in Europe and Japan nor eventually the outbreak of World War II produced any relevant transformation in this besides spurring the migration of many leading architects. Still, with the post-War, the outreach of some architects—the very famous ones like Le Corbusier, comparable to today's archistars, and the ones with the profile of a reliable expert—became more global, not least favoured by innovation in transportation that made flights faster and cheaper. Despite the ongoing process of decolonisation in Africa and Asia, networks and links persisted. Now working in practices established back in their home countries, architects, planners and engineers that used to work for the colonial authorities continued to find opportunities in the post-colonial world.

The 1970s then marked another watershed moment. The completion of the Sydney Opera House not only embodied the concept of architectural icon in the meaning that we give to the word today but also became the paradigm of an increasingly common pattern of work, with a project elaborated thousands of miles away from the site of its construction. The event, however, was nothing more than a small detail in comparison to the geopolitical changes undergoing in the decade: the oil shock for the West was just the mirror of the oil boom of the Middle East that drove to the region hundreds of US, European, and Japanese architects, and many from Socialist countries, too. The architectural profession was becoming more global, new markets were growing, and opportunities were flocking for those willing to take them. While it will take two more decades for the internet to transform communications entirely and thus allow an instantaneous transmission of information (including architectural drawings), by the 1970s, the architects' involvement in selected overseas markets grew consistently, with South-East Asia on the rise in the 1980s, and substantial trans-Pacific flows between the USA and Japan and South Korea, and trans-Atlantic ones between Europe and the USA, starting from the UK.

References

Adam, Robert. 2013. Doha, Qatar. In *Architecture and Globalisation in the Persian Gulf Region*, ed. Murray Fraser and Nasser Golzari, 105–127. Farnham: Ashgate.

Al-Ragam, Asseel. 2015. Critical Nostalgia: Kuwait urban modernity and Alison and Peter Smithson's Kuwait urban study and mat-building. *The Journal of Architecture* 20 (1): 1–20.

Al-Ragam, Asseel. 2017. Negotiating the politics of exclusion: Georges candilis, housing and the Kuwaiti welfare state. *International Journal of Urban and Regional Research* 41 (2): 235–250.

Alkhabbaz, Mohammed H. 2017. Yamasaki's Dhahran Civil Air Terminal and the Shaping of Saudi Modernity. *Prometheus* 1: 26–35.

Alkoud, Amjad. 2017. The manifestation of Dubai's petroleum economy in its architecture and urban development: 1930–1980. *Prometheus* 1: 64–71.

Almandoz, Arturo. 2006. Urban planning and historiography in Latin America. *Progress in Planning* 65: 81–123.

Almandoz, Arturo, ed. 2013. *Planning Latin America's Capital Cities 1850–1950*. Hoboken, NJ: Taylor and Francis.

Alofsin, Anthony. 2012. American modernism's challenge to the beaux-arts. In *Architecture School. Three Centuries of Educating Architects in North America*, ed. Joan Ockman, 91–119. Cambridge, MA; Washington, DC: MIT Press; Association of Collegiate Schools of Architecture.

Alonso, Pedro Ignacio, and Palmarola Sagredo Hugo. 2012. A Panel's tale. The soviet I-464 system and the politics of assemblage. In *Latin American Modern Architectures: Ambiguous Territories*, edited by Patricio del Real and Helen Gyger, 153–169. New York, NY: Routledge.

Álvarez Prozorovich, Fernando V., and Henry Vicente Garrido. 2007. *Arquitecturas desplazadas: arquitecturas del exilio español*. Madrid: Ministerio de la Vivienda.

AMO, Todd Reisz, and Kayoko Ota. 2007. Gulf survey—Drawn in the sand: John Harris, Dubai's pioneering modernist. *Volume* [special issue *Al Manakh*] (12): 152–168.

Arango, Silvia. 2012. *Ciudad y arquitectura seis generaciones que construyeron la América Latina moderna*. Mexico City: Fondo de Cultura Económica.

Architectural Record. 1953. Intercontinental hotels: Design for turism. *Architectural Record* 114 (4): 12.

Avermaete, Tom. 2005. *Another Modern: The Post-War Architecture and Urbanism of Candilis-Josic-Woods*. Rotterdam: NAi Publishers.

Avermaete, Tom, Serhat Karakayali, and Marion von Osten. 2010. *Colonial Modern: Aesthetics of the Past—Rebellions for the Future*. London: Black Dog.

Ávila-Gómez, Andrés. 2019. Estudiantes latinoamericanos en el Institut d'Urbanisme de l'Université de Paris 1923–1941. *Revista De Arquitectura* 21 (2): 44–56.

Baldwin, Richard. 2016. *The Great Convergence: Information Technology and the New Globalization*. Cambridge, MA; London: The Belknap Press of Harvard University Press.

Banham, Reyner. 1971. *Los Angeles: The Architecture of Four Ecologies*. London: Penguin.

Barjot, Dominique. 2012. Entrepreneurs, contractors, public works in the Maghreb and the middle east from the 1860s to the 1940s. In *Building Beyond the Mediterranean: Studying the Archives of European Businesses (1860–1970)*, ed. Claudine Piaton, Ezio Godoli and David Peyceré, 13–17. Arles: Publications de l'Institut national d'histoire de l'art, Honoré Clair, InVisu (CNRS-INHA).

Bauchet-Cauquil, Hélène., Françoise-Claire. Prodhon, Patrick Seguin, Michael Roy, and John Tittensor. 2014. *Le Corbusier, Pierre Jeanneret: Chandigarh, India, 1951–66*. Paris: Galerie Patrick Seguin.

Baweja, Vandana. 2011. Otto Koenigsberger and the tropicalization of British architectural culture. In *Third World Modernism: Architecture, Development and Identity*, ed. Duanfang Lu, 236–254. Abingdon; New York, NY: Routledge.

Baweja, Vandana. 2015. Messy modernisms: Otto Koenigsberger's early work in princely Mysore, 1939–41. *South Asian Studies* 31 (1): 1–26.

References

Bernhardsson, Magnus T. 2008. Visions of Iraq modernizing the past in 1950s Baghdad. In *Modernism and the Middle East: Architecture and Politics in the Twentieth Century*, ed. Sandy Isenstadt and Kishwar Rizvi, 81–96. Seattle, WA: University of Washington Press.

Bertacchi, Silvia. 2012. Modelli compositivi per la difesa 'alla moderna'. L'esperienza di Giovanni Battista Antonelli. PhD dissertation. Università degli Studi di Firenze, Firenze.

Bini, Elisabetta, Giuliano Garavini, and Federico Romero. 2016. Introduction. In *Oil Shock: The 1973 Crisis and Its Economic Legacy*, ed. Elisabetta Bini, Giuliano Garavini and Federico Romero, 1–10. London, New York: I.B.Tauris.

Blackmore, Lisa. 2017. *Spectacular modernity: dictatorship, space, and visuality in Venezuela, 1948–1958*. Pittsburgh, PA: University of Pittsburgh Press.

Botti, Giaime. 2017. Geographies for another history: Mapping the international education of architects from Colombia (1930–1970). *Architectural Histories* 5 (1): 7.

Botti, Giaime. 2021. *Tra modernità e ricerca identitaria. Architettura e città in Colombia, 1920–1970*. Milano: FrancoAngeli.

Botz-Bornstein, Thorsten. 2015. *Transcultural Architecture: The Limits and Opportunities of Critical Regionalism*. Burlington, VT: Ashgate.

Bremner, G.A., ed. 2016. *Architecture and Urbanism in the British Empire*. Oxford: Oxford University Press.

Bromley, Ray. 2003. Towards global human settlements: Constantinos Doxiadis as entrepreneur, coalition-builder and visionary. In *Urbanism Imported or Exported?*, ed. Joe Nasr and Mercedes Volait, 316–340. Chichester: Wiley.

Bruegmann, Robert. 2010. The architect as urbanist: Part 2. *Places Journal*.

Buck, David D. 1999. Railway city and national capital. Two faces of the modern in Changchun. In *Remaking the Chinese City. Modernity and National Identity, 1900–1950*, ed. Joseph W. Esherick, 65–89. Honolulu, HI: University of Hawai'i Press.

Bull, Catherin. 2018. Early engagement with Asia. *Landscape Architecture Australia* 157: 30–33.

Burke, Peter. 1998. *The European Renaissance: Centres and Peripheries*. Oxford: Blackwell.

Carranza, Luis E., and Fernando L. Lara. 2015. *Modern Architecture in Latin America: Art, Technology, and Utopia*. Austin, TX: University of Texas Press.

Caruso, Adam, and Helen Thomas. 2013. *The Stones of Fernand Pouillon. An Alternative Modernism in French Architecture*. Zurich: gta Verlag.

Checa-Artasu, Martín Manuel. 2021. Adamo Boari y el concurso para la construcción del Palacio Legislativo. In *Adamo Boari (1863–1928). Arquitecto entre América y Europa*, edited by Martín Manuel Checa-Artasu and Olimpia Niglio, 88–139. Roma: Aracne.

Ching, Francis D.K., Mark M. Jarzombek, and Vikram Prakash. 2017. *A Global History of Architecture*, 3rd ed. Hoboken, NJ: Wiley.

Cody, Jeffrey W. 2003. *Exporting american architecture, 1870–2000*. Abingdon: Routledge.

Cody, Jeffrey W., Nancy Shatzman Steinhardt, and Tony Atkin. 2011. *Chinese Architecture and the Beaux-Arts*. Honolulu, HI: University of Hawai'i Press.

Cohen, Jean-Louis, and Monique Eleb. 1998. *Casablanca. Mythes et figures d'une aventure humaine*. Paris: Hazan.

Correa, Felipe. 2021. *Beyond the city: Resource extraction urbanism in South America*. Austin, TX: University of Texas Press.

Crinson, Mark. 1996. *Empire Building Orientalism and Victorian Architecture*. London; New York, NY: Routledge.

Culot, Maurice, and Jean-Marie Thieveaud. 1992. *Architectures françaises outre-mer*. Liège: Pierre Mardag.

Curtis, William J.R. 2000. *Modern architecture since 1900*. London: Phaidon.

D'Amia, Giovanna. 2022. La participación italiana en los grandes concursos internacionales para las capitales de Argentina y Uruguay. Entre tradición académica y modelos internacionales. In *El modelo beaux-arts y la arquitectura en América Latina, 1870–1930: transferencias, intercambios y perspectivas transnacionales*, edited by Fernando Aliata and Eduardo Gentile, 333–351. La Plata: Universidad Nacional de La Plata. Facultad de Arquitectura y Urbanismo.

d'Auria, Viviana. 2010. From tropical transitions to ekistic experimentation: Doxiadis associates in Tema, Ghana. *Positions* 1: 40–63.

de Filgueiras Gomes, Marco Aurélio A., and José Carlos Huapaya Espinoza. 2009. Diálogos modernistas com a paisagem: Sert e o Town Planning Associates na América do Sul, 1943–1951. In *Urbanismo na América do Sul: circulação de ideias e constituição do campo, 1920–1960*, ed. Marco Aurélio A. de Filgueiras Gomes, 149–173. Salvador: EDUFBA.

del Real, Patricio. 2012. Constructing Latin America: Architecture, Politics, and Race at the Museum of Modern Art. PhD dissertation. Columbia University.

Desmoulins, Christine, ed. 2015. *Bernard Zehrfuss, architecte de la spirale du temps.* Milano: Silvana Editoriale.

Deupi, Victor, and Jean-Francois Lejeune. 2021. *Cuban Modernism: Mid-Century Architecture 1940–1970.* Berlin; Boston, MA: Birkhäuser.

Douki, Caroline, and Philippe Minard. 2007. Histoire globale, histoires connectées: Un changement d'échelle historiographique ? Introduction. *Revue D'histoire Moderne & Contemporaine* 54–4 (5): 7–21.

Duncan, Olivia, and Sonny Tomic. 2013. Abu Dhabi, UAE. In *Architecture and Globalisation in the Persian Gulf Region*, ed. Murray Fraser and Nasser Golzari, 129–153. Farnham: Ashgate.

Edwards, Jay D. 2006. Creole architecture: A comparative analysis of upper and lower Louisiana and Saint Domingue. *International Journal of Historical Archaeology* 10 (3): 241–271.

Elleh, Nnamdi. 2001. *Abuja: The Single Most Ambitious Urban Design Project of the 20th Century.* Weimar: VDG.

Elleh, Nnamdi. 2016. *Architecture and Politics in Nigeria: The Study of a Late-Twentieth-Century Enlightenment- Inspired Modernism at Abuja, 1900–2016.* London: Routledge.

Emami, Farshid. 2014. Urbanism of grandiosity: Planning a new urban center for Tehran (1973–76). *International Journal of Islamic Architecture* 3 (1): 69–102.

Ettinger, Catherine R. 2018. *Richard Neutra en América Latina: una mirada desde el sur.* Guadalajara: Arquitónica.

Fazio, Michael W., Marian Moffett, and Lawrence Wodehouse. 2003. *A World History of Architecture.* London: Laurence King Publishing.

Farès, El-Dahdah. 2005. *CASE: Lucio Costa, Brasilia's Superquadra.* Munich, New York, NY: Prestel; Harvard University, Graduate School of Design.

Flynn, Dennis O., and Arturo Giráldez. 1995. Born with a "silver spoon": The origin of world trade in 1571. *Journal of World History* 6 (2): 201–221.

Folkers, Antoni S. 2014. Planning and replanning Ng'ambo—Zanzibar. *South African Journal of Art History* 29 (1): 39–53.

Frampton, Adam, Clara Wong, and Jonathan D. Solomon. 2012. *Cities Without Ground: A Hong Kong Guidebook Book.* Novato, CA: ORO Editions.

Frampton, Kenneth. 2020. *Modern Architecture: A Critical History*, 5th ed. London: Thames & Hudson.

Frapier, Christel, and Simon Vaillant. 2012. The organization of the Hennebique Firm in the countries of the Mediterranean Basin: Establishment and communications strategy. In *Building Beyond the Mediterranean: Studying the Archives of European Businesses (1860–1970)*, ed. Claudine Piaton, Ezio Godoli and David Peyceré, 35–43. Arles: Publications de l'Institut national d'histoire de l'art, Honoré Clair, InVisu (CNRS-INHA).

Fukuyama, Francis. 1992. *The End of History and the Last Man.* New York, NY: Free Press.

Fuller, Mia. 2006. *Moderns Abroad: Architecture, Cities and Italian Imperialism.* London: Routledge.

Giedion, Sigfried. 1941. *Space, Time and Architecture: The Growth of a New Tradition.* Cambridge, MA: Harvard University Press.

Giedion, Sigfried. ed. 1954. *A Decade of Contemporary Architecture.* Zurich: Editions Girsberger.

González, Robert. 2007. El concurso del Faro de Colón: Un reencuentro con el monumento olvidado de la arquitectura panamericana. *ARQ* 67: 80–87.

References

Goodwin, Philip L. 1943. *Brazil Builds: Architecture New and Old 1652–1942*. New York, NY: The Museum of Modern Art.

Gropius, Walter. 1925. *Internationale Architektur*. München: Albert Lange.

Hardoy, Jorge Enrique. 1988. Repensando la ciudad de América Latina. In *Teorías y prácticas urbanísticas en Europa entre 1850 y 1930. Su traslado a América Latina*, edited by Jorge Enrique Hardoy and Ricardo Morse, 97–126. Buenos Aires: Grupo Editor Latinoamericano.

Hatton, Timothy J., and Jeffrey G. Williamson. 1994. What drove the mass migrations from Europe in the late nineteenth century? *Population and Development Review* 20 (3): 533–559.

Hein, Carola. 2002. Maurice Rotival: French pPlanning on a World-Scale. *Planning Perspectives* 17 (3): 247–265.

Hein, Carola. 2003. The transformation of planning ideas in Japan and Its colonies. In *Urbanism: Imported or Exported? Native Aspirations and Foreign Plans*, ed. Joe Nasr and Mercedes Volait, 51–82. Chichester: Wiley.

Hernández Rodríguez, Carlos Eduardo. 2004. *Las ideas modernas del Plan para Bogotá en 1950. El trabajo de Le Corbusier, Wiener y Sert*. Bogotá: Alcaldía Mayor de Bogotá.

Herz, Manuel, Ingrid Schröder, Hans Focketyn, and Julia Jamrozik. 2015. *African Modernism. The Architecture of Independence: Ghana, Senegal, Côte d'Ivoire, Kenya, Zambia*. Zurich: Park Books.

Hilberseimer, Ludwig. 1928. *Internationale Neue Baukunst*. Stuttgart: Julius Hoffmann.

Hinchcliffe, Tanis. 2013. British architects in the Gulf, 1950–1980. In *Architecture and globalization in the Persian Gulf region*, ed. Fraser Murray and Nasser Golzari, 23–36. Farnham: Ashgate.

Hines, Thomas S. 1974. *Burnham of Chicago: Architect and Planner*. New York, NY: Oxford University Press.

Hitchcock, Henry-Russell. 1955. *Latin American Architecture: Since 1945*. New York, NY: Museum of Modern Art.

Hitchcock, Henry-Russell, and Philip Johnson. 1932. *The International Style: Architecture Since 1922*. New York, NY: Museum of Modern Art.

Hobsbawm, Eric J. 1995. *Age of Extremes: The Short Twentieth Century, 1914–1991*. London: Abacus.

Hofer, Andreas. 2003. *Karl Brunner y el urbanismo europeo en América Latina*. Bogotá: El Áncora-Corporación La Candelaria.

Holston, James. 1984. *On Modernism and Modernization: The Modernist City in Development, the Case of Brasília*. Notre Dame, IN: Helen Kellogg Institute for International Studies.

Home, Robert K. 1997. *Of Planting and Planning: The Making of British Colonial Cities*. London: Spon.

Irving, Robert Grant. 1981. *Indian Summer: Lutyens, Baker and Imperial Delhi*. New Haven, CT: Yale University Press.

Jackson, Iain, and Jessica Holland. 2014. *The Architecture of Edwin Maxwell Fry and Jane Drew: Twentieth Century Architecture, Pioneer Modernism and the Tropics*. Farnham: Routledge.

James-Chakraborty, Kathleen. 2008. *Architecture of the Cold War: Louis Kahn and Edward Durell Stone in South Asia*, in *Building America: Eine große Erzählung*, ed. Anke Köth, Kai Krauskopf and Andreas Schwarting, 169–182. Dresden: Thelem.

James-Chakraborty, Kathleen. 2013. Louis Kahn in Ahmedabad and Dhaka. *ABE Journal* (4).

James-Chakraborty, Kathleen. 2014. *Architecture Since 1400*. Minneapolis, MN: University of Minnesota Press.

Jencks, Charles. 2002. *The New Paradigm in Architecture. The Language of Post-Modernism*. New Haven, CT; London: Yale University Press.

Jones, Gwyn Lloyd. 2013. Kuwait City, Kuwait. In *Architecture and Globalisation in the Persian Gulf Region*, ed. Murray Fraser and Nasser Golzari, 37–56. Farnham: Ashgate.

Jones, Lee. 2015. *'South Africa: Sanctioning Apartheid', Societies Under Siege: Exploring How International Economic Sanctions (Do Not) Work*. Oxford: Oxford University Press.

Joyce, Horatio H. 2021. Introduction: Rethinking the American renaissance. *Architectural History* 64: 1–22.

Kalia, Ravi. 2006. Modernism, modernization and postcolonial India: A reflective essay. *Planning Perspectives* 21 (2): 133–156.

Kentgens-Craig, Margret. 1999. *The Bauhaus and America: First Contacts, 1919–1936*. Cambridge, MA: MIT Press.

King, Anthony D. 1976. *Colonial Urban Development. Culture, Social Power and Environment*. London: Routledge and Kegan Paul.

Koolhaas, Rem. 1995. Singapore songlines. Portrait of a potemkin metropolis... Or thirty years of tabula Rasa. In *S, M, L, XL*, ed. OMA, Rem Koolhaas and Bruce Mau, 1008–1089. New York, NY: The Monacelli Press.

Koolhaas, Rem, and Hans Ulrich Obrist. 2011. *Project Japan. Metabolism Talks...* Cologne: Taschen.

Kubo, Michael. 2021. Genius versus expertise. Frank Lloyd Wright and the architects collaborative at the university of Baghdad. *Histories of Postwar Architecture* 5 (8): 14–42.

Kultermann, Udo. 1985. Contemporary Arab architecture. The architects in Saudi Arabia. *Mimar* 16: 42–53.

Le Corbusier. 1930. *Précisions sur un état présent de l'architecture et de l'urbanisme*. Paris: Crès.

Le Roux, Hannah. 2004. Modern architecture in post-colonial Ghana and Nigeria. *Architectural History* 47: 361–392.

Lee, Rachel. 2012. Constructing a shared vision: Otto Koenigsberger and Tata & Sons. *ABE Journal* (2).

Lefebvre, Henri. 2009. The worldwide experience (1978). In *State, Space, World: Selected Essays*, edited by Neil Brenner and Stuart Elden [Translated by Gerald Moore, Neil Brenner and Stuart Elden], 274–289. Minneapolis, MN: University of Minnesota Press.

Levin, Ayala. 2022. *Architecture and Development: Israeli Construction in Sub-Saharan Africa and the Settler Colonial Imagination, 1958–1973*. Durham, NC: Duke University Press.

Liernur, Jorge Francisco. 2001. *Arquitectura en la Argentina del siglo XX. La Construccion de la modernidad*. Buenos Aires: Fondo Nacional de las Artes.

Liernur, Jorge Francisco. 2004. Vanguardistas versus Expertos. Reconstrucción europea, expansión norteamericana y emergencia del 'Tercer Mundo' (una mirada desde América Latina). *Block* 6: 18–39.

Liernur, Jorge Francisco. 2015. Mutaciones de Cancer a Capricornio. La construcción del discurso occidental sobre la vivienda en territorios tropicales: De instrumento colonialista a factor de conflicto en la Guerra Fría. *Estudios Del Hábitat* 13 (1): 1–60.

Liscombe, Rhodri Windsor. 2006. Modernism in late imperial British West Africa: The work of Maxwell Fry and Jane Drew, 1946–56. *Journal of the Society of Architectural Historians* 65 (2): 188–215.

Loeffler, Jane C. 1998. *The Architecture of Diplomacy: Building America's Embassies*. New York, NY: Princeton Architectural Press.

Loeffler, Jane C. 2005. Embassy design: Security vs. openness. *Foreign Service Journal* 9: 44–51.

Logan, William S. 1995. Russians on the red river: The soviet impact on Hanoi's townscape, 1955–90. *Europe-Asia Studies* 47 (3): 443–468.

Lu, Duanfang. 2006. Travelling urban form: The neighbourhood unit in China. *Planning Perspectives* 21 (4): 369–392.

Lucena Giraldo, Manuel, and Felipe Fernández-Armesto. 2022. *Un imperio de ingenieros. Una historia del Imperio español a través de sus infraestructuras*. Barcelona: Taurus.

Lynch, Kevin. 1960. *The Image of the City*. Cambridge, MA: MIT Press.

Marisela, Mendoza, and Manuel Cresciani. 2013. Pier Luigi Nervi, Felix Candela and the Kuwait sports centre competition in 1968. In *Proceedings of the International Association for Shell and Spatial Structures (IASS) Symposium 2013*, ed. J.B. Obrębski, and R. Tarczewski.

Matsubara, Kosuke. 2020. A Shift from 'Habitat pour le plus Grand Nombre' to 'Habitat Évolutif' in post-war francophonie: A study on the history of international and regional exchange activity of ATBAT(Atelier des Bâtisseurs). Part 2. *Japan Architectural Review* 3: 601–614.

References

McNeill, Donald. 2009. *The Global Architect: Firms, Fame and Urban Form*. New York, NY: Routledge.

Meadows, Donella H., Jorgen Randers, and William W. Behrens III. 1972. *The Limits to Growth*. New York, NY: Universe Books.

Melnikova-Raich, Sonia. 2010. The soviet problem with two 'unknowns': How an American architect and a soviet negotiator jump-started the industrialization of Russia, part I: Albert Kahn. *IA, the Journal of the Society for Industrial Archeology* 36 (2): 59–73.

Merrill, Elizabeth. 2017. The Professione di Architetto in Renaissance Italy. *Journal of the Society of Architectural Historian* 76 (1): 13–25.

Metcalf, Thomas R. 1989. *An Imperial Vision: Indian Architecture and Britain's Raj*. London: Faber and Faber.

Mignolo, Walter D. 2005. *The Idea of Latin America*. Malden, MA; Oxford: Blackwell.

Mota, Nelson. 2021. Incremental housing: A short history of an idea. In *The New Urban Condition: Criticism and Theory from Architecture and Urbanism*, ed. Leandro Medrano, Luiz Recamán, and Tom Avermaete, 160–182. Milton: Routledge.

Mühlhahn, Klaus. 2013. Mapping colonial space. The planning and building of Qingdao by German colonial authorities, 1897–1914. In *Harbin to Hanoi. The Colonial Built Environment in Asia, 1840 to 1940*, ed. Laura Victoir and Victor Zatsepine, 103–150. Hong Kong: Hong Kong University Press.

Mumford, Eric. 2018. *Designing the Modern City: Urbanism Since 1850*. New Haven, CT: Yale University Press.

Nancy, Jean-Luc. 2007. *The Creation of the World, or Globalization*. Albany, NY: State University of New York Press.

Niglio, Olimpia, and Martín Manuel Checa-Artasu. 2021. *Architetti e artisti nella diaspora italiana in America Latina. Arquitectos y artistas en la diáspora italiana en Latinoamérica*. Roma: Aracne Editrice.

Niglio, Olimpia, and Rubén Hernández Molina. 2016. *Ingenieros y arquitectos italianos en Colombia*. Roma: Aracne.

O'Rourke, Kathryn E. 2012. Mies and Bacardi. Mixing modernism, c. 1960. *Journal of Architectural Education* 66 (1): 57–71.

O'Rourke, Kevin H., and Jeffrey G. Williamson. 2002. When did globalisation begin? *European Review of Economic History* 6: 23–50.

O'Byrne Orozco, María Cecilia, ed. 2010. *Le Corbusier en Bogotá, 1947–51*, 3 vols. Bogotá: Edicioned Uniandes.

Ockman, Joan, and Avigail Sachs. 2012. Modernism takes command. In *Architecture School. Three Centuries of Educating Architects in North America*, edited by Joan Ockman, 121–159. Cambridge, MA, Washington, DC: MIT Press, Association of Collegiate Schools of Architecture.

Oddy, Jason. 2019. *The Revolution Will Be Stopped Halfway: Oscar Niemeyer in Algeria*. New York, NY: Columbia Books on Architecture and the City.

Olgyay, Victor. 1963. *Design with Climate. Bioclimatic Approach to Architectural Regionalism*. Princeton, NJ: Princeton University Press.

Pearlman, Jill E. 2007. *Inventing American Modernism: Joseph Hudnut, Walter Gropius, and the Bauhaus Legacy at Harvard*. Charlottesville, VA: University of Virginia.

Pérez Oyarzún, Fernando, ed. 1991. *Le Corbusier y Sudamérica: viajes y proyectos*. Santiago de Chile: Eds. ARQ. Pontificia Universidad Católica de Chile.

Peyceré, David. 2012. Perret Frères, architect/contractors in Northern Africa. In *Building Beyond the Mediterranean: Studying the Archives of European Businesses (1860–1970)*, ed. Claudine Piaton, Ezio Godoli and David Peyceré, 44–49. Arles: Publications de l'Institut national d'histoire de l'art, Honoré Clair, InVisu (CNRS-INHA).

Piccarolo, Gaia. 2020. *Architecture as Civil Commitment: Lucio Costa's Modernist Project for Brazil*. Abingdon; New York, NY: Routledge.

Pieris, Anoma. 2005. The search for critical identities: A critical history. In *New Directions in Tropical Asian Architecture*, ed. Philip Goad, Anoma Pieris and Patrick Bingham-Hall. Singapore: Periplus Editions.

Piketty, Thomas. 2014. *Capital in the Twenty-First Century* [Translated by Arthur Goldhammer]. Cambridge, MA: Harvard University Press.

Prakash, Vikramaditya. 2002. *Chandigarh's Le Corbusier. The Struggle for Modernity in Postcolonial India*. Seattle: University of Washington Press.

Pyla, Panayiota. 2008. Back to the future: Doxiadis's plans for Baghdad. *Journal of Planning History* 7 (1): 3–19.

Raisbeck, Peter. 2020. *Architecture as a Global System: Scavengers, Tribes, Warlords and Megafirm*. Bingley: Emerald Publishing.

Ramón, Gutiérrez, and Jorge D. Tartarini. 1996. *El Banco de Boston: la casa central en la Argentina, 1917–1997*. Buenos Aires: Fundación Banco de Boston.

Reisz, Todd. 2021. *Showpiece City: How Architecture Made Dubai*. Stanford, CA: Stanford University Press.

Ricard, Serge, ed. 1990. *An American Empire: Expansionist Cultures and Policies, 1881–1917*. Aix-en-Provence: Université de Provence.

Ridley, Jane. 1998. Edwin Lutyens, New Delhi, and the architecture of imperialism. *Journal of Imperial and Commonwealth History* 26 (2): 67–83.

Robinson, Willard B. 1971. Military architecture at mobile bay. *Journal of the Society of Architectural Historians* 30 (2): 119–139.

Rogaski, Ruth. 1999. Hygienic modernity in Tianjin. In *Remaking the Chinese City. Modernity and National Identity, 1900–1950*, ed. Joseph W. Esherick, 30–46. Honolulu, HI: University of Hawai'i Press.

van Roosmalen, Pauline K.M. 2015. Netherlands indies town planning: An agent of modernization (1905–1957). In *Cars, Conduits, and Kampongs: The Modernization of the Indonesian City, 1920–1960*, ed. Freek Colombijn and Joost Coté, 87–120. Leiden: Brill.

Roskam, Cole. 2015. Non-aligned architecture: China's designs on and in Ghana and Guinea, 1955–92. *Architectural History* 58: 261–291.

Rossi, Aldo. 1966. *L'architettura della città*. Padova: Marsilio.

Rostow, Walt W. 1960. *The Stages of Economic Growth: A Non-Communist Manifesto*. Cambridge: Cambridge University Press.

Saniga, Andrew. 2012. *Landscape Architecture in Australia*. Sydney: NewSouth Publishing.

Schnitter Castellanos, Patricia. 2007. *José Luis Sert y Colombia: de la Carta de Atenas a una Carta del Hábitat*. Medellín: Universidad Pontificia Bolivariana.

Schwenkel, Christina. 2014. Socialist palimpsests in Urban Vietnam. *ABE Journal* (6).

Scriver, Peter, and Amit Srivastava. 2019. Cultivating Bali Style: A Story of Asian Becoming in the Late Twentieth Century. In *Southeast Asia's Modern Architecture: Questions of Translation, Epistemology, and Power*, ed. Jiat Hwee Chang and Imran bin Tajudeen, 85–111. Singapore: NUS Press.

Sennewald, Bea. 1989. Challenges of building abroad: Foreign Billings by U.S. firms are again on the rise. *Architecture: The AIA Journal* 78 (1): 87–92.

Shannon, Kelly. 2014. Beyond tropical regionalism: The architecture of Southeast Asia. In *A Critical History of Contemporary Architecture: 1960–2010*, ed. Elie G. Haddad and David Rifkind, 359–377. Surrey: Ashgate.

Song, Ke, and Jianfei Zhu. 2016. The Architectural Influence of the United States in Mao's China (1949–1976). *Fabrications* 26 (3): 337–356.

Sosa, Marco, and Lina Ahmad. 2022. Urban portraits: Preserving the memory of modern architectural heritage in the United Arab Emirates. In *Urban Modernity in the Contemporary Gulf: Obsolescence and Opportunities*, ed. Roberto Fabbri and Sultan Sooud Al-Qassemi, 246–263. Abingdon: Routledge.

Stanek, Łukasz. 2012. Miastoprojekt goes abroad: The transfer of architectural labour from socialist Poland to Iraq (1958–1989). *The Journal of Architecture* 17 (3): 361–386.

References

Stanek, Łukasz. 2015a. Architects from socialist countries in Ghana (1957–67): Modern architecture and mondialisation. *Journal of the Society of Architectural Historians* 74 (4): 416–442.

Stanek, Łukasz. 2015b. Mobilities of architecture in the global cold war: From socialist Poland to Kuwait and back. *International Journal of Islamic Architecture* 4 (2): 365–398.

Stanek, Łukasz. 2019. *Architecture in Global Socialism. Eastern Europe, West Africa, and the Middle East in the Cold War.* Princeton, NJ: Princeton University Press.

Stanek, Łukasz. 2021. Buildings for dollars and oil: East German and Romanian construction companies in cold war iraq. *Contemporary European History* 30 (4): 544–561.

Stanek, Łukasz, and Nikolay Erofeev. 2021. Integrate, adapt, collaborate: Comecon architecture in socialist Mongolia. *ABE Journal* 19: 1–37.

Tabb, Phillip. 2014. Greening architecture: The impact of sustainability. In *A Critical History of Contemporary Architecture: 1960–2010*, ed. Elie G. Haddad and David Rifkind, 91–114. Surrey: Ashgate.

Tucker, D. 2003. Learning from Dairen, learning from Shinkyo: Colonial City planning and postwar reconstruction. In *Rebuilding Urban Japan after 1945*, ed. Carola Hein, Jeffrey M. Diefendorf, and Yorifusa Ishida, 156–187. New York, NY: Palgrave Macmillan.

Tyack, Geoffrey. 2005. *Modern Architecture in an Oxford College: St John's College 1945–2005.* Oxford: Oxford University Press.

Underwood, David K. 1991. Alfred Agache, French sociology, and modern urbanism in France and Brazil. *Journal of the Society of Architectural Historians* 50 (2): 130–166.

Utting, Brittany, and Daniel Jacobs. 2022. Revisit: Climat de France, Algiers by Fernand Pouillon. *The Architectural Review*, Apr 21. https://www.architectural-review.com/essays/revisit/climat-de-france-algiers-by-fernand-pouillon. Accessed 10 May 2022.

Van der Heiden, C.N. 1990. Town planning in the Dutch Indies. *Planning Perspectives* 5 (1): 63–84.

Vásquez Benítez, Edgar. 2001. *Historia de Cali en el siglo 20: sociedad, economía, cultura y espacio.* Cali: Universidad del Valle.

Venturi, Robert, Denise Scott Brown, and Steven Izenour. 1972. *Learning from Las Vegas.* Cambridge, MA: MIT Press.

Venturi, Robert. 1966. *Complexity and Contradiction in Architecture.* New York, NY: Museum of Modern Art.

Verdeil, Éric. 2012. Michel Écochard in Lebanon and Syria (1956–1968). The spread of modernism, the building of the independent states and the rise of local professionals of planning. *Planning Perspectives* 27 (2): 243–260.

Victoir, Laura, and Victor Zatsepine. 2013. *Harbin to Hanoi. The Colonial Built Environment in Asia, 1840 to 1940.* Hong Kong: Hong Kong University Press.

Wallerstein, Immanuel. 1974. *The Modern World-System. Capitalist Agriculture and the Origins of the European World Economy in the Sixteenth Century*, vol. 1. San Diego, CA: Academic Press.

Ward, Stephen V. 2010. Transnational planners in a postcolonial world. In *Crossing Borders: International Exchange and Planning Practices*, ed. Patsy Healey and Robert Upton, 47–72. Abingdon: Routledge.

Watkin, David. 2005. *A History of Western Architecture*, 4th ed. New York, NY: Watson-Guptill Publications.

Wharton, Annabel Jane. 2001. *Building the Cold War: Hilton International Hotels and Modern Architecture.* Chicago, IL: University of Chicago Press.

Wilson, Samuel. 1973. Religious architecture in French Colonial Louisiana. *Winterthur Portfolio* 8: 63–106.

Wolf, Caroline Olivia M., and Fernando Martínez Nespral. 2022. Introduction to the dialogues on rethinking interpretations of the Mudéjar and its revivals in modern Latin America. *Latin American and Latinx Visual Culture* 4 (3): 75–82.

Wright, Gwendolyn. 1991. *The Politics of Design in French Colonial Urbanism.* Chicago, IL: The University of Chicago Press.

Wright, Gwendolyn. 2008. Global ambition and local knowledge. In *Modernism and the Middle East: Architecture and Politics in the Twentieth Century*, ed. Sandy Isenstadt and Kishwar Rizvi, 221–254. Seattle, WA: University of Washington Press.

Xing, Ruan. 2002. Accidental affinities: American Beaux-Arts in twentieth-century Chinese architectural education and practice. *Journal of the Society of Architectural Historians* 61 (1): 30–47.

Xue, Charlie Q. 2016. *Hong Kong Architecture 1945–2015: From Colonial to Global*. Singapore: Springer.

Xue, Charlie Q., and Guanghui Ding. 2022. *Exporting Chinese Architecture—History, Issues and One Belt One Road*. Singapore: Springer.

Xue, Charlie Q., Guanghui Ding, and Yingting Chen. 2021. Overseas architectural design in China: A review of 40 years. *Architectural Practice* 29: 8–21.

Yakushenko, Olga. 2021. Building Connections, Distorting Meanings. Soviet Architecture and the West, 1953–1979. PhD dissertation. European University Institute, Firenze.

Zarucchi, Jeanne Morgan. 2006. Bernini and Louis XIV: A duel of Egos. *Notes in the History of Art* 25 (2): 32–38.

Zimmerman, Claire. 2019. Building the world capitalist system: The 'invisible architecture' of Albert Kahn associates of Detroit, 1900–1961. *Fabrications* 29 (2): 231–256.

Zubovich, Katherine. 2021. *Moscow Monumental: Soviet Skyscrapers and Urban Life in Stalin's Capital*. Princeton, NJ: Princeton University Press.

Chapter 4
Architecture in Emerging Markets: A "Distant Reading"

The global turn of the architectural practice on which we focus in this book can be considered a long-term process that began in the decades following World War II and accelerated towards the end of the century. To put things in order, with the reunification of Germany (1990), the collapse of the Soviet Union (1991), and the dissolution of the Warsaw Pact (1991), in the last decade of the twentieth century, the Cold War era was at its end. Indeed, while British historian Hobsbawm (1995) recognised in these events the closing of what he called "the short twentieth century," Fukuyama (1992)—mistakenly—foresaw the very "end of history," in the form of the final triumph of the free market and liberal democracy. Since then, globalisation, intended as the process of increasing integration and interdependence of societies at the global scale, has accelerated and, above all, changed its nature. The "new globalisation" that Baldwin (2016) describes as the product of lower coordination costs thanks to the ICT revolution and the consequent possibility of moving labour-intensive stages of production to low-wage countries (North–South offshoring) deindustrialised G7 countries and rapidly industrialised a bunch of developing nations.

Large free trade blocs were established or strengthened throughout the globe in the very same years. The Treaty of Maastricht, signed in 1992 by twelve European states, transformed the European Community into the European Union (EU), paving the way for the adoption of a common currency, the Euro, in 1999 (but circulating from 2002). Since then, through successive treaties—Amsterdam 1999, Nice 2003, Lisbon 2009—the European Union has not only enlarged by including former Soviet-Bloc countries but also broadly expanded its political scope and areas of exclusive competence. Although only the case of the EU implied such a significant loss for states' sovereignty, other important treaties were signed during the 1990s, defining extended free trade areas. The North American Free Trade Agreement (NAFTA) was ratified by the USA, Canada, and Mexico in 1993, while the Mercosur, covering most of South America, came into reality between 1991 and 1994. In the following decade, China joined the World Trade Organization (WTO) in 2001, while Russia did it only in 2011. In macroeconomic terms, since the 1990s, international trade has

© The Author(s), under exclusive license to Springer Nature Singapore Pte Ltd. 2023 111
G. Botti, *Designing Emerging Markets*,
https://doi.org/10.1007/978-981-99-1552-1_4

thrived. In 1970, it represented 25% of global GDP, and in 1990, 34%; by 2008, it had reached 61%, according to the World Bank.

These conditions and the overall politico-ideological framework underpinning them lasted until the second half of the 2010s. After that moment, which followed the Great Recession of 2007–08 and the crisis of sovereign debt in Europe of 2009–10, the (side-)effects of globalisation—and in the case of Europe of the nation-states' loss of sovereignty—became a political argument of right-wing populist movements across the West, which in many ways replaced the progressive anti-globalisation movements of the late 1990s. Events like Brexit or Donald Trump's 'trade wars' with China and the EU eventually highlighted the ongoing paradigm change. And then it came the COVID-19 pandemic, with closed borders and disrupted supply chains, and, in early 2022, the Russian invasion of Ukraine, which for the first time in decades made the possibility of a nuclear conflict imaginable again. It is not difficult, therefore, to state that 'globalisation as we know it' may have come to an end (Olivié and Gracia 2020). Still, the future is not the scope of this book as we look at the recent past. And limitedly to the architecture field. Moreover, as the next section explains, this study focuses on the globalisation of the architectural practice with a precise, although partial, perspective: that of architectural firms from some developed countries working in emerging markets. After discussing these limits in scope and perspective, the present chapter will analyse the global architectural market in the last thirty years, relying on measurable indicators. To put it plainly, we argue that as the world entered a new phase of globalisation in the 1990s so did the architectural profession.

4.1 BRICS and Other Emerging Markets: Defining the Scope of This Study

This book deals with what happened in the architectural field during these last thirty years at the global scale. As mentioned (Sect. 2.5), it features a quantitative analysis of the work of 1,025 architectural firms from 20 countries belonging to the so-called "developed world," not limited to the Euro-Atlantic countries, but including also nations from the Asia–Pacific region, part of what, during the Cold War, was the Capitalist Bloc. The present analysis thus concerns the work of these firms in what we call here 'emerging markets' for architecture. While this definition generally overlaps with the notion of emerging economies, it should be noted that for us it also includes some high-income countries that nonetheless 'emerged' as hotspots for the architectural profession only in these last few decades. These countries, but again with exceptions, were also part of either the so-called "Second World," i.e., the Soviet Bloc, or the "Third World," i.e. the Non-Aligned Movement established after the Bandung Conference of 1955. Many of these countries, but again not all of them, are, in today's terms, part of the Global South. Although things may be now changing, another critical feature of these markets is that they have been mainly places of consumption of

global architectural production rather than places of production (although, again, with exceptions). Finally, some of these markets opened up or further developed during the last three to four decades, sometimes profoundly impacting and transforming the world economy and the architectural profession.

To operate the study, a series of countries and regions have been selected, forming a batch that encompasses 56% (4.31 billion) of the world population and 30% (U\$26 trillion) of the GDP, according to data from the World Bank as of 2018 (Appendix A).[1] The survey considers the work of international architectural firms in 20 countries divided across seven regions. It includes the two most populated nations in the world, China and India, both individually considered. The reasons for covering them are too obvious to be stated, as they are together home to about a third of the world's population and represent the second and the fifth largest economies by GDP, accounting for U\$13.89 and 2.7 trillion respectively. Mainland China, as we will see, represented in the last twenty years the largest market for foreign architects in absolute terms.[2] This because the country, while undergoing an urbanisation process of unprecedented scale and speed (Campanella 2008), which completely transformed its territory, economy, and society (Logan 2002; Wu 2006; Mars and Hornsby 2008; Wu and Gaubatz 2013; Forrest et al. 2019; Bonino et al. 2019), reshaped the image of its major cities now conceived as "international metropolis"—*guojihua dadushi*—or "global cities"—*quanqiuhua chengshi*—(Ren 2011, 11). Cities like Shanghai today represent the ultimate and most successful examples of the construction of an "official imagination of modernity" (King 2004, 125) for the global public achieved by means of architecture (Dreyer 2012); an architecture mostly delivered by foreign architects. On the other hand, India, while featuring a similar size in terms of population and boasting one of the largest economies in the world, has never offered a comparable quantity of opportunities. Although the country has been open to the influx of foreign architects since the colonial time, and also after its independence— we have mentioned Le Corbusier's and Louis Khan's works in the previous chapter, for example—, it has represented a far less important market in these last three decades compared to China and other regions. It is arguable that the slower pace of economic growth—6.2% on average between 1990 and 2019 compared to 9.3% of China—and the lower level of urbanisation (Biau 2007; Dobbs and Sankhe 2010), with China's urban population (829.7 million by 2018) being almost twice as large as India's (460.3 million)—played a role in such differentiation.[3]

We continued our survey in South-East Asia, analysing three countries: Indonesia, Malaysia, and Vietnam. Together, they account for 394 million inhabitants and

[1] Unless otherwise stated, all GDP and population data in this chapter refer to the year 2018 and are based on the World Bank Open Data (World Bank n.d.).

[2] The survey neither includes projects located in the Special Administrative Regions (SARs) of Hong Kong and Macau nor in Taiwan, as these territories have historically featured different market conditions.

[3] India, in any case, represents a strong anomaly in our data. The number of office branches mapped in Sect. 4.5, for instance, suggests a wider and quantitatively more significant activity of foreign firms in the country than our data indicate. One possibility is that, in the country, overseas firms are busier with 'cash' rather than 'flagship' projects (Sect. 2.5).

an output of U$1.64 trillion, or about 1.89% of global GDP. Although politically unaligned in the present and in the past, they all represent some of the most dynamic economies in the region and on a global scale. Since 1990, Indonesia has grown at an average rate of 4.93% year-on-year, Malaysia at 5.7%, and Vietnam at 6.86%. South-East Asian cities have developed into international megacities with modern and impressive skylines, often benefitting from foreign architects' work. The vertical growth of cities became well visible before the 1997 Asian financial crisis, which originated from the over-supply of residential and commercial properties (Bello 1999). As the following chapters will show, the region has seen relevant participation of overseas architecture firms for the design of prime corporate and mixed-use skyscrapers in major cities, and large hotels and fine beach resorts in renowned touristic destinations. Similar patterns would have been visible by including in our survey other countries of the region, like, for instance, Thailand or the Philippines. On the other hand, quite different would be the case of Singapore, making its exclusion from the survey a choice that deserves clarification. The city-state, which boasts one the highest per capita incomes in the world, is a global city with an impressive set of contemporary buildings designed by high-profile international architects. Singapore emerged as a market for foreign design firms in the 1980s, when architects like Paul Rudolph, Kenzo Tange and many others delivered several important projects (Sect. 3.4). The burgeoning city-state attracted European, US, and Australian firms, which established many branch offices that served as platforms to operate in the whole South-East Asian market. And today, Singapore also hosts a growing number of successful local firms working across the region. Notwithstanding this, it still remains mainly a "consumer city" of architectural services (Ren 2011, 35). That said, this reality may be changing soon, as for other cases that we will discuss in Sect. 4.5.

The following region of interest is the Middle East, and the Arabic Peninsula and the Persian Gulf in particular. In this case, the research has focused on oil- and gas-rich, high-income countries—actually some of the richest in the world in terms of GDP per capita, but also among the more unequal ones—like the Kingdom of Saudi Arabia (KSA) and three Persian Gulf states: Oman, Qatar, and the United Arab Emirates (UAE). In the book, we use the term "Middle East" to designate these countries when we refer to the data collected in our research. Although in popular Western imaginary, their emergence has been seen as a recent outcome of globalisation—one deserving a great deal of criticism in terms of urban and architectural development (Davis 2007; Kanna 2011)—, some of them have been for centuries hubs for maritime traffic across the region, making their current position in no ways "exceptional" compared to other Arab capitals (Fuccaro 2014). In addition to being well-supplied with these resources, a feature shared by others in the region, these countries are all important US allies, with colonial ties to the British Empire and strong links with the Western Bloc during the Cold War.

On the other hand, excluding the recent political divergence that led in 2017 to the blockade of Qatar by the KSA, UAE and other regional ex-allies, the increasing tension between Saudi Arabia and the USA, and a significant difference in size, there is another major dissimilarity among this group of countries. Although they have used

4.1 BRICS and Other Emerging Markets: Defining the Scope of This Study

architecture as a means to attract "foreign expertise, tourists and businesses" while promoting the "image of ruling families as far-sighted, modernizing technocrats" (Boodrookas and Keshavarzian 2019), their degree of openness has been different, at least until the last years. While Qatar and the UAE have been hugely investing to position cities like Doha, Abu Dhabi, and Dubai as global cities, attracting not only tourists but also large immigrant communities of both low-skilled and highly-paid workers, the KSA has remained, at least until very recently, a pretty closed-off country. In the end, the region, including other nations not covered in the survey (Fraser and Golzari 2013), has been an increasingly important market for foreign architects, with a first boom in the mid-1970s (Sect. 3.4) and a new one in the last two decades. Hence, even though, in strictly economic terms, these countries cannot be considered emerging markets, they have certainly been for the architectural profession.

Of course, from our survey, we excluded other countries that had been attractive markets for foreign architects since the 1970s, like Kuwait or, looking at the region more broadly and comprehensively, Turkey. Neither we considered Lebanon, which before the outbreak of its bloody Civil War (1975–90) was the financial and lifestyle hub of the region. Indeed, also the 2000s, following the reconstruction of Beirut's old centre initiated after the end of the War, saw a great presence of international starchitects, making the Lebanese capital an architectural hotspot. Signature high-rise residential designed by Foster + Partners, Herzog & De Meuron, and KPF, fancy restaurants and shopping malls, and the new Marina by Steven Holl restored that hype that the War had erased. Regretfully, the financial and economic crisis experienced since 2019 and the devastating blast in the port of Beirut on 4th August 2020 plunged the country again into the abyss. In any case, we cannot overestimate the role of European and US firms, as Beirut was in the 1960s a regional hub for engineering and architecture with local firms like Dar Al-Handasah and Rafik El Khoury & Partners that became multinationals working across the whole Middle East.

Moving northward, in-between Europe and Asia, the largest market that opened after 1990 is the Russian Federation, a prominent global actor with a permanent seat in the United Nations Security Council, a member of the G8 (although suspended since 2008), and one of the BRICS. Unlike China, economic reforms came to Russia without gradualism after the country abandoned Communism with the dissolution of the Soviet Union in 1991. As a result, the 1990s were rough years. 'Shock reforms' of liberalisations and privatisations introduced by Boris Yeltsin did not produce an immediate positive effect. In fact, the economic output plunged, and the country went through a constitutional crisis in 1993 and a bloody war in Chechnya (1994–96). As a result, the GDP in 1999 was less than half of that of 1990, although the decline may have been actually lower for a variety of reasons, not least that it used to be highly dependent on inflated military expenditures, whose reduction did not affect people's quality of life (Shleifer and Treisman 2005). All these conditions, exacerbated by the 1997 Asian financial crisis and the decline in oil prices, conflagrated in August 1998 in a financial crisis that resulted in the default of the country (Melloni 2006). After that moment, however, and especially thanks to the rising price of oil and gas,

the Russian economy grew almost uninterruptedly until 2013. During those years, European architects found an appetible market for their design services. Interestingly to note, while the timid sanctions imposed after the annexation of Crimea in 2014 did not stop the trend, the recent invasion of Ukraine, with some of the toughest sanctions ever imposed on a country by the EU, the USA, and the G7, may have changed the scenario. Surprisingly, while multinationals like H&M, MacDonald's, Netflix, Visa, and Zara have pulled out of the country fearing the backlash from both consumers and governments, this time even some high-profile architectural firms have done so. Firms that declared they would pull out or suspend all going projects include BIG, David Chipperfield, Foster + Partners, MVRDV, OMA, Snøhetta, UN Studio, and Zaha Hadid Architects (Hickman 2022; Totaro 2022). As it will emerge many times in this book (Sects. 5.8, 6.2 and Chap. 7), this stance represents a novelty in a global professional panorama where involvement in political issues has remained taboo.

Together with Russia, we surveyed another country in the post-Soviet space: Kazakhstan. The largest and richest Central Asian republic formerly part of the Soviet Union, it is also the most extended landlocked country and the ninth in the world for dimensions. Kazakhstan features a strategic geopolitical position between East and West, and since its independence, it has shaped its foreign policy accordingly. Rather than pursuing mono-directional relations, the country has embraced a "multi-vectorial" foreign policy, balancing between Russia, China, the USA, and Europe (Costa Buranelli 2018), while not neglecting relations with Japan, South Korea, and Turkey, too. Presenting itself as a bridge, Kazakhstan has successfully attracted Chinese investments in the framework of the One Belt One Road Initiative to develop the so-called new Silk Road, or Eurasian Land Bridge, a rail freight route now connecting China to Central Europe in about 16–18 days. The choice of Kazakhstan to complement our survey on the post-Soviet space is thus motivated by economic and geopolitical reasons that made the country an attractive market for international design firms, which found in the development of the new capital city, Astana (renamed Nur-Sultan in 2019), additional motivations to engage with it. Indeed, no other country except perhaps Ukraine (and excluding those that entered the EU) represented an emerging market of comparable relevance for European, North American, Japanese, South Korean, and Australian architects. For sure, neither other central Asian republics nor Belarus had the same attractiveness as Kazakhstan. To be noted that, for the sake of simplicity, along the text and in tables and graphs, the reference to Russia and Kazakhstan will be done as to "Eurasia," without charging the word of any ideological implication.

We then refer to "Sub-Saharan Africa" when we consider the six countries surveyed in this book, all located South of the Sahara Desert. In our research, we included two oil-rich countries, Nigeria and Angola, with the former being the largest African country by GDP and population. Then, we surveyed South Africa, a country that was admitted into the BRIC in 2010 and one the highest income per capita in the continent; in addition, it is also the only one to have hosted a major international sports event: the 2010 FIFA World Cup. Finally, we added two fast-growing neighbouring nations of West Africa, Ghana and Ivory Coast, and the largest economy in Eastern Africa: Kenya. This sample is less homogenous compared to the others

but it reflects a diverse reality in geographic, historical, and economic terms. Such diversity is also useful from the perspective of the survey. It helps include countries with different historical ties (former British, French, and Portuguese colonies), which may have persisted in the post-colonial era and influenced connections in the architectural field. In addition, by studying different economies, it is easier to recognise how investments may have been directed towards specific sub-markets, thus creating diversified opportunities for foreign architects.

Finally, on the other side of the Atlantic Ocean, we have investigated three Latin American countries from the North and the South of the continent: Mexico, Colombia, and Brazil. Together, they account for 385 million inhabitants, roughly 5% of the world's population, and an aggregate GDP of U$3.4 trillion, or about 3.9% of the global one. Brazil, the Latin American component of the BRICS, represents the first economy in the region (the third after the USA and Canada, if we include North America) and the ninth in the world. Mexico is the third largest economy in Latin America and a member state of the Organisation for Economic Co-operation and Development (OECD), to which also Colombia has been recently admitted. Thus, the Andean country has been included to further expand the batch with a smaller (49.6 million inhabitants) upper-middle-income economy, which has enjoyed, after difficult decades of political and narco-terrorist violence, a relatively stable period, making it an attractive destination for foreign investments. Since 2000, and until the Covid-19 pandemic, Colombia has never experienced negative growth, with a + 1.1% even in 2009, while it also boasted solid figures before (5–6% year-on-year growth between 2004 and 2007) and after (4–6% between 2010 and 2014) the Great Financial Crisis.

Once again, the construction of the sample for this region implies choices that may be questioned. Firstly, Latin America, as known, is neither a geographical concept nor a political one. The Mercosur, for instance, does not include either Colombia or Mexico, which, on the contrary, is tied to the USA and Canada through NAFTA. Therefore, the idea of Latin America cannot be disconnected from that of a common history of colonisation—although the Spanish and Portuguese rule produced different legacies—and of economic dependency.[4] In addition, Latin America differs to a certain extent in a major feature shared by most of the other emerging markets insofar as it has been since the 1940s a recognised centre—a centre within the global periphery—of the architectural culture. Compared to other countries, the quality of the work of modernist architects in Mexico (Born 1937) and Brazil (Goodwin 1943) was early presented to the US public through a cultural operation, especially in the case of Brazil, orchestrated by the Museum of Modern Art (MoMA) of New York. All this happened within the framework of the Good Neighbor Policy and through efforts in public diplomacy needed to promote ties with strategic allies during World

[4] For decolonial authors like Mignolo (2005, xiii–xiv), studying "the idea of Latin America" means understanding "how the West was born and how the modern world order was founded" because, following the path of Colombian-American anthropologist Arturo Escobar, "there is no modernity without coloniality." The "idea of Latin America" was therefore constructed from two subsequent historical periods: the European Renaissance, during which the idea of "America" was constructed, and the Enlightenment, during which the idea of "Latinity" (*latinidad*) emerged.

War II (Liernur 1999). Then, in the post-War, architectural historian Giedion (1954, 9) recognised the role of Brazil (and Finland) as a new epicentre of modernism, while it was again the MoMA that in 1955 displayed the best of the architecture of Latin America in its prestigious rooms (Hitchcock 1955). This does not certainly imply that the historiography of modern architecture, together with European and US architectural magazines, had fairly and inclusively looked at Latin America in the second half of the twentieth century. Still, at least we cannot ignore the different position that Latin American architects enjoyed in the field during those decades compared to professionals from many other countries of the Global South. To further prove this, we can also look at the Pritzker Prize, which in its first decade of existence, was awarded to two Latin American architects: Luis Barragán in 1980 and Oscar Niemeyer in 1988. It will take until the 2010s for a Chinese or an Indian architect to gain it.

4.2 A Broad, But Still Incomplete, Picture: Globalisation Versus Mondialisation

Before proceeding more in-depth, we want to point out a few potential limits of the present research related to our selection of emerging markets. Obviously, any choice can be questioned; any gap can be highlighted. Here, the most pressing issue is to stress again the broad scope of this survey, which includes twenty countries accounting for more than half of the world population. While certain countries, namely China and India, because of their size, could be studied autonomously, for others, the best choice has been to cluster them. In this sense, there is an overall consistency in the South-East Asian, African, and Latin American clusters in terms of the general population: 397, 366, and 385 million inhabitants, respectively. Geographically, politically, and economically speaking, the Arab and Persian Gulf cluster also displays a strong coherence, with four oil-rich countries led by monarchs historically aligned with the Western powers. On the contrary, the diversity of the African cluster has already been explained, while the Latin American one, although geographically loose, is primarily intended to include the region and encompass different countries to achieve a certain representativeness. For the case of Russia, finally, rather than expanding to former Soviet Bloc countries now belonging to the EU, our focus has moved towards the Central Asian region, with Kazakhstan as the most obvious choice because of its economic weight in the area and its attractiveness for architects, due to the expansion of its new capital city and the organisation of the 2017 Expo.[5]

Overall, countries and regions selected for this study offer a broad, consistent, and representative picture of architectural globalisation. Nonetheless, this picture

[5] Including the other four Central Asian republics would have added little to the survey because the number of sampled architectural firms that had any involvement in these countries is very limited according to the collected data (see numbers in brackets): Kyrgyzstan (0), Tajikistan (1), Turkmenistan (6), Uzbekistan (4).

is limited, as it depicts the mono-directional agency of Euro-Atlantic (and Western aligned Asia–Pacific countries) architectural firms in emerging markets. Thus, before proceeding any further and critically discussing the metrics of this study, some additional considerations are required. First, as already emphasised, this book does not cover transnational interactions within the Euro-Atlantic space. It does not analyse, for instance, how the EU has created a unique and integrated market for architects, facilitated by the mutual recognition of university degrees and the growing circulation of architecture students and interns thanks to the Erasmus and the Leonardo exchange programmes. The EU enlargement, with the admission of eight Eastern European countries in 2004, followed by Romania and Bulgaria in 2007, would be another theme worth investigating in terms of transformations for the architecture market in the continent. Neither this study examines how the common market boosted participation in design competition from European firms from different member states, nor the emergence of more and more transnational firms within the European Union, something very common today for young architects who meet somewhere during their early work experiences (for example internship in famous offices) and then open joint studios based in two or more locations. Indeed, more than office branches, a concept that reminds of a hierarchy and a derivation from a centre, many young European firms have been characterised by polycentrism since their birth.

This book does not consider trans-Atlantic flows, which emerged with strength since the late 1980s. Back then, ties between the USA and the UK intensified as the London boom attracted US developers and architects. In Canary Wharf, firms like SOM, KPF, and I. M. Pei & Partners were busy designing the new tallest buildings of the British capital, while Venturi, Rouch & Scott Brown did the project of the Sainsbury Wing of the National Gallery. Then, more works by US firms were underway, from Spain to Italy, from Germany to Asia, especially in Japan and Hong Kong (Greer 1989). As Adam (2012, 90–93) reports, SOM opened its London office in 1986, KPF in 1989, and RTKL in 1990. In most cases, they represented the first overseas branches of these companies. The recently approved, although not fully ratified, CETA Treaty between Canada and the EU may open new perspectives, as a Mutual Recognition Agreement for the Practice of Architecture was signed in 2018 (Canadian Architect 2018). The present study does not delve into other routes of intense exchanges, namely those involving Japan and South Korea. Both countries have been important markets for European boutique firms and US mega-ones. At the same time, Japanese architects have worked in Europe since the 1970s. In Italy, we have mentioned the projects of Kenzo Tange of the 1970s and 1980s (Sect. 3.4), while in the 1990s, it was the turn of other star architects like Tadao Ando, with the Benetton Factory (1992–2000) in Treviso, and later the Punta della Dogana restoration (2007–09) in Venice, and SANAA with the Bocconi University Campus in Milan completed in 2019. In 1988, Arata Isozaki invited Rem Koolhaas, Oscar Tusquèts, Christian de Portzamparc, Marc Mack, and Steven Holl to design a series of housing blocks called Nexus. By the 1990s, it was common to see European and US architects gaining competitions and major commissions in Japan and South Korea, and vice versa. Just to name some significant projects: Renzo Piano's Kansai International Airport (1988–94), Foreign Office Architects' Yokohama Terminal (1995–2002),

Dominique Perrault's Ewha Womans University (2004–08, 70,000 m^2) in Seoul. Once again, mapping these flows is not within the scope of this book, but it would be highly beneficial to delve further into the process of architectural globalisation from this perspective. In the same way, it would be important to consider transnational work between Australia and New Zealand, on the one hand, and Europe, especially the UK, on the other. Along these routes, too, flows have been intense, as proved, for example, by the presence of several British firms with office branches in Australia: in Sydney (Atkins, Farrells, Foster + Partners, Grimshaw, Make Architects, Rogers Stirk Harbour + Partners), Melbourne (Farrells, Grimshaw), and Perth (Atkins).

Nonetheless, there would be much more to add. We have already mentioned (Sect. 3.3) how Stanek (2012, 2015, 2019, 2021) has framed his extensive studies on the agency of architects, planners, and engineers from Socialist countries in Africa and the Middle East within the concept of *mondialisation*, borrowed from authors like Lefebvre (2009) and Nancy (2007). In this perspective, studying architectural globalisation in an expanded and comprehensive fashion (or architectural *mondialisation*) would mean investigating similar phenomena and measuring comparable indicators in many other contexts. South-to-south networks and relationships, we may call them. In this regard, the case of China is paradigmatic to understand the underway changes visible in the growing circulation of expertise and firms expanding overseas. Firms like MAD Architects—a Chinese company that fits in the category of celebrities—have ongoing projects in Japan, Europe, and the USA and opened branch offices in Rome and Los Angeles. Shanghai-based Neri & Hu has completed several projects in Europe and the USA and touched on Australia, South America, Japan, and South-East Asia. Other significant experiences, on the other hand, can be related to the background of the principal architects. Ma Qingyun studied and worked in the USA, where he established his firm, MADA s.p.a.m., in New York in 1996. In 1999 he moved the office to Beijing and then Shanghai, but in 2007 a second office was opened in Los Angeles.

In the meantime, large state-owned firms known as design institutes (Xue and Ding 2018) are increasing their activities in the Global South. For instance, a 359-hectare high-rise, hyper-modern project for the Gujarat International Finance Tech-City is currently under construction in Ahmedabad according to the initial planning delivered by the East China Architectural Design & Research Institute (ECADI). For decades, projects elaborated by these institutes have been donated to several countries (Xue and Ding 2022). Theatres, for example, were designed and built in Ghana already in 1989 (Roskam 2015), in Senegal in 2011, in Sri Lanka in 2012, and in Algeria in 2016 (Xue 2019, xxii). Stadiums have been built across South-East Asia, Africa, and Latin America since the late 1950s, originating some sort of "stadium diplomacy" (Will 2012; Xue et al. 2019). Thus, Chinese involvement in Africa, for both infrastructural and architectural projects, is not a novelty, as the story of the TAZARA railway built during the 1970s between Tanzania and Zambia (Monson 2009), or the many projects built in West Africa for decades prove, up to the completion in 2011 of the African Union Headquarters in Addis Ababa designed by the Architectural Design & Research Institute of Tongji University (Roskam 2015). Recently, the launch of the Belt and Road initiative has also promoted the design of

"pastiche" architectures for business centres and logistic hubs erected from Pakistan to Belarus (Marri 2019).

Mapping the transnational agency of firms based in Beirut, Doha, Dubai, and Abu Dhabi across the whole Middle East would be another very important task, even more interesting because many of these practices were established already during the 1950s and 1960s. We already mentioned Lebanese multinationals Dar Al-Handasah, founded in 1956 and with branches today in Amman, Cairo, London, and Pune, and Rafik El Khoury & Partners, established in 1967 and with branches in Abu Dhabi, Dubai, and Riyadh. Doha-based Arab Engineering Bureau has operated since 1966 and has branches in Manila (since 2007), Muscat (since 2013), and Salalah (2018), while National Engineering Bureau, established in 1984 in Dubai, works through offices in Bahrein, Egypt, India, Iran, Libya, Qatar, Saudi Arabia, and Tunisia. Abu Dhabi-headquartered Dewan Architects + Engineers, since its foundation in 1984 has expanded to Dubai (1999) and then opened offices in Baghdad (2008), Manila (2008), Riyadh (2009), Basra (2012), Cairo, Ho Chi Minh City, and Barcelona. The work of Singaporean design firms—megapractices like DP Architects, established in 1967, or boutique firms like WOHA—today spans across the Middle East and the whole of South-East Asia. And some Latin American architects have experienced global success in the post-War, too, obviously starting from Oscar Niemeyer. Today several firms successfully work across the region, although still not many have been able to reach North America, Europe, or Asia; in many cases, due to their smaller dimension compared for example with Asian competitors. In the end, as we mentioned in Sect. 2.1, there are many globalisations (Pieterse 2004, 38) and there are many other forms of integration that are cross-border but not universal, making the word globalisation of dubious usefulness (Cooper 2001). As figures in the next section show, for instance, Latin America has been touched more limitedly compared to other regions by the expansion of architectural markets. However, today, it would be impossible to neglect cross-border architectural production involving professionals from the region and, more in general, transnational academic, educational, and media networks. Once again, this is just one of the limits—because of the clear demarcation we gave—of our work.

4.3 The Globalisation of the Architectural Practice: Building in Emerging Markets

Looking at our data in the following graphs, several issues leap off the page. Since the 1990s, and especially after the 2000s, China has been, in absolute terms, the largest emerging market for the export of design services (Fig. 4.1).[6] We recorded 3,040 projects delivered by overseas firms in the country, of which at least 1,484 have been completed or are currently under construction. In the same period, only 318

[6] Unless otherwise stated, all data presented in this section refer to our sample of 1,025 firms in the surveyed regions/countries.

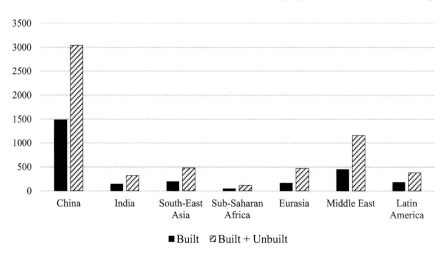

Fig. 4.1 Number of projects designed by overseas firms (surveyed sample) in emerging markets, 1990–2020. Copyright Giaime Botti

designs were proposed in India, with less than half being built. Indeed, the second most important market, in absolute terms, has been the Middle East. Here, foreign architects have delivered 1,155 projects, of which 451 were built. To complete the overview, we can note the design of 477 projects in surveyed South-East Asian countries, with 197 completed; 469 in Eurasia (Russia and Kazakhstan), with 164 built; 380 in Latin American countries, with 182 built. Lastly, the batch of Sub-Saharan African countries—Angola, Ghana, Ivory Coast, Kenya, Nigeria, and South Africa—recorded only 116 projects, with less than half completed. Overall, data show data less than half of the project delivered arrives at the construction stage.[7]

Another way to gauge the involvement of foreign firms in emerging markets is by considering the number of square metres built according to projects designed by our sample of firms (Fig. 4.2). Again, China stands out as the main 'consumer' of projects,[8] with over 156 million square metres built, followed by the Middle East with 27 million, and South-East Asia with about 11. In this sense, it is also interesting to take into account the average size of the projects, which in China is about 137,000 m^2, in India and South-East Asia approximately 111,000; in the Middle East 154,500[9]; in Eurasia 81,600; in Latin America 51,000; in Sub-Saharan Africa 20,500 (but on a small sample).

Absolute data, thus, put China at the very top of the scale and explain its importance in the global architecture market. In proportion to the aggregate population of the

[7] The percentage is likely even lower, as it is common that an unbuilt project remains unfeatured on the online portfolio of a firm (Sect. 2.5).

[8] Again, we remind the reader that data on square metres are available for about 56% of the built projects, although this percentage varies across surveyed regions (for more details, Sect. 2.5).

[9] We excluded projects of tensile structures by SL Rausch from the calculation as their large size (one over 2.4 million m^2) could excessively distort the values.

4.3 The Globalisation of the Architectural Practice: Building in Emerging … 123

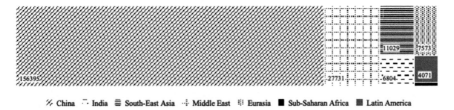

% China ⁓ India ☰ South-East Asia ⋅⋮ Middle East ⁞ Eurasia ■ Sub-Saharan Africa ■ Latin America

Fig. 4.2 Total GFA (thousand m^2) of built projects designed by overseas firms (surveyed sample) in emerging markets. Copyright Giaime Botti

region/country, instead, other markets have been even more attractive. In China, the ratio between built projects and population is approximately 1.06 (1.06 built projects per 1 million inhabitants), in the Middle East is 8.7, and in Eurasia is approximately 1. On the other side of the spectrum, in India and Sub-Saharan Africa, it is only 0.1, and in South-East Asia and Latin America is below 0.5. This confirms how, despite their small size and thanks to their wealth and ambitions, countries in the Persian Gulf have been a real 'golden goose' for architects.

Once established that China has been the main 'consumer' of projects designed by foreign firms and some other regions have also played a relevant role in the global market, our analysis can shift to the chronological dimension. As this book puts forward, neither architectural globalisation is a new phenomenon nor the conditions experienced since the end of the 1980s, especially during the last two decades, are the same. Our thesis is that architectural globalisation took off in the late 1990s. To claim this, we rely on quantitative indicators to complement the qualitative considerations that we will present ahead. For us, a key indicator is represented by the number of projects delivered annually by our sample of firms in the surveyed emerging markets. The trend is stunningly clear and shows strong growth since the early 2000s with respect to the previous decades when the number of projects was almost insignificant (Fig. 4.3). In other words, it is as if we passed from a condition in which the work of foreign firms in emerging markets was sporadic, anecdotical, so much so that it could be recounted almost on a case-by-case basis like in Chap. 3, to a condition in which such presence is structural and understandable only (or at least firstly) in quantitative terms. For the sake of truth, we must remind again about the possible limits of our database and refer to Sect. 2.5 for a discussion on our methodology. Indeed, whilst our data may be slightly biased towards the present due to how they have been collected, we have demonstrated their overall validity, and we should not overlook the clarity of the trend and the scale of the change between before and after the 2000s.

What happened during these last three decades is worth remembering. In 1977, Deng Xiaoping initiated a gradual opening of the Chinese economy known as the "Four Modernisations," partly inspired by the economic success of Singapore. In many ways, the culmination of this long process was the admission of the country to the World Trade Organisation in 2001. In the meantime, the Soviet Union had collapsed in 1991, bringing the Russian Federation, the biggest of all the former

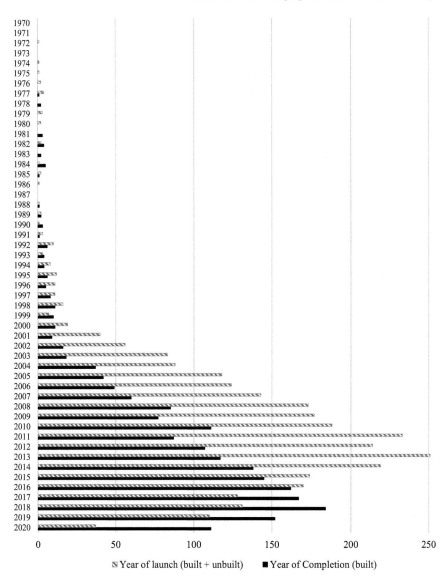

Fig. 4.3 Number of launched (regardless of the outcome) and completed (built) projects designed by overseas firms (surveyed sample) by year in emerging markets, 1970–2020.[10] Copyright Giaime Botti

[10] For Figs. 4.3 and 4.4, we need to remind the reader that the year of the launch of a project (year of the first competition, direct commission, or proposal by the architect) is counted from our database of projects organised by firms. This means that in the case of design competitions in which more than one surveyed firm participates, the project is counted as many times as the number of firms involved. As a result, a particular year may reflect a higher number of projects than the actual one

4.3 The Globalisation of the Architectural Practice: Building in Emerging ... 125

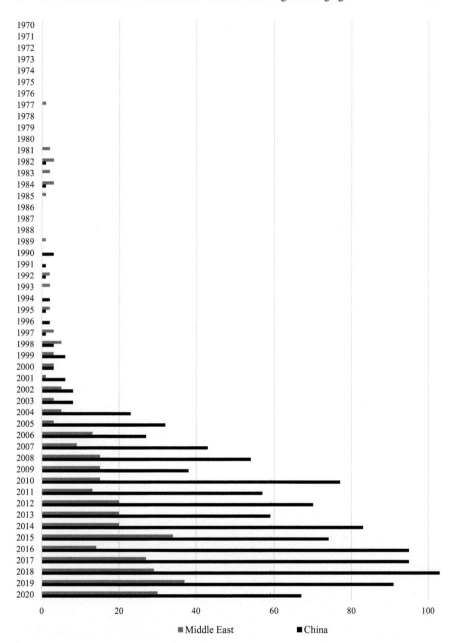

Fig. 4.4 Number of built projects in China and the Middle East designed by overseas firms (surveyed sample) by year of completion, 1970–2020. Copyright Giaime Botti

Soviet Republics, to embrace a painful process of economic liberalisation, which produced a persistent drop in the GDP over the whole decade until a strong rebound occurred after 1999, favoured by political stability and the growing price of oil and gas. With Russia, almost the entire space of the former Soviet Union opened to the market, including a large and oil-rich country such as Kazakhstan, whose GDP also ballooned after 1999. In economic terms, the 1990s and the 2000s represented (forgive the generalisation) a period of more robust growth for both Latin America and Africa compared to the decade of the 1980s. For oil-rich countries of the Middle East, then, the 2000s represented a booming period: Saudi Arabia's GDP more than doubled between 2000 and 2010, that of the UAE almost tripled, and that of Qatar increased sevenfold. In other words, despite 9/11 and the wars in Afghanistan (since 2001) and Iraq (since 2003), the geopolitical context appeared relatively stable, and the economic one was favourable, even considering the "Dot-com" bubble of 1995–2000. To this general scenario, we can add some essential transformations that affected the architectural practice, like the broad diffusion of communication technologies, starting from the internet, and digital design tools that made the jump into the global of so many architecture firms (and not only the big ones) possible. While this will be discussed in the following sections, to further study changes over time, we can disaggregate the data and focus on the two most relevant regions we identified: China and the Middle East (Fig. 4.4).

From the perspective of foreign architects (Xue et al. 2021), since the beginning of the Reform Era, China has gone through an initial phase marked in the 1980s by the direct commission of a limited number of projects following cooperation programmes, inputs by foreign diplomacies, and joint ventures, with the hospitality sector as one of the most relevant in this first period (Sect. 10.4). At that time, many architects told of a real cultural and professional shock for Western professionals, whether because of client-architect relations, planning process, or technical standards and know-how (Hoyt 1983; Rush 1995). As reported in another article (McKee 1994, 106), building codes were not updated and did not contemplate components like curtain walls and low-emissivity glass; documents risked being misinterpreted, and problems did not end there: "Architects are advised not to surrender too much information without payment, and not to perform any work on spec. 'It's an enormous process of education,' Hackl [principal at Chicago-based Loebl Schlossman & Hackl] asserts. 'Culturally, it's an incredibly interesting experience,' he adds, 'but for the uninitiated, China can be exploitative from a business standpoint."

By the early 1990s, the first high-rises designed by US, Japanese, and Hong Kong architects were built, especially in Shanghai. At that time, the work of John Portman stood out for its influence on the city skyline, while only after the 2000s the real boom in the construction of skyscrapers, including supertall ones, took place (Sect. 5.2). At the same time, the first decade of the twenty-first century was marked

because several firms participated in the same competition. In any case, this does not appear as a problem because our mapping is intended from the perspective of the design firms, of which we try to grasp the involvement in a certain market. In addition, this can also be read as an indicator of the vitality of a market in a certain period.

4.3 The Globalisation of the Architectural Practice: Building in Emerging … 127

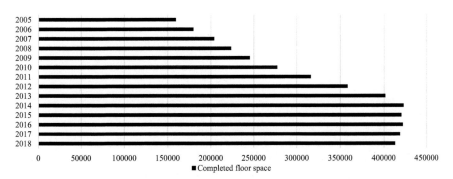

Fig. 4.5 Completed floor area in China (10,000 m^2) per year (National Bureau of Statistics of China 2019, Point 14–23). Copyright Giaime Botti

by the organisation of the first high-profile international competitions for landmark cultural projects, followed in the second decade by an upsurge in the construction of museums, theatres, and public libraries (Sect. 6.1). Meanwhile, the megaevents of the 2000s and the need to promote a new, global image of China created an even more favourable environment for foreign architects (Sect. 7.1). However, while China certainly played an important role in keeping Western architects afloat after the 2007 Great Financial Crisis, it also began to slow down after 2014. By that year, warnings about an impending real estate bubble burst multiplied on international news outlets (Jericho 2014; Rapoza 2014). Nonetheless, despite ominous predictions shared by the press as well as by academics (Zhao et al. 2017), the bubble never burst. That said, since 2014 the pace of new constructions has sensibly slowed down, showing a small year-on-year decline in the completion of floor area (Fig. 4.5).

Such a trend is well visible also in a previous graph (Fig. 4.3), where we can notice a decrease, after 2013, in the number of launched projects (thus including all those that will remain unbuilt) at the global scale (based on our surveyed emerging markets). Interestingly to note, the decrease is general and not only due to China, albeit disaggregate data (Fig. 4.4) shows different temporalities, with the Middle East showing more resilience, probably also as a consequence of the preparation for megaevents like the Dubai Expo 2020 and the FIFA World Cup Qatar 2022. Before moving on, it seems helpful to explain the value of data that includes unbuilt projects. By counting all projects regardless of their outcome, we consider a higher number of them, making our statistics more representative where figures are overall low (for example Sub-Saharan Africa). In addition, the fact that a project is drafted, even if it will remain on paper, is significant as it reflects the demand for a service, even if the outcome will be negative, i.e., unbuilt. Finally, 2020 marked the beginning of the Covid-19 pandemic that literally halted the world for months. Repercussions in the global architecture market, especially in China, whose borders re-opened only at the beginning of 2023, cannot be grasped yet but will have to be studied in the future.

Still, by simply counting the number of projects, we face another problem, which we have already discussed in Sect. 2.5, but that deserves further attention.

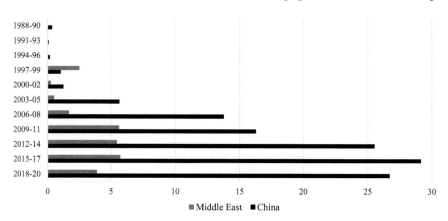

Fig. 4.6 Completed floor area (in million m^2) designed by overseas firms (surveyed sample) in China and the Middle East per triennium, 1988–2020. Copyright Giaime Botti

A 1,000-square-metre project is inherently, and rather obviously, different from one of 500,000. However, it does count in the same way in our statistics. To further refine our data, we chose to display the historical trend in terms of built GFA. Given the more limited availability of data, we decided to do so only for China and the Middle East and by aggregating data per trienniums (Fig. 4.6). One of the most interesting aspects emerging from the graph is the stable amount of built GFA during the 2010s decade in the Middle East compared to the strong growth of China. The other is the stunning growth of 2003–05 for China, and 2009–11 for the Middle East (the moment in which the construction frenzy of the pre-2008 Crisis actually materialised with the completion of many projects).

To all these data, we want to add another quantitative indicator, which brings us to the analysis of the architectural media and critical discourse: the featuring of a country in architectural magazines. Looking at such sources is relevant insofar as they have been, for over a century, one of the main, if not the main, editorial platforms for theoretical and professional debate on architecture and a vehicle for the diffusion of models and imaginaries. Their scrutiny, which recent scholarship has performed in quantitative terms too (Esteban Maluenda 2021; Botti 2022), offers an important insight into reception trends that have generally been studied through a close and qualitative reading of these same sources. In this light, we can use architectural periodicals to examine how and to what extent the global architectural system—architectural media and academic, cultural and professional institutions—has focused on the architectural production of a certain region (Fig. 4.7 for China and the Middle East; Fig. 4.8 for South-East Asia). To do so, we collected data from twenty-two magazines from Europe, the USA, Japan, South Korea, and Australia. The sample includes publications with over one hundred years of history, like *Architecture: The AIA Journal* and *Architectural Record*, and others with just a few decades, like *Arquitectura Viva*; some are still published many decades after their first issue, like *Domus*

4.3 The Globalisation of the Architectural Practice: Building in Emerging … 129

and *Casabella*, while others have ceased their publication, like *Progressive Architecture*. The sample thus covers different geographies and includes magazines of great influence in the field, making it representative and adequate for this type of research,[11] which has been conducted primarily through the Avery Index, the richest database of architectural publications available for scholars.[12]

Being our sample based on magazines published in some of the same countries of the firms we have surveyed, we can propose some reflections. Comparing data about China and the Middle East (Fig. 4.7) makes it interesting to note some similarities in overall trends and differences related to specific historical events. Overall, the first element we can notice is that the presence of both regions has been much higher in the last two decades than ever before. Of course, this may result from bias in the sample of magazines, as several of them started being published in the last twenty to thirty years. Yet, more than this alone would be needed to explain the trend we see, because in any case, more than half of the magazines have been continuously published throughout the period. Indeed, the increase simply reflects one issue: the centrality these two regions have gained in the global architecture market. A centrality that they acquired in the last three decades, especially China. Before concluding this analysis, however, there is one final point to consider. Finer data on mainland China show that from the late-1990s to 2010, most of the occurrences referred to the work of foreign architects active in the country, while only in the last decade Chinese architects have been gaining more space on these publications (Botti 2022). For the Middle East, on the other hand, a rough bibliometric study like the one proposed does not allow go deep and in detail into the articles' content. Still, an approximate estimate suggests that most of the works published refer to foreign architects.

Going more in detail into the trends, we notice a first peak for the two regions in the 1970s. However, this parallel is rather causal as they are due to different historical facts. In the case of China, the (small) surge followed the visit of US President Richard Nixon to China in 1972 and the re-establishment of diplomatic relations between the two countries in 1979. For the Middle East, on the other hand, the peak of the 1970s reflects the post-1973 construction boom that attracted scores of US, European, and Japanese architects (Sect. 3.4). Later on, we notice a growing focus on China, initially motivated by the interest in the extraordinary process of urban transition of the country (1990s), and later by the megaprojects designed by foreign architects for

[11] Occurrences related to both China and the Middle East have been searched in: *Casabella, Domus, Arca* (also *Arca Plus* and *Arca International*), *Lotus International, Architectural Record, Architecture: The AIA Journal* (also *Architecture* and *Architect* as it changed name), *Azure, Canadian Architect, Le Moniteur AMC, L'Architecture d'Aujourd'hui, Arquitectura Viva, Architectural Design, Architectural Review, Blueprint, Baumeister, Bauwelt*. Occurrences related to China have also been searched in: *Architecture Australia, Azure, Deutsche Bauzeitung*; for the Middle East also in: *A+U, C3 Korea, GA Document, Progressive Architecture*.

[12] The search has been performed with the keywords "China", and, for the Middle East, "Abu Dhabi", "Bahrein", "Doha", "Dubai", "Qatar", "Saudi Arabia", "Sharjah", "UAE". It should be noted that monographic issues may distort the results as they involve the publications of several articles on the same theme/region. That said, dedicating a whole issue to a specific theme implies an editorial choice that reflects a relevance for the disciplinary debate and therefore it is detected by our analysis.

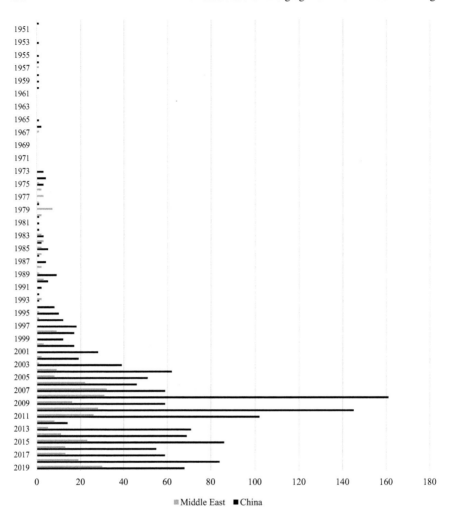

Fig. 4.7 Featuring of China and the Middle East in selected architecture magazines, 1950–2019. Copyright Giaime Botti

the 2008 Beijing Summer Olympic Games and Shanghai Expo 2010. On the other hand, it is remarkable to note that the Middle East peaked and fell between 2006 and 2013. Such movements appear to be the result of the construction frenzy, first, and of the collapse following the 2007 Great Financial Crisis, later, which strongly hit Dubai's real estate. Thus, articles moved from covering the many projects launched (and in many cases never completed) during the boom to discussing the bubble burst. Then, a second surge after 2015 reflects the preparation for two megaevents, namely the Dubai Expo 2020 and the 2022 Qatar FIFA World Cup, as well as the completion of a few landmark projects, including Jean Nouvel's Louvre Abu Dhabi and the National Museum of Qatar (Sect. 6.2).

4.3 The Globalisation of the Architectural Practice: Building in Emerging … 131

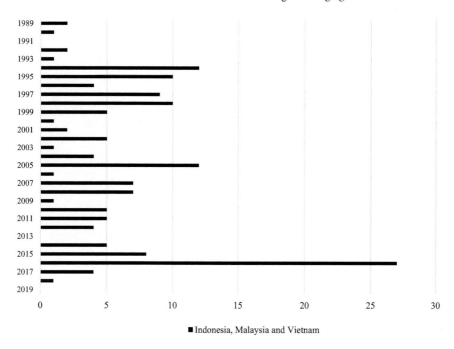

Fig. 4.8 Featuring of Indonesia, Malaysia, and Vietnam in selected architecture magazines, 1989–2019. Copyright Giaime Botti

Another case we investigated, on a shorter time frame, is the presence of projects from South-East Asia (limitedly to our three countries: Indonesia, Malaysia, and Vietnam) in a smaller sample of magazines (Fig. 4.8).[13] Over the three decades analysed, there is no evident trend as in the previous graphs. However, from a closer reading, we can infer a few things. During the 1990s, there was more substantial attention to the region, with the number of articles peaking immediately before and after the Asian financial crisis of 1997. It is the same pattern we just observed in the Middle East, probably due to the same reasons: a construction boom involving local and foreign architects, a bubble burst (less of interest if we read the articles' content compared to Dubai), and a recovery in the press coverage, not least because some of the projects initiated before the crisis achieved their completion in the years following the crisis. Among them was Pelli Clarke Pelli's Petronas Twin Towers, the tallest in the world at that time (Sect. 5.4). On the other hand, the two other peaks visible in the chart mirror clear editorial choices, which became very evident due to the small sample of magazines analysed. The 2005 surge is due to a monographic issue of *A+U* on South-East Asia, the one of 2016 to one on Vietnamese firm Vo Trang Nghia Architects in the same magazine. For sure, like Malaysia in the 1990s,

[13] *A+U*, *Architectural Design*, *Architectural Review*, *Architectural Record*, and *Architecture Australia*.

Vietnam has been in the last decade a market raising great expectations among Western architects (Hughes 2011).

Beyond what was or was not represented and reproduced in magazines, the 1990s (before the Asian financial crisis) were a moment in which the entire Pacific region, from South Korea to Australia, was providing great opportunities to US architects. Just before the burst of the Asian bubble, *Architectural Record* proposed an overview of the Pacific Rim countries, with data on their economy and significant ongoing projects. Despite "corruption, a lack of coordinated planning, and widespread damage to the environment," and a general overbuilding, opportunities still seemed to flock in the broader region (Pearson 1997). However, they did not come without further problems and challenges, as we have already seen with China: "Once Asian projects are under way, logistical problems usually surface. Design specifications and documents throughout the region vary widely from American conventions. Codes don't always cover the types of structures clients commission. Standard building components such as structural steel and curtain wall are arduous or impossible to procure" (McKee 1994). In any case, since the beginning of the 1990s, the importance of East and South-East Asia appeared evident to US architects still struggling with the consequences of the overproduction of the 1980s and the unemployment at 15–20% of the 1990s (Langdon 1995, 44–45). Comprehensive data are not available, but anecdotical information helps clarify the picture. At that time, RTKL had a 30% of its work outside of the USA, half of which was in Asia, while KPF also got about a third of its commissions from the region (Langdon 1995, 44–45). By the end of the 1990s, also the export value of architectural services by Australian firms grew more than three times compared to the beginning of the decade, achieving a 22% of the gross fees earned by Australian architects (Tombesi 2001). Although we do not have specific data from this source, it is evident that most of the overseas work of Australian firms at that time was in South-East Asia. Overall, in the 1990s, countries of the Pacific Rim were beginning to replace the Middle East as the new frontier for architectural export. However, the rise of China by the end of the decade completely changed the order of magnitude in the export of architectural services.

Individual stories like those of John Portman or Paul Rudolph display this trend too. Although invited already in 1979 to China, it took until 1990 for Portman to complete his first building there. In the meantime, however, he completed the Regent in 1982 and the Marina Square in 1987 in Singapore, the Hyatt Regency Jeju (1985) in South Korea, and Capital Square in Kuala Lumpur in 1994. The trajectory of Paul Rudolph is also noteworthy. After the unsuccessful involvement in the East Pakistan Agriculture University project in the 1960s, Rudolph's activity was re-directed towards Asia in 1979. By that time, the once-celebrated architect had experienced a professional decline initiated in the mid-1960s with the premature physical decay of his milestone Yale A&A Building and the loss of support from the University and the students in that same period. Rudolph was thus one of the first in the 'wave' of Western architects to get to South-East Asia, establishing a base in Singapore to work across the region. Even here, however, turning everything into gold was not so easy and Rudolph designed a large number of projects that were never built. That said, he eventually managed to complete four high-rise buildings

in Singapore, Hong Kong, and Jakarta (Sect. 3.4), "fulfilling his dream of becoming a 'skyscraper architect'" (Rohan 2014, 251).

As a matter of fact, in the 1980–90s, Asia became a destination for architects with an already solid reputation, whether the case of Portman and Rudolph or that of I. M. Pei and others, rather than the terrain of experimentation for younger ones as it will also be later. The growth of South-East Asia not only brought projects produced at distance but also spurred a movement of Western professionals towards these countries (Vatikiotis et al. 1994), including architects then working in local firms. Forced by the recession at home, for instance, several British designers moved to Malaysia; as a result, in a local firm like T.R. Hamzah & Yeang, almost one-third of its thirty-two employees were foreigners, mostly from Britain (Vatikiotis 1994). In that period, Malaysia was both developing an interesting local scene and attracting architects from overseas, as a monographic issue of *The Architectural Review* displayed. Some articles recognised the emergence of a local hybrid architecture influenced by "tradition, culture and climate" informed by "ecological concerns" and "pacific-wide construction traditions" like the timber frame (C.S. 1994; Abel 1994). Indeed, Indonesia and Malaysia were becoming strategic markets for Australian, Japanese, European, and American architects. A growing Australia-Malaysia "connection" was recognised at the beginning of the 1990s (Hegvold 1990), while opportunities for Australian architects were multiplying across the whole of South, South-East, and East Asia (Architecture Australia 1995). High-rise projects like the Petronas Towers by Pelli Clarke Pelli Architects, or new airports like Jakarta Soekarno-Hatta (1985–1991) designed by Paul Andreu—ADP Ingénierie, Kuala Lumpur International (1992–98) by Kisho Kurokawa, and Bali International (1992) by Takenaka Corporation (Sect. 10.1) can explain the relevance of the region in the period.

Asia, including China, was thus replacing the Middle East and even Western Europe, especially for firms with specific know-how: "In Asian cities where cranes still bristle on the skyline, American know-how about integrating elevators, air conditioning, and industrialized curtain walls into big commercial structures is very much in demand" (Dixon 1995, 25). In this regard, US architects were seen as the right ones for fast-track design and construction and for their experience with typologies like shopping malls (Sennewald 1989) and, obviously, skyscrapers. After all, however, by the 1990s, more changes were undergoing in the profession, and the next two sections will deal precisely with them.

4.4 The Aeroplane and the Internet: Towards a 24 h Working day with CAAD

To understand how the architect's profession has changed since the post-War, the most typical example is that of Le Corbusier. Beatriz Colomina (2011), not without reasons, called him the "first global architect," noting how he "saw this collapse of traditional space and time as nothing less than the emergence of a new kind of human."

Such a collapse was due, first and foremost, to the introduction of the jetliner, which made travel around the world faster and cheaper than ever before. The jetliner was introduced in 1958, quickly producing, among other things, the end of trans-Atlantic ship travels. Since then, however, no further major improvements in speed or comfort have occurred in civil aviation, while prices have declined but not as much as between the 1940s and 1960s (Gordon 2016, 374–408). Indeed, air travel allowed architects to travel fast. From 1951, for instance, Le Corbusier went to India twenty-three times (Colomina 2011). At his office in Paris, in the meantime, his collaborators, who were recruited without difficulties from all over the world, complemented the insufficient knowledge about distant project sites with their expertise and their links to local stakeholders. The case of the Colombian collaborators that worked at 35, Rue de Sèvres since Le Corbusier was assigned to draft the Bogotá Pilot Plan in 1947 is paradigmatic. After the first trip to Colombia, Corbu started developing the Plan from Paris with the help of three recently graduated Colombian architects (Rogelio Salmona, Germán Samper, and Reinaldo Valencia), while a fourth one, Fernando Martínez, changed his mind at the last moment and eventually remained in his home country. In the following years, until the project was handed over to Sert and Wiener for the Regulatory Plan, Le Corbusier visited Colombia three more times, while a few meetings with Bogotano municipal architects were held in France.

When Jørn Utzon won the 1957 competition for the Sydney Opera House, it took six months before he first visited the project site; and many things from the winning proposal had to be changed. The difficult collaboration with ARUP, the takeover of the project by Australian architects, and the inability of Utzon's small office in Copenhagen to deliver the constant flow of drawings required for such a complex, large-scale project led the architect to abandon the project in 1966. And even though he later changed his mind, it was too late. The case is therefore not only interesting for our comprehension of the complexity of the design process and the n-fold actors involved and responsible for the final outcome as mapped by Yaneva (2012) but also because we have an example of an iconic building—as much iconic for Sydney as the Eiffel Tower is for Paris—designed by an architect based at the antipodes of the construction site. Indeed, we may say that the architecture of the 1950s onwards, as Hitchcock (1955, 11) claimed for the case of Latin America, "belongs specifically to the age of the airplane." Without the aeroplane, in the 1970s, the Architectural Association, at that moment an increasingly international school under the guidance of Alvin Boyarsky, could not have had Bernard Tschumi coming every two weeks from New York to teach in London (Colomina 2011). In the end, after Le Corbusier, Rem Koolhaas has been the figure that has most embodied the image of the global architect and developed a narrative about it. Not by chance, *S, M, L, XL* opened with a chart displaying the kilometres travelled and nights spent in hotels by Koolhaas and OMA's staff (Office for Metropolitan Architecture, Koolhaas and Mau 1995, xii–xiii).

Yet, Koolhaas' rhetoric of the global architect in the 1990s reflected a professional world still more similar to that of the 1950–70s than that of the post-2000s. And this is one of the critical issues that we want to discuss in this chapter and more in general in this book. OMA in the 1990s, for example, was more similar to Le Corbusier's

4.4 The Aeroplane and the Internet: Towards a 24 h Working day with CAAD 135

Atelier in the 1950s than to OMA in the 2010s. A central and unique office where the best students and young architects from all over the world were working on projects procured by an increasingly recognised architect who spent most of the year travelling across the globe to look for potential commissions while giving conferences and lectures. As of today, OMA has five office branches across all the time zones, from Australia to New York, via Hong Kong, Doha, and Rotterdam. This is key today, when "Practice is no longer local and time is continuous" with office branches "connected through the Internet and by video conferencing, [which] work 24 h a day. As the New York office goes to sleep, the office in Beijing, for example, picks up a project that New York worked on the day before" (Colomina 2011). If this is possible, it is because of three changes. The first one is the internet and all the other ICT innovations that make a videoconference possible and almost free of charge. To this, we need to add the second one, i.e., the digitalisation of the design process using computer-aided architectural design (CAAD) software. Lastly, we can add the growing presence of office branches, something that will be thoroughly discussed in the next section. But before doing so, let us consider how specific innovations have facilitated the process of architectural globalisation.

Unlike in many sectors where the quality and quantity of innovations have generally been minimal after the 1970s, for entertainment and communications, the progress has been even faster. The cost of a landline phone call between New York and San Francisco passed from U$75 in 1939 to U$3 in 1981, and from New York to London from U$240 to U$6. Cell phones were introduced in the 1980s; in the 1990s, only 2% of Americans had one, but a decade later, the percentage had risen to 39% (Gordon 2016, 409–440). More importantly, in December 1991, the World Wide Web became accessible, and in 1995 the introduction of Windows 95 provided with Microsoft Internet Explorer marked the beginning of the internet revolution (Gordon 2016, 454). With the internet and email, the fax, a short-lived invention also used to transmit small-size drawings (the archive of OMA offers several examples of sketches transferred via fax in the 1990s by Koolhaas) or larger ones sliced into strips in near-real-time, was made obsolete. As McNeill (2009, 54) explained, by the 2000s, there was "confidence" in the possibility of replacing physical travel with the reliable delivery of information through the internet. By that moment, a competition entry composed of several coloured drawings could be sent from Australia to London on the same morning of the submission deadline, be printed there, and then physically delivered in a third city a few hours later. In addition, the internet, through companies' internal networks (intranets) made also possible to share information and know-how across multiple offices (McNeill 2009, 52–53).

All this, of course, can be understood by considering another parallel process: the digitalisation of architectural design. Beginning with the introduction of PRONTO in 1957 and Design Automated by Computer by General Motors and IBM in 1963, a new era was opening. In 1966, Computer-Aided Design & Drafting was used by aerospace manufacturer McDonnell Douglas while by the 1970s, this technology was spreading in architectural firms (Kalay 2004). By that time, the first studies on computer-designed architectures (Mitchell 1977) and confident statements on the future role of machines in the design (Negroponte 1975) were published, too. In 1982 AutoCAD

by Autodesk was released, being the first CAD software for personal computers rather than mainframes. By 1999, 83% of US architecture firms had transferred drawings electronically, according to the AIA, marking a stark increase from the 35% recorded just three years earlier (Tombesi, Dave and Scriver 2003). While all this was happening, more changes were ongoing: design production started to be displaced.

4.5 "Boots on the Ground": Office Branches

Paolo Tombesi (2001) distinguishes between the "globalisation of architectural markets" from that of the "design production," considering the latter as a system to exploit the "international division of labur" to lower organisational and production costs. Although this may be true for the cases of India, Malaysia, and Mexico documented by Tombesi (2001; Tombesi et al. 2003), other aspects also need some consideration. A Western architect working in an emerging market can generally count on a very competitive salary, and Tombesi (2001) himself mentioned the cases of Chinese architects working for Western firms in China and earning 2.7 times the average salary of colleagues working in national firms, or successful US firms located in Mexico City that attract local talents with higher wages to the detriment of Mexican companies. Still, what we want to explore in this section is not the global division of architectural labour but rather the globalisation of architectural markets that commenced in the post-War and strengthened in the 1970s, producing a change in the organisational patterns of design firms from the 1990s and globalising design production but not in the same terms explained by Tombesi and others.

One of the main indicators of how the architectural profession has changed and become more global in the last few decades comes from the territorial spread of office branches of many design firms worldwide. As a matter of fact, what happened since the 1990s, and even more after 2000, represents a significant difference compared to a not-so-distant past. Kerwin (2008), a partner at SOM, explained the need to have "boots on the ground" to successfully work in China because "all things personal and business-related ultimately devolve to relationship building." A permanent outpost in a country, therefore, allows firms' principals to avoid constantly flying in and out to procure new works and follow ongoing projects. In practical terms, these "boots on the ground" mean opening an office branch. And this is the core element discussed in this section and a major change brought about by the 1990s.

Before that decade, in general, transnational organisational patterns were different. We mentioned, for example, how the work of Le Corbusier was centralised in his Paris atelier. On the contrary, Gropius' The Architects Collaborative opened an office in Rome for the project of the University of Baghdad (Sect. 3.3), and then one in Kuwait; Rader Mileto Associates also had an office in the Italian capital in the 1970–80s working on projects in Saudi Arabia (Kultermann 1985; Hoyt 1975). In the 1950–60s, Ove Arup had offices in West and South Africa (Stanek 2015). John Harris opened an office in Tehran in 1957 (AMO, Reisz and Ota 2007, 154) and

4.5 "Boots on the Ground": Office Branches

Dubai, the real epicentre of his work, in 1962. In 1971, also RMJM had an office in Dubai. In the same decade, some office or outpost was also active in Tripoli, Lybia, and Jeddah. In 1975, SOM opened an office in Teheran where about twenty to forty people worked until its sudden closure in 1978 (McNeill 2009, 119). HOK, in the early 1980s, had eight offices in the USA and one in Riyadh (McCue 1982) to follow the university and airport projects then under construction in Saudi Arabia (Sect. 3.4). All this, and indeed the many more cases that have escaped our view, represent something anecdotical compared to the post-1990 conditions when we find a few relevant cases of large firms showing similar expansion patterns (Figs. 4.9, 4.10, 4.11 and 4.12). Gensler started expanding from San Francisco to other US cities in the mid-1960s, then opened an office in London in 1988 and Tokyo in 1993 (Knox and Taylor 2005). And it was not an isolated case. As Adam (2012, 90–93) reported, at the end of the 1980s, with the London docks under redevelopment and Canary Wharf emerging as the new financial centre of the British capital (and of Europe), US firms like SOM, Gensler, KPF, and RTKL inaugurated their first overseas branches respectively in 1986, 1989, and 1990. The same year, the RTKL also opened a branch in Tokyo. Not surprisingly, such geography—New York, London, Tokyo–matches that of Sassen's (1991) global cities.

Other US firms followed similar patterns: Wilson Associates first expanded within the USA, from Dallas, where it was established in 1971, to New York and Los Angeles in the 1980s, then towards Asia, with Singapore in 1990 and Shanghai in 2002 (Wilson Associates 2009). Indeed, one of the most relevant issues to highlight is that even for megafirms with decades of existence behind it took until the end of the 1980s—and, therefore, some of the conditions we previously emphasised—to make such a move. Callison RTKL's history is also exemplary. The megafirm resulting from the merger in 2015 of Callison (established in 1975 in Seattle) and RTKL (established in Annapolis in 1946), during the 1980s, had cumulatively two offices in the USA, and projects in twenty-four countries, from South America to Australia.

Fig. 4.9 Office branches, 1970–80. A map with the office headquarters and branches of five megafirms: B+H, Chapman Taylor, HOK, Nikken Sekkei, and RMJM. Copyright Giaime Botti

Fig. 4.10 Office branches, 1980–95. A map with the office headquarters and branches of five megafirms: B+H, Chapman Taylor, HOK, Nikken Sekkei, and RMJM. Copyright Giaime Botti

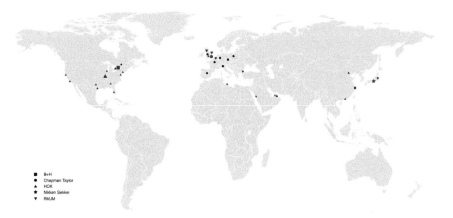

Fig. 4.11 Office branches, 1995–2005. A map with the office headquarters and branches of five megafirms: B+H, Chapman Taylor, HOK, Nikken Sekkei, and RMJM. Copyright Giaime Botti

A decade later, the number of offices increased to six in North America, and the activities reached thirty-one countries. Only in the 2000s, however, the number of branches grew to sixteen scattered between the USA and Mexico City, London and Manchester, Dubai, Beijing, and Shanghai. Gensler, as mentioned, after London and Tokyo, opened an office in Shanghai in 2003 and San José de Costa Rica in 2005. By 2010, it had offices (in chronological order) in Dubai, Beijing, Abu Dhabi, Singapore, and Bangkok; by 2015, in São Paulo, Bangalore, Mexico City, and Sydney; by 2020, in Bogotá, Shenzhen, and Dubai. All this while consolidating its positions within Canada and the USA, with 20 more offices opened since 1995 and two more in Europe (Gensler Research Institute 2020, 256–257). Another case is that of Hirsch Bedner Associates—HBA (not included in our survey), a large firm established in the

4.5 "Boots on the Ground": Office Branches

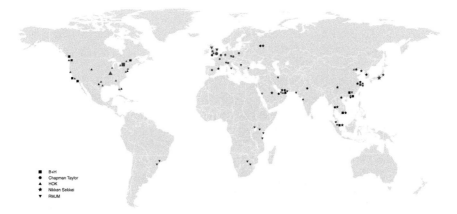

Fig. 4.12 Office branches, 2005–20. A map with the office headquarters and branches of five megafirms: B+H, Chapman Taylor, HOK, Nikken Sekkei, and RMJM. Copyright Giaime Botti

USA in 1965 and specialising in hospitality architecture. Just in the last two decades, HBA established twenty-four offices across the world, starting with London and Hong Kong, and completed projects in eighty countries.

Nikken Sekkei also boasts many offices outside of Japan; they all opened after 2000: Shanghai (2006), Hanoi (2007), Seoul (2008), Dubai (2008), Ho Chi Minh City (2008), Dalian (2009), Beijing (2012), Riyadh (2012), Singapore (2013) Moscow (2013), Barcelona (2016), Bangkok (2018), and Chengdu (2019). Another interesting case showing how chronological patterns of branch expansion are squeezed in little more than two decades is Chapman Taylor. The British megafirm, today active in about ninety countries, was established in 1959 in London. Still, its first branch offices were established in continental Europe only in the 1990s: Bruxelles 1993, Dusseldorf 1997, then Prague and Warsaw anticipating the EU enlargement, and Madrid, Paris, and Milan in the early 2000s. Then, the expansion took an Eastward direction: Moscow in 2007, New Delhi and Shanghai in 2008, and Bangkok in 2011. Later on, Abu Dhabi and Dubai branches were opened in 2015. Such a chronology provides another example of change that has occurred since the 1990s in the global modes of production of architecture and even more on how was actually the first decade of the 2000s the most significant one in terms of expansion in emerging markets: China, India, the Persian Gulf, the former Soviet space of Eastern Europe (already by the end of the 1990s) and Russia. However, while we neither mapped the expansion of US firms in Europe nor that of the British ones in continental Europe, including in the former Warsaw Pact countries, we want to focus on the two most important markets for the (also physical) presence of overseas architects: China and the Persian Gulf, where more 'boots are on the ground' can be found.

As early as 1979, John Portman was asked to design a hotel in China after visiting the country following an invitation by Deng Xiaoping. To develop the project, due to the difficulties in settling a branch office on the mainland, the US architect opened one in Hong Kong and in 1993 a second in Shanghai (Xue and Li 2008). By the

late 1970s, Australian landscape architects firm Yuncken Freeman's involvement in Hong Kong was growing, but some of its projects were taken over by a new firm, Edmond, Bull and Corkery (EBC), which established an office in Sydney and one in Hong Kong (Saniga 2012, 250).[14] In Hong Kong, Foster + Partners had also opened a temporary office during the development of the HSBC HQ (Sect. 3.4) and re-opened it after the successful bid for the Chep Lap Kok Airport in the early 1990s (Xue 2016, 191). As a matter of fact, the British colony represented a suitable landing platform to prepare the take-off in the whole region for its strategic location a few kilometres south of some of the most dynamic Chinese cities—and their recently-established Special Economic Zones—and a few hours of flight away from all South-East Asian capitals. In addition, Hong Kong was a dynamic real estate market, a place where financial capitals were readily available, as well as technical know-how on high-rise design and construction (albeit with that, it also came the competition from local architecture and engineering firms).

Hong Kong became, for many firms, the platform for the next jump: entering China. In any case, this was neither an easy nor a quick process. In 1984, HOK opened a branch in Hong Kong, but only in 2003 in Beijing and in 2006 in Shanghai. Benoy followed the same pattern in the same order: 2000, 2008, and 2010. Gensler started in Hong Kong in 1993 and then doubled in Shanghai in 2002. Farrells also started with Hong Kong in 1995 and then Shanghai in 2012. B+H, on the other hand, followed a different order, setting up an office in Shanghai in 1992 after winning the design competition for the Xiamen Gaoqi International Airport (Sect. 10.1), using the city as a platform for its work in Asia: branches in Ho Chi Minh City and Singapore were opened in 2010, and in 2013 in Hong Kong (B+H Architects 2018). OMA also started from mainland China, with the establishment of its Beijing office in the early 2000s to follow the design and construction process of the CCTV tower (Sect. 5.7), and later opened an office in Hong Kong in 2009. Overall data on this chronology are incomplete, but a trend can be seen in terms of acceleration during the early 2000s in the number of office branches opened in mainland China (Fig. 4.13),[15] corresponding with the take-off of China as a market for foreign architects (Fig. 4.4).

The result is that today China hosts the highest number of office branches of Western architectural firms. Further digging into these data, Canadian firm Stantec landed in 1998 in Shanghai, Perkins Eastman in 2000, the same year that AREP opened a branch in Beijing. The French firm later opened one in Shanghai in 2007, while AIA Life Designers in Shanghai in 2012. In the last few years, in addition, Shenzhen has been adding offices, with PBK opening a branch in 2019 (one year after doing the same in Beijing) and German firm HPP the same year (after Beijing in 2006 and Shanghai in 2017). Based on the data collected from our sample, there are at least 150 branches in mainland China, 39 in Hong Kong, three in Macau, and

[14] Xue (2016, 171), instead, refers to Yuncken Freeman as the branch office of Denton Corker Marshall in Hong Kong. Please note that neither Yuncken Freeman nor EBC is included in our surveyed sample.

[15] The graph displays the opening year of 91 office branches, which represent more than 45% of the total number of branches (of surveyed firms) mapped in China.

4.5 "Boots on the Ground": Office Branches

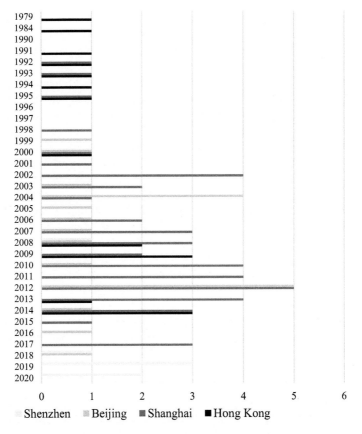

Fig. 4.13 Number of office branches opened in China's main cities per year (based on available data on surveyed firms). Copyright Giaime Botti

about four between Taipei and Kaohsiung, in Taiwan. Of this, the vast majority are located in Shanghai (82), Beijing (43), and Shenzhen (15), while a few are in other second and third-tier cities.

Such concentration, and its effects, are particularly interesting for at least two reasons. As pointed out by different authors (Bologna 2019, 44; Xue, Ding and Chen 2021), many protagonists of the current generation of leading Chinese architects have been trained in the USA or Europe and begun their careers working for overseas firms in China. Li Xinggang, after returning from France collaborated with AREP for the project of the Xizhimen Station in Beijing. Zhang Ke, the founder of ZAO/standard architecture assisted Herzog & De Meuron in the development of the Brid's Nest Stadium (Sect. 7.1), Gong Dong of Vector Architects, after working in the USA for Richard Meier and Steven Holl collaborated with the latter for the development of the Linked Hybrid (Sect. 8.6), while Li Hu, founder of OPEN Architecture, had also worked with Holl. And the list is long: Ma Yansong and Dang Chun (MAD Architects) started working at Zaha Hadid's Beijing office; Wang Ning assisted Christian de

Portzamparc in the design of two theatres (Sect. 6.3), while others took over the local offices of Arata Isozaki (Hu Qian) and Arte Charpentier (Zhou Wenyi). All this leads to a second point to consider. Xuefei Ren (2011, 37–38) distinguished between "consumption" and "production cities" in the field of architecture, categorising Chinese cities, as well as the Persian Gulf capitals and other centres like Singapore, as part of the former typology, because they have an "active construction markets and a great number of international architecture offices," but at the same time "they have yet to develop an institutional infrastructure, an ecological system of architecture schools, publications, critics, and exhibition spaces that is necessary for continuous design innovation." On the opposite side of the spectrum, "production cities" feature "a less active real estate sector but many small boutique design firms," supported by a rich and mature institutional and cultural background, and so able to produce innovative ideas. As highlighted by Ren, this is the case of global cities like London, New York and Tokyo, but also of Porto, Basel, or Rotterdam, perhaps the best example of a medium size city where a perfect ecosystem and an unusual concentration of top-end design firms can be found (Kloosterman and Stegmeijer 2005). Such a distinction reflects what US economist Reich (1991) explained as the division between "routine producers" and "symbolic analysts," which in architecture translates into patterns of transnational collaboration characterised by a "marked geographic subdivision between conceptual work and production tasks" in which "outsourcing firms from higher-wage areas tend to use remote offices as drafting bureaux whilst retaining most of the professional component at home" (Tombesi et al. 2003).

This distinction provides a framework to understand the current "disjuncture" between places where the designs are elaborated and those where they are applied (Ren 2011, 37–38). At the same time, this distinction is neither rigid nor fixed. For the reasons stated above, certain cities may be now in a transformation process. As new generations of architects mature professionally, new local practices are established. At the same time, the academic and editorial ecosystem also develops, transforming some of these cities from places of design consumption into places of design production. In this regard, Xue et al. (2021) wonder about this possibility by noting that today, despite large overseas production by Chinese firms, few of them can win competitive bids in the West, while, overall, the market position of Chinese design is still that of "made in China." In any case, many of the conditions needed for such change begin to materialise, especially in a city like Shanghai, and a shift might not be too far away.

Outside China, only the Persian Gulf states have kept the pace, with the UAE boasting 62 offices: 37 in Dubai, 25 in Abu Dhabi, and one in Sharjah. It follows Qatar, with ten branches in Doha, and Saudi Arabia, with nine: six in Riyadh, and one each in Jeddah, King Abdullah Economic City, Al-Khobar, and Jubail Industrial City. No other cities can compete within a radius of 3,000 kms or about six hours of flight: Istanbul has five, Kuwait City two, Manama one, and Tehran one. Considering branches in Oman, Qatar, Saudi Arabia, and the UAE, we have been able to map the year of opening of about 20% of the total. They all opened after 2000, the majority after 2008. In the other regions, figures referring to office branches remain lower, although not insignificant. In India, 38 branches are mainly located in Mumbai (12),

New Delhi (11) and Bangalore (6), and then scattered among a few other cities: Gurgaon/Gurugram (3), Hyderabad (3), Kolkata (1), Pune (1), and Vadodara (1). In Sub-Saharan Africa, the Kenyan capital Nairobi features four, and Mombasa one, while in Ghana, Accra has two. Abidjan and Lagos, in Nigeria, have one each; the same for Cape Town, Johannesburg, Pretoria, and Durban in South Africa. In other African countries (not included in our survey), our sample of architectural firms has offices in Casablanca (4), Dar es Salaam (2), Algiers (2), and a few other cities scattered across the continent.[16] In South-East Asia, Vietnam stands out, with ten branches in Ho Chi Min City and just as many in Hanoi. In Malaysia, nine branches are located in Kuala Lumpur, one in Penang, one in Johor Bahru, and one in Sabah. In the Indonesian capital Jakarta, instead, we find eight. However, the major centre in the region remains Singapore, with 25 branches, not counting local firms that are also very active across the whole Asian Indo-Pacific area. In addition, European and US firms operating in South-East Asia may also find it convenient to be based in Australia.[17] Not many firms, on the other hand, have opened a branch in Russia, likely because, for European architects, the short distance does not make it convenient; something similar to what happens between Japan and China. In Moscow, there are eight offices, and in Kazakhstan, four, three in Astana and one in Almaty. In the rest of the Central Asian and Caucasian region, we find just one office in Tashkent (Uzbekistan), and Baku (Azerbaijan). Finally, in the Latin American countries analysed, we find thirteen offices in Mexico City, plus one in Monterrey; nine in São Paulo and one in Cabo do Santo Agostinho (Pernambuco), in Brazil; seven in Bogotá and two in Medellín, in Colombia. Considering other Latin American countries, Santiago de Chile features four branches, Lima (Peru), and San José (Costa Rica) three each, and Buenos Aires, Panama City, and Trinidad, two each (Fig. 4.14).

Before concluding this section, it is also important to consider two more issues. The first one is that what we have presented is a snapshot of a moment, our present. Although we tried to delve into the chronology of the opening of office branches, the reality is that some of the ones we counted could now be closed. Despite this, the growing trend we highlighted is evident and hardly questionable. In the second place, we have yet to discuss the size of these office branches in terms of employees. As a matter of fact, this is a difficult question to answer because available data are limited, not least due to the confidentiality of the information, which firms tend not to disclose. Through our research, we understood that figures sensibly change from firm to firm and, of course, in time. We know of branches which are little more than a mail address or a single-person desk and of others employing about one hundred architects. For the case of China, where we have been able to collect more data, we can say that on 24 offices on which we know the size, the average dimension is 29 employees, with a median of 20. As for changes throughout time, data from a sample of some large British firms show fluctuations in the number of the overseas workforce but also an overall upwards trend, in line with what was seen before

[16] Addis Ababa, Cairo, Dakar, Gaborone, Harare, Kampala, Malabo, Maputo, Oran.

[17] Outside surveyed countries, in the region we find five branches in Manila, and four in Phnom Penh and Bangkok.

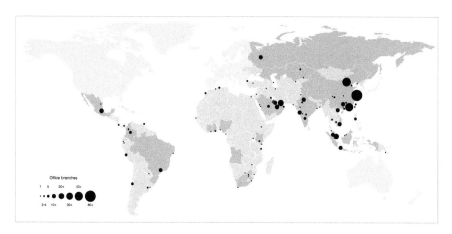

Fig. 4.14 Office branches by city, 2020. A map showing the location of office branches of the surveyed sample of firms in the world (excluding Europe, Canada and USA, Japan and South Korea, Australia and New Zealand). Copyright Giaime Botti

(Fig. 4.15). Taking a sample of ten firms, the total number of employees working overseas was 1,093 in 2008; then, it went down to 896 in 2011 to start growing again and peaking at 1,600 in 2018.

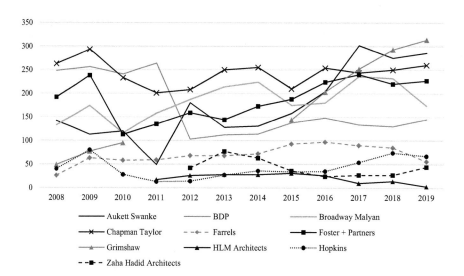

Fig. 4.15 Number of staff employed overseas by selected British firms, 2008–19. Data retrieved from Architects' Journal. 2018. "AJ100." *Architects' Journal*. https://aj100.architectsjournal.co.uk/view/practice/2018/view.aspx. Copyright Giaime Botti

4.6 Successful Export and Unaccomplished Ambitions: Europe Versus the USA Versus the Asia–Pacific

To conclude this chapter, another level of analysis should be added, once again primarily relying on our data. After seeing where international design firms have delivered their projects and measured this, we want to explore the geographical provenience of these designs for emerging markets. Hence, this section will highlight which type of firms and from which countries have been more able to engage with and exploit the potentialities of these emerging markets. Only looking at the regions surveyed for this study, the UK emerges as the top exporter of architectural design services, with 17% of its (surveyed) firms with at least one completed (built) project in one of the regions. This value is even higher for Danish firms (18.5%) and also significant for Dutch ones (14%). However, as we commented regarding the methodology and the limits of this study (Sect. 2.5), the sample of surveyed firms, mainly varying by country's population and despite the use of corrective weighting factors, remains too low for countries below fifty million inhabitants (and thus with a surveyed number of firms below fifty). For these reasons, we will abstain as much as possible from quantitative considerations for Scandinavian countries, Belgium and the Netherlands, Austria and Switzerland, Portugal, New Zealand, and even Australia and Canada. That said, British firms' global ambition and scope leap off the page, especially by comparing them to US, German, and French ones (Fig. 4.16; full data available in Appendix B). British firms' strength in designing overseas is also demonstrated by their widespread presence, with 26.5% having at least one branch in China, 17.7% in the Middle East, and 10% in India.

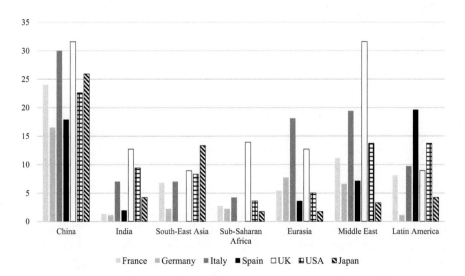

Fig. 4.16 Percentage of firms from selected countries successfully involved (at least one built project) in surveyed emerging markets. Copyright Giaime Botti

Some disaggregated data on different emerging markets are of interest, too. In China, approximately 30% of British and Italian firms, 25% of Japanese and French, 22% of US, and less than 20% of Spanish and German firms have completed at least one project. On the contrary, in India, where overall involvement has been very low, 12.6% of British firms and 9.3% of US ones have been successful. In South-East Asia, Japan leads with 13.3%, while just 8.9% of British and 8.3% of US firms have successfully worked in this market. British firms are also leading in Sub-Saharan Africa, with 13.9% of firms successfully involved, against a mere 3.6% of US ones. Despite historical ties, only 2.7% of French firms have completed at least one project in Sub-Saharan Africa. While this reflects an overall low involvement in the region, it also comes because, from our survey, we excluded North Africa, where French architects have been quite active. For Sub-Saharan Africa, we can also note a higher presence of Portuguese firms (11.8%). While this is not statistically relevant for a cross-countries comparison because of the small Portuguese sample, it does have some interest when the comparison is made between the involvement of firms from Portugal across different regions. Specifically, there are no projects in India and South-East Asia; just one firm (thus 5.9% of the sample) completed about 32,000 m^2 in China, one firm was successful in the Middle East (again 5,9% of the sample), and two in Eurasia (11.8%). On the contrary, and not unexpectedly, Portuguese firms have been more active and successful in Latin America due to the obvious ties with Brazil. Indeed, also Spanish firms have far more grip on Brazil, Colombia, and Mexico (19.6%) than in the Middle East (7.1%) and Eurasia (3.6%).

To proceed region by region, in Eurasia emerges a strong role of Italian firms (18%), while France (5.4%) and German (7.7%) have lagged, despite strong historical and economic ties. US firms' involvement has been minimal: only 5% of the firms had at least one built project in the two countries. In the Middle East, British firms are ahead, with 31.6% of active and successful (at least one built project) firms against 13.7% of US ones, 19.4% of Italian, and 10.8% of French. Finally, in Latin America, where, as seen, Spanish and Portuguese firms have been more successful, US firms have a larger share of the market than British ones, with 13.7% against 8.9%; Italy and France follow with 9.7% and 8.1% respectively, whereas the activity of German architects has been basically inexistent. In this sense, it is quite surprising how Italian firms, which are very small in size, have succeeded overseas. The average Italian architecture firm has less than two employees, whereas in the UK or Scandinavia, the average is four (Architecture Council of Europe 2018, 3–33). One Works, ranked the biggest Italian firm, had annual revenues of €21.5 million in 2017 (Norsa 2019), while Foster + Partners received £22 million in fees in the UK and a total of £191 million, including overseas works in that same year (Architects' Journal 2018). However, this data might also be misleading. For instance, if it is true that almost the same percentage (around 30%) of British and Italian firms (and a similar absolute number, with 25 and 22 firms, respectively) have been successful in China, their actual deliveries have been very different. One telling parameter we can analyse is the built GFA (Fig. 4.17).

Indeed, when we look at the projects' size, issues deriving from the dimension and the type of firms emerge. Focusing again on Italy and the UK, it stands out

4.6 Successful Export and Unaccomplished Ambitions: Europe Versus …

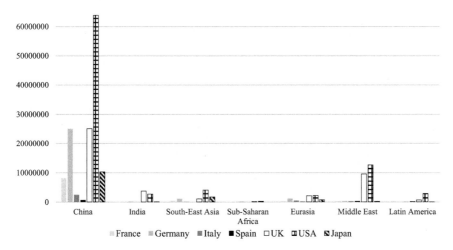

Fig. 4.17 Built GFA (m^2) by firms from selected countries in emerging markets. Copyright Giaime Botti

that the average size (GFA) of a project designed by an Italian firm in China has been approximately 24,000 m^2, against the 186,000 m^2 of the buildings designed by British firms. As a matter of fact, while many British firms have designed, for example, large mixed-use complexes, office buildings, shopping malls, and expansive cultural facilities, Italian firms had an edge in the interior design of fancy boutiques inside those very shopping malls, or restaurants and rooms in upscale hotels. This case proves that going global is no longer an impossible aspiration for small-to-medium-sized architectural firms, which can be successful as long as they can find their market niche.

Another metric we can analyse is the success rate of these firms, measured as the percentage of companies with at least one project built or under construction over the number of companies with any project (thus including unbuilt ones). In China, this is very high for Japanese, British and US firms (81.6%, 73.5% and 68.5%, respectively); it is also high for the Italian ones, while sensibly lower for Spanish companies (43.5%), with most major countries in the middle (Fig. 4.18). All this means, for example, that a company from Japan or the UK, if involved in the Chinese market, is statistically more likely to have its projects actually built. On average, firms are more successful in China and Latin America (62% and 58%, respectively) than in the other regions (about 39% to 47%). Perhaps more interestingly is to note the high success rate of Japanese firms overall (61%, with a peak of 81% in China), which may reflect the fact that most of the firms going global are either megapractices or Pritzker-awarded architects, both typologies of firms more risk-averse than ordinary medium-sized practices. Still, also US (57.8%), Italian (56.3%), and British (54.7%) firms, which are overall very different in typology and size, have been similarly successful; on the contrary, French (44.8%), German (43%) and Spanish (25.9%) ones have been less. The most calling aspect in these figures is the difference between

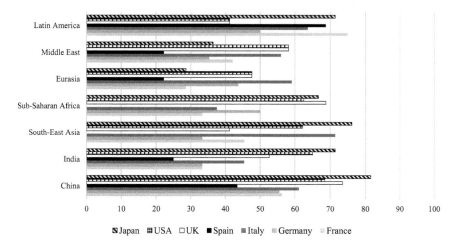

Fig. 4.18 Success rate of firms from selected countries in emerging markets. Copyright Giaime Botti

Spanish and Italian firms, being both smaller on average compared to those from the other countries.

This leads us to close this section with the last series of data that we can use to identify the main international actors active in the different markets. Once again, we can start from China, where German megafirm GMP completed, in slightly more than two decades, an impressive portfolio of at least 153 projects for a total of over 21 million square metres of GFA, with an average project size of almost 140,000 m^2. Other impressive outcomes have been achieved by KPF, with 47 completed projects and 12.5 million square metres, for an average GFA of 260,000 m^2, or SOM with 39 projects and 9.7 million built square metres, including a record number of supertall skyscrapers (Sect. 5.1). These figures, and those of other firms like HOK (5.6 million), Heerim Architects & Planners (5.2 million), and Benoy (4.8 million), dwarf performances that would be otherwise considered exceptional, if we think that the lower band of values in Fig. 4.19, representing the top-fifty actors by built GFA in China, is over 600,000 m^2 of GFA. In this regard, we need to highlight the enormous amount of work delivered by firms generally not categorised as megapractices, at least because of their more creative and experimental approach (sometimes under the leadership of a Pritzker architect). Zaha Hadid Architects completed nine projects for a total of over 3.6 million square metres, OMA the same number of projects for 1.2 million square metres, Christian de Portzamparc three for over 980,000 m^2, Fuksas & Associati six for about 930,000, and Steven Holl five for 652,000.

In the Middle East (Fig. 4.20), the activity of RMJM and Perkins & Will stands out, with over 2.7 million square metres of built GFA. It is worth remembering that RMJM has been working in the region since the 1970s, with an office in Dubai that opened in 1971. Other important actors are Atkins (with 29 completed projects for a total number of square metres significantly higher than the mapped 1.2 million due

4.6 Successful Export and Unaccomplished Ambitions: Europe Versus … 149

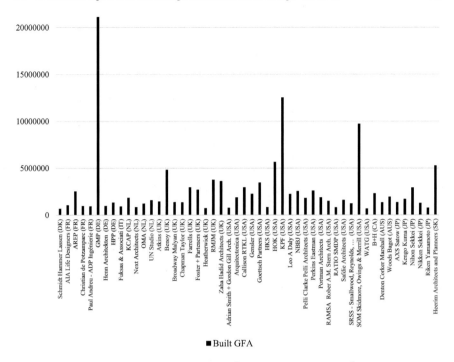

Fig. 4.19 Top-fifty firms in China by built GFA (m^2; lowest value: 665,802 m^2). Copyright Giaime Botti

to the lack of data), Foster + Partners with 1.86 million, Henning Larsen with 1.79, HOK with 1.76, Hopkins Architects with 1.2.

While more complete data on all the regions are available in Appendix A, we can highlight a few relevant performances, usually split between British and US firms. In India, the biggest player has been Chapman Taylor, with almost 1.6 million square metres built, and Benoy, with over 1.1. On the American side, SOM has completed 610,000 m^2, DLR group 427,000, and Pei, Cobb, Freed & Partners 422,000. In Latin America, on the other hand, US companies have the upper hand. Pelli Clarke Pelli Architects, whose principal César Pelli was Argentinian-American, have completed 567,000 m^2 in the surveyed countries, Miami-based Arquitectonica more than 400,000, SOM 383,000, and KPF 326,000, while Foster + Partners 363,000. On the other side, South-East Asia's scenario is more diverse. The most successful actors have been Smallwood, Reynolds, Stewart, Stewart & Associates (USA), with more than 1.1 million square metres built, and Heerim Architects & Planners (South Korea), with over 986,000. Still, here we find more US firms, like Callison RTKL (917,000 m^2), Arquitectonica (740,000 m^2), and KPF (649,000 m^2), another South Korean one, Samoo (673,000 m^2), and Japanese ones, like Takenaka Corporation (671,000 m^2) and Kisho Kurokawa (405,000 m^2). We also see Australian architects, starting from Denton Corker Marshall, which completed at least 28 projects in the region but for which data on GFA is minimal; to this, we can

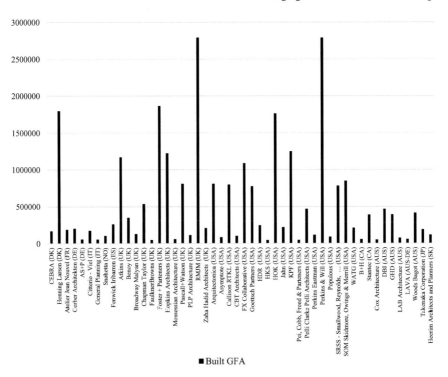

Fig. 4.20 Top-fifty firms in the Middle East by built GFA (m^2; lowest value: 44,965 m^2). Copyright Giaime Botti

add Cox Architecture and LAVA, with respectively 220,000 and 206,000 m^2 (both underestimated though). Foster + Partners completed 561,500 m^2, Atkins a 241,000 m^2 project, German firm Franken Architekten a single work of 720,000 m^2, GMP about 363,000 in three projects, and AREP over 221,000. In Eurasia, a few companies have completed projects for significant cumulative GFAs: Tchoban Voss Architekten and NBBJ over one million square metres each, RMJM 936,000, Nikken Sekkei 500,000, SOM 447,000, Aukett Swanke 390,000, and at least other thirteen firms have completed more than one hundred thousand square metres each. Finally, for Sub-Saharan Africa, we see firms delivering one or two projects for overall surfaces below one hundred thousand square metres, like CVDB (one project, 95,400 m^2), FX Collaborative (1 project, 76,200 m^2), and Perkins & Will (73,850 m^2), to name the first three.

Overall, US firms have outperformed European ones in terms of the number of projects and, above all, GFA. According to our data, US firms delivered 1,988 projects, of which 885 were built for a total GFA of over 104,129,080 m^2; firms from surveyed European countries delivered a total of 3,006 projects, of which 1,333 were built for over 88,296,967 m^2. Considering that we surveyed 278 US firms and 512 European ones, the performance of US firms is proportionally stronger. As for GFA, US firms outperform European ones even in absolute terms due to the

4.6 Successful Export and Unaccomplished Ambitions: Europe Versus ...

larger average size of projects on which they work. These figures, therefore, display a reversal compared to the end of the 1980s, when US firms lagged compared to European ones, which were able to get about half of the share of the U$4 billion in foreign billing recorded for the top two hundred firms in 1987 (Sennewald 1989). Today's reality, indeed, seems to reflect again the polarisation of the market. As seen, the involvement (as the percentage of firms with projects on the total number of surveyed firms) of US firms in emerging markets is not higher than for European ones. On the contrary, we can note that several large US firms, ranked in the 100–200th percentile, with incomes comparable to European firms in the top twenty or ten of France or Italy and provided with multiple offices across the USA, have no projects at all outside a few US states.[18] The figures we commented on, therefore, are in reality the result of the impressive overseas performance of a limited number of US firms.

Finally, some more data gauge the involvement of Pritzker-laureate architects in our sample of emerging markets (Table 4.1), providing some additional insights into the top level of the global profession. While some of these starchitects have, established successful practices that achieved the status of megafirms (like Foster + Partners and Pei, Cobb, Freed & Partners, and to a lesser extent Zaha Hadid Architects, OMA, and Tange Associates), others have barely crossed the borders of their countries, from Peter Zumthor to Glenn Murcott, from Paulo Mendes da Rocha to Wang Shu. In this regard, there has been a growing number of Pritzker assigned to architects from the Global South in the last years, especially from Asia, with Wang Shu in 2012, Balkrishna V. Doshi in 2018, and Alejandro Aravena in 2016, although the work of Latin American architects has generally been better acknowledged since the birth of this award: Luis Barragán was awarded in 1980, Oscar Niemeyer in 1988, Mendes da Rocha in 2006. Still, among non-Euro-Atlantic and Japanese Pritzker-winners, only Niemeyer had a really global professional perspective, with projects completed across Latin America, Europe, North Africa, and Israel, and some unbuilt design also in the Persian Gulf. On the contrary, Barragán never built anything outside Mexico, nor did Wang outside China. Doshi unsuccessfully competed for the Kuwait National Assembly in the 1970s. At the same time, Mendes da Rocha had only completed overseas the Brazilian Pavilion at the Expo Osaka 1970 and, more recently, a house in Lisbon, Portugal. Aravena and his firm Elemental have just completed a couple of projects outside Chile, one in Texas and the other in Mexico.

These data, thus, highlight a varied involvement in emerging markets for famed architects. Celebrities like Zumthor, Murcutt, or Eduardo Souto de Moura have not produced any project there, while others, like Lacaton & Vassal, or Rafel Aranda, Carme Pigem and Ramón Vilalta of RCR Arquitectes had just developed few unsuccessful designs in some of these regions. Neither several architects awarded in the

[18] To provide some concrete examples of large firms with no projects outside the USA: Huntsman Architectural Group –with offices in San Francisco, New York and Chicago—was ranked 101st in the USA in 2019, with revenues for U$16 million (a sum that would position it just outside the top ten in France and well within it in Italy). Other similar cases along the following position in the same ranking include Margulies Peruzzi (103rd), Weber Thompson (105th), BSB Design (106th), SEI Design Group (107th), M+A Architects (108th), HMFH Architects (110th).

Table 4.1 GFA (m^2) of built projects designed by Pritzker Prize winners in emerging market

Designer	China	India	South–East Asia	Eurasia	Middle East	Sub-Saharan Africa	Latin America
Tadao Ando, 1995	89,200 (2009)	–	–	–	0 (2012)	–	N.A. (2007)
Shigeru Ban, 2014	N.A. (2008)	N.A. (2001)	0 (2010)	0 (2017)	0 (2008)	N.A. (2017)	0 (2010)
Gordon Bunshaft-SOM, 1988	>9,714,621 (1994)	610,400 (2007; 2010s)	176,485 (1995)	447,085 (2011)	>1,165,739 (1970s)	0 (2017)	383,273 (2000)
Norman Foster, 1999	2,702,456 (1995)	0 (2008)	561,500 (1998)	177,450 (2004)	>1,863,331 (1994)	–	363,000 (2011)
Frank O. Gehry, 1989	0 (2010)	–	–	–	30,000 (2007)	–	–
Zaha Hadid, 2004	3,634,143 (2002)	N.A. (2017)	0 (2009)	0 (2013)	>208,345 (1997)	–	0 (2015)
Jacques Herzog & Pierre De Meuron, 2001	258,000 (2002)	0 (2008)		133,979 (2002; 2013)	0 (2002)	–	1,964 (2002; 2011)
Hans Hollein, 1985	80,000 (1998; 2009)	–		0 (2003)	0 (2007)	–	–
Arata Isozaki, 2019	>345,730 (1994; 1998)	–	N.A. (2006)	0 (2002)	N.A. (1979; 2004)	–	–
Toyo Ito, 2013	–	–	–	–	–	–	18,149 (2012)
Diébédo Francis Kéré, 2022	0 (2013)	–	–	–	1,416 (2019)		–
Rem Koolhaas—OMA, 2000	>1,231,000 (2002)	0 (2008)	20,000 (1997; N.A.)	>5,408 (2006; 212)	>32,250 (2005; 2008)	–	0 (1998)
Fumiko Maki, 1993	73,918 (2010s)	24,000 (2011)	0 (1977)	–	–	–	0 (1976)

(continued)

Table 4.1 (continued)

Designer	China	India	South–East Asia	Eurasia	Middle East	Sub-Saharan Africa	Latin America
Tom Mayne—Morphosis, 2005	370,800 (2005)	–	0 (2004)	–	0 (2008)	–	0 (1998)
Richard Meier, 1984	11,000 (2005; 2008)	0 (2010)	N.A. (1997)	–	–	–	148,583 (2010; 2011)
Jean Nouvel, 2008	384,777 (2013)	–	N.A. (1995; N.A.)	0 (2006)	187,000 (2002)	0 (2010)	37,000 (1999; 2012)
I. M. Pei—Pei, Cobb, Freed & Partners, 1983	> 89,000 (1982)	422,000 (2007; 2009)	N.A. (1991)	–	45,000 (2000s)	–	0 (1980s)
Renzo Piano—PRBW, 1998	288,000 (2013)	–	–	20,000 (2015)	–	–	–
Christian de Portzamparc, 1994	982,000 (2010; 2013)	–	–	–	–	–	90,000 (2002)
Richard Rogers—RSH+P, 2007	80,000 (1992)	–	–	–	–	–	245,177 (2009)
Kazuyo Sejima, Ryue Nishizawa—SANAA, 2010	N.A. (2004)	–	–	0 (2010)	–	–	–
Álvaro Siza, 1992	> 32,300 (2009)	–	–	–	–	–	1,350 (1998)
Kenzo Tange, 1987	512,747 (1994; 2000s)	–	72,642 (1995; 2000s)	–	263,783 (1977)	0 (1979)	–

Note: – stands for no projects; 0 stands for 0 built m^2, but implies that there are unbuilt projects; N.A. means that there are built projects but data on GFA are not available. The year in brackets is that of beginning of the oldest projects in case of one or more built projects; in case of unbuilt, it refers to the year of launch of the oldest projects; when two different years are indicated, the first one refers to the oldest unbuilt and the second one to the oldest built (year of beginning)

1980–90s had engaged with these markets; it is the case of James Stirling (1981), Gottfried Böhm (1986), Aldo Rossi (1990), Robert Venturi (1991), Rafael Moneo (1996), Sverre Fehn (1997). On the opposite, Frei Otto, who was awarded the Pritzker in 2015, had completed projects in Saudi Arabia in the 1970s, while Kevin Roche (1982) in Malaysia in the 1990s. In the same decades, Jørn Utzon worked in the Middle East (Sect. 3.3 and Chap. 4). In addition, we can note the global outreach and success of firms like OMA, Foster + Partners, and Zaha Hadid Architects, and the long involvement of Tange Associates in certain markets. Another interesting element is, instead, the limited work of Frank O. Gehry, Toyo Ito, and SANAA in emerging markets, as well as the late arrival of Renzo Piano's RPBW. Finally, it must be noted the solid record of Álvaro Siza in mainland China, who, with the collaboration of Carlos Castanheira, has completed a few remarkable projects (Sects. 6.1 and 9.2) that enrich a predominantly European portfolio not devoid of works in Taiwan, South Korea, Japan, Argentina, Brazil, and Capo Verde.

4.7 Conclusions

Once we understood the relevance and the overall representativity of the emerging markets mapped for this research, we moved through a series of metrics complemented by qualitative considerations that displayed how the international market for architectural services has changed in the last three decades for Western (in the broad sense) architecture firms. The number of projects we identified, for example, demonstrates a dramatic acceleration in the delivery of design services in emerging markets since the mid-2000s. Indeed, as also seen in Sect. 3.4, this reflects a trend that saw a relevant change in the 1970s, when the Middle East emerged as a key market for US, British, and Japanese architects, who in some cases established a few overseas branch offices (or used geographically intermediate platforms, like Italy for US architects). Until the 1980s–90s all this remained quantitatively limited, although, by that time, a growing number of US megafirms started looking at Europe, especially London, for work opportunities, sometimes establishing their first overseas branches. These same firms also landed in Tokyo and Hong Kong in this same period, while East and South-East Asia emerged as new key markets. By the end of the 1990s, in addition, Russia and China had embraced the market economy in different ways, with the latter becoming, in the following years, the biggest importer of architectural services.

The global architectural market created after 2000 was, therefore, one in which China and the Middle East attracted Western firms more than any other emerging region; in this regard, the difference in attractiveness that India and China had, despite their similar size (at least in terms of population), is staggering. Indeed, while we advanced some hypotheses about the reasons, we recognised how our data might have missed projects of little aesthetic value and consequently delivered but not openly advertised by firms. We called these 'cash' projects as opposed to 'flagship' designs. As a result, if it is true that no emerging markets remained unaffected, it is equally

true that many regions remained quite marginal to the expansion of design service exports by our sampled firms.

A mix of qualitative and quantitative indicators, then, explained how the modes of production and the places of production changed. The combination of cheap real-time communication and the digitalisation of the design process made it possible to work across long distances collaboratively, but at the same time (and it might be one of the many proves that localisation and physical presence still matter), flocking opportunities pushed large and medium firms to open branch offices in the most promising markets, once again China and the Middle East. In this scenario, architectural firms of different sizes and typologies have engaged, or tried to, with these markets. Firms from many countries have shown a remarkable ability to go global, with British firms actively searching for new markets with more ambition than several larger US firms. We thus argue, supported by our findings, that with the new century, a new phase of globalisation has also begun for architecture.

References

Abel, Chris. 1994. Localisation versus globalisation. *The Architectural Review* 196 (1171): 6–9.

Adam, Robert. 2012. *The Globalisation of Modern Architecture: The Impact of Politics, Economics and Social Change on Architecture and Urban Design since 1990*. Newcastle-upon-Tyne: Cambridge Scholars Publishing.

AMO, Todd Reisz, and Kayoko Ota. 2007. Gulf survey—Drawn in the sand: John Harris, Dubai's pioneering modernist. *Volume* [special issue *Al Manakh*] (12): 152–168.

Architects' Journal. 2018. AJ100. *Architects' Journal*. https://aj100.architectsjournal.co.uk/view/overview/2018/view.aspx. Accessed 20 June 2020.

Architecture Australia. 1995. Radar projects: Australian architects design for Asia. *Architecture Australia* 14–15.

Architecture Council of Europe. 2018. The architectural profession in Europe 2018. A sector study. https://www.ace-cae.eu/fileadmin/New_Upload/7._Publications/Sector_Study/2018/2018__ACE_Report_EN_FN.pdf. Accessed June 2020.

B+H Architects. 2018. New opportunities for growth China: Looking ahead. *B+H Architects*, Mar 20. https://bharchitects.com/en/2018/03/20/new-opportunities-for-growth/. Accessed 15 Feb 2022.

Baldwin, Richard. 2016. *The Great Convergence: Information Technology and the New Globalization*. Cambridge, MA; London: The Belknap Press of Harvard University Press.

Bello, Walden. 1999. The Asian financial crisis: Causes, dynamics, prospects. *Journal of the Asia Pacific Economy* 4 (1): 33–55.

Biau, Daniel. 2007. Chinese cities, indian cities: A telling contrast. *Economic and Political Weekly* 42 (33): 369–372.

Bologna, Alberto. 2019. *Chinese Brutalism Today: Concrete and Avant-Garde Architecture*. San Francisco, CA: ORO Editions.

Bonino, Michele, Francesca Governa, Maria Paola Repellino, and Angelo Sampieri. 2019. *The City after Chinese New Towns: Space and Imaginaries from Contemporary Urban China*. Basel: Birkhäuser.

Boodrookas, Alex, and Arang Keshavarzian. 2019. The forever frontier of urbanism: Historicizing persian gulf cities. *International Journal of Urban and Regional Research* 43 (1): 14–29.

Born, Esther. 1937. *The New Architecture in Mexico*. New York, NY: The Architectural Record, W. Morrow & Company.

Botti, Giaime. 2022. Changing narratives: China in western architecture media. In *China's International Communication and Relationship Building*, ed. Xiaoling Zhang and Corey Schultz. London: Routledge.

C.S. 1994. Pacific age vision. *The Architectural Review* 196 (1171): 25.

Campanella, Thomas J. 2008. *The Concrete Dragon: China's Urban Revolution and What It Means for the World*. New York, NY: Princeton Architectural Press.

Canadian Architect. 2018. Canada and European union agree to recognize architect credentials. *Canadian Architect*, Oct 26. https://www.canadianarchitect.com/canada-and-european-union-agree-to-recognize-architect-credentials/. Accessed 20 Jan 2022.

Colomina, Beatriz. 2011. Towards a global architect. *Domus*, Apr 30. https://www.domusweb.it/en/architecture/2011/04/30/towards-a-global-architect.html. Accessed 25 July 2022.

Cooper, Frederick. 2001. What is the concept of globalization good for? An African historian's perspective. *African Affairs* 100 (399): 189–213.

Costa Buranelli, Filippo. 2018. Spheres of influence as negotiated hegemony—The case of Central Asia. *Geopolitics* 23 (2): 378–403.

Davis, Mike. 2007. Sand, fear, and money in Dubai. In *Evil Paradises: Dreamworlds of Neoliberalism*, ed. Mike Davis and Daniel Bertrand Monk, 48–68. New York, NY: The New Press.

Dixon, John Morris. 1995. Exporting architecture. *Progressive Architecture* 76 (1): 25–28.

Dobbs, Richard, and Shirish Sankhe. 2010. Comparing urbanization in China and India. *McKinsey & Company*, July 1. https://www.mckinsey.com/featured-insights/urbanization/comparing-urbanization-in-china-and-india. Accessed 5 June 2021.

Dreyer, Jacob. 2012. Shanghai and the 2010 Expo: Staging the City. In *Aspects of Urbanization in China: Shanghai, Hong Kong, Guangzhou*, ed. Gregory Bracken, 47–58. Amsterdam: Amsterdam University Press.

Esteban Maluenda, Ana. 2021. La mirada distante: La imagen de la arquitectura latinoamericana en los medios internacionales tras la II Guerra Mundial. *Estudios del Hábitat* 19 (1).

Forrest, Ray, Julie Ren, and Bart Wissink. 2019. *The City in China: New Perspectives on Contemporary Urbanism*. Bristol: Bristol University Press.

Fraser, Murray, and Nasser Golzari. 2013. *Architecture and Globalisation in the Persian Gulf Region*. Farnham: Ashgate.

Fuccaro, Nelida. 2014. Rethinking the history of port cities in the gulf. In *The Persian Gulf in Modern Times: People, Ports, and History*, ed. Lawrence G. Potter. New York: Palgrave Macmillan.

Fukuyama, Francis. 1992. *The End of History and the Last Man*. New York, NY: Free Press.

Gensler Research Institute. 2020. *Gensler Research Catalogue Volume 3: Shaping the Future of Cities*. New York, NY: ORO Editions.

Giedion, Sigfried, ed. 1954. *A Decade of Contemporary Architecture*. Zurich: Editions Girsberger.

Goodwin, Philip L. 1943. *Brazil Builds: Architecture New and Old 1652–1942*. New York, NY: The Museum of Modern Art.

Gordon, Robert J. 2016. *The Rise and Fall of American Growth: The U.S. Standard of Living since the Civil War*. Princeton, NJ: Princeton University Press.

Greer, Nora Richter. 1989. Americans abroad: Some coming attractions. *Architecture: The AIA Journal* 78 (1): 64–71.

Hegvold, Laurie. 1990. The Australia/Malaysia connection. *Architecture Australia* 79 (1): 36–48.

Hickman, Matt. 2022. As Russia's invasion of Ukraine continues, Architects speak out. *The Architect's Newspaper*, Mar 4. https://www.archpaper.com/2022/03/russia-war-ukraine-rages-firms-speak-out/#:~:text=%E2%80%9CZaha%20Hadid%20was%20originally%20inspired,hold%2C%E2%80%9D%20the%20statement%20continued. Accessed 7June 2022.

Hitchcock, Henry-Russell. 1955. *Latin American Architecture: Since 1945*. New York, NY: Museum of Modern Art.

Hobsbawm, Eric J. 1995. *Age of Extremes: The Short Twentieth Century, 1914–1991*. London: Abacus.

References

Hoyt, Charles. 1975. The oil-rich mid-east: The new frontier for professional services? *Architectural Record* 157 (7): 101–108.

Hoyt, Charles. 1983. Practice: So you want to do business in China? *Architectural Record* 9 (II): 30.

Hughes, C.J. 2011. Is Vietnam the new frontier for architects? *Architectural Record* 199 (8): 23.

Jericho, Greg. 2014. China's housing market is on the brink of collapse. Should Australia be worried? *The Guardian*, Sept 8. https://www.theguardian.com/business/grogonomics/2014/sep/08/why-a-collapse-in-chinas-housing-market-will-hurt-australia. Accessed 12 Aug 2022.

Kalay, Yehuda E. 2004. *Architecture's New Media: Principles, Theories, and Methods of Computer-Aided Design*. Cambridge, MA: MIT Press.

Kanna, Ahmed. 2011. *Dubai, the City as Corporation*. Minneapolis, MN: University of Minnesota Press.

Kerwin, Thomas. 2008. Building tall (and designing deep) in China. *The Architectural Review* 224 (7): 78–80.

King, Anthony D. 2004. *Spaces of Global Cultures: Architecture, Urbanism, Identity*. London, New York, NY: Routledge.

Kloosterman, Robert C., and Eva Stegmeijer. 2005. Delirious Rotterdam: The formation of an innovative cluster of architectural firms. In *Learning from Clusters. A Critical Assessment from an Economic-Geographical Perspective*, ed. Ron A. Boschma and Robert C. Kloosterman, 203–224. Berlin: Springer.

Knox, Paul L., and Peter J. Taylor. 2005. Toward a geography of the globalization of architecture office networks. *Journal of Architectural Education* 58 (3): 23–32.

Kultermann, Udo. 1985. Contemporary Arab architecture. The architects in Saudi Arabia. *Mimar* 16: 42–53.

Langdon, Philip. 1995. Asia bound: What are American architects' responsibilities in developing countries? *Progressive Architecture* 76 (3): 43–51.

Lefebvre, Henri. 2009. The worldwide experience (1978). In *State, Space, World: Selected Essays*, ed. Neil Brenner and Stuart Elden [Translated by Gerald Moore, Neil Brenner and Stuart Elden], 274–289. Minneapolis, MN: University of Minnesota Press.

Liernur, Jorge Francisco. 1999. 'The South American Way'. El 'milagro' brasileño, los Estados Unidos y la Segunda Guerra Mundial (1939–1943). *Block* 4: 23–41.

Logan, John R., ed. 2002. *The New Chinese City*. Oxford: Blackwell.

McKee, Bradford. 1994. American architects in Asia. *Architecture: The AIA Journal* 83 (9): 105–113.

Marri, Sohrab Ahmed. 2019. Toward local pastiche: Business center architecture along new silk road. *Il Giornale dell'Architettura*. June 11. https://ilgiornaledellarchitettura.com/2019/06/11/toward-local-pastiche-business-center-architecture-along-new-silk-road/?lang=en. Accessed 20 Mar 2021.

Mars, Neville, and Adrian Hornsby. 2008. *The Chinese Dream: A Society Under Construction*. Rotterdam: 010 Publishers.

McCue, George. 1982. George E. Kassabaum. *The AIA Journal* 71 (11): 17.

McNeill, Donald. 2009. *The Global Architect: Firms, Fame and Urban Form*. New York, NY: Routledge.

Melloni, Nicola. 2006. *Market Without Economy: The 1998 Russian Financial Crisis*. Stuttgart: Ibidem-Verlag.

Mignolo, Walter D. 2005. *The Idea of Latin America*. Malden, MA; Oxford: Blackwell.

Mitchell, William J. 1977. *Computer-Aided Architectural Design*. New York, NY: Petrocelli.

Monson, Jamie. 2009. *Africa's freedom railway: How a Chinese development project changed lives and livelihoods in Tanzania*. Bloomington, IN: Indiana University Press.

Nancy, Jean-Luc. 2007. *The Creation of the World, or Globalization*. Albany, NY: State University of New York Press.

National Bureau of Statistics of China. 2019. *China statistical yearbook 2019*. National Bureau of Statistics of China.

Negroponte, Nicholas. 1975. *Soft Architecture Machines*. Cambridge, MA: MIT Press.

Norsa, Aldo. 2019. Report 2018. Update version on the Italian construction, architecture and engineering industry. *Guamari*. https://www.guamari.it/pubblicazioni. Accessed 20 June 2020.

Office for Metropolitan Architecture, Rem Koolhaas, and Bruce Mau. 1995. *S, M, L, XL*. New York, NY: The Monacelli Press.

Olivié, Iliana, and Manuel Gracia. 2020. Is this the end of globalization (as we know it)? *Globalizations* 17 (6): 990–1007.

Pearson, Clifford. 1997. Reports from the Pacific Rim. Architects find business from Indonesia to China. *Architectural Record* 185 (7): 81–95.

Pieterse, Jan Nederveen. 2004. *Globalization or Empire?* New York, NY: Routledge.

Rapoza, Kenneth. 2014. China gives up on housing bubble. *Forbes*, Dec 27. https://www.forbes.com/sites/kenrapoza/2014/12/27/china-gives-up-on-housing-bubble/. Accessed 12 Aug 2022.

Reich, Robert B. 1991. *The Work of Nations*. New York, NY: Alfred A. Knopf.

Ren, Xuefei. 2011. *Building Globalization: Transnational Architecture Production in Urban China*. Chicago, IL: The University of Chicago Press.

Rohan, Timothy M. 2014. *The Architecture of Paul Rudolph*. New Haven, CT: Yale University Press.

Roskam, Cole. 2015. Non-aligned architecture: China's designs on and in Ghana and Guinea, 1955–92. *Architectural History* 58: 261–291.

Rush, Richard D. 1995. Shanghai: Home of the handmade highrise. *Progressive Architecture* 76 (3): 35–36.

Saniga, Andrew. 2012. *Landscape Architecture in Australia*. Sydney: NewSouth Publishing.

Sassen, Saskia. 1991. *The Global City: New York, London, Tokyo*. Princeton, NJ: Princeton University Press.

Sennewald, Bea. 1989. Challenges of building abroad: Foreign billings by U.S. firms are again on the rise. *Architecture: The AIA Journal* 78 (1): 87–92.

Shleifer, Andrei, and Daniel Treisman. 2005. A normal country: Russia after communism. *Journal of Economic Perspectives* 19 (1): 151–174.

Stanek, Łukasz. 2012. Miastoprojekt goes abroad: The transfer of architectural labour from socialist Poland to Iraq (1958–1989). *The Journal of Architecture* 17 (3): 361–386.

Stanek, Łukasz. 2015. Architects from socialist countries in Ghana (1957–67): Modern architecture and mondialisation. *Journal of the Society of Architectural Historians* 74 (4): 416–442.

Stanek, Łukasz. 2019. *Architecture in Global Socialism. Eastern Europe, West Africa, and the Middle East in the Cold War*. Princeton, NJ: Princeton University Press.

Stanek, Łukasz. 2021. Buildings for dollars and oil: East German and Romanian construction companies in cold war Iraq. *Contemporary European History* 30 (4): 544–561.

Tombesi, Paolo, Bharat Dave, and Peter Scriver. 2003. Routine production or symbolic analysis? India and the globalization of architectural services. *Journal of Architecture* 8 (1): 63–94.

Tombesi, Paolo. 2001. A true south for design? The new international division of labour in architecture. *arq: Architectural Research Quarterly* 5 (2): 171–179.

Totaro, Romina. 2022. How architecture has reacted to the war in Ukraine. *Domus*, Mar 7. https://www.domusweb.it/en/news/2022/03/04/how-architecture-has-reacted-to-the-war-in-ukraine.html. Accessed 7 June 2022.

Vatikiotis, Michael, Mark Clifford, and John McBeth. 1994. The lure of Asia. *Far Eastern Economic Review*, 3: 32–34.

Vatikiotis, Michael. 1994. Hungry architects. *Far Eastern Economic Review*, 3: 35.

Will, Rachel. 2012. China's stadium diplomacy. *World Policy Journal* 29 (2): 36–43.

Wilson Associates. 2009. Wilson associates finds international expansion key to success. *Cision PR Newswire*, May 12.. https://en.prnasia.com/releases/global/Wilson_Associates_Finds_International_Expansion_Key_to_Success-19667.shtml Accessed 13 Sept 2022.

World Bank. n.d. World Bank open data. https://data.worldbank.org/. Accessed 20 Sept 2022.

Wu, Fulong, ed. 2006. *Globalisation and the Chinese City*. New York, NY: Routledge.

Wu, Weiping, and Piper Gaubatz. 2013. *The Chinese City*. Abingdon: Routledge.

References

Xue, Charlie Q.L. 2016. *Hong Kong Architecture 1945–2015: From Colonial to Global*. Singapore: Springer.

Xue, Charlie Q.L. 2019. Introduction: Grand theaters and city branding—Boosting Chinese cities. In *Grand Theater Urbanism: Chinese Cities in the 21st Century*, ed. Charlie Q.L. Xue, v–xxix. Singapore: Springer.

Xue, Charlie Q.L., and Guanghui Ding. 2018. *A History of Design Institutes in China: From Mao to Market*. London: Routledge.

Xue, Charlie Q.L., and Guanghui Ding. 2022. *Exporting Chinese Architecture—History, Issues and One Belt One Road*. Singapore: Springer.

Xue, Charlie Q.L., and Yingchun Li. 2008. Importing American architecture to China: The practice of John Portman & associates in Shanghai. *The Journal of Architecture* 13 (3): 317–333.

Xue, Charlie Q.L., Guanghui Ding, and Yingting Chen. 2021. Overseas architectural design in China: A review of 40 years. *Architectural Practice* 29: 8–21.

Xue, Charlie Q.L., Guanghui Ding, Wei Chang, and Yan Wan. 2019. Architecture of 'stadium diplomacy'—China-aid sport buildings in Africa. *Habitat International* 90: 101985.

Yaneva, Albena. 2012. *Mapping Controversies in Architecture*. Farnham: Ashgate.

Zhao, Simon X.B.., Hongyu Zhan, Yanpeng Jiang, and Wenjun Pan. 2017. How big is China's real estate bubble and why hasn't it burst yet? *Land Use Policy* 64: 153–162.

Part II
Architectural Geographies of Globalisation

Chapter 5
The Skyscraper: Go East, Go High, Go Hybrid

The image of the World Trade Center collapsing after being hit by two aeroplanes on 11th September 2001 has hurriedly pushed many commentators to foresee a premature end of the skyscraper typology.[1] In an age of global terrorism and uncertainty, storing thousands of people in such costly and vulnerable structures was becoming a risky bet. A few years before, when the 1997 Asian financial crisis broke out, property analyst Andrew Lawrence put forward the idea of a correlation between the boom of high-rise constructions and economic downturns, measurable through the Skyscraper Index, noting that the completion of the world's tallest buildings anticipated recessions (Lawrence 1999). More recently, warnings about the environmental unsustainability of skyscrapers have become more common. Nonetheless, some twenty years after the 1997 Asian financial crisis and 9/11, and a decade after the Great Recession, most of these claims have been proved wrong. A recent study from the Council on Tall Buildings and Urban Habitat (CTBUH 2021a) has found that the 84% of 200+ m buildings now standing have been completed after 9/11. Between 1990 and 2001, an average of 12 skyscrapers of 200+ m were built every year, but from 2002 the average has been 68. The Index has found little scientific ground, and neither terrorism nor the Great Recession that followed the global financial meltdown of 2007 inverted the trend. At the most, there has been a temporary slowdown (Oldfield and Wood 2019). Today, climate change and COVID-19 are again challenging this typology. For the first time since 2012–13, in 2019, a decrease in the annual number of 200+ metre-tall buildings completed yearly was reported. This is partly due to efforts to contain debts and new policies against tall buildings in China (Bloomberg 2021; Ni 2021), which, as we will soon discover, account for a disproportionate number of skyscrapers. Then, 2020, the year of the COVID-19 pandemic, recorded an additional 20% decline (CTBUH 2020). What will happen is

[1] In this regard, CTBUH clarify the lack of an absolute definition of a tall building, being height a factor relative to context. Here, we use the term 'skyscraper' broadly, generally referring to 100+ m buildings. We also use the word 'tower' as many buildings carry it in their name, although CTBUH distinguishes telecommunication/observation towers from buildings, having the former less than 50% of their heights occupiable.

© The Author(s), under exclusive license to Springer Nature Singapore Pte Ltd. 2023
G. Botti, *Designing Emerging Markets*,
https://doi.org/10.1007/978-981-99-1552-1_5

unknown, and forecasts are not within the scope of this book. What is instead of our concern is what has happened since the 1990s globally, with specific attention to our selected emerging markets.

As Donald McNeill (2009, 115) emphasised, "skyscrapers are important to debates about globalisation because they can act as switches for globalised flows, whether metaphorical or material." From skyscrapers, therefore, we start this second part of the book, touching on and expanding several of the themes discussed by McNeill. After a quick quantitative overview of the new global geography of skyscrapers, this chapter will focus on the two regions that, during the last three decades, have most invested, financially and symbolically, into this typology: China and the Middle East. Then, we will explore other regions where the multiplication of skyscrapers is read as an indicator of the attempts to position cities in the global spotlight. As Rennie-Short (2004, 3) pointed out, "global cities" should be instead called "globalising cities," as their condition is non-permanent, meaning that we generally consider as such "both global cities seeking to maintain their position and non-global cities seeking to become global." Despite all the efforts, well visible in their skylines, many of these centres have failed to achieve such a status. In this regard, we can also note that while many Asian cities have only recently (since about three decades or so) seen a strong development of high-rise construction, some Latin American centres have been visibly expanding in their vertical dimension since the first half of the twentieth century, continuing to grow vertically although at an incomparably slower—but perhaps more steady—pace. Thus, while the average height of the tallest buildings has been increasing (CTBUH 2021a), so it has the average height of our cities as well as their 'cumulative' height, given the increasing number of high-rises built every year. In this context, studying the verticalisation of cities worldwide means dealing with multiple urban and architectural problems. Among the latter, questions of style have arisen on many occasions with regard to skyscrapers designed by Western architects in Asia and the Middle East. At the same time, these places and their conditions have offered the ground for outstanding experimentations that led to questioning the very essence of this typology, and have fostered multiple debates, touching on formal matters and the architectural profession's ethical dimension.

5.1 A Changing Geography, a Changing Typology: Asian and Hybrid

Never been a diffused reality in European cities, where the skyscraper was an isolated landmark rather than part of a dense cluster like in American CBDs, until the last decade of the previous century, tall buildings were a predominantly American phenomenon. However, things were then in the process of change. As noted in the pages of OMA/AMO's *Content*, the skyscraper was "migrating" eastward, from the USA to Asia, which, for the first time, featured not only an overall larger number of skyscrapers but also the tallest buildings on earth (AMO 2004). As data shown,

5.1 A Changing Geography, a Changing Typology: Asian and Hybrid 165

this overtaking was primarily due to the economic rise of countries like China, the United Arab Emirates, and, to a lesser extent, South-East Asia—on top of more mature markets like Japan and South Korea. By 2022, according to statistics meticulously compiled by the CTBUH, mainland China with Hong Kong, Macau, and Taiwan, boasted the highest number of 150+ metre buildings in the world (2992), with a large margin on the second-ranked (860 in the USA), 200+ m (976 vs. 233), and 102 supertalls and megatalls (skyscrapers above 300 and 600 m in height), almost as much as the rest of the world together. According to the same ranking elaborated by the CTBUH, after China and the USA, the top ten comprise the UAE, South Korea, Japan, Malaysia, Australia, Indonesia, Canada, and Thailand. After Russia, ranked 17th, the first European country on the list is the UK, just 22nd. On the other hand, most of the emerging markets on which this book focuses are ranked higher: Brazil, Mexico, Qatar, Saudi Arabia, and Vietnam (in order from 16th to 21st).

Looking at the ranking by cities, it starts with Hong Kong, followed by Shenzhen, New York, Dubai, and Shanghai, if we count 150+ metre buildings. In the top ten, five cities are Chinese. In the top twenty, they are eight (nine one year ago, as things keep changing). Overall, in the top fifty, 37 cities are in East, South, and South-East Asia, plus three in the Persian Gulf (Dubai, Doha, and Abu Dhabi). Moscow and Istanbul are the only European cities (one year ago, London was on the list, too), and Panama City is the only one in Latin America (one year ago also Mexico City was on the list). Finally, four cities are in North America (three less than in 2021), and two in Australia, while no African centres enter this ranking. A different perspective, in addition, can be offered by considering only supertall buildings (300+). In this case, Dubai ranks first in the world, with 28, followed by Shenzhen and New York with 15 each, Guangzhou with 10, Chicago with 7, Nanjing, Nanning, Moscow, and Hong Kong with 6, Shanghai, Wuhan, Kuala Lumpur, and Changsha with 5. These figures alone depict a precise picture of the current conditions of the global skyscraper market, making it obvious where the work of design firms with expertise in tall buildings concentrates. As these initial data clearly show, China is by far the largest market in the world for tall, supertall, and megatall buildings, most of which have been designed by foreign architects. Having such a large number of projects to deal with, a complete and detailed analysis would exceed our possibilities. Hence, in the next section, we will mainly focus on super and megatall, present additional data on skyscrapers designed by international firms, and discuss some 'signature' projects. More innovative designs, instead, will be presented further ahead (Sect. 5.7).

Before moving on, we also chose to further refine our overview with an insight into the geography of mainland China. Considering the country's weight in the skyscraper market, its geographical extension and geo-economic complexity, we believe necessary to display the Chinese urban geography of tall buildings (Fig. 5.1). This is because while in several other regions skyscrapers are highly concentrated in minimal number of cities, in mainland China the phenomenon is more complex and varied. To understand the current conditions, we can look at two aspects: the localisation of 150+ and 300+ m skyscrapers, noticing that the two geographies only partially overlap. As a matter of fact, tall buildings (150+ m) concentrate in China's main economic and demographic regions, the Pearl River Delta and the Yangtze River

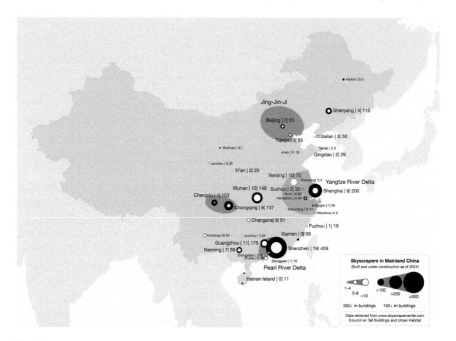

Fig. 5.1 The geography of mainlan China's tall (150+ m) and supertall (300+ m) buildings. Copyright Giaime Botti

Delta, and in three cities in particular: Shenzhen, Guangzhou, and Shanghai. Two more important areas, Jing-Jin-Ji (Beijing-Tianjin) and Chongqing-Chengdu trail at a distance. To this, we can add two industrial hubs, one in the northeast and one in the centre of China, where 150+ m buildings exceed the hundred: Wuhan and Shenyang. As for supertalls, the Pearl River Delta is again the core area, followed by the Yangtze River Delta region, with the city of Nanjing standing out with Shanghai. In addition, it is interesting to note not only the position of Wuhan but also how several provincial capitals with an overall limited number of tall buildings boast quite a few supertalls: Nanning, Kunming, Changsha, Xi'an. And this is exactly the result of the so-called "vanity projects" that current policies in China tried to stop (Ni 2021). Finally, it is also interesting to point out the position of Tianjin, where five supertalls can be counted, and Beijing, where instead, for reasons that will be discussed ahead (Sect. 5.2), skyscrapers have been more limited in number.

Before concluding this section, one last remarkable aspect related to the programme of the skyscrapers should be mentioned. Before 2001, over the world, more than 80% of the 200+ m towers were monofunctional office buildings, but now they only represent 46% (CTBUH 2021a). This is due to the increase in the number of mixed-use projects, which often combine office space, retail at the ground level, and hotel and residential (usually in the form of serviced apartments) in the upper part. Such "hybrid buildings" (Fenton 1985; Shane 2007, 253–257), however, are not a novelty, as different examples can be identified already in the first half of the

twentieth century, starting from the Downtown Athletic Club described by Koolhaas (1978) in *Delirious New York*. Still, it is since the late 1990s that the trend took strength. Looking at the work of KPF, one of the major firms involved in the design of skyscrapers, including several super and megatall ones, can be helpful. In 1989, 900 North Michigan Avenue (195,100 m^2, 265 m) was inaugurated in Chicago. The tower integrated five major programmes: a shopping mall inside the podium, a hotel, office space, and apartments on the upper floors. In 2000, the JR Central Towers & Station (681,000 m^2, 245, 226, and 211 m) in Nagoya marked another step in KPF's growing expertise in mixed-use towers. The transit-oriented development, with an almost triple GFA compared to the previous building, included three towers with distinct programmes (office, hotel, and residential) above a train station and a high podium. While more projects of mixed-use developments composed of several high-rise buildings with differentiated programmes were completed in Asia during the 2000s, the following step was represented by integrating different programmes within a single skyscraper. With the International Commerce Centre (2000–10, 260,000 m^2, 484 m) in Hong Kong and the Shanghai Financial Centre (Sect. 9.2), the typology of the supertall tower with a commercial base, office in its central part, and hotel function at the top was defined. Looking at the supertall buildings of China, such a trend towards a more programmatic complexity is well visible. In our sample of supertall buildings designed by overseas architects, most are mixed-use, and just a few are mono-functional skyscrapers, usually for offices. In this regard, the last decade has seen a rapid growth of mono-functional tall and supertall residential buildings, although, of the latter typology, not many have been built (Sect. 8.1). At the same time, more and more programmes are now envisioned within tall buildings, from prisons in New York (Wainwright 2019) to schools in Australia (Newton 2019).

5.2 At the Top (the Largest Number): China

As seen, China hosts by far the highest number of tall buildings in the world. Given these figures, in the present section, we will limit our discussion to the supertalls designed by international design firms from our batch, highlighting and measuring their importance as actors in this market. The geography of tall buildings designed by overseas firms in China, which is quite similar to the general one previously seen, can be explored in its historical development. During the 1980s, buildings above 100 m flourished in Hong Kong, thanks to the work of local firms like Ng Chun Man & Associates, Roland & Lu, and Wong & Ouyang, to name a few. By 1990, in addition, Norman Foster had already completed a high-tech milestone HSBC Headquarters, while I.M. Pei was designing its counterpoint, the Bank of China Tower (Sect. 3.4; Fig. 5.2). In mainland China, on the other hand, the construction of skyscrapers gained steam during the 1990s. At that time, most buildings were designed by Hong Kongese firms, although there were notable exceptions. In Beijing, Nihon Sekkei completed the Jing Guang Centre (1986–90, 145,000 m^2), an early example of a mixed-use

Fig. 5.2 The HSBC Headquarters by I. M. Pei, Hong Kong. Photograph by WiNG, distributed under a CC BY 3.0, available at https://commons.wikimedia.org/wiki/File:HK_Bank_of_China_Tower_2008.jpg

5.2 At the Top (the Largest Number): China

office and hotel tower with one apartment at the top. Thanks to its 208 m, it remained the tallest building in China until 2006. In Shanghai, the Japanese megafirm, one of the first to land in China during the 1980s, completed the Shanghai International Trade Centre (1988–91, 90,000 m², 146 m), another mixed-use tower with office and residential space occupied by Japanese companies and expats. The skyline of the city was then changing, mainly thanks to projects of John Portman like the Shanghai Centre (1985–1990, 181,000 m², 164, 112, and 112 m; Fig. 5.3), first, and the Bund Centre (2002, 198 m; Fig. 5.4), later, or the BOCOM Financial Tower (1999, 230 m) by ABB Architekten (not included in our survey) and the East China Architectural Design & Research Institute (ECADI). More complicated, instead, was the fate of one of Shanghai's landmarks: the Shimao International Plaza (1995–2006; 318 m; Fig. 5.5). Designed by Ingenhoven in 1995, its development was halted by the consequences of the 1997 Asian financial crisis, and when construction started, the project passed into the hands of Chinese architects. The 1990s thus marked the beginning of a frantic period for foreign firms with expertise in skyscrapers, then drafting unsuccessful projects across the country, from the 21st Century Tower by Murphy/Jahn in Shanghai to HLW's Chongqing Tower and Loebl Schlossman & Hackl's (not included in our survey) AVIC Plaza Tower in Shenzhen (Dietsch 1994). By the decade's end, the first supertall was also completed: SOM-designed Jin Mao Tower (Fig. 5.6). It was then followed by some skyscrapers sensibly taller than the average of the period but still below the three-hundred metres benchmark: KPF's Plaza 66 (1994–2001, 213,800 m², 288 m; Fig. 5.7), built beside the Shanghai Centre, the Hong Kong New World Tower (1998–2004, 140,000 m², 278 m) by B+H, and John Portman's Tomorrow Square (1996–2003, 93,000 m², 285 m; Sect. 10.4). As skyscrapers grew higher, foreign firms, especially American ones, got more involved up to create a kind of oligopoly.

Overall, since the early 2000s, buildings have gone higher and higher worldwide: in 2000, there were 24 supertall skyscrapers built; by 2020, they were 185. And nearly half of these new ones have been built in China. A detailed analysis shows that this market belongs to a very restricted number of architectural firms that dominate all the design phases of these demanding projects. US firms lead. SOM has completed nine supertalls in China, with at least four more currently under construction. KPF has completed eight, while Gensler has designed the tallest building in China: the Shanghai Tower, soaring 632 m in the sky. Other relevant players have also been Adrian Smith + Gordon Gill, RMJM, and Goettsch Partners, plus a few more firms able to complete at least one supertall. We can easily observe the role of these firms by looking at the cities of the Pearl River Delta. Here, most of the existing supertalls have been designed by foreign firms (Table 5.1) and constitute key elements of monumental urban configurations. In Shenzhen, the 600-m-tall Ping An Finance Centre crowns the Futian CBD along the Civic Centre urban axis, while other supertalls are scattered in the different CBDs of the city (Fig. 5.8). In Guangzhou, the International Finance Centre (IFC) and the CTF Finance Centre are located at the intersection between the north–south urban axis of Tianhe District and one of the branches of the Pearl River (Fig. 5.9). While the CTF emerges for its more fragmented and receding volume, the IFC is characterised by a smoothly curving continuous surface, a profile

Fig. 5.3 The Shanghai Centre by John Portman Architects, Shanghai. Photograph by Giaime Botti, distributed under a CC BY 4.0

5.2 At the Top (the Largest Number): China 171

Fig. 5.4 The Bund Centre by John Portman Architects, Shanghai. Photograph by Giaime Botti, distributed under a CC BY 4.0

172 5 The Skyscraper: Go East, Go High, Go Hybrid

Fig. 5.5 The Shimao International by Ingenhoven, Shanghai. Photograph by Giaime Botti, distributed under a CC BY 4.0

Fig. 5.6 The Jin Mao Tower by SOM in-between the Shanghai Tower and the Shanghai World Financial Centre, Shanghai. Photograph by Giaime Botti, distributed under a CC BY 4.0

Fig. 5.7 The Plaza 66 by KPF, Shanghai. Photograph by Giaime Botti, distributed under a CC BY 4.0

5.2 At the Top (the Largest Number): China

Table 5.1 Mega and supertall skyscrapers in the Pearl River Delta region designed by overseas firms

Designer	Project	City	Year	Programme	GFA (m^2)	Height (m)
KPF	Ping An Finance Centre	Shenzhen	2019	Mixed-use	462,000	600
KPF	CTF Finance Centre	Guangzhou	2013	Mixed-use	508,000	530
Farrells	KK100	Shenzhen	2007–11	Mixed-use	417,100	448
WilkinsonEyre	Guangzhou International Finance Centre	Guangzhou	2004–10	Mixed-use	250,095	440
KPF	China Resources Tower	Shenzhen	2019	Office	210,000	392
SOM	Shen Ye Upperhill Mixed Use	Shenzhen	2017	Mixed-use	442,991	388, 299
Morphosis	Hanking Centre Tower	Shenzhen	2012–20	Office	166,800	350
KPF	One Shenzhen Bay, Raffles Shenzhen	Shenzhen	2013–19	Mixed-use	460,000	341
Goettsch Partners	Poly 335 Financial Centre	Guangzhou	2017–23 (UC)	Mixed-use	302,998	332, 189, 185, N.A.
Gensler	Qianhai Shimao Financial Centre	Shenzhen	2015–20	Office	150,000	330
RMJM	Shenzhen Bay Innovation and Technology Centre	Shenzhen	2014–20	Mixed-use	540,000	320
RMJM	Zhuhai St Regis Hotel & Office Tower	Zhuhai	2017	Mixed-use	484,000	320
SOM	Pearl River Tower	Guangzhou	2005–13	Office, retail	214,000	309

(continued)

Table 5.1 (continued)

Designer	Project	City	Year	Programme	GFA (m^2)	Height (m)
Adrian Smith + Gordon Gill	Shenzhen Zhongzhou Holdings Financial Centre	Shenzhen	2007–15	Mixed-use	233,000	300

Fig. 5.8 The Ping An Finance Centre by KPF (on the right) and the Civic Centre by US firm Lee/Timchula Architects (in the foreground at the centre) in Futian CBD, Shenzhen. Photograph by Jie Luo, distributed under a CC BY 3.0, available at https://commons.wikimedia.org/wiki/File: City_(247882861).jpeg. Modified by Giaime Botti

that widens as it rises and then narrows towards the top, and a diagrid visible behind its glazed surface. Seen from the north, the two skyscrapers frame the view of the Canton TV Tower (2004–10, 114,000 m^2, 600 m), a touristic landmark designed by Dutch firm Information Based Architecture and positioned south of the river. The axis, conceived as a traffic-free linear public space with cultural facilities, including Zaha Hadid's Opera House (Sect. 6.3), and shopping malls (Sect. 10.5), ends in the north with the CITIC Plaza Tower. Designed in the 1990s by Hong Kong firm Dennis Lau & Ng Chun Man Architects & Engineers, with its symmetrical two-antenna top, it dominates the northern end of the axis with a striking resemblance (noted in popular culture on the internet), especially in foggy nights, to the eye of Sauron of the Barad-dûr fortress in the *Lord of the Rings*.

5.2 At the Top (the Largest Number): China

Fig. 5.9 The International Finance Centre by WilkinsonEyre (on the left) and the CTF Finance Centre by KPF (on the right) in Zhujiang New Town (Tianhe CBD), Guangzhou, in 2014. Photograph by Giaime Botti, distributed under a CC BY 4.0

The race to the top, in quantitative terms, has been won by Shenzhen, but it was started by Shanghai, where we can still find the tallest building in China and the third in the world (but the second when it was built), Gensler-designed Shanghai Tower (Table 5.2). This twisting skyscraper is the last of three that create an impressive cluster of supertalls, initiated by the construction of SOM's Jin Mao Tower in the mid-1990s and continued with the completion of KPF's World Financial Centre in 2008, popularly known as the 'bottle opener' tower. The three supertalls, together with the iconic Oriental Pearl Radio & Television Tower (1991–94) by the Shanghai Modern Architectural Design Co., define the crowded skyline of Lujiazui, the main business district of the city (Fig. 5.10). On the opposite side of the Huangpu River, where some traces of the historical Shanghai still resist, we find the Bund, with its early-twentieth-century neo-classical and eclectic buildings like the HSBC and the Custom House (Sect. 3.2), and the central area around People's Square, where several high-rises built in the 1990s and early 2000s are located. Thus, Lujiazui and this area constructed the image of Shanghai as an international, modern metropolis open to business (King 2004, 125; Ren, 2011, 11).

On the contrary, Beijing has embraced a different urban narrative. In fact, only two supertalls have been built in Chaoyang CBD: KPF's CITIC Tower and SOM's China World Trade Centre (Fig. 5.11), a complex composed of a 330-m tower plus a second one measuring 295 m. Although there have been more restraints on buildings' heights, the CBD hosts several more skyscrapers. In any case, its development is also

Table 5.2 Mega and supertall in Beijing and Shanghai designed by overseas firms

Designer	Project	City	Year	Programme	GFA (m²)	Height (m)
Gensler	Shanghai Tower	Shanghai	2008–15	Mixed-use	540,000	632
KPF	CITIC Tower	Beijing	2018	Office	437,000	528
KPF	Shanghai World Financial Centre	Shanghai	1997–2008	Mixed-use	381,600	492
SOM	Jin Mao Tower	Shanghai	1994–99	Mixed-use	287,000	421
SOM	China World Trade Centre 3A and 3B	Beijing	2010	Mixed-use	280,000	330, 295
SOM	Sinar Mas Centre	Shanghai	2018	Mixed-use	396,700	319
Ingenhoven	Shimao International Plaza	Shanghai	1995–2006	Office	N.A.	318

interesting in light of the scope of this book. The idea of building a CBD to compete with Shanghai was put forward in 1993, and in 1998 the area of Chaoyang was identified. In 2000, an international competition for the master plan was launched, with eight firms invited: NBBJ, SOM, GMP, and, not included in our survey, Johnson Fain, the Urban Environment and Research Institute of Japan, Kuipercom & Pangnons, Beijing Planning and Design Institute, and Shanghai Urban Planning and Design Institute. The winning scheme, announced in 2003, was that of Johnson Fain, which organised the four-square-kilometre CBD in a mixed-use area with a resident population of 51,000 and an employee population of over 162,000 to be accommodated in 1.7 million square metres of residential space, 3.6 million of office, plus 319,000 of hotel, 556,000 of commercial, 755,000 of culture and entertainment, and 51,000 of conference and exhibition. The same year, a second competition was held and won by Pei, Cobb, Freed and Partners for the detailed design of the core area of the CBD (Ren 2008, 523).

Still, the cities of the Pearl River Delta, Shanghai, and Beijing together do not make for the majority of the supertalls of China, which in fact have popped up in many more urban centres. Super and megatalls have been built in several provincial capitals and other second or third-tier cities (Table 5.3), while several more are currently under construction despite the recent ban (Table 5.4).[2] Going into the details of every one of them is of little interest. For the moment, it is enough to notice, once again, the condition of oligopoly of this market, which is mostly dominated by some US megafirms. And one more time SOM stands out, with three supertalls built only in Tianjin (Fig. 5.12), for example. In this regard, exceptions are Zaha Hadid Architects' Nanjing International Youth Centre, Morphosis' Hanking Centre Tower in Shenzhen, two projects by WilkinsonEyre, including the Guangzhou IFC, and one by GMP under construction. A significant and more original project from this list is Safdie Architects' Raffles City in Chongqing, which we will discuss later (Sect. 5.7).

[2] Data may be incomplete due to the difficulty of mapping all projects, sometimes not publicised by the design firms as well as in understanding the project's actual status.

5.2 At the Top (the Largest Number): China 179

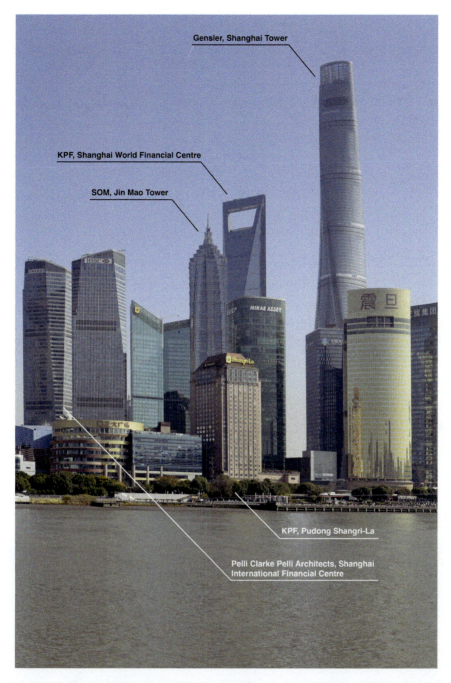

Fig. 5.10 Lujiazui's skyline, Shanghai, with marked the Jin Mao Tower by SOM, the Shanghai World Financial Centre by KPF, the Shanghai Tower by Gensler, the Shanghai International Financial Centre by Pelli Clarke Pelli Architects, and the Shangri-La Pudong by KPF. Photograph by Giaime Botti, distributed under a CC BY 4.0

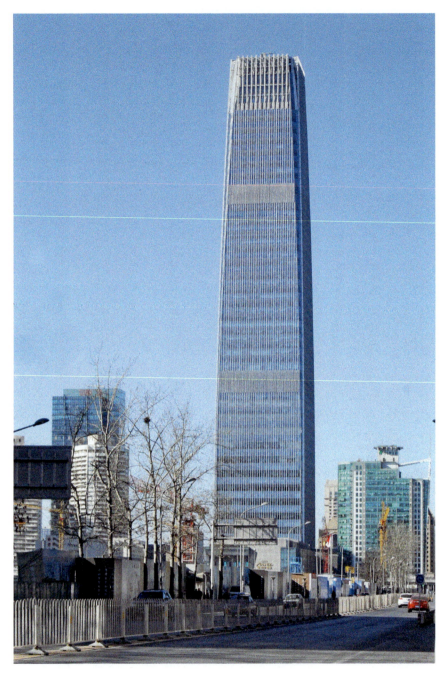

Fig. 5.11 China World Trade Centre by SOM in Chaoyang CBD, Beijing, in 2014. Photograph by Giaime Botti, distributed under a CC BY 4.0

5.2 At the Top (the Largest Number): China

Table 5.3 Mega and supertall in second and third-tier cities (New Tier 1) designed by overseas firms (surveyed sample)

Designer	Project	City	Year	Programme	GFA (m^2)	Height (m)
SOM	CTF Finance Centre	Tianjin	2019	Mixed-use	389,980	530
KPF	International Finance Square-Niccolo Suzhou	Suzhou	2010–19	Mixed-use	303,000	452
SOM	Zifeng Tower	Nanjing	2009	Mixed-use	308,000	450
Goettsch Partners	Nanning China Resources Centre Tower	Nanning	2014–20	Office	272,260	403
NBBJ	Eton Place Dalian	Dalian	2015	Mixed-use	250,000	383, 260, 150
WilkinsonEyre	Yuexiu Fortune Centre	Wuhan	2011–17	Mixed-use	205,000	330, 165
KPF	Forum 66, Shenyang City Hang Lung Plaza	Shenyang	2007	Mixed-use	836,200	351
Safdie Architects	Raffles City Chongqing	Chongqing	2020	Mixed-use	1,127,000	354 (×2), 255 (×4), 228 (×2)
SOM	Tianjin Modern City	Tianjin	2010–16	Office	N.A.	338
SOM	Tianjin Global Financial Centre	Tianjin	2011	Mixed-use	345,000	336
Callison RTKL	Wuxi Suning	Wuxi	2010–14	Mixed-use	N.A.	328
Zaha Hadid Architects	Nanjing International Youth Centre	Nanjing	2011–18	Mixed-use	465,000	314, 255
SOM	Jianxi Nanchang Greenland Central Plaza	Nanchang	2015	Office	220,000	303
RMJM	Gate of the East	Suzhou	2016	Mixed-use	340,000	300

Table 5.4 Mega and supertalls in second and third-tier cities (New Tier 1) designed by overseas firms (surveyed sample) and currently under construction

Designer	Project	City	Year	Programme	GFA (m^2)	Height (m)
SOM	Greenland Jinmao International Financial Centre	Nanjing	2017–25	Mixed-use	N.A.	499
SOM	Greenland Centre	Xi'an	2017–24	Mixed-use	N.A.	498
Adrian Smith + Gordon Gill	Greenland Centre	Wuhan	2010–22	Mixed-use	N.A.	475
Adrian Smith + Gordon Gill	Greenland Tower	Chengdu	2011–22	Mixed-use	300,000	468
Atkins	Shenyang Baoneng Global Financial Centre	Shenyang	2013–23	Mixed-use	475,000	453, 308
Pelli Clarke Pelli	Riverview Plaza	Wuhan	2009–21	Mixed-use	407,000	450
GMP	Nanjing Financial City II	Nanjing	2016-?	Mixed-use	786,000	411
Pelli Clarke Pelli	1 Corporate Avenue	Wuhan	2010-?	Office	N.A.	376

As just mentioned, there is a continuous stream of new supertalls initiated in the last years, with Chinese developers and local administrators still betting on skyscrapers, even on supertall ones, despite the difficulties in the real estate sector and the new, restrictive policies issued by the central government. Thus, while the season of the megatalls seems over due to the overall ban on exceeding 500 m, it will be more difficult for small cities (small by Chinese standards) to build skyscrapers. Buildings higher than 150 m will be generally prohibited in cities below three million inhabitants, where it will be, in any case, impossible to exceed 250 m (Ni 2021). Nonetheless, the race to the sky, even if with limits now, has not ended. In Wuhan, the megalopolis of central China that has become a key industrial hub for the automotive sector, we can find five supertalls and eight more currently under construction, many of them designed by international firms surveyed in this book. The latest ones, launched in 2019–20 (and, therefore, not considered in our survey given their recent start), are KPF's Bund Fosun Centre, a two-supertall mixed-use complex, and the 420-m Great River Centre. But other stories are more telling. For instance, Adrian Smith + Gordon Gill's Greenland Centre is now close to completion after more than a decade since its announcement. This 475-m skyscraper was initially planned to achieve 636 m. Still, the financial problems of Greenland (one of China's biggest developers) forced it to put the project on hold several times, while its final height was also reduced due to the policies mentioned above. The building is also on track to become the most expensive in China and one of the most expensive in the world: its

5.2 At the Top (the Largest Number): China

Fig. 5.12 The Tianjin Global Financial Centre by SOM, Tianjin. Photograph by Giaime Botti, distributed under a CC BY 4.0

cost soared to U$4.5 billion, almost twice as much as that of China's tallest building, the Shanghai Tower, which cost U$2.4 billion, and much more than other supertalls. The Shanghai World Financial Centre cost U$850 million, The Gate to the East 0.7, The Ping An International Financial Tower 0.68, and the Jin Mao 0.54 (Emporis 2022). A mix of financial problems and the impact of new regulations have affected other projects, too. SOM's Greenland Centre in Xi'an (and probably also the Greenland Jinmao IFC in Nanjing), currently under construction, was lowered from 501 to 498 m during its development. The same happened to Atkins' Shenyang Baoneng Global Financial Centre, a complex currently under construction composed of two supertalls, one of which was originally planned to achieve 568 and then lowered to 453 m due to new regulations as well as to financial difficulties that put the project on hold for some years.

Beyond our interest in mega and supertalls, we must acknowledge the impressive overall size of some firms' skyscrapers (100+ m) portfolio (Fig. 5.13). SOM, perhaps the practice that most in the world can be identified with high-rises, has cumulatively completed 9.3 kms of tall buildings in China. Two other US firms, Goettsch Partners and KPF, finished 5.1 and 4.8 kms, respectively. Still, the average height of these two firms' projects is different: 216 m for the former against 404 m for the latter. As for the rest, few other firms seem competitive in this market. GMP, with 3.5 kms of tall buildings, is still one of the top players, although it is interesting to note that the average height of its skyscrapers is only 175 m. In the lower band of this list, other successful actors are British megafirms like Atkins, Farrells, and RMJM, but also Zaha Hadid Architects, Foster + Partners, UN Studio, and OMA.

To conclude this section, we can look at some 'signature' towers, meaning those skyscrapers with formal qualities that distinguish them from more standardised projects. Such buildings, in addition, sometimes represent exceptions in terms of scale or height in a firm's portfolio. Zaha Hadid Architects' Nanjing International Youth Centre is so far the only supertall completed by the office. It consists of two towers, one of which reaches 314 m in height, connected to the lower volume of the conference centre through the building skin, which provides an image of fluid continuity between the fabric's vertical and horizontal bodies. A more extreme version of this would be the Shenzhen Bay Super Headquarters, a project launched in 2021 (and thus not included in our survey) and now claimed under construction. Other projects by Zaha Hadid, including some high-rise, will be commented on in Sect. 5.7, while we can now mention another firm that works with similar formal strategies: UN Studio. Its Raffles City Hangzhou (2008–17, 392,500 m², 256 and 156 m; developed by CapitaLand; Fig. 5.14) is a perfect example of such fluid geometries, with the commercial anchor of this mixed-use complex smoothly transforming into two towers. Morphosis' Hanking Centre Tower in Shenzhen features a vertical crystal volume with a slightly changing floorplan connected to an offset circulation core. Such a formal approach seems in line with other projects where formal games are developed on a simpler volumetry. The Guosen Securities HQ Tower (2010–19, 80,000 m², 228 m) in Shenzhen by Fuksas & Associati, for instance, is shaped as a simple rectangular extrusion vertically 'cracked' by a three-dimensional void. On the other hand, BIG's Shenzhen Energy HQ (2009–18, 96,000 m², 220 and 120 m;

5.2 At the Top (the Largest Number): China

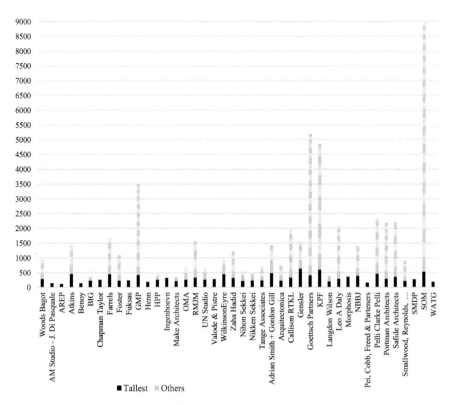

Fig. 5.13 Cumulative height of skyscrapers (100+ m) designed (built and under construction) by overseas firms (surveyed sample) in mainland China. Copyright Giaime Botti

Chap. 10, Fig. 10.29) consists of two towers linked by a podium and is characterised by a skin of continuous vertical fins denser at the buildings' edges, accompanying the volumes' twisting and folding at the bottom. Based on a different aesthetic, directly recovering the structural boldness of the HSBC Tower, is the recently completed DJI Sky City (2016–22, 160,000 m^2, 212 and 194 m) in Shenzhen by Foster + Partners. This complex accommodates photography drone manufacturer DJI's office headquarters and research space in two towers connected by a suspension bridge. The two buildings are made of floating multi-storey volumes cantilevering from the central cores. Thanks to the external truss systems, these glazed boxes have column-free interiors to provide better-quality office space, and in some cases, they have a quadruple height to allow drone flight testing. A project like this proves that complex parametrically designed shapes do not make for all the innovation in high-rises; on the contrary, simple geometries and bold tectonic choices can still make the difference and produce a high-quality design.

Remaining in Shenzhen, a certain geometric rigour characterises two more skyscrapers built one next to the other: OMA's Stock Exchange (2006–13, 265,000 m^2, 254 m; Fig. 5.15) and Hans Hollein's SBF Tower (2009–14, 80,000 m^2, 200 m, Fig. 5.16). The first is a square-plan extruded building featuring four equal facades

Fig. 5.14 Raffles City Hangzhou by UN Studio, Hangzhou. Photograph by Giaime Botti, distributed under a CC BY 4.0

5.2 At the Top (the Largest Number): China

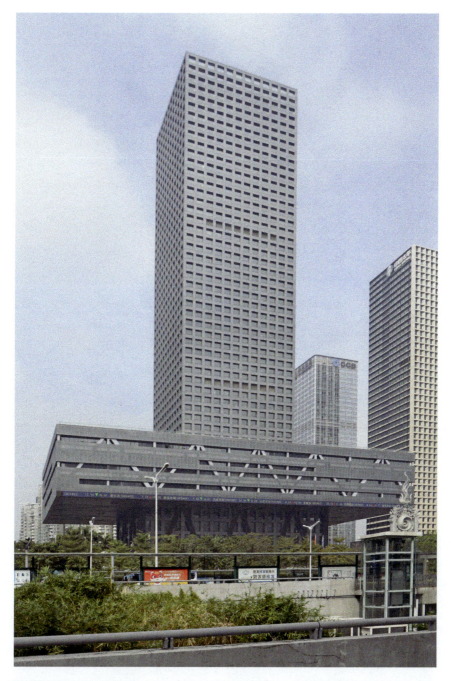

Fig. 5.15 The Shenzhen Stock Exchange by OMA in Futian CBD, Shenzhen. Photograph by Giaime Botti, distributed under a CC BY 4.0

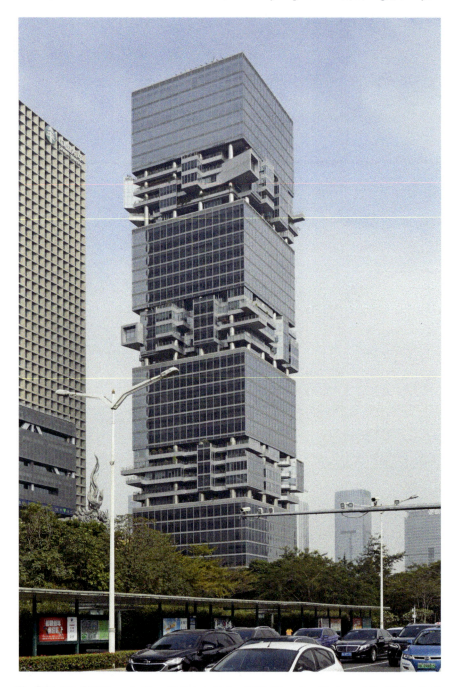

Fig. 5.16 The SBF Tower by Hans Hollein in Futian CBD, Shenzhen. Photograph by Giaime Botti, distributed under a CC BY 4.0

drawn on a deep and regular grid. What stands out, however, is the podium, which rather than connecting the tower to the ground as in every project since SOM's Lever House, is lifted 36 m above the ground floor and expansively cantilevered from its supports, a system of steel columns and diagonals anchored to the façade. How and how much the public space freed at the ground through this gesture will be used remains to be seen. Ultimately, the project is "creditworthy primarily because of its simplicity and restraint in the face of audacious GDP growth and fiscal confidence" (Williams 2013, 49). A simple but bold gesture that puts this tower conceptually into the line of Dubai Renaissance (Sect. 5.7) while at the same time it proposes a visibly bold structural solution comparable in terms of relevance in the economy of the design to the one of the CCTV Tower of Beijing (Sect. 5.7). In this way, the Shenzhen Stock Exchanges produces real distress to the podium plus tower typology. In contrast, the adjacent SBF Tower by Hollein does not propose anything beyond the formal game. Also square in plan, it raises alternating simple six-floor blocks (four in total) with multi-storey compounds formed by receding and cantilevering smaller volumes that fragment the overall mass and provide a pixelated image to these parts.

Finally, there is a formal trend to point out: the diffusion of high-rises that develop the theme of the gate. While OMA's CCTV could also be considered one of them, such a reading would be too limiting. On the other hand, the RMJM-designed Gate of the East in Suzhou is the most striking example of such type of project. The building was made the object of mockery for its resemblance to a pair of pants (Business Insider 2012), something like what happened to CCTV, although it was even Koolhaas' *Content* to make irony of this. Indeed, while also Chinese firms like MAD Architects have worked with similar shapes—the Sheraton Huzhou Hot Spring Resort (2009–12, 59,686 m^2)–, it was Italian architect Joseph di Pasquale to spark outrage with his Guangzhou Circle (2013, 85,000 m^2, 238 m). This doughnut-like building, in the mind of the architect inspired by old coins, was, in fact, together with CCTV (may the comparison be forgiven!), one of those buildings designed by foreign architects that pushed the Chinese leadership to adopt a tougher stance on "weird" architecture (Frearson 2014).

5.3 At the Top (the Tallest): The Middle East

The Middle East, and especially the Persian Gulf monarchies, boasts some of the most vertically developed cities in the world. Dubai is currently ranked 4th for high-rises, and a few other cities are well positioned in this ranking: Abu Dhabi 34th, Doha 35th, and Riyadh 61st (CTBUH, Cities 2022). The region is also proud of hosting the tallest building in the world. Historically (Fig. 5.17), the verticalisation of Persian Gulf cities began at the very end of the 1990s, accelerating before the global financial crisis of 2007–08, which produced an evident slowdown in the following years, and only partially recovered since then. Compared to the Emirates, disaggregated data would show some growth even after 2008 for Qatar, and more steady numbers in Saudi Arabia. Still, 2019 has been a positive year, particularly in the UAE, with 12

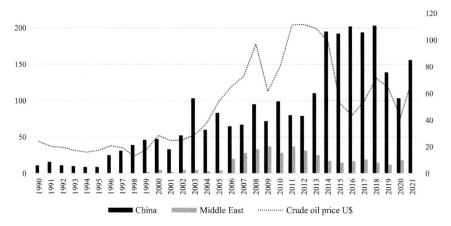

Fig. 5.17 Number of high-rises (150+ m) completed per year in China and the Middle East (data from CTBHU) and average crude oil price (in U$; data from en2x 2022). Copyright Giaime Botti

completions of 200+ m buildings, almost as much as in the USA (CTBUH 2020). While a specific correlation between construction and oil price is not a surprise, it is quite astonishing the correspondence of the two trends, mainly because we could expect a more marked temporal shift given the time that passes between the launch of a project (imagined in a positive economic context) and its completion (which can arrive years later during an economic downturn). That said, it is now time to explore the Middle Eastern cities' skyline, starting from Dubai, where we can count at least 26 mega and supertall buildings.

Any discussion on mega and supertalls cannot but begin with the highest building in the world, the Burj Khalifa (2003–10, 454,249 m^2), towering at 828 m in Dubai (Fig. 5.18). Developed by Emaar Properties as the landmark of Downtown Dubai next to the Dubai Mall and nearby the International Financial Centre, this 162-storey building designed by SOM features a Y-shaped floor plan, defining three separate accesses to its three main programmes: residential, hotel, and office. Moving upward, the floor plan surface reduces through spiralling setbacks up to the spire at the top. The success of SOM in the market of skyscrapers, so visible in China, is also evident in this region. The firm completed several projects, from the mixed-use Rolex Tower (2005–10, 60,400 m^2, 235 m) to the more impressive—with its looping and cantilevering volume—Mashreq Bank Headquarters (2013–20, 40,000 m^2, 165 m) in Dubai; from the folding-and-unfolding Muqarnas Tower (2020, 70,000 m^2) in the King Abdullah Financial District (KAFD) of Riyadh to the Al Hamra Tower (2006–11, 195,000 m^2, 412 m; Fig. 5.19) in Kuwait (a country that we did not survey). This mixed-use skyscraper with a glazed curtain wall twists on the three sides like an unravelling dress and leaves exposed the fourth one, corresponding to the building's core. This side, thus, was not only carved out from the tower's volume but also clad in stone and left almost blind due to its south orientation. That said, SOM is not the only big

5.3 At the Top (the Tallest): The Middle East

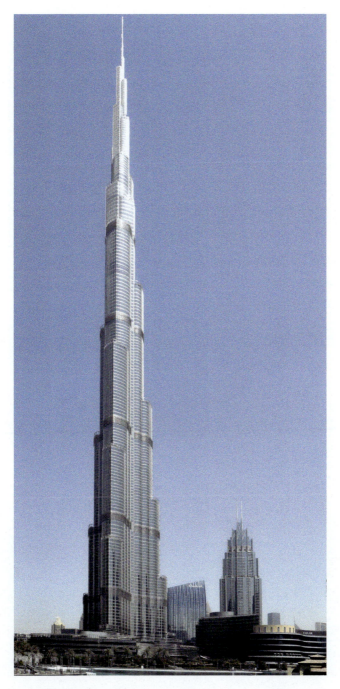

Fig. 5.18 The Burj Khalifa by SOM in Downtown Dubai. Photograph by Giaime Botti, distributed under a CC BY 4.0

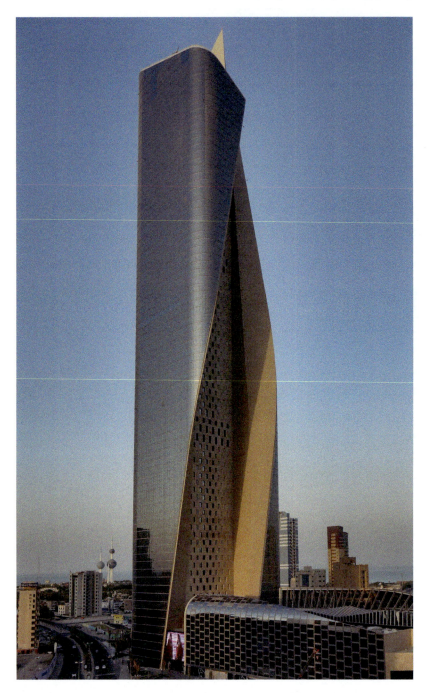

Fig. 5.19 Al Hamra Tower by SOM, Kuwait City. Photograph by Rob Faulkner, distributed under a CC BY 4.0, available at https://en.wikipedia.org/wiki/File:Al_Hamra_Tower.jpg. Modified by Giaime Botti

5.3 At the Top (the Tallest): The Middle East

player in the region, although for sure it could be considered the one with the highest design standards.

Canadian megafirm NORR boasts an extensive portfolio of projects in UAE, where it has been active since the 1990s, with at least 40 completed buildings and several more unbuilt projects,[3] while it has also been the Architect of Record for projects like SOM's Burj Khalifa and The Address Sky View (Sect. 8.1). In addition to some low-rise office buildings often designed before the new century, the firm has delivered at least 23 high-rise buildings for a cumulative built height of over 4,000 m. They include the Jumeirah Emirates Towers (2000, 354 m and 309 m; Fig. 5.20), which marked the beginning of the development of Dubai International Financial Centre (DIFC), a Special Economic Zone with a tax-friendly regime and an autonomous jurisdiction under a common law framework. A few hundred metres southwest, on the opposite side of Sheikh Zayed Road, the Shangri-La Hotel tower (2001–03, 196 m) imitated the American architecture of the "Roaring Twenties." Another prolific megapractice is Atkins, whose portfolio in Dubai includes at least 26 built works of different typologies for a total of over 1.2 million square metres. While several residential towers will be discussed in Sect. 8.1, we will now look at office skyscrapers, more to provide a comprehensive perspective in quantitative terms than an in-depth assessment, being these buildings rather unremarkable. Overall, they display a repeated, sober but banal, formal repertoire that includes straight geometries with more or less pronounced setbacks—The Aspect Tower (2005–09, 135 m) and the IPIC Square (2009–13, 185 m) in Abu Dhabi–, sail-like curvatures—Almas Tower (2005–08, 160,000 m^2, 360 m), Tiffany Tower (2005–09, 49,000 m^2, 181 m), and Iris Bay (2006–15, 36,000 m^2, 175 m)–, a 1990s high-tech emphasis on structural elements—the two almost identical Indigo Icon Tower on Jumeirah Lakes Cluster F (2005–09, 122 m) and Indigo Tower on Cluster D (2005–09, 139 m), or pastiche-like juxtapositions—Al Salam Tecom Tower (2003–09, 94,500 m^2, 195 m). Perhaps, the most valuable indication coming from these projects, well visible also looking at the residential high-rise presented further ahead in this section, is the frenzy of the years preceding the Great Financial Crisis of 2007–08, when all these works were initiated.

More in general, in Dubai (and the same for the rest of the region), designs oscillate between a relatively anonymous international (late)modernism and the pseudo-historical pastiche, with, in-between, many nuances and overlaps, as mirror glass often lies behind regionalist decorative elements. In the DIFC, for example, we can find the modernist tapered profile of Foster + Partners' office and residential Index Tower (2005–11, 51,407 m^2, 326 m; Fig. 5.21) and the reflecting volumes of the Central Park District 08 (2014, 42,000 m^2; Fig. 5.22) designed by Hopkins Architects as a positional and formal counterpoint to the Emirates Towers. These buildings stand *vis-à-vis* the Al Yaqoub Tower (2006–13, 328 m), which could be described as an over-scaled copy of the Big Ben—or more likely a reference to the Royal Clock Tower (2002–12, 601 m) in Mecca–, and The Tower (2000–02, 242 m), another pastiche of glazed surfaces regionalised with the Arab motif of interlaced

[3] Regretfully, data on built GFA by NORR are not available.

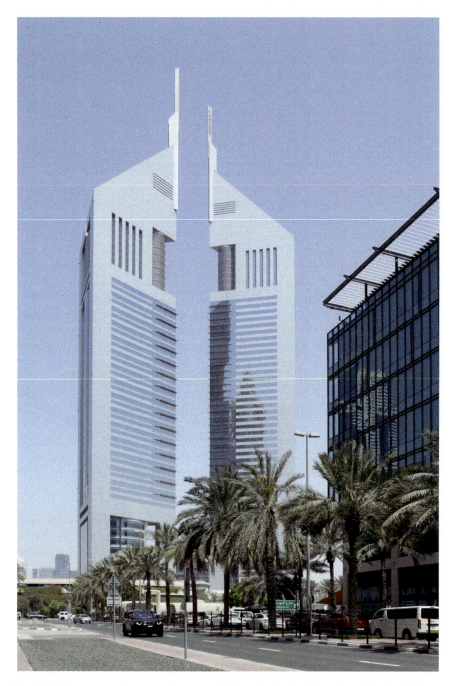

Fig. 5.20 The Jumeirah Emirates Towers by NORR in the Dubai International Financial Centre. Photograph by Giaime Botti, distributed under a CC BY 4.0

5.3 At the Top (the Tallest): The Middle East

Fig. 5.21 The Index Tower by Foster + Partners in the Dubai International Financial Centre. Photograph by Giaime Botti, distributed under a CC BY 4.0

Fig. 5.22 The Central Park District 08 by Hopkins Architects in the Dubai International Financial Centre. Photograph by Giaime Botti, distributed under a CC BY 4.0

5.3 At the Top (the Tallest): The Middle East

pointed arches (Fig. 5.23). An anonymous, and not particularly refined, modernism characterises several more residential, office, and hotel high-rise buildings, from Smallwood, Reynolds, Stewart, Stewart's Conrad Dubai (2006–13, 134,730 m², 250 m) to Cox Architecture's Park Place (2007, 232 m); from Woods Bagot's International Tower (2009–12) and Prime Tower (2007–13, 43,200 m², 158 m) to Nikken Sekkei's Dubai Chamber of Commerce & Industry (1995, 91 m). However, the Japanese firm has also authored the more daring One Za'abeel (2012-u.c., 330 and 235 m), composed of two simple prismatic towers connected at mid-air by a long and narrow cantilevering volume. Four more low-rise buildings will complete this complex currently under construction. It will then display a bold and recognisable image based on daring structural games and volumetric juxtapositions à la OMA rather than on weird shapes. In the Cayan Cantara Hotel and Apartments (2015-u.c., 175 and 150 m), on the other hand, the same conceptual boldness is not visible, despite the presence of a similar horizontal volume connecting the two towers. Before concluding our overview of Dubai, there is another aspect to highlight. Despite the strong presence of Western firms in the region, there are large AEC companies based in the UAE and in Qatar, as well as in India, sometimes established back in the 1960–70s, that have played a significant role in the development of the region. In Dubai, for instance, more than half of the ten highest skyscrapers were designed by firms like the Dubai-based National Engineering Bureau and Eng. Adnan Saffarini Office, KEO International Consultants, and Mumbai-based Architect Hafeez Contractor. Studying these firms' activities is outside this book's scope, but it would be essential in the future to broaden our view on architectural globalisation by making it less Western-centric.

In Abu Dhabi, the UAE's capital, skyscrapers are concentrated in the CBD along the eight-kilometre-long Corniche and at its Western extremity. The centre of the waterfront is dominated by Pelli Clarke Pelli's The Landmark (2004–13, 158,000 m², 324 m; Fig. 5.24), a residential and office skyscraper that, despite claims of establishing links with local traditions through sun-screens in the façade and a dodecagonal plan to recall Islamic patterns (Pelli Clarke Pelli Architects 2013), fails to engage with local identity as strongly as, for instance, the Petronas Towers did in Malaysia. On the next block, we also find the Abu Dhabi Investment Authority HQ (2008, 87,400 m²; Fig. 5.24) by KPF. In urban terms, the prominence of The Landmark on the Abu Dhabi waterfront is reinforced by the presence, a few blocks inwards, of the two polylobate glazed towers of the World Trade Centre Souk (2006–14, 607,000 m², 381 and 276 m; Fig. 5.25) designed by Fosters + Partners. This mixed-use development is composed of two towers—the tallest (Burj Mohammed Bin Rashid) is residential, and the other one accommodates office space—above a shopping mall also designed by the British firm in the form of a terraced podium wrapped by a textured façade of screens with geometrical motives. A third tower, with a hotel function, was initially envisioned but never built due to the consequences of the 2008 crisis. Further to the East along the Corniche stands the late-post-modern Capital Plaza (2006–11, 222,000 m²) by Smallwood, Reynolds, Stewart, Stewart, composed of five stone-clad towers (the three major ones achieving 210, 200 and 166 m) with different crowning elements, containing office, hotel, and residential on top of a commercial

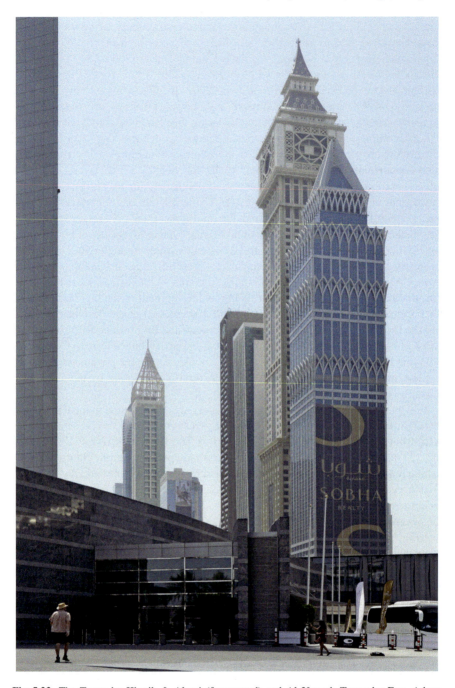

Fig. 5.23 The Tower by Khatib & Alami (foreground) and Al Yaqoub Tower by Eng. Adnan Saffarini (behind) in the Dubai International Financial Centre. Photograph by Giaime Botti, distributed under a CC BY 4.0

5.3 At the Top (the Tallest): The Middle East

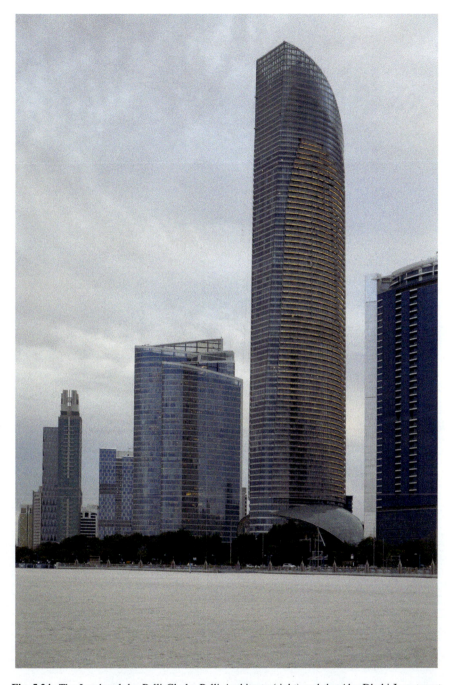

Fig. 5.24 The Landmark by Pelli Clarke Pelli Architects (right) and the Abu Dhabi Investment Authority HQ by KPF (left) in Abu Dhabi's Corniche. Photograph by Giaime Botti, distributed under a CC BY 4.0

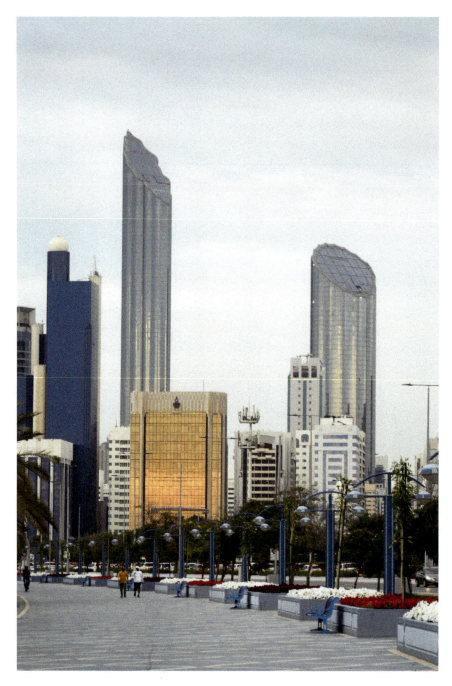

Fig. 5.25 The two towers of the World Trade Centre Souk by Foster + Partners viewed from the Corniche, Abu Dhabi. Photograph by Giaime Botti, distributed under a CC BY 4.0

5.3 At the Top (the Tallest): The Middle East

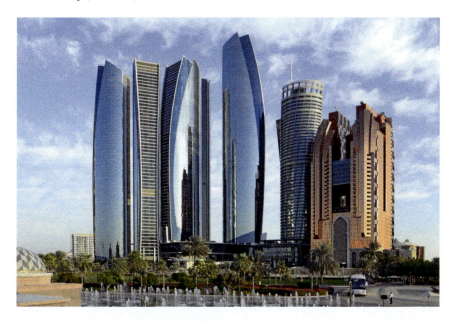

Fig. 5.26 The Etihad Towers complex by DBI, Abu Dhabi. Photograph by Giaime Botti, distributed under a CC BY 4.0

podium. On the West edge of Corniches, the most striking vertical development is the Etihad Towers (2006–11, 452,341 m^2; Fig. 5.26) designed by Australian firm DBI, a cluster of five twisting skyscrapers ranging from 217 to 305 m, quite reminding of HOK's Flame Towers (2007–13) in Baku, Azerbaijan. Nearby stands the second-tallest building in the city, the Abu Dhabi National Oil Company HQ (2009–15, 175,300 m^2, 342 m; Fig. 5.27), designed by HOK with the shape of a large bottle opener, and the Nation Towers (2012, 300,000 m^2, 268 and 233 m) by Canadian firm WZMH Architects (not included in our survey): two skyscrapers for apartments and hotel connected by a sky bridge at 202 m.

Outside the Corniche, other areas of the city boast towers authored by international architects. On Al Maryah Island, two rigorous projects by Goettsch Partners stand out: the staggered glass boxes of the Al Hilal Bank Office Tower (2012–15, 87,570 m^2, 120 m) and the monumental Abu Dhabi Global Market Square (2007–12, 529,360 m^2, LEED-CS Gold), a complex of paired symmetrical towers (131 m and 155 m on each side) with a lifted inverted and truncated pyramid in the middle (Fig. 5.28). In terms of massing and overall size, one of the most impressive developments in Abu Dhabi is the Gate Shams (2007–13, 809,600 m^2), designed by Arquitectonica. It extends over two city blocks and consists of several buildings. The smaller block is composed of two elliptical towers, the Sky (residential + office, 292 m) and Sun Towers (residential, 237 m), rising above a podium occupied by a shopping mall connected with the other block by a pedestrian bridge to a C-shaped residential volume (The Arc at Gate Towers, 84 m; Fig. 5.29) carved by some multi-storey

Fig. 5.27 The Abu Dhabi National Oil Company HQ by HOK, Abu Dhabi. Photograph by Giaime Botti, distributed under a CC BY 4.0

5.3 At the Top (the Tallest): The Middle East

Fig. 5.28 The Abu Dhabi Global Market Square by Goettsch Partners in Al Maryah Island, Abu Dhabi. Photograph by Giaime Botti, distributed under a CC BY 4.0

voids. Next to it, three 227-m towers (Gate Towers 1–3; Fig. 5.30) connected on top by a horizontal volume with penthouses follow the model established by Moshe Safdie in Marina Bay (2005–11, 845,000 m^2), Singapore, and form a gigantic gate-like crescent. Despite the boldness of the composition, the outcome is questionable from different points of view. The volume of the mall does not work as an active urban frontage because most of the ground floor is occupied by parking. Regarding the envelope, the whole complex is sealed with a sleek glazed curtain wall, making the interiors inhabitable only through the continuous use of air conditioning. Finally, while the overall composition of the Gate Towers is formally daring, the units do not gain anything from it but a nice view from a high point like in any other skyscraper. Spatial complexity is missing; apartments have no balconies; the roof of the massive sky bridge is not exploited. The only interesting exception is the presence of two elliptical voids in the sky bridge, to which the double-height living rooms of the penthouses open. In the end, the whole complex is much ado about (almost) nothing.

In Riyadh, in the mid-1990s, Fosters + Partners developed the Al Faisaliah Centre (1994–2000, 240,000 m^2, 267 m), a mixed-use complex towered by a 267-m-high pyramidal office tower. More recently, the British firm has also completed the SNB (former Samba) HQ (2009–20, 92,000 m^2, 160 m), characterised by a diamond-shaped floor plan and a diamond-like façade made of three-dimensional triangular panels of opaque and high-performance glass to reduce solar gains and energy demand. The building stands in the King Abdullah Financial District (KAFD; Fig. 5.31), a new three million square metres development master-planned by

Fig. 5.29 The Arc at Gate Towers (Gate Shams development) by Arquitectonica in Al Reem Island, Abu Dhabi. The Sky and Sun Towers are visible in the background (right). Photograph by Giaime Botti, distributed under a CC BY 4.0

Fig. 5.30 The Gate Towers 1–3 Towers (Gate Shams development) by Arquitectonica in Al Reem Island, Abu Dhabi. Photograph by Giaime Botti, distributed under a CC BY 4.0

5.3 At the Top (the Tallest): The Middle East

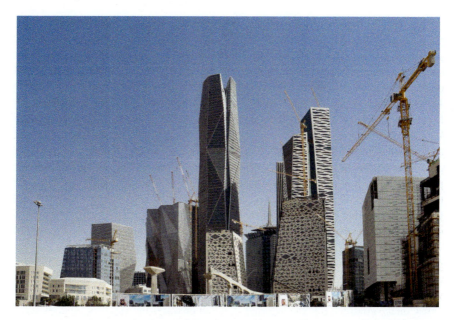

Fig. 5.31 The King Abdullah Financial District under construction in Riyadh. The PIF Tower by HOK is visible on the left, the KAFD World Trade Centre by Gensler on the right. Photograph by Mohamed Hussain Younis

Henning Larsen, where, according to data by CTBUH, 44 buildings from 26 to 385 m of height are currently built or under construction. Here, the Public Investment Fund (PIF) Tower (2009–21, 182,130 m^2, 384 m, LEED Gold), designed by HOK, soars above the new CBD. A cluster of skyscrapers designed by foreign architects is currently in the construction phase and includes SOM's Muqarnas Tower, Gensler's Gulf Cooperation Council Bank (2010-u.c., 264 m) and KAFD World Trade Centre (2010-u.c. 304 m), and Henning Larsen's Crystal Towers (2018-u.c., 93,000, 138 and 80 m). Both the WTC and the Crystal feature an envelope with irregularly shaped openings, in the first case like a torn building skin, in the latter according to a varied rhomboidal pattern, which indeed recalls Islamic geometric patterns. The KAFD also hosts mixed-use buildings like Henning Larsen's "Villas in the Sky" (209–18, 41,000 m^2, 160 m), a tower folding at the top as if pressed from above, but not really consistent with its name, and two projects by Adrian Smith + Gordon Gill: the Hilal Tower (u.c., 138 m) and the Ahlamana (2009–18, 78 m and 105 m), a two-building complex for office and dwellings. Several parcels with office, residential, and commercial space have been designed by FX Collaborative (over 300,000 m^2). In addition, a conference centre has been completed by SOM (Sect. 10.7). The area is also connected by the new Riyadh Metro through a station (2012–22, 45,000 m^2) designed by Zaha Hadid. Further north of the city, along king Fahd Road, in another area under development, stands the new Saudi British Bank Head Office (2020, 34,400 m^2, 135 m) by Callison RTKL.

The last city we analyse is Doha, Qatar, where several tall buildings have been popping up just after 2004. In these fifteen years, they granted the city the 36th position worldwide for buildings over 150 m, with 45 completed and a few more currently under construction. Like in Dubai, most of the tallest have been designed by companies based in Qatar or the UAE. They include MZ Architects' Palm Tower 1 and 2 (2006–11, 245 m each) and Doha WTC (2008–13, 241 m), and the Arab Engineering Bureau's Kempinski Residences and Suites (2009, 253 m), all built in the West Bay business district. The area and its high-rise architecture have been defined as "a lurid Notopian Hydra-head composed of more than 80 glimmering and often desperately, if not comically, overwrought towers. It's a traffic-dominated failure in planning and public realm terms" (Merrick 2018, 36), with one notable exception: the Burj Doha (2002–12, 60,000 m^2, 231 m) designed by Jean Nouvel. A cylindrical volume culminating with a dome, it reinterprets Nouvel's Agbar Tower (1999–2005, 47,5000 m^2, 142 m) in Barcelona and previous studies on the Tour Sans Fin (1989) with a circular plan and a peripheral structure. In both projects, the double skin plays an important role, not only in visual terms. But there are differences. In Spain, the tower is wrapped by a homogenous system of horizontal glass blades behind which we find changing background colours and a varied pattern of openings; in Doha, on the contrary, it is the external skin that provides the variation. It consists of star-shaped aluminium elements of three different dimensions, whose complete or partial overlapping creates different patterns and different degrees of transparency according to the orientation (Fig. 5.32); in many ways, it also reminds of Nouvel's studies applied to the façade of the Institut du Monde Arabe (1981–87, with AS) in Paris. As Davide Ponzini (2020) highlighted, the project represents a paradigmatic case of "transfer" from one original context to another. Architecturally speaking, nothing more shines out in the rest of the West Bay (Fig. 5.33), although a couple of buildings stand out for their formal twisting and squeezing. One is Al Bidda Tower (2006–09, 90,000 m^2, 196 m), designed by Australian firm GHD; the other is the Tornado Tower (2009, 134,000 m^2, 195 m), delivered by the Qatari firm CICO Consulting Architects & Engineers and German SIAT. In addition, but in a different part of the city, another tower with comparable lines raises: the torch-shaped Aspire designed by AREP, a multi-programme landmark (hotel, museum, restaurant, and platform view) overlooking the site of the 2006 Asian Games. With 300 m, it is also the tallest building in Qatar.

With these architectural ups and downs, metaphorically and not, the Persian Gulf region became a fundamental terrain for architectural experimentations, as Rem Koolhaas (2015) has provocatively emphasised in contrast to widespread and certainly not unmotivated negative narratives (Davis 2007). Like in China and a few other places, cities of the Middle East have triggered the imagination of many architects in different ways. Our reflections on formal and typological experimentations will be discussed later in the chapter. Now, our focus is on the dreams of highness that architects have always expressed. Still below the one mile (1,609 m) envisioned by Frank Lloyd Wright's The Illinois (1956), several more or less realistic megatalls have been proposed in the last two decades. The one-thousand-metre Nakheel Tower, previously known as Al Burj, was initially designed by Pei Architects, which Woods

5.3 At the Top (the Tallest): The Middle East

Fig. 5.32 The base of the Burj Doha and its *mashrabiya* pattern by Atelier Jean Nouvel, Doha. Photograph by Giaime Botti, distributed under a CC BY 4.0

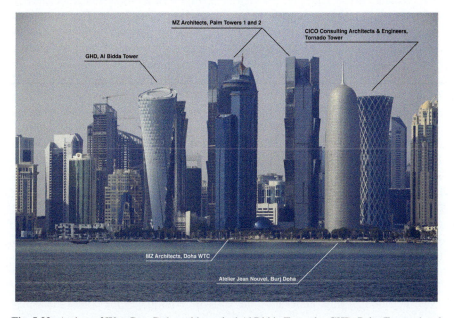

Fig. 5.33 A view of West Bay, Doha, with marked Al Bidda Tower by GHD, Palm Towers 1 and 2 and Doha WTC by MZ Architects, the Burj Doha by Atelier Jean Nouvel and the Tornado Tower by CICO Consulting Architects & Engineers and SIAT. Photograph by Giaime Botti, distributed under a CC BY 4.0

Bagot then replaced. This building even reached the construction phase until it was eventually put on hold. Unbuilt remained Adrian Smith + Gordon Gill's One Dubai, a three-tower complex planned to achieve at least 600 m. At the same time, the construction of the shard-like Jeddah Tower (2011, 1,000 m) in Saudi Arabia has begun, although it does not appear certain that it will come to an end. Other unbuilt megatalls of more realistic height also include Atkins' Entisar Tower (2016, 570 m) and Arabtec Tower (2013, 314 m), both put on hold in Dubai, Kenzo Tange's Park Square (2005, 666 m), and Nikken Sekkei's Burj Al Alam (501 m), not very originally shaped like a blossoming flower. Indeed, while these proposals would raise more than a few eyebrows, they often had behind the same developers that created the artificial islands of Palm Jumeirah (Nakheel) and the Burj Khalifa (Emaar). This is to say that in the Persian Gulf, for architects, nothing should seem impossible.

5.4 Unsatisfied Global Aspirations and Regionalist Reactions: South and South-East Asia

Many other cities worldwide, including major state capitals, have been undergoing a process of verticalisation resulting from a convergence of speculation on increasingly valuable urban land and growing competition in terms of image constantly making use of comparisons with other urban centres (Ong 2011). The aspirations of these "globalising cities" (Rennie-Short 2004) have found a visible outcome in constructing tall, supertall, and megatall buildings. However, despite the efforts, none of these cities has been able to sufficiently climb up international rankings and position itself at the top. Comparing the 2010 report on global cities elaborated by the consultancy Kearney to the one of 2018, it is not hard to spot a declining trend for a series of capital cities that have been hugely investing in megaprojects and skyscrapers to boost their image and their real estate market with the hope of increasing their attractiveness. In 2010, Mexico City ranked 30th, Mumbai 46th, Kuala Lumpur 48th, Jakarta 53rd, and Ho Chi Minh City 61st (Kearney 2010). By 2018, they had all lost positions: Mexico City to 38th, Kuala Lumpur to 49th, Mumbai to 52nd, Jakarta to 59th, and Ho Chi Minh City to 80th (Kearney 2018). All these cities, to varying degrees and at slightly different times, have been critical markets for overseas design firms with expertise in high-rise projects. In addition, their vertical growth can be taken as an indicator of changing dynamics at the global scale and thus be used to investigate how this affected the architecture market.

To discuss this, we can start with one event: the completion of the Petronas (twin) Towers (1992–99, 994,000 m^2, 451 m; Fig. 5.34) in Kuala Lumpur, Malaysia, in 1999. For the first time in decades, the USA were no longer the country boasting the highest building in the world. For the first time, it was an Asian country. This marked the beginning of a trend that has only changed in the present. Designed by Pelli Clarke Pelli Architects, the Petronas Towers were completed just after the 1997 financial crash, which hit Malaysia particularly hard. However, their construction

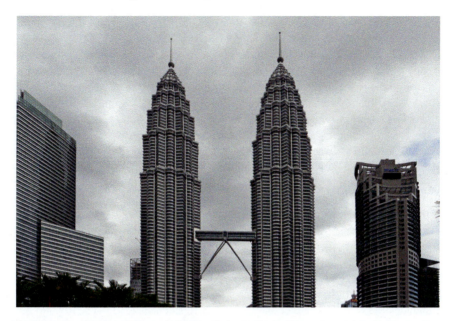

Fig. 5.34 The Petronas Towers by Pelli Clarke Pelli Architects in KLCC, Kuala Lumpur. Photograph by Giaime Botti, distributed under a CC BY 4.0

had begun in a moment of economic euphoria, the first half of the 1990s. This period saw the rise of several countries in East and South-East Asia, starting from the so-called 'Asian tigers.' For its part, Malaysia's GDP growth rate was never below 9% between 1988 and 1996. Economic buoyancy, however, does not alone explain the project. As Tim Bunnell (1999) pointed out, the towers could not "be understood merely as a function of land values," as they "articulate[d] state versions of modern Malaysia for consumption by the 'world' and by national citizens." Such buildings, indeed, reflected aspirations declined both at the global and the local scale, making a "powerful representational work in the production of definitions of Islam and Malayness" with the final aim of producing a spendable image of a "modern multicultural nation." To achieve this result, the project was part of a larger development named Kuala Lumpur City Centre (KLCC), which included a new concert hall, a high-end hotel, two office towers, and a park designed by Brazilian landscape architect Roberto Burle Marx. KLCC was "unprecedented" for Malaysia in terms of scale and ambition; it was the "centrepiece of a nation-building project" aimed at making Malaysia a modern and developed country by 2020 and symbolising a new, unified nation ready to face globalisation and its business opportunities (Loo 2013, 78). Overall, KLCC, according to the vision of Malaysian political leadership, was a "world class" megaproject aimed at transforming Kuala Lumpur into a "world city" (Bunnell 1999). Whatever this had since then happened or not is beyond the scope of this study, although this section of the chapter suggests a general failure in meeting these ambitious goals. What is certain is that KLCC and the surrounding

area have grown into a vertical cluster of towers of different programmes projecting an image of international modernity not devoid of local characters.

While in the 1990s, some US architects had designed skyscrapers in other areas of the city—from the unbuilt Sogo Pernas by HOK to John Portman's Capital Square, a mixed-use tower completed in 1994 and supposed to be paired by a second one whose works were interrupted after the 1997 crisis–, only from the early 2000s the Petronas Towers catalysed the development of KLCC area, with overseas firms at the forefront of this operation. Pelli Clarke Pelli Architects later designed the Menara Carigali/Petronas Tower 3 (2006–12, 141,300 m^2, 267 m), an office building with a commercial podium on the Southwest corner of KLCC. Foster + Partners designed the mixed-use Ilham Tower (2009–16, 92,000 m^2, 275 m), whose diamond-shaped plan and diagonal *brise-soleil* in the façade were presented as a response to local climate, and The Troika apartment buildings (2004–11, 95,000 m^2, 204 m). In the area (Fig. 5.35), US firm Arquitectonica has also recently completed the Permata Sapura Tower (2012–21, 171,000 m^2, 252), and BroadwayMalyan the Menara Prudential (2018, 51,000 m^2), while in another part of the city, the works for the mixed-use Dayabumi Tower are still underway (2012-under construction, 153,000 m^2, 290 m). Indeed, further fancy residential has also been added to KLCC. It includes SOM's WKL Hotel and Tropicana Residences (2011–18, 107,000 m^2, 238 m) and Le Nouvel at KLCC (2016, 200 m), named after its designer, Jean Nouvel. This high-end residential complex facing the Petronas Towers consists of two towers characterised by lush vegetation hanging from the thin metal frames running along the facades and by the mirroring crowning elements on their top (Fig. 5.36). With all this, Kuala Lumpur kept growing in other areas of the city. By 2019, the Exchange 106 Tower (445 m), designed by Indonesian firm Mulia Group was completed. And by 2023, the 678-m Merdeka 118 will be finished, too. By then, it will be the second-tallest building in the world. Designed by Australian firm Fender Katsalidis (not included in our survey) in association with the local branch of Singaporean studio RSP, the Merdeka 118 seems to respond to the same ambitions and reveal the same concerns of the Petronas Towers during the 1990s. As the Prime Minister of Malaysia claimed, the tower—whose name means "independent" in Malay—is not only "a great achievement in the field of engineering," but "it also further strengthens Malaysia's position as a modern and developed country" (Holland 2021).

It is thus surprising how little has changed in more than twenty years. Back in the 1990s, the Petronas Towers, beyond their role in promoting a modern and national image of Malaysia, or the fact that they represented the first world-tallest building erected in the East, also marked an important moment for contemporary architecture. In a time of declining postmodernism, they embodied an architectural language that

drew from Islamic culture, Kuala Lumpur's climate and light, and Malaysian craft and design. The plan of the towers is generated from two overlapping squares that form an 8-pointed star, a pattern frequently found in Islamic design. As the buildings rise, they step back six times, and at each setback, the walls tip outward slightly, adding complexity reminiscent of traditional Malaysian architecture" (Pelli Clarke Pelli Architects, Petronas Towers 1997).

5.4 Unsatisfied Global Aspirations and Regionalist Reactions: South … 211

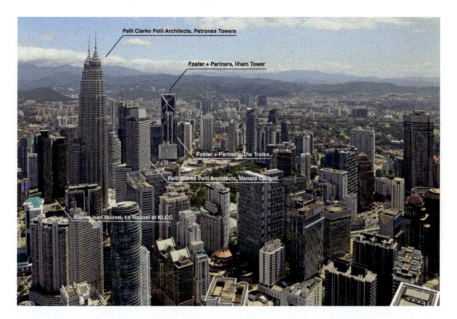

Fig. 5.35 A view of KLCC, Kuala Lumpur, with marked the Petronas Towers and the Menara Carigali (Petronas Tower 3) by Pelli Clarke Pelli Architects, Le Nouvel at KLCC by Atelier Jean Nouvel, the Ilham Tower and The Troika Apartments by Foster and Partners. Photograph by Giaime Botti, distributed under a CC BY 4.0

Fig. 5.36 The crowning element at the top of Le Nouvel at KLCC by Atelier Jean Nouvel in KLCC, Kuala Lumpur. Photograph by Giaime Botti, distributed under a CC BY 4.0

At the same time, their roof profile "unintentionally" recalled the Indo-Buddhist stupa, while the number of floors, 88, winked at the Chinese tradition. The two towers thus symbolised "a kind of dichotomy between the search for national identity and a unity between 'equals'" so important to Malaysian multi-ethnic reality (Jahn Kassim and Kamaruddin 2018, 232). Still, their embodiment of both (multiple) national tradition(s) and international modernisation was nothing new. On the contrary, it appears as the last step of a process initiated in the 1960–70s, when standardised, Western-like, high-rise designs were "regionalised" in Malaysia by the use of bioclimatic strategies to improve cross-ventilation and reduce solar gains (Jahn Kassim, Zainal Abidin and Mohd Nawawi 2018, 158–159). This modernist approach—dating back, we may argue, to Le Corbusier and Brazilian-Carioca architects, for instance—was by the 1970s replaced by the use of archetypal vernacular elements added to the fabric and later by more explicit symbolic elements—both in plans and façade patterns—in a moment of Islamic resurgence (Goh and Liauw 2009). Then, by the 1990s, steel and glass replaced concrete, and "a more iconic approach was to challenge the 'established' high-rise" to produce "powerful cultural landmark[s] through a visually strong form" (Jahn Kassim et al. 2018, 160–162). This may apply to the Petronas Towers but also to projects by local architects in Malaysia, Indonesia, and Singapore, who felt the pressure to counter the grip of foreign firms on the skyscrapers market by developing national and "supranational" responses (Kusno 2002, 131).

"Bioclimatic skyscrapers" (Yeang 2002) featuring sky-gardens and passive solar strategies meant as much an acceptance of the dominant global forms of the high-rise as an adaptation to local climate (Shannon 2014, 362–364). Projects like the Menara Mesiniaga designed by Malaysian firm T.R. Hamzah and Yeang Sdn Bhd, and the Telekom Tower (1998–2001, 310 m) by Hijas Kasturi Associates emerged as strong responses to "Western-related" glass boxes (Jahn Kassim et al. 2018, 167). Skyscraper design in South-East Asia during the 1990s was, therefore, marked by these tensions between the global and the local/national. Another example in Kuala Lumpur is Smallwood, Reynolds, Stewart, Stewart's Millennium Tower (2000, 60,000 m², 101 m), whose eclectic design "fashions the Manhattan look but not forgetting its local context and characteristics with a postmodernism treatment. The roof design features a dome-like structure that expresses the local Malaysian flavors" (Smallwood 2001). And these were not isolated cases in Asia. The most relevant one, for its dimensions and location, was SOM's Jin Mao Tower in Shanghai, but on the same page, we can also consider the Taipei 101 (1997–2004, 508 m; Fig. 5.37) designed by Taiwanese US-trained architects Chu-Yuan Lee and Wang Chung-Ping. Explicitly inspired by the Asian pagoda, both megatalls featured a tiered profile with multiple eaves and a pointed top. These buildings, "icons celebrating the name of a multinational" while "assert[ing] local identity," thus appeared to Jencks (2011, 120–122) "more convincing than Late-Modern monoliths" of many cities. And some twenty years after the Petronas Towers, the Merdeka 118 tries to answer similar political and cultural anxieties: the global and the local, modernisation and identity. How it does so, in the end, is only slightly different from the 1990s. As the project architects state, its "faceted design is an expression of its structural pathways, resulting in a pattern of triangular shapes reminiscent of those found in traditional Malaysian arts

5.4 Unsatisfied Global Aspirations and Regionalist Reactions: South ... 213

Fig. 5.37 The Taipei 100 by Chu-Yuan Lee and Wang Chung-Ping, Taipei. Photograph by Tianmu Peter, distributed under a CC BY 3.0, available at https://commons.wikimedia.org/wiki/File:%E5%8F%B0%E5%8C%97101%E5%A4%A7%E6%A8%93Look_around_-_panoramio_-_Tianmu_peter_(30).jpg

and crafts" (Katsalidis no date). Patterns, in this case, have almost dematerialised, being considered more symbolically than visually, but apparently, they remain the best way of regionalising international design. Or at least, this is how global architects understand the problem.

The tension between the anonymous glass box and the attempt to express local/national values—whether in the form of surface patterns recalling traditional artistry, symbolic monumentalism, bioclimatic approaches, or a combination of them—is also visible, although with less clarity, in other South-East Asian cities. In terms of high-rise presence, Jakarta currently ranks 13th in the world for 150+ m buildings, with 110, of which 46 are over 200 m. Reading more in detail the data elaborated by the CTBHU (2022a, b), it can be noted that the vast majority (78 on 149) of 100+ m buildings have been completed between 2007 and 2019, with a peak in 2015 (14) and 2018 (12), while also between 1996 and 1998 a peak is visible in the number of completions—respectively two, four, and eight–, followed by a few years of stagnation, due to the bust of the 1997 bubble. In achieving such a prominent position on the world map of tall buildings and developing a skyline worthy of an aspiring global city, the work of international firms has been fundamental. Overall, data collected in this research confirm a peak in the involvement of foreign architects in the region between 2016 and 2018, as well as steady growth throughout the twenty-first century's first decade.

In the 1990s, Pei, Cobb, Freed & Partners completed the Anggana Danamon (1991–97, 158 and 158 m) twin towers within a broader master plan that they had developed but that was later abandoned. In the meantime, KPF has finished the Bank Niaga Headquarters (1989–93, 64,000 m^2, 109 m), a tower featuring a similar 1990s aesthetic and the two main facades treated differently as to better respond to local climatic conditions (KPF 2005, 10). Since then, the US megafirm has been very active in the skyscraper market, with office buildings like the Niaga II Tower (2008, 65,100 m^2, 217 m), the LEED Platinum-certified Sequis Tower (2013–18, 138,800 m^2, 206 m), which features multiple sky-gardens—a greenwashing appropriation of the South-East Asian bioclimatic skyscraper of the 1990s–, and the Jakarta MPP (2017-under construction, 186,000 m^2, 266 m), expected to achieve a Green Mark Platinum certification. In the meantime, KPF also developed the mixed-use Thamrin 9 complex (2013-under construction, 186,000 m^2) that will soon include the tallest buildings in Jakarta: The Autograph Tower (382 m), paired with the Luminary (275 m), which will be ranked third. Indeed, another mixed-use project currently under construction will achieve second place: Broadway Malyan's 7Point8 (298 m). Broadening the view, it is clear that two phenomena have been taking place: the average building height has grown, while the programmes have gained in complexity, with more skyscrapers now featuring a rich *mixité* rather than simple office or hotel functions plus some retail.

Like in the case of China, the sub-market of tall and supertall buildings in South-East Asia remains in the control of a few players, mainly from the USA. Smallwood, Reynolds, Stewart, Stewart designed the mixed-use Pacific Place Jakarta complex (2007, 220,822 m^2, 180 and 180 m) plus The Ritz-Carlton Jakarta at Pacific Place (2005, 212 m), Altira Office Tower (2011–15, 61,391 m^2, 155 m) and the high-rise

5.4 Unsatisfied Global Aspirations and Regionalist Reactions: South ... 215

residences Taman Anggrek (240,000 m², 30 and 40 storeys). Callison RTKL designed the mixed-use Ciputra World Jakarta (2008–15, 583,000 m², 253, 206 and 194 m) and Grand Indonesia (241,540 m²), which includes the 240-m-tall Menara BCA office tower, high-end retail, hotel, and residences. The firm also developed a three-towers residential complex, the Jakarta Four Seasons. While also Pelli Clarke Pelli designed the mixed-use Capital Place and Four Seasons Hotel (2012–17, 135,000 m², 91 and 215 m), notable for its sky-gardens, Arquitectonica, which in the 1990s completed the residential Bona Vista Tower I (1997, 60,000 m², 147 m), later authored four office high-rises: the Adaro Energy Tower—Menara Karya (2005–06, 52,000 m², 126 m), the Menara Standard Chartered (2007, 38,20 m², 143 m), the Muamalat Tower (2012–16, 60,000 m², 87 m), and the Tempo Scan Tower (2012–16, 44,000 m², 143 m). Finally, NBBJ designed the rather anonymous, wholly and smoothly glazed, International Financial Centre (2010–16, 83,000 m², 213 m).

In addition, some other firms have been able to complete tall buildings, usually mono-functional office towers. Australian Woods Bagot completed the ornate Telkom Landmark Tower 1 and 2 (2012–17, 115,500 m², 105 m and 220 m), featuring a glass façade coupled with a *batik*-inspired metal frame aimed at reducing solar gains. Indeed, pixelated panels appear to protect the glazed façades of Denton Corker Marshall's Kompas Multimedia Towers (2014–18, 113 m), although their presence on every side and the lack of a full cover of the surface raise the suspicion that they perform a decorative function, perhaps reminding of an Islamic geometric pattern, rather than one of climatic control. The Australian firm also designed the relatively anonymous Menara Palma Office Building (2005–08, 126 m), the Allianz Tower (2008–11, 120), The Tower (2013–16, 212 m), and the formally more complex UOB Plaza Office Tower (2002–09, 194 m), characterised by a volume composed of slightly staggered glass boxes. To these, other office buildings can be added, including the Indonesian Ministry of Trade Building (2006–08), the Kuningan Place (2005–10), the Australian Embassy (2009–16, 46,400 m²), and several more buildings of different typologies that make Denton Corker Marshall one of the most active international firms in Indonesia since the end of the 1980s. Finally, a limited Japanese presence is also visible, although neither the recently completed Menara Astra office tower (2012–18, 160,000 m², 261 m) by Nikken Sekkei nor Tange Associates' Bank Danamon New HQ (2006, 39,292 m², 109 m), an unremarkable prism with a glass undulated façade, add anything to Jakarta's skyline. Indeed, more interesting would have been Tange's failed attempt in the 1990s to build the Kemayoran Telecommunication Tower (1995, 345 m), a straightforward synthesis of two of Norman Foster's best works of the time, the Hong Kong HSBC (1979–86) and the Commerzbank (Frankfurt, 1991–97).

In the world, Kuala Lumpur ranks 8th, Jakarta 13th, Bangkok 14th, and Singapore 16th for 150+ m buildings (CTBUH 2022a, b). This could be read as the result of an "aggressive global positioning" that has also relied on the construction of luxury residential and office skyscrapers for an "economically mobile and culturally independent wealthy middle class" (Shannon 2014, 369). Staying in South-East Asia, further behind in this ranking, we find Vietnam's largest city, Ho Chi Minh City (HCMC), formerly known as Saigon, in 66th position with 22 buildings above

150 m in height, three above 200 m, and one above 300 m. After it, the capital Hanoi ranks 94th, with 12 buildings above 150 m, five above 200 m, and one above 300 m (CTBUH 2022a). While Vietnam had experienced the second-highest average growth rate of GDP in the region during the last two decades (2000–19)—Cambodia 7.74%, Indonesia 5.26%, Malaysia 5.05%, Thailand 3.98%, Vietnam 6.47% according to the World Bank–, its cities, unlike Jakarta, Kuala Lumpur, or Bangkok, have only recently started their race to the sky. Again, to fulfil these ambitions, the expertise of a few international firms was requested. Albeit some US megapractices had their fair share of works, the tallest buildings were, in this case, designed by others. British multinational Atkins has recently completed the 469-m-heigh Vincom Landmark 81 in HCMC (2015–18, 241,000 m^2; Fig. 5.38), the tallest building in the country and the 15th in the world (as of 2022). This glazed skyscraper with an irregularly terraced volume accommodates retail at the lower level, residences in the intermediate part, and a hotel on top, confirming the recent trend in mixed-use supertalls. In Hanoi, the Keangnam Landmark 72 (2007–13, 603,584 m^2, 328 m), designed by South Korean firms Heerim Architects & Planners and Samoo, also features a mix of commercial, office, residential and hotel activities. On the other hand, more than ten years ago, Carlos Zapata in collaboration with the French firm AREP completed the BITEXCO Financial Tower in HCMC (2005–2010, 95,000 m^2, 264 m; Fig. 5.39), an office building characterised by a cantilevering helipad popping out from the main volume, which raises above a commercial podium. Other office towers in Hanoi include AREP's Vinacomin Tower (2009–19, 126,460 m^2, 160 m), the headquarters of the homonymous Vietnamese mining company, and KPF's 63 Ly Thai To (94,000 m^2), while Callison RTKL elaborated the project of the mixed-use Lotte Centre (2009–14, 92,900 m^2, 292 m).[4] On the contrary, Foster + Partners' VietinBank Business Centre (365 and 252 m), initiated in 2010, is currently on hold after the ground-breaking. In HCMC, Pelli Clarke Pelli completed the Vietcombank Tower (2010–15, 71,000 m^2, 206 m) and NBBJ the mixed-use Saigon Centre (2010–17, 92,000 m^2, 193 m). Currently under construction are also two more mixed-use complexes: SOM's Viet Capital Centre (2015-u.c., 69,485 m^2, 160 m, Gold LEED) and Arquitectonica's Spirit of Saigon + Ritz-Carlton Hotel and Residences (2010-u.c., 162,400 m^2, 224 and 218 m). In the end, while such projects demonstrate the growing verticalisation of major Vietnamese cities, they have not stimulated any significant debate nor displayed experimental results. Once completed, Arquitectonica's paired towers will be the most interesting product in formal terms.

Ranked 18th by the CTBHU (2022a), Mumbai is the tallest city in India, with 81 buildings above 150 m in height and 23 above 200 m, followed at a distance by Kolkata (111th) and Noida (178th). Its ranking reflects its standing as the country's financial and commercial capital. Like in Vietnam, tall buildings in Mumbai have been built almost exclusively in the last decade: construction works started as early as 2000, and the first significant number of completions were recorded in 2009 (CTBUH 2021b). Over a decade ago, Foster + Partners failed to complete the 700-m-high

[4] The Lotte World Tower (2011–17, 555 m) in Seoul, currently ranked as the 5th tallest building in the world, instead, was designed by KPF.

5.4 Unsatisfied Global Aspirations and Regionalist Reactions: South … 217

Fig. 5.38 The Vincom Landmark 81 by Atkins, Ho Chi Minh City. Photograph by Nick, distributed under a CC BY 2.0, available at https://commons.wikimedia.org/wiki/File:Vincom_Landmark_81_(49012084043).jpg

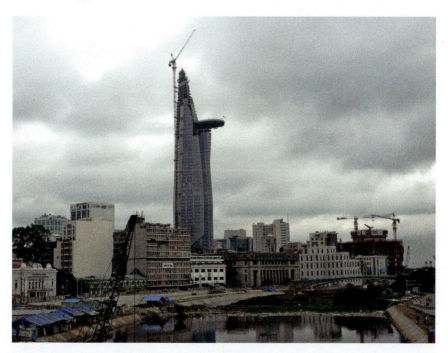

Fig. 5.39 The BITEXCO Financial Tower by Carlos Zapata and AREP, Ho Chi Minh City. Photograph by Ngô Trung, distributed under a CC BY 3.0, available at https://commons.wikimedia.org/wiki/File:Bitexco_Financial_Tower_view_from_Calmette_Bridge.JPG

India Tower (2010), whose works halted after the ground-breaking and never again resumed, and the Ocean Tower (2016, 331 m), while Gensler could not even start the Four Seasons Mumbai Tower (380 m). Today, a supertall is finally near completion, thanks to KPF's Three Sixty West (2011-u.c., 360,000 m^2, 361 and 255 m), a mixed-used hotel and residential complex split over two towers. Despite these failures, in Mumbai, firms designing luxurious high-rise residential developments have been successful, as this typology accounts for the 90% of the 150+ m buildings erected in the city (CTBUH 2021b), including the only skyscraper villa in the world (Sect. 8.1). All in all, tall buildings in India and South-East Asia are generally devoid of the experimental character of certain projects developed in China and the Persian Gulf, and they have never generated a particular debate, except for the Petronas Towers, which have also represented the only record-breaking building in the region, and the bio-climatic skyscrapers of the 1990s. In the region, office and residential towers tend to be even more anonymous than many of the projects seen elsewhere, while also the involvement of foreign architects is often limited to the concept design phase and, for this reason, gathering information on the actual development of the project is more complicated. Even a signature building like Le Nouvel in Kuala Lumpur does not appear in the architect's portfolio, likely because of the loose connection between the designer and the developer during the latest phases of the design process.

5.5 The Oil and Gas Boost: Russia

Moscow is today the second tallest city in Europe, after Istanbul and before London. It is also the 34th in the world, with 46 buildings above 150 m, of which six are supertalls. Indeed, while the first 100+ m skyscrapers arrived in many Western European countries during the 1960s, the tallest buildings in Europe could then be found in the Communist Block: the antenna spire of the Moscow State University main tower reached 240 m in 1953, while the Palace of Culture and Science in Warsaw 237 m in 1955 (Hollister 2013). In Moscow, the University Tower was just one of the seven so-called *Stalinskie Vysotki* (Stalinist high-rises), the skyscrapers built during the 1950s following the mainstream monumental, neo-Gothic-inspired style inaugurated by the winning project of the Palace of the Soviets competition of the 1930s. The other six projects were the Hotel Ukraina (1947–57, 206 m), the Kotelnicheskaya Embankment Building (1947–52, 176 m), the Kudrinskaya Square Building (1950–54, 176 m), the Ministry of Foreign Affairs (1948–53, 172 m), the Leningradskaya Hotel (1949–54, 136 m), and the Red Gate Administrative Building (1947–53, 138 m). Since then, however, and until the early 2000s, basically no more tall buildings have been added to the Moscow skyline. And one of the first in the new century was the Triumph Palace, a monumental residential tower inspired, very literally, by the architecture of the Stalinist skyscrapers. By the early 2000s, more tall buildings were ready for construction, many designed by German, British, and US firms in a rather international, modern fashion.

5.5 The Oil and Gas Boost: Russia

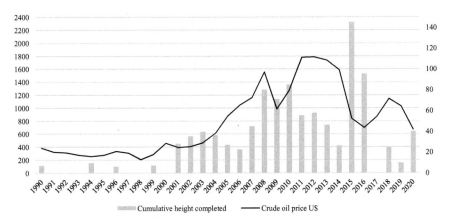

Fig. 5.40 High-rise (100+ m) buildings completed in Russia and average crude oil price per year (U$), 1990–2020. Copyright Giaime Botti

As data about the yearly completion of 100+ m buildings in the Russian capital show (Fig. 5.40 displays the cumulative height), we find a not-so-surprising correlation between crude oil price (and the same could be said for natural gas) and construction of tall buildings, which accelerates during the first decade of 2000, when oil prices were on the rise, drops few years after the 2007 financial crisis, and recovers soon after to then decay again. Another piece of information that can be inferred from the graph is the average height of the skyscrapers (CTBUH 2022b). Overall, it has been growing, and we can compare years in which several buildings were completed to understand this. In 2008 and 2009, ten and nine 100+ m buildings were completed, with an average height of 126–128 m. In 2015 and 2016, the completions were thirteen and ten, and the average was 178 and 152 m, respectively. In addition, we can notice that all the supertalls were completed after 2010. And while several residential high-rises have grown across the city, the tallest structures are clustered in the Moscow International Business Centre (MIBC; Fig. 5.41), the Russian financial district planned in 1992 and developed since then up to achieve one of the highest concentrations of skyscrapers in Europe.

The MIBC is dominated by the Federation Complex (2009–17, 442,915 m^2, 373 m), a mixed-use supertall designed by Russian-German Tchoban Voss Architekten[5] and Schweger Assoziierte Architekten. The second tallest building in the MIBC is SOM's OKO South Towers, a residential plus hotel supertall paired with a lower office tower. Both skyscrapers are fully glazed prisms with no visible special features, while certainly more calling is the spiralling Evolution Tower (2011–14, 169,000 m^2, 246 m) by RMJM. The whole area, indeed, hosts several more skyscrapers, most of which were designed by international firms. They include the

[5] Projects by Tchoban Voss' firm SPEECH, established in Moscow in 2006 have not been included in our survey.

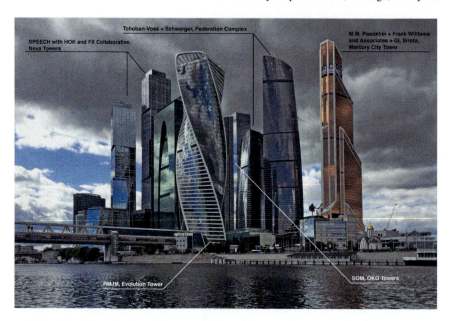

Fig. 5.41 A view of Moscow International Business Centre. Photograph by Gennady Grachev, distributed under a CC BY 2.0, available at https://commons.wikimedia.org/wiki/File:Moscow-city,_riverfront_view(31631549126).jpg. Modified by Giaime Botti

two City of Capitals towers by NBBJ, shaped with staggered volumes of constructivist inspiration, and the Imperia Tower by the same firm (Table 5.5). It is to be noted that the area, and more precisely the plot of the Neva Tower, was supposed to provide the space for a megatall skyscraper designed by Foster + Partners in 2006, the Russia Tower (600 m). The project, however, was abandoned due to the consequences of the Great Recession.

The development of areas like the MIBC and its multiple skyscrapers could not have been possible without the money from the oil and gas-generated *bonanza* of the first decade of the 2000s, which enriched companies like Gazprom and its parent Gazprombank. In 2006, the powerful Russian state-owned energy corporation launched an international design competition for its headquarters. The contest

Table 5.5 Skyscrapers designed by overseas firms in Moscow IBC

Designer	Project	Year	Programme	GFA (m^2)	Height (m)
Tchoban Voss Architekten + Schweger Assoziierte Architekten	Federation Complex	2009–17	Mixed-use	442,915	373
SOM	OKO Towers	2011–15	Mixed-use	447,085	354, 224

(continued)

5.5 The Oil and Gas Boost: Russia

Table 5.5 (continued)

Designer	Project	Year	Programme	GFA (m^2)	Height (m)
SPEECH in collaboration with HOK and FXCollaborative	Neva Towers	2014–20	Residential + hotel	349,232	345, 302
M. M. Posokhin + Frank Williams and Associates* + G. L. Sirota	Mercury City Tower	2014	Mixed-use	173,960	338
Swanke Hayden Connell Architects*	Eurasia Tower	2003–14	Mixed-use	212,900	308
NBBJ	City of Capitals	2003–10	Mixed-use	300,000	302, 257
Werner Sobek*	Grand Tower	2012-u.c	Office	390,000	283
Callison RTKL	Naberezhnaya Office Towers	2005–08	Office	N.A.	246, 127
NBBJ + ENKA	Imperia Tower	2001–11	Mixed-use	287,700	238
NBBJ + GPI 2	IQ Quarter	2006–15	Office	350,000	177, 141, 83

* Firms not included in our survey

produced some visionary projects signed by famous architects. Atelier Jean Nouvel, for instance, proposed a linear structure made of thin, transparent volumes, one on top of the other. OMA, for its part, envisioned a tower of vertically staggered elongated volumes, while Herzog & De Meuron a Baroque-inspired spiralling building. The outcome, however, was RMJM's Lakhta Centre (2012–17, 330,000 m^2, 426 m), a more banal, pointed spiralling tower (Fig. 5.42). For the rest, Saint Petersburg does not feature many high-rises, with just a bunch of 100–150 m towers, not least because its city centre is listed as a UNESCO World Heritage site, a status put under threat by the construction of the Lakhta Centre back in the 2000s (Harding 2007).

Thus, after Moscow, the tallest city in Russia is Yekaterinburg, but the figures are not comparable. Buildings over 100 m are in the dozen, with the tallest, the Iset Tower (2010–15), designed by Werner Sobek, achieving 209 m. In this competition, also French firm Valode & Pistre participated. It later produced the unsuccessful design of the Ural Tower, a 395-m supertall. Still, it is interesting to observe that despite these small numbers, a city like Yekaterinburg is ranked 14th in Europe, like Paris (the ranking is misleading, however, as most of the high-rises concentrate in the nearby area of La Défense, spread over different municipalities). At the same time, Madrid is 8th, and Milan 11th, just to provide some references. Finally, in Kazakhstan, Astana/Nur-Sultan boasts some tall buildings, starting from the currently under-construction 310-m Abu Dhabi Plaza designed by British firm HKR Architects (not included in our survey). The blueprint of the project, however, derived from a master plan by Foster + Partners, which replicated the Abu Dhabi World Trade Centre Souk's scheme for the same developer, Aldar. Indeed, the whole project was launched

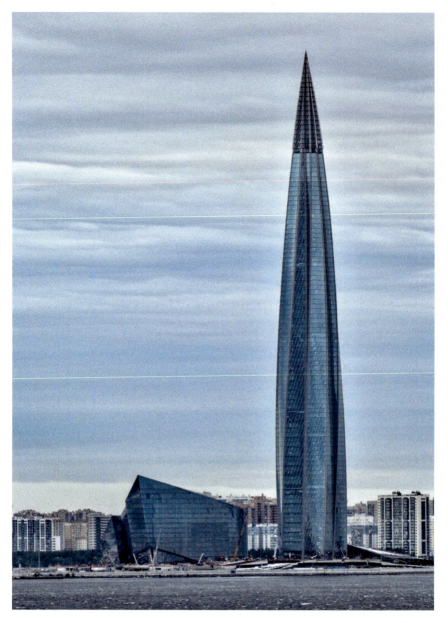

Fig. 5.42 The Lakhta Centre by RMJM, Saint Petersburg. Photograph by Mark Freeth, distributed under a CC BY 2.0, available at https://commons.wikimedia.org/wiki/File:Gazprom_tower_(Lakhta_Center)_St_Petersburg._Russia.jpg

following an agreement between Kazakhstan and Abu Dhabi for the creation of a Special Economic Zone (Ponzini 2020, 216–218). Located along one of the two main axes of the city, the tower, now near completion, stands not far away from the second tallest building of Astana, the Emerald Tower 2 (174 m). Designed by Canadian firm Zeidler Architects (also not included in our survey), it is part of a three-tower complex that is only partially completed (Tower 1 was never built while the 161-m-tall Tower 3 is standing beside it). All in all, while Nur-Sultan has extraordinarily developed in the last two decades thanks to oil and gas revenues (Sect. 7.3), it is still far from boasting an impressive skyline like that of other cities grown on fossil fuels' wealth.

5.6 A Different Chronology? Latin America

Except for Panama City (25th), Latin American urban centres do not rank high when it comes to tall buildings. Mexico City ranks 56th, with 26 buildings higher than 150 m and six above 200; São Paulo 81st (down from 64th just a year ago) with 17 buildings above 150 m, Bogotá 96th (down from 88th) and Buenos Aires 97th (down from the 88th too), both with 12 buildings higher than 150 m and respectively two and one above 200 m. Other capitals are even worse positioned, like Santiago de Chile ranking 210th (down from 192nd), even though it boasts one of the few supertalls of South America, Pelli Clarke Pelli's Torre Costanera (2005–14, 300 m). Still, any person familiar with certain Latin American cities could hardly consider their skylines low-rise, especially if compared to Europe and even many North American urban areas outside of the CBDs. Latin American cities feature a consistent presence of high-rise residential buildings lower than 150 m (and, for this reason, not mapped in the CTBUH statistics).

Phenomena of urban verticalisation have been evident in the last two decades, although data are scattered and incomplete. In Santiago de Chile, for example, the vertical growth of residential and office buildings has been recorded in the last twenty-five years, although it has involved only certain areas of the city (Vidal and Eduardo 2017). São Paulo, as anybody can experience, is not a horizontal city (Fig. 5.43), and it as such since the first decades of the twentieth century (Somekh 1992). This point prompts other considerations. Latin American major cities are vertical to a certain extent and have been as such for much longer than most of their Asian counterparts. While Asia has grown vertically only in the last three decades, except for colonial-era Shanghai (though at a different scale) and Japan, urban history tells something different in Latin America. By 1940, São Paulo counted 1,232 elevators in 813 buildings, most of them offices located in the city centre. Among these, the Martinelli Building (1924–29), designed by Hungarian architect Vilmos Fillinger, stood out with its 105 m. Until the end of the 1950s, 2,700 more buildings equipped with elevators were added (Somekh 1992). In 1943, while most of the world was under the bombs of World War II, the 120-m-high Acaiaca Building was inaugurated in Belo Horizonte. In 1947, after eight years of work, the Altino Arantes Building opened. Standing 160 m high, it surpassed all the skyscrapers built in Western Europe,

Fig. 5.43 A view of São Paulo from the roof of the Copan Building. Photograph by Giaime Botti, distributed under a CC BY 4.0

where it will take two decades to get higher. Milan's Torre Velasca, which engendered so much debate because of its medieval-inspired profile, only reached 106 m at its completion in 1958; Gio Ponti's so-called 'Pirellone' achieved 127 m the same year. Back in Brazil, it is thus not casual that some of the modernist masterpieces designed by Oscar Niemeyer were high-rises: the sinuous Copan in São Paulo (1952–61, 118 m), the geometrically more rigorous Conjunto Governador Juscelino Kubitschek (1951, 100 m) in Belo Horizonte, or the cylindrical Hotel Nacional in Rio de Janeiro (1968–72).

Argentinian capital Buenos Aires shares a similar history. The Railways Building achieved 87 m in 1910, and the Barolo (1919–23), designed by Italian architect Mario Palanti, 100. With the Kavanagh Building completed in 1936, the first one featuring a clean Art Deco aesthetics steering towards the formal features of modernism, residential construction reached 120 m. At the end of the 1940s, while Amancio Williams, with his "suspended office building" anticipated Norman Foster's HSBC Tower by thirty years, several corporate towers wrapped with curtain walls were popping up in the city. In 1962, the international competition for the tallest building in South America, the Peugeot Tower, attracted vast participation from all over the world (Liernur 2001, 302). In Bogota, Colombia, high-rise corporate buildings—hosting the headquarters of insurance, banks, and oil companies—grew in the 1950s along the so-called International Centre area and the newly-opened 10th Avenue. While most of these buildings were designed by large Colombian engineering and architecture firms, a few were designed by US firms, like the Esso Buildings by Lathrop Douglass

5.6 A Different Chronology? Latin America

(though not a tower) and the Bogota Bank by SOM and Martínez Cárdenas y Cía Ltda. & Lanzetta. In 1963, the Bavaria Centre Tower (89 m) by Obregón & Valenzuela marked a milestone, surpassed in 1969 by the 161 m of the Avianca Tower in the city's historical centre, designed by a group of Colombian architects led by former Le Corbusier collaborator Germán Samper. Then, in the 1970s, the verticalisation continued, primarily concentrated in the International Centre, with the Colpatria Tower (1973–79, 196 m) by Obregón & Valenzuela and the International Commercial Centre (1974–77, 192 m) of Cuéllar Serrano Gómez & Cía to mention the tallest ones (Montenegro Miranda 2018; Botti 2021). Since the 1980s, however, the city's construction of skyscrapers has stagnated and only recently restarted.

To investigate these last thirty years in Latin America, we will start from Mexico City, which currently ranks as one of the most vertically developed cities in the region. The highest buildings in the Mexican capital rise along the Paseo de la Reforma (Reforma Avenue), the monumental artery connecting Chapultepec Park with the historical centre. In particular, four of them, all taller than 200 m, concentrate where the Avenue gently curves towards the Park, thus defining a monumental entrance to the urban section of the Paseo. The most compelling project, and the tallest among the four, is Benjamin Romano-LBR&A Architects' Reforma Tower (2007–16, 246 m), defined by a today-uncommon structure of load-bearing concrete walls. Two orthogonal walls, stiffened by a third one connecting the two in their middle part, design the core of a more extended triangular plan, whose hypotenuse (segmented in two pieces) becomes the main façade, opened to the South, glazed but protected by louvres, and with visible diagonal stiffeners. Not far away, another remarkable building is the Headquarters of BBVA Mexico (2009–16, 188,777 m^2, 235 m, LEED Gold; Fig. 5.44) designed in partnership between Rogers Stirk Harbour + Partners and Legorreta + Legorreta, the firm of one of the Mexican most-renowned late-modernist architects, Ricardo Legorreta, who passed away in 2011. The BBVA Tower not only features the recognisable Rogers' aesthetic of diagonal stiffeners and other structural and bioclimatic devices visible all over the façades but also a few sky gardens, each distinct by the use of a strong colour for the ceiling and the spiral staircases. In this way, they stand out as playful elements in line with previous works of Legorreta. This cluster of skyscrapers is completed by the elegant but anonymous Chapultepec Uno R-509, a glazed prismatic mixed-use building (2012–19, 240 m) designed by the Taller Global S.C. on the base of a concept elaborated by US firm KMD Architects (not included in our survey), and by the Torre Mayor (1999–2003, 225 m; Fig. 5.44), a forgettable skyscraper composed by a curved glazed volume on the front, and a solid, stone-clad thinner volume on the back, according to the design of the Canadian company Zeidler Partnership Architects (not included in this survey).

Nearby, in front of the Diana Fountain roundabout, Pelli Clarke Pelli Architects' Libertad Tower (2004–09, 71,000 m^2, 150 m; Fig. 5.45), another banal, curved and glazed building, hosts serviced apartments and the St. Regis Hotel. It faces the refurbished and re-cladded, equally banal, glazed curved volume of the Ángel Tower (2000, 25,186 m^2) by Robert A.M. Stern Architects (RAMSA). Along the Paseo de

Fig. 5.44 The BBVA Mexico HQ by Rogers Stirk Harbour + Partners and Legorreta + Legorreta (right) and the Torre Mayor by Zeidler Partnership Architects in the Paseo de la Reforma, Mexico City. Photograph by Alexcrab

la Reforma, the other most significant 'signature' project is Richard Meier & Partners' Cuarzo Tower (2012–18, 120,000 m^2, 180 and 110 m). This polished office and commercial development, featuring in the main tower an all-white atrium and an intermediate sky garden, however, does not add much to the area where other tall buildings are located too. They include Enrique Macotela y Asociados' University Tower (203 m) and Vergara & Fernández de Ortega's Downtown & Be Grand Reforma (158,000 m^2, 199 m), both currently under construction, while not far from the Paseo

5.6 A Different Chronology? Latin America 227

Fig. 5.45 The Libertad Tower by Pelli Clarke Pelli Architects in the Paseo de la Reforma, Mexico City. Photograph by Felipe Alfonso Castillo Vázquez, distributed under a CC BY 3.0, available at https://commons.wikimedia.org/wiki/File:Torre_Libertad,_St_Regis_Ciudad_de_Mexico.JPG

stands since the 1970s the Pemex Tower (1979–84, 211 m; Fig. 5.46), a typical late-International Style corporate tower designed by Mexican architect Pedro Moctezuma Diaz Infante. To complete this overview, the last relevant project is SOM's BBVA

Fig. 5.46 The Pemex Tower by Pedro Moctezuma Diaz Infante, Mexico City. Photograph by Matthew Rutledge, distributed under a CC BY 2.0, available at https://commons.wikimedia.org/wiki/File:Torre_Pemex_is_easily_visible_from_our_terrace.jpg. Modified by Giaime Botti

Bancomer Operations Centre (2008–15, 154,000 m^2, 135 m, LEED Gold), a massive but dynamic building made of different interlocked volumes standing in the former industrial area of Parques Polanco, nearby the upscale Polanco neighbourhood.

In Brazil, foreign architects have designed some high-rise office buildings in the last two decades. In São Paulo, except for SOM's Bank of Boston HQ (2000–2002, 80,000 m^2, 145 m), they all cluster in the area at the crossroad between the Avenida Faria Lima and the Avenida Juscelino Kubitschek, the new financial core of the city. Faria Lima was a paradigmatic Urban Partnership Operation (**Operações** Urbanas Consorciadas), an instrument to transform large parts of the city through public–private partnerships, launched in the mid-1990s with the extension of the existing homonymous avenue. The area already had a dynamic real estate market, and, by the early 2000s, it enjoyed the possibilities offered by a new tool, the CEPAC (Certificados de Potencial Adicional Construtivo, or Additional Building-Rights Certificates), something comparable to the Transferable Development Rights in New York. The CEPACs, which are auctioned on the stock exchange, allow the municipality to finance public infrastructures and social housing in the Urban Partnership Operation area by selling these additional construction rights, receiving the money well before the developer has started the work. Still, the success of these operations, which, among other consequences, produce exclusionary effects on lower-income strata

5.6 A Different Chronology? Latin America

of the population, depends on the locations, having to rely on a complex alliance between multiple actors, from political decision-makers to real estate developers, from financial investors to architectural firms (Fix 2011; Klink and Stroher 2017).

Hence, it is not surprising to find a concentration of premium office buildings signed by international firms in such an area. Clustered next to each other, we see the complex of the Banco Real Santander Headquarters, the JK Iguatemi Mall, and the WTorre Plaza (2008–14, 412,000 m^2, 135, 123 and 123 m) designed by Arquitectonica, and Pelli Clarke Pelli's twin Corporate Towers (2012–15, 258,000 m^2, 139 m each, LEED Platinum). They consist of two glazed sculptural volumes, with the same plan but different orientations to grant more dynamism to the overall composition and enjoy a finely designed landscape in which low-rise complementary buildings like restaurants and the convention centre are immersed. Nearby, on Faria Lima Avenue, we also find the minimalist glass prism of the Faria Lima B32 (2020, 62,155 m^2, 125 m) by Pei Architects, and the nearby Infinity Tower (2009–12, 39,000 m^2, 118 m, LEED Gold), designed by KPF. The latter features a curved glazed and wooden lobby surrounded by dark water pools, emerging as an elegant high-end office building for international tenants interested in renting prime-quality office space. The recently completed Faria Lima Plaza (2019–21, 41,500 m^2, 126 m, LEED Gold; Fig. 5.47), further north along the Avenue, does emerge with a stronger shape, resulting from the apparent interlocking of two inclined volumes. KPF has also delivered two other office high-rise buildings in Rio de Janeiro. The Ventura Towers (2005–10, 172,200 m^2, 151 m, LEED Gold) stand in the city centre just in front of the brutalist Cathedral designed by Edgar Oliveira de Fonseca in the 1960s. Their clean and smooth surfaces counterpoint the rough concrete latticework of the Cathedral, while their glazed box-like volumes are laterally wrapped by gigantic upside-down L-shaped stone-clad planes that close and unify the composition. Finally, not far away, in the Porto Maravilha waterfront (Sect. 7.2), another area redeveloped through an Urban Partnership Operation, the Vista Guanabara (2013–16, 44,100 m^2) stands out among the recent completions. Overall, most of these buildings are characterised by a high-quality and efficient design—so-called "Class A" offices (Sect. 9.2)—and excellent environmental performances, often recognised by Gold or Platinum LEED certifications rather than by any formal adventure.

In the Colombian capital Bogotá, two recent projects have revived the market of skyscrapers after more than three decades of stasis. At the edges of the International Centre stands the new Atrio North Tower (2012–20, 56,400 m^2, 201 m, LEED Gold) designed by Rogers Stirk Harbour + Partners and Colombian firm El Equipo Mazzanti. Rogers' signature is evident in the orange-painted steel stiffeners and joints connecting the concrete structure of the tower and in the careful design of the ground floor to maximise public use. While waiting for the beginning of the construction of the second tower, which should reach 268 m if completed, the tallest building in Colombia was completed in 2018 after a halt due to the developer's financial problems. The Bacatá Towers (2010–18, 167 and 216 m), designed by Barcelona-based firm Alonso Balaguer Arquitectes Associats (not included in the survey), consist of two connected mixed-use skyscrapers with terracing volumes, potentially able to promote the regeneration of this central area of Bogota, which still suffers the

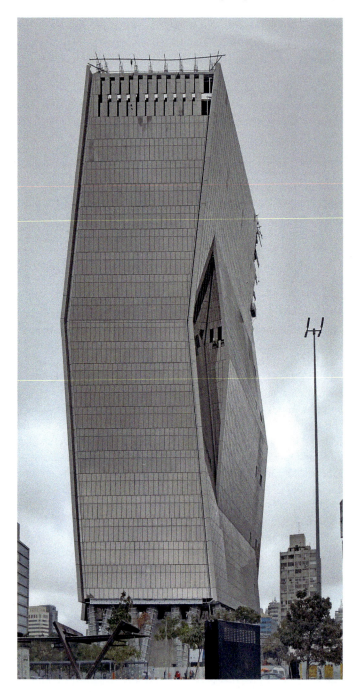

Fig. 5.47 The Faria Lima Plaza by KPF along Avenida Faria Lima, São Paulo. Photograph by Mauro Cateb, distributed under a CC BY 2.0, available at https://www.flickr.com/photos/mauroescritor/51135429125/.Modified by Giaime Botti

5.6 A Different Chronology? Latin America

consequences of non-diversified land use, but also to further congest its traffic with more than 700 car parks added.

As evident from some of these projects, which included mixed-use skyscrapers featuring serviced apartments or standard residential programmes, also in Latin America there is an evident growth of high-rise residential. Taking Panama City, 80% of its 150 + m buildings are residential; in Cartagena de Indias, the Colombian colonial jewel on the Caribbean coast, 60% of them, with the rest dedicated to hotels rather than office space, according to CTBUH's (2022a, b) data. Again, in many of these cities, it is common to find luxury high-rise residential developments designed by overseas architects. In Mexico City, the new tallest building is Pelli Clarke Pelli's Mitikah Tower (2012–21, 108,000 m^2, 267 m), currently under construction, which will contain residences and a hotel. The same firm had already completed in the late 1990s the Del Bosque complex (1992–96, 70,000 m^2) in the affluent neighbour-hood of Polanco, composed of two polylobate residential towers (128 m each), and one office building hosting the Coca-Cola North-Latin America HQ. Other cities like Monterrey—the commercial capital of Nuevo León and Northern Mexico in general—and the neighbouring San Pedro Garza García, where many large Mexican companies locate their headquarters, have been growing vertically since 2000 and now feature the only supertall of the country—the T.OP Corporativo (2016–20, 305 m) by Pozas Arquitectos–, and other three 200+ m buildings, all of them designed by local architects. Moreover, in the wealthy suburbs of Monterrey and San Pedro Garza García, exclusive residential enclaves have been created by local and foreign architects (Sect. 8.3).

Before moving to the next section, a final geographical displacement is required for a few words about another region object of our study: Africa. Regarding the surveyed countries, there is little to say about high-rises. Johannesburg, the tallest city in the continent according to CTBUH data, has only five buildings over 150 m. And, except for a recent mixed-use tower—The Leonardo (2011–19, 227 m) by local firm Co-Arc International Architects–, most of them were built during the 1970s and 1980s, when also the Hillbrow Tower (1968–71, 269 m), the iconic radio tower dominating Johannesburg's skyline, was erected. And other African cities do show similar patterns, with a bunch of buildings over 100 m, very few ones over 150, and just one (overall) above 200. In terms of chronology, the oldest constructions usually date back to the 1970s. Since then, we have found no more than a couple of addition per decade to the skyline of cities like Cape Town or Lagos. At the same time, Luanda (although with minimal numbers) and Nairobi show an acceleration in the construction of high-rises during the last two decades. In the Kenyan capital, where the oldest 150+ m building dates back to 2016, we find the 201-m Britam Tower (2012–17), designed by South African firm GAPP Architects and Urban Design and by the local Triad Architects, and some more skyscrapers. In this regard, it should be noted that most recent projects are designed by African or Indian firms rather than major Western megapractices or boutique architects. In the meantime, Egypt is on its way to hosting the first supertall of Africa: The Iconic Tower (393 m) in the New Administrative Capital. Designed by the Beirut-headquartered multi-national Dar al-Handasah, it is currently under construction and expected to be completed by

2023. It will then be the tallest building in Africa, as the 447-m Symbio-City project by German-South African firm Architects @126 in the Gauteng province of South Africa never broke ground. Having completed our overview across different regions, we can move to the following two sections, to first discuss technical innovations and formal experimentations, and then how skyscrapers in emerging markets brought back ethical aspects in the professional debate.

5.7 Innovation, Technology Transfer, and Experimental Conditions: Tall, Anti, and Hyper

One of the critical aspects of architectural globalisation that this book tries to emphasise is how much the emerging markets provided a terrain for architectural experimentations elsewhere impossible. For better or for worse. However, before delving into this intriguing matter, we will discuss another important question: technological innovations and technology transfer processes related to tall construction. Skyscraper projects represent extraordinary technological achievements, which in many cases result from both a consolidated know-how and a research-oriented approach by AEC firms, and their collaboration with several more top engineering consultancies. As seen in the previous sections, there are a few firms in the world able to deliver an impressive flow of projects in a kind of assembly line. Between 2000 and 2020, for instance, SOM completed 103 buildings over 150 m, including the 828-m Burj Khalifa; KPF 99; Gensler 43. The global scope of the high-rise market for megafirms like SOM, KPF, Goettsch Partners, and Pelli Clarke Pelli is also visible in Fig. 5.48.

In this light, it is perhaps obvious to start with SOM and the Burj Khalifa to discuss technological innovation in tall construction. The building exploited the potentialities

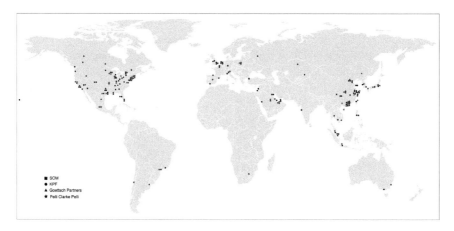

Fig. 5.48 A map of high-rise (built) projects by SOM, KPF, Goettsch Partners and Pelli Clarke Pelli Architects. Copyright Giaime Botti

of the hexagonal buttressed core reinforced by three buttresses, thus forming the recognisable Y-shaped floorplan of the tower. This core type was invented by SOM's structural engineering partner Baker (2010) for the Samsung Tower Palace (2001–04) in Seoul. Then it became the point of departure for the structural design and the plan of the Burj Khalifa. Such a solution represented a "paradigm shift" in tall construction, allowing an increase in the height of about 60% between the Burj Khalifa and its predecessor as the world's tallest building (Baker and Pawlikowski 2021). In this regard, SOM emerges as a firm able to innovate and deliver final products informed by the most advanced technologies. Following the Saturday Session at the Illinois Institute of Technology initiated in the 1960s by SOM's partner Myron Goldsmith, alumnus and then professor of the IIT, Baker created the Chicago Research Gang, a weekly forum to discuss and experiment issues related to form and structure, with research carried out independently from ongoing projects but then used to feed them (Bögle and Ratschke 2015), focusing not only on tall buildings but on the overall problem of structural optimisation (Bögle and Hartz 2015). Of course, a building like the Burj Khalifa and the technological innovations it integrates have been possible thanks to multiple actors. Still, having the same firm able to develop both the architectural and structural concept of a building of such complexity is a remarkable fact, perfectly proven by the building's coherence between form and structure. On *Architectural Record*, the review of the building was flattering: "And the Burj Khalifa easily meets — and exceeds — and exceeds — that standard, soaring in both height and design quality above Dubai's often-ludicrous collection of architectural cartoons" (Kamin 2010).

Even though technical know-how and technological innovation appear to be solidly in the hands of some of these firms, different mechanisms of technology transfer take place, willingly or unwillingly, when such know-how is deployed in a specific context. As a matter of fact, none of the current ten tallest buildings in China has been designed by a Chinese continental firm, with only one—the Changsha IFS Tower T1—designed by Wong Tung & Partners from Hong Kong. However, all these buildings had a Chinese design institute, usually ECADI or BIAD, as the Architect of the Record. Thus, while the market of the supertalls is still solidly in Western hands, for tall buildings in general (150+), we notice different proportions between first-tier cities, where foreign presence appears more robust, and secondary urban centres.[6] Still, one of the key points is to understand how local design institutes have benefitted in terms of gaining know-how from working together with foreign firms for over three decades. Regretfully, there are not many studies on this except for some early research that highlights how every project developed in partnership between Western firms and Chinese design institutes represented an opportunity to gain new knowledge and skills in the design and construction (Hsu 1999). Indeed, it

[6] From a quick sampling of buildings above 150 m (based on incomplete data on The Skyscraper Center), in Shanghai, the proportion of projects designed by overseas firms is somewhere between 60 and 80%; in Xiamen or Foshan, for example, it is much less (but we refrain from providing figures as data are incomplete).

was evident to observers in Shanghai during the 1990s how different was the technical know-how compared to the USA. Even for high-rise construction, heavy brick infill walls were used, and buildings were erected with cast-in-place concrete mixed on the site and column reinforcing hand-tied on the site, slowing down the construction process (Rush 1995). The case of the Petronas Towers in Kuala Lumpur is also interesting in this regard, as a government scheme formally promoted technology transfer according to which foreign "experts" were assigned with a young Malaysian "understudy" while the KLCC Property Holdings (the developer and operator) was publicly asked by the Ministry of Education of its duties of social responsibility in terms of knowledge transfer (Bunnell 1999). In the same period, the Association of Indonesian Architects suggested the government lift the ban on foreign architects, not least to favour the dissemination of new procedures in the country (McBeth 1994). All this would deserve new broader, and deeper investigations, which this book, due to its scope and focus, cannot provide.

What is instead time to consider now is how the emerging markets have been the terrain of architectural experimentation beyond the mere technological dimension. A relevant number of projects have proved the extraordinary conditions of experimentation that the most profitable emerging markets have granted to architects. Rem Koolhaas (1995) has often used the term *tabula rasa*, for instance referring to Singapore, to explain a condition of greater freedom for the architect. The Dutch designer has certainly not been the only one thinking this, nor is Singapore the only place where these conditions apply. Ahmed Kanna (2011, 91) reported that starchitects share the vision of the Persian Gulf as a place where things that cannot be done elsewhere—read the West—can actually be done. China, too, as local architects and academics have critically observed, was considered a place of experimentation (in negative terms), where foreign architects came up with proposals that "could have never been built in their own countries" (Brownell 2008, 89–90). Thus, to understand what formal and typological experimentation means, we can reference a photomontage that AMO and OMA created together with their (unbuilt) high-rise project Dubai Renaissance. The most recent high-rise projects designed worldwide were collected along a desertic landscape to form a hypothetical skyline. In opposition to this recollection of formal extravagances—pagoda-like, twisting, amorphous–, OMA proposed a 300-m thin, rectangular monolith with no façade variation. That was Koolhaas' answer to the "age of the icon" (OMA 2006).

Waging war to the icon became a quite cynical game for Koolhaas after having designed one of the most interesting, for some outrageous, certainly iconic, buildings of the twenty-first century: the CCTV Headquarters (2002–12, 473,000 m^2, 234 m; Fig. 5.49) in Beijing. Beyond polemics on its pants-like shape, as well as about the very issue of working for the Chinese government, which will be discussed in the next section, the CCTV HQ re-defined the same idea of what a skyscraper is. Koolhaas' theories of "Manhattanism" and "bigness" seemed finally reflected in an actual building, where the internal division of programmatically different floor blocks recalled the very idea of the "reproduction of the world" explained in *Delirious New York* (Koolhaas, 1978, 82–83). More than at OMA's Hyperbuilding (1996) project for Bangkok (Spencer 2016, 106), however, the CCTV seemed to look back

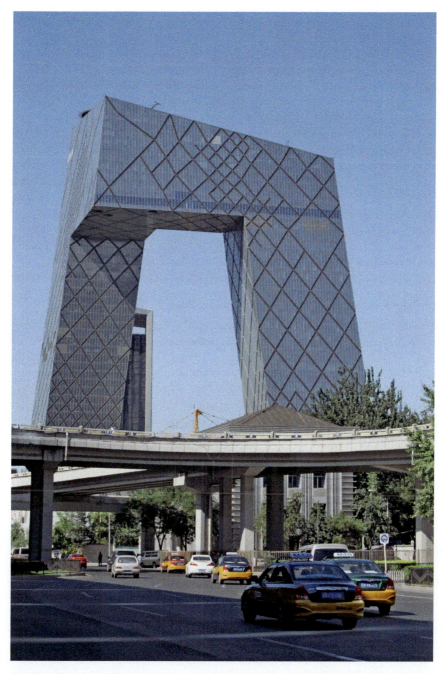

Fig. 5.49 The CCTV Tower by OMA in Chaoyang CBD, Beijing. Photograph by Giaime Botti, distributed under a CC BY 4.0

at Manhattan, as the programmatic complexity was reduced to a single architectural gesture wrapped by a continuous, dark envelope displaying structural forces through its irregular diagrid, designed together with Cecil Balmond. As Charles Jencks wrote, the CTTV offered the client an "antiskyscraper" as an icon, while the other competitors had just provided the n-fold towers that would have been lost among the hundreds of different towers. CCTV was thus "radical post-modern" as it mixed metaphors and provided an enigmatic icon that "relates to Chinese puzzles, the Chinese moon gate, the Chinese emphasis on bracket construction, the spider's web of structure" (Jencks and Koolhaas 2011, 38). Not a skyscraper, nor a gate or a tower plus sky-bridge *à la* Marina Bay, its looping structure and complex form made it an anti-monumental landmark, an ever-changing structure according to the point of view of the observer trapped in the traffic congestion of Beijing CBD's speedways and roads. Still, after this work, OMA has smartly steered towards a different way of dealing with high-rise projects. Rather than extravagance, by now left to those architects interested in the triviality of the iconic, "simplicity" (OMA 2006) became the new keyword. Albeit the Dubai Renaissance represented the extremisation of this new logic, some successful projects proved how simple formal gestures—shifts, extrusions, cantilevers—on basic prismatic volumes can achieve far better results than complex, computer-generated forms. Is this the case of the De Rotterdam (1997–2013, 162,000 m^2, 150 m) and the more recent Prince Plaza (2012–21, 106,500 m^2, 205) in Shenzhen, not to repeat what was already written about the Shenzhen Stock Exchange. Although relying more on formal virtuosity and complexity, the MahaNakon (2008–18, 150,000 m^2, 320 m) in Bangkok, conceived by Ole Scheeren while working at OMA and then concluded by his office, could be put alongside these projects, too. This outstanding supertall consists of a monolithic glazed prism that partially dissolves in a pixelating spiral excavating the volume and revealing its interior.

Finally, if the CCTV represented the "antiskyscraper", the work of Moshe Safdie has been instead moving in the direction of making a hyper-skyscraper. Indeed, our use of the prefix "hyper" is not random, as we want to refer to OMA's Hyperbuilding. That unbuilt project represented an experiment in creating a megastructural city composed of multiple interconnected vertical, horizontal, and diagonal elements. Since experiments of the 1960s like Habitat 67 (Sect. 8.5), Safdie's projects have shown this tendency towards the idea of a megabuilding. With the new century and the rise of emerging markets where the availability of resources and the lack of formal constraints allowed bolder experimentations, Safdie was finally able to carry out the construction of what could be considered a new hyper-skyscraper typology based on multiple towers connected by a horizontal volume that is more than a simple sky bridge. Marina Bay in Singapore proved these ideas feasible, allowing the architect to double down and re-propose them through a "transfer" (Ponzini 2020): the Raffles City Chongqing developed by CapitaLand (Fig. 5.50). Completed in 2020, it is a complex of six 250-m and two 350-m towers for a total of 1.2 million square metres of residential, office, and hotel space. The two tallest towers and four more (of the other six) are connected at 250 m by "The Crystal", a 300-m-long horizontal element housing an infinite pool and amenities like a garden, bars, the hotel lobby, a

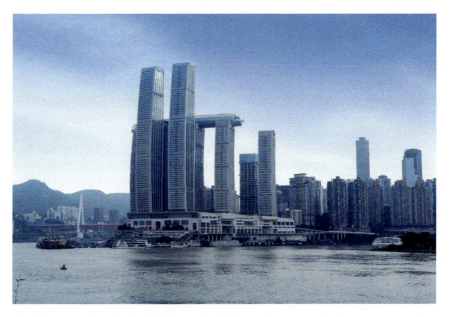

Fig. 5.50 Raffles City Chongqing by Safdie Architects, Chongqing. Photograph by WangAnQi

clubhouse, and event space. These types of skyscrapers are multiplying, and not by chance, in places like Dubai or Abu Dhabi.

5.8 Entangled Debates: The (Un)ethics of the Skyscraper

The last section of the present chapter introduces some of the debates revolving around the ethics of the architectural practice, in this case with specific attention to the design of tall buildings. Such a concern, which will emerge in other parts of the book, reflects an essential consequence of architectural globalisation: the returning interest in (but also the persistent rejection of) the ethical dimension of architecture. This section will then deal with at least three entangled problems related to the ethical sphere. The first one concerns the political and social context in which Western architects are involved, questioning the work in undemocratic countries where human rights are systematically abused or in countries where labour rights are strongly reduced and work conditions are dreadful (themes that will be considered in more detail in Sect. 6.2). The second problem regards the formal quality of the architecture proposed in emerging markets. In this sense, it is interesting to note how the perception by local and external actors changed during the decades. If in the 1990s the problem was the recycling of outdated ideas, by the 2000s, it seemed more the proposal of extravagant ones (still with a subtle line to consider and distinguish between extravagance and experimentation). Lastly, we discuss the issue

of sustainability because self-proclaimed green architecture often results in simple greenwashing, above all if we consider typologies inherently costly and energy-intensive like skyscrapers. All these three problems, however, are intrinsically so entangled that sometimes the criticism seems to encompass all of them.

In the early 2000s, one of the catalysers of the debate was OMA's CCTV tower. Dutch writer Ian Buruma (2002) harshly criticised the project, considering the idea of designing a monument to the CCP's propaganda and Western architects' overall work as "not a noble enterprise." To this, Koolhaas and Scheeren responded by emphasising the public nature of the commission, something for them by that time almost impossible to achieve in the market-dominated West, and the publicity of their design, based on a public circulation loop crossing the whole building (Spencer 2016, 98–99), albeit that space never actually functioned as such. In the meantime, megaprojects related to the Summer Olympic Games of Beijing 2008 (Sect. 7.1) also created a growing debate about architecture and human rights (Bonami 2008). By the next decade, however, the spotlight had moved to the Persian Gulf and migrants' labour conditions especially. Several cases related to fancy cultural projects will be discussed later (Sect. 6.2), but the same criticism was raised for skyscrapers, too. The standard response, as Adrian Smith from AS+GG stated, was that architects were not responsible as all issues involving workers rested with the contractor (Fixsen 2014).

While the questions of human and labour rights strongly emerged at the beginning of the twenty-first century in relation to China, for the former, and the Persian Gulf monarchies, for the latter, issues concerning the responsibilities in terms of design quality had already surfaced in the 1990s. In fact, with growing work opportunities in China and South-East Asia, new concerns arose, too. Dietsch (1994) on *Architecture*, the American Institute of Architects' magazine, questioned the export of "recycled" designs from the 1980s that were "shelved during the recession" and then "gussied up with minarets and pagoda tops" when re-proposed a decade later around the world. On *Progressive Architecture*, a strong criticism of this article was stated, but the problem of the responsibility of American architects in developing countries was not avoided:

> Galloping toward industrialization at a pace that makes Western economies look practically indolent, the modernizing nations of the East are providing plentiful work for American architects. But the buildings being produced raise nettlesome questions about the responsibilities architects should bear when they take their advanced technical skills into societies that have had little experience with the problems that big, Modern, Western-style development brings. Even a cursory inspection suggests that something is going very wrong. Many buildings planned or constructed in the emerging Asia are glaringly slick. The horizons of East Asia and Southeast Asia increasingly are punctuated by brightly lighted towers of reflective glass and shiny metal, in shapes that shout novelty above all else. Some Asian towers, especially in mainland China, are so flashy they make Houston seem a paragon of restraint (Langdon 1995, 44).

The author's conclusion sounded rather paternalistic (or colonialist) when he explained what happened during the design competition for the Jin Mao tower: SOM's proposal "suggested, in a gracefully abstracted way, a Chinese pagoda; it promised to be distinctively Chinese while avoiding cliches such as a pagoda roof

5.8 Entangled Debates: The (Un)ethics of the Skyscraper 239

on top of a skyscraper." However, had not been for American, British, and Japanese jurors, noted Philip Langdon with relief, this graceful example of contextualisation would not have been selected. This example leads us to consider an overall problem, which we have already touched on here and there: superficial contextualism. As seen, some of the most significant skyscrapers of the late 1990s and early 2000s in Asia and many more secondary projects had proposed a set of formal strategies to "regionalise" the design. They include the design of floorplans based on some evocative shapes, the definition of silhouettes recalling traditional architecture in a stylised and abstract fashion, and the use of patterns based on local tradition for the building envelope. The ancient art of *FengShui* has sometimes been taken into account, as in Foster's uncompromisingly modern HSBC HQ in Hong Kong, as narrated by Bruce Chatwin (1990). Such concerns have continued throughout the following decades, and similar strategies can be seen in several more buildings, from Jean Nouvel's Burj Doha, a transposition of his Barcelona Agbar Tower with a latticework skin of Arab flavour, to OMA's Prince Plaza in Shenzhen, where facades looking at the sky-decks and in part of the podium feature an abstract hexagonal latticework reminding of the traditional Chinese element and its patterns. In many cases, however, regional differences within an otherwise homogenous production have been somehow unintended, resulting in peculiar patterns of occupation and use, as the case of residential supertalls proves (Radović 2020).

By the 2000s, ethical concerns about form were no longer related to the recycling of outdated designs but rather to the over-emphasis given to form. Or in other words, the concern was the problem of the icon, which we introduced in the previous section. On this theme, while Charles Jencks (2005) has chanted the enigmatic power of icons, Sklair (2006, 36) has stressed how these buildings assume their iconic status through a framework set by the corporate sector "to facilitate the assimilation of the general public into the culture-ideology of consumerism." In this light, icons appear "deliberately manufactured" and even pre-announced as such even before their construction, purposefully anticipating that process of professional and public recognition that had historically defined architectural icons. In this regard, one key problem became the position of architecture with respect to the subtle line dividing extravagance from experimentation. Again, the CCTV provided space for polemics from any side. The analogy between this and other buildings and underwear became a popular image among Beijingers and escalated to the highest political level when in 2014 a ban on "weird" architecture was decided in China (Frearson 2014). The objective was not only CCTV—ironically, the State-owned television network—but many more buildings of bad taste (for whom?). Back at the time of their design, this project and the egg-shaped National Grand Theatre by Paul Andreu (Sect. 6.3) were questioned since the public announcement of the competitions' outcomes for their forms and later their cost (Xue 2006, 42–43). Xuefei Ren (2011, 134), for instance, reports the word of Chinese architect Wu Chen, who called Beijing "the laboratory for foreign architects," arguing that these projects would have been impossible in their own countries.

The last great topic concerning the ethical sphere of the architectural profession that started being questioned in the 1990s in relation to architectural globalisation is

that of sustainability in its broadest sense. Albeit without directly using this word, the article mentioned above by Dietsch (1994), for example, examined the very idea of building skyscrapers in cities that lack basic infrastructure and called for greater responsibility by the AIA on considering "the full impact of American architectural export," its cultural, environmental, and social effects. This echoed concerns raised in the 1970s about the construction of tall buildings in developing countries' urban centres. As written on the pages of Constantinos Doxiadis' *Ekistics*, these buildings were "more expensive and take longer to construct" and they required "more sophisticated management and capital-intensive construction equipment as well as skilled labor" and imported materials to be paid in a hard currency whose purchase could add burden to the public finances. Accordingly, low-rise construction should have been preferred for producing "less traffic congestion, less pollution, and a more human urban environment. Traditional sections of the central areas c[ould] be preserved to avoid large-scale displacement of the urban poor, wastage of valuable physical assets, and destruction of historical and environmental continuity" (Lim 1975). Indeed, both texts, in many ways, showed a not complete understanding of the local forces and the dynamics for which these projects were so crucial as concrete embodiments of national aspirations in developing countries. On the contrary, this was clear to Philip Langdon (1995, 86), who praised the Petronas Towers for being "Malaysian while accomplishing its other purpose: advertising the country's arrival as a modern industrial nation."

All these problems fit in the comprehensive definition of sustainability—environmental, social, economic, and cultural—and again display the entangled nature of ethical debates in architecture. Are dense cities packed with high-rise buildings sustainable? Or, at least, are they more sustainable than other urbanisation models? Overall, different studies agree on the fact that higher densities are more sustainable in terms of resource use (Newman 2014), as well as embodied energy (Norman, Maclean and Kennedy 2006) compared to sprawling cities (Gurin 2003). Just consider the different land occupation and carbon footprint for transportation of a compact city like Barcelona and a sprawling one like Atlanta: respectively, 2.8 million inhabitants, 162 km^2, 0.7 tons CO_2 per person in transportation, and 2.5 million inhabitants, 4,280 km^2, 7.5 tons CO_2 per person in transportation (New Climate Economy 2014). Still, nuances exist between avoiding sprawl with a reasonable density and filling a city with supertall skyscrapers. Skyscrapers may reflect and exacerbate social segregation, turning into vertical 'slums,' like the infamous Ponte City in Johannesburg (Smith 2015), or secluded escapes for the billionaires, like in Manhattan or in cities across the Global South (Graham 2015). They may cause traffic congestion in cities already lacking an adequate road network and efficient public transportation. The project of the Bacatá Tower in Bogotá, now the tallest building in the city, raised concerns about the additional traffic generated in an already congested city centre. In economic terms, skyscrapers are risky and expansive enterprises; a skyscraper is costlier than a low-rise building in unitary terms and less efficient in floor areas (Watts 2013). However, evidence suggests that skyscrapers pay off, although more studies are needed to understand all the "positive and negative externalities associated with tall buildings" and "the costs of and returns to height" (Ahlfeldt and

5.8 Entangled Debates: The (Un)ethics of the Skyscraper

Barr 2002). And then, there is the use of resources, embodied energy, and operational energy to consider. In other words, we have to question the environmental sustainability of skyscrapers.

For sure, super and megatalls and many other skyscrapers today feature very high standards in terms of environmental performance, generally recognised through certifications like the LEED, which these architectural firms know how to achieve easily. A study on Manhattan, for example, has shown that retrofitting existing office buildings dating from the 1950–70s would allow savings of up to 40% in energy consumption, but also that replacing them with new ones, even with a 44% increase in floor area, would lead to an absolute gain of 5% compared to current consumption patterns (Browning et al. 2013). This is to understand the scale of the improvements theoretically obtainable today. In practice, LEED registrations are growing worldwide. In China, LEED certifications have increased at an average pace of 40% year-on-year since the early 2000s, while the number of buildings rated with the Chinese system GBEL (Green Building Evaluation and Labelling) is steadily increasing (BEE-U.S. Consulate General Shanghai 2015). By 2015, over 125 million gross square metres of commercial space in greater China were LEED-certified, with the expectation of achieving the 30% of all new construction by 2020 (USGBC 2014). To this general trend, super and megatall skyscrapers are not alien. Gensler's Shanghai Tower was the first megatall to be certified with LEED Platinum for its hotel function, while the adjacent Jin Mao and Shanghai World Financial Centre both achieved a Gold rating.

Devoid of similar certifications, the Burj Khalifa nonetheless claims a significant environmental performance. Sustainability elements emerge from the project, including a wide range of solutions, from high-performance glazing to a system of sky-sourced ventilation for the top part of the building where the air is cooler and less humid (Wood and Parker 2013, 464–471), something similar to Foster + Partners' SNB HQ in Riyadh, where the top spire works as a radiator to capture the cooler breeze (Foster + Partners 2020). Still, the reality is that when the Dubai megatall project was launched, sustainability was not the keyword (Kamin 2010). Indeed, one of the most extraordinary and paradigmatic shifts is due to the fact that something like the Burj Khalifa introduces new spatial needs in the city because its functioning relies on two buildings, located almost one kilometre away, used to cool the tower and part of the Dubai Mall. Not of much interest is that these buildings look like old Arab fortresses. On the contrary, they make us reflect on the emergence of a new kind of 'colonial' urban relationship, in which buildings are conceived to 'feed' other buildings.

In the end, the environmental sustainability of these projects remains controversial. Different green options may benefit various stakeholders, but we must still consider and quantify the advantages and disadvantages of different technologies and strategies. Wind turbines seem limitedly efficient on top of skyscrapers, as cases like the Strata SE1tower in London and the Bahrein World Trade Centre in Manama show. Photovoltaic is still "impractical" due to the small surface of roofs, which have a little positive impact also when covered with vegetation. Glass skins are "controversial" as they increase the energy demand for cooling and heating. Height alone, because of wind strength, leads to a massive increase in the building structure

(Al-Kodmany 2022). Thus, the path to a sustainable, self-sufficient skyscraper is still long. Despite claims, actual results have been difficult to be considered fully successful, even in the case of the most advanced proposals. For instance, SOM's Pearl River Tower in Guangzhou (2005–13, 214,000 m^2, 309 m) relies on a structurally efficient design that reduces wind pressure and makes it lighter than average supertalls. Internally ventilated double walls minimise heat gain, and radiant cooling with displacement ventilation reduces energy consumption; narrow floor plates allow maximum daylighting, and photovoltaic cells are integrated into the roof and horizontal sunshades on the large and most exposed facades. In addition, the form and orientation of the tower help capture and funnel wind into channels that reduce structural wind loadings and include turbines to generate electricity (Cook et al. 2013, 149), although their actual efficiency does not seem high (Al-Kodmany 2022).

Lastly, it is necessary to point out one more issue, which concerns sustainability as it relates to resource use. The race to the sky and the will to go as high as possible architecturally translates into what has been called "vanity height." The CTBUH has defined this as "the distance between a skyscraper's highest occupiable floor and its architectural top" (Taylor 2013). If it exceeds 50% of the total height, the building would no longer be considered a skyscraper but a communication tower. In this regard, one may wonder how much it costs, in environmental terms, the addition of 244 m of the unusable spire to the Burj Khalifa, to name the most extreme case. With this, we conceptually close our loop on skyscrapers by highlighting how the "ephemerality of 'symbolic capital'" (Dovey 1992) according to the paradigm of competing cities is reflected by the banal fact that, when it comes to skyscrapers, "there is nothing especially thrilling about being the fourth, third or even the second tallest building in any world" (Bunnell 1999, 10).

5.9 Conclusions

During the last three decades, the skyscraper as an architectural typology has found new territories, evolved, and grown higher on average. Today, the largest number of skyscrapers are located in Asia, mostly along latitudes comprised between the Tropic of Cancer and the Equator, thus passing through the Persian Gulf, India, and South-East Asia, and then expanding and steering north with the whole of Central and Eastern China, Japan and South Korea. In the twenty-first century, it seems that only Asian cities are able or willing to compete for the tallest building on earth. In this scenario, a bunch of Western megafirms, mostly for the USA, consolidated a sort of oligopoly in this sub-market, especially when it comes to super and megatalls. Local firms from emerging markets trail behind, although some AEC companies have established a remarkable track record of high-rise completions in several countries. At the same time, creative (boutique) firms have sometimes been preferred for designs with an explicit request for iconicity. Overseas activities also stimulated reflections on the essence of national architecture. In the mid-1990s, stimulated by

5.9 Conclusions

the expanding scope of work of US firms, Fisher (1995) on *Progressive Architecture*'s pages questioned the essence of "American architecture." The answer was obviously not straightforward. Our data tell us that the export of architectural design from the US is especially solid in high-rise architecture, with US firms proving to be the most capable in this sector. In many ways, US architecture, and therefore US firms, is identified abroad with the skyscraper and the corporate office building. The changing geography of the skyscrapers and the super and megatall do not actually match (yet) with a shift in the geography of their production. There are today more skyscrapers elsewhere than in the USA, but they have been mostly designed by US firms.

While the global geography of the skyscraper shifted eastwards, its typology also evolved from a monofunctional monolith to a more complex building integrating multiple programmes, making the expression "vertical urbanism" a fashionable one. In many cases, formal extravagances are re-proposed over and over again by a repertoire of gestures that spans from the twisting to the stacking, from the bulging to the fragmenting, and by combinations of all of them. Still, beyond more or less successful formal experiments, the typology is changing, and together with programmatic complexity, the idea of the skyscraper as a single, vertical building is being more and more challenged by that of a hyper or 'multi'-skyscraper, composed of several towers interconnected by sky bridges and horizontal volumes. In this light, we can read some of Anthony Wood's remarks about the principles to take into account for the future of tall buildings. In addition to some formal considerations, the president of CTBUH highlights the need to further increase the number of functions accommodated in skyscrapers, the presence of communal spaces, and the systems of horizontal connections (including sky bridges) to develop a truly "three-dimensional urban framework" (Wood 2013, 355–360). At the same time, more captivating proposals are coming, like NEOM, a 100-mile-long linear city recently envisioned in Saudi Arabia. Should it ever be built, the city will consist of two parallel 500-m-tall slabs, making it a sort of immense horizontal skyscraper (Chulov 2022).

Despite being inherently resources-intensive, both in terms of embodied and operating energy, tall buildings are seen by many as a necessary evil as they create density, which overall is more sustainable than its contrary, sprawl. Indeed, the excuse, in this case, does not work too much as high-rise density and sprawl have developed side by side in the CBD+ suburbs configuration of American cities during the twentieth century. On the other hand, today, many skyscrapers achieve extremely high environmental performances recognised through certifications like LEED Gold and Platinum. Façades perform as airtight and low-transmission screens isolating interiors where air conditioning maintains the environment at 18 °C while outside the temperature passes 45 °C. Sometimes, these façades become the opportunity to regionalise the design through *mashrabiya*-inspired solar screens, especially in the Middle East, or simple decorative patterns more or less related to local traditions. In East and South-East Asia, on the other hand, the abstraction of the pagoda form has also become part of the formal strategies to define the massing and the silhouette of Asia skyscrapers. All these problems have also entered a theoretical debate that, since the

1990s, has not avoided questioning the ethics behind the agency of Western architects in the developing world in relation to the construction of skyscrapers.

References

Ahlfeldt, Gabriel M., and Jason Barr. 2002. The economics of skyscrapers: A synthesis. *Journal of Urban Economics* 129: 103419.

Al-Kodmany, Kheir. 2022. Sustainable high-rise buildings: Toward resilient built environment. *Frontiers in Sustainable Cities* 4: 782007.

AMO. 2004. Map: Skyscraper migration. The high rise relocates to Asia. In *Content*, ed. Rem Koolhaas, Brendan McGetrick and Simon Brown, 466–467. Cologne: Taschen.

Baker, William F. 2010. The Burj Khalifa triumphs: First person: Engineering an idea: The realization of the Burj Khalifa. *Civil Engineering Magazine* 80 (3): 44–47.

Baker, William F., and James J. Pawlikowski. 2021. Higher and higher: The evolution of the buttressed core. *Civil Engineering Magazine* 82 (9): 58–65.

BEE-U.S. Consulate General Shanghai. 2015. *China's growing green building industry and how U.S. companies can get involved*. BEE—Bisagni Environmental Enterprise—The U.S. Consulate General Shanghai Commercial Service.

Bloomberg. 2021. *China bans tallest skyscrapers following safety concerns*. Bloomberg News, July 7. https://www.bloomberg.com/news/articles/2021-07-07/china-bans-tallest-skyscrapers-following-concerns-about-safety. Accessed 10 Mar 2022.

Bögle, Annette, and Christian Hartz . 2015. Structural optimisation—Developing new design tools. In *SOM: Iconic Architecture as a Result of Structural Solutions: from Sears Tower to Burj Khalifa*, ed. Christian Schittich, 111–121. Munich: Detail Business Information GmbH.

Bögle, Annette, and Nils Ratschke . 2015. Quo Vadis—Megatalls as the focus of the SOM research gang. In *SOM: Iconic Architecture as a Result of Structural Solutions: from Sears Tower to Burj Khalifa*, ed. Christian Schittich, 106–110. Munich: Detail Business Information GmbH.

Bonami, Francesco. 2008. Facing human rights. *Domus* 916: 102–104.

Botti, Giaime. 2021. *Tra modernità e ricerca identitaria. Architettura e città in Colombia, 1920–1970*. Milano: FrancoAngeli.

Brownell, Susan. 2008. *Beijing's Games: What the Olympics Mean to China*. Portland, OR: Rowman and Littlefield.

Browning, William, Alice Hartley, Travis Knop, and Curtis B. Wayne. 2013. *Midcentury (Un)Modern: An Environmental Analysis of the 1958–73 Manhattan Office Building*. New York, NY: Terrapin Bright Green LLC.

Bunnell, Tim. 1999. Views from above and below: The Petronas Twin Towers and/in contesting visions of development in contemporary Malaysia. *Singapore Journal of Tropical Geography* 20 (1): 1–23.

Buruma, Ian. 2002. *Don't be fooled—China is not squeaky clean*. The Guardian, July 30. http://www.guardian.co.uk/world/2002/jul/30/china.features11. Accessed 15 June 2020.

Business Insider. 2012. *People in China thinks this lavish new skyscraper resembles some sort of underwear*. Business Insider, Sept 5. https://www.businessinsider.com/gate-to-the-east-suzhou-everyone-in-china-thinks-this-lavish-new-skyscraper-resembles-underwear-2012-9. Accessed 4 Feb 2022.

Chatwin, Bruce. 1990. *What Am I Doing Here?* Harmondsworth: Penguin Books.

Chulov, Martin. 2022. *Saudi Arabia plans 100-mile-long mirrored skyscraper megacity*. The Guardian, July 27. https://www.theguardian.com/world/2022/jul/27/saudis-unveil-eye-popping-plan-for-mirrored-skyscraper-eco-city. Accessed 31 Jan 2023.

References

Cook, Rick, Bill Browning, and Chris Garvin. 2013. Sustainability and energy considerations. In *The Tall Buildings Reference Book*, ed. Antony Wood and David Jr. Parker, 145–155. London: CRC Press LLC.

CTBUH. 2020. *Tall buildings in 2020: COVID-19 contributes to dip in year-on-year completions.* Council on Tall Buildings and Urban Habitat. https://www.skyscrapercenter.com/year-in-review/2020. Accessed 20 Sept 2021.

CTBUH. 2021a. *The global impact of 9/11 on tall buildings.* Skyscraper Center. https://www.skyscrapercenter.com/9-11-global-impact. Accessed 20 Sept 2021.

CTBUH. 2021b. *Mumbai.* Council on Tall Buildings and Urban Habitat. https://www.skyscrapercenter.com/city/mumbai. Accessed 25 Sept 2021.

CTBUH. 2022a. *Cities.* Council on Tall Buildings and Urban Habitat. https://www.skyscrapercenter.com/city/. Accessed 20 Sept 2022a.

CTBUH. 2022b. *Moscow.* Council on Tall Buildings and Urban Habitat. https://www.skyscrapercenter.com/city/moscow. Accessed 10 Sept 2022b.

Davis, Mike. 2007. Sand, fear, and money in Dubai. In *Evil Paradises: Dreamworlds of Neoliberalism*, ed. Mike Davis and Daniel Bertrand Monk, 48–68. New York, NY: The New Press.

Dietsch, Deborah K. 1994. Carpetbegging in Asia. *Architecture* 83 (9): 15.

Dovey, Kim. 1992. Corporate towers and symbolic capital. *Environment and Planning b: Planning and Design* 19 (2): 173–188.

Emporis. 2022. *Most expensive buildings in Asia.* Emporis. https://www.emporis.com/statistics/tallest-buildings/country/100030/china. Accessed 10 Sept 2022.

en2x. 2022. Rohölpreisentwicklung Jäarlich. *en2x.* https://en2x.de/service/statistiken/rohoelpreise/. Accessed 10 Nov 2022.

Fenton, Joseph. 1985. *Hybrid buildings.* New York, NY: Pamphlet Architecture.

Fisher, Thomas. 1995. What is American architecture? *Progressive Architecture* 76 (1): 11.

Fix, Mariana. 2011. A bridge to speculation or the art of rent in the staging of a global city? In *Urban Developments in Brazil and Portugal*, ed. Márcio Moraes Valença, Fernanda Cravidão and José Alberto Rio Fernandes, 35–75. New York, NY: Nova Publishers.

Fixsen, Anna. 2014. *Site unseen.* Architectural Record, June 16. https://www.architecturalrecord.com/articles/5868-site-unseen. Accessed 30 Aug 2021.

Foster + Partners. 2020. *SNB Head Office.* Foster + Partners. https://www.fosterandpartners.com/projects/snb-head-office/. Accessed 20 July 2022.

Frearson, Amy. 2014. 'No more weird architecture' says Chinese president. Dezeen, Oct 20. https://www.dezeen.com/2014/10/20/no-more-weird-architecture-in-china-says-chinese-president/. Accessed 5 Feb 2021.

Goh, Beng-Lan., and David Liauw. 2009. Post-colonial projects of a national culture. *City* 13 (1): 71–79.

Graham, Stephen. 2015. Luxified skies: How vertical urban housing became an elite preserve. *City* 19(5): 618–645, https://doi.org/10.1080/13604813.2015.1071113.

Gurin, David. 2003. *Understanding Sprawl: A Citizen's Guide.* Vancouver: David Suzuki Foundation.

Harding, Luke. 2007. *Skyscraper may see St Petersburg lose world heritage status.* The Guardian, Sept 3. https://www.theguardian.com/world/2007/sep/03/russia.architecture. Accessed 10 Sept 2022.

Holland, Oscar. 2021. *World's second tallest building tops out in Malaysia.* CNN, Dec 3. https://edition.cnn.com/style/article/merdeka-118-second-tallest-skyscraper/index.html. Accessed May 10, 2022.

Hollister, Nathaniel. 2013. The history of the European skyscraper. *CTBHU Journal* 2: 52–55.

Hsu, Vadim Menstell. 1999. *Shanghai high-rise construction: Technology transfer for developing tall buildings in China.* MSc thesis, California Polytechnic State University.

Jahn Kassim, Shireen, and Zumahiran Kamaruddin. 2018. Urban syncretism: Conscious and unconscious architectural formation of national identity. In *Modernity, Nation and Urban-Architectural Form: The Dynamics and Dialectics of National Identity vs Regionalism in a Tropical City*, ed. Shireen Jahn Kassim, Norwina Mohd Nawawi and Mansor Ibrahim, 209–234. Basingstoke: Palgrave Macmillan.

Jahn Kassim, Shireen, Norzalifa Zainal Abidin, and Norwina Mohd Nawawi. 2018. Criticality, symbolic capital and the high-rise form. In *Modernity, Nation and Urban-Architectural Form: The Dynamics and Dialectics of National Identity vs Regionalism in a Tropical City*, ed. Shireen Jahn Kassim, Norzalifa Zainal Abidin and Norwina Mohd Nawawi, 155–175. Basingstoke: Palgrave Macmillan.

Jencks, Charles. 2005. *The Iconic Building: The Power of Enigma.* London: Frances Lincoln.

Jencks, Charles. 2011. *The Story of Post-Modernism: Five Decades of the Ironic, Iconic and Critical in Architecture.* Chichester: Wiley.

Jencks, Charles, and Rem Koolhaas. 2011. Radical post-modernism and content: Charles Jencks and Rem Koolhaas debate the issue. *Architectural Design* 81 (5): 32–45.

Kamin, Blair. 2010. Burj Khalifa. *Architectural Record* 198 (8): 79.

Kanna, Ahmed. 2011. *Dubai, the City as Corporation.* Minneapolis: University of Minnesota Press.

Katsalidis, Fender. no date. *Merdeka PNB 118.* FKAustralia. https://fkaustralia.com/#featured. Accessed 10 Sept 2022.

Kearney. 2010. The urban elite. The A.T. Kearney global cities index 2010. Kearney. https://www.kearney.com/documents/20152/436064/Global+Cities+2010.pdf/1880d48e-4ac2-7b30-b24e-a0ac47382307?t=1500555506672. Accessed 20 Sept 2021.

Kearney. 2018. *2018 global cities report.* Kearney. https://www.kearney.com/global-cities/2018.

King, Anthony D. 2004. *Spaces of Global Cultures: Architecture, Urbanism, Identity.* London; New York, NY: Routledge.

Klink, Jeroen, and Laisa Eleonora Maróstica. Stroher. 2017. The making of urban financialization? An exploration of Brazilian urban partnership operations with building certificates. *Land Use Policy* 69: 519–528.

Koolhaas, Rem. 1978. *Delirious New York: A Retroactive Manifesto for Manhattan.* New York, NY: Oxford University Press.

Koolhaas, Rem. 1995. Singapore songlines. Portrait of a potemkin metropolis... Or thirty years of tabula rasa. In *S, M, L, XL*, ed. OMA, Rem Koolhaas and Bruce Mau, 1008–1089. New York, NY: The Monacelli Press.

Koolhaas, Rem. 2015. *Dubai: From judgment to analysis.* Sharjah Biennial.

KPF. 2005. *KPF: Asian Projects.* Mulgrave: Images Publishing.

Kusno, Abidin. 2002. Architecture after nationalism: Political imaginings of Southeast Asian architects. In *Critical Reflections on Cities in Southeast Asia*, ed. Tim Bunnell, Lisa B. Welch Drummond and Kong-Chong Ho, 124–149. Singapore: Times Media.

Langdon, Philip. 1995. Asia bound: What are American architects' responsibilities in developing countries? *Progressive Architecture* 76 (3): 43–51.

Lawrence, Andrew. 1999. *The skyscraper index: Faulty towers.* Property report, Dresdner Kleinwort Wasserstein Research.

Liernur, Jorge Francisco. 2001. *Arquitectura en la Argentina del siglo XX. La Construccion de la modernidad.* Buenos Aires: Fondo Nacional de las Artes.

Lim, William S.W.. 1975. Tall buildings for urban centers in third world countries. *Ekistics* 40 (238): 196–198.

Loo, Yat Ming. 2013. *Architecture and Urban Form in Kuala Lumpur: Race and Chinese Spaces in a Postcolonial City.* Farnham: Ashgate.

McBeth, John. 1994. Merry go round. *Far Eastern Economic Review* 157 (5): 36.

McNeill, Donald. 2009. *The Global Architect: Firms, Fame and Urban Form.* New York, NY: Routledge.

References

Merrick, Jay. 2018. A map in search of lost territory: The development of Msheireb Downtown Doha is intended to recreate the cultural roots of the district while accepting the march of time. *The Architectural Review* 244 (1451): 34–40.

Montengro Miranda, Germán. 2018. Edificación de gran altura y paisaje metropolitano. Reedificación versus reurbanización en Bogotá. *Bitácora Urbano Territorial* 28 (2): 73–83.

New Climate Economy. 2014. *Better Growth, Better Climate.* Washington, DC: New Climate Economy.

Newman, Peter. 2014. Density, the sustainability multiplier: Some myths and truths with application to Perth, Australia. *Sustainability* 6 (9): 6467–6487.

Newton, Clare. 2019. *Vertical schools on the rise in Australian cities.* ArchitectureAU, Dec 6. https://architectureau.com/articles/vertical-schools-on-the-rise/. Accessed 31 Jan 2023.

Ni, Vincent. 2021. *'Vanity Projects': China to introduce tighter limits on skyscrapers.* The Guardian, Oct 28. https://www.theguardian.com/world/2021/oct/28/vanity-projects-china-to-introduce-tighter-limits-on-skyscrapers. Accessed 10 Mar 2022.

Norman, Jonathan, Heather L. Maclean, and Christopher A. Kennedy. 2006. Comparing high and low residential density: Life-cycle analysis of energy use and greenhouse gas emissions. *Journal of Urban Planning and Development* 132 (1): 10–21.

Oldfield, Philip, and Antony Wood. 2019. Tall buildings in the global recession: 2008, 2020 and beyond. *CTBUH Journal* 1: 20–26.

OMA. 2006. *Dubai renaissance.* OMA. https://www.oma.com/projects/dubai-renaissance. Accessed 20 July 2022.

Ong, Aihwa. 2011. Introduction worlding cities, or the art of being global. In *Worlding Cities: Asian Experiments and the Art of Being Global*, ed. Ananya Roy and Aihwa Ong, 1–26. Chichester; Malden, MA: Wiley-Blackwell.

Pelli Clarke Pelli Architects. 1997. *Petronas towers.* Pelli Clarke Pelli Architects. https://pcparch.com/project/petronas-towers/. Accessed 20 Sept 2021.

Pelli Clarke Pelli Architects. 2013. *The landmark.* Pelli Clarke Pelli Architects. https://pcparch.com/project/the-landmark/. Accessed 25 Sept 2020.

Ponzini, Davide. 2020. *Transnational Architecture and Urbanism: Rethinking How Cities Plan, Transform, and Learn.* London: Routledge.

Radović, Vuk. 2020. Density through the prism of supertall residential skyscrapers: Urbo-architectural type in global megacities. *Sustainability* 12 (4): 1314.

Ren, Xuefei. 2008. Architecture as branding: Mega project developments in Beijing. *Built Environment* 34 (4): 517–531.

Ren, Xuefei. 2011. *Building Globalization: Transnational Architecture Production in Urban China.* Chicago, IL: The University of Chicago Press.

Rennie-Short, John. 2004. *Global Metropolitan: Globalizing Cities in a Capitalist World.* London; New York, NY: Routledge.

Rush, Richard D. 1995. Shanghai: Home of the handmade highrise. *Progressive Architecture* 76 (3): 35–36.

Shane, David Grahame. 2007. *Recombinant Urbanism: Conceptual Modeling in Architecture, Urban Design, and City Theory.* Chichester: Wiley-Academy.

Shannon, Kelly. 2014. Beyond tropical regionalism: The architecture of Southeast Asia. In *A Critical History of Contemporary Architecture: 1960–2010*, ed. Elie G. Haddad and David Rifkind, 359–377. Surrey: Ashgate.

Sklair, Leslie. 2006. Iconic architecture and capitalist globalization. *City* 10 (1): 21–47.

Smallwood, Reynolds, Stewart, Stewart & Associates. 2001. *Millenium tower.* Smallwood, Reynolds, Stewart, Stewart & Associates. https://www.smallwood-us.com/work/case-study/millennium-tower. Accessed 20 Sept 2020.

Smith, David. 2015. Johannesburg's Ponte City: 'The tallest and grandest urban slum in the world'. The Guardian, 11 May. https://www.theguardian.com/cities/2015/may/11/johannesburgs-ponte-city-the-tallest-and-grandest-urban-slum-in-the-world-a-history-of-cities-in-50-buildings-day-33. Accessed 31 Jan 2023.

Somekh, Nadia. 1992. A (Des)Verticalização de São Paulo e o Plano Diretor da Cidade. *Pós. Revista do Programa de Pós-Graduação em Arquitetura e Urbanismo da FAUUSP* 1 (2): 77–84.

Spencer, Douglas. 2016. *The Architecture of Neoliberalism: How Contemporary Architecture Became an Instrument of Control and Compliance.* London: Bloomsbury.

Taylor, James. 2013. *Vanity height: How much of a skyscraper is usable space?* Archdaily, Sept 6. https://www.archdaily.com/425730/vanity-height-how-much-of-a-skyscraper-is-usable-space. Accessed 28 June 2022.

USGBC. 2014. *LEED® in Motion: Greater China. China, Hong Kong, Taiwan.* USGBC.

Vidal, Vergara, and Jorge Eduardo. 2017. Verticalización. La edificación en altura en la Región Metropolitana de Santiago (1990–2014). *Revista INVI* 32 (90): 9–49.

Wainwright, Oliver. 2019. *New York's high-rise jails: what could go wrong?* The Guardian, Dec 9. https://www.theguardian.com/cities/2019/dec/09/new-yorks-high-rise-prisons-what-could-go-wrong. Accessed 31 Jan 2023.

Watts, Steve. 2013. Tall building economics. In *The Tall Buildings Reference Book*, ed. Antony Wood and David Jr. Parker, 49–70. London: CRC Press LLC.

Williams, Austin. 2013. Yuan diagram. *The Architectural Review* 234 (1401): 42–53.

Wood, Antony. 2013. Afterword. The future of tall buildings. In *The Tall Buildings Reference Book*, ed. Antony Wood and David Jr. Parker, 353–361. London: CRC Press LLC.

Wood, Antony, and David Parker. 2013. *The Tall Buildings Reference Book.* London: CRC Press LLC.

Xue, Charlie QL. 2006. *Building a Revolution: Chinese Architecture Since 1980.* Hong Kong: Hong Kong University Press.

Yeang, Ken. 2002. *Reinventing the Skyscraper: A Vertical Theory of Urban Design.* Chichester; Hoboken, NJ: Wiley-Academy.

Chapter 6
Art and Culture: Global Icons for the Starchitects

A thriving and diverse cultural offer is increasingly required to meet the demand of the "creative class" (Florida 2012) that cities compete to attract as well as the expectations of international tourists in any aspiring global city or simple urban centres with some ambitions. The construction of expansive facilities, primarily museums and art centres, but also theatres, public libraries, and multi-functional cultural centres, has become a key strategy in urban regeneration processes since the 1970s in the USA and Europe. The case of Bilbao, the capital of the Basque Country in Spain, is one of the most emblematic in this regard. At the end of the 1980s, this once-burgeoning industrial and port city was nothing more than a decaying de-industrialising provincial centre. However, by the end of the next decade, everything had changed. The construction of the Guggenheim Museum (1991–97), designed by Pritzker architect Frank O. Gehry, turned the city into a world-famous cultural destination with a thriving cultural and gastronomic offer. What happened in Bilbao soon became a model throughout the world. While architects, critics, and historians have debated about the qualities of Gehry's Guggenheim and what this titanium-clad, computer-designed complex shape meant for the future of architecture—as much praised by Jencks (2011) as trashed by Frampton (2020, 624)—, economists and sociologists have focused on its broader legacy, the so-called "Guggenheim" or "Bilbao effect" (Gómez 1998; Plaza 2000; Gómez and González 2001).

Whatever such an effect did or did not exist entirely depends on how the issue is framed, one would be tempted to say, because the effect did not apparently work in attracting "international capital and advanced services, although it did prove effective in creating a new city image associated with art and culture, thereby making it possible to pursue an economic revitalisation strategy based on the 'new leisure economies'" (Vicario and Manuel Martínez Monje 2003). It is important to point out here that this carefully planned operation showed how a declining post-industrial secondary city could be transformed into an international cultural and tourist hotspot thanks to the right planning and architectural choices. Indeed, Gehry's titanium building was nothing more than the "olive in the Martini" (Edwin Heathcote cited

© The Author(s), under exclusive license to Springer Nature Singapore Pte Ltd. 2023 249
G. Botti, *Designing Emerging Markets*,
https://doi.org/10.1007/978-981-99-1552-1_6

in Apollo 2017) within a broader plan which included the construction of a rapid-transit system and a recreational and commercial harbour (Rectanus 2000, 177–178). More deeply and expansively, the *Grandes opérations d'architecture et d'urbanisme*, simply known as the *Grand Travaux* ("big works"), launched by French president François Mitterand in the 1980s, had already displayed the transformative power of cultural policies intermingled with large-scale urban and architectural operations (Chaslin 1985; Campobenedetto 2017). To reposition Paris as the world capital of art and culture and regain its nineteenth-century role celebrated by Walter Benjamin, the *Grand Travaux* resulted in a series of high-profile interventions, from the Grand Louvre (1981–90s), with its iconic glass pyramid (1983–88) designed by I. M. Pei, to the Opéra Bastille (1983–89) by Uruguayan architect Carlos Ott, from the Institut du Monde Arabe (1981–87) by Jean Nouvel to Dominque Perrault's National Library (1989–95).

Still, in the last three decades, the construction of expansive cultural facilities has not been a prerogative of Western cities. Glossy architecture contributed to creating the new image of many emerging global cities, like Shanghai and Abu Dhabi, but also of many world cities striving to become global.[1] Throughout the world, national and local governments have been able to mobilise massive resources and know-how to initiate "world-conjuring" megaprojects aimed at achieving a condition of "worldclassness" for cities in which "planners and developers can persuade people to accept potentially controversial projects in the name of the greater metropolitan good" (Ong 2011). As noted, this has been particularly true in Asia because of "inter-city comparisons [that] reinforce the link between economic speculation and urban aspiration" (Ong 2011). Indeed, this chapter will explore how aspiring global cities, especially Chinese ones, have represented a key market for overseas architects designing museums and other cultural facilities while other regions have lagged behind in this race. As the development of such a cultural offer is at least partly based on the physical infrastructure of buildings and their seductive image, these fanciful pieces of architecture have been generally designed by starchitects, including many Pritzker Prize winners and boutique firms, rather than megafirms. Undoubtedly, they are the ones with the power to construct that "new image" of the city that any place branding strategy needs "to replace either vague or negative" ones (Holcomb 1993, 133).

6.1 The Museum Boom: China

Without a doubt, in the last two decades, China is the country that has seen the most significant transformation of its cultural infrastructure. Among the many typologies, museums have experienced unprecedented growth, which some authors have defined as the "Chinese museum boom" (Zhang and Courty 2021). At an average pace of 120 new museums built every year since 1996, China now boasts more than 4,000

[1] The "soft" definition of global city as a temporary condition used by Rennie-Short (2004, 3) is adopted here.

6.1 The Museum Boom: China

of such institutions. By comparison, the pace of growth in the USA in the decade before the Great Recession was between 20 and 40 per year. In parallel, between 1996 and 2015, public spending on culture grew faster than the GDP in China, and the allocation for museums also increased faster than the overall cultural budget (Zhang and Courty 2021). Among the sample of projects collected in this research (either built or unbuilt), China shows the highest percentage of museums (5.4%) and cultural buildings (9.8%) designed by foreign architects compared to the other regions analysed. They include some of the most important museums in the country, built in prestigious urban locations, as well as minor ones; they comprise public and private institutions.

By the end of the 1990s, invited design competitions became frequent, especially after the introduction of new regulations imposing such tender schemes for buildings over 3,000 m^2 (Xue 2006, 41), starting in cities like Shanghai and Shenzhen. With this new regulatory framework, foreign architecture firms were often invited to participate. The first major competition was held in 1999 for the Beijing National Centre for Performing Arts. For museums, the first major call happened in 2004, when a competition for the renewal and extension of the National Museum of China in Beijing was launched. German firm Gerkan Marg & Partners (GMP) was awarded the first prize—beating Denton Corker Marshall, Foster + Partners, Herzog & De Meuron, KPF, and OMA—and the building was eventually completed in 2010. The same year, another major competition for the expansion of the National Art Museum of China (NAMOC) was initiated. Again, a very similar bunch of competitors was selected: Coop Himmelb(l)au, Frank O. Gehry, GMP, Morphosis, OMA, Safdie Architects, UN Studio, Zaha Hadid, the Chinese firm MAD Architects, and the eventual winner, announced three years later, Jean Nouvel with the Beijing Institute of Architectural Design (BIAD). Since then, however, the museum has remained on hold and the fate of the proposal, conceptualised as a light brushstroke, is currently uncertain. Nonetheless, the Atelier led by the French Pritzker-winner has recently completed in Shanghai the Pudong Art Museum (2015–21, 54,000 m^2; Fig. 6.1), a white-granite-clad block featuring an over-scaled window, or screen, directly facing the Bund. The Atelier is also currently busy developing the smaller Start Museum (1,777 m^2) and the Artists' Garden in Qingdao, a 107,000-square-metre complex that includes a museum, residences for artists, and a hotel.

For China, the list of museums designed by overseas firms since 2000 is long. It includes large complexes of several tens of thousands of square metres and smaller ones, buildings located in first-tier cities, and more remote locations in inner China. Among the large museums, a characteristically Chinese type deserving some attention is the urban planning exhibition centre. As noted (Fan 2015), they tend to be large in scale, situated in prime urban locations, and provided with generous exhibition areas and of large three-dimensional models to display the current or future development of the city. They usually consist of ad hoc buildings and perform the very precise function of preparing "the mass for what is about to come and to accept the grand vision of the local government, and to cater to high-level officials (*lindao*) who come to the city to inspect local development" (Fan 2015). While Fan (2015)

Fig. 6.1 The Pudong Art Museum by Atelier Jean Nouvel in Lujiazui, Shanghai. Photograph by Giaime Botti, distributed under a CC BY 4.0

may be right in claiming that urban planning exhibition halls "are not iconic buildings" overall but rather "dull designs by the faceless architectural institutes," there is a remarkable set of examples to assert the contrary. Ambitious buildings designed by foreign architects have appeared in many cities in the last decade (Table 6.1). The most important examples are Coop Himmelb(l)au's and Playze's parametrically designed buildings in Shenzhen (Fig. 6.2) and Ningbo (Fig. 6.3), respectively, and GMP's Zhuhai Museum and Planning Exhibition Centre.

More in general, we can find several large-scale museums designed by foreign firms all over China (Table 6.2), comprehending a great variety of museum

Table 6.1 Built urban planning exhibition centres designed by overseas firms (surveyed sample) in China

Designer	City	Project	Year	GFA (m^2)
AREP	Chengdu	Chengdu Planning Exhibition Building	2012	113,000
BDP	Suzhou	Suzhou District Planning Exhibition Hall	2012	12,000
Coop Himmelb(l)au	Shenzhen	Museum of Contemporary Art and Planning Exhibition	2007–16	80,000
GMP	Zhuhai	Zhuhai Museum and Planning Exhibition Hall	2020	55,000
Playze	Ningbo	Ningbo Urban Planning Exhibition Centre	2019	24,900
Progetto CMR	Tianjin	Tianjin Planning Exhibition Hall	2008	30,000

Fig. 6.2 The Museum of Contemporary Art and Planning Exhibition by Coop Himmelb(l)au in Futian CBD, Shenzhen. Photograph by Giaime Botti, distributed under a CC BY 4.0

Fig. 6.3 The Ningbo Urban Planning Exhibition Centre by Playze in Ningbo Eastern New City, Ningbo. Photograph by Giaime Botti, distributed under a CC BY 4.0

Table 6.2 Built museums (over 20,000 m^2) designed by overseas firms (surveyed sample) in China

Designer	City	Project	Year	GFA (m^2)
Archea	Liling	Liling World Ceramic Art City	2010–15	210,000
AREP	Beijing	Capital Museum of Beijing	2006	60,000
AS Architecture Studio	Chongqing	City of Science and Technology	2009	40,000
	Lhasa	Tibet Natural Science Museum	2015	32,000
Bernard Tschumi	Tianjin	Science and Technology Museum	2013–19	33,000
Cox Architects	Tianjin	National Maritime Museum	2011–19	80,000
David Chipperfield	Shanghai	West Bund Museum	2013–19	22,000
	Jingdezhen	Ceramic Art Avenue Taoxichuan	2018–22	265,000 (including grand theatre, hotels, and shops)
Ennead	Lingang New City, Shanghai	Shanghai Astronomy Museum	2015–21	39,000
Foster and Partners	Datong	Datong Art Museum	2011–21	32,200
GMP	Shanghai	Museum in Shanghai-Pudong	2006	41,000
	Lingang New City, Shanghai	China Maritime Museum	2005–09	46,400
	Tianjin	Tianjin Binhai Cultural Centre and Museum	2013–17	31,600
	Suzhou	Suzhou Museum West	2017–21	45,540
Henn	Beijing	Automotive Expo Museum	2009	55,000
I.M. Pei	Nanjing	Six Dinasties Musuem	2014	69,795
Jean Nouvel	Shanghai	Pudong Art Museum	2015–21	54,000
KSP	Nanjing	Jiangsu Provincial Art Museum	2006–10	27,450
	Tianjin	Tianjin Art Museum	2009–11	33,000
Maki and Associates	Shenzhen	Sea World Culture and Arts Centre	2007	73,918
Mario Botta	Beijing	Tsinghua Art Museum	2002–16	30,000

(continued)

6.1 The Museum Boom: China

Table 6.2 (continued)

Designer	City	Project	Year	GFA (m^2)
Next Architects	Beijing	Chaoyang Museum of Urban Planning	N.A.	17,000
Paul Andreu—ADP Ingénierie	Shanghai	Shanghai Oriental Art Centre	2004	39,694
	Suzhou	Suzhou Arts and Science Centre	2003–07	128,900
Paul Andreu—Richez Associés	Taiyuan	Taiyuan Archaeological Museum	2011	50,000
Perkins & Will	Shanghai	Shanghai Natural History Museum	2015	45,000
Shin Takamatsu	Tianjin	Tianjin Museum	2004	33,900

types, spanning from those dedicated to historical relics or contemporary art to others focusing on science and technology. Several well-known boutique firms and renowned architects have signed the projects of these large buildings as well as of smaller ones, while also some megapractices have been successful. GMP designed the China Maritime Museum of Lingang (then renamed Nanhui) New City as the cultural icon of this planned satellite settlement. Shaped around an artificial circular lake located at the East of Pudong, its 74-square-kilometre master plan was also elaborated by GMP. Soon, Nanhui will also claim a new cultural facility, the Shanghai Astronomy Museum by Ennead. In Tianjin, GMP completed the Binhai Cultural Centre and Museum, the cultural core of the new area of Tianjin Binhai. This complex integrates MVRDV's Library, Bernard Tschumi's Science and Technology Museum, a theatre designed by Revery Architecture, and a Citizens' Centre by Hua Hui Architects (both firms not included in our survey). Overall, most of the museums designed by overseas architects do emerge as key urban elements, often clustered with other major cultural facilities like grand theatres and libraries. As seen, this has happened in major cities as well as in urban centres of lower hierarchical levels, like Miralles Tagliabue-EMBT's Zhang Daqian Museum (2010–16, 2,150 m^2) in Neijiang, and sometimes even in remote cities in Western China. French firms Arte Charpentier designed the 'broken' glazed pyramid of the Ala'er Museum in Xinjiang (2003–09, 10,000 m^2), AS Architecture Studio the Tibet Natural Science Museum in Lhasa, Cambridge Seven the Children's Discovery Museum in Hohhot, Inner Mongolia (2018, over 9,000 m^2).

As a matter of fact, however, most of these buildings contributed little to the architectural debate, either in China or at the international level, nor they featured significant innovations. In this regard, one of the exceptions was I. M. Pei's Suzhou Museum (2006, 15,390 m^2). With a rigorous geometry symmetrically organising the overall layout of an irregular site and equally rigorous use of basic shapes—squares, rectangles, octagons—in the typical manner of Pei, the building proposed an interpretation of the local vernacular in a design that was also "consciously modern or abstract," to

use the words with which Zhu (2009, 115) described Pei's Fragrant Hill Hotel (1979–82; Sect. 10.2).[2] The Museum not only features an aesthetic reminding of Suzhou vernacular architecture, with white plastered walls contrasting with dark clay tiles, but also provides a variety of outdoor spaces, like small courtyards and a large Chinese garden, that conceptually integrates the complex into its context, as the site borders the Humble Administrator Garden, one of China's most famous historic gardens. The same conceptual force, on the other hand, is not visible in The Six Dynasties Museum (2014, 69,795 m^2) in Nanjing, a rather conservative building clad in limestone, whose main quality, rather than in the interpretation of traditional Chinese elements like the circular openings overlooking the atrium, lies in the narrow plaza defined by the protruding entrance of the museum and the setback of the hotel linked to it.

Although most of the growth in the number of museums during the last two decades relied on public funds and policies (Zhang and Courty 2021), private companies have also financed several museums and cultural facilities. Smaller museums, usually below 10,000 m^2 in GFA, have been commissioned by public–private institutions, foundations, private companies, and real estate developers. In many cases, they have been designed by celebrity architects, like in the case of Daniel Libeskind's Museum of Zhang Zhidong in Wuhan (2018, 7,240 m^2), and even Pritzker-winners. Tadao Ando completed the Aurora Museum (2013, 6,300 m^2) and the Pearl Art Museum in Shanghai (2017, 4,000 m^2), as well as the larger He Art Museum in Shunde (2020, 16,000 m^2), while Arata Isozaki the CAFA (Central Academy of Fine Arts) Art Museum in Beijing (2003–08), the Pavilion of Japanese Army in World War II in Jianchuan Museum Cluster in Chengdu (2004–15), and the introverted and not well-resolved Hangzhou Xixi Wetland Museum (2009 19,692 m^2; Fig. 6.4). Kengo Kuma, on the other hand, designed the more interesting Xinjin Zhi Museum

Fig. 6.4 The Xixi Wetland Museum by Arata Isozaki, Hangzhou. Photograph by Giaime Botti, distributed under a CC BY 4.0

[2] Also described as a "blend of modernism with iconic historicism" (Zhu 2009, 205).

Fig. 6.5 The Folk Art Museum by Kengo Kuma in the Xiangshan Campus of the China Academy of Art, Hangzhou. Photograph by Giaime Botti, distributed under a CC BY 4.0

in Chengdu (2011, 787 m^2) and the Folk Art Museum (2015, 4,970 m^2) inside the Xiangshan Campus of the China Academy of Art in Hangzhou (Fig. 6.5). The latter one, internally organised as a continuous terraced space, features an intriguing light screen made of traditional roof tiles hanging from metal wires, similar but not identical to the one proposed in Chengdu. Such buildings establish a dialogue with regional construction traditions and their contemporary reinterpretations, especially in Xiangshan, where Kuma's Museum stands just a few hundred metres away from some Wang Shu's buildings (Sect. 9.5). And inside the same campus also stands the China Museum of Design Bauhaus Collection (2018, 16,000 m^2; Fig. 6.6), a project that appears to promote more the architectural poetics of its authors, Álvaro Siza and Carlos Castanheira, than any local character. Indeed, the more recent Huamao Museum of Art Education in Ningbo (2020, 5,300 m^2; Fig. 6.7) seems a bit self-referential, too. With its sinuous black volume lifted from the ground, this introverted building boasts a masterly designed atrium with a ramp that stretches its full height. This case represents a good example of the ambitions of wealthy private clients and the connections between cultural enterprises and real estate in contemporary China. The Huamao Group is a local company specialising in international education with a few English schools in Ningbo. The museum is located in a new development on the shores of Dongqian Lake, a popular resort area on the outskirts of Ningbo. Such a site, which lies just beside the Hilton Hotel, will soon accommodate several small villas and artists' studios (artists' communities with atelier and house-studio is a

Fig. 6.6 The China Museum of Design Bauhaus Collection by Álvaro Siza and Carlos Castanheira in the Xiangshan Campus of the China Academy of Art, Hangzhou. Photograph by Giaime Botti, distributed under a CC BY 4.0

Fig. 6.7 The Huamao Museum of Art Education by Álvaro Siza and Carlos Castanheira in Dongqian Lake area, Ningbo. Photograph by Giaime Botti, distributed under a CC BY 4.0

diffused typology in China), some of which are currently being designed by Siza, as well as another small complex by Chinese firm Atelier Feichang Jianzhu, or FCJZ (founded by Yung Ho Chang in 1993, it is commonly considered the first private architecture firm in China). The development will then count on the museum as an iconic element, increasing the value of the surroundings, where high-end residential and cultural activities mix in a scenic natural area.

Fig. 6.8 The Liangzhu Art Centre by Tadao Ando in Liangzhu New Town, Hangzhou. Photograph by Giaime Botti, distributed under a CC BY 4.0

Another comparable example is the Sifang Art Museum (2013, 2,787 m^2), designed by Steven Holl near Nanjing as part of the Contemporary International Practical Exhibition of Architecture. Such a name does not refer to some kind of new Weißenhofsiedlung to promote the future of housing but rather to an estate where art and leisure mix under the auspices of (supposedly) high-quality design. In addition to the museum, the park boasts the work of other renowned foreign and Chinese architects. Arata Isozaki was in charge of the conference centre, and Liu Jiakun of the Hotel, while others designed the villas that are temporarily rented out for weekends or more extended stays. Among foreign architects, we count David Adjaye (2012, 370 m^2), Mansilla + Tuñón (Fo-shou House, 2003–14), Odil Decq (Flying Horse House), and, not included in our survey, Alberto Kalach, Ettore Sottsass, and Matti Sanaksenaho & Pirjo Sanaksenaho; among the Chinese, Ai Weiwei, Wang Shu, Zhang Lei, and Ku Cai. This connection between speculative real estate operations and cultural buildings, often in the form of small museums or art galleries designed by well-known architects, has been exploited since the early 2000s, although in different forms. At that time, the SOHO Commune by the Great Wall showed the potentiality of relying on top architects to design luxury villas marketed through "a well-orchestrated media operation", reaching out to museum curators, architects, and critics (Ren 2011, 74). The Today Art Museum, designed by Atelier FCJZ in 2002, for instance, brought a touch of glamour to the Pingod gated communities, two compounds popular among expat professionals in Beijing. Gensler designed the Vantone (a large real estate developer) History Museum in Beijing, while Schmidt Hammer Lassen the Gaoyao Clubhouse and Gallery (2016–17, 3,160 m^2), meant to (culturally) enrich the life of the owners of the luxury villas of the residential complex.

Vanke, another real estate giant, has promoted itself as an "urban service provider" rather than a simple real estate developer (Carota 2019, 316). We should not be

Fig. 6.9 The Liangzhu Museum by David Chipperfield, in Liangzhu New Town, Hangzhou. Photograph by Giaime Botti, distributed under a CC BY 4.0

surprised by finding that in a development near Qingdao, Vanke commissioned Iroje Architects & Planners, the same South Korean firm already involved in two phases of SOHO's Commune by the Great Wall, to design a small building as a promotion hall and cultural centre (2013, 2,340 m^2) for the community. Indeed, more interesting is the case of Liangzhu New Town, near Hangzhou, branded as an example of a "new rural lifestyle" (Jia et al. 2015, 172) not devoid of public facilities designed by acclaimed architects (Guan et al. 2021). Among the buildings, Tadao Ando's Art Centre (2016, 7,000 m^2; Fig. 6.8), which encompasses a library, a gallery, and a theatre under a single roof, and David Chipperfield's Liangzhu Museum (2003–07, 9,500 m^2; Fig. 6.9) stand out for the fame of the professionals involved. As often happens, the museum was developed with neither a defined programme nor an exhibition agenda, and the architect was only provided with a minimum brief (Jacobson 2014, 125), resolved with a sculptural gesture based on a simple scheme: four shifted parallel bars of same length and widths but different height cladded in travertine and immersed in a landscaped park. Such projects, and we can add the Christian church designed by Japanese architects Shikyo Fu and Tsushima Design Studio (not included in our survey), further display the role of some developers in bringing top international architects to China (Sect. 8.6). In Shanghai, mixed-use developments with strong office and commercial components are also increasingly enriched by museums and art spaces. In the Bund Finance Centre designed by Foster + Partners, we find Heatherwick Studio's Fosun Foundation, an exhibition and performance space boasting a partnership with the Lincoln Centre for the Performing Arts (Sect. 9.2). In the newly completed Rockbund, an office-oriented renovation of some early twentieth-century buildings operated by Chipperfield and developed by the Rockefeller Group and Sinolink Worldwide Holdings, we also find the Rockbund Art Museum (2,300 m^2). These and other cases thus show how real

6.1 The Museum Boom: China

estate developers have fuelled the Chinese museum boom. The result is, in most cases, a more or less well-designed box with very little to exhibit inside, as M + curator Aric Chen denounces: "In China, it's often not so much about creating a museum, with well-defined content that will attract and engage the public; it's more about using a museum as a tool for real estate development" (Howarth 2015).

Thus, the list of foreign celebrities involved in museum design continues. Chipperfield, for example, has been one of the most active. His firm, which counts on a Shanghai branch, has completed the Zhejiang Museum of Natural History (2014–19, 5,800 m^2) in Hangzhou, a small museum in the recently completed Ceramic Art Avenue Taoxichuan in Jingdezhen, and the West Bund Museum in Shanghai. This not-impressive building nonetheless represents the principal projection of a Western museum in China, as it boasts a stable partnership with the Centre Pompidou. It stands along the Huangpu River in the Xuhui Waterfront, an area now filled with cultural facilities designed by prominent Chinese and foreign architects. They include Atelier Deshaus' Long Museum (2014; Fig. 6.10) and OPEN Architecture's Shanghai Tank (2019), but also Jean Nouvel's Start Museum and Sou Fujimoto YUZ Museum (2014, 9,000 m^2). And, of course, the Xuhui Waterfront does not represent the only cultural cluster. On the north waterfront of Lujiazui, the financial district of Shanghai Pudong, OMA completed the cantilevering Lujiazui Harbour City Exhibition Centre (2014–17), a few hundred meters away from Kengo Kuma's Shipyard 1862, a former shipyard transformed into a mixed-use cultural and commercial complex (Sect. 10.6), while further along the river we find another

Fig. 6.10 The Long Museum by Atelier Deshaus in Xuhui Waterfront, Shanghai. Photograph by Giaime Botti, distributed under a CC BY 4.0

Fig. 6.11 The Ningbo History Museum by Amateur Studio, Ningbo. Photograph by Giaime Botti, distributed under a CC BY 4.0

Fig. 6.12 The Huang Gongwang Museum by Amateur Studio in Fuyang, near Hangzhou. Photograph by Giaime Botti, distributed under a CC BY 4.0

industrial relic turned into a cultural space, Atelier Deshaus' Minsheng Wharf Silos (2017), another piece in the broader project of the Pudong waterfront regeneration.

These examples bring us to consider a last but not minor point. As it might have already emerged, a selected group of Chinese architects, often with strong ties with specific contexts, have won competitions or received commissions for museums and cultural buildings, many of which are of remarkable quality and international praise. They include the works mentioned above by Atelier Deshaus and Vector Architects' Suzhou Intangible Cultural Heritage Museum (2015–16); in Zhejiang, Wang Shu

and Lu Wenyu's (Amateur Studio) Ningbo Contemporary Art Museum (2005) and Ningbo History Museum (2008; Fig. 6.11), both mentioned by the Pritzker Jury's citation in 2012, the lesser-known but extraordinary Huang Gongwang Museum (2017; Fig. 6.12), and the recent Lin'an Museum (2021). In Chengdu, Sichuan, Liu Jiakun designed the Buddhist Sculpture Museum (2002), a "convincing" example of "place-based tectonic modernism" (Zhu 2009, 123) built in a rough exposed-concrete now a kind of signature of Chinese avant-garde architects (Bologna 2019). In Xi'an, Shaanxi, the local architect and academic Liu Kecheng has been behind many of the major cultural projects of the last two decades, from the Fuping Ceramic Museum to the Silk Road Museum.

6.2 Emerging Cultural Hubs? Museum Franchises and Cultural Clusters in the Persian Gulf

Looking at other emerging markets, we cannot find anything quantitatively comparable to China. Nevertheless, some of the most iconic new museums were built in the Persian Gulf, sometimes developed as franchises of US or European institutions. Jean Nouvel's Louvre Abu Dhabi (2006–17; Fig. 6.13) is undoubtedly the most relevant example and probably the most striking piece of architecture. White low-rise volumes containing the exhibition galleries and all the other facilities were irregularly arranged by Nouvel in an artificial peninsula reminding of an Arab medina. This was then roofed with a double perforated metallic circular dome spanning 180 m (Fig. 6.14). The dome not only gathers the fragmented fabric below it as a unifying spatial and conceptual element but also produces a unique atmosphere resulting

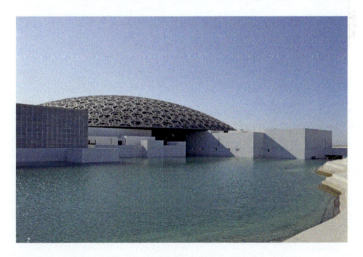

Fig. 6.13 The exterior of the Louvre Abu Dhabi by Atelier Jean Nouvel in Saadiyat Island, Abu Dhabi. Photograph by Giaime Botti, distributed under a CC BY 4.0

Fig. 6.14 The internal courtyard of the Louvre Abu Dhabi by Atelier Jean Nouvel on Saadiyat Island, Abu Dhabi. Photograph by Giaime Botti, distributed under a CC BY 4.0

Fig. 6.15 The Abu Dhabi Guggenheim under construction by Frank O. Gehry on Saadiyat Island, Abu Dhabi. Photograph by Giaime Botti, distributed under a CC BY 4.0

from the changing sunlight that penetrates its irregular holes. For this building, like almost forty years ago with the Institut du Monde Arabe in Paris, Nouvel conceptually engaged with a generic Arab context with remarkable results. By showing a less-vernacular and more-abstract way of contextualising international architecture in non-Western countries, he showed a different path compared, for instance, to Pei's work in Suzhou.

From an urban perspective, this project falls within a larger plan. The museum was built on Saadiyat Island Cultural District, a coastal piece of land where, since the

6.2 Emerging Cultural Hubs? Museum Franchises and Cultural Clusters …

early 2000s, the Abu Dhabi Emirate has been heavily investing to turn it into a prime cultural hub with museums and the campus of the New York University (the latter designed by Rafael Viñoly). The area, together with others like, for instance, Masdar City (Sect. 8.7) and Yas Island (Sect. 10.6), well reflect the ambitions of this emirate to become a real capital in the region for culture, tourism, and research (Duncan and Tomic 2013, 141). In this context, the franchise of the Louvre, worth 400 million euros directly paid to the French government for a 30-year-licence (Graebner 2014), likely represented the most valuable operation of this type in history. More valuable, for instance, than the licensing of the Abu Dhabi Guggenheim, which is now under construction a few hundred metres away (Fig. 6.15). As the most renowned French architect designed the Louvre via a direct appointment, the Guggenheim was assigned, unsurprisingly, to Gehry. The importance of the investment in Saadiyat Island in architectural terms is visible also from other projects, from Foster and Partners' Zayed National Museum (2007–22), currently under construction, to the unbuilt Abu Dhabi Performing Arts Centre (2007) and the Maritime Museum (2012) respectively designed by Zaha Hadid and Tadao Ando. More successful, on the contrary, has been David Adjaye. His Abrahamic Family House (2019–22; Fig. 6.16) is expected to be completed soon. Like the Louvre's collection embraces diversity by showing universal connectivity in human history through artefacts from different civilisations, this complex embodies a message of fraternity and inter-religious dialogue between Catholicism, Islam, and Hebraism. It is composed of three cubic buildings of the same size distinguished by their orientations, interiors, and vertical structures. The three blocks appear as architectural variations of the same theme, highlighting in a way the common ground of the three monotheistic religions.

In the UAE, Abu Dhabi is thus emerging as a tourist destination with a rich cultural offer. Dubai has reinforced its financial and trading global profile, although some

Fig. 6.16 The Abrahamic Family House under construction by David Adjaye on Saadiyat Island, Abu Dhabi. Photograph by Giaime Botti, distributed under a CC BY 4.0

attempts to enrich its cultural offer have produced iconic but questionable projects like the recent Museum of the Future (2022; Fig. 6.17), by local firm Killa Design. Other cities have struggled to carry out similar enterprises and nothing even remotely comparable to the Louvre Abu Dhabi can be found in Sharjah or Ajman, where the main museums occupy buildings dating back to the eighteenth and early nineteenth century or more recent ones, but of very little quality, like for the Sharjah Maritime Museum. The new Buhais Geology Park Museum (2020) by Hopkins Architects represents the most interesting case and an exception. Located in a rocky desertic area, it is composed of five interconnected pods gently posed on the ground like a nomadic settlement but without any vernacular feature.

In the rivalling state of Qatar, its capital city Doha has been expanding its cultural offer for more than a decade (Moore 2018). Although no franchise of major museums can be found here, two buildings stand out. The first one is the Museum of Islamic Art, conceived by I. M. Pei (2008, 45,000 m^2; Fig. 6.18) as an attempt to display the "essence of Islamic architecture" (Adam 2013, 122). An essence expressed through a terraced building resulting from the progression of solid volumes extruded from basic geometric shapes like the octagon, the square, and the circle, and culminating on the top with a kaleidoscopic dome with an oculus. As Robert Adam noted, the Museum must be considered in relation to the nearby Qatar Centre for the Presentation of Islam, a proselytising organisation that found its house in a building inspired by the famous ancient minaret of Samarra but actually resembling more the Egyptian Ibn Tulun

Fig. 6.17 The Museum of the Future by Killa Design in the Dubai International Financial Centre. Photograph by Giaime Botti, distributed under a CC BY 4.0

Mosque, the same building that Pei took as reference. The second building meant to become the new cultural icon of Doha is Jean Nouvel's National Museum of Qatar. Far from Pei's rigid geometry, it is an astonishing complex made of different connected buildings shaped by intersecting disks inspired by the desert rose (Fig. 6.19). More museums, in addition, were built in the Msheireb Downtown, where John McAslan + Partners designed the Msheireb Museums and the M7 Cultural Forum (Sect. 8.6; Fig. 8.22).

N-fold attempts of repeating the Bilbao effect, all these fanciful pieces of architecture contributed to promoting the image of these cities as prime destinations for cultural tourism. At the same time, however, the dark side of many of these projects emerged. The international press depicted Saadiyat Island in Abu Dhabi as a "place of misery" rather than the supposed "Happiness Island" (according to its Arabic meaning) because of the labour conditions that construction workers faced (Carrick and Batty 2013; Batty 2013). In this respect, while pressure has arrived from some major Western investors and stakeholders involved in the development, starting from the New York University, the Louvre, and the Guggenheim, the response from architects has been varied, spanning from action to indifference. The most significant case has been that of Frank O. Gehry, who has been collaborating with Scott Horton, a well-known human rights lawyer, to improve workers' conditions, also pushing the Guggenheim Foundation to take a clear position in front of the Tourism Development and Investment Company of Abu Dhabi. As reported by *Architectural Record*,

Fig. 6.18 The Museum of Islamic Art by I. M. Pei, Doha. Photograph by Giaime Botti, distributed under a CC BY 4.0

Fig. 6.19 The National Museum of Qatar by Atelier Jean Nouvel Doha. Photograph by Giaime Botti, distributed under a CC BY 4.0

Gehry's requests have focused on five main issues that strongly affect the workers' life: health and safety, accessibility to passports and other documents retained by employers, appointment of a law-abiding and accountable general contractor, establishment of an independent site monitor, abolition or reimbursement of steep recruitment fees associated with the *kafala* system. In the end, as Horton pointed out in an interview, for the architect, "it's not a legal responsibility, but it's a moral responsibility" (Fixsen 2014a). On the other hand, Jean Nouvel, once questioned about the same issues regarding the construction of the Louvre, denied the problem (Willsher 2017), while Zaha Hadid, whose opinion was invoked regarding the death of a worker at the construction site of the Al Wakrah stadium in Qatar, another country in the spotlight for labour conditions, has defended herself from some accusation. Acknowledging the problem, she has also candidly admitted: "I'm not taking it lightly but I think it's for the government to look to take care of. It's not my duty as an architect to look at it" (Riach 2014; also, Clark 2014; Fixsen 2014b). Questions regarding the architects' moral responsibility persist and the agency of Western professionals in the global market cyclically reignites this debate (also Sect. 5.8 and Chap. 7).

6.3 Opera and Theatres: China, Again

Museums do not represent the only typology of cultural buildings whose growth in the last few decades has been unprecedented, especially in certain regions. Back in 1973, the Sydney Opera House opened its door almost two decades after the launch of the international design competition won by Danish architect Jørn Utzon. The significance of this project in the history of architectural globalisation has already

6.3 Opera and Theatres: China, Again

Fig. 6.20 The Norwegian National Opera and Ballet by Snøhetta, Oslo. Photograph by Jorge Láscar, distributed under a CC BY 2.0, available at https://commons.wikimedia.org/wiki/File:The_Oslo_Opera_House_(Operahuset)_(29585744210).jpg

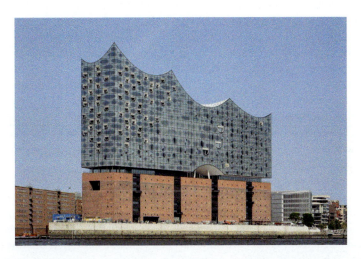

Fig. 6.21 The Elbphilharmonie by Herzog & De Meuron, Hamburg. Photograph by Nightflyer, distributed under a CC BY 4.0, available at https://commons.wikimedia.org/wiki/File:Hamburg,_Barkassenfahrt_NIK_3536.jpg

been mentioned (Sect. 3.3), while for the history of contemporary architecture, the milestone which challenged the spatial configuration of the concert hall had already appeared in 1963 with Hans Scharoun's Berlin Philharmonic. Indeed, when, in 1989, the Opéra Bastille in Paris by Carlos Ott was inaugurated, despite the framework of Mitterand's *Grand Travaux* and the historical significance of the site where it was erected, the building did not stand out as strongly as other iconic projects of the time.

On the contrary, a few years later, the competition for the Cardiff Bay Opera House produced more interesting results, which unfortunately remained on paper. Established figures like Rafael Moneo and Mario Botta, and some of the most promising architects that will take over the field in the following decade, including Rem Koolhaas, submitted their entries. The (unlucky) winner was a young Zaha Hadid. Then, in the next two decades, several important theatres were completed in Europe. Scandinavian capitals emerged on the scene with large new opera houses, from Snøhetta's Norwegian National Opera and Ballet in Oslo (2000–07; Fig. 6.20)—a Mies van der Rohe Prize-winner white-stone telluric building emerging from the waters of the Oslofjord—to Henning Larsen's Royal Danish Opera (2005) in Copenhagen and Harpa Concert Hall and Conference Centre (2011) in Reykjavik. In the meantime, Herzog & De Meuron carried out the project of the Elbphilharmonie (2001–16, 120,383 m^2; Fig. 6.21) in Hamburg, a spectacular tent-shaped volume placed on top of a nineteenth-century brick warehouse, which, like in the Madrid Caixa Forum (2001–08, 11,00 m^2), pushes the dialectic between industrial pre-existence and addition to extreme paradoxes. By the same year, Jean Nouvel's metal-clad Paris Philharmonic (2007–15, 42,000 m^2) was also completed. In common, both projects had a longer-than-expected process that resulted in substantial extra costs: six years of delay and a budget passed from €241 to €866 million for the former (Moore 2016), and three years of delay and an increase from €200 to €387 millions for the latter (Winston 2015).

Some of these same architects, in the early 2000s, had the opportunity to build in the emerging markets what they could not accomplish in Europe at that time; others doubled down with more successes. Once again, China represented the major outpost for these enterprises. In addition to the "museum boom," in China has taken place another parallel phenomenon, which exactly follows the same pattern. As Xue (2019) recounts, between 1998 and 2015, 364 new theatres were built in the country, 200 of which had more than 1,200 seats. As for the case of museums, the construction of theatres also reflected the different and complementary needs of an emerging middle class looking for cultural entertainment and the will of national and local governments to project their soft power and compete on the global stage. In the case of theatres, many projects—about 50% of the biggest ones, according to Xue (2019, vii)—have been designed by foreign firms. One of the first international competitions of this kind was launched in 1999 for the National Grand Theatre in Beijing and was won by French ADP Ingénierie and Paul Andreu (Fig. 6.22). In the subsequent years, many more followed and iconic pieces signed by overseas architects rejuvenated Chinese cultural infrastructures with shiny theatres (Table 6.3), alongside museums and public libraries. The Shanghai Opera was delivered by Arte Charpentier already in 1998 (Fig. 6.23), and many more followed: Arata Isozaki's Shenzhen Cultural Centre (1998–2007), which included a concert hall and a library, Zaha Hadid's Guangzhou Opera House (2002–10), Paul Andreu's Jinan Opera (2013), GMP's grand theatres in Qingdao (2004–10), Chongqing (2004–09), and Tianjin (2009–12), Tadao Ando's Poly Theatre in Shanghai (2009–14), Christian de Portzamparc's Shangyin Opera House (Shanghai, 2014–19; Fig. 6.24), Henning Larsen's Hangzhou Yuhang Opera (2019), Snøhetta's Shanghai Grand Opera House (2017–u.c.), and Gensler's Yulin

6.3 Opera and Theatres: China, Again

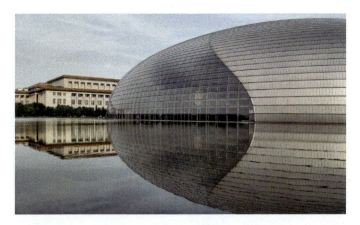

Fig. 6.22 The National Grand Theatre by ADP Ingénierie and Paul Andreu, Beijing. Photograph by Haluk Comertel, distributed under a CC BY 3.0, available at https://commons.wikimedia.org/wiki/File:Xicheng,_Beijing,_China_-_panoramio_(110).jpg

Grand Theatre. Outside of mainland China, in Taiwan, three outstanding theatres have been completed in the last few years after a long gestation. OMA's Taipei Performing Arts Centre (2009–21, 58,658 m^2) delayed completion finally resulted in a sort of late-constructivist landmark, a kind of assemblage of simple volumes corresponding to the different internal spaces, including a shored-up sphere in an apparent precarious equilibrium. Formally different, but not less spectacular, is the National Kaohsiung Centre for the Arts (2007–18, 141,000 m^2) by another Dutch firm, Mecanoo. This impressive building somehow recalls an over-scaled version of SANAA's Rolex Centre: a continuous horizontal undulated volume punctuated by functional 'bubbles' that reinforce the dialectic relationship between organic interiors and the regular geometry of the whole building. On the contrary, a quick gaze at Toyo Ito's Taichung Metropolitan Opera House (2009–16, 43,264 m^2) shows that the building does not fulfil the expectations of this sponge-like piece of architecture.

Most of the designers of these projects were again creative firms, including many led by Pritzker winners and a few large corporate firms. Again, in this vast sample, a few buildings stand out for their story's relevance or architectural qualities. In chronological order, the first project deserving further explanation is Paul Andreu's National Grand Theatre in Beijing. In 1999, it was one of the first large-scale projects in China assigned via an international competition for which Terry Farrell, Arata Isozaki, HPP, and the Design Institute of Construction Industry were invited. Somehow, the building and its design process perfectly tell the story of that period (Xue 2006, 41–43). Completed before the 2008 Beijing Summer Olympic Games, it was one of the many, and among the major, projects aimed at reshaping the image of the Chinese capital city. Still, the fact that such an important and symbolic building was assigned to a foreign architect, its questionable egg shape, and the enormous costs for its development and construction contributed to long controversies. While many citizens, some of which also directly affected by the displacements to clear the area, focused the

Table 6.3 Built theatres designed by overseas firms (surveyed sample) in China

Designer	City	Project	Year	GFA (m^2)
Arata Isozaki	Shenzhen	Shenzhen Cultural Centre	1998–2007	N.A.
	Shanghai	Symphony Hall	2008–14	6,038
	Datong	Theatre	2009–19	N.A.
	Harbin	Concert Hall	2011–14	79,000
Arte Charpentier	Shanghai	Opera	1998	55,000
	Taiyuan	Changfeng Culture and Business District—Shanxi Grand Theatre	2006–12	73,000
AS Architecture Studio	Shanghai	Daguan Theatre—Himalaya Centre	2013	10,000
Christian de Portzamparc	Shanghai	Shangyin Opera House	2014–19	30,000
	Suzhou	Cultural Centre	2013–20	202,000 (including museum)
David Chipperfield	Jingdezhen	Jingdezhen Grand Theatre (Ceramic Art Avenue Taoxichuan)	2018–22	265,000 (including museum, hotels, and shops)
Gensler	Yulin	Grand Theatre	–	41,500
GMP	Qingdao	Grand Theatre	2004–10	80,000
	Chongqing	Grand Theatre	2004–09	99,010
	Tianjin	Grand Theatre	2009–12	85,000
	Nanning	Guangxi Culture & Arts Centre	2014–18	113,700
Henning Larsen	Hangzhou	Yuhang Opera	2019	133,000
Paul Andreu—ADP Ingénierie	Beijing	National Centre for Performing Arts	1999–2008	149,500
Paul Andreu—Richez Associés	Jinan	Jinan Opera	2013	72,000
PES Architects	Fuzhou	Strait Culture and Art Centre	2004–08	153,000
	Wuxi	Grand Theatre	2008–11	77,200
Snøhetta	Shanghai	Grand Opera House	2017-u.c	134,000
Studios Architecture	Shanghai	JKS Future Art Centre	2019	37,100
Tadao Ando	Shanghai	Poly Theatre	2009–14	55,900

(continued)

6.3 Opera and Theatres: China, Again

Table 6.3 (continued)

Designer	City	Project	Year	GFA (m^2)
Zaha Hadid	Guangzhou	Opera House	2002–10	70,000
	Changsha	Meixihu International Culture and Art Centre—Grand Theatre	2017	115,000 (including museum)

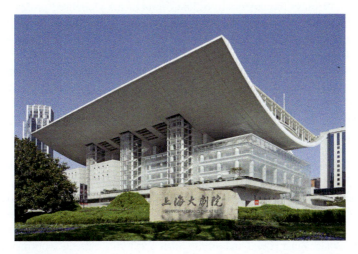

Fig. 6.23 The Shanghai Opera by Arte Charpentier, Shanghai. Photograph by Giaime Botti, distributed under a CC BY 4.0

Fig. 6.24 The Shangyin Opera House by Christian de Portzamparc, Shanghai. Photograph by Giaime Botti, distributed under a CC BY 4.0

criticism towards the costs and the lack of respect for the historical architecture of the area (Holland 2000), many Chinese architects strongly emphasised how these types of proposals would have been impossible in the foreign architects' home countries (the debate overlapped with that about the buildings for the 2008 Summer Olympic Games: Brownell 2008, 89–90). Indeed, as it will emerge throughout the book, these conditions of experimentation are exactly one of the key aspects, controversial but productive at the same time, of the architecture of globalisation.

In this regard, another project deserves some comments because of the clarity by which it displays the potentialities and limits of the globalised profession. The building in question is Zaha Hadid's Guangzhou Opera (2002–10, 70,000 m^2; Fig. 6.25). It represented her first work in China and a major one in terms of scale and programme during a turning point of her career, as she will be awarded the Pritzker just two years after defeating OMA and Coop Himmelb(l)au in this competition. By its completion in 2010, the Opera represented her largest built work and a sort of model for future projects, from the Heydar Aliyev Centre in Baku (2017–12) to the Changsha Meixihu International Culture and Art Centre (2019). The Opera also became a point of reference in legitimising parametrically designed fluid architectures, as shown by MAD's victory in the competition for the Harbin Opera (2010–15). All this being said, the construction of this building was also a reminder of the inherent difficulties in bringing these complex shapes into reality, above all in contexts with an abundant unskilled labour force and little know-how on such construction. Even for the least qualified observer, indeed, the result of the construction was poor (Ouroussoff 2011). A final remark on this project helps us better grasp another design challenge: scale. Zaha Hadid and all the other Western architects working in China had to consider that the same typologies they designed in Europe had to be doubled or tripled in size in China. Zaha Hadid's unbuilt project for the Cardiff Bay Opera House spanned 25,000 m^2, almost a third of the one built in Guangzhou; Snøhetta's Norwegian Opera covers 38,500 m^2, while the ongoing project for the Shanghai Grand Opera House extends over 134,000.

In other emerging markets, the number of theatres mapped is minimal because of a non-comparable rise of this typology and, in some cases, of a minor involvement of foreign architects. For instance, a recent book featuring a long list of theatres built in the last seventy years (Staples and Hamer 2021) clearly displays the lack of remarkable examples outside certain regions. Even in the Persian Gulf, where money has been abundantly poured into cultural facilities, there are not many notable examples. In this sense, it is surprising to note the anonymity of The Dubai Opera, considering its prime location almost at the feet of the Burj Khalifa. Designed by the multi-national firm Atkins (2016; Fig. 6.26) and developed by Emaar Properties as the cherry-on-the-cake cultural facility of Downton Dubai, it is a pretty forgettable building. Though, this story could have had a different conclusion because the competition held in 2005 was initially won by Zaha Hadid against Bernard Tschumi and Jean Nouvel, among others. Unfortunately, the financial crash of 2008 blocked the project (Sell 2009). No more luck, however, had Zaha Hadid in Abu Dhabi, where her Performing Arts Centre (2007) was never built. Moreover, given a limited tradition in music and performance arts in the region, little more has been developed

6.3 Opera and Theatres: China, Again 275

Fig. 6.25 The Guangzhou Opera by Zaha Hadid Architects in Zhujiang New Town (Tianhe CBD), Guangzhou. Photograph by Giaime Botti, distributed under a CC BY 4.0

Fig. 6.26 The Dubai Opera by Atkins in Dubai Downtown, Dubai. Photograph by Giaime Botti, distributed under a CC BY 4.0

in terms of theatre typology, except for the Royal Opera House of Muscat, Oman, designed in a traditionalist fashion by US firm WATG. While no significant projects by foreign architects have been identified in India and the surveyed African countries, in Indonesia Benoy designed a private art space with a flexible gallery and an auditorium: the Ciputra Artpreneur (14,000 m^2). Finally, a case worth mentioning was mapped in Russia. The Mariinsky II Theatre of Saint Petersburg—the extension of one of the city's most important cultural facilities—was awarded in 2003 to Dominique Perrault, whose daring idea of a golden geometrical structure covering

the main volume defeated the proposals of Mario Botta, Arata Isozaki, Hans Hollein, Eric Owen Moss, Erick Van Egeerat, and five Russian architects in the final stage of the competition. However, as often happens with bold designs, construction difficulties, rising costs, and political interventions eventually halted the project. A new competition was held in 2009 and won by Canadian firm Diamond Schmitt, whose unimpressive project did not satisfy most of the public (Ivanov 2013).

6.4 Temples of Knowledge in the Age of Information: Libraries

When considering other cultural facilities like public libraries, once again and not surprisingly, China comes first, at least from a quantitative perspective, while some intriguing buildings can be found elsewhere. Several large libraries, spanning between 30,000 and 60,000 m^2, have been built around the country in the last twenty years. The most important one is the National Library of China, designed by German firm KSP Jürgen Engel Architekten, which cost over £124 million in the framework of Beijing works of the early 2000s. The building consists of a large semi-transparent podium covered by a floating horizontal volume detached from it by a glazed intermediate level, bringing light to the central, column-free, triple-hight reading room. During the same years, the already mentioned Shenzhen Cultural Centre by Isozaki, which contains a concert hall and a library, was also built. In the last decade, more buildings have been erected, with the involvement of foreign architects (larger firms rather than boutique firms) usually limited to major cities (Table 6.4). Perkins & Will—Schmidt Hammer Lassen, for instance, has recently completed two libraries, one in Ningbo and one in Shanghai. The latter, located next to Century Park in Pudong, consists of a single volume conceptually inspired by the traditional Taihu stones; indeed, its volume is shaped with cuts like a gem, but the use of a marble-like pattern printed on the skin's glass panels actually denies the building's mass (Fig. 6.27).

In general, most of these buildings are rather generic and unremarkable boxes, while unquestionably more—literally—eye-catching is MVRDV's Tianjin Binhai Library (Fig. 6.28). This apparently banal louvres-coated prismatic volume—shaped as such by GMP's master plan—features a glazed opening that allows seeing the carved and sinuous interior of the building, in whose centre stands a spherical luminous auditorium. From the outside, such a design looks like the pupil of an eye. At the same time, inside the building, the most striking feature is the cantilevering narrow platforms that run all along the curvilinear walls, where users collect books from shelves embedded in the walls (while at a higher level books are just printed on a decorative wallpaper) and sit to read them. In a way, it may be said that the design of a library as a three-dimensional interior landscape has remarkable antecedents, like, for instance, Alvar Aalto's Viipuri/Vyborg Library (1927–35) and, on a larger

6.4 Temples of Knowledge in the Age of Information: Libraries

Table 6.4 Built libraries designed by overseas firms (surveyed sample) in China

Designer	City	Project	Year	GFA (m^2)
Arata Isozaki	Shenzhen	Shenzhen Cultural Centre	1998–2007	N.A.
Coldefy & Associés	Shenzhen	Bao'an Public Culture and Art Centre	N.A.–u.c	94,055
GMP	Suzhou	No. 2 Library	2014–19	45,300
KSP Jürgen Engel Architekten	Beijing	National Library of China	2003–2008	80,000
Mario Botta	Beijing	Tsinghua University Library	2008–11	16,000
MVRDV	Tianjin	Binhai Library	2017	33,700
Nihon Sekkei	Shanghai	Pudong Library	2009	60,800
Nikken Sekkei	Guangzhou	Library	2012	98,000
Perkins & Will—Schmidt Hammer Lassen	Ningbo	New Library	2019	31,000
	Shanghai	Library East	2016–20	115,000
Perkins Eastman	Chongqing	Library	2009	50,000
Riken Yamamoto	Tianjin	Library	2012	58,100
RMJM	Shenzhen	University City Library	2012–18	46,730

Fig. 6.27 The Library East by Perkins & Will—Schmidt Hammer Lassen, Shanghai. Photograph by Giaime Botti, distributed under a CC BY 4.0

scale, Snøhetta's Bibliotheca Alexandrina (1988–2001, 80,000 m^2), which we will comment shortly.

This seems to be an important theme also for one of MVRDV's main competitors, OMA. Koolhaas has been reflecting on the library typology since the late 1980s when he produced two influential but unsuccessful entries for two major competitions: the

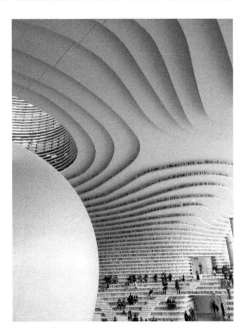

Fig. 6.28 The interior of the Tianjin Binhai Library by MVRDV in Binhai New Area, Tianjin. Photograph by Muzzlefkesh, distributed under a CC BY 1.0, available at https://commons.wikimedia.org/wiki/File:Binhai_library_bookshelves.jpg

so-called Trés Grande Bibliothèque (the National Library of France) and the Jussieu Library. While the latter was never built, the former was won by Dominique Perrault, who eventually completed this massive complex (365,178 m^2) in the framework of Paris *Grand Travaux*. Since then, Koolhaas and OMA have never abandoned the theme of the library (Botti and Pisani 2022), constantly questioning its future in the age of digitalisation. And after the more sculptural Seattle Central Library (1999–2004, 38,300 m^2), OMA has recently completed two projects characterised by more straightforward, though not banal, volumetric solutions, and a great deal of attention for their inner core conceived as an internal landscape devoted to studying and socialisation. This is true in the Bibliothèque Alexis de Tocqueville in Caen, France (2010–16, 14,430 m^2), and above all in the larger Qatar National Library in Doha (2017, 31,000 m^2; Fig. 6.29). The interior has been described on *Domus* by Mascolo (2018) as follows: the "main foyer is "practically open plan, divided by walls of books over multiple levels. There is no separation between books and people. Conceptually, culture here is carried on the air, involving as many visitors as possible." And the text continues: "Indeed, the library is like a centre for culture and entertainment, similar to the Centre Pompidou in Paris, for it organises many activities." As a matter of fact, this and other examples, such as the Tianjin Binhai Library, show how this typology in the last two decades has been increasingly conceived as a place for a wide range of social and cultural activities rather than just for books' preservation and individual study. As noted, this "new social vocation of libraries" have boosted formal experimentation that, although "not yet openly expressed," may soon produce "a phenomenon similar to the one that took place 20 years ago in Bilbao with the

6.4 Temples of Knowledge in the Age of Information: Libraries

Fig. 6.29 The Qatar National Library by OMA in the Qatar Education City, Doha. Photograph by Giaime Botti, distributed under a CC BY 4.0

Guggenheim—a trend that encouraged the creation of many landmark-museums around the world" (Piciocchi 2018).

In this perspective, outcomes have been varied. It might be said that Snøhetta's Bibliotheca Alexandrina (Fig. 6.30) in Egypt has failed in putting the ancient port city of Alexandria on the global spot, despite all expectations and efforts. The story of this U$220 million large cultural complex consisting of a library plus museum and exhibition space is interesting because it perfectly shows how the scale of the local and the global interact in such megaprojects, where processes of urban regeneration are entangled with the ambitions of the local cultural elite, but also where external geopolitical forces are at play (Butler 2007). The design competition, won by the then-unknown Norwegian firm, was launched in 1988 with the support of UNESCO and received over 1,400 entries. The building, completed more than a decade later, stood out for its vast reading room, occupying over 20,000 m^2 and a third of the whole volumes, conceived by Snøhetta as a grand terraced space covered by a large, inclined roof that acts as an immense skylight. On the exterior, the volume of the reading hall appears as an inclined cylinder that seems to slide underground, with later walls clad with stone carved with signs and symbols reminding of the world's ancient languages.

The library intended to foster the myth of the Alexandrine cosmopolitanism dating back to the Hellenistic period and to the modernising governorate of Mohammed Ali (1769–1849), while it also represented an enterprise charged with geopolitical implications, drawing money from Saddam Hussein's Iraq, Saudi Arabia and the UAE, extensive collections of books from France, and archaeological relics and expertise from Greece. In the post-9/11 world, the library inauguration brought together European and Arab chiefs of state, while during its more than ten years of construction, several more projects aimed at transforming the city of Alexandria were launched

Fig. 6.30 The Bibliotheca Alexandrina by Snøhetta, Alexandria. Photograph by Avjoska, distributed under a CC BY 3.0, available at https://commons.wikimedia.org/wiki/File:IMG_012 3Aleksandria_raamatukogu.jpg

with the impulse of the local business community. In the end, instead of an achievement to be proud of, the Alexandrina became for many the "white elephant" of Egyptian ruler Hosni Mubarak, a multi-million-dollar project that diverted money from more urgent needs of the Egyptian people, while further contradictions related to the freedom of expression and censorship in the country were noted (Butler 2007, 187). It might be tempting to consider the recent King Abdulaziz Centre for World Culture (2007–18, 100,000 m^2, LEED Gold), designed by Snøhetta in the deserted and desertic periphery of Dammam, on the East coast of Saudi Arabia, a similar enterprise. This multi-programme cultural centre that includes a museum, library, archive, and theatre, financed by the state oil company Saudi Aramco to foster cultural development in the Kingdom, would hardly help in positioning an oil hub like Dammam in the tourist map of the Persian Gulf, despite recent efforts in opening up the country. On the other hand, more oriented towards local users is a recent project worth mentioning: the House of Wisdom of Sharjah (40,386 m^2) by Foster + Partners. Inaugurated in 2021, the building is located near the airport and the American University of Sharjah. Somehow like for the Carré d'Art (Mediathèque) of Nîmes (1984–93), Foster conceived a contemporary, light building with a classical taste and a monumental presence: flanked by two formal gardens, the House of Wisdom features an open, column-free square plan with four enclosed square cores and a central courtyard conceived as a green oasis, or better, as a small and enclosed paradise garden. The building stands lightly, with its glazed walls protected by vertical aluminium screens and a thin but deeply cantilevering floating roof.

6.5 Marginal Geographies and Import Substitution Architecture: From Africa to Latin America

Considering the other regions surveyed in the present book, the agency of overseas architects appears significantly less relevant in quantitative terms. Given the small figures for the African continent, considerations about the statistical relevance of cultural buildings designed by foreign architects lack solidity (3 on 116 recorded projects). According to our mapping, the reuse of old silos for the V&A Waterfront Zeitz MOCAA (2011–17) by Heatherwick Studio and the restoration of the São Francisco do Penedo fort in Luanda, Angola, currently under construction, by the Portuguese firm Saraiva + Asociados to transform it into the Museum of Liberation Struggle represent the totality of the museum projects together with the still ongoing design for the GoDown Arts Centre in Nairobi by White Arkitekter. Nevertheless, even expanding the outlook to the whole continent, the agency of international architects for cultural buildings appears extremely limited, but not marginal. Significant competitions for cultural projects have been few in the last three decades. The already mentioned case of the Alexandrina Library represented the main one, while the Grand Egyptian Museum (100,000 m^2) in the Giza plateau has not opened its door yet twenty years after it was assigned in a competition to the Irish studio Heneghan Peng Architects (Mansour 2003). Meanwhile, in 2013, a competition for the Great Museum of Africa was launched in Algiers, in which firms like UN Studio and Arte Charpentier took part, although nothing followed up. More recently (2016), Steven Holl was appointed to design the Malawi Library in Lilongwe, but the project's fate remains uncertain.

More surprisingly, in other regions, the production of cultural buildings by foreign architects has been particularly weak, despite the relevance of these markets for other typologies, starting from office and residential high-rises. In our sample of South-East Asian countries, for instance, just four museum projects were recorded, and only one of them was completed: GMP's Hanoi Museum (2005–10, 30,000 m^2). In India, ten museum projects were mapped, three of which were completed: Safdie Architects' Khalsa Heritage Centre (2011, 23,226 m^2) in Anandpur Sahib, Chapman Taylor's renovation of the Indian Museum in Kolkata (2014, 20,000 m^2), and Maki and Associates' Bihar Museum (2011–17, 24,000 m^2) in Patna. In Russia and Kazakhstan, of a dozen museum projects just two were completed. They are OMA's renovation of the Small Hermitage in Saint Petersburg (2012–16) and the Garage Museum of Contemporary Art in Moscow (2011–15, 5,408 m^2). To these, we could add RPBW's GES2 House of Culture (2015–21, 20,000 m^2, LEED Gold), a multi-programme cultural centre that includes exhibition space, a library, and various auditoriums located in a renovated industrial building. In Nur-Sultan, instead, works for Adrian Smith + Gordon Gill's Astana Art Centre are apparently not progressing. In the end, the difference between the role played by foreign architects in China and the Persian Gulf, on the one hand, in boosting the image of cities through iconic cultural buildings, mainly but not exclusively museums, and in the rest of the surveyed regions, on the other, is crystal clear. Reasons behind this, instead, might be multiple,

from self-reliance on local architects to the scarcity of financial resources or the lack of willingness to invest in cultural infrastructures. Still, it would be wrong to generalise, given the macroscopic differences among these contexts.

On the contrary, Latin America, where museum buildings account for a not irrelevant 4.5% of the batch (i.e., 17, on 380 mapped projects in total), deserves deeper exploration. Looking at the surveyed sample, eight of these projects have been built, mostly in Brazil. In Rio Janeiro, Santiago Calatrava completed the Museu do Amanhã (Museum of Tomorrow, 2010–15; Fig. 6.31) just before the opening of the 2016 Summer Olympic Games, although the project was not directly linked to the event, but rather the result of a public–private partnership to renovate the port area (de Oliveira Sanchez and Essex 2017, 106–107). More recently, Diller Scofidio + Renfro's Museum of Image and Sound (2009–20) was opened on the Copacabana waterfront. Embedded in an urban block, the building was conceived as a vertical extension of the famous seafront promenade, with a continuous system of vertical circulation along the facade. In São Paulo, Perkins & Will, which has successfully brought into being over 200,000 m^2 of office, laboratories, and residential buildings in the country, designed the "A Casa" Museum of the Brazilian Object (2014). All in all, the most significant work was Álvaro Siza's Fundação Iberê Camargo (2008; Fig. 6.32) in Porto Alegre, a white-concrete sculptural building marked by the presence of free-standing enclosed ramps popping out from the main body. In Mexico, Grimshaw completed the renovation of a former steel furnace, the Horno 3 Museo del Acero in Monterrey (2007) and Toyo Ito the Museo Internacional del Barroco (International Museum of Baroque; 2012–16) in Puebla, an 18,000 m^2 building based on folding precast concrete walls reminding of Baroque dynamism. In Mexico City's affluent neighbourhood of Polanco, David Chipperfield designed the private Jumex Museum (2009–13; Fig. 6.33) just in front of another privately funded museum, the iconic Soumaya (2011). Designed by OMA-trained Mexican architect Fernando Romero for his father-in-law, Carlos Slim, for a while the wealthiest person on earth, the Soumaya resembles an irregular solid of revolution, standing as a sculptural object of limited inner spatial qualities but strong urban presence thanks to its complex geometry and its hexagonal aluminium tiles cladding that vibrates under the sunlight. In other countries of the region, significant projects by overseas architects based outside Latin America have not been completed either. The only exception is represented by Gehry's Biomuseo (1999–2014; Fig. 6.34) in Panama City, a building, indeed, unable to compete with other creations of the same architect.

Looking at this small sample of Latin American museums designed by European, US, and Japanese architects, a series of reflections arise. Firstly, countries like Brazil and Mexico had their major museums already built during a period spanning from the 1950s to the 1980s, and sometimes even earlier. In addition, although not negligible, economic growth in the last three decades has been lower than in China or other emerging economies. Public budgets are generally more stretched, making it harder to invest in costly buildings like museums designed by renowned architects. In Latin America, hardly any government would be able to justify in front of the public opinion the expanses that the Basque Country had sustained for the Guggenheim in Bilbao in the 1990s or the UAE for the Louvre Abu Dhabi more recently. Not by

6.5 Marginal Geographies and Import Substitution Architecture: From …

Fig. 6.31 The Museu do Amanhã by Santiago Calatrava, Rio de Janeiro. Photograph by Tomaz Silva/Agência Brasil, distributed under a CC BY 3.0, available at https://commons.wikimedia.org/wiki/File:Museu_do_Amanh%C3%A3_em_sua_inaugura%C3%A7%C3%A3o_04.jpg

Fig. 6.32 The Fundação Iberê Camargo by Álvaro Siza, Porto Alegre. Photograph by Secretaria Especial da Cultura do Ministério da Cidadania, distributed under a CC BY 2.0, available at https://commons.wikimedia.org/wiki/File:Funda%C3%A7%C3%A3o_Iber%C3%AA_Camargo_-_dia.jpg

chance, the projects for the Guggenheim Rio de Janeiro assigned to Jean Nouvel in 2002, and the one in Guadalajara (2005) both failed. For the latter, a design competition was organised, eventually won by Mexican firm TEN Arquitectos, which defeated Asymptote's proposal and Nouvel's spectacular cube on the edge of the cliff. However, when the economy boomed, like in Brazil during the two mandates of Luiz Inácio Lula da Silva and the first one of Dilma Rousseff, more projects—both public

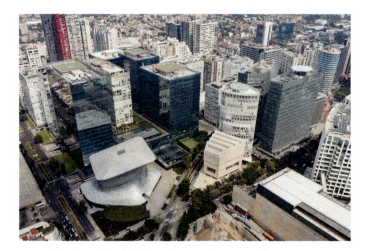

Fig. 6.33 An aerial view of the Polanco neighbourhood in Mexico City with the Soumaya Museum by Fernando Romero on the left and the Jumex Museum by David Chipperfield on the right. In the middle, is the Telcel Theatre by Ensamble Studio. Photograph by Erich Sacco

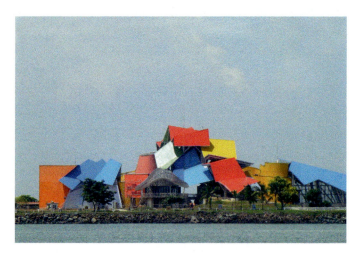

Fig. 6.34 The Biomuseo by Frank O. Gehry, Panama City. Photograph by F Delventhal, distributed under a CC BY 2.0, available at https://commons.wikimedia.org/wiki/File:Biomuseo_(10229212235).jpg. Modified by Giaime Botti

and private—were initiated, also favoured by the push coming from the preparation of the World Cup and the Summer Olympic Games (Sect. 7.2). Then, a second point deserves attention. As previously highlighted, Latin America has always boasted the strongest modernist architectural scene outside Europe and the USA, internationally recognised already in the 1950s. The presence of some great architects and the overall quality of local professionals, often with deep personal connections with Europe and

6.5 Marginal Geographies and Import Substitution Architecture: From …

the USA, had perhaps made it less necessary to look outside for the design of national cultural landmarks.

Indeed, some architects have become real symbols and sources of pride for Latin American countries. Probably, no other connection between one architect and one country exists as strong as the one between Oscar Niemeyer and Brazil (Piccarolo 2020). Looking back at the history of Brazilian architecture, some museums stood out as unquestioned modernist masterpieces: Affonso E. Reidy's MAM (Museum of Modern Art; 1952–55; Fig. 6.35) in Rio de Janeiro, Lina Bo Bardi's MASP (Museum of Modern Art of São Paulo, 1957–68), Niemeyer's Museu de Arte Moderna de São Paulo (1954). More recently, Niemeyer designed the Museu de Arte Contemporânea de Niterói (Contemporary Art Museum; 1996; Fig. 6.36) and the New Museum of Curitiba (now Oscar Niemeyer Museum), not to mention Paulo Mendes da Rocha's Museu Brasileiro de Escultura (Brazilian Museum of Sculpture, 1995) in São Paulo. In such a context, getting a direct commission or winning a competition can be arduous for a foreign architect, as the link between architecture and cultural identity still appears strong in many countries. Mexico, for instance, provides other examples. Neglecting the nationalistic version of modernism elaborated in the 1940–50s and epitomised by the National Autonomous University of Mexico (UNAM) campus designed by Mario Pani and many others following the principles of the *integración plástica* ("plastic integration") between architecture, sculpture, painting, and landscape, the link between Mexican architects and major cultural works is still solid. While Pedro Ramírez Vásquez and others designed the landmark National Museum of Anthropology and the Museum of Modern Art in the 1960s, Teodoro González de León designed the Rufino Tamayo Museum (1981) and the University Museum of Contemporary Art (2008). Lately, in Mexico City, Rojkind Arquitectos finalised the 49,000-square-metre Cineteca Nacional (National Film Library; 2012). In Colombia, between the late 1980s to the 2000s, several museums, libraries, and cultural centres were designed by the country's most acclaimed architect, Rogelio Salmona. More recently, competitions like the one for the Museo Nacional de la Memoria de Colombia (National Museum of Colombian Memory) recorded a broad participation of local architects, who gained the first three positions, although the winning one—MGP Arquitectura y Urbanismo—was in partnership with Spanish firm Estudio Enetresitio. A content-wise similar project, the Museo de la Memoria y los Derechos Humanos (Museum of Memory and Human Rights) in Santiago de Chile (2007–10; Fig. 6.37), was designed by a group of Brazilian architects (Mario Figueroa, Lucas Fehr and Carlos Dias).

For other cultural typologies, the discourse would not be so different either. When it comes to classical opera theatres, unlike in other countries, Latin American main cities are already provided with such infrastructures since the early twentieth century. As a result, few significant competitions have been called to build new theatres and auditoriums. And when needed, again, there was no lack of local talent. In Mexico, the Foro Boca Concert Hall (2014–17, 5,410 m^2), with its well-balanced concrete volumes standing along the Boca del Río's waterfront, was designed by Rojkind Arquitectos. On the other hand, in the Mexican Federal District, the Telcel Theatre (2013; Fig. 6.33) was designed by Madrid and Boston-based Ensamble Studio as an

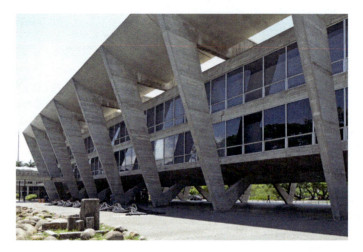

Fig. 6.35 The Museum of Modern Art by Affonso E. Reidy, Rio de Janeiro. Photograph by Giaime Botti, distributed under a CC BY 4.0

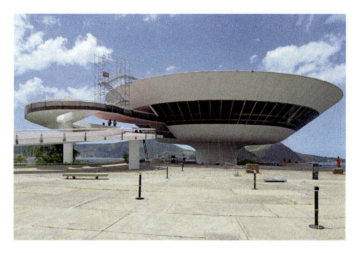

Fig. 6.36 The Contemporary Art Museum of Niteró by Oscar Niemeyer, Niterói. Photograph by Giaime Botti, distributed under a CC BY 4.0

underground facility located in-between the Jumex and the Soumaya museums only visible for its large black-steel canopy covering the entrance. As a result, significant cultural projects involving architects from the USA and Canada, Europe, or the Asia–Pacific region remain limited. If in the Persian Gulf they are the norm, and in China they represent a significant share, in Latin America overall numbers are lower and relative numbers too. In Brazil, another country where major opera theatres, from Manaus to São Paulo via Rio de Janeiro, were built in the late nineteenth century or the first decades of the twentieth, not much was assigned to foreign architects. Not by chance, while planned capitals of the post-World War II like Chandigarh or

Fig. 6.37 The Museum of Memory and Human Rights by Mario Figueroa, Lucas Fehr and Carlos Dias, Santiago de Chile. Photograph by Giaime Botti, distributed under a CC BY 4.0

Islamabad relied on foreign expertise—Le Corbusier and Fry, Drew and Partners, for the former, and Doxiadis Associates for the latter (Sect. 3.3)—, Brasilia was a more autarchic operation and for this reason source of greater pride. All the civic and cultural infrastructure in front of the government area along the Eixo Monumental (Monumental Axis) was, in fact, designed by Oscar Niemeyer and built over the next fifty years: the Cláudio Santoro National Theater (1960–66), the Cathedral (1958–70), and the Cultural Complex of the Republic (Fig. 6.38) composed of the

Fig. 6.38 The Cultural Complex of the Republic by Oscar Niemeyer in the Eixo Monumental, Brasilia. In the foreground is visible the National Museum of the Republic and in the background the National Library. Photograph by Giaime Botti, distributed under a CC BY 4.0

National Museum of the Republic (1999–2006) and the National Library (2008). In São Paulo, Niemeyer's Ibirapuera Auditorium was also conceived in 1954 but never built until 2002. In this scenario, the major work elaborated by a foreign architect has been Christian de Portzamparc's Cidade das Artes (2002–13) in Rio de Janeiro. This impressive exposed-concrete building, in any case, seems to pay homage to the Brazilian modernist tradition of concrete construction, with reference to both Affonso Eduardo Reidy's MAM and the work of *paulistano* architect João Batista Vilanova Artigas. But again, when it comes to cultural facilities, how not to mention that foreign architects had to contend with works of the calibre of Paulo Mendes da Rocha's and MMBB Arquitetos' SESC 24 de Maio in São Paulo (2017, 27,865 m^2) or the older SESC Pompéia by Italian *émigrée* Lina Bo Bardi (1982)?

6.6 Conclusions

After the success of the Guggenheim Bilbao by Gehry, which not only represented a sort of "redemption" for American architecture (Rectanus 2000, 181–185) but also became a paradigm of successful urban regeneration, glossy cultural buildings have been erected across the world. In China, this has happened at such an unprecedented pace as to be described as a "museum boom" (Zhang and Courty 2021). Unlike in the West, this cultural frenzy reflected in the construction of museums, theatres and public libraries has been driven by the needs of a burgeoning middle class and the will of policymakers to position their cities at the national or global level. In many ways, an iconic museum designed by a famed architect for globalising cities has become the complementary element to a skyline dominated by modern skyscrapers. While China has invested more than any other country in this, and Qatar and the UAE have also poured enormous resources into the construction of impressive museums, countries in South-East Asia and India have not done anything comparable, at least not with the involvement of foreign architects. In Latin America, on the other hand, new cultural buildings, usually private, have been designed by European and Japanese architects, while most of the great public museums and libraries date back to the 1960–70s and were designed by local professionals.

In this scenario, therefore, we highlight the aggressive positioning of cities like Abu Dhabi and Doha as cultural and tourist centres through milestone projects like Nouvel's Louvre Abu Dhabi and the National Museum of Qatar, and Gehry's Abu Dhabi Guggenheim, marking the arrival of museum franchises in the Gulf, backed by some of the most lucrative deals in the history of art institutions. In addition, in China like in the Persian Gulf or in Latin America, museums and other cultural facilities often represent the 'cherry on the cake' of speculative real estate operations more than the expression of public-led operation with a nation-building value: the Huamao Museum in Ningbo, the Dubai Opera at the feet of the Burj Khalifa, or the Jumex and the Soumaya in Polanco, Mexico City, well display this trend. Given the expectations, more than for any other typology of buildings, it is for museums, theatres, libraries, and art and cultural centres that the archistars are requested. As a result, although

6.6 Conclusions

we do find some megafirms like AREP, GMP, Nikken Sekkei, or Perkins & Will delivering some of these projects, the market is dominated by Pritzker architects like Ando, Gehry, Hadid, Herzog & De Meuron, Koolhaas, Nouvel, Portzamparc, or Siza, and others well-known names like Botta, Chipperfield, MVRDV, or Snøhetta (Fig. 6.39). In this, European and Japanese architects outperform US-American ones, and medium-size firms win over megapractices.

Most of these projects are aesthetically calling but have added little to the architectural debate. In many cases, architects have re-proposed formal and material solutions already successfully applied in previous works, or have delivered introverted, abstract, and sculptural designs that emerge from their surroundings in terms of quality but hardly engage with them, often justified by the *tabula rasa* or the uncertain conditions of these contexts. Nevertheless, sometimes we have also seen projects that have displayed precise positions in front of the problem of global/local and the relation with history and historical forms, like in some of Pei's works. Still, the museum building as typology and museums as institutions have never been challenged by these projects in the same way Renzo Piano and Richard Rogers' Centre Pompidou did in the 1970s. Very often, especially in China, projects resulted in empty boxes with an unclear programme and diverse architectural values. In many cases, however, local architects had completed medium-sized buildings of remarkable quality, internationally well-acknowledged. Compared to the West, overseas architects in China and the Middle East had the opportunity to experiment with the form more freely, count on more resources, and work on buildings whose size was usually much bigger.

Like for the case of skyscrapers, and even more for the architecture of the megaevents that we will explore in the next chapter, the agency of Western architects in countries with poor records on human and labour rights have been scrutinised by the press, the public and NGOs, and even some in the architectural system. Exactly

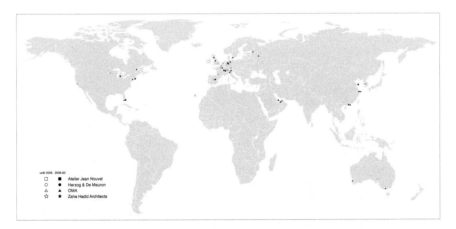

Fig. 6.39 A map of museum projects (built) by Atelier Jean Nouvel, Herzog & De Meuron, OMA, and Zaha Hadid Architects before and after 2005. Copyright Giaime Botti

like in the previous cases, most Western professionals have turned their eyes to the other side or justified their work with clumsy statements, although sometimes there has also been an acknowledgement of responsibilities and the undertaking of some concrete actions. As a matter of fact, the question remains, and it will resurface here and there in this book. For the moment, we end with the dubitative conclusions written by Moore (2018) in *The Guardian* referring to some of these projects and OMA's Qatar National Library specifically: "What can be said is that these cultural and architectural projects are, in themselves, for the good. There doesn't seem much to be gained by wishing they weren't there."

References

Adam, Robert. 2013. Doha, Qatar. In *Architecture and Globalisation in the Persian Gulf Region*, ed. Murray Fraser and Nasser Golzari, 105–127. Farnham: Ashgate.

Apollo. 2017. Is the Bilbao effect over? *Apollo*, Feb 27. https://www.apollo-magazine.com/is-the-bilbao-effect-over-guggenheim/. Accessed 20 Aug 2021.

Batty, David. 2013. Campaigners criticise UAE for failing to tackle exploitation of migrant workers. *The Guardian*, Dec 22. https://www.theguardian.com/world/2013/dec/22/uae-migrant-workers-exploitation-emirate-criticised. Accessed 30 Aug 2021.

Bologna, Alberto. 2019. *Chinese Brutalism Today: Concrete and Avant-Garde Architecture*. San Francisco, CA: ORO Editions.

Botti, Giaime, and Daniele Pisani. 2022. Rem Koolhaas e as Bibliotecas. *Revista Da Biblioteca Mário De Andrade* 74: 32–51.

Brownell, Susan. 2008. *Beijing's Games: What the Olympics Mean to China*. Portland, OR: Rowman and Littlefield.

Butler, Beverley. 2007. *Return to Alexandria: An Ethnography of Cultural Heritage Revivalism and Museum Memory*. Walnut Creek, CA: Left Coast Press.

Campobenedetto, Daniele. 2017. *Paris les Halles. Storia di un futuro conteso*. Milano: FrancoAngeli.

Carota, Francesco. 2019. China brand homes business history and projects' analysis of China Vanke Co. Ltd., 1988–2016. PhD Thesis, Politecnico di Torino.

Carrick, Glenn, and David Batty. 2013. In Abu Dhabi, they call it happiness Island. But for the migrant workers, it is a place of misery. *The Guardian*, Dec 22. https://www.theguardian.com/world/2013/dec/22/abu-dhabi-happiness-island-misery. Accessed 30 Aug 2021.

Chaslin, François. 1985. *Les paris de François Mitterrand. Histoire des grands projets architecturaux*. Paris: Gallimard.

Clark, Tim. 2014. Exclusive AJ interview: Hadid & Schumacher. *Architects' Journal*, Sept 18. https://www.architectsjournal.co.uk/news/exclusive-aj-interview%e2%80%89hadid-schumacher. Accessed 30 Aug 2021.

De Oliveira Sanchez, Renata Latuf, and Stephen Essex. 2017. Architecture and urban design: The shaping of Rio 2016 olympic legacies. In *Rio 2016: Olympic Myths, Hard Realities*, ed. Andrew Zimbalist, 97–120. Washington, DC: Brookings Institution Press.

Duncan, Olivia, and Sonny Tomic. 2013. Abu Dhabi, UAE. In *Architecture and Globalisation in the Persian Gulf Region*, ed. Murray Fraser and Nasser Golzari, 129–153. Farnham: Ashgate.

Fan, Peilei. 2015. Producing and consuming urban planning exhibition halls in contemporary China. *Urban Studies* 52 (15): 2890–2905.

Fixsen, Anna. 2014a. What is Frank Gehry doing about labor conditions in Abu Dhabi? *Architectural Record*, Sept 25. https://www.architecturalrecord.com/articles/3234-what-is-frank-gehry-doing-about-labor-conditions-in-abu-dhabi. Accessed 30 Aug 2021.

References

Fixsen, Anna. 2014b. Site unseen. *Architectural Record*, June 16. https://www.architecturalrecord.com/articles/5868-site-unseen. Accessed 30 Aug 2021.

Florida, Richard L. 2012. *The Rise of the Creative Class: Revisited*. New York, NY: Basic Books.

Frampton, Kenneth. 2020. *Modern Architecture: A Critical History*, 5th ed. London: Thames & Hudson.

Gómez, María V. 1998. Reflective images: The case of urban regeneration in glasgow and Bilbao. *International Journal of Urban and Regional Research* 22 (1): 106–121.

Gómez, María V., and Sara González. 2001. A reply to Beatriz Plaza's 'The Guggenheim-Bilbao Museum Effect.' *International Journal of Urban and Regional Research* 25 (4): 898–900.

Graebner, Seth. 2014. The Louvre Abu Dhabi: French universalism, exported. *L'esprit Créateur* 54 (2): 186–199.

Guan, Chenghe, Richard Peiser, Shikyo Fu, and Chaobin Zhou. 2021. New towns in China. The Liangzhou story. In *New Towns for the Twenty-First Century: A Guide to Planned Communities Worldwide*, ed. Richard Peiser and Ann Forsyth, 167–181. Philadelphia, PA: University of Pennsylvania Press.

Holcomb, Briavel. 1993. Revisioning place: De- and re-constructing the image of the industrial city. In *Selling Places: The City as Cultural Capital, Past and Present*, ed. Gerry Kearns and Chris Philo, 133–144. Oxford: Pergamon Press.

Holland, Lorien. 2000. Magnum opus. *Far Eastern Economic Review* 27: 62–63.

Howarth, Dan. 2015. China 'can't buy culture' with museum boom, say critics. *Dezeen*, Dec 11. https://www.dezeen.com/2015/12/11/new-chinese-museums-construction-boom-opening-money-cant-buy-culture-china/. Accessed 22 Nov 2021.

Ivanov, Stepan. 2013. Design of mariinsky theater 2 causes uproar in Petersburg. *Russia Beyond*, Feb 15. https://www.rbth.com/arts/2013/02/15/design_and_cost_of_mariinsky_theater_2_causes_uproar_in_petersburg_22907.html. Accessed 28 Aug 2021.

Jacobson, Clare. 2014. *New Museums in China*. New York, NY: Princeton Architectural Press.

Jencks, Charles. 2011. *The Story of Post-Modernism: Five Decades of the Ironic, Iconic and Critical in Architecture*. Chichester: Wiley.

Jia, F., J. Gosling, and M. Witzel. 2015. *Sustainable Champions: How International Companies are Changing the Face of Business in China*. Sheffield: Greenleaf Publishing.

Mansour, Yasser, ed. 2003. *The grand museum of Egypt: International architecture competition*. Cairo: Egypt Egyptian Ministry of Culture.

Mascolo, Olga. 2018. Qatar National Library. Rem Koolhaas: 'Libraries produce radical architecture'. *Domus*, Sept 5. https://www.domusweb.it/en/architecture/2018/09/05/national-library-del-qatar-rem-koolhaas-le-biblioteche-producono-architettura-radicale.html. Accessed 30 Aug 2021.

Moore, Rowan. 2016. Elbphilharmonie: Hamburg's Dazzling, costly castle in the air. *The Observer*, Nov 6. https://www.theguardian.com/artanddesign/2016/nov/06/elbphilharmonie-hamburg-herzog-de-meuron-costly-castle-in-the-air. Accessed 30 Aug 2021.

Moore, Rowan. 2018. How Landmark buildings became weapons in a new gulf war. *The Guardian*, July 21. https://www.theguardian.com/artanddesign/2018/jul/21/landmark-buildings-weapons-in-new-gulf-war. Accessed 18 Jan 2022.

Ong, Aihwa. 2011. Introduction worlding cities, or the art of being global. In *Worlding Cities: Asian Experiments and the Art of Being Global*, ed. Ananya Roy and Aihwa Ong, 1–26. Chichester; Malden, MA: Wiley-Blackwell.

Ouroussoff, Nicolai. 2011. Chinese gem that elevates its setting. *The New York Times*, July 5. https://www.nytimes.com/2011/07/06/arts/design/guangzhou-opera-house-designed-by-zaha-hadid-review.html. Accessed 20 Dec 2021.

Piccarolo, Gaia. 2020. *Architecture as Civil Commitment: Lucio Costa's Modernist Project for Brazil*. Abingdon; New York, NY: Routledge.

Piciocchi, Alice. 2018. Spectacular forms in the library. *Abitare*, July 22. https://www.abitare.it/en/architecture/projects/2018/07/22/biblioteche-punto-riferimento-citta/. Accessed 30 Aug 2021.

Plaza, Beatriz. 2000. Evaluating the influence of a large cultural artifact in the attraction of tourism: The Guggenheim Museum Bilbao case. *Urban Affairs Review* 36 (2): 264–274.

Rectanus, Mark W. 2000. *Culture Incorporated: Museums, Artists, and Corporate Sponsorships.* Minneapolis: University of Minnesota Press.

Ren, Xuefei. 2011. *Building Globalization. Transnational Architecture Production in Urban China.* Chicago, IL: The University of Chicago Press.

Rennie-Short, John. 2004. *Global Metropolitan: Globalizing Cities in a Capitalist World.* London; New York, NY: Routledge.

Riach, James. 2014. Zaha Hadid defends qatar world cup role following migrant worker deaths. *The Guardian*, Feb 25. https://www.theguardian.com/world/2014/feb/25/zaha-hadid-qatar-world-cup-migrant-worker-deaths. Accessed 30 Aug 2021.

Sell, Christopher. 2009. Zaha's Dubai opera house set to be cancelled. *Architect's Journal*, Apr 23. https://www.architectsjournal.co.uk/archive/zahas-dubai-opera-house-set-to-be-cancelled. Accessed 28 Aug 2021.

Staples, David, and David Hamer. 2021. *Modern Theatres 1950–2020.* New York, NY: Routledge.

Vicario, Lorenzo, and P. Manuel Martínez Monje. 2003. Another 'Guggenheim Effect'? The generation of a potentially gentrifiable neighbourhood in Bilbao. *Urban Studies* 40 (12): 2383–2400.

Willsher, Kim. 2017. Architect defends treatment of workers at Louvre Abu Dhabi. *The Guardian*, Sept 24. https://www.theguardian.com/world/2017/sep/24/architect-defends-treatment-workers-louvre-abu-dhabi-jean-nouvel. Accessed 30 Aug 2021.

Winston, Anna. 2015. Jean Nouvel Boycotts opening of his Paris Concert Hall. *Dezeen*, Jan 14. https://www.dezeen.com/2015/01/14/jean-nouvel-boycotts-opening-of-philharmonie-de-paris-concert-hall/. Accessed 30 Aug 2021.

Xue, Charlie Q.L.. 2006. *Building a Revolution: Chinese Architecture Since 1980.* Hong Kong: Hong Kong University Press.

Xue, Charlie Q.L. 2019. Introduction: Grand theaters and city branding—Boosting Chinese cities. In *Grand Theater Urbanism: Chinese Cities in the 21st Century*, ed. Charlie Q.L. Xue, v–xxix. Singapore: Springer.

Zhang, Fenghua, and Pascal Courty. 2021. The China museum boom: Soft power and cultural nationalism. *International Journal of Cultural Policy* 27 (1): 30–49.

Zhu, Jianfei. 2009. *Architecture of Modern China: A Historical Critique.* London; New York, NY: Routledge.

Chapter 7
Megaevents: Dubious Legacies and Empty Shells

The history of international megaevents has been entangled with the one of globalisation and Western imperialism since the Great Exhibition of the Works of Industry of All Nations of 1851, when, for the occasion, Joseph Paxton devised one of the most revolutionary buildings in the history of architecture: the Crystal Palace, "a building process made manifest as a total system, from its initial conception, fabrication and trans-shipment, to its final erection and dismantling" (Frampton 2020, 39). A prerogative of industrialised countries initially, national, international, and universal exhibitions by the early twentieth century were already organised in many Latin American countries to celebrate the centennials of their independence and other events: Buenos Aires 1910, Bogotá 1910, Rio de Janeiro 1922, just to name the most important ones. All these events represented appetising opportunities for architects. However, not so many buildings envisioned for such occasions did deserve a place in the history of architecture, especially in the last few decades. The same can be said for other megaevents that in the second half of the twentieth century assumed more relevance: major international sports events like the Summer and Winter Olympic Games and the FIFA World Cup. Still, there certainly are buildings that marked the history of architecture. Without going too far back in time to the Crystal Palace or the Eiffel Tower erected for the Exposition Universelle de Paris 1889, since the 1930s, we find some celebrated projects worth mentioning: Alvar Aalto's Finnish Pavilion and Lucio Costa and Oscar Niemeyer's Brazilian Pavilion at New York World's Fair of 1939; Le Corbusier's Philips Pavilion at the Expo 58 in Bruxelles (although the popular icon of the exhibition was the Atomium); Moshe Safdie's experimental dwellings Habitat 67 at Montreal 1967; Arata Isozaki's Festival Plaza and Paulo Mendes de Rocha's Brazilian Pavilion at Osaka 1970. Still, following up with this list would not lead anywhere, while it is more important to point out that all these events, until the end of the 1990s, had one thing in common: the venues were in Europe and North America, Japan and South Korea, and the Soviet Union, with Mexico City 1968 Summer Olympic Games and some World Cup hosted by Latin American countries as the only exceptions. Then, since the turn of the century, the situation radically changed.

© The Author(s), under exclusive license to Springer Nature Singapore Pte Ltd. 2023 293
G. Botti, *Designing Emerging Markets*,
https://doi.org/10.1007/978-981-99-1552-1_7

Looking at the venues of major international megaevents in the twenty-first century is another way to explain globalisation and the rise of new economies. After Tokyo and Seoul, the Summer Olympic Games touched Asia again in 2008, but this time the location was Beijing, China. After that, they moved for the first time to South America, landing in a no-more-booming Brazil, with Rio de Janeiro 2016. In the meantime, the Winter Olympic Games were organised in Sochi, Russia, in 2014, and in Beijing in 2022. For the first time, the FIFA World Cup touched Africa, with South Africa 2010, then Brazil 2014, Russia 2018, and Qatar in 2022. In the same decades, international exhibitions were also organised for the first time in countries like Kazakhstan, with Astana 2017, and the United Arab Emirates, with Dubai 2020 (postponed to 2021 due to the COVID-19 pandemic). As immediately visible, this new geography overlaps with that of the new most dynamic global economies, especially BRICS and oil-rich countries in the Middle East. In many ways, in the new century, these countries became the only ones that could afford and wanted to undertake such big spending without too much public debate (Cornelissen 2010; Braathen et al. 2015).

On the contrary, public opinion in many developed countries has generally shown an increasing apathy, when not frank adversity, towards these costly megaevents, which have often stressed too much the already-stretched public finances of the hosting country (Zimbalist 2015). Not by chance, scholars and the press have highlighted the link between the Athens 2004 Olympics and the successive Greek government-debt crisis of 2009 (Associated Press 2010; Berlin 2015), as well as other negative urban phenomena like a growing sprawl in a loosely regulated context (Salvati and Zitti 2017). Still, despite unproved claims of greater economic impact, which is generally positively overestimated (Barclay 2009), it is sometimes true that the Summer Olympic Games may stimulate GDP growth, while it is equally proved that the FIFA World Cup does not do it (Sterken 2006). Thus, during the last three decades, competition to host these megaevents has grown in parallel with costs and financial guarantees provided by governments (Szymanski 2011). Still, in recent years there have also been several cases of cities abandoning the bid in due course: for the 2024 Summer Olympic Games, only Paris and Los Angeles remained in the final phase after Hamburg, Rome, and Budapest abandoned the bid. As a result, Paris got the 2024 edition and the Californian city the one of 2028, in an unprecedented simultaneous awarding.

Nonetheless, for megaevents, cost–benefit considerations are not the only important ones, and their broader consequences have also been scrutinised from other points of view. Similar to what we discussed in relation to skyscrapers (Sect. 5.8) and grand cultural projects (Sect. 6.2), megaevents sparked a debate that involved politicians, public opinions, several stakeholders, and various professionals, including architects. And this was not only due to the often-exorbitant costs of the works but also to the very fact that such works took place in countries where labour or human rights are not respected or because of displacements of more vulnerable people from locations within or too close to the venues of these events. In this regard, the Summer Olympic Games of Rio de Janeiro, with the clearing of several *favelas* and the militarisation of others, represented a paradigmatic case under the spotlight of both the press

(Douglas 2015) and the academia (Gaffney 2010; Zimbalist 2017). Indeed, all these controversies will be a central point of this chapter, intermingled with the story of the involvement of overseas design firms, which, as we will see, usually peaks in these countries in the proximity of these megaevents.

7.1 The Rise of Global China: Beijing 2008 Summer Olympic Games and Expo 2010 Shanghai

The first decade of the twentieth century represented an extraordinary period for China. In 2007, before slowing down, not least as a consequence of the global financial crisis, Chinese GDP grew a stunning 14.2%, a rate not seen since 1992, and never achieved again in the following years. Its access to the World Trade Organization in 2001 marked a real watershed, and by 2004, China's foreign trade accounted for U$1.1 trillion, making it the third largest trading country in the world (Branstetter and Lardy 2008, 633). As seen in Sect. 4.3, during that decade, the growth in the number of projects designed by overseas firms in China sharply accelerated, peaking in 2008 and 2010. Several remarkable projects designed by famed international architects have already been mentioned, from OMA's CCTV (Sect. 5.7) to the many theatres, museums, and public libraries that popped up first in Beijing and Shanghai and then in second and third-tier cities throughout the country (Sect. 6). As Ren (2008) pointed out, unlike in many Western countries, urban megaprojects, rather than responding to the pressure of de-industrialisation, were the result of the strength of the Chinese industrialising economy and the availability of local, rather than international, capitals to be invested. In addition to the limited intervention of foreign capitals in real estate developments, the other relevant difference was the deep involvement in and control by governmental actors, aware of the potential benefits of these "image projects" on their political careers. In such a context, two major international events driving hundreds of foreign architects to the country took place: the 2008 Summer Olympic Games in Beijing and the Expo 2010 Shanghai. To these, the XVI Asian Games held in Guangzhou in 2010, the 2022 Beijing Winter Olympic Games, and the XIX Asian Games of Hangzhou 2022 (now postponed to 2023 due to COVID-19) can also be added.

After hosting the XI Asian Games in 1990 and unsuccessfully bidding for the Summer Olympic Games of 2000, Beijing eventually won its bet in 2001 for the 2008 Games. Making the most of the past experiences, both successful and non, the capital city underwent massive transformations. Architecture was used to "updated and re-brand" the city as a "prosperous world metropolis," while more in general, it served to restore China's "international image and to legitimise the power of China's ruling elite" (Broudehoux 2004, 2007, 2010; Østbø Haugen 2008). As noted (Lovell 2009, 9), the Games represented "the country's international coming out party: a global recognition of this ancient civilization's euphoric twenty-first-century resurgence," a way to restore "national greatness" in front of the humiliations of the past

two centuries (Mangan 2009). Accordingly, Chinese leadership promoted multiple narratives depicting the country as "developed and prosperous," "politically stable and orderly," respectable in front of the international community, and "globalised," while not abandoning a more patriotic and nationalistic rhetoric (deLisle 2008; Broudehoux 2011; Marvin 2008).

To achieve these ambitious objectives, Beijing was profoundly transformed in a moment in which it was already undergoing a process of urbanisation and renewal at an unprecedented scale and pace. The master plan for the Olympic Green, the monumental north–south axis aligned with the Forbidden City, along which the main venues of the Games had to be located, was assigned to Sasaki after an international competition. This esplanade, known as the Cultural Axis, is linked to the north with the Forest Park. At the same time, it is also crossed by a secondary diagonal axis, the Olympic Axis, connecting the existing Asian Games stadium with the new National Stadium to end at the Memorial of the Olympic Spirit in Forest Park. At its southern edge, the esplanade begins with the two most iconic buildings: the National Stadium, also known as "Bird's Nest" designed by Herzog & De Meuron with Ai Weiwei (Fig. 7.1), and PTW Architects' National Aquatics Centre, or "Watercube" (Fig. 7.2). The former became the main architectural icon of the Games and introduced the Swiss Pritzker duo to the Chinese market in 2002. After that, however, several projects, some of which elaborated in collaboration with Ai Weiwei, failed to materialise.

The Stadium represented a milestone also for another reason beyond being the main venue of the Games: unlike the stadium of the Asian Games, designed by a

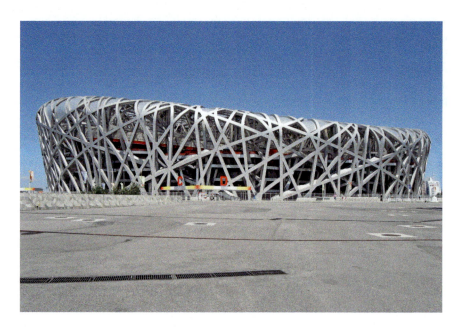

Fig. 7.1 The National Stadium ("Bird's Nest") by Herzog & De Meuron with Ai Weiwei in the Olympic Green area, Beijing. Photograph by Giaime Botti, distributed under a CC BY 4.0

Fig. 7.2 The National Aquatics Centre ("Watercube") by and PTW Architects in the Olympic Green area, Beijing. Photograph by Giaime Botti, distributed under a CC BY 4.0

Chinese architect, and I. M. Pei's project for the failed bid of 1993 for the 2000 Olympic Games, the "Bird's Nest" was the result of an international competition, a clear display of the will of giving up with the idea of needing a Chinese architect for the task. The project sparked controversies, as a group of Chinese academics criticised the proposal with the argument that foreign Western architects were coming to China to design buildings that "could have never been built in their own countries" (Brownell 2008, 89–90). Outside of China, instead, the debate revolved around human rights concerns, but, as Thomas Herzog admitted, "only an idiot would have said no" to such a project (Spiegel 2008). Indeed, by the time it was completed, Ai Weiwei had already distanced himself from the work (Artlyst 2012). Another firm that authored many projects for the Games, RMJM, energetically rejected similar criticisms, albeit with relatively weak argumentations about not "widening the gulf" between China and the West (Stewart 2008).

The "Watercube" also became a well-recognised piece of architecture thanks to its innovative ETFE bubble-like envelope. And the Australian firm PTW Architects (not included in our survey) was acquired in 2013 by a Chinese architecture and engineering consulting firm, CCDI. Lastly, of little architectural interest, but part of our survey are some projects delivered by RMJM. The British megafirm produced some designs for the Beijing Olympic Main Press Centre and the Olympic International Broadcast Centre (27,000 m^2), while it also completed the larger Multi-Purpose Arena (220,000 m^2), one of the main buildings located along the western edge of the Cultural Axis. It hosted the media centre and fencing and pentathlon competitions.

After the Games, it re-opened as the National Convention Centre. Despite media clamour, we stress again the fact that Beijing, during the years before and after the Olympic Games, was undergoing such a vast and profound transformation that the architecture directly envisioned for the event represented a real drop in the ocean, while the most interesting buildings of the decade were then under construction in other parts of the city and for other purposes.

For Shanghai, the Expo 2010 played a similar role in driving urban transformations and attracting foreign architects within a general context of rapid urban growth. The nine million square metres Expo master plan was elaborated by a team led by Tongji University's professor Wu Zhiqiang, based on some ideas developed by a previous master plan elaborated in Paris by French firm AS Architecture Studio, whose architects have been temporarily residing in China since 1998 until they opened a branch office in Shanghai in 2004. The Expo was launched as a national project but got integrated into the local strategies envisioned by the Master Plan of Shanghai Metro Region (1999–2020). The Expo became a "catalyst" for urban restructuring, driving land prices up and thus facilitating the involvement of private actors, and promoting the improvement of transportation, including the completion of several new metro lines (Chen 2018, 117–119). More in general, the megaevent gave a push to the transformation of the city's economy from a manufacturing to a service-based one, with emphasis on knowledge, culture, and leisure. The cross-river site, a 5.28 km^2 area occupied by shipyards and other heavy industries with some historical significance, was organised into five zones, three on the Pudong side (south) of the Huangpu River and two on the Puxi (north). In the southern part, a central spine—the Expo Axis, or Expo Boulevard—separated Zone A, where the China Pavilion and the national pavilions of Asian countries were erected, from the B and C, where most of the other national pavilions were located. On the other side of the river, in zone D and E, more thematic and private pavilions were placed.

The spine was designed by German firm SBA Architekten (not included in our survey) with ECADI. It consisted of a one-kilometre-long, one-hundred-metre-wide axis covered with the largest membrane roof ever built, with a free span of almost one hundred metres. Arte Charpentier, another French firm with a solid record of landscape projects in the city—notably the Central Plaza of Pudong (1996) and the renovation of Nanjing Road (1999), one the busiest commercial streets of the city–, designed the 1.5 hectares Celebration Plaza. Indeed, for many foreign firms, especially small-to-medium size, the Expo represented a first involvement with the Chinese market, often after the design of national pavilions. After winning the competition and completing the French Pavilion, Ferrier Marchetti successfully established its presence in China, consolidating it by opening an office branch in Shanghai in 2012. EMBT opened a branch office in the city to develop their winning project for the Spanish Pavilion. Firms like Heatherwick Studio and Ratio SMDP had in the UK Pavilion (Fig. 7.3) and the Expo Public Event Centre (145,000 m^2), respectively, their first built projects in the country. The same happened to BIG, which, after completing the loop-shaped Danish Pavilion, one the few of a certain architectural relevance within the Expo precinct, followed up with larger projects. German firm HPP, which by 2021 has developed over 1.3 million square metres in China, entered

Fig. 7.3 The UK Pavilion by Heatherwick Studio and Ratio SMDP at the Expo 2010, Shanghai. Photograph by Dingyuang, distributed under a CC BY 3.0, available at https://commons.wikimedia.org/wiki/File:UK_Pavillion_at_2010_Shanghai_Expo.jpg. Modified by Giaime Botti

this market at that time with the project of the Expo Village. In the end, the number of overseas firms involved was significant, with about thirty just considering our sample (Table 7.1).

While we have stated that the architectural programme of an international exhibition is not necessarily ground-breaking and of particular interest for disciplinary advancement, the Expo 2010 Shanghai has certainly given room to remarkable pavilions, in which El-Khoury and Payne (2010) recognise some common themes and preoccupations that more broadly reflect the current state of the art. In particular, they acknowledged a trend towards biomimicry, well exemplified in the UK Pavilion, whose 60,000 fibre optic filaments wrapping the building bring daylight inside, shine at night, and react to changes in the surroundings. The second trend, somehow connected, concerns surfaces that, from simple façades, transform into interfaces not only through digital technologies, as proved by the Spanish Pavilion, with its wicker panels clad in a shingle pattern. A third tendency consists in blurring the building with the landscape, like in the case of the "Expo Boulevard" (El-Khoury and Payne 2010, 13–17).

More importantly, the legacy of this megaevent can be questioned from different perspectives. The five areas of the master plan were already conceived with the legacy projects in mind. Of the 2.3 million square metres built, about 50% was maintained in

Table 7.1 Overseas firms (surveyed sample) involved in Expo 2010 Shanghai

Designer (Country)	Project	Status	GFA (m^2)
Archea (IT)	Pavilion UBPA B3-2	Built	2,000
Arte Charpentier (FR)	Celebration Plaza	Built	156,000
AS Architecture Studio (FR)	Expo 2010 Master Plan	Partially built	9,000,000
	Public Event Centre	Unbuilt	145,000
AZPML (ES)	Madrid Pavilion	Built	2,800
BIG (DK)	Danish Pavilion	Built	3,000
CEBRA (DK)	Danish Pavilion	Unbuilt	N.A.
Conix RDMB (BE)	Belgian Pavilion	Built	5,250
Ecosistema Urbano (ES)	Spanish Pavilion	Unbuilt	N.A.
Ferrier Marchetti Studio (FR)	French Pavilion	Built	6,700
Foster + Partners (UK)	UAE Pavilion	Built	3,500
Guallart Architects (ES)	Spanish Pavilion	Unbuilt	N.A.
Heatherwick Studio (UK)	UK Pavilion	Built	N.A.
HPP (DE)	Expo Village	Built	555,000
JDS (DK)	Belgian Pavilion	Unbuilt	N.A.
JKMM (FI)	Finnish Pavilion	Built	3,400
John Portman Architects (USA)	Expo Hotel	Unbuilt	N.A.
Mass Studies (SK)	Korean Pavilion	Built	7,683
EMBT—Miralles Tagliabue (ES)	Spanish Pavilion	Built	8,842
Playze (DE)	German Pavilion	Built	6,000
	Tony's Booth	Built	N.A.
	Luxembourg Pavilion	Unbuilt	N.A.
Ratio SMDP (USA)	Public Event Centre	Built	145,000
Rudy Ricciotti (FR)	French Pavilion	Unbuilt	N.A.
Samyn and Partners (BE)	Belgian Pavilion	Unbuilt	N.A.
Sasaki (USA)	Expo Park	Unbuilt	N.A.
Shigeru Ban (JP)	Japanese Industry Pavilion	Built	N.A.
Shin Takamatsu (JP)	Devnet Pavilion	Unbuilt	N.A.
Sweco (SW)	Swedish Pavilion	Built	N.A.
Terada Design (JP)	Pavilion	Unbuilt	N.A.
Unsangdong Architects Cooperation (SK)	Korean Corporate Pavilion	Unbuilt	N.A.
Urban Design System (JP)	Japan Industrial Hall Mirai Post Office	Built	N.A.
Vudafieri Saverino (IT)	Italian Pavilion	Unbuilt	N.A.

the form of flagship buildings, restored industrial heritage, and new landscaped parks and riverbanks (Deng et al. 2016, 165). In 2011, the Expo region was established with the objective of making the area a "world-class civic centre" similar to Lujiazui (Deng et al. 2016, 169). On the Puxi side, zone D has been transformed into a cluster of cultural and museum buildings, and E into an eco-living quarter. In zone A and B, flagship buildings have been kept and reused. The Expo Boulevard was transformed into a shopping mall, the Performance Centre into the Mercedes-Benz Arena, the Thematic Pavilion into an exhibition centre, and the China Pavilion into the China Art Museum. This latter example deserves some words, as it represented one of the most iconic buildings erected for the Expo, and it was not designed by a foreign architect. On the contrary, the red-flammant Pavilion was built according to a project of He Jingtang, a well-known architect and scholar based in Guangzhou (Xue 2006, 119–125). The building was shaped as an inverted pyramid constructed by stacking large interlocking beams to recall the traditional *dougong* (interlocking wooden brackets with a function comparable to the capital in Western classical architecture), to make it a symbol of a modern China rooted in historical architectural traditions (Fig. 7.4). Making a balance of the legacy of the Expo, therefore, appears a complex task. The urban renewal process unleashed by the megaevent set the foundations for a new sub-centre; the adaptive reuse strategies were innovative in their approach to "temporality and permanence," defining a benchmark for future projects (Deng et al. 2016, 173). At the same time, other aspects remained more problematic. Neglecting considerations about costs and people's displacement, or the value it had as an exercise of public diplomacy (Cull 2012), there is a clear problem of affordability in the site, while the large volumes of office and hospitality space planned with little flexibility may resent more from any future economic slowdown (Deng et al. 2016, 173). Finally, the site is far from being a lively piece of the city after a decade. It instead appears a quite desolated, undesigned collection of urban voids, separated by wide roads and populated by large, isolated, often fenced, massive buildings.

As the involvement of foreign design firms proves, both the Summer Olympic Games and the Expo represented a gluttonous occasion for overseas architects more than for the Chinese (Xue 2006, 43). Such a fact can be easily observed in architectural magazines, where during those years, the presence of projects by foreign architects in China peaked (Botti 2022). Indeed, the relationship between the work of international architects and the country's rise on the global stage in a period of tremendous economic growth and deepening integration into the global trade system is not casual. In the first decade of the twentieth-first century, China promoted a new image of openness and modernity to match its global aspirations. At that time, Shanghai emerged as the city able to embody best the concept of "international metropolis," or "*guojihua dadushi*" (Ren 2011, 11). Shanghai was "central to 'China's official imagination of modernity'" (King 2004, 125) and this image was built primarily through the works of foreign architects (Dreyer 2012). At that time, it appeared that the fate of cities, especially those of second and third-tier, was tied to the work of these architects, who could have changed the very perception of any place in which they operated (Xue 2019, xix). Since then, other cities have been touched by megaevents, too, albeit of minor relevance.

Fig. 7.4 The China Pavilion (now China Art Museum) by He Jingtang in the area of the Expo 2010, Shanghai. Photograph by xiawilliams, distributed under a CC BY 3.0, available at https://commons.wikimedia.org/wiki/File:%E4%B8%AD%E5%9B%BD%E9%A6%86_-_panoramio_-_xiawilliams_(1).jpg

When Guangzhou hosted the XVI Asian Games in 2010, the capital of Guangdong was undergoing deep urban transformation, especially in Tianhe, where the monumental axis of Zhujiang New Town, the new CBD, was under development, with the construction of two supertall skyscrapers just in front of the Canton tower on the other side of the river (Sect. 5.2), and cultural buildings like Zaha Hadid's Opera. In between, the small Haixinshan Island became the venue for the opening and closing ceremonies. At the same time, other competitions took place in the Guangdong Olympic Stadium designed by US architect Ellerbe Becket (not included in our survey) and opened in 2001. The same year was also inaugurated a sports centre designed by Paul Andreu—ADP Ingénierie. More recently, the XIX Asian Games of Hangzhou 2022 has sparked the development of the Olympic Sports Expo Centre along the Qiangtan River, in front of Qianjiang New City, the new CBD built to decentralise the city from the West Lake area to the south. Here, NBBJ has designed a lotus flower-shaped stadium, while a smaller tennis centre also features the same shape. A second area was master-planned by US-Dutch firm Archi-Tectonics (not included in our survey), which also designed two arenas.

Overall, during the 2000s, the sports infrastructure of Chinese cities was renovated and developed beyond these major events, with some flagship projects designed

7.1 The Rise of Global China: Beijing 2008 Summer Olympic Games … 303

Table 7.2 Stadium projects (built) by GMP in surveyed emerging markets

Project	Country	City	Year	Capacity
National Stadium Mané Garrincha	Brazil	Brasilia	2008–13	72,800 seats
Estádio Mineirão [renovation]	Brazil	Belo Horizonte	2010–13	66,000 seats
Arena da Amazônia	Brazil	Manaus	2010–14	44,000 seats
Century Lotus Sports Park Stadium	China	Foshan	2003–06	36,000 seats
Bao'an Stadium, Universiade 2011	China	Shenzhen	2007–11	40,050 seats
Suzhou Park Sports Centre	China	Suzhou	2013–18	N.A.
Haikou Wuyuan River Sports Park	China	Haikou	2013–18	41,400 seats
Jawaharlal Nehru Stadion	India	New Delhi	2006–10	57,000 seats
New Arena and Park of FC	Russia	Krasnodar	2013–16	33,000 seats
Nelson Mandela Bay Stadium	South Africa	Port Elizabeth	2005–09	48,000 seats
Cape Town Stadium	South Africa	Cape Town	2006–09	68,000 seats
Moses Mabhida Stadium	South Africa	Durban	2006–09	70,000 seats

by overseas design firms. GMP delivered several projects for stadiums (Table 7.2), a basketball arena (Dongguan, 2006–14, 60,600 m^2, capacity 15,000), and sports parks with multiple facilities, like the Shanghai Oriental Sports Centre (2008–11), consisting of numerous indoor and outdoor swimming pools, and the Suzhou Park Sports Centre (2013–18, 460,000 m^2), formed by a 45,000-seat stadium, an indoor pool, and a 15,000-seat indoor sports hall. AXS Satow in 2007 completed the Tianjin Olympic Centre Stadium (158,000 m^2) and the Shenyang Olympic Sports Centre Stadium (103,900 m^2), while the Shenzhen Bay Sports Centre (2011, 256,500 m^2) comprehends a 20,000-seat stadium and a 13,000-seat arena. More sports venues were built in Tianjin, with Progetto CMR designing the visually modest Tianjin Quanjian FC Stadium (2011, 34,000 m^2, capacity 25,000), and KSP Jürgen Engel Architekten the equally modest sports arena (2006–10, 13,835 m^2). Populous completed, in 2005, a large Sports Park in Nanjing to host the X China National Games, formed by a 60,000-seat stadium, an 11,000-seat arena, a swimming and tennis centre, and other outdoor sports facilities. Interestingly, all these facilities were located on top of a common podium connecting all the venues and allowing separate circulation flows, making the riverside park accessible to the general public even during events.[1]

Finally, for the Winter Olympic Games of Beijing, scattered between the capital and Zhangjiakou ski resort, the legacy of the previous Games has been fully exploited by reusing the same buildings with minimum or no interventions. The two main exceptions to this were the National Speed Skating Oval, designed by Populous (which also won the competition for the master plan of Zhangjiakou Sports Park)

[1] For the sake of completeness, the other mapped projects of sport typology are: Dalian Sports Centre (2009–11, 20,000 m^2) by RMJM, Xiamen Olympic Tennis Centre (2004–08, 45,000 m^2) by Beyond Space - Ryu Choon-soo, Pudong Soccer Arena (2017–21, 65,000 m^2) by HPP, Taiyuan Water Sports Centre (2017–19) by Delugan Meissl, and Zhuhai Tennis Centre (2015, 5,000 seats) by Populous.

with BIAD, and the Big Air Shougang, the iconic venue for big air ski and snowboard competitions hosted in a former industrial complex with one building, the Oxygen Factory, renovated by a joint team of the Politecnico di Torino and the Tsinghua University. This industrial landscape, characterised by the presence of giant cooling towers and other relics, has been criticised as "dystopian" but perhaps represented in reality a sustainable choice of preserving the local memory while reusing existing structures. In this regard, Betsky (2022) has been vocal in defending the project as "a shining example of what we should be doing a lot more of, and what the Chinese are, as usual, rolling out at a vast scale: repurposing old industrial sites for new uses." Nonetheless, if sustainability is an issue, the very fact of holding an event in a place where climatic conditions are not naturally favourable to its programme is something making it inherently unsustainable. In this case, the dry climate, lack of natural snow, and the consequential massive use of artificial snow represented the primary concern of many, despite the organisers' reassurances. The Winter Olympic Games of 2022, held without the general public in a containment bubble that separated athletes, staff, and workers from everyone else due to the COVID-19 pandemic, in many ways, also became a metaphor for a country that was closing its doors to the world compared to a decade before (Gan 2021; Mierzejewski 2022). A decade in which, however, China was not the only emerging power using international megaevents to signal its new role on the global stage. Brazil was on the rise, too.

7.2 The Brazilian Bet: Brazil 2014 FIFA World Cup and Rio de Janeiro 2016 Summer Olympic Games

The hosting of two major international sports events like the FIFA World Cup and the Summer Olympic Games in less than three years was for Brazil an important occasion to show to the world its new position as a rising global economic power and boost its national pride while expectations for the positive economic effects were also high. Thus, such a case shares many similarities with China as well as significant differences. In the decade preceding the events, the South American giant experienced solid economic growth boosted by high prices of commodities and their growing demand, especially from China. Not for nothing, Brazil was considered an integral part of the new emerging bloc of the BRIC(S) countries (Armijo 2007; Avila and Araujo 2012). Nonetheless, after being assigned during a *bonanza* period, these events occurred during the adverse economic cycle that characterised Brazil's second decade of the twenty-first century. In 2014, the Brazilian economy was growing a meagre 0.5%, to fall into a deep recession, recording a—3.5% and—3.3% in 2015 and 2016, respectively. And after that moment, the country never again achieved the same growth rate as the previous decade. Therefore, while both China and Brazil bet on international megaevents in a period of economic growth and ascent on the world stage, the latter was already tuning down its forecasts by the time the World Cup and the Summer Olympic Games took place.

In 2013, with the economy slowing down, protests erupted in the country triggered by an apparently secondary fact: a small increase in public transportation fares. Indeed, the discontent was deeper and more widespread. Despite the decade of economic growth and a general improvement in living conditions for many, inequalities had not disappeared at all. In a city like Rio de Janeiro, which was preparing to host the two megaevents, policies and projects did not seem to tackle disparities nor to aim at improving the lives of the hundreds of thousands living in slums devoid of any essential service. In fact, planning concentrated on megaprojects and punctual intervention to beautify parts of the city and let real estate speculators exploit these transformations (Seldin and Ledo 2014, 201–202). During the years preceding the World Cup and the Games, Rio de Janeiro's renewal of two zones stood out for its scope and consequences: Porto Maravilha and the Olympic Park. The first one, an historical and central area that suffered the de-industrialisation of the port, was set to be transformed into a commercial and cultural district, marked by the presence of high-rise office buildings (Sect. 5.6) and some cultural facilities like Santiago Calatrava's Museo da Amanhã (Sect. 6.5). This operation of urban renewal pushed out vulnerable homeless communities living in the area and the inhabitants of the nearby *favela*—as informal settlements are known in Brazil—through forced evictions, and mostly benefited the private sector despite the huge costs sustained by public finances. Then, at a certain moment, the Olympic Media Village originally planned in Porto Maravilha was relocated to the Olympic Park, showing how the project was, in the end, a highly speculative operation not really connected to the needs of the Games (Seldin and Ledo 2014, 205–206). As for the second case, the Olympic Park, we will get back to it soon. Before doing so, however, we need to focus on the first of the two megaevents, the FIFA World Cup that took place in 2014 (preceded in 2013 by the FIFA Confederation Cup), not only in Rio de Janeiro but also in eleven more cities.

For this occasion, several high-capacity stadiums needed to be built anew or refurbished. Looking at architectural firms involved in these projects, we note that stadium design is a sub-market dominated by a limited number of international players. Among them, two especially shine: GMP and Populous. The German megafirm has completed more than two dozen stadiums around the world (Table 7.2), from China to Germany, including the refurbishment of the 1936-Berlin Olympiastadion (Marg 2010). Populous, a firm specialised in sports facilities, which originated in 2009 from HOK Sport Venue Event, has also completed dozens of sports projects, some of them in the emerging markets mapped in this chapter (Table 7.4). In Brazil, in collaboration with Castro Mello Arquitetos, GMP designed the elevations and the light roof in polycarbonate and PTFE-coated fibreglass fabric for the Mané Garrincha Stadium of Brasilia—a city itself a masterpiece of modernist urbanism and architecture wholly listed as UNESCO World Heritage–, thus providing the national capital with a neat and monumental circular building surrounded by a "forest" of columns (Fig. 7.5). Somehow, the need to establish a dialogue with a solid architectural tradition emerged also in the renovation of the Estádio Mineirão of Belo Horizonte, a modernist concrete building with a strong sculptural character. In this case, GMP refurbished part of the lower tier of the tribunes without touching the exterior concrete

Fig. 7.5 The Mané Garrincha Stadium by GMP, Brasilia. Photograph by Brazilian Government, distributed under a CC BY 3.0, available at https://commons.wikimedia.org/wiki/File:Brasilia_Stadium_-_June_2013.jpg

shell and added a lightweight ring cable structure as a new roof. On the contrary, the Arena da Amazônia in Manaus was built anew and featured a light structure with a white façade of translucent fibreglass fabric folding into the roof; it was also one the first (Silver) LEED-certified stadiums in the world. In the end, however, of twelve stadiums built or refurbished for the World Cup, only four were designed by foreign firms. In addition to the ones already mentioned, Populous designed the Arenas das Dunas in Natal, and Gensler took the lead in the interior design of the Arena Corinthians of São Paulo.

All in all, the 2014 FIFA World Cup can hardly be considered a success in terms of material and economic legacy. The stadiums built for the occasion rank among the most expansive in the world, and most of the promised urban and infrastructural projects have been cancelled or delayed (Sennes 2014). And this without counting the hardships for the over 250,000 inhabitants of informal settlements that were displaced with little chance to be heard and with even less in return, or the conditions of those living in neighbourhoods that were put under siege by the police (Zimbalist 2015, 100). This process of militarisation (Livingstone 2014) has been described as a paradigmatic expression of the neoliberal "shock doctrine" (Gaffney 2010). The acknowledgement of these experiences just reinforces our interest in investigating the (un)ethical dimension of the contemporary globalised architectural profession, which represents one of the key themes of this book. In the second place, as we study the involvement of different professional actors, we can note that in Brazil, the

number of overseas firms that designed iconic venues and other attractors remained rather limited if compared to what happened in China or, as we will see, in the Persian Gulf and Kazakhstan. Again, the reasons are varied: the slower growth rate of the Brazilian economy, the larger availability of local architects, and the smaller permanent presence of foreign architectural firms can explain these differences (Sect. 6.5). And the 2016 Summer Olympic Games did not rely too much on foreign expertise either.

In Rio de Janeiro, no archistars were involved, while some megafirms took some projects (De Oliveira Sanchez and Essex 2017), starting for the initial consultations with WilkinsonEyre, Pujol Arquitectura, and AECOM for the definition of the overall urban strategy (Zimbalist 2015, 90). Looking in detail at the event's architectural legacy, only a few buildings catch the eye, some of which were designed by foreign architects. Proceeding in order, we start from the specific locations chosen for the venues of the Games and the master plan of the Olympic Park. Following the scheme adopted for the 2007 Pan American Games, the Summer Olympics were hosted in four different clusters: Copacabana, Deodoro, Maracanã, and Barra da Tijuca (Rezende and Leitão 2014). The latter is an upper-class Ocean-facing neighbourhood developed according to a master plan by Lucio Costa in the late 1960s. Here was located the Olympic Park (Fig. 7.6). For the master plan, an international competition organised by the Institute of Architects of Brazil was called in 2011, resulting in the victory of Brazilian architect Daniel Gusmão with AECOM (which has already designed the Olympic Park for London 2012) over Gensler and Portuguese firm Risco, respectively second and third in the contest, while another surveyed firm, Huitt-Zollars also took part. The master plan, like in London, envisioned three phases: Games, transition, and legacy (De Oliveira Sanchez and Essex 2017). The Park occupies a 120-hectare triangular plot developing into the Jacarepaguá Lagoon, where AECOM located a circular plaza partially covered by a tensile canopy at the end of the undulating Olympic Way, an explicit homage to Roberto Burle Marx's Copacabana promenade. Along this axis, WilkinsonEyre designed the Cariocas Arenas, a complex of three connected arenas of sculptural presence used for several indoor sports events. In addition, GMP (with Schlaich Bergermann Partner) designed the 10,000-seat Tennis Centre and AECOM the International Broadcast Centre (2013–15, 80,000 m^2). The rest of the buildings, instead, were designed by Brazilian architects who won the respective competitions: Lopes Santos e Ferreira Gomes Arquitetos for the Olympic Handball Arena, and BCMF Arquitetos for the Aquatic Stadium, the Velodrome (with Backheuser Arquitetura e Cidade), and several other buildings located in the other clusters. BCMF was also responsible for the original master plan that helped Rio de Janeiro to win its bid, making the most of its experience for the 2007 Pan American Games. Another Brazilian firm, Vigliecca & Associados, despite losing the competition for the Olympic Park in Barra da Tijuca, was successful in the bid for the Deodoro Olympic Park master plan, also designing the Youth Arena and the Radical Park for canoe slalom. To all this, we can add some minor buildings designed by foreign architects, like the Samsung Galaxy Studio Pavilion (1,200 m^2) by UN Studio and Henning Larsen's Danish Pavilion (300 m^2) on the Ipanema sidewalk.

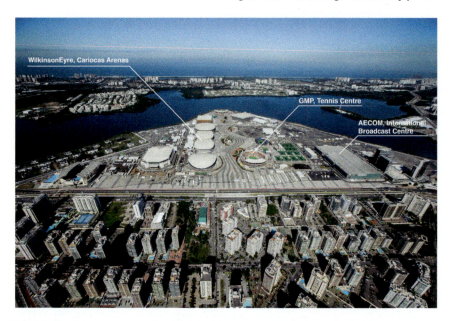

Fig. 7.6 The Olympic Park by Daniel Gusmão with AECOM in Barra de Tijuca, Rio de Janeiro with marked the Cariocas Arenas by WilkinsonEyre, the Tennis Centre by GMP, and the International Broadcast Centre by AECOM. Photograph by Miriam Jeske/Brasil2016.gov.br, distributed under a CC BY 3.0, available at https://commons.wikimedia.org/wiki/File:Parque_Ol%C3%ADm pico_Rio_2016.jpg

As a result, for Brazil, and for Rio de Janeiro in particular, the experience of the FIFA World Cup and of the Summer Olympic Games seems to justify a generally critical view towards such megaevents. Not only these operations of urban renewal produced negative fallouts in their surroundings, but they also failed to envision a better future city. In a way, the point is not the lack of any remarkable piece of architecture (in fact, some of the sports facilities are of the highest design standards) but rather the many unexploited opportunities. The theme of the public space gives a good example of such missed opportunities. As acutely noted by Renata L. De Oliveira Sanchez and Stephen Essex (2017, 100), this type of megaevents promoted the design of empty esplanades that are precisely contrary to what a good public space should be. In this regard, Barcelona remains the model and the exception. In the end, protests should not come as a surprise when costs outweigh benefits, the private sector benefits more than the public one despite the injection of public funding, ordinary people do not see any improvement in public services like education and health because money is diverted towards these events, and vulnerable people are affected through evictions. And in other contexts, while we can easily spot similar problems, people's aspirations and dissatisfaction could not always be expressed as freely as in Brazil.

7.3 Beyond Oil? National Monuments and Economic Diversification in Astana 2017 and Dubai 2020

As the rise of Brazil in the early 2000s was favoured by the high price of commodities like oil and soybean pushed by China's growing demand, other countries had oil revenues as their primary source of public funding. Thus, two more events, the Expo 2017 Astana and the Expo 2020 Dubai (postponed to 2021–22 because of the COVID-19 pandemic), display the entanglements between megaevents, projection of soft power, and architecture in oil-based economies that need to move beyond oil. Undoubtedly, Kazakhstan owes its current wealth to the oil and gas sector and a few more natural resources, including uranium. Still, the exhibition's official motto, "Future Energy," implied the search for low-carbon alternatives on which the country (apparently) was willing to bet. And Expo 2020, too, under the motto "Connecting Minds, Creating the Future," showed the path toward a future of mobility, opportunity, and sustainability, according to the three sub-themes of the event, in which fossil fuels had little space. Indeed, while the UAE overall is one of the world's biggest oil producers, the Emirate of Dubai does not actually count on substantial reserves. In fact, it has developed as the financial and trading hub of the region.

Starting from Astana's Expo, we cannot avoid discussing the position of Kazakhstan and the city itself before anything else. Its strategic position between Europe, Russia, and China, wisely exploited through a "multi-vectorial" foreign policy (Costa Buranelli 2018), has made it a pivotal country in the region, attracting relevant Chinese investments in the framework of the One Belt One Road Initiative. Through Kazakhstan transits a new rail freight route connecting China to Central Europe, and along this line, in a more central position than the former capital city Almaty, located all way south near the border with Kyrgyzstan, stands the new capital, Astana/Nur-Sultan. Although founded in the 1830s, the decision of Kazakhstan's ruler Nursultan Nazarbayev to move the capital from Almaty in 1994 marked a turning point, making Astana the last completed example of a planned capital city. A first master plan was developed in 1996 by local firm Ak-Orda, followed by one by the Saudi Bin Laden Group, and finally one by Kisho Kurokawa. This was the result of an international competition, which Kurokawa did not win. Still, thanks to the support of the Japanese government, the architect, who was also the only high-profile figure in the competition, was personally chosen by Nazarbayev.[2] Indeed, the selection of a well-known modernist architect not coming from a Western country was coherent with Kazakhstan's attempt to follow a "third way" for modernisation between the West and the former Soviet Bloc (Shelekpayev 2020; Bissenova 2013). Kurokawa's architectural proposal followed the notion of "abstract symbolism," but Astana, overall, resulted in a "stylistic chaos" artificially crafted to induce the idea of a truly global city (Anacker 2004), not least because of the lack of concrete details on the architecture, replaced by general guidelines prioritising freedom and flexibility (Köppen 2013). The outcome is well expressed by Albo's (2017) description of Astana as "a blend of

[2] Kurokawa also successfully designed the city international airport (200–05; Sect. 10.1) and the master plan for the Nazarbayev University (2009–ongoing).

postmodernism, Central Asian art, Islamic decor, Russian baroque, neoclassicism, orientalism, all melded into something that looks like Las Vegas meets Disneyland on nationalist steroids" (quoted in Wainwright 2017). The statehood of the former Soviet republic, now independent, had to be "sustained" by an adequately built landscape rich in symbols of political and cultural identity, but also of economic development and progress (Bekus 2017).

Astana's master plan, which suffered major modifications after 2005, was rooted in the Japanese Metabolist tradition, following the concept of "symbiosis" between the old and the new city, organic biological growth and renewal, and the use of functional linear zoning. However, the idea of constant transformation clashed with the monumental axis, which was not envisioned by Kurokawa but likely by the Saudi Bin Laden Group (Shelekpayev 2020). Along this axis, comparable to the National Mall in Washington, DC, or Brasilia's *Eixo Monumental*, major public buildings stand as a built representation of Kazakhstan's political and economic power. Such a representation is embodied by a "pervasive monumental architecture in 'Neo-Kazakh Style'," with references to "oriental and Islamic architectural traditions," visible in the use of blue and white colours and pointed arches (Köppen 2013).

The eastern side of the axis culminates with the over-sized, disproportioned White House-like Presidential Palace, behind which stands Foster + Partners' Palace of Peace and Reconciliation (2004–06, 35,000 m^2; Fig. 7.7), a 62 by 62 by 62-m pyramid containing a congress centre and other facilities. Exactly on the opposite side of the axis, then, the British Pritzker designed the Khan Shatyr Entertainment Centre (2006–10, 100,000 m^2), a mix of leisure and shopping areas under a 100-m-tall ETFE conoid recalling traditional nomadic tents. Moreover, Foster + Partners also completed the Nazarbayev Centre (2011–14, 24,000 m^2), a monumental public library whose project was initially awarded to BIG in 2009. These three buildings, once again, explains the love, or at least the like, that starchitects have for strongmen, even despite questionable aesthetic preferences: "He [Foster] said the president of Kazakhstan wants a pyramid. It has to be finished in 21 months. Let your imagination soar," recalls a senior partner of the firm interviewed by Wainwright (2017). More ethical concerns were recalled in the same interview by a reference to how Amnesty International ranks the country for human rights. In the end, the interviewed architect at Foster + Partners shielded the firm from criticism by adducing the peaceful purpose (mutual religious understanding) of the Palace of Peace and Reconciliation, exactly as Bjarke Ingels defended his will to work in Kazakhstan with the argument that the city would have been better off with a new library (Parker 2012). Ironically, both Foster + Partners and BIG pulled out from Russia after the 2022 invasion of Ukraine, which happened a few weeks after the eruption of a strong wave of protests in Kazakhstan, violently sedated by the government with the support of the Russian military.

As for the Expo, when Astana was selected in 2012 by the Bureau International des Expositions for the 2017 specialised exhibition, for the first time, a former Soviet republic was awarded the organisation of such an event. With the new, glittering capital under development, a renewed global image of Kazakhstan was promoted in every sector without sparing efforts, from sport, with the leading cycling team Astana,

7.3 Beyond Oil? National Monuments and Economic Diversification ...

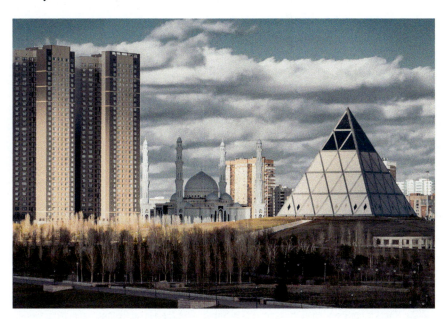

Fig. 7.7 The Palace of Peace and Reconciliation by Foster + Partners, Nur-Sultan. Photograph by Mathias Rhode

to international education, with the establishment of the Nazarbayev University, to depict the country as an "open, dynamic and successful" one despite its authoritarian reality (Fauve 2015). The Expo 2017 Astana, therefore, took place in this context and represented the most important international event in the country. In the 2013 design competition for the master plan, many recognised firms participated, including (from our sample) Arte Charpentier, EMBT, Fuksas & Associati, Gansam, J. Mayer H., Mecanoo, Safdie Architects, Saraiva + Associados, Snøhetta, Stefano Boeri, UN Studio, and Zaha Hadid Architects. Eventually, Adrian Smith + Gordon Gill (AS + GG) was awarded the design of the 160-hectare plan, which also contained residential and office space that could have been further expanded after the end of the Expo (Fig. 7.8). The whole design revolved around the central Kazakhstan Pavilion, an energy-efficient glass sphere transformed into a science and technology museum after the Expo, that appears as nothing more than the n-fold variation of Buckminster Fuller's Biosphere of Expo 67 in Montreal. More in general, the architectural proposals lacked interest, not least because most of the exhibition space was incorporated in the four major buildings also designed by AS + GG around the sphere (Fig. 7.9). The US firm, in addition, designed the Congress Centre and transformed one of the core pavilions into an art centre. Overall, the mobilisation of architects based on our survey (16 firms involved) appears more limited when compared to Expo 2020 Dubai, where more than thirty firms have participated (including those with unsuccessful proposals).

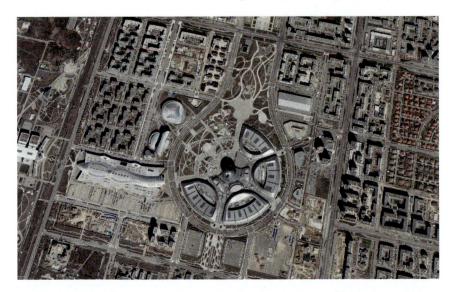

Fig. 7.8 A satellite picture of the Expo 2017 area master-planned by Adrian Smith + Gordon Gill with the Kazakhstan Pavilion at the centre, Nur-Sultan. © 2023 Maxar Technologies from Google Earth Pro

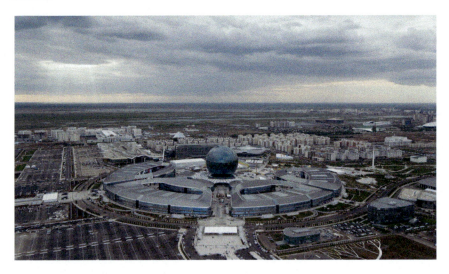

Fig. 7.9 The Kazakhstan Pavilion at Expo 2017 Astana by Adrian Smith + Gordon Gill, Nur-Sultan. Photograph by aerialcamturkey

7.3 Beyond Oil? National Monuments and Economic Diversification ... 313

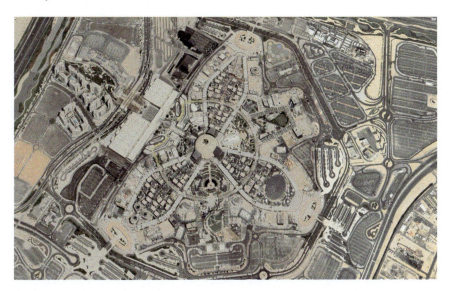

Fig. 7.10 A satellite picture of the Expo 2020 Dubai area master-planned by Adrian Smith + Gordon Gill, Dubai. © 2023 Maxar Technologies from Google Earth Pro

The different level of attractiveness for foreign architects exerted by the two events was not only due to the general perception of Dubai as a global city compared to Astana; the two expositions were inherently different as Astana 2017 was a so-called Specialised Expo, while Dubai 2020 an actual World Expo. In the UAE, the master plan of the Expo was developed by HOK with Populous and Arup. Following the three main themes of the event—Mobility, Opportunity, Sustainability–, the exhibition area was organised in three thematic districts irradiating like three petals in different directions from the central Al Wasl Plaza, a large domed structure part of the legacy project designed by AS + GG (Fig. 7.10). The master plan for these thematic districts and their landscape features were delivered by Hopkins Architects in collaboration with LAND Italia, aiming to provide each of the plan's three petals with a unique character in terms of geometry, landscape, and colours. In each of the three districts, we find the main pavilions dedicated to the corresponding theme. Foster + Partners, which had previously elaborated the projects for the UAE Pavilion at Expo 2010 Shanghai and 2015 Milano, designed the trefoil-shaped Mobility Pavilion. Awarded with a LEED Gold certificate, it features stainless-steel continuous horizontal blades running all around the building to evoke the idea of movement and aerodynamics. Explicitly seeking a net zero energy and water consumption is Nicholas Grimshaw's Sustainability Pavilion, a hypogeous exhibition space shaded by a large canopy built with 97% of recycled steel and containing over 8,000 m^2 of photovoltaic panels. The pavilion is also surrounded by the so-called energy and water trees, smaller tree-inspired canopies with either PV panels or a dew harvesting system. After the Expo, it will be transformed into the Sustainability Museum. Finally, Kuwait and Madrid-based AGi Architects (not included in our survey) replaced Cox Architects, which

had previously replaced BIG, for the project of the Opportunity Pavilion, a concrete-free building made only of organic and recycled materials. Before considering the national pavilions, two more important buildings need to be mentioned: the Dubai Exhibition Centre by Woods Bagot and UAE Pavilion (LEED Platinum) by Santiago Calatrava with Pascall + Watson. The latter was inspired in its geometric but organic shape by a falcon, whose image appears more evident once the operable white clads of the roof are opened, resembling wing feathers in the wind.

Among the many national pavilions built in Dubai, several proudly rely on and exhibit a wide array of sustainability features. For example, the German Pavilion by LAVA followed the principle of Design for Disassembly and is potentially 95% recyclable. Querkraft's Austrian Pavilion was built with local and reusable materials and was conceived to increase passive cooling and reduce the use of air conditioning. Still, such discourse seems to reflect a mono-dimensional view of sustainability as a purely environmental problem to be solved by technical means. As coverage from the international press made clear, allegations about human rights violations, especially for migrant workers, remained a concern (Pattisson 2022). Still, in some cases, it was the overall architectural proposal to stand out. The undulating wooden interior of the Finnish Pavilion by JKMM, which recalled Alvar Aalto's famous design for the 1939 World's Fair in New York, is certainly one of them. Or, outside our sample, the kaleidoscopic light volumes of the Pakistan Pavilion, envisioned by Rashid Rana, one the most recognised contemporary Asian artist, is another one. Finally, it can be noted that firms usually design national pavilions from their country, even if this comes from an open competition. However, small countries, sometimes devoid of an active architectural scene, often rely on these same firms (Table 7.3). Calatrava, for instance, also designed the Qatar Pavilion; Christian Kerez the Bahrein Pavilion; OSS (not included in our sample) both the Swiss and the Monaco Pavilion.

Despite the undoubted primacy of Dubai over Astana also visible in terms of architectural outcomes, both expos featured a vast majority of unremarkable buildings, although Dubai can boast a few of some interest. More in general, it is since the 1970s—usually, Montreal and Osaka are the last expos to deserve an acknowledgement in architectural histories—that these events do not display significant architectural innovations, if not perhaps in terms of showcasing and testing some technical solutions. A second point to highlight is the growing involvement of overseas firms of different sizes and types, albeit with a limited presence of starchitects (especially Pritzker winners). While this does not represent a novelty since national pavilions have always been a motivation for undertaking an overseas project, we now see major international firms more involved in the planning phase of the expos. Finally, we notice again how the ethics of the profession return to be an issue when Western architects are involved in countries with a poor track record on human rights. And the same will be even more evident when looking at the three FIFA World Cups that took place in South Africa, Russia, and Qatar.

7.3 Beyond Oil? National Monuments and Economic Diversification …

Table 7.3 Overseas firms (surveyed sample) involved in Expo 2020 Dubai

Designer (country)	Pavilion/Other	Status	GFA (m^2)
Adrian Smith + Gordon Gill (USA)	Al Wasl Plaza	Unbuilt	N.A.
	World Expo [master plan]	Unbuilt	N.A.
	Global Mobility Centre	Unbuilt	18,233
AT Projects (IT)	Italian Pavilion	Unbuilt	5,150
BIG (DK)	Opportunity Pavilion	Unbuilt	N.A.
Bossley Architects (NZ)	New Zealand Pavilion	Unbuilt	N.A.
Carlo Ratti Associati with Italo Rota (IT)	Italian Pavilion	Built	N.A.
Cox Architecture (AUS)	Opportunity Pavilion	Unbuilt	1,200
Christian Kerez (CH)	Bahrein Pavilion	Built	N.A.
Fentress Architects (USA)	US Pavilion	Built	5,574
Foster + Partners (UK)	Mobility Pavilion	Built	N.A.
FRPO Rodriguez & Oriol Arquitectos with Selgascano (ES)	Spanish Pavilion	Unbuilt	N.A.
Ga.a Architects with Samooo (SK)	Korean Pavilion	Unbuilt	N.A.
Gnosis Progetti (IT)	Amphitheatre	Built	N.A.
GRAFT (DE)	German Pavilion	Unbuilt	N.A.
Grimshaw (UK)	Sustainability Pavilion	Built	N.A.
HHF (CH)	Swiss Pavilion	Unbuilt	N.A.
HOK with Populous (USA) and ARUP (UK)	World Expo [master plan]	Built	N.A.
Hopkins Architects (UK)	Thematic Districts [master plan]	Built	N.A.
JKMM (FI)	Finnish Pavilion	Built	1,867
LAND Italia (IT)	Thematic Districts [landscape]	Built	N.A.
LAVA (DE)	German Pavilion	Built	4,500
K.O.M.A. (SK)	Korean Pavilion	Unbuilt	1,885
One Works (IT)	Gulf Cooperation Council Pavilion	Unbuilt	N.A.
	Italian Pavilion	Unbuilt	3,000
	Algerian Pavilion	Unbuilt	1,500
Partisans (CA)	Canadian Pavilion	Unbuilt	3,850
Playze (DE)	Luxembourg Pavilion	Unbuilt	3,700
Querkraft (AT)	Austrian Pavilion	Built	1,600
Santiago Calatrava (CH) with Pascall + Watson (UK)	UAE Pavilion	Built	15,000
Santiago Calatrava (CH)	Qatar Pavilion	Built	620
Saraiva + Associados (PT)	Portuguese Pavilion	Built	N.A.
Shigeru Ban (JP)	Mobility Pavilion	Unbuilt	N.A.

(continued)

Table 7.3 (continued)

Designer (country)	Pavilion/Other	Status	GFA (m^2)
Studio Farris Architects (BE)	Belgium Pavilion	Unbuilt	N.A.
UN Studio (NL)	Dutch Pavilion	Unbuilt	N.A.
XTU (FR)	Luxembourg Pavilion	Unbuilt	3,700
Weston Williamson + Partners (UK)	UK Pavilion	Unbuilt	N.A.
Woods Bagot (AUS)	Dubai Exhibition Centre	Built	180,000

7.4 FIFArchitecture: South Africa 2010, Russia 2018, and Qatar 2022

The unimpressive architectural and urban legacy of Brazil 2014 FIFA World Cup has already been analysed in the previous pages. Still, since the second decade of the twentieth-first century, more editions of the FIFA-organised tournament have been hosted in the emerging markets on which this book focuses. In general, while Summer Olympic Games bring the global public physically or virtually into a single city, or at the maximum, in a few more scattered venues for specific sports events, the World Cup typically involves ten or more urban centres. Several studies show that hosting the World Cup generally does not boost the economy (Baade and Matheson 2004). In fact, even negative correlations have been recorded (Szymanski 2002), not only for major sports events but for the construction of sports stadiums in general (Baade and Dye 1990; Coates and Humphreys 2000), although some have pointed out exceptions, like in the case of Germany 2006 FIFA World Cup (Allmers and Maennig 2009). But again, as highlighted by many authors, such events represent huge bets that go beyond the simple economic discourse. The importance of intangible benefits, such as civic pride and "feel good effect" are part of the equation, as well as the projection of political and economic power (Baade and Matheson 2004). The case of South Africa and Russia (considering both Sochi 2014 Winter Olympics and the 2018 World Cup) are exemplary.

Hosting the 2010 FIFA World Cup represented an extraordinary moment of pride and hope for South Africa and the ruling African National Congress party, especially because it was the first time an African country organised such an event. The national leadership not only expressed its ambitions for a boost to the country's economy by promoting business, trade, and tourism but also a deeper aspiration to transform the event into a catalyser of national unity in a country still lacerated by the wounds of the Apartheid (Tayob 2012, 722). As usual, such illusions mostly remained illusions. Still, the same things can be seen from different perspectives. Some foreign design firms, like in the case of Brazil, were able to capitalise on the South African momentum. Overall, of ten stadiums, five were designed by foreign architects. Populous, together with the local firm Boogertman and Partners, refurbished Johannesburg's Soccer City Stadium by designing an upper tier of seats, a fabric roof, and a colourful façade of fibre-cement panels (Fig. 7.11). UK-based AFL

7.4 FIFArchitecture: South Africa 2010, Russia 2018, and Qatar 2022 317

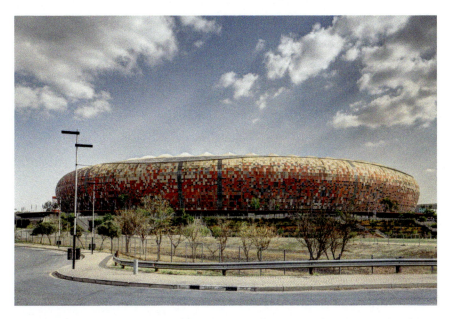

Fig. 7.11 The Soccer City Stadium by Populous and Boogertman and Partners, Johannesburg. Photograph by Andreas Wulff, distributed under a CC BY 2.0, available at https://commons.wikimedia.org/wiki/File:Soccer_City_Stadium_Exterior.jpg

Architect designed the Peter Mokaba Stadium in Polokwane. After winning three competitions between 2005 and 2006, GMP secured contracts for these three major venues: Green Point Stadium in Cape Town (Fig. 7.12), Moses Mabhida Stadium in Durban, and Nelson Mandela Bay Stadium in Porth Elizabeth (Fig. 7.13). The first one features an elegant elliptical undulated shape that raises from a low podium against the backdrop of Signal Hill and Table Mountain in the middle of a large park in Green Point, a few hundred metres away from the V&A Waterfront, the major shopping, leisure, and upscale residential development of Cape Town. The fine envelope of fibre-glass fabric, while screening the interior during the day, reveals it once illuminated at night. Similarly, in Durban, the Moses Mabhida Stadium, whose development required the work of 32 local firms with the consultancy of GMP, also strived to become a city icon. Located on the shores of the Indian Ocean, it stands out with its longitudinal arch, to which the membrane roof is suspended through steel cables. All around, a perforated metal sheet façade screens from the sun, wind, and rain, while it allows ventilation and visual permeability, not dissimilarly from the case of Cape Town. Furthermore, in Porth Elizabeth, GMP's design addresses a similar ambition for an iconic, although not extravagant, presence and an environmentally friendly architectural solution. Both objectives were successfully achieved with an elegant envelope that alternates aluminium leaf-shaped façade modules, which fold into the roof, and white PTFE membranes to fill the gaps between them. Ultimately, these three projects show again the quality of GMP's work and a strong degree of

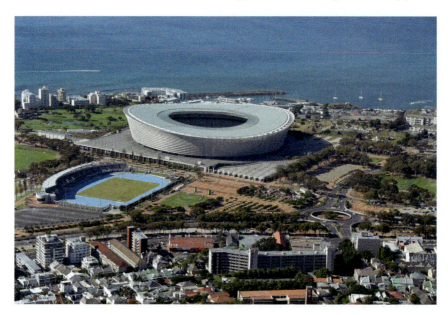

Fig. 7.12 The Green Point Stadium by GMP, Cape Town. Photograph by Ngrund, distributed under a CC BY 3.0, available at https://commons.wikimedia.org/wiki/File:Kapsk%C3%A9_m%C4%9Bsto,_fotbalov%C3%BD_stadion_-_Jihoafrick%C3%A1_republika_-_panoramio.jpg. Modified by Giaime Botti

design consistency exemplified by the pursuit of beauty through geometry, elegance through lightness, and environmental comfort through technical solutions adapted to the local climate.

These considerations make more evident how challenging can be the definition of critical tools needed to evaluate the architecture of globalisation (and architecture *tout court*). One may ask if the 'game' was worth the candle. Despite the quality of the buildings, the legacy of the World Cup and its projects is questionable. While studies confirm the general lack of positive effects on income and employment from sports megaevents and the construction of related venues, in Durban, benefits were perceived by residents of the areas nearby but not immediately adjacent to the stadium (Maennig and Schwarthoff 2011). Around the Ellis Park Precinct of Johannesburg, where two renovated stadiums are located—although not the Soccer City—there has been a "moderate [positive] change in people's lives across a range of indicators," primarily thanks to the arrival of the BRT transport (Karam and Rubin 2014). In fact, the implementation of this relatively low-cost and efficient mass transportation system, successfully experimented with in many Latin American cities since its invention by the architect and Curitiba major Jaime Lerner in the mid-1970s, could be considered one the lasting legacies of the World Cup in Cape Town, Johannesburg, and Port Elizabeth (Gauthier and Weinstock 2010).

On the contrary, a far more problematic legacy is related to securitisation policies. These policies, especially in the Global South, are crucial to hosting cities

7.4 FIFArchitecture: South Africa 2010, Russia 2018, and Qatar 2022 319

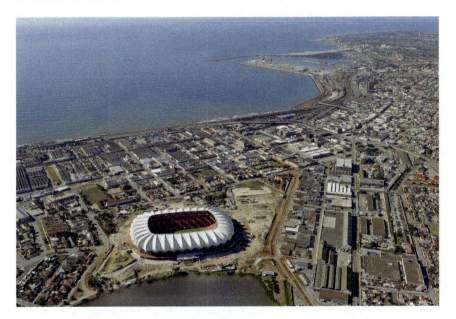

Fig. 7.13 An aerial view of the Nelson Mandela Bay Stadium by GMP, Porth Elizabeth. Photograph by Pavel Špindler, distributed under a CC BY 2.0, available at https://commons.wikimedia.org/wiki/File:Nelson_Mandela_Stadium_in_Port_Elizabeth.jpg. Modified by Giaime Botti

to improve their image and attractiveness by improving their safety. The previously commented case of Brazil is emblematic in this regard, but also South Africa, coming a few years earlier, offered an important model. Although the country allocated a budget for security sensibly lower than the one available for the previous Olympic Games, it was not negligible. As a result, South African cities broadly extended their CCTV surveillance networks in addition to investments in law enforcement personnel and equipment (Cornelissen 2011). In general, the event marked a shift in FIFA's approach to security governance towards more proactive policing, which included extensive use of GIS for crime mapping and analysis. Indeed, it remains to be seen how, in the longer term, the "spatial, class and racial consequences of securitisation processes in cities" will be felt and if "the World Cup might have reinforced zones of urban exclusivity" (Fonio and Pisapia 2015). The preparation for the event diverted public money (there were, for example, cuts in subsidy for housing projects), costs in the construction sector soared given the growing demand due to infrastructure and renewal projects, and low-income people suffered rising costs, gentrification, and displacement (Steinbrink, Haferburg and Ley 2011) following an unwritten but repetitive scheme that we have seen at play also elsewhere in the Global South.

Significant investments were also deployed in Russia for the 2018 FIFA World Cup, for which twelve stadiums in eleven cities were either built or renovated by the same protagonists we have already seen at work. GMP designed the Krasnodar Arena

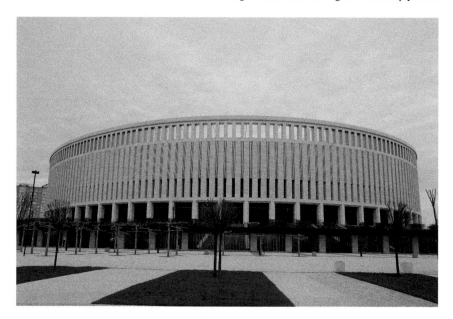

Fig. 7.14 The Krasnodar Arena by GMP, Krasnodar. Photograph by Anna Novikova, distributed under a CC BY 2.0, available at https://commons.wikimedia.org/wiki/File:Fk_Krasnodar_stadion.jpg

(2013–16; Fig. 7.14) in a very classical and monumental fashion, while in Nizhny Novgorod and Volgograd, GMP's original design (2013) was modified by the Russian partners during the development and the construction process. In Samara, too, the project was more deeply altered compared to the original design (as much as we did not include these three projects in Table 7.2). Finally, also the Luzhniki Stadium in Moscow, heavily renovated, saw an initial involvement of the German megafirm. On the other hand, Populous acted as a consultant for the Mordovia Arena of Saransk and completed the Kazan Arena in 2013 and the Rostov-on-Don Arena in 2018, proving its grip on the market of sports venues in the emerging markets (Table 7.4). The Otkritie Arena in Moscow was designed by AECOM, while Kisho Kurokawa successfully designed the Krestovsky Stadium (2007–17, 190,000 m^2; Fig. 7.15) in Saint Petersburg, and French firm Wilmotte & Associés the Kaliningrad Stadium (2012–18). The remaining ones were developed according to projects elaborated by local architects.

Before the World Cup, Russia had also hosted the 2014 Winter Olympic Games in the Black Sea city of Sochi. Compared to similar events of the decade, especially to Summer Games, Sochi 2014 did not attract the architectural star system, even though the participation of overseas firms was not negligible. In the Olympic Park master-planned by the Los Angeles-based firm WET (not included in our survey, although a Spanish firm we surveyed, AZPML, did propose a master plan for the post-event), Populous designed the Fisht Stadium, while most of the other sports

7.4 FIFArchitecture: South Africa 2010, Russia 2018, and Qatar 2022 321

Table 7.4 Stadiums and arenas (built) by Populous in surveyed emerging markets

Project	Country	City	Year	Capacity
Arenas das Dunas	Brazil	Natal	2014	39,900 seats
Nanjing Sports Park	China	Nanjing	2005	60,000 seats
Narendra Modi (Motera) Cricket Stadium	India	Ahmedabad	2020	110,000 seats
Astana Arena	Kazakhstan	Astana (Nur-Sultan)	2006–09	N.A.
KL Sport City	Malaysia	Kuala Lumpur	2017	N.A.
Estadio BBVA Bancomer	Mexico	Monterrey	2015	N.A.
Kazan Arena	Russia	Kazan	2013	45,000 seats
Rostov-on-Don Stadium	Russia	Rostov-on-Don	2012–18	45,000 seats
Fisht Olympic Stadium	Russia	Sochi	2013	45,000 seats
Soccer City Stadium [renovation]	South Africa	Johannesburg	2009	90,000 seats
Zayed Sports City [renovation]	UAE	Abu Dhabi	2009	43,000 seats
Coca Cola Arena	UAE	Dubai	2019	17,000 seats

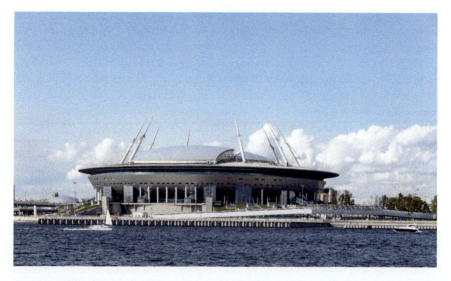

Fig. 7.15 The Krestovsky Stadium by Kisho Kurokawa, Saint Petersburg. Photograph by Ninara, distributed under a CC BY 2.0, available at https://commons.wikimedia.org/wiki/File:Saint_Petersburg,_Russia_(43506287930).jpg

facilities were designed by Russian architects. Still, a certain activity in the city was visible, with German firm RKW completing the unremarkable Olympic Committee Office Building, Valode & Pistre the Hyatt Regency Hotel, and Aukett Swanke the Azimut Hotel and Resort. The preparation for the Games also caused environmental problems while labour practices in construction work were also questioned (Zimabalist 2015, 82–83), making this megaevent not any different from the others from this perspective.

All in all, the years between 2013 and 2018 recorded a peak in the number of completed projects by foreign architects in Russia (and Kazakhstan; Fig. 7.16). A certain frenzy is also visible from the annual number of launched projects (including unbuilt) by these same firms. Although there may be the temptation to read these figures in relation to three megaevents that took place in the last decade—namely the 2014 Winter Olympic, the 2018 FIFA World Cup, and, because of the data aggregation, the Expo 2017 Astana–, this is not all. Overseas firms, for instance, were active in important developments like the Moscow International Business Centre (Sect. 5.5) and the Skolkovo area (Sect. 9.5). What we can do, therefore, is to highlight the relationship between the growing involvement of international architects in Russia and Kazakhstan, and the overall performance of their economies. Figure 7.16, in addition to the number of projects annually designed/completed by our surveyed sample of firms, also shows the aggregate GDP of the two countries in US$ trillions, although we need to warn that Russian GDP grew much faster, and it is today much larger compared to Kazakhstan than it was ten or twenty years ago. Still, what matters for us is considering how the Russian economy, which until 2013 experienced a sustained growth briefly interrupted only by the 2008 financial crisis, created a booming real estate market, which, together with megaevents reflecting the geopolitical ambitions of the country, attracted the interest of foreign architects. The slowdown of the economy, related to the decline of the oil price and Western sanctions implemented after the annexation of Crimea, is also reflected in the current declining number of projects launched and built (of course, considering the temporal shift between the design phase and completion and the fact that megaevents are assigned about five to ten years in advance).

Lastly, we will examine the preparation for the FIFA World Cup Qatar 2022. Being the first international sport megaevent of this level in the Middle East, the organisation of the Cup has not passed without scrutiny, nor the hosting country has spared its resources. For football matches, eight stadiums have been built or renovated. Dar Al-Handasah, a Beirut-based megafirm established in 1956 and active in architecture, planning, engineering, and environmental consultancy, designed the Al Bayt Stadium with a roof inspired by the traditional Qatari tent, while it also refurbished the Khalifa International Stadium, originally built in 1975. The most iconic venue, however, and also the most discussed one, is the Al Janoub Stadium (2014–19) in Al Wakrah. From an architectural point of view, this building, designed by Zaha Hadid and AECOM, stands out for its form, which recalls the white sail of a *dhow*, the traditional vessel used in the region. Indeed, most of the notoriety of the buildings derived once again from the controversies about labour conditions in the country, towards which Zaha Hadid has always been rather dismissive (Riach 2014; Clark 2014; Fixsen 2014;

7.4 FIFArchitecture: South Africa 2010, Russia 2018, and Qatar 2022

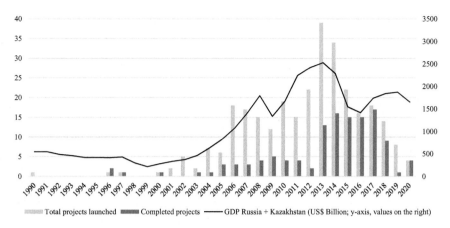

Fig. 7.16 Number of projects by overseas firms (surveyed sample) in Eurasia (Russia + Kazakhstan) and region's GDP (1990–2020). Copyright Giaime Botti

Sect. 6.2). A less formal concept, on the other hand, is behind the Ras Abu Aboud Stadium, designed by the Spanish firm Fenwick Iribarren. Based on the extensive use of shipping containers, the building—with a standard capacity of 40,000 seats—can be easily assembled, disassembled, and moved elsewhere. The same architects not only delivered several unsuccessful proposals for other sports facilities in Qatar but also designed another major venue of the World Cup, the Qatar Foundation Stadium. Currently under construction, it has been compared by the designers to a diamond because of its multifaceted volume.

A high-profile competition was held for the Lusail Stadium in 2015 when Foster + Partners defeated David Chipperfield, Mossessian & Partners, and Mangera Yvars Architects (Winston 2015). However, the project was later carried on by AFL Architects, which also designed one of the venues of South Africa 2010. South-Korean megafirm Heerim Architects & Planners supported Oman-based Ibrahim M. Jaidah (Arab Engineering Bureau) in the development of the Al Thumama Stadium (2017–20), one of the most recognisable venues: a perfect circular volume wrapped by a perforated façade whose pattern was inspired by the traditional *gahfiya* cap. Lastly, Pattern Design (not included in our survey), a British firm recently acquired by BDP with projects of sports facilities scattered around the globe and branches in nine countries, completed the Ahmed bin Ali Stadium. Tom Wilkinson (2021) in *The Architectural Review* blasted the design of this air-conditioned building wrapped by a cut-out façade inspired by traditional geometric patterns that leave the interior exposed to the elements; something "emblematic of the destructive tendencies of international sporting organisations," he wrote. Such criticism highlights once again the many contradictions of contemporary practice in facing the challenges of architectural globalisation. Sustainability often becomes an empty word when the problem is inherent in choosing a location like Qatar for this sport event. In the meantime, ornament makes its comeback as a strategy to regionalise the design but fails to become a constitutive element of a situated project able to find a synthesis

between climatic and formal instances. This not considering other issues, including labour conditions for migrant workers, which, despite some improvements, remains a concern (MacInnes 2022).

In the end, the involvement of foreign architects, and especially of the ones surveyed in this book, has been far greater and went beyond the design of sports facilities specific for football, thanks to the opportunities opened by the will of the Qatari government to heavily invest on the sports sector beyond the 2022 horizon. In 2018, Qatar hosted the FINA Swimming World Cup and the World Artistic Gymnastic Championship; in 2021, its first Formula One Grand Prix, while in 2030, it will host the Asian Games. This trend responds to multiple motivations, from the exercise of soft power—of which the ownership of the Paris Saint-German football club by Qatar Sports Investment and the sponsorship to Bayern Munich and AS Roma by Qatar Airways is not extraneous—to the need for diversifying the economy, boost tourism, and provide adequate infrastructures to local and international residents (Oxford Business Group 2019). Hence, it does not surprise that many of our surveyed architectural firms were involved in the country, although many projects did not eventually materialise. MEIS Architects unsuccessfully bid for several World Cup stadiums and other sports projects. In addition, Grimshaw, Populous, Sigge Architects, and RMJM also failed to complete similar projects. Among the successful ones, however, we can mention the Lekhwiya Sports Complex in Doha, completed in 2012 by Perkins Eastman. It has served since then as the stadium for the Qatari football team Al-Duhail SC and will be used as a training centre during the World Cup.

7.5 Conclusions

Drawing general conclusions from such a comprehensive and diverse set of experiences is challenging but not impossible. First, we need to acknowledge the role played by overseas design firms in emerging countries dealing with their first global megaevents, generally launched in periods of economic growth and increasing geopolitical visibility to cast their soft power and boost and diversify their economy. In such contexts, we find in action megafirms with great expertise in master-planning for large events as well as others (or sometimes the same) specialised in the design of sports venues. Expos, on the other hand, drive to the hosting cities a larger number of international architects, which usually and primarily compete for their national pavilions. As a matter of fact, however, and despite the glamour around these events, we find a limited involvement of superstar architects (Pritzker-winner and other very famed boutique firms).

A second point worth commenting on concerns the quality of the architecture delivered for these occasions. It spans from the very ordinary (the vast majority) to the rigorous and well-executed (GMP's projects, for instance) but rarely includes works that set the future paths of architecture or, even less ambitiously, that would deserve some room in the history of the discipline. That said, we can notice a difference, for example, between what was done in China in the early 2000s and the other cases.

In a context of real globalising frenzy, Beijing and Shanghai have attracted the most sought-after architects to compete for grand projects that, in some cases, did mark the decade. Even the Expo 2010, the largest and most expansive ever organised, could be considered a showcase of far richer and more significant architectural trends than usual. Nonetheless, the projects that really showed new directions in contemporary architecture were not directly built for these events, even though they materialised in that period. More critically, megaevents generally result in the construction of over-dimensioned facilities often in the form of large boxes of little value for the cities despite an increasing centrality given to the legacy project already in the bidding and planning phase. Furthermore, these buildings tend to be located in vast esplanades that can be barely considered enjoyable and well-functioning public spaces.

Finally, the organisation of Expos, the Olympic Games, and the FIFA World Cup leads to powerful conflicts between stakeholders, sometimes soothed by more or less violent repression, sometimes more freely expressed. Megaevents, in the vast majority of the cases, result in huge costs sustained by the public, significant gains for the private (organisers, real estate developers), little advantages for ordinary people, and great suffering for vulnerable communities, which generally represent the most affected ones, directly (evictions and displacements, for example) and indirectly (decrease in public resources that could have been otherwise used). As a consequence, while scholars debate about these megaevents' economic, social, and urban legacy, architects are constantly reminded by NGOs and the press about their responsibility for choosing (or not) to work in certain countries for certain events. Regretfully, their answer is generally silence.

References

Albo, Frank. 2017. *Astana: Architecture, Myth and Destiny*. Manitoba: Vidacom Publications.

Allmers, Swantje, and Wolfgang Maennig. 2009. Economic impacts of the FIFA soccer world cups in France 1998, Germany 2006, and outlook for South Africa 2010. *Eastern Economic Journal* 35 (4): 500–519.

Anacker, Shonin. 2004. Geographies of power in Nazarbayev's Astana. *Eurasian Geography and Economics* 45 (7): 515–533.

Armijo, Leslie Elliott. 2007. The BRICS countries (Brazil, Russia, India, and China) as analytical category: Mirage or insight. *Asian Perspective* 31 (4): 7–42.

Artlyst. 2012. Ai Weiwei i wish i never designed birds nest. *Artlyst*, Mar 9. https://artlyst.com/news/ai-weiwei-i-wish-i-never-designed-birds-nest/. Accessed 20 Sept 2022.

Associated Press. 2010. Did 2004 olympics spark greek financial crisis? *CNBC*, June 3. https://www.cnbc.com/id/37484301#:~:text=Greek%20Olympic%20officials%20insist%20the,Some%20financial%20experts%20agree. Accessed 7 Sept 2020.

Avila, Carlos Federico Domínguez, and João Paulo Santos Araujo. 2012. Brazil and other BRICS members: Convergences and divergences among emergent powers. *World Affairs: THe Journal of International Issues* 16 (1): 164–179.

Baade, Robert A., and Richard F. Dye. 1990. The impact of stadium and professional sports on metropolitan area development. *Development Growth and Change* 21 (2): 1–14.

Baade, Robert A., and Victor A. Matheson. 2004. The quest for the cup: Assessing the economic impact of the world cup. *Regional Studies* 38 (4): 343–354.

Barclay, Jonathan. 2009. Predicting the costs and benefits of mega-sporting events: Misjudgement of olympic proportions? *Economic Affairs* 29 (2): 62–66.

Bekus, Nelly. 2017. Ideological recycling of the socialist legacy. Reading townscapes of Minsk and Astana. *Europe-Asia Studies* 69 (5): 794–818.

Berlin, Peter. 2015. How the olympics rotted Greece. *Politico*, July 10. https://www.politico.eu/art icle/how-the-olympics-rotted-greece/. Accessed 25 Oct 2021.

Betsky, Aaron. 2022. The Shougang Olympics site is a prime example of reuse elegance. *Dezeen*, Feb 16. https://www.dezeen.com/2022/02/16/shougang-olympics-beijing-site-reuse-opinion/. Accessed 7 May 2022.

Bissenova, Alima. 2013. The master plan of Astana: Between the 'art of government' and the 'art of being global'. In *Ethnographies of the State in Central Asia. Performing Politics*, ed. Madeleine Reeves, Johan Rasanayagam and Judith Beyer, 127–148. Bloomington, IN: Indiana University Press.

Botti, Giaime. 2022. Changing narratives: China in western architecture media. In *China's International Communication and Relationship Building*, ed. Xiaoling Zhang and Corey Schultz. London: Routledge.

Braathen, Einar, Gilmar Mascarenhas, and Celin Sørbøe. 2015. Rio's ruinous mega-events. In *BRICS: An Anti-Capitalist Critique*, ed. Patrick Bond and Ana Garcia, 186–199. London: Pluto Press.

Branstetter, Lee, and Nicholas Lardy. 2008. China's embrace of globalisation. In *China's Great Economic Transformation*, ed. Loren Brandt and Thomas G. Rawski, 633–682. New York: Cambridge University Press.

Broudehoux, Anne-Marie. 2004. *The Making and Selling of Post-Mao Beijing*. London: Routledge.

Broudehoux, Anne-Marie. 2007. Delirious Beijing: Euphoria and despair in the olympic metropolis. In *Evil Paradises: Dreamworlds of Neoliberalism*, ed. Mike Davis and Daniel Monk, 87–101. New York, NY: New Press.

Broudehoux, Anne-Marie. 2010. Images of Power: Architectures of the Integrated Spectacle at the Beijing Olympics. *Journal of Architectural Education* 63 (2): 52–62.

Broudehoux, Anne-Marie. 2011. Images of Power: Architectures of Spectacle Integrated into the Beijing Olympics. *Novos Estudos* (89): 39–56.

Brownell, Susan. 2008. *Beijing's Games: What the Olympics Mean to China*. Portland, OR: Rowman and Littlefield.

Chen, Yawei. 2018. Not just 'better city, better life.' Creating sustainable urban legacy beyond world expo 2010 in Shanghai. In *Expositions et transformations urbaines = Expo Cities Urban Change*, 114–133. Paris: Bureau International des Expositions.

Clark, Tim. 2014. Exclusive AJ interview: Hadid & Schumacher. *Architects' Journal*, Sept 18. https://www.architectsjournal.co.uk/news/exclusive-aj-interview%e2%80%89hadid-schumacher. Accessed 30 Aug 2021.

Coates, Dennis, and Brad Humphreys. 2000. The stadium gambit and local economic development. *The Cato Review of Business and Government Regulation* 23 (2): 15–20.

Cornelissen, Scarlett. 2010. The geopolitics of global aspiration: Sport mega-events and emerging powers. *The International Journal of the History of Sport* 27 (16–18): 3008–3025.

Cornelissen, Scarlett. 2011. Mega event securitisation in a third world setting: Glocal processes and ramifications during the 2010 FIFA world cup. *Urban Studies* 48 (15): 3221–3240.

Costa Buranelli, F. 2018. Spheres of influence as negotiated hegemony—The case of Central Asia. *Geopolitics* 23 (2): 378–403.

Cull, Nicholas J. 2012. The legacy of the Shanghai expo and Chinese diplomacy. *Place Branding and Public Diplomacy* 8 (2): 99–101.

Deng, Ying, S.W. Poon, and E.H.W. Chan. 2016. Planning mega-event built legacies—A case of expo 2010. *Habitat International* 53: 163–177.

De Oliveira Sanchez, Renata Latuf, and Stephen Essex. 2017. Architecture and urban design: The shaping of Rio 2016 olympic legacies. In *Rio 2016: Olympic Myths, Hard Realities*, edited by Andrew Zimbalist, 97–120. Washington, DC: Brookings Institution Press

References

deLisle, Jacques. 2008. 'One world, different dreams': The contest to define the Beijing olympics. In *Owning the Olympics: Narratives of the New China*, ed. Monroe E. Price and Daniel Dayan, 17–66. Ann Arbor, MI: The University of Michigan Press.

Douglas, Bruce. 2015. Brazil officials evict families from homes ahead of 2016 olympic games. *The Guardian*, Oct 28. https://www.theguardian.com/world/2015/oct/28/brazil-officials-evicting-families-2016-olympic-games. Accessed 25 Oct 2021.

Dreyer, Jacob. 2012. Shanghai and the 2010 expo: Staging the city. In *Aspects of Urbanization in China: Shanghai, Hong Kong, Guangzhou*, ed. Gregory Bracken, 47–58. Amsterdam: Amsterdam University Press.

El-Khoury, Rodolphe, and Andrew Payne. 2010. *States of Architecture in the Twenty-first Century: New Directions from the Shanghai World Expo*. London: Thames & Hudson.

Fauve, Adrien. 2015. Global Astana: Nation branding as a legitimization tool for authoritarian regimes. *Central Asian Survey* 34 (1): 110–124.

Fixsen, Anna. 2014."Site unseen. *Architectural Record*, June 16. https://www.architecturalrecord.com/articles/5868-site-unseen. Accessed 30 Aug 2021.

Fonio, Chiara, and Giovanni Pisapia. 2015. Security, surveillance and geographical patterns at the 2010 FIFA world cup in Johannesburg. *The Geographical Journal* 181 (3): 242–248.

Frampton, Kenneth. 2020. *Modern Architecture: A Critical History*, 5th ed. London: Thames & Hudson.

Gaffney, Christopher. 2010. Mega-events and socio-spatial dynamics in Rio de Janeiro, 1919–2016. *Journal of Latin American Geography* 9 (1): 7–29.

Gan, Nectar. 2021. Xi's China is closing to the world. And it isn't just about borders. *CNN*, Nov 15. https://edition.cnn.com/2021/11/14/china/china-border-closure-inward-turn-dst-intl-hnk/index.html. Accessed 20 Oct 2022.

Gauthier, Aimee, and Annie Weinstock. 2010. Africa: Transforming paratransit into BRT. *Built Environment* 36 (3): 317–327.

Karam, Aly, and Margot Rubin. 2014. The 2010 world cup and its legacy in the Ellis Park precinct: Perceptions of Local residents. In *Changing Space, Changing City: Johannesburg after Apartheid*, ed. Philip Harrison, Graeme Gotz, Alison Todes, and Chris Wray, 437–442. Johannesburg: Wits University Press.

King, Anthony D. 2004. *Spaces of Global Cultures: Architecture, Urbanism, Identity*. London, New York: Routledge.

Köppen, Bernhard. 2013. The production of a new eurasian capital on the Kazakh Steppe: Architecture, urban design, and identity in Astana. *Nationalities Papers* 41 (4): 590–605.

Livingstone, Charlotte. 2014. Armed peace: militarization of Rio de Janeiro's favelas for the world cup. *Anthropology Today* 30 (4): 19–23.

Lovell, Julia. 2009. Prologue: Beijing 2008—The mixed messages of contemporary Chinese nationalism. In *Beijing 2008: Preparing for Glory. Chinese Challenge in the 'Chinese Century'*, ed. J.A. Mangan and Jinxia Dong, 8–28. Abingdon: Routledge.

MacInnes, Paul. 2022. Human rights abuses in Qatar 'persist on significant scale', says Amnesty report. *The Guardian*, Oct 20. https://www.theguardian.com/football/2022/oct/20/fifa-world-cup-human-rights-abuses-qatar-amnesty-international. Accessed 20 Oct 2022.

Maennig, Wolfgang, and Florian Schwarthoff. 2011. Stadiums and regional economic development: International experience and the plans of Durban, South Africa. *Journal of Architectural and Planning Research* 28 (1): 1–16.

Mangan, J.A. 2009. Preface: Geopolitical games: Beijing 2008. In *Beijing 2008: Preparing for Glory. Chinese Challenge in the 'Chinese Century'*, 1–7. Abingdon: Routledge.

Marg, Volkwin. 2010. *From Cape Town to Brasília. New Stadiums by GMP = Neue Stadien der Architekten von Gerkan, Marg und Partner*. Munich: Prestel Verlag.

Marvin, Carolyn. 2008. 'All under heaven'—Megaspace in Beijing. In *Owning the Olympics: Narratives of the New China*, ed. Monroe E. Price and Daniel Dayan, 229–259. Ann Arbor, MI: The University of Michigan Press.

Mierzejewski, Dominik. 2022. *Is China about to close the door?* SOAS China Institute, 11 May. https://blogs.soas.ac.uk/china-institute/2022/05/11/is-china-about-to-close-the-door/. Accessed 20 Oct 2022.

Østbø Haugen, Heidi. 2008. 'A very natural choice': The construction of Beijing as an olympic city during the bid period. In *Owning the Olympics: Narratives of the New China*, ed. Monroe E. Price and Daniel Dayan, 145–162. Ann Arbor, MI: The University of Michigan Press.

Oxford Business Group. 2019. The report: Qatar 2019.

Parker, Ian. 2012. High rise. A bold Danish architect Charms his way to the top. *The New Yorker*, Sept 10.

Pattisson, Pete. 2022. Allegations of worker exploitation at 'world's greatest show' in Dubai. *The Guardian*, Feb 2. https://www.theguardian.com/global-development/2022/feb/02/allegations-of-worker-exploitation-at-worlds-greatest-show-expo-2020-dubai. Accessed 20 June 2022.

Ren, Xuefei. 2008. Architecture as branding: Mega project developments in Beijing. *Built Environment* 34 (4): 517–531.

Ren, Xuefei. 2011. *Building Globalization: Transnational Architecture Production in Urban China*. Chicago: The University of Chicago Press.

Rezende, Vera, and Geronimo Leitão. 2014. Lucio Costa e o plano piloto para a barra da Tijuca: a vida é mais rica e mais selvagem que os planos urbanísticos. *URBANA: Revista Eletrônica do Centro Interdisciplinar de Estudos sobre a Cidade* 6 (1): 673–693.

Riach, James. 2014. Zaha Hadid defends Qatar world cup role following migrant worker deaths. *The Guardian*, Feb 25. https://www.theguardian.com/world/2014/feb/25/zaha-hadid-qatar-world-cup-migrant-worker-deaths. Accessed 30 Aug 2021.

Salvati, Luca, and Marco Zitti. 2017. Sprawl and mega-events: Economic growth and recent urban expansion in a city losing its competitive edge (Athens, Greece). *Urbani Izziv* 28 (2): 110–121.

Seldin, Claudia, and Isabela Ledo. 2014. Preparations for the sports mega-events in brazil and the popular protests of 2013. In *Reading the Architecture of the Underprivileged Classes*, ed. Nnamdi Elleh, 200–212. Abingdon: Routledge.

Sennes, Ricardo. 2014. *Will Brazil get what it expects from the world cup?* Atlantic Council.

Shelekpayev, Nari. 2020. Whose master plan? Kisho Kurokawa and 'capital planning' in post-soviet Astana, 1995–2000. *Planning Perspectives* 35 (3): 505–523.

Spiegel. 2008. Herzog on building Beijing's olympic stadium. 'Only an idiot would have said no'. *Spiegel*, July 30. https://www.spiegel.de/international/world/herzog-on-building-beijing-s-olympic-stadium-only-an-idiot-would-have-said-no-a-569011.html. Accessed 20 Nov 2021.

Steinbrink, Malte, Christoph Haferburg, and Astrid Ley. 2011. Festivalisation and urban renewal in the global south: Socio-spatial consequences of the 2010 FIFA world cup. *South African Geographical Journal* 93 (1): 15–28.

Sterken, Elmer. 2006. Growth impact of major sporting events. *European Sport Management Quarterly* 6 (4): 375–389.

Stewart, Dan. 2008. RMJM blasts olympic boycott and defends work in China. *Building*, Mar 5. https://www.building.co.uk/news/rmjm-blasts-olympic-boycott-and-defends-work-in-china/3107920.article. Accessed 6 Sept 2022.

Szymanski, Stefan. 2002. The economic impact of the world cup. *World Economics* 3 (1): 169–177.

Szymanski, Stefan. 2011. About winning: The political economy of awarding the world cup and the olympic games. *The SAIS Review of International Affairs* 31 (1): 87–97.

Tayob, Shaheed. 2012. The 2010 world cup in South Africa: A millennial capitalist moment. *Journal of Southern African Studies* 38 (3): 717–736.

Wainwright, Oliver. 2017. 'Norman said the president wants a pyramid': How starchitects built Astana. *The Guardian*, Oct 17.

Wilkinson, Tom. 2021. Ahmed Bin Ali Stadium in Al Rayyan, Qatar by Pattern Design. *The Architectural Review*. https://www.architectural-review.com/essays/typology/ahmed-bin-ali-stadium-in-al-rayyan-qatar-by-pattern-design. Accessed 30 Oct 2021.

References

Winston, Anna. 2015. Foster + partners wins Lusail stadium job for Qatar 2022 FIFA world cup. *Dezeen*, Mar 9. https://www.dezeen.com/2015/03/09/foster-partners-lusail-stadium-qatar-2022-fifa-world-cup-football/. Accessed 25 Oct 2021.

Xue, Charlie Q.L. 2006. *Building a Revolution: Chinese Architecture Since 1980*. Hong Kong: Hong Kong University Press.

Xue, Charlie Q.L. 2019. Introduction: Grand theaters and city branding—Boosting Chinese cities. In *Grand Theater Urbanism: Chinese Cities in the 21st Century*, ed. by Charlie Q.L. Xue, v–xxix. Singapore: Springer.

Zimbalist, Andrew. 2015. *Circus Maximus: The Economic Gamble Behind Hosting the Olympics and the World Cup*. Washington, DC: Brookings Institution Press.

Zimbalist, Andrew. 2017. Introduction: 'Welcome to hell.' In *Rio 2016: Olympic Myths, Hard Realities*, ed. Andrew Zimbalist, 1–12. Washington, DC: Brookings Institution Press.

Chapter 8
Dwelling: New Forms of Housing, New Forms of City

With the rise of the "Modern Movement" and its historiography, the problem of housing assumed a central space in the disciplinary discourse and the historiographic narrative. When a general history approaches the 'heroic' period of modernism, from the mid-1910s to the 1930s and then the post-World War II, the sequence of exemplary projects commonly dealt with is consistent. It spans from canonic houses like the Villa Savoye by Le Corbusier (1928–31) in Poissy and the Tugendhat House (1929–30) in Brno by Mies van der Rohe to Walter Gropius' Bauhaus masters' houses in Dessau (1925–26), to larger-scale public housing developments like Ernst May's *Siedlungen* in Frankfurt (1927–31). And the post-War adds more material, from Le Corbusier's Unité d'Habitation (1945–52) in Marseille to the architecture of Alison and Peter Smithson. Only with investments in public housing fading from the 1970s and the "death" of modern architecture (Jencks 2002, 9), historiographic narratives have effectively centred on a wider variety of typologies: more cultural buildings, more office buildings and towers, more railways stations and airports. Still, across the world, (mass) housing—in many cases, the lack of it or its poor quality—is the problem pushing architects to find innovative solutions to provide everyone with something more than a decent shelter.

'Housing deficit' has been a keyword for decades during the twentieth century, and today it still represents a crucial problem. It has been calculated that by 2030, three billion people will need access to adequate housing, meaning a need for 96,000 new houses per day worldwide (Un-Habitat n.d.). On the other hand, for architects, the design of a dwelling, whether in the form of a simple family house or a luxury villa, a block of social housing or a high-end residential tower, continues to be a typical and relevant source of work. And this is true for different types of architectural practice, from the solo architect dealing with a simple suburban house to the archistar working for the weekend house of a wealthy client, from mid-size firms involved in public housing to megapractices dealing with a high-rise project.

This chapter, therefore, focuses on the trends and projects of residential architecture. To do so, we start from the emerging typology of the residential supertall to then analyse the housing market in China, exposing the criticalities of its real estate

© The Author(s), under exclusive license to Springer Nature Singapore Pte Ltd. 2023 331
G. Botti, *Designing Emerging Markets*,
https://doi.org/10.1007/978-981-99-1552-1_8

332 8 Dwelling: New Forms of Housing, New Forms of City

sector and the role of foreign architects in providing modern, upscale dwellings to the burgeoning Chinese middle class. After that, we will expand our overview to other regions to better understand how international architects shape the upper tier of the global housing market with deluxe condominiums and towers from South-East Asia to Latin America. Investigating villa communities will add more to this, while we will also highlight how some of the most interesting residential buildings of the last decades designed in the emerging markets have targeted the upper middle class rather than its lower end. The last two parts of the present chapter will then encompass the broader urban scale beyond individual buildings or the anti-urban enclosed residential compounds that constitute the most diffused form of housing in many countries. The study of mixed-use developments will allow us to explore portions of the city where the residential programme becomes just one of the many components of a more complex urban system. At the same time, the focus on new towns will bring us into some of the most daring and expansive enterprises of the last few decades.

8.1 Supertall Residential: Living the Sky from Australia to New York

Despite the loss of most of its record-breaking statistics related to skyscrapers, New York can still boast the presence of the highest residential supertall buildings: Central Park Tower (2010–20, 472 m) designed by Adrian Smith + Gordon Gill Architecture, 111 West 57th Street Tower (2012–21, 435 m) by SHoP Architects, 432 Park Avenue (2011–15, 425 m; Fig. 8.1) by Raphael Viñoly, and One57 Tower (2009–14, 306 m) by Christian de Portzamparc. These and other projects are characterised by extreme slenderness and very high Floor Area Ratios (FAR). They have been possible thanks to a mechanism—the Transferable Development Rights—that allowed developers to buy unexploited air space in the surroundings and transfer it to the project. These buildings, with their "skinny," "pencil-like" silhouettes, have quickly changed the skyline of Manhattan, and now even Brooklyn, with ShoP Architects' 324-m Brooklyn Tower currently near completion. In addition, they have also, once again, somehow revealed the extreme inequalities existing in cities where, while a multitude struggles to find decent and affordable accommodation, few can buy apartments sold for dozens or even hundreds of millions of US dollars (Wainwright 2019). It has been calculated, for example, that a median apartment in 432 Park Avenue costs approximately 290 times the median annual salary on Manhattan (Radović 2020). But ethical concerns are not the only ones if it is true, with some irony, that design and construction issues—ominous cracking noises, wind sway, flooding, and electrical explosions (Chen 2021)—are making the owners of some of these apartments regret the purchase. Still, New York is not the only place where residential supertalls concentrate. The first examples were in fact built in Gold Coast and Melbourne, Australia, in the years preceding the 2007 financial crisis, to later expand in cities

8.1 Supertall Residential: Living the Sky from Australia to New York

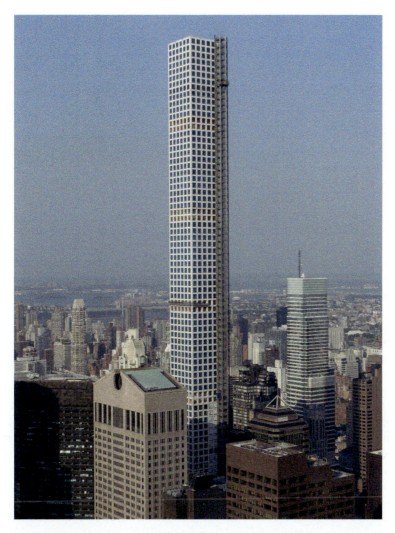

Fig. 8.1 The 432 Park Avenue supertall residential by Raphael Viñoly in Manhattan, New York City, NY. Photograph by Citizen59, distributed under a CC BY 3.0, available at https://commons.wikimedia.org/wiki/File:432ParkAvenueJuly2015.JPG

like Dubai, Abu Dhabi, Moscow, Busan, and finally, New York. Thus, supertall residential buildings are a product of the twenty-first century, and even if their number is growing—for instance, there are a few under construction in Mumbai—, by 2017, only fourteen were built (Radović 2020). All in all, residential supertalls appear as the most extreme representation of the "secession of the elites" into the sky (Graham 2015).

Unlike other cities, in Dubai, 52% of the high-rise stock is purely residential (CTBUH 2022). This reflects the real estate frenzy of the early 2000s and, in some cases, a trend typical of the new century: the rise of the supertall residential building.

334 8 Dwelling: New Forms of Housing, New Forms of City

Overall, the quality of residential high-rises in Dubai (and the rest of the region) spans from the trivial to the 'elegant & banal,' up to the weird, while bold proposals are missing. Among the surveyed firms, Atkins stands out for its extended and anonymous portfolio of residential towers. The list is long and it is worth looking at its chronology: 21st Century Tower (2001–03, 86,000 m^2, 269 m), Millennium Tower (2004–06, 99,8000 m^2, 285 m), Le Reve (2004–06, 75,000 m^2, 210 m), Goldcrest Views 1 & 2 (2004–07, 57,231 m^2, 146 m and 159 m), Marina Mansions (2005–07, 136 m), The Address Downtown (2004–08, 302 m; Fig. 8.2; also Sect. 5.2), Sky Gardens (2005–08, 160 m), Executive Tower L (2005–09, 170 m), Global Lake View (2004–09, 38,000 m^2, 136 m), Sama Tower (2005–10, 93,500 m^2, 193 m, include office), Pier 8 (2006-on hold, 160 m), Windsor Manor Tower (2007–11, 102 m), Bay's Edge (2014–17), and the Al Abtoor City development (2013–20), where we find the supertall Amna and Noora Towers (307 m) and the lower Meera Towers (213 m). As visible, most of these projects began before 2007. As a matter of fact, Atkins' residential portfolio in the years after the Great Recession did not enlarge substantially, while the commissions for hotels recovered faster. We can also note with The Address Downtown the appearance of one of the first residential supertalls of Dubai before 2007, and then two new ones more recently, after a decade-long break (either considering the start or the end of both projects).

Looking at the work of NORR, too, we can find several unremarkable projects for residential towers, again concentrated in a similar chronology. In the 2000s, the Canadian architecture and engineering megafirm completed Marina Terrace (2003–06, 183 m), Marina Tower (2004–06, 145 m), Al Fattan Marine Towers (2003–06, 245 and 245 m), and Burj Lofts (2005–09, 134, 134 and 119 m), while in the second half of the 2010s Vida Residence (2014–19, 238 m), Creek Gate Towers (2020, 123 and 95 m), and the currently near completion Downtown Views II (266, 244 and 217 m). As most of the former designs stand in the category of the trivial, so they do Leo A Daly's Deira Twin Towers (1998, 102 and 102 m), RMJM's Marina Heights Tower (2006, 208 m), Emaar 8 Boulevard Walk Downtown Dubai (2008, 61,750 m2), Silverene Dubai Marina (2011, 117,600 m^2, 150 and 120 m), and West Wharf at Business Bay (2006–14). To these, we can add Woods Bagot's The Residences Downtown Dubai (2003–07, 140, 121, 115, 86 and 76 m), and the more recent Forte Towers (2015–21, 215 and 183 m), Tower 42 and 52 (2017–20, 198 and 198 m), all designed by Nikken Sekkei. Adrian Smith + Gordon Gill's Burj Vista—The Grand Boulevard (2013–18; Fig. 8.3) adds little to the skyline of the area around the Burj Khalifa, while nearby SOM-designed The Address Sky View (2013–19, 264 and 235 m), composed of two elliptical towers connected by an asymmetrical sky bridge (Fig. 8.4), displays the ongoing trend in formally hybrid typologies of interconnected buildings. More elegant than most of the projects mentioned so far, but by now not particularly original, is SOM's spiralling Cayan Tower (2005–13, 111,000 m^2, 307 m), an example of a 'signature' residential supertall. Another neat supertall, combining office space on the lower floors and residences on top, is Foster + Partners' Index Tower (2005–11, 51,407 m^2, 326 m; Sect. 5.3), a skyscraper with a tapering profile and visible concrete fins raising like buttresses along the façade. Similar in terms of design quality, but again not original at all, is Pelli Clarke Pelli's City Tower One (171,900 m^2, 358 m), a supertall currently under construction with a New York

Fig. 8.2 The Address Downtown by Atkins in Downtown Dubai. Photograph by Giaime Botti, distributed under a CC BY 4.0

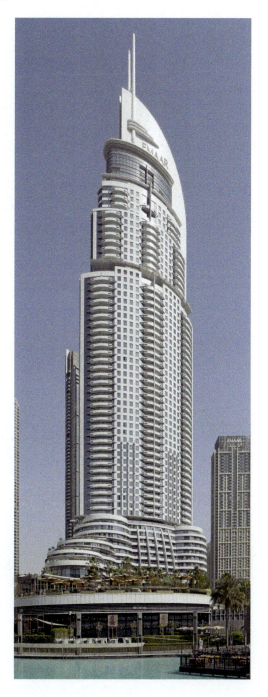

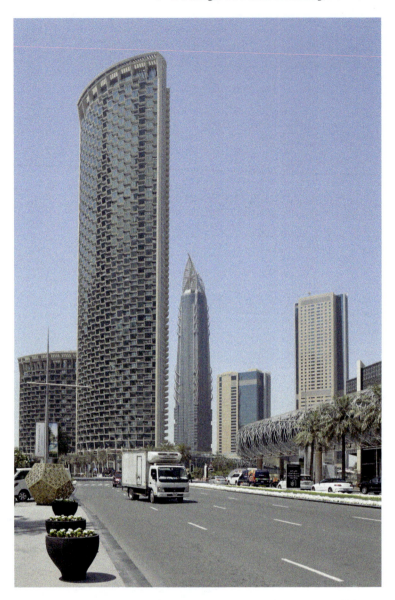

Fig. 8.3 The Burj Vista—The Grand Boulevard by Adrian Smith + Gordon Gill in Downtown Dubai. Photograph by Giaime Botti, distributed under a CC BY 4.0

8.1 Supertall Residential: Living the Sky from Australia to New York

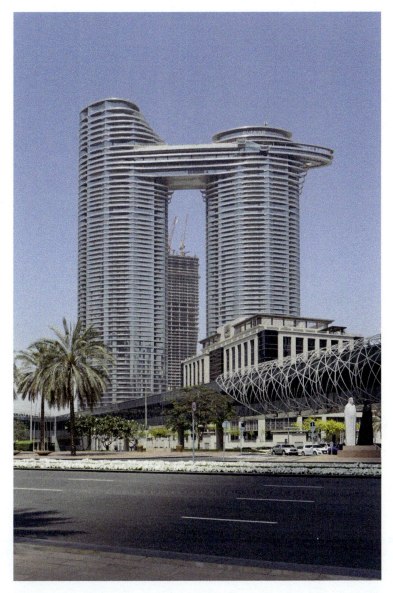

Fig. 8.4 The Address Sky View by SOM in Downtown Dubai. Photograph by Giaime Botti, distributed under a CC BY 4.0

Art Deco-inspired aesthetic of clear geometries, slight setbacks, and an emphasis on vertical lines. The residential supertalls of Abu Dhabi—namely The Landmark by Pelli Clarke Pelli Architects and the Burj Mohammed Bin Rashid at WTC Souk by Foster and Partners—and several complexes, including residential skyscrapers starting from the Gate Shams by Arquitectonica have already been presented in Sect. 5.3, allowing us now to focus on other regions.

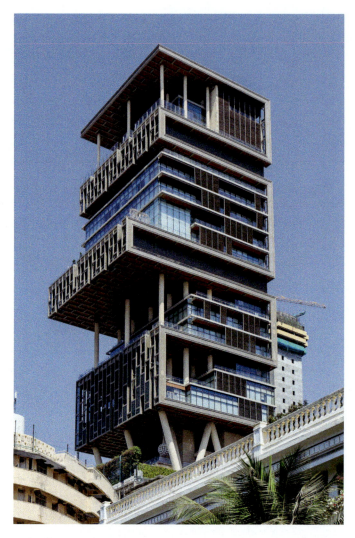

Fig. 8.5 Antilia villa-tower by Perkins & Will and Hirsch Bedner Associates, Mumbai. Photograph by A. Savin, distributed under a Free Art License, available at https://commons.wikimedia.org/wiki/File:Mumbai_03-2016_19_Antilia_Tower.jpg

In India, luxury high-rise residential developments are diffused in Mumbai, where they account for 90% of the 150+ metres buildings (CTBUH 2021). Even private villas for the super-riches are evolving into high-rises. The most expansive, for many outrageous, house in the world (worth between U$ one and two billion) was completed in 2010 along Altamount Road, also known as the Billionaires Row of the Indian financial capital. Designed by Perkins & Will and Hirsch Bedner Associates (not included in our survey), Antilia is a 27-storey, 173-m-tall house covering an area of 37,000 m^2 (Fig. 8.5). Beyond any moral consideration, one of the most interesting

aspects of the design is its 'cumulative' form with different multi-storey compounds stacked one on top of the other, somehow in the logic of MVRDV's Dutch Pavilion at the Expo 2000 Hannover. In addition, several high-rise apartment buildings have been recently completed. In 2020, opened Pei, Cobb, Freed & Partners' World One (2009–20, 422,000 m^2), a complex featuring three organic-shaped slender residential towers of 222, 277 and 280 m developed according to a master plan which also included an office building whose fate is still uncertain. Callison RTKL has also been active in India, with several residential and mixed-use projects, including some large residential high-end estates in Mumbai. The 70- and 85-storey buildings of the Sky Towers, as well as the office and residential Alta Monte, are currently under construction, while the six interconnected towers (respectively 239, 222, 206, 200, 187 and 180 m) of the Crescent Bay (2012–19) have been completed. We can add more projects to these, like the Lohana Tower and the Powai Lake community, whose fate is unknown. In China, on the other hand, while we find a large concentration of mixed-use supertalls, we do not find, as of today, any residential supertalls. Overall, skyscrapers (150+ m) are predominantly for offices or mixed-use rather than mono-functional residential. Indeed, this does not mean that there is a lack of high-rise residential buildings; on the contrary, as we will see in the next section, the most diffused typology of housing developments usually includes several towers, often about 30 stories high.

8.2 Concrete or Terracotta Dragon? China's Real Estate

About a decade ago, Thomas J. Campanella's (2008) book *The Concrete Dragon* explained the Chinese phenomenal urbanisation process through a rich set of astonishing data. In quantitative terms, what China was experiencing had no precedents in history or comparisons in the world. In the 1970s, there were about 200 cities in the country; by the 2000s, their number had increased to 700, 102 of which with more than one million inhabitants (Campanella 2008, 14). Many more data could be cited from this precious book, but due to the time that has passed since its publication, we prefer to look at the most updated version of the *China Statistical Yearbook*. Between 2005 and 2019, a total of 18.89 billion square metres of residential space was built in China (Fig. 8.6) at an average pace of 1.18 billion square metres per year (National Bureau of Statistics of China 2021, 19–9). The construction of new residential buildings peaked in 2011, with 1.47 billion square metres, and in 2019, with 1.67, and saw a minimum in 2015, with 1.06. To give perspective to the figures, the whole housing stock in the USA in 2005 accounted for 20.31 billion square metres (Campanella 2008, 303). Such quantities can also be translated into 98,545,742 apartments put on the market during these sixteen years, an average of 6,159,108 per year (National Bureau of Statistics of China 2021, 16–6).

Given these numbers, we easily understand that the contribution of even the most successful architecture firms completing some million square metres of residential

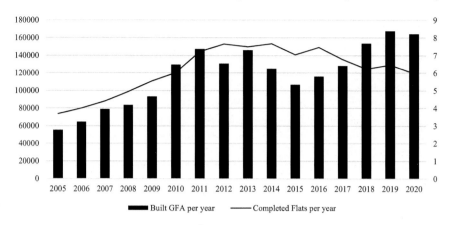

Fig. 8.6 Residential built GFA (10,000 m^2; y-axis, values on the left) and number of completed apartments (in millions; y-axis, values on the right) per year in China, 2005–20. Copyright Giaime Botti

projects in the country may be considered irrelevant. Still, we will try to understand the importance of their role and highlight some relevant works. Before doing so, however, we continue investigating the real estate sector. As a matter of fact, while official statistics calculate the weight of the construction sector at about 7% of Chinese GDP, other economists have estimated that, including all direct and indirect inputs, it accounted for 23–24% (in 2016 and 2018), to which a further 3% for import contents could be added (Tilton et al. 2021; Rogoff and Yang 2021). If China is considered the factory of the world, another piece of data could make us change this perception: in 2019, 64% of the total industrial output was due to the construction sector, while manufacturing accounted only for 15.5% (National Bureau of Statistics of China 2021, 26–12). Thus, while this contributed to the extraordinary growth of the last decades, it also resulted in an element of fragility for the economy. For over a decade, recurring alarms about a real estate bubble burst's imminence have multiplied. In 2013, which actually marked the first moment of slow down, warnings about an upcoming bubble were common in the international press (Jericho 2014; Rapoza 2014).

Although most apocalyptic views have been proved wrong so far, significant concerns remain. With housing prices growing faster than incomes (17% against 11% annually), high vacancy rates (around 22% in 2013), and a high rate of return to capital (about 20%), trends appear unsustainable in the long run, even if they can be explained by the transition phase of the Chinese economy (Chen and Wen 2017). In the end, while "China looks like a classic housing bubble," such a scenario is far from granted due to a multiplicity of factors, spanning from the long-term investment perspective of Chinese homebuyers, who would not sell with temporary declining prices, to the potential role of the Government in reducing the supply. Of course, all this will have a significant social cost (Glaeser et al. 2017). In this uncertain scenario, financial problems of developers like Evergrande, the second largest in China with

liabilities for U$300 billion (something corresponding to more than one percentage point of Chinese GDP), Sunshine 100, Shimao, Sunac China Holdings, and many other local actors loom on the horizon (Mathis and Alfaro 2021; Hsu 2022). Thus, although the dragon has been erected in concrete, it seems more and more like a terracotta one.

Moving now to the strictly architectural dimension, in this section, we deal with different residential typologies and several projects that are not skyscrapers, but mostly high- and mid-rise developments, usually formed by several buildings. Indeed, a sharp distinction with the previous section, if not for supertalls, is rather difficult as many developments often include mid-rise blocks, high-rise blocks, and even buildings which can be considered skyscrapers, as the very definition of a tall building is not precise and varies according to its context according to the Council on Tall Buildings and Urban Habitat. A certain ambiguity, therefore, needs to be excused. At the same time, every pretension of completeness should be abandoned, given the number of projects to be considered. The result, consequently, is a panoramic view in which we highlight the role of certain design firms and developers, the triviality of many projects as well as the quality of few.

Since the Reform Era, the Chinese housing market has undergone radical and impressive transformations. Housing became a commodity from a state provision, and the real estate sector was transformed into one of the main engines behind the Chinese economic boom. Following the Soviet model adapted during the 1950s, urban residential compounds were organised in parallel blocks (*hanglieshi*) north–south facing or sometimes perimetral blocks (Soviet *kvartal* typology) with non-residential functions in the middle of these large urban blocks (400–600 m per side). Generally, this configuration resulted in a work-unit (*danwei*), i.e., a settlement comprehending factory plants, workers' housing, and communal services spanning from the canteen to community hall, from kindergartens and schools to clinics and libraries (Rowe et al. 2016, 55–56). If high-rise residential were rare, not to say exceptional, before 1978, by 1981, there were 416 high-rise housing complexes built, mainly in Beijing. By then, it was also becoming common in new settlements a mix of high-rise (now of different floorplans, including Y-shaped, cross-shaped, and frog-shaped) and mid-rise slab blocks (Rowe et al. 2016, 59–62). Today, China's dominant form of housing settlements is that of a mixed-typology (high-rise, slabs, and villas, too) superblock (usually about 400 m per side), which originates a coarse-grain urban fabric with non-porous boundaries being organised as a gated community (Rowe et al. 2016, 120).

In this context, since the early 2000s, overseas design firms have found room to operate for real estate developers willing to introduce higher standards in housing design. This story is, therefore, as much a story of architects and architecture as one of the real estate developers, their boom, and, sometimes, their bust. Among the many, we can mention Sunshine 100, on which we will briefly focus, Vanke, well-known for its high-quality developments, and SOHO China. Established in 1995 by Pan Shiyi and Zhang Xin, the latter emerged as one the most innovative actors in the Chinese real estate market. SOHO, which means "Small Office, Home Office,"

quickly became synonymous with a high-quality, well-marketed workplace architecture for companies and hybrid home-office solutions for the younger, emerging creative class in signature buildings. Its success story began in the late 1990s with the launch of the SOHO New Town in Beijing. For the first time, fully furnished apartments with colourful façades and artworks displayed in the public space were promoted through a newspaper advertisement campaign, the first of this type in China (Ren 2011, 71–72; Sect. 10.4 for the Commune by the Great Wall). Still, SOHO China was not the only real estate developer relying on foreign architects to place their products.

In the early 2000s, Sunshine 100 China, a real estate company established in Guanxi in 1992, contracted Denton Corker Marshall for a few housing projects in different cities. In Beijing (2000–04), the development consisted of five towers of different heights (from 20 to 34 storeys) and linking blocks (eight to eleven storeys), characterised by façades in bright red, yellow, and white. Similar colours were adopted in Shenyang (2004–08) for a development of over 440,000 m^2 divided into two phases, with towers and slabs. In Nanning (2005–08), instead, it took the form of residential buildings featuring facades with irregularly shaped openings for the interior balconies or three-storey square frames, while the Euro-City Plaza (2001–07, 210,000 m^2) consisted of a mixed-use complex with commercial and office podium and residential blocks. In Changsha (2003–05), another large development, primarily of slab types, was also completed in that period, while in Chongqing, by 2010, about 690,000 m^2 of the International New Town mixed-use development were built. The same year was also finalised the Yantai City Plaza, 552 apartments in two towers rising on a commercial podium. The Australian firm was, indeed, very active in that period, with several more projects that we cannot mention here (some of which are of unclear status, however), not all of them only for Sunshine 100 China. Indeed, in Beijing, one of Denton Corker Marshall's first projects was a luxury condominium located nearby Chaoyang Park in the capital's expansive CBD. The Victoria Gardens consisted of a sinuous courtyard block with over two hundred luxury apartments and some penthouses, ranging from 125 to 279 m^2. A typical example of a real estate product directed to the growing Chinese upper-middle class and the well-off expat community, the same clientele targeted, for instance, by GBBN-designed Vanke Park 5 (125,880 m^2) also in Chaoyang. The complex is formed by three L-shaped blocks aligned along a major road in Beijing, thus creating a monumental front and three internal semi-enclosed courtyards.

During this decade, it was easy to find in the Chinese capital several extensive upscale residential developments targeting the same clientele. In Dongzhimen, another area favoured by expats, Baumschlager Eberle Architekten completed two of the four developments of Moma: 600,000 m^2 over an area of 120,000 (in total), immersed in a large park with a lake. The two parts designed by the German firm consisted of two residential towers—Moma Beijing (2002–05)—with advanced energy optimisation features for the time, and the 388 apartments of the PopMoma (2001–07), a three-tower complex raising on a continuous four-storey base accommodating shops and office space. The PopMoma houses slightly smaller apartments, targeting a younger clientele, and features a highly homogenous and rigorous grid

façade in copper tones. In the same period, GMP started one of its first projects in China, the Xinzhao Residential Area (2000–04, 235,000 m^2), a large residential compound with nine towers located along a central axis and linear and L-shaped slabs organised in the four corners of the megaplot.

In Shanghai, Top of City (2005, 245,000 m^2; Fig. 8.7) by B+H is a typical upscale gated community with a lavishly landscaped park with two artificial lakes in the Chinese-garden fashion and high-rise buildings with large panoramic windows and glazed balconies. As often happens, the aesthetic proposal is uncertain, with curved forms, abundant glass surfaces, and a certain outmoded touch in the volumetric games and the coating materials. On the other hand, more consistent is the Shama Century Park (300,000 m2) in Lijiazhui District by Arquitectonica, a large complex composed of several curving slabs featuring façades with coloured balconies and a system of frames that create three-dimensional abstract compositions. Another example along a similar line is AXS Satow's Guangzhou Science City Science and Technology Apartment (2010, 105,400 m^2), which displays a contemporary language of tropical minimalism, with light shading devices and canopies on façades and roofs.

On the opposite side of this spectrum, Robert A. M. Stern Architects (RAMSA) has designed a series of successful residential projects in several Chinese cities over the last few years. They are all large-scale (from 100,000 to 800,000 m^2), high-rise, and quite old-fashioned in terms of the aesthetic proposal. Heart of the Lake in Xiamen is a 185,800 m^2 development completed in 2018. It is a paradoxical community at the tip of a peninsula, where we find villas and apartment blocks in a

Fig. 8.7 Top of City residential compound by B+H in Jing'an District, Shanghai. Photograph by Giaime Botti, distributed under a CC BY 4.0

Californian neocolonial style and scattered towers looking like they were extruded from the lower blocks. Other projects mix dense clusters of towers, usually of a generic Manhattan Art Deco inspiration, with lower buildings of similar aesthetic (Dalian AVIC International Square, 2016, 352,000 m^2; Metropolis 79 Hangzhou; Metropolitan Chongqing, 102,000 m^2) and even a crescent and an arcaded ground floor (Emerald Riverside in Shanghai). The most impressive development, in terms of size, is AVIC Jinjiang Uptown, an 825,000-square-metre gated community with high, mid, and low-rise buildings with a wide pedestrian boulevard with shops and two crescent streets. Indeed, while we will later discuss the typology of the villa and the increasingly diffused typology of single-family-houses gated communities, we should notice that many residential communities feature a mix of typologies with villas, single-family houses, or semi-dethatched ones co-existing with mid-rise and even high-rise buildings. To the examples by RAMSA, we can add the Vanke Paradiso (2015, 600,000 m^2) in Guangzhou by RATIO SMDP, a community developed along a small artificial lake, with modern-looking towers and dark-red bricks villas with pitched roofs and arched entrance gates. Niles Bolton Associates' Jade Valley in Chongqing re-proposed a mix of townhouses and garden apartments in a 21-hectare landscaped site, all with a Loire-Valley-inspired aesthetic of bricks and pitched roofs that actually appears very suburban American in its confusion. On the contrary, a similar mix of high-rises and villas, but with an overtly modern aesthetic, was designed by RMJM in two phases (2007 for the second phase, 60,000 + 47,000 m^2) for the Mont Orchid Shekou Riverlet community in Suzhou.

Most of these and other developments materialise the typical form of the contemporary Chinese city organised in gated communities of high-rise and slab buildings standing in a rather generic, sometimes greened, void (Fig. 8.8). Indeed, since the early 2000s and until today, we find several more of these projects, whose quality and architectural expression broadly vary. Vast developments of towers or slabs that we mapped include Studio On Site's Crystal Town housing (2004) in Chengdu and Vanke Castle (2006, 100 he site) in Wuxi. Other similarly unremarkable projects are Heerim Architects and Planners' Ziwei Ideal Garden City Master Plan (2001–03) in Xi'an, STX Residential Cluster Master Plan (2007–12, 1,730,000 m^2) in Dalian, and Quingdao International City. More high-end developments include Huafa Century City (470,000 m^2) in Zhuhai, and Zhongda City Luxury Residences in Xi'an, both by WATG, and Callison RTKL's Bayview/Kingold Pearl River Residences in Guangzhou, composed of five 40-storey towers facing the Pearl River. In addition, we can also name some more unique projects that provide examples of a very differentiated market in which higher standards are met by designs of more formal and technological complexity.

Excellent environmental performances and a high-tech aesthetic characterise the Nanjing Landsea Ecohouse (2012) by BDP, but also the recently completed Ningbo Gateway (2009–20, 80,000 m^2; Fig. 8.9) by RSH+P. Located in the new CBD of Ningbo, not far from the Urban Planning Exhibition Centre (Sect. 6.1), it consists of two 152-m towers composed of a concrete core and two wings of different heights, with a recognisable profile and the typical aesthetic developed by Richard Rogers of visible external diagonal bracings and flaming red steel balconies in the corners.

8.2 Concrete or Terracotta Dragon? China's Real Estate

Fig. 8.8 A typical high-rise gated community along Suzhou Creek in Putuo District, Shanghai. Photograph by Giaime Botti, distributed under a CC BY 4.0

Excellent care for details, materials, and spaces marks two 'signature' residential projects in Hangzhou by David Chipperfield. The first one was the Ninetree Village (2004–08, 235,000 m^2), a community of twelve apartment buildings freely scattered in a hilly area covered by a bamboo forest. The interiors, of different layouts, reach 450 m^2 and are characterised by flowing spaces and solid cores for the bedrooms and the auxiliary functions. A skin of wooden screens of different densities wraps the volumes. A second project with a similar level of refinement is the Xixi Wetland Estate (2007–15, 11,800 m^2). Here, several two-storey dark stone blocks are more rigidly organised within the water-dominated landscape of the wetlands and its vegetation, creating a strong contrast between this natural setting and the geometric volumes. Sometimes, projects may have to deal with complex topographies, like in Safdie Architects' Eling Residences (42,700 m^2) in Chongqing, where apartments are organised in terracing blocks following the sloping site and immersed in a lush landscape with expansive views of the Yuzhong Peninsula and the Yangtze River. In other cases, it is the scale and the massing to make the project interesting, like not only in some works by Safdie, which we will comment on in the following sections, but also, for instance, in Arquitectonica's Mangrove West Coast (2005) in Shenzhen. This 1,200-unit, 250,000-square-metre condominium located on the shoreline beside a golf course is an impressive complex of three buildings organised in a windmill composition around an artificial lagoon. The 10- to 31-storey slabs, sometimes interrupted by a vertical void in the volume, feature long staggered balconies that create deep and dynamic fronts with a bold abstract image. Less commonly, residential

Fig. 8.9 Ningbo Gateway by RSH+P in Ningbo Eastern New City, Ningbo. Photograph by Giaime Botti, distributed under a CC BY 4.0

developments can take the shape of a single urban block, like in the case of Next Architects' Shouxi Building (2012, 48,000 m^2) in Fuzhou, a dense U-shaped block with a secondary smaller building, both characterised by an expressive façade of continuous sinuous balconies of changing shapes to differentiate the exterior space of every unit from the one above and below it.

Lastly, a specific residential sub-market is gaining ground in certain countries, China *in primis*: the senior living, often following the Continuing Care Retirement Community (CCRC) model imported by the USA. There, the CCRC includes three levels of assistance: Independent Living, Assisted Living, and Skilled Nursing, and is based on different forms of lease, with residents buying their Independent Living unit and paying for monthly service, renting it, or paying an upfront higher fee and then monthly fees with the possibility of moving to higher levels of care, either temporarily or for the time being (Denton and Polhamus 2014). The design of such communities thus implies know-how on flexible residential projects with indoor and outdoor spaces for social activities and wellness areas, either concentrated in one building or spread across different areas. In this sector, US design firms have developed significant expertise thanks to decades of experience, which is well visible in China. Smith Group, for example, has completed two senior living facilities. The largest one, the Jade Tower in Shanghai (22,300 m^2), mixes Independent Living and Skilled Nursing in a single tower block, reflecting the societal shift from at-home care to professional care. The development of this market in China, and the role played by US architects, is visible, in our sample, from the involvement of firms like REES Associates, LRS Architects, Steinberg Hart, WATG, and WDG Architects, for the design of several senior living projects (of uncertain status). To name other cases, Thomson Adsett completed in 2017 the Shuangqiao Golden Homes, a 350-apartment complex linked to a geriatric hospital, Perkins Eastman the Taikang Changping New Town (70,000 m^2), both in Beijing, John Portman Architects the Taikang Community Shen Garden (2013, 274,000 m^2) in Shanghai, a very dense and massive complex of seven high-rise slabs definitely less friendly than the better-scaled work of Thomson Adsett. Another firm with a large portfolio of senior living projects, Atlanta-based THW Design (not included in our survey), has also produced several projects in China. Ultimately, this market appears as a very promising one (Sudo 2019).

8.3 Signature Housing for an Emerging Middle-Class: A Global Picture

Deluxe condominiums targeting a well-off clientele have been popping up during the last ten to twenty years across major cities of Europe, the USA, Japan, and Australia and in the wealthiest centres of the Global South. Some people can now live in an apartment building designed by Jean Nouvel in Kuala Lumpur, São Paulo, New York, or Sydney. Others can choose a condominium by David Chipperfield in London, Antwerp, Madrid, or Hangzhou. High-rise residential buildings by Pelli Clarke Pelli are scattered across the USA, Mexico, Argentina, the United Arab Emirates, and Japan. Apartments buildings by Richard Meier can be found in New York and Bogotá, Tel Aviv and Osaka (Fig. 8.10). Of course, we could go on with this list, citing Arquitectonica's projects in Miami and Milan, Shenzhen and Manila, and Foster + Partners' in New York and London, Dubai and Kuala Lumpur.

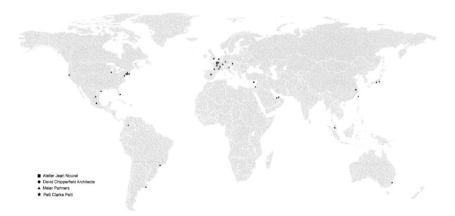

Fig. 8.10 A map of high-end residential condominiums (built) by Atelier Jean Nouvel, David Chipperfield Architects, Meier Architects, and Pelli Clarke Pelli Architects. Copyright Giaime Botti

Large gated-communities of mixed typology but with an evident prevalence of high-rise enclosing urban superblocks and provided with abundant green and amenities have been built in India, too. In Gurugram, Chapman Taylor master-planned and designed the Park View Ananda (2015, 75,000 m^2) and Park View Grand Spa (2017). Targeting the emerging upper middle class of the city, the former consists of eight 15-storey towers and 11 villas, with apartments ranging from 80 to 250 m^2, the latter of nine 20-storey towers and one 33-storey tower, both organised around a central landscaped park with playgrounds and swimming pools. In Ahmedabad, Benoy completed a four-tower complex with a neat contemporary image, which despite being presented as a mixed-use project, consists of two separate parts, the luxury residential Paarijat Eclat towers (approx. value in 2022 U$960–1,400/m^2), and the Privilon office towers (2018, 80,000 m^2). Several more projects of unremarkable nature can be listed, from Smallwood, Reynolds, Stewart, Stewart's The Atlantic Chennai Residential Development (37,650 m^2), a two-tower complex of luxury apartments on a commercial podium, in Chennai, to Woods Bagott's Trtitvam Towers in Kochi. RMJM, a firm with a historical presence in the country, also completed the Uniworld City Residential Township in Kolkata, a 4,600-unit development divided across several high-rise blocks, and the low-rise Silver Springs Residential Township in Indore, with over 1,600 residential units and sports facilities and amenities over 56 hectares. Another British firm with an office in Mumbai since 2007 and a strong presence in commercial interior projects in India, Lewis & Hickey, completed three large high-rise residential developments: the ACME Boulevard, composed of six 26-storey towers, and the ACME Sardovaya, composed of several high-rise blocks in three different neighbouring sites in Mumbai, and the Metro Residences in Kalyan. In this rather generic panorama, it is still possible to sometimes identify more original proposals for single buildings. One example is John Portman Architects' Taj Wellington Mews (2004, 39,641 m^2) in Mumbai, a 14-storey tower accommodating

8.3 Signature Housing for an Emerging Middle-Class: A Global Picture 349

88 luxury apartments with an irregular plan inscribed within two cylindrical frameworks that provide a unitary volume to the building. Another one is a Residential Development (79,896 m^2) in Jaipur by Studios Architecture designed as a rectangular courtyard block with a terraced front *à la* BIG (Mountain Dwelling) presented as a tribute to the rich historical architecture of the city. A third one would be MVRDV's Future Tower in Pune, which we will discuss in the next section.

In South-East Asia, residential projects signed by Western or Japanese firms are primarily located in the national capitals. In Kuala Lumpur, for instance, high-rises concentrate in the KLCC area, where we find The Troika apartment buildings by Foster + Partners, Le Nouvel at KLCC (Sect. 5.4), and luxurious condo-towers with lavish green and inviting swimming pools like the St Mary Residences (25,500 m^2) designed by WATG. In other areas of the city, we find low-rise apartment buildings of small scale like Eric Parry Architects' Damai Suria (1999, 32 units) and Iringan Hijau (2002–09), or the recent Arcoris Mont Kiara complex (2009–19, 134,500 m^2, 130 m) also by Foster + Partners, which consists of two slabs with a residential and office programme. In another dynamic market like Jakarta, we find at least three two-towers complexes designed and developed by Tokyu Sekkei for its brand Branz, the AXIA South Cikarang Tower 1 (2014, 14,752 m^2) by Takenaka Corporation, and Smallwood, Reynolds, Stewart, Stewart's Botanica (210,760 m^2), another deluxe gated community composed of one 35-storey and two 37-storey towers and provided with a large swimming pool, a clubhouse, and expansive landscape. In Hanoi, Vietnam, the US firm has also delivered the project for a larger community with a mix of high-rise and villas, complemented with retail, amenities, and schools: the Vinhomes Paradise Me Tri (384,297 m^2). Another massive project currently under construction in Hanoi is Franken Architekten's U-Silk City (720,000 m^2), a linear development of nine 28-to-50-storey residential towers connected by a continuous system of sky gardens above the commercial podiums. A more daring work, currently in the initial construction phase, is the LAVA-designed Van Phu Tower (200,000 m^2), a complex composed of three towers interconnected by double and triple multi-storey bridges. In Ho Chi Minh City, Arata Isozaki completed the Diamond Island New Urban Quarter in 2006, a dense high-rise development of the banks of the Sông Sài Gòn (Saigon River), not far from where Kengo Kuma has more recently finished the Waterina Suites (2019, 24,880 m^2, approx. value in 2022 U\$3,100/m^2), a 25-storey tower with sinuous staggered balconies. One of the very few housing projects mapped in Africa, Villaggio Vista (2016) in Accra's expansive Airport area, designed by British architects Allford Hall Monaghan Morris, was supposed to target the emerging middle-class of the Ghanaian capital. Still, its current prices (rent for a 4-bedroom apartment over U\$6,500/month in 2022) put this option out of that range. In any case, it represents an interesting example of a mid-rise blocks and towers complex, with a variety of apartment typologies, fancy amenities, and an eye-catching colourful façade pattern inspired by traditional Kente weavings.

In Russia, in addition to some luxurious residential and mixed-use skyscrapers located in the new CBD of Moscow (Sect. 5.5), we mapped a certain number of residential interiors designed by European firms like Tchoban Voss Architekten, Iosa Ghini Associati, and A4 Architekten. The latter firm also completed a coloured

but anonymous high-rise complex (2011, 33,000 m^2), while RAMSA the Barkli Residence (2016) in central Moscow: two 17- and 18-storey stone-clad towers rich in arcades, pilasters, and corniches with a not dissimulated reference to Stalinist neo-classicism. In Saint Petersburg, on the other hand, one large mixed-use but primarily residential development master-planned by Orange Architects and KCAP deserves some words. Golden City is located on the western tip of Vasilievsky Island facing the Gulf of Finland, and consists of a linear sequence of perimeter blocks inspired by the local morphology with homogenous and rigorous fronts. The blocks designed by Orange Architects and KCAP (22,950 and 45,000 m^2, approx. value for residential in 2022 U\$4,100/m^2) feature a rigid but elegant façade composition culminating with golden volume-tops and a golden geometric spire in the head block standing in front of the sea.

In the UAE, and especially in Dubai, we have acknowledged an extreme concentration of high-rise residential buildings; nonetheless, such presence did not hinder the development of a sprawling city of extended, monotonous neighbourhoods of gated communities of villas or single-family houses devoid of any shared space. More limited, on the other hand, especially looking at the work of our sample of design firms, have been the mid-rise residential blocks. Smallwood, Reynolds, Stewart, Stewart's Standpoint in Downtown Dubai just behind the Opera, is a low two-tower complex of little design value to the point it can hardly be singled out (Fig. 8.11). RMJM's The Jewels Dubai (2008, 49,293 m^2) is a waterfront development in Dubai Marina composed of two 20-storey towers with a tapering silhouette and a sail-like profile and five villas at the base, while Dubai Hills Estate Collective 2.0 (2019, 35,746 m^2) consists in an interior design intervention that develops an interesting experiment in co-living, something quite unusual in the Middle East. Located within Emaar's Dubai Hills, a high-end residential area mainly for expats built along a park, this work by RMJM involved one of the several high-rise residential slabs. In Abu Dhabi, two main areas are now under development, in addition to Saadiyat Island (Sects. 6.2 and 10.3). The first is Al Reem Island, owned by Tamouh Properties, Sorouh Real Estate (now merged with Aldar Properties), and Reem Investments. Here, not far from the Sorbonne campus and nearby a newly constructed marina, Foster + Partners completed two low Residential Towers (2008–20, 78,000 m^2) with a strong sculptural presence. In Al Raha Beach, a more residential and leisure-oriented waterfront development by Aldar and partly master-planned by RMJM, we mapped NORR's Al Raha Beach Development (2012) and Broadway Malyan's Al Bandar (90,000 m^2), a complex with 511 luxury apartments and retail divided between a gated community for families and three sea-front terraced blocks (Fig. 8.12). This project, as highlighted by Ponzini (2020, 183–188), can be read as the second of a series that was initiated with a very similar project in London, Battersea Reach (2012), and continued with other waterfront designs, one in London (St George Wharf, 2014) and one in Baku (Port Baku Residences, 2017). Finally, in Al Marasy Marina, in central Abu Dhabi, US firm CBT Architects designed an eight-block waterfront complex of residential buildings. As Al Reem Island, Al Raha Beach, and Al Marasay will further develop in the following years, more projects by overseas architects will undoubtedly follow.

8.3 Signature Housing for an Emerging Middle-Class: A Global Picture 351

Fig. 8.11 The Standpoint apartment building by Smallwood, Reynolds, Stewart, Stewart in Downtown Dubai. Photograph by Giaime Botti, distributed under a CC BY 4.0

Fig. 8.12 The three main apartment blocks of Al Bandar by Broadway Malyan in Al Raha Beach Development, Abu Dhabi. Photograph by Giaime Botti, distributed under a CC BY 4.0

In Latin America, we have also mapped a limited number of residential projects designed by our sample of firms, most of which target the upper middle class and above. In San Pedro García Garza, the wealthy municipality linked to Monterrey, we find Pelli Clarke Pelli's Sofia Building (2011–15, 60,000 m^2, 158 m; approx. value in 2022 U\$5,500–6,000/m^2), and, at little distance, Foster + Partners Saqqara Residences (2011–18, 140,000 m^2, 162 m). The former is an elegant, glazed tower with an undulated volume cut by balconies supported by thin slabs, accommodating lavish apartments spanning up to 710 m^2. The latter is a less-convincing complex of two luxury apartment towers (with the second one still under construction) and an office building, which results in nothing more than the n-fold suburban gated community with apartments up to 600 m^2 (approx. value in 2022 U\$4,900–5,600/m^2). To close this section, we highlight some more projects. They are all urban and high-end and have been developed by well-known international architects in the last few years. The Vitrum (2013–18, 21,553 m^2, approx. value in 2022 U\$3,700/m^2) in Bogotá, designed by Richard Meier & Partners, is composed of two connected blocks of 10 and 13 storeys respectively, with no outstanding features apart from Meier's signature 'whiteness.' Another polished building is Daniel Libeskind's Vitra (2015, 14,000 m^2, 77 m, approx. value in 2022 U\$5,400/m^2) in São Paulo, a multi-faceted wholly glazed block containing expansive apartments spanning from 500 to 1,100 m^2. On the other hand, Atelier Jean Nouvel's Cidade Matarazzo also in São Paulo (2012-u.c., 37,000 m^2, 93 m, approx. value in 2022 U\$8,400/m^2) will stand out once completed for the extensive use of vegetation and latticework to protect the privacy of the dwellers. This project, but also Le Nouvel in Kuala Lumpur, or others like, for example, Boeri Architects' "Bosco Verticale" ("Vertical Forest") in Milan (2007–14, 18,200 m^2, 80 m and 112 m, approx. value in 2022 U\$12–15,000/m^2), well display another now fashionable trend in the luxury high-rise market, the extensive use of greeneries, attached to simple, prismatic volumes, as well as to more fragmented, complex volumetry rich in balconies and terraces. Boeri is now vigorously promoting this idea in China, where some projects of residential high-rise (Easyhome Huanggang Vertical Forest and Nanjing Vertical Forest) and low-rise (10,000 Peaks Valle in Guizhou), hotel (Guizhou Mountain Forest Hotel) and larger residential developments (Liuzhou Forest City) are ongoing, all branded with the 'vertical forest' concept.

São Paulo's dynamic real estate market has seen some recent additions in its upper band designed by foreign architects, especially Perkins & Will. They include the "You, Perdizes" (2021, 12,000 m^2), a podium plus tower multi-family residence, and the Oscar Ibirapuera (2022, 25,000 m^2), two parallel slabs accommodating apartments spanning from 186 to 233 m^2 with uninterrupted panoramic views thanks to a *pilotis* structure that is reminiscent of Niemeyer's modernist legacy, and a system of wooden movable *brise-soleil*. Finally, with the RiverOne (2021, 44,978 m^2; approx. value in 2022 U\$3,500/m^2), Perkins & Will added a hybrid building composed of a glazed office vertical block and a residential tower on top exploiting the wide roof of the lower volume for the apartments' amenities, while UN Studio the EZ Parque da Cidade (79,000 m^2), a two-tower complex now near completion quite similar to other towers designed by the Dutch firm. Other luxury residential buildings we

mapped include the Palazzo Barro Vermelho in Natal, Brazil, a high-rise by Spanish firm HCP, and, in Cancún, Mexico, Italian firm Archea Associati's Kiara Complex (2016–18, 5,234 m^2), an elegant, curved building featuring a façade in which the continuous white strips of slabs and balconies are alternated by panels of copper and rosed tones.

In such a panorama where foreign architects are called to design upscale residences in trending neighbourhoods or fanciful gated communities, a rare exception is represented by SO-IL's Las Americas Social Housing (2016–21, 3000 m^2) in León, Mexico. The building stands out in the low-rise landscape of a low-income neighbourhood with a terraced profile and a two-courtyard configuration resulting from the intersection of two curved blocks. It accommodates 60 units arranged in a single-loaded corridor and features a façade with concrete blocks devised as shading elements. In addition, in our record of works, we have identified a few more projects for which the designers seemed to be moved by 'good intentions' (Sect. 9.6) rather than search for profit. Shigeru Ban's Paper Loghouse developed in 1995 after the Kobe earthquake (the cost of materials for one 52-square-meter unit was below U\$2,000 at that time), has been re-proposed with variations in many places struck by natural or human disasters from Turkey (2000) to Dhaneti and Bhuj (2001), India, to Cebu (2014) in the Philippines, and more recently in Kalobeyei refugee camp (2017) in Kenya. Ramboll, on its side, has developed a prototype of a bamboo house with the Indonesian NGO Grenzeloos Milieu and the University College London to be deployed in Lombok after the earthquakes of 2018, an anti-seismic and sustainable solution based on local materials and handicraft skills and optimised with advanced know-how.

8.4 Villa No More: Housing Communities and the End of Privacy

We have previously discussed the role that real estate developers like SOHO China and Vanke had played in transforming the Chinese housing market, using signature architecture as a marketing strategy to place a product qualitatively different from the standard residential building. We have also seen how in China, the typology of the single-family house, and even of the villa, is almost always developed inside a gated community. This is not unusual in the United States and many developing countries, from Latin America to Africa and Asia. One peculiarity of China, instead, lies in the fact that villas are often part of urban, rather than suburban, gated communities that often include also mid and high-rise buildings, as seen in various examples. At the same time, it is also true that Chinese sprawl is inherently different from the one of North America, being a "curious hybrid form of sub-urbanism that is not quite urban nor fully suburban" (Campanella 2008, 202). Furthermore, as pointed out by Wu (2006), globalisation in China does not only manifest itself in the megaprojects designed by foreign architects but also in the "ordinary" landscape of residential

communities, especially villas (more often than not townhouses, terraced o semi-detached houses with high standards defined as "economic villas"). As recounted, after an initial boom in the early 1990s and a subsequent bust, in 1999, the market of villas estate started recovering, boosted by foreign expats and a new domestic upper middle class. In Beijing, they were mainly located in the northeast, outside the third ring road. These estates' names—Orange County, Yosemite Villas, Venice Garden, and Fontainebleau Villas—echoed a Western way of life, with a stylistic proposal designed accordingly. For example, the Fontainebleau Villas in Shanghai Nanhui, near Pudong Airport, represents an excellent example of a "globalised golden ghetto," as such kind of communities became in the early 2000s some of the "most globalised places in China" (Giroir 2006), often developed by Hong Kong and Taiwanese investors, and sold to an elite of well-travelled businessmen. Very interestingly, they represent an escape from the "ideological constraints" of China materialised in a luxurious, Western-looking villa within a secured and secluded environment, at the same time blended with Chinese features, starting from the lavish landscape design inspired by the tradition of the Chinese garden and the respect of *Feng Shui* (Giroir 2006).

Still, since the early 2000s, many more of these compounds have been built, no longer appealing to the expat community (numerically insignificant in China) but to a broader well-off domestic clientele, and no longer just in cities like Beijing and Shanghai but across the whole country. In this context, Chinese villa estates usually feature a relatively high density, not always much privacy, and expansive landscaped parks generally designed in forms inspired by the traditional Chinese garden or the old waterways, and thus with an abundant presence of water bodies. The architectural language is broadly variable, ranging from the historical pastiche of European ascendance to the frankly contemporary. As an example, RAMSA's Residences at Zero Island (2014) occupies a 9-hectare island on an artificial lake according to an elliptical configuration, with a central green area and freestanding two- and three-storey townhouses arranged in two rings. In terms of language, the architectural proposal is generically inspired by Tianjin's colonial architecture, i.e., a mixture of European nineteenth and early-twentieth-century classicism. BDP's Jinchen Villas (2014) in Shanghai is an urban community of 40 apartments and 94 villas plus a clubhouse on a 17-hectare park with water canals. The villas can be categorised as modernised classicism. Near Shanghai, Callison RTKL's Zhujiajiao Watertown also abounds in canals and features a generic architecture of white houses blandly inspired by local water villages. Equally unremarkable is the Sheshan Villas estate by CBT Architects in Shanghai, while the Vanke Deep Blue Villas (2007) in Shanghai designed by PES and Evian Town (2006, 220,000 m^2) in Suzhou by RMJM feature a more contemporary and abstract language of cubic volumes, cantilevers, canopies, and screens. Once again, in these projects, we find excellent care for the landscape inspired by the local presence of waterways. A more refined proposal was also elaborated by Japanese firm K Associates for a model Villa for Vanke (2007) in Suzhou, in a modern and clean reinterpretation of traditional houses. Still, it is unknown if more have been developed. Finally, an uncompromisingly contemporary design was drafted by Next Architects for Lianjiang Butterfly Bay (2016, 120,000 m^2) in Fuzhou, a development with villas ranging from 480 to 675 m^2 and two low

8.4 Villa No More: Housing Communities and the End of Privacy

towers with a hotel and apartments. The villas are formally complex, with staggered floors corresponding to boxy volumes resembling big frames to define and maximise the main views. Although the presence of a swimming pool in front of each unit within an exuberant green provides some refresh in beautiful sceneries, we cannot neglect the paradox of having such an expansive real estate product in which, unlike in every real villa, privacy is reduced almost to zero.

All these projects, which we mention more as a pretext to discuss architectural globalisation rather than for any intrinsic design quality, represent just the tip of the iceberg of hundreds more developments scattered across China, easily visible, for example, while travelling on a train, even in far more remote areas, usually of far lower quality. Indeed, it is in the quite remote but wealthy city of New Ordos/Kangbashi, the administrative district of Old City of Ordos/Dongsheng, in Inner Mongolia, that one of the most ambitious projects of this kind was launched in 2008 by Ai Weiwei's Fake Design with Herzog & De Meuron. The master plan of "Ordos 100" envisioned the construction of one hundred 1,000-square-metres villas designed by one hundred international architects. Today, five unfinished buildings lie abandoned in the desert. This failure has been harshly criticised by Williams (2013) in *The Architectural Review*, who claimed that the real "ghost town" is the one produced by such a failed operation of and for the architectural star system, rather than Kangbashi, which has made the headlines on Western media as a paradigmatic example of a Chinese "ghost town" with thousands of empty apartments and large public buildings without a public to use them (Day 2012; Howarth 2016).

Indeed, while in China not a single building mapped here can be categorised as an individual suburban villa placed in a landscape of some quality, some real villas immersed in beautiful natural sceneries have been designed across Latin America. In Brazil, we mapped luxurious residences in Ribeirão Preto (2018, 1,000 m^2) by Perkins & Will, which also in 2022 (and therefore not in our statistics) completed another large house, the Fazenda da Grama. Spanish firm Fran Silvestre Arquitectos, known for its "Acantilado House" ("Cliff House") in Alicante, completed a villa in Rio de Janeiro with the same language of white rectangular boxes used to define macro-corniches to frame views. For sure, for the Brazilian elite the choice of hiring a foreign architect must be a very well-motivated one if we consider the extraordinary tradition of houses designed by local architects, from Oscar Niemeyer to Sergio Bernardes in the 1950s and 1960s, from Paulo Mendes da Rocha until a few years ago to Marcio Kogan, one of the most successful Brazilian architects in the sector of luxury houses. In Mexico, the country of some of the most photogenic houses of the last century, like those designed by Luis Barragán, the local architecture scene can boast professionals like Rojkind Arquitectos (see the P34 Villa, Tecamachalco, 2003, 136 m^2) or Tatiana Bilbao (see the Observatory House, with and for Gabriel Orozco, 2008). Indeed, one exception is the Casa Wabi Artist Retreat, designed by Tadao Ando for Mexican artist Bosco Sodi and the Wabi Foundation (2011–14). Located on the beach of Puerto Escondido, Oaxaca, the house is organised by a 312-m-long concrete wall that cuts the house longitudinally, dividing the large living from the rest and defining another private area, and screens along the beach the six small, isolated cabins used as guesthouses. In the house, the universal and technologically

advanced tectonic of Ando's smooth exposed concrete interacts *vis-à-vis* the local tradition of the *palapa* roof in dried palm leaves. Later, a very original building was also added: a chicken coop (2018, 155 m^2) designed by Kengo Kuma.

When it comes to high-end domestic architecture, personal dynamics and stories between the client and the architect appear even more relevant than in any other typology of projects, making overall of little significance a generalised approach. That said, we can draw a few considerations from the small sample of projects we mapped (excluding 'serial' villas). The first one is precisely about the fact that the sample is tiny (no more than ten projects per region, except China). And this is not only because of the exclusivity of the typology, but also because, for such projects, it can be easier, less expansive, in the end, better to rely on a local architect, someone like Marcio Kogan in Brazil, Vo Trong Nghia in Vietnam, or Bijoy Jain of Studio Mumbai in India. Then, of course, there are exceptions. Tadao Ando has built individual houses in Sri Lanka and the United States. In Kuala Lumpur, Richard Meier & Partners completed the Tan House (1997–2003). This project does not pretend to develop the same level of synthesis between the global and the local seen in Ando's work in Mexico but integrates considerations related to orientation, climate, and views with the typical aesthetic of Meier. Genericity characterises the few individual projects mapped in the Middle East, too. Despite the presence of extended gated and non-gated urbanisations of single-family houses, generally lacking any distinctiveness, VMX Architects in Oman have carried out some interesting projects. The first one, Villa Dar Hassan, is a three-level house nestled on the cliffs of Muscat overlooking the waters of the Gulf of Oman. The second one, Villa Ali, currently under construction in Muscat too, is a lifted box *à la* OMA (Maison à Bordeaux), though supported by columns, within a small walled plot. Another original construction, but already conceived as a standardised and replicable solution, is the Floating Villas Marasi Business Bay by Finnish firm Sigge Architects with ADMARES.

While we have already highlighted the role of Western workers in the market of high-end apartments and villas communities in China at the end of the 1990s, it is even more common to find the latter typology of settlements in oil-rich countries in the Middle East and Africa, where individual family-houses are a typical provision paid by the employers to skilled expats. Although we have yet to identify any of these projects in countries like Saudi Arabia (while, for example, Kuwait was not part of our survey), we have mapped some in Angola, not surprisingly related to oil companies. US firm EDI International, for example, completed expatriate communities like the 23-family-houses Imbonidero Village (2000) for Esso, and the 400-family-houses Bairro Sonangol, named after the Angolan national oil company. It goes without saying that these projects have no architectural interest, precisely like the Atlantic Towers (2009) in Luanda—a complex composed of an 18-storey office tower and a 15-storey residential tower for ESSO, BP, and Sonangol—and other expatriate communities also designed by EDI International in Equatorial Guinea, another oil-producer country.

In the end, most of these projects can be seen as a trivialisation of the domestic architectural typology *par excellence*, the single-family house, especially when it comes to industrialised pseudo-historical products built within gated communities

where the proximity of the units and their repetition create an alienating landscape devoid of any individuality and relationship with the landscape. While it could not be possible to understand any design from Andrea Palladio's La Rotonda (1560s) to Ludwig Mies van der Rohe's Tugendhat House (1928–30) without considering their surrounding landscape, most of these projects, especially the serial ones, are nothing more than standardises solutions copy-pasted on the site. Moreover, although we also find some 'signature' and individual projects located in precious natural settings, it is hard to point out any example able to move our imaginations and catalyse the debate like some projects of the 1980–90s did. In that decade, it was the case of the Möbius House (1994–98) by UN Studio in Het Gooi, Netherlands, which marked the direction in the conceptual experimentations on topological space and parametric design, or of OMA's Villa dall'Ava (1984–91) and Maison à Bordeaux (1994–98), readable as architectural essays reflecting on domesticity and design narratives while subverting structural and tectonic common sense. It was also the case, somehow on the opposite side of the barricade, of the "(critical) regionalist" proposals of Glenn Murcutt in Australia with the Magney House (1984) and the Marika-Alderton House (1994), or Álvaro Siza in Portugal, with the Casa Vieira de Castro (1994). Simply put, the architecture of globalisation seems to have relegated the theme of the individual house to the background of the architectural debate. Or perhaps, it has shown the limits of the globalised architectural profession when the relationship with the client and the place needs to be tight but the work appears less profitable given the limited scale. Last but not least, it also touches on the problem of authoriality: if it is true that a local branch of a design firm can provide a closer follow-up of the projects (although boutique firms, the most involved in these types of works, do not often have branches), still it has to be seen if the principal architect, in Europe, Japan, or the USA, will ever come to visit the project site.

8.5 New Experiments in Mass Housing: Dwellings for the Well-Off?

While usually well-designed, sometimes luxurious, and often quite banal, the residential projects seen so far have rarely questioned the *status quo* on housing nor displayed strikingly innovative solutions. High-rise residential projects, including supertall ones, have generally been devoid of any real experimental character, if not in terms of record-breaking heights. Even a signature building like Le Nouvel in Kuala Lumpur does not appear in the architect's portfolio, probably because of the loose connection between the designer and the developer during the latest phases of the design process. In many ways, once fading the 'heroic' period of modernism in the post-War, experiments with new typologies for mass housing faded away, too. Having apparently failed the multiple versions of Le Corbusier's Unité d'Habitation, and, even more, of French *grand ensemble* designed by architects like Émile Aillaud,

or the Smithson's Robin Hood Gardens (1972) and Erno Goldfinger's Balfron Tower (1965–67) in London, by the 1970s mass (social) housing was becoming a distant memory. In Latin America, too, nothing comparable to the great housing projects of the 1950s and the early 1960s was produced in the following decades. Middle-class settlements like Affonso E. Reidy's Pedregulho (1946–52) in Rio de Janeiro, or, for lower-income inhabitants, Carlos Raúl Villanueva's '23 de Enero' housing (1955–58) in Caracas, and Mario Pani's Nonoalco-Tlatelolco (1957–74) in Mexico City, did not find any adequate descendants. In 1977, the demolition of the Pruitt-Igoe Apartment complex in Saint Louis, Missouri, marked the end of modern architecture for Charles Jencks (2002). For sure, it represented a symbol of the changing times. In less than twenty years, this public housing project, from a solution to housing problems, had become, in the narrative, the problem itself and a concrete representation of all the negative features of modern architecture; a distorted myth (Bristol 1991).

By the 1970s, US cities were sprawling, while in Europe, from the north of Italy to the Flanders, the new urbanisation pattern of the *città diffusa* (diffuse city) was emerging alongside the de-industrialisation of former productive centres. Not by chance, Moshe Safdie, an architect with the ability to put into practice his large-scale housing dreams, tried "to demonstrate" the possibility of "delivering some of the benefits of suburban living in an otherwise dense, medium-rise residential structure" (Frampton 2020, 370) with the Habitat 67 (22,160 m², Fig. 8.13) in Montreal. Although Safdie failed to challenge the dominance of suburbia (but could have him alone ever won such a battle?), Habitat 67 successfully resisted "the lazy distinction of high-rise inner city and low-rise suburbia" (Abrahams 2018, 108) with an alternative proposal. Cleverly incorporated into the Expo master plan that Safdie was drafting, this experimental housing project consisted of 158 apartments formed by 354 prefabricated concrete boxes, irregularly stacked to form three semi-pyramids around the vertical cores. Despite the reliance on a single structural element, one of the most extraordinary aspects of the project lies in the variety of its configurations—14 different apartment layouts—and in the provision of private terraces by exploiting the staggered array of the units. One of the unintended consequences of its influence is that Habitat 67 has somehow defined "a benchmark for luxury high-rises," some of which were designed by Safdie himself (Abrahams 2018, 108). Indeed, by commenting on some projects we mapped in the emerging markets, we realise exactly how a consistent number of experimental and innovative housing projects of the last few decades have been designed for the well-off rather than for the masses.

Considering Safdie's more recent works, for instance, we find high-rise mixed-use developments that defy the skyscraper typology, like the Marina Bay in Singapore and Raffles City Chongqing (Sect. 5.7), and some other projects that further explored the legacy of the Habitat 67. One explicitly doing so is the Habitat Qinhuangdao (2013, 445,500 m²), a beachfront large-scale residential experiment in the northern Chinese province of Hebei promoted by Kerry Properties. With a second phase currently under construction, it consists of 2,500 apartments in a series of 15-storey simple and terraced slabs, oriented in two directions and stacked on top of each other to form 30-storey-tall structures connected by sky bridges accommodating gardens

8.5 New Experiments in Mass Housing: Dwellings for the Well-Off?

Fig. 8.13 The Habitat 67 by Moshe Safdie, Montreal. Photograph by Jon Evans, distributed under a CC BY 2.0, available at https://commons.wikimedia.org/wiki/File:Habitat-67_-_Flickr_-_rezendi.jpg.Modified by Giaime Botti

and amenities. The scale and boldness of the project are one of the best reminders of the possibilities of experimental architecture offered by emerging markets like China. Not by chance, smaller but still indicative projects of Safdie have been built in other Asian countries: they are the Sky Habitat (2016, 58,786 m^2; developed by CapitaLand) in Singapore, composed of two terraced towers connected by three sky-bridges, the uppermost one provided with a swimming pool, and the Altair Tower (2021, 139,355 m^2; Fig. 8.14) in Sri Lankan capital Colombo, consisting of two vertical blocks, one of which, inclined, leans against the other. Other interesting residential projects of massive scale and innovative typology can be found in Singapore. The Pinnacle@Duxton (2001–09; Fig. 8.15) was designed by local firms ARC Studio Architecture + Urbanism and RSP Architects Planners & Engineers for the Housing & Development Board of the Ministry of National Development. It consisted of seven 50-storey towers connected by sky bridges with gardens at two levels. However, the boldest residential design ever carried out is The Interlace (2007–13, 170,000 m^2; developed by CapitaLand; Fig. 8.16), designed by OMA and Ole Scheeren and developed by CapitaLand. The complex comprises 31 identical 70.5-m-long by 22-m-wide, 6-storey blocks stacked at a 120-degree angle to form eight hexagonal courtyards. The result is an impressive megastructure that defies the common typological categories of high-rise, courtyard block, and slab.

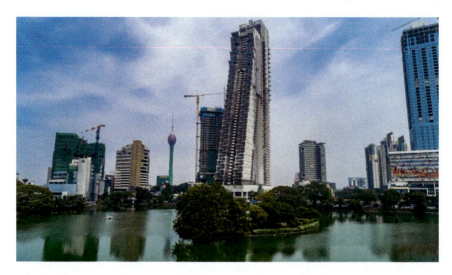

Fig. 8.14 The Altair Tower by Safdie Architects, Colombo. Photograph by MariusLtu

Residents inhabit apartments ranging from 75 to 586 m^2, sometimes provided with private balconies and terraces, or anyway able to access the shared roof gardens of the block, part of a rich and curated landscape project (by Singaporean firm ICN Design) that also involves all the ground level. The result is a work that "combines boldness and intelligence in a way rarely seen in housing." In terms of affordability, although not in "the lower end of the mid-tier" as Scheeren claims, The Interlace is neither in the "luxury bracket," according to CapitaLand (Moore 2015, 94), despite a current price ranging from U$7,700 to 14,000 per square metre.

Promoting an uncommon social mix, with apartments targeting different income groups, is instead MVRDV's Amanora Future Tower (2018, 140,000 m^2; approx. value in 2022 U$1,350/m^2) in Pune, India. Despite the name, the building comprises multiple interconnected double-loaded slabs sloping from 17 to 30 storeys according to a hexagonal plan. The result is formally as bold as the Mirador in Madrid (2005) by MRDV itself or other residential projects of the last decade, like BIG's 8Tallet in Copenhagen (2010) or the VIA 57 West in New York (2016). More interestingly, the complex features several one- to three-storey holes in the façade technically motivated by the Indian building regulation code for emergencies but transformed by MVRDV into unique outdoor spaces for different activities, from yoga to socialisation (Pearson 2018). Indeed, it would not be difficult to find other residential projects by local architects worthy a mention in today's India, as well as in the past, from Raj Rewal's Asian Games Village (1980–82) in New Delhi to Charles Correa's Kanchenjunga Apartments Tower (1983) in Mumbai. And the same, but only with reference to the last two decades, can be said for China.

Here, we want to name two cases in which local architects have produced bold housing projects. The first one refers to the work of Atelier GOM, led by Zhang Jiajing, whose Lingang Fixed-price Housing and Longnan Garden Social Housing

8.5 New Experiments in Mass Housing: Dwellings for the Well-Off? 361

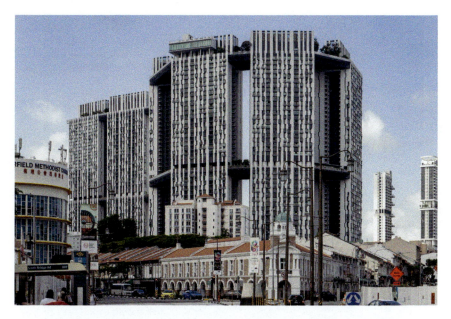

Fig. 8.15 The Pinnacle@Duxton by ARC Studio Architecture + Urbanism and RSP Architects Planners & Engineers, Singapore. Photograph by Jon Evans, distributed under a CC BY 4.0, available at https://commons.wikimedia.org/wiki/File:The_Pinnacle@Duxton_(I).jpg

in Shanghai, beyond a high-quality design of the blocks and the units, present interesting solutions like connecting bridges that expand the outdoor space (in the former) and accessible terraced roofs (in the latter). Similar solutions are also provided in the Baiziwan Social Housing (2014–21, 473,300 m^2) in Beijing by MAD Architects. By the time of its completion, the Chinese firm had already designed relevant housing projects like, for example, the so-called "Fake Hills" (2008–15, 492,369 m^2) in Beihai, Guanxi, an 800-m-long residential slab with a unique undulated profile, a dense habitat not unique in its dimensions (the Corviale in Roma is 986-m-long) and quite bothersome at the urban level for acting as a screen in front of the sea, despite the presence of large, irregular holes (the only positive note is that the beach is facing north and thus the building does not bring any massive shadow to the surroundings). Baiziwan, on the other hand, represented the first social housing work of Ma Yansong's firm and is composed of 12 buildings containing six different apartment typologies spanning from 40 to 60 m^2. The project has several merits, not least the one of assuring a larger-than-usual provision of green space compared to average social housing in China and a well-designed outdoor landscape. More importantly, it questions established typologies and residential organisational forms by bringing the road network inside the superblock, clustering the buildings in six blocks, and, in this way, creating a finer urban grain. The residents still enjoy the security of a gated community, but the communal space is raised above the level of the commercial podium and is connected by several pedestrian bridges. These allow experiencing the

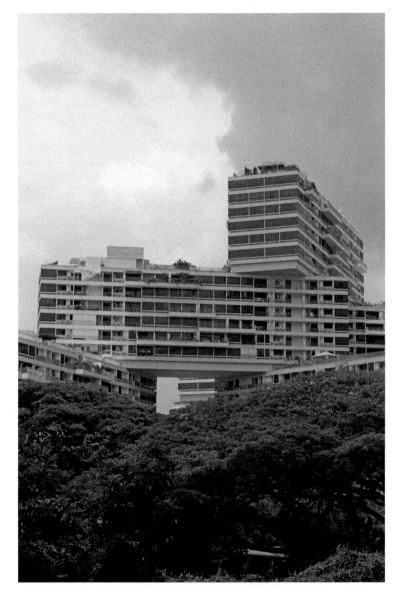

Fig. 8.16 The Interlace by OMA, Singapore. Photograph by Giaime Botti, distributed under a CC BY 4.0

outdoor community space as a unified whole despite the subdivision into six urban blocks. At the same time, the superblock can be freely crossed at the street level, avoiding the usual situation for pedestrians (and cars) of having to circumnavigate extended and uncrossable blocks. These last projects brings us back to China and to the urban dimension, too. And from there, we will start the next section.

8.6 Pieces of a New, Hybrid City: Mixed-Use Developments and Real Estate Developers

Besides and beyond innovative housing projects, the contemporary city (may the generalisation be pardoned) is more and more formed by new fragments of mixed-use unitary and architecturally consistent developments, where, in different percentages, ingredients like housing, office, retail, hotel, cultural facilities, and (privately owned) public space are combined, fostering a more active, varied, and porous urban space that breaks with the predominant mono-functional urban block that characterises most areas of these cities. From these projects, thus, emerge pieces of hybrid cities not following CIAM monofunctional zoning patterns dominated by widely spaced slabs and towers surrounded by a poorly defined open space that has become the norm across the world, from the Middle East to China (Mumford 2018, 330). To achieve these results, indeed, experimental architects must encounter the right real estate developers in emerging markets.

In 2009, Steven Holl completed the Linked Hybrid (also Moma Beijing; 2003–09, 212,000 m^2; Fig. 8.17) in Beijing and the Horizontal Skyscraper in Shenzhen (Sect. 9.2). Still, to fully understand his work, we need to take a step back and look at the USA. In 2002, the Simmons Hall (18,116 m^2) in Cambridge, MA, was built. It consisted of a 140-m-long, 10-storey building to serve as a dormitory and community centre for the students of MIT. With this project, Holl renewed the modernist quest for a "social condenser" in many ways. Its scale made it a real "piece of city," as Safran (2003) explained before commenting on the technological innovations of this building, erected using a prefabricated façade module that incorporated windows and walls with a load-bearing structure. After finishing this project, the development of the Linked Hybrid in China began. Once completed, it became one of the most striking examples of contemporary attempts to re-aggregate individual dwellings into a "collective whole" (Frampton 2020, 636), with its eight blocks of residential and hotel programme linked by sky bridges provided with services and (not successful) cultural-oriented commercial activities. Regretfully, the porous nature of the complex was denied due to the choice of walling the complex. Thus, the fact that Holl's project has been disfigured by a surrounding wall topped with Chinese roofs and, in this way, made impermeable to urban life is just a reminder of the distance that sometimes exists between architects' intentions and actual outcomes. Nonetheless, Holl's activity in China did not stop there. The next and final step was the Sliced Porosity Block-Raffles City Chengdu (2010, 310,000 m^2, LEED Gold; Fig. 8.18) for CapitaLand. In this case, the project was a real permeable mixed-use development made of five sculptural towers. These blocks were then glazed on their side as if 'sliced' to display their interior, while they featured a homogenous grid interrupted only by the diagonals of the anti-seismic stiffeners on the main fronts. This solution for the façade already experimented with in Cambridge and Beijing provided a unifying aesthetic but also represented the result of a construction solution that incorporated the envelope, openings, and structure into a single prefabricated

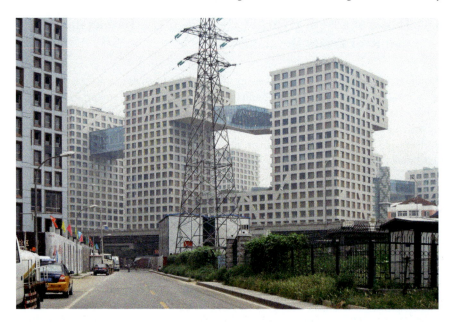

Fig. 8.17 The Linked Hybrid by Steven Holl, Beijing. Photograph by Giaime Botti, distributed under a CC BY 4.0

element. Then, regarding the programme, the Sliced Porosity Block accommodates offices, serviced apartments, and hotels in its towers. At the same time, a multi-storey commercial and leisure podium mediates between scales, providing a more human scale to the terraced internal courtyard.

These projects may help us better understand the contemporary city's new mixed-use and hybrid forms. By looking at skyscrapers, we have distinguished between monofunctional office buildings and mixed-use towers. Indeed, while large multinational companies tend to occupy single-tenant buildings directly and purposefully commissioned as their central or local headquarters, many more companies and professionals rely on rented office space housed in multi-tenant buildings. Indeed, some of the most interesting examples built in the last two decades are hybrid mixed-use complexes. In many ways, the most interesting aspect of these projects lies in their urban proposal. The most successful schemes, in fact, provided a rich, vibrant, and protected urban space and high-quality, sometimes innovative architecture. This is particularly true in China, where the economic and urban boom has granted the financial resources needed for such developments under the direction of famed overseas architects. To choose one developer to tell this story, the one is SOHO China (Sect. 9.2). At the beginning of the 2000s, it successfully marketed hybrid home-office solutions for a young and creative clientele. This was the concept behind the first large operation involving a foreign architect, Jianwai SOHO (2000–02, 703,000 m^2; Fig. 8.19), in Beijing, designed by Riken Yamamoto. This open superblock, devoid

8.6 Pieces of a New, Hybrid City: Mixed-Use Developments and Real Estate … 365

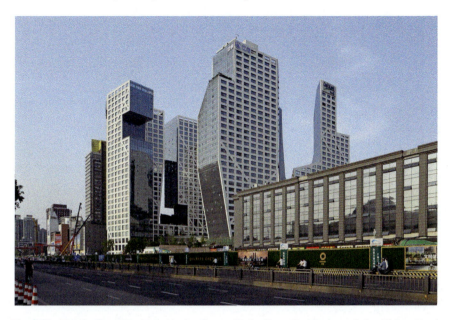

Fig. 8.18 The Raffles City Chengdu by Steven Holl, Chengdu. Photograph by Giaime Botti, distributed under a CC BY 4.0

of typical fences and walls but in exchange well provided with CCTV cameras and guards (Schmidt and Fach 2020), featured eleven towers of different heights, two of which were for offices, while the others contained apartments often provided with a workplace at their entrance, reflecting the new hybrid work-and-live reality of young independent professionals in the early 2000s. However, the real success of the project stood in the quality of its urban proposal: Jianwai was completely pedestrianised and rich in quieter piazzas and commercial activities at the ground level. Overall, the balanced scale of the complex became even more evident thanks to the striking contrast with John Portman's Yantai Centre (2008, 350,000 m^2), which was erected at its northern edge. This three-tower complex (186, 250, 186 m), accommodating offices on the two sides and hotel and apartments in the central and taller tower, followed a scheme already experimented with by Portman in Shanghai (Sect. 5.2). Unluckily, and despite Portman's role in introducing mixed-use, high-rise developments in China, the Yantai Centre just dwarfed the surrounding buildings in scale and did not define any pleasant urban outdoor space at the ground level.

For SOHO China, Jianwai represented just the beginning, and in the following years, the developer promoted many projects, always counting on top local and foreign architects. Being these projects mostly devoid of residential space, they will be discussed in Sect. 9.2. Were it not for quality as a parameter, several more mixed-use projects could be mentioned. In China, there are many high-rise developments with commercial podiums and residential and office towers designed by firms like

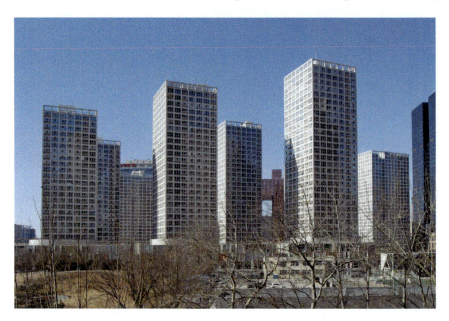

Fig. 8.19 Jianwai SOHO by Riken Yamamoto in Chaoyang, Beijing. Photograph by Giaime Botti, distributed under a CC BY 4.0

Smallwood, Reynolds, Stewart, Stewart and Callison RTKL. Nevertheless, looking at other countries in our sample of emerging markets seems more profitable. In Doha, for instance, three interesting cases quite different in terms of architectural and urban proposals can be compared. The first two projects to consider are West Bay, masterplanned by Smallwood, Reynolds, Stewart, Stewart, and The Pearl, by Callison RTKL for the United Development Company. The former is a mixed-use development that includes a tall office tower, two residential towers, and the Four Seasons Hotel, all designed in the traditional Qatari fashion according to the architects, i.e., adding arches along the façades and domes on top of the buildings (Sect. 10.3, Fig. 10.20). Callison RTKL also adopted such an architecturally conservative approach in The Pearl, Doha's answer to Dubai when it comes to artificial islands. This development is shaped around one irregular and two circular lagoons, surrounded by high-rise condominiums and several villas (Fig. 8.20). At the centre of Port Arabia, the central lagoon provided with a marina and a fancy boardwalk, stands the Kempinski Marsa Malaz Hotel, designed by the Arab Engineering Bureau (AEB) in a blend of Arab and Venetian style. As a result, West Bay and The Pearl have in common not only an aesthetic proposal of domes, arches, and any other type of generically Arab repertoire pasted on top of the buildings but also the construction of an urban space dominated by over-scaled, separated volumes, more isolated in West Bay, relatively densely arranged in The Pearl, where at least we find some mediating elements in the form of low-rise commercial and residential blocks in the boardwalk of Port Arabia.

8.6 Pieces of a New, Hybrid City: Mixed-Use Developments and Real Estate … 367

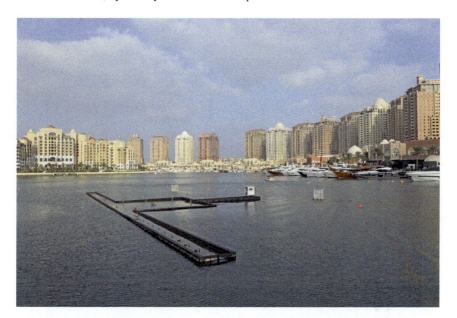

Fig. 8.20 A view of Port Arabia, Doha, master-planned by Callison RTKL with buildings by the same firms. On the left side is visible the Kempinski Marsa Malaz Hotel by Arab Engineering Bureau. Photograph by Giaime Botti, distributed under a CC BY 4.0

To such a type of development, in Doha, the most convincing counterpoint has been Msheireb Downtown (2006–21; Fig. 8.21), master-planned by EADW (a US landscape firm not included in our survey and acquired by AECOM at that time) and ARUP, with Allies and Morrison as lead architectural consultants to define architectural and urban design; the developer was Msheireb Properties, a subsidiary of Qatar Foundation. Recognised as the "first large-scale city scheme in the Gulf whose architecture and urban morphology are generated specifically by local historical vernaculars and spatial precedents" by Merrick (2018, 36) in *The Architectural Review*, this project set an alternative to both the mega-scale high-rise city grown along the Corniche and the sprawl of family-houses urbanisations of the interior, with an urban proposal aimed at creating a sustainable neighbourhood (all buildings target the LEED Gold certification) made of a dense and walkable fabric at a human scale. The master plan of this 31-hectare central area reconnected the Souq Waqif and the Diwan through the construction of about one hundred new buildings and the preservation of some of the old streets and houses, four of which transformed into the Msheireb Museums and the M7 Cultural Forum (Fig. 8.22) by John McAslan + Partners (not included in our survey). In this master plan, Allies and Morrison have not only designed the Friday Mosque (2021, 1,560 m^2) but also over thirty buildings of different typologies. They include three government buildings in the Diwan Amiri Quarter, the Diwan Annexe (another administrative building), the Amiri Guard's barracks, and the Qatar National Archive (phase 1A, 150,000 m^2), plus residences

Fig. 8.21 A view of Msheireb Downtown by Allies and Morris from the Wadi Msheireb Street, Doha. Photograph by Giaime Botti, distributed under a CC BY 4.0

8.6 Pieces of a New, Hybrid City: Mixed-Use Developments and Real Estate …

Fig. 8.22 The M7 Cultural Forum by John McAslan + Partners on one side of Barahat Al-Nouq Square in Msheireb Downtown, Doha. Photograph by Giaime Botti, distributed under a CC BY 4.0

(phase 1B, 27,000 m^2) and offices, and a commercial quarter (phases 2–4). Following the "Seven Step" they defined with Tim Makower, a real effort to create a "modern Qatari architectural language" on the basis of "key features of historic dwellings and settings" (Merrick 2018, 38), Allies and Morrison designed townhouses on courtyard blocks inspired by the traditional typologies of *fereej* (communal gardens), which also help naturally cool the shared gathering space called *majilis*. Contemporarily, Mossessian Architecture designed over 59,000 m^2 of residential, retail, and office space following the same guidelines, and the Barahat Al-Nouq Square, a piazza covered by operable canopies to improve thermal comfort (Fig. 8.23). As stated by Merrick (2018, 38), Msheireb Downtown represents "an important attempt to demonstrate an architectural, cultural and commercial alternative to the generically internationalised placemaking that so often produces questionable, if not culturally toxic expressions of timeless placemaking." At the same time, despite evident architectural and urban differences, both The Pearl and Msheireb Downtown seem moved by the same logic of real estate financialisation to target foreign investors and some well-off expats.

Fig. 8.23 Barahat Al-Nouq Square by Mossessian Architecture in Msheireb Downtown, Doha. Photograph by Giaime Botti, distributed under a CC BY 4.0

8.7 The New Town in the Twenty-First Century: From Shanghai "One City and Nine Towns" to Masdar

While mixed-use developments materialise new portions of a city boasting a vital combination of programmes, usually vertically zoned, entire new towns have been established from scratch. Although it may seem that the 'heroic' period of the new capitals, from Brasilia to Islamabad, represented a memory of times of developmentalist illusions (Holston 1984), more new capital cities were later established, from Astana-Nur-Sultan in Kazakhstan (Sect. 7.3) to the New Administrative Capital-NAC of Egypt, currently under construction, or the new Indonesian capital, Nusantara, in the Borneo/Kalimantan Island. In addition to these *grand* enterprises, until the 1980s, many more new towns were built, with well-known examples in the UK, France, and the USA. After that moment, however, changes in the political and ideological landscape, increasing costs, and evident difficulties paused such developments, which, on the global scale, retook strength at the end of the 1990s. More than 140 new towns were initiated since 2000, more than a third of which are in China, about 20 in India, seven in Kenya, and four each in Algeria, Saudi Arabia, the United States, and Vietnam (Forsyth 2021, 40–41). In this sense, the contribution of China outweighed all the rest and differed from the previous models: new towns in China are explicitly profit-oriented with a corporate presence since their conception and initiation, with public authorities relegated to the role of facilitators (Shatkin 2011); they tend to

be gentrified urban environments with Western-standard amenities boasting a spectacular design. They are exclusionary from the beginning, automobile-centred, and inherently speculative (Freestone 2021, 23). In many ways, twenty-first-century new towns also differ from past ones as they are not dormitory cities but service-oriented centres with amenities and services. Still, a new urban settlement is primarily devoted to accommodating a certain amount of the population, and this is the rationale for including this section in the present chapter. Following the work of international firms, we mainly focus in the following pages on China, the Shanghai metropolitan region in particular, and Masdar City in the UAE, a smaller-scale eco-tech city conceived by Foster + Partners.

New towns developed in China after 2000 arose from different factors, including the need to decentralise and decongest major urban centres, while part of the very urban population was looking for better living conditions, lower costs, and more space outside of cities. These towns tend to be compact developments around strategic transport nodes (Transport-Oriented-Development, or TOD), whose funding has been made possible by public development corporations able to borrow money from banks for infrastructural projects that become the backbone of the area's transformation. These new towns are then "wholly planned through comprehensive strategies and branding tactics" (Wu 2021, 154–155), and they feature a denser urban paradigm than the traditional image of the suburb would otherwise suggest, with high-rise residential and even clusters of skyscrapers alongside gated communities of villas or low-to-mid-rise blocks. Overall, Chinese new towns are "an urbanisation strategy" rather than "a niche marketing of lifestyle choices" in the *suburbia* (Wu 2021, 158), and, in fact, their development is entangled with the macro-economic scale and the comprehensive planning at the national level. Thus, although Shanghai offers multiple examples of new towns built according to the "One city and nine towns" vision inscribed in its *1999–2020 Masterplan* that called for the transformation of the region into a polycentric structure (Wu 2021, 158–159; den Hartog 2010), this phenomenon has touched the whole country, from the Pearl River Delta to the interior of the territory. Especially interesting in this regard is the "Go West" policy of urbanisation in inland China, mainly along the strategic hubs of the New Silk Road initiative (and of the high-speed railway network) in cities like Lanzhou, Xi'an, and Luoyang (Berta and Frassoldati 2019).

For these many mega projects, overseas architects have played different roles; in some instances, they have master-planned the whole new town and designed its main buildings; in others, they have been entirely absent from the process. From this perspective, one of the main projects has been Lingang New Town. Some seventy kilometres southeast of Shanghai, Lingang was a coastal manufacturing area supporting Shanghai port since the 1990s. In 2002, an international design competition was won by GMP to give form to a new 74-square-kilometre town merging with the industrial area (Wu 2021, 161–163). Conceived for 800,000 inhabitants, the city is organised into two main zones, one industrial and one residential and administrative, and shaped ideally following the model of the English garden city in a radial fashion, developing from a circular artificial lake (Fig. 8.24). The lake is faced by a first mixed-use semi-ring conceived as the CBD and the city's commercial centre, though

Fig. 8.24 A satellite picture of Lingang New Town, Shanghai, master-planned by GMP. © 2023 Maxar Technologies from Google Earth Pro

not devoid of housing. A second ring creates a green belt that separates this inner part from at least three main residential districts, arrayed in a radial fashion from the centre but internally organised according to a standard orthogonal grid following the cardinal points. These areas are formed by standard superblocks (up to 20 hectares) bound by arterial roads and containing a repetitive pattern of mid-rise and high-rise east–west oriented slabs. The green ring, however, features a continuous landscaped park in which the administrative centre and some cultural facilities are located. They include the Nanhui District Administration Centre (2005–08, 100,860 m^2), designed by GMP as an elongated east–west axial complex intersecting a north–south axis leading to the China Maritime Museum (2005–09, 46,400 m^2), also by GMP, and further north, the Shanghai Astronomy Museum (2015–21, 39,000 m^2) by Ennead. The German megafirm has also completed the Service Centre (2005–06, 45,000 m^2) and several warehouses in the industrial area of the city (Sect. 9.7). More importantly, we need to highlight how such a provision of cultural facilities, whose names even refer to a metropolitan or even national rather than local scope, induces a reflection on how these new cities differ, at least in the ambitions, from older examples of primarily residential settlements devoid of attractors and for this reason more strongly dependent from the centre (see also Liangzhu New Town; Sect. 6.1). The success of this operation, however, is still to be seen. Its population targets do not seem to be achieved yet (by 2010, it had only 212,000 from 156,000 a decade before), and the current result is a car-dependent city, with problematic circulation due to the lake's presence and shape, and an unfriendly scale of superblocks and wide roads (Wu 2021, 161–163).

8.7 The New Town in the Twenty-First Century: From Shanghai "One City … 373

Around Shanghai, the "One city and nine towns" vision promoted the development of new urban centres with different Western characters. The general plan for Greater Shanghai established a hierarchy of five classes: the proper city of Shanghai, three major new towns (including Songjiang), 11 general new towns, 22 central rural towns, and general rural towns. At the third level of this hierarchy, among the "general new towns", we find Pujiang (Minhang District) assigned to Italy, Anting (Jiading District) to Germany, Luodian (Baoshan District) to Scandinavian countries, Fengjing (Jinshan District) to Canada, Gaoqiao (Pudong District) to The Netherlands, Fengcheng (Fengxian District) to Spain, and Zhoupu (Nanhui District) and Buzhen (Chongming County) as Euro-American (Xue and Zhou 2007). Of these, only Songjiang, Pujiang, Anting, and Luodian followed up in concrete forms quite rapidly. Songjiang was master-planned by Atkins after getting the job through an international competition in which the firm participated against Sheppard Robson and Natural Building Design from the UK, Architettiriuniti from Italy, and S.C.U. from France. The plan envisioned a mixed-use city with a green belt and a British taste, sometimes as literal as to involve Tudor-style houses and red telephone boxes. Among third-level new towns, the largest project was the Italian one, Pujiang, assigned to Gregotti & Associati through an international competition held in 2001. At that time, Gregotti, an established architect and academic, had under his hands the redevelopment of the Bicocca district of Milan, a larger former industrial area transformed into a residential and university pole. In Pujiang, which had not least to accommodate the population relocated to free the site for the Expo 2010 (Sect. 7.1), the master plan's formal proposal was based on the superimposition of different grids, with the main one related to residential areas, and a pedestrian and a green one, while also the canal network was reconfigured. The residential area, where four different typologies inspired by both Italian and Chinese historical patterns define large blocks (300 by 300 m) forming villages with their own identity, is crossed by a central green axis containing major public buildings and commercial venues (den Hartog 2010; Xue and Zhou 2007). The city was, in the end, quite successful, with apartments quickly sold despite the high prices, whereas the social *mixité* sought by Gregotti was not achieved (den Hartog 2010). The area, which is comparatively closer to the centre than other new towns and just a few kilometres south of the Expo site, attracted investments that promoted further involvement of foreign architects. GMP designed the Pujiang High-Tech Park (2006–08, 145,000 m^2) and some additional office projects, Wilson the Crowne Plaza Shanghai Pujiang (2017), while Ennead has planned (the status is uncertain) a master plan for an east–west axis called Pujiang Science and Creation Corridor Phase 1.

Anting New Town, the German one, was master-planned by Albert Speer & Partners (AS+P) in 2000. And the link with the European industrial powerhouse is not casual, as Anting is one of the centres of the Chinese automotive industry, is home to Shanghai Volkswagen Automotive, is located not far from the Formula One Audi circuit, and hosts the Shanghai Auto Museum, designed by the Architectural Design & Research Institute of Tongji University and German firms IFB and, for part of the exhibition space, Atelier Brückner (not included in our survey). In Anting, the core of the residential area is surrounded by an irregular canal ring and features

low-rise blocks with coloured façades and pitched roofs, perhaps recalling some of Bruno Taut's *Siedlungen* in Berlin. In contrast, another ring of buildings around this inner core features a more Bauhaus aesthetic. The project successfully introduced a human scale and abundant pedestrian and green spaces, while problems arose due to the poor quality of construction and the financial difficulties of the developer (den Hartog 2010). AS+P, in addition to the original master plan and the updated one that was drafted after winning a second competition in 2009, designed over one thousand housing units, an exhibition centre, and a five-star hotel, while another German firm, Auer Weber, 90,000 m^2 of housing in a modernised version of a German Town. Due to the problems we mentioned, Anting was soon labelled a "ghost town", especially by the German press (Yang 2011). On the other hand, Loudian New City, designed by Swedish megafirm Sweco and partly completed already in 2004, did not manifest the same issues. Sweco defined different residential typologies, from large villas to townhouses, and a city centre with pedestrian streets and a Swedish small-town flavour. Luodian successfully positioned itself as an upper-middle-class suburb, so much that the Shanghai Golden Luodian Development Co. Ltd later launched a second development targeting the lower-income population, this time in Chinese style (den Hartog 2010). After this experience, Sweco was also involved in planning Tangshan Caofeidian Eco-City (2008), whose actual status is unknown.

Hence, these and other new settlements in the Shanghai metropolitan region did not represent the totality of the cases in China. As a complete mapping appears out of the scope of this book, we will concentrate on some more significant projects, especially from the perspective of studying the work of foreign architects in China. At the time when the "One city and nine towns" vision was initiated, another important project was also undertaken: Zhengdong New Town (New District now) in Zhengzhou (Xue et al. 2013). The master plan was drafted by Kisho Kurokawa, who won an invited competition in 2001 in which also Cox Architects, Sasaki Associates, Arte Charpentier, PED Consultants of Singapore, and the China Urban Planning Institute of Beijing participated. With its 150 km^2, the master plan almost doubled the existing city with a single gesture. However, the first phase involved just 33 km^2, where Kurokawa planned the CBD and residential areas. As explained by Charlie Xue and others, the master plan re-proposed Metabolist ideas of "cluster cells" but with little respect for the context: the extensive use of water for artificial lakes in an area with a problem of scarcity, for example, was criticised, as it was the new road system for being unrelated to existing patterns, while also the scale and the pedestrian unfriendliness of the urban space were a concern (Xue et al. 2013). Since the death of Kurokawa in 2007, his firm has not been further involved in Zhengdong, although by then, the Japanese architect had already designed an 80,000 m^2 model residential development and the Conference and Exhibition Centre (Sect. 10.7), while the egg-shaped Henan Arts Centre (2003–08, 63,000 m^2) was completed following a design by Carlos Ott (not included in our survey). In addition, Paul Andreu and Arata Isozaki unsuccessfully participated in subsequent competitions for the new CBD.

Indeed, in the last decade, Eco-Cities have been replacing, at least in the nomenclature, the New Towns. Some of them are the result of local initiatives, like, for example, the Chongming Eco-Island in Shanghai, others are national-level flagship

8.7 The New Town in the Twenty-First Century: From Shanghai "One City ... 375

projects, like the Meixi Lake Eco-City in Changsha (whose development involved KPF, Atkins, Arup, and Gale International), and others are the result of international cooperation projects, like the Sino-Swedish Wuxi Eco-City and the Sino-Singapore Tianjin Eco-City (Deng and Cheshmehzangi 2018, 105–155). The latter one, whose construction began in 2008 following an agreement between the two governments, is expected to achieve a population of 350,000 by 2020, although in 2019, only about 100,000 people lived there. The Sino-Singapore Tianjin Eco-City represents an interesting case for its political value, for having set some Key Performance Indicators that guided the master-planning process, and for being built over partly salt field, non-arable lands lacking water resources, thus minimising its impact on fertile farmland (Deng and Cheshmehzangi 2018, 131–142). Regarding eco-cities, we can conclude this section by abandoning China and looking at one of the international flagship projects for a sustainable city: Masdar, in the United Arab Emirates.

Conceived as part of a broader strategy to diversify the economy of Abu Dhabi's Emirate and lead in the future transition from a fossil-fuel based to a sustainable economy (Reiche 2010), Masdar City aims at defining the blueprint for the sustainable, carbon–neutral, zero-waste city of the future. To understand the sky-high ambition beyond this project, let us just consider that the Masdar Institute's researchers originally envisioned a currency, the Ergos, working as a sort of individual energy balance, for which consumptions exceeding the allocated energy budget (a certain quantity of energy to be consumed during a certain time) would make necessary the purchase of costly Ergos on the spot market (Günel 2019, 101–126). Masdar was launched with much fanfare in 2006, with Foster + Partner developing the master plan in 2008, planning to house 50,000 inhabitants and a floating population of 40,000 more. The city was thus designed to extend over an area of six square kilometres and be car-free, counting on a system of Personal Rapid Transit (PRT) later not implemented, although experimentations on different automated electric vehicles are ongoing. This ambitious PRT system, an integral part of Foster's vision, consisted of an underground network of on-demand transportation, combining the logic of private and public mobility, with 1,800 vehicles stopping in 84 stations (Günel 2019, 127–154). As for the urban scheme, the city was designed by Foster as a mixed-use, low-rise, and dense fabric, inspired by traditional Arab cities, with shaded streets and courtyards to promote pedestrian fruition. In terms of energy consumption, the city was expected to be autonomous and fully sustained by its photovoltaic and concentrated solar power plants. Still, the reality has been more disappointing, with the need to rely on energy elsewhere produced and the inability to desalinate water autonomously (Crot 2013). More criticism, on the other hand, has also been expressed for its overall proposal, seen as an ultimate "gated community" for a refined global elite *vis-à-vis* the countless ghettos where sustainability does not really seem to matter (Ouroussoff 2010).

By 2022, no more than a tenth of the city was built, including Foster-designed Masdar Institute (2007–15, 340,000 m^2; Fig. 8.25). It consists of several buildings to accommodate residences and educational and research facilities, complemented by a wide array of services, all arranged in a low-rise, dense and compact fabric, crossed by pedestrian streets with arcades and piazzas. Green and water features

Fig. 8.25 The south-eastern front of the Masdar Institute with residences (on the two sides with sand-coloured GRC façades) and the Laboratories (in the centre with ETFE cushion façades) by Foster + Partners in Masdar City, Abu Dhabi. Photograph by Giaime Botti, distributed under a CC BY 4.0

on the street level and cooling towers mitigate the outdoor climate, while residences feature latticework screens in desert-sand coloured GRC panels reminding traditional *mashrabiya*. In the new area, while Adrian Smith + Gordon Gill's Masdar HQ seems not to have materialised yet, two office projects that distinguish themselves for their environmental performances have been completed. The first one was the Siemens Middle East HQ (2013, 20,000 m^2, LEED Platinum; Fig. 8.26) designed by Sheppard Robson as a horizontal square-plan block with a parametrically designed system of aluminium shadings and an overall high-tech aesthetic; the second one was the International Renewable Energy Agency HQ (2015, 32,000 m^2; Fig. 8.27) by Woods Bagot. Next to this building, the same firm has designed the MC2 office campus (48,000 m^2), currently under construction with completion expected for 2023, and, in the residential sector, the Etihad Eco-Residence (2017, 226,600 m^2, LEED Platinum; Fig. 8.28), a 500-apartment complex spread over eleven building. The next phase of the development was then taken over by CBT Architects, which completed the Etihad Eco-Residence II in 2020 (100,840 m^2; Fig. 8.28). IBI Group was also involved in the master plan of a residential sector of Masdar and Sasaki in the one for the Khalifa University of Science, Technology and Research, whose actual implementation is difficult to verify. Unsuccessful design proposals in the city also include Heatherwick Studio's Masdar Mosque, and two projects by Denton Corker Marshall, one for a Hotel and Convention Centre and the other for a Shopping Centre, both dated 2008.

8.7 The New Town in the Twenty-First Century: From Shanghai "One City ... 377

Fig. 8.26 The Siemens Middle East HQ by Sheppard Robson in Masdar City, Abu Dhabi. Photograph by Giaime Botti, distributed under a CC BY 4.0

Fig. 8.27 The International Renewable Energy Agency HQ by Woods Bagot, in Masdar City, Abu Dhabi. Photograph by Giaime Botti, distributed under a CC BY 4.0

Fig. 8.28 Etihad Eco-Residence by Woods Bagot (in the background) and Etihad Eco-Residence II by CBT Architects (on the right) in Masdar City, Abu Dhabi. Photograph by Giaime Botti, distributed under a CC BY 4.0

8.8 Conclusions

For almost a century the main interest of progressive architects, housing represents today for the globalised profession an opportunity to work on large-scale projects for the middle and upper-middle-class, especially in China, and luxury high-rise condominiums in South-East Asia, India, the Persian Gulf, and Latina America. The vast majority of these projects are of little architectural interest but relevant to show standard patterns across the emerging markets in which foreign architects are requested to design 'golden ghettos' for the better offs who can enjoy, protected by fences and walls within their gated communities, lavish green spaces and fancy amenities. On the opposite of the typological spectrum, then, we have communities of villas, usually even less notable in terms of the architectural proposal, in which many of the advantages of the single-family house are paradoxically erased or eroded: privacy is reduced by density and proximity, individuality is denied by the repetition of a standardised model.

In this not-so-encouraging panorama, however, two realities stand out. The first one is represented by some bold architectural experimentations carried out in emerging markets by architects who found developers able and willing to invest in high-density, large-scale projects that defy traditional housing typologies and evoke the audacity of some megastructural visions of the 1960s. That is the case of several projects by Moshe Safdie between China and Singapore or of Koolhaas/OMA/Ole Scheeren's Interlace in Singapore. Indeed, unlike some decades ago, all this creativity is put at the service of developers selling these apartments to the local upper-middle-class. From our mapping, it also clearly emerges that social housing in emerging markets is not business for overseas firms (in their own regions, the discourse could be different). The second point to stress is the emergence of new fragments of cities resulting from unitary mixed-use developments that generally feature higher design standards and a porous character. Extended over one or more blocks (superblocks in the case of China) and some hundreds of thousands of square metres, pedestrianised in their cores and richer in public space, they usually include a mix of programmes, with retail at the lower floors—sometimes in the form of a shopping mall anchor, others in a more village-like ground floor of shops and F&B–, and some office, hotels, and residential space on the upper floors. These developments may take the form of a podium plus towers configuration, of medium-rise slabs or blocks of more complex shape like in Raffles City Chengdu, but also of a denser, compact fabric like in Msheireb Downtown. Finally, at a broader scale, there are several projects for new towns that have involved foreign architects, especially in China. Here, some of these settlements appeared as revivals of the dormitory satellite town, although targeting the middle rather than the working class; others, like Nanhui, displayed bigger ambitions, embodied by the presence of large cultural facilities. Then, the most ambitious project can be found in the UAE, where Masdar City, currently under construction but partly already functioning, aspires to be the blueprint for a sustainable urban future.

All in all, the exploration of the work of international design firms in residential architecture displays an agency that involves different levels of the profession, from boutique firms delivering projects for high-quality residential estates (those designed by Chipperfield in China, for instance) to megapractices designing large and generic compounds of several high-rise buildings. The result, in any case, is always and increasingly the one of a tale of two cities. Whether gated or porous, mono-functional residential or mixed-use, experimental and bold or generic and banal, this architecture reflects the growing social polarisation and division of the global (Sassen 1991) and globalising cities.

References

Abrahams, Tim. 2018. Revisiting habitat 67: Moshe Safdie's montreal masterpiece has stood the test of time. *The Architectural Review* 224 (1451): 106–111.

Berta, Mauro, and Francesca Frassoldati. 2019. New urbanisation and 'go west' policies. In *The City After Chinese New Towns. Spaces and Imaginaries from Contemporary Urban China*, ed. Michele Bonino, Francesca Governa, Maria Paola Repellino and Angelo Sampieri, 78–89. Basel: Birkhäuser.

Bristol, Katharine. 1991. The Pruitt-Igoe Myth. *Journal of Architectural Education* 44 (3): 163–171.

Campanella, Thomas J. 2008. *The Concrete Dragon: China's Urban Revolution and What It Means for the World*. New York, NY: Princeton Architectural Press.

Chen, Kaiji, and Yi Wen. 2017. The great housing boom of China. *American Economic Journal: Macroeconomics* 9 (2): 73–114.

Chen, Stefanos. 2021. The downside to life in a supertall tower: Leaks, creaks, breaks. *The New York Times*, Feb 3. https://www.nytimes.com/2021/02/03/realestate/luxury-high-rise-432-park.html. Accessed 27 Sept 2022.

Crot, Laurence. 2013. Planning for sustainability in non-democratic polities: The case of Masdar City. *Urban Studies* 50 (13): 2809–2825.

CTBUH. 2021. Mumbai. *Council on tall buildings and urban habitat.* https://www.skyscraperce nter.com/city/mumbai. Accessed 25 Sept 2021.

CTBUH. 2022. Cities. *Council on tall buildings and urban habitat.* https://www.skyscrapercenter. com/city/. Accessed 20 Sept 2022.

Day, Peter. 2012. Ordos: the biggest ghost town in China. *BBC*, Mar 17. https://www.bbc.com/news/magazine-17390729. Accessed 17 Oct 2022.

den Hartog, Harry. 2010. *Shanghai New Towns: Searching for Community and Identity in a Sprawling Metropolis.* Rotterdam: Nai010.

Deng, W., and A. Cheshmehzangi. 2018. *Eco-Development in China: Cities, Communities and Buildings.* Singapore: Palgrave Macmillan.

Denton, Alexis, and Joyce Polhamus. 2014. American senior living models in China. *Smith Group.* https://www.smithgroup.com/sites/default/files/2018-07/The_CCRC_Model_in_China.pdf. Accessed 15 June 2022.

Forsyth, Ann. 2021. The promises and pitfalls of new towns. In *New Towns for the Twenty-First Century: A Guide to Planned Communities Worldwide*, ed. Richard Peiser and Ann Forsyth, 32–42. Philadelphia, PA: University of Pennsylvania Press.

Frampton, Kenneth. 2020. *Modern Architecture: A Critical History*, 5th ed. London: Thames & Hudson.

Freestone, Robert. 2021. A brief history of new towns. In *New Towns for the Twenty-First Century: A Guide to Planned Communities Worldwide*, ed. Richard Peiser and Ann Forsyth, 14–31. Philadelphia, PA: University of Pennsylvania Press.

References

Giroir, Guillaume. 2006. A globalized golden Ghetto in a Chinese garden. The fontainebleau villas in Shanghai. In *Globalization and the Chinese City*, ed. Fulong Wu, 209–225. London; New York, NY: Routledge.

Glaeser, Edward, Wei Huang, Yueran Ma, and Andrei Shleifer. 2017. A real estate boom with Chinese characteristics. *The Journal of Economic Perspectives* 31 (1): 93–116.

Günel, Gökçe. 2019. *Spaceship in the Desert: Experimental Futures.* Durham, NC: Duke University Press.

Holston, James. 1984. *On Modernism and Modernization: The Modernist City in Development, the Case of Brasilia.* Notre Dame, IN: Helen Kellogg Institute for International Studies.

Howarth, Dan. 2016. Ordos: A failed Utopia photographed by Raphael Olivier. *Dezeen*, Jan 10. https://www.dezeen.com/2016/01/10/ordos-a-failed-utopia-china-raphael-olivier-photo-essay/. Accessed 17 Oct 2022.

Hsu, Sara. 2022. China's real estate slump: Underlying issues. *The Diplomat*, May 26. https://thediplomat.com/2022/05/chinas-real-estate-slump-underlying-issues/. Accessed 10 Aug 2022.

Jencks, Charles. 2002. *The New Paradigm in Architecture. The Language of Post-Modernism.* New Haven, CT; London: Yale University Press.

Jericho, Greg. 2014. China's housing market is on the brink of collapse. Should Australia be worried? *The Guardian*, Sept 8. https://www.theguardian.com/business/grogonomics/2014/sep/08/why-a-collapse-in-chinas-housing-market-will-hurt-australia. Accessed 12 Aug 2022.

Graham, Stephen. 2015. Luxified skies: How vertical urban housing became an elite preserve. *City* 19(5): 618–645.

Mathis, Will, and Tiago Ramos Alfaro. 2021. Repeat Chinese defaulter sunshine 100 misses another payment. *Bloomberg*, Dec 5. https://www.bloomberg.com/news/articles/2021-12-05/china-developer-sunshine-100-defaults-on-170-million-of-bonds. Accessed 10 Aug 2022.

Merrick, Jay. 2018. A map in search of lost territory: The development of Msheireb Downtown Doha is intended to recreate the cultural roots of the district while accepting the march of time. *The Architectural Review* 244 (1451): 34–40.

Moore, Rowan. 2015. Tropical megalith. *The Architectural Review* 237 (1418): 88–95.

Mumford, Eric. 2018. *Designing the Modern City: Urbanism Since 1850.* New Haven, CT: Yale University Press.

National Bureau of Statistics of China. 2021. *China Statistical Yearbook 2021.* Beijing: China Statistics Press.

Ouroussoff , Nicholai. 2010. In Arabian desert, a sustainable city rises. *The New York Times*, Sept 26. https://www.nytimes.com/2010/09/26/arts/design/26masdar.html?_r=0&pagewanted=all. Accessed 10 Feb 2021.

Ponzini, Davide. 2020. *Transnational Architecture and Urbanism. Rethinking How Cities Plan, Transform, and Learn.* London: Routledge.

Pearson, Clifford A. 2018. MVRDV, megastructure. Pune, India. *Architectural Record* 206 (10): 118–123.

Radović, Vuk. 2020. Density through the prism of supertall residential skyscrapers: Urbo-architectural type in global megacities. *Sustainability* 12 (4): 1314.

Rapoza, Kenneth. 2014. China gives up on housing bubble. *Forbes*, Dec 27. https://www.forbes.com/sites/kenrapoza/2014/12/27/china-gives-up-on-housing-bubble/. Accessed 12 Aug 2022.

Reiche, Danyel. 2010. Renewable energy policies in the gulf countries: A case study of the carbon-neutral 'Masdar City' in Abu Dhabi. *Energy Policy* 38 (1): 378–382.

Ren, Xuefei. 2011. *Building Globalization: Transnational Architecture Production in Urban China.* Chicago, IL: The University of Chicago Press.

Rogoff, Kenneth, and Yuanchen Yang. 2021. Has China's housing production peaked? *China and the World Economy* 21 (1): 1–31.

Rowe, Peter G., Ann Forsyth, Kan, and Har Ye Kan. 2016. *China's Urban Communities: Concepts, Contexts, and Well-Being.* Basel; Berlin; Boston, MA: De Gruyter.

Safran, Yehuda. 2003. La Simmons Hall. *Domus*, Apr 1. https://www.domusweb.it/it/architettura/2003/04/01/la-simmons-hall.html. Accessed 15 May 2021.

Sassen, Saskia. 1991. *The Global City: New York, London, Tokyo*. Princeton, NJ: Princeton University Press.

Schmidt, André, and Joris Fach. 2020. Superblock security. In *The China Lab Guide to Superblock Urbanisms*, ed. Jeffrey Johnson, Cressica Brazier, and Tam Lam, 342–347. Barcelona; New York, NY: Actar.

Shatkin, Gavin. 2011. Planning privatopolis: Representation and contestation in the development of urban integrated mega-projects. In *Worlding Cities: Asian Experiments and the Art of Being Global*, ed. Ananya Roy and Aihwa Ong, 77–97. New York, NY: Wiley-Blackwell.

Sudo, Chuck. 2019. Best international design of 2018: City meets nature in sprawling Chinese campus. *Senior Housing News*, Feb 6. https://seniorhousingnews.com/2019/02/06/best-intern ational-design-of-2018-the-future-of-chinese-senior-living-is-sprawling-cities-within-a-city/. Accessed 18 May 2022.

Tilton, Andrew, Jonathan Sequeira, Hui Shan, Goohoon Kwon, Helen Hu, Maggie Wei, and Xinquan Chen. October 2021. *How Big is the China Property Sector?* Goldman Sachs China Data Insights, Goldman Sachs.

Wainwright, Oliver. 2019. Super-tall, super-skinny, super-expensive: The 'pencil towers' of New York's super-rich. *The Guardian*, Feb 5. https://www.theguardian.com/cities/2019/feb/05/ super-tall-super-skinny-super-expensive-the-pencil-towers-of-new-yorks-super-rich. Accessed 20 Sept 2021.

Williams, Austin. 2013. The ghost town Ai Weiwei built. *The Architectural Review*, Sept 23. https:// www.architectural-review.com/essays/the-ghost-town-ai-weiwei-built. Accessed 17 Oct 2022.

Wu, Fulong. 2006. Transplanting cityscapes: Townhouse and gated community in globalization and housing commodification. In *Globalization and the Chinese City*, ed. Fulong Wu, 190–207. London; New York, NY: Routledge.

Wu, Fulong. 2021. A governance perspective on new towns in China. In *New Towns for the Twenty-First Century: A Guide to Planned Communities Worldwide*, ed. Richard Peiser and Ann Forsyth, 152–165. Philadelphia, PA: University of Pennsylvania Press.

Xue, Charlie QL., and Minghao Zhou. 2007. Importation and adaptation: Building 'one city and nine towns' in Shanghai: A case study of Vittorio Gregotti's plan of Pujiang town. *Urban Desing International* 12: 21–40.

Xue, Charlie QL., Ying Wang, and Luther Tsai. 2013. Building new towns in China—A case study of Zhengdong new district. *Cities* 30: 223–232.

Yang, Xifang. 2011. Anting German town: Chinas Deutsche Geisterstadt. *Der Spiegel*, Oct 7. http:// www.spiegel.de/reise/staedte/0,1518,783475,00.html. Accessed 17 Sept 2022.

Chapter 9
Workplace: The Office and Beyond the Office

An illuminating passage of Koolhaas' (1995, 1260) "The Generic City" reads as follows: "Offices are still there, in ever greater number. People say they are no longer necessary. In five to ten years, we will work at home. But then we will need bigger homes, big enough to use for meetings. Offices will have to be converted to homes." Some twenty-five years later, although this reality is challenged by events, the office is still there. Neither co-working emerging after the Great Financial Crisis of 2007–08, nor remote working becoming a common, even compulsory practice throughout the world in a matter of weeks with the COVID-19 pandemic have delivered the fatal blow to the office as primary workplace typology. Certainly, in a very short time, the pandemic has made it possible to overcome company management's resistance to allowing staff to work from home. What was a practice involving a small percentage of highly qualified workers became the new normal. Data show that, in the European Union, between 2009 and 2019, a mere 5.2% of employees used to work from home. In those ten years, casual remote work had increased only to 9% (European Commission—Joint Research Centre 2020). However, more than two years after the pandemic's beginning, many workers who experienced the benefits (and the problems, too) of working from home are back to the office, mostly unwillingly. According to a survey by McKinsey (Dua et al. 2022), 87% of US workers, for instance, would take the chance to work flexibly if allowed, and flexibility is one of the highest-ranked reasons to accept a new job; needless to say, flexibility implies the possibility of working from home or any other place at choice. As another report from McKinsey explains, the potential for remote work is higher in advanced economies: in the UK, Germany, or the USA, for example, the workforce could work up to 33%, 30%, and 29% of the time remotely without losing productivity against a mere 12% in India, 16% in China, and 18% in Mexico. Or to see the same issue from another angle, 26% of British employees, 24% of German, and 22% of US could potentially work remotely up to five days a week without a loss of productivity. The same is valid only for 15% of the Mexican workforce, 11% of the Chinese, and 5% of the Indian (McKinsey Global Institute et al. 2020). All in all, many firms are now pushing to

© The Author(s), under exclusive license to Springer Nature Singapore Pte Ltd. 2023
G. Botti, *Designing Emerging Markets*,
https://doi.org/10.1007/978-981-99-1552-1_9

have their employees back in the office, but remote work will not disappear (Robinson 2022).

What is certain is that despite several obituaries written too early, people will keep working—at least partially—in offices for a good while (Tisch 2020). That said, the global picture is diverse, as diverse were conditions before the pandemic struck. While forecasts about the future are inherently tricky and flawed, we can look at what has been happening since 2020. Unlike in the USA, for instance, in the Asia–Pacific region, the office market has shown remarkable resilience. According to a report by Cushman & Wakefield (Brown 2022), this was due to three reasons: the overall growth in office (tertiary) jobs in the region, the "vital" role of the office space, and a "weaker adoption of flexible working practices." This last factor sees a significant divide across countries in terms of employees' preferences: in Australia or the USA, up to 26% and 51% of the workers preferred to attend the office infrequently; in China, this number is a mere 6%, and in India 16%, with APAC countries' average on 21%. Thus, while in India in the first six months of 2021 office space lease was down 22% compared to the previous year (Press Trust of India 2021), it had significantly recovered in the second part of the year (Kahn 2021). By September 2021, it has been calculated that 40% of office workers worldwide have returned to their workplace, with significant variations across countries and regions. While in China, it was nearly 100% (harsh lockdowns of late 2021 and the first half of 2022 had not happened yet); in Europe was 40%; in the USA, 34%; in the APAC region, 32% (Cushman & Wakefield 2021). Figures appear, therefore, influenced by the structural economic factors, cultural diversities in terms of employees' and management's preferences, and the evolution of the pandemic.

Although the COVID-19 pandemic has quickly and profoundly changed so much in our lives, especially in relation to work habits, our investigation does not certainly focus only on the last two years. In fact, we have about three decades of architecture to explore. During those years, an enormous amount of office space has been added in many cities worldwide, especially in emerging markets, where the very structural conditions of their economies will add millions of office jobs in the following decades after having already done so in the previous ones. In such a context, international design firms, and especially some megapractices with an almost centennial know-how, have delivered dozens of office projects. We will thus study major office developments starting from China to move to other regions and different typologies. The focus of this chapter, in fact, is not only on the office but, more generally, on the architecture of the workplace. Following this broad concept, we will investigate the multiple typologies of offices—single-tenant or multi-tenant office skyscrapers, low-rise office blocks, mixed-use developments, and hybrid buildings—and also factories, research centres and laboratories sometimes clustered in science and technology parks, universities as places of knowledge production, and even hospitals. The rationale for including them here is the highly specialised character of these facilities, the consequent specific know-how requested for their design, and the minor interest clients and developers may have in seeking iconic, flashy buildings. Hence, the architecture of the workplace emerges as a mixed reality to be read at different scales, from that of the single building to the one of larger urban areas, even real

9.1 Global Cities and Multinational Companies: The Office is Dead; Long ... 385

cities within cities for technology parks and university campuses. In most cases, this architecture appears dominated by the principles of efficiency, high design standards (for instance, in terms of building energy performance), and symbolic expressions related to corporate values (transparency, technological avant-gardism).

9.1 Global Cities and Multinational Companies: The Office is Dead; Long Live the Office

As anticipated, the office building is still alive, but more changes are underway. One of the most important is the shift in the market towards higher standards. In the USA, for example, different indicators show that the office lease activity has not recovered pre-pandemic levels (CBRE 2022), but also that the lease market is now a "tale of two cities," with offices within Class-B- and -C buildings that struggle to find occupiers and are leased with huge discounts, while for grade-A office the competition among potential tenants can be strong (Cohen 2022), showing a clear trend that favours larger offices of higher standards. And this is true not only in the USA. In India, too, 'de-densification' is one of the new keywords, meaning the request for larger office space in terms of square metres per worker to ensure social distancing and the availability of more space for collaborative work and well-being areas (Jain 2022).

For our study, therefore, while changes related to the pandemic are only minimally considered as they touch the very end of our timeframe, they also predict, in a way, an even greater involvement of overseas architects in designing office buildings across many emerging economies. This is because some of these firms have already gained a conspicuous market share in office design thanks to their ability to deliver high-quality projects with efficient use of space, flexible and varied interiors to adopt contemporary ways of working that enhance horizontal collaboration and employees' well-being, and very high environmental standards, often acknowledged by LEED Gold and Platinum certifications. Although such buildings may be more costly, in the long-term, the leaser would save on bills and emerge as a leader in corporate social responsibility. Accordingly, this chapter explores the office building as the main typology of the workplace in emerging economies, with particular attention to China and Asia.

In China alone, this study counted at least 26 million square metres of office space spread over almost two hundred projects designed by our sample of firms. To put numbers in perspective, since 2000, about 800 million square metres of office space have been developed in the country, according to official data (National Bureau of Statistics of China 2021; Chap. 19.9). However, our 26 million square metres do not include mixed-use developments, which generally feature a large share of office space together with a variety of programmes spanning from residential to hospitality and retail. From our data, we can also infer an average GFA of about 95,000 m^2 for office projects. Still, variations are vast, as differences among typologies are very significant, too. Behind this average, in fact, we may find refurbishments accounting

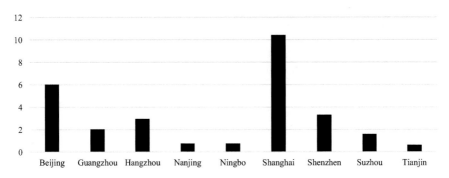

Fig. 9.1 Built office GFA (million m^2) by overseas firms (surveyed sample) in selected Chinese cities, 1990–2020. Copyright Giaime Botti

for a few thousand square metres as well as large office complexes made of multiple buildings of a few hundred thousand square metres.[1] Outside of China, other surveyed regions do not feature a comparable amount of built GFA by our sample of firms: 1.8 million square metres in South-East Asia, 1.5 in India, a few hundred thousand in Africa, about 1.7 million in Russia and Kazakhstan, 4.8 in the Persian Gulf, 2.3 in Latin America.[2] According to these initial data, the rest of the present section will discuss overall trends, geographical concentrations, market dominance by specific firms, and the connections between corporate clients and architectural firms. Architecturally significant examples, instead, will be debated in the next section, along with different office typologies.

The millions of square metres of office space designed in China by foreign firms are spread unevenly across the country (Fig. 9.1), with more than half of them—not surprisingly—concentrated in Shanghai, the financial capital of China and its most international city. Foreign banks, insurance companies, and major corporations have chosen Shanghai, since the 1990s, for their landing in mainland China, while the city still receives the highest share of FDI. In 2019, for example, Shanghai received U$19.05 billion in FDI, compared to 14.21 of Beijing and 13.17 of Chengdu, the third-ranked (National Bureau of Statistics of China 2020, 118–124). In the megalopolis of the Yangtze River Delta region, multinational companies find the top-end infrastructure of office buildings, hotels, airports, museums, international private schools and so on necessary to attract the "global class" of professionals they employ (Sassen 2006, 262–266). And Chinese companies, too, often locate their headquarters in Shanghai, although other cities have also emerged, especially Shenzhen and Hangzhou, while Beijing, in any case, holds a central position in terms of office GFA designed by overseas firms.

[1] It must be reminded again about the limits of such data, which help understand the scale and macro-differences rather than micro-comparisons. Of many projects, data on GFA are, in fact, missing (Sect. 2.5), while another problem is the difficulty in calculating the office programme in mixed-use projects (which have been excluded from this account).

[2] Figures always refer to the countries object of this study, not to the whole continent/region.

9.1 Global Cities and Multinational Companies: The Office is Dead; Long ...

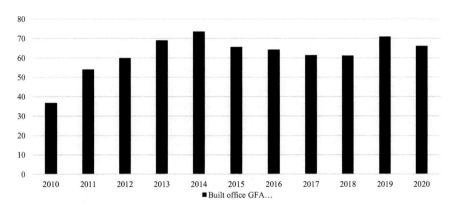

Fig. 9.2 Office GFA (million m^2) started per year in China for real estate development (Data from National Bureau of Statistics of China 2021, 19–9). Copyright Giaime Botti

To understand the relevance of these numbers, we can compare them to the total floor space of office real estate completed every year in China in the last decade. As visible in Fig. 9.2, on average, 61 million square metres of office floor space have been added every year since 2010. In this light, the ten million square metres in Shanghai delivered by our sample of foreign firms are not irrelevant. Similarly, the 10 million square metres completed by GMP across China in about two decades are impressive. And other firms, too, had remarkable performances: KPF 2.8, Goettsch Partners 1.9, and SOM 1.7.[3]

Having already identified major cities for office projects, we may now delve more into some of them by exploring the connections between major multinational companies and overseas design firms, generally megapractices, which are their preferred choice. Before proceeding, there are two issues to clarify. First, this section overlaps with Chap. 5, as many office buildings and corporate headquarters are skyscrapers. Second, several more projects will be explored in the next section.

Starting our overview from some major automotive multinationals, we can find in Shanghai the General Motors Administrative Office Building (2010, 26,850 m^2) by B+H, the recently completed SAIC Volkswagen Technology Management Phase II also by B+H, and the Porsche Lujiazui Software Park by US firm HLW. In the same city, RMJM delivered the project for the US chemical giant Dow Corning China R&D HQ (2006, 25,000 m^2), while Gensler designed the Johnson Controls Headquarters Asia Pacific (2019, 35,117 m^2), an elongated building conceived as a demonstration of sustainable design, boasting not only a LEED Platinum certification, but also a China Three Star rating, and an EDGE (Excellence in Design for Greater Efficiencies) recognition. Other significant cases include the several tech multinationals that have

[3] These figures are still an approximation as they refer to projects categorised as purely office space or office plus retail, but do not include mixed use developments, which usually have strong share of office space, but also retail, residential, and/or hotel space. For these reasons, some actors may be under-represented, especially SOM that designed many large mixed-use developments.

established local headquarters, offices, and research centres in buildings designed by our sample of firms. The Microsoft R&D Headquarters (150,000 m^2) in Beijing and the Microsoft Zizhu Campus in Shanghai were designed by NBBJ. At the same time, South Korean firm Samoo in collaboration with Chicago-based RATIO SMDP delivered the 260-m-tall tower for the Samsung HQ (2018, 168,000 m^2) in Beijing.

Chinese tech giants Tencent and Alibaba have also relied on foreign architects for their headquarters and office buildings. In 2018, NBBJ completed the spectacular Tencent Seafront Towers (270,000 m^2, 250 m, interiors by B+H; Fig. 9.3) in Shenzhen, composed of two rectangular skyscrapers interlocked by three multi-storey skybridges, while another tower is currently under construction in Guangzhou according to a project of the Atelier Jean Nouvel (105,000 m^2, 207 m). When completed, it will boast a series of cantilevering gardens culminating with a deep projecting terrace at the top. In Beijing, OMA has recently completed the new local Headquarters (2011–19) of Tencent. This seven-storey extruded square of 180 by 180 m is diagonally sliced in its corners to highlight the entrances and represents for the designers a horizontal counterpoint to corporate towers. In Hangzhou, Hassell designed the Alibaba Headquarters (2009, 150,000 m^2) as a campus-like cluster of buildings organised around a central green space, while for the Alibaba Centre Ant Financial Z Space (2014, 80,000 m^2) and the Alibaba Group "Taobao City" (2013, 260,000 m^2) the company relied on NBBJ and Kengo Kuma respectively. The Alibaba Jiangsu HQ (850,000 m^2) in Nanjing is currently under construction, according to a project by Benoy. GMP, as mentioned before, boasts an impressive portfolio of office, technology parks, and mixed-use projects in the country. To give an example of GMP's involvement, we can mention the works for Chinese telecommunication giants China Telecom and China Mobile. For the former, the German megafirm completed the CT Office and Technical Buildings B12&B13 (2005–07, 50,000 m^2) in Shanghai, while for the latter, the CM South Base (2006–09, 176,000 m^2) in Guangzhou, the CM North Operation Centre (2008–13, 150,350 m^2) in Beijing, the CM Research Centre Phase I (2014–17, 80,250 m^2) in Suzhou, and the CM Data Centre (2012, 615,635 m^2) in Harbin. Chinese computer manufacturer Lenovo counted on Callison RTKL for its Campus Global HQ in Beijing, while iron and steel producer Baosteel on Pelli Clarke Pelli for both the Shanghai HQ (2016, 81,000 m^2, 199 m) and its Guangzhou office tower (2016, 83,300 m^2, 140 m). The headquarters of the largest bank in the world, the Industrial and Commercial Bank of China, was designed by I. M Pei (63,500 m^2, 2011) in a monumental, glazed crescent building, while FX Collaborative developed the drawings for its Shanghai main office (2000, 59,000 m^2). Pei also designed the Bank of China Beijing Headquarters (173,000 m^2) back in 2001, as well as the Suzhou tower (2015, 100,000 m^2), Nikken Sekkei the Shanghai tower (2000, 116,900 m^2, 226 m), SOM the Ningbo HQ (107,800 m^2, 246 m; Fig. 9.4), while Atkins' tower for Chongqing is currently under construction (82,000 m^2, 198 m).

Fig. 9.3 The Tencent Seafront Towers by NBBJ, Shenzhen. Photograph by luxizeng

Further digging into our data, other cities outside China emerge for the presence of a relatively large amount of office space designed by international firms. Not surprisingly, within our regional samples, such cities are the administrative and political capitals or represent these countries' economic and financial powerhouses (Fig. 9.5). As the Middle East is the largest market for foreign architects after China (Sect. 4.3), we see strong demand for office space designed by foreign architects in cities like Riyadh, Dubai, and Abu Dhabi. In other surveyed regions, Jakarta stands out. Once again, however, we must warn that these numbers underestimate reality for the reasons we have explained before.

From the numbers in Fig. 9.5, Riyadh appears to outpace other cities in terms of office space delivered by overseas firms. Such a difference can be due to the comparatively more extensive involvement of (Western) foreign firms in the KSA than in the UAE, where several local big AEC companies are based, but also to flaws in our data collection. For example, data on GFA are only available for some office and mixed-use (residential + office) towers designed in Dubai by Atkins (Sect. 5.3). That said, as also seen in the same chapter, in Riyadh, the King Abdullah Financial District is currently emerging as a new national centre for business, boasting a concentration of tall buildings, primarily monofunctional office towers, mainly designed by US firms. Its three million square metres alone, even if only partially occupied by office space, can explain the primacy of Riyadh in our figures. Although most of the office area is vertically stacked in towers in Dubai, medium and low-rise typologies have also been built. In terms of design, examples span from simple prismatic glazed volumes like in Broadway Malyan's HSBC Dubai (2019, 37,000 m^2) and KPF's Standard Chartered Dubai (24,200 m^2) to the extruded blob with a perforated concrete shell of Reiser + Umemoto's O-14 (2006, 31,400 m^2); from the triangular Chamber of Commerce & Industry designed by Nikken Sekkei and

Fig. 9.4 The Bank of China Ningbo HQ by SOM in Ningbo Eastern New City, Ningbo. Photograph by Giaime Botti, distributed under a CC BY 4.0

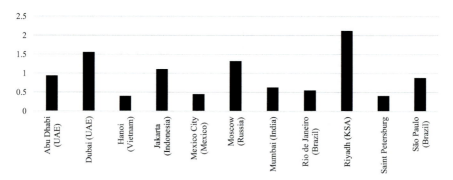

Fig. 9.5 Built office GFA (million m^2) by surveyed firms in selected cities. Copyright Giaime Botti

completed in 1995, to Gensler's The Gate (Fig. 9.6), a not well-proportioned repetition of Johan Otto V. Spreckelsen's Grande Arche (1989) in La Défense, but devoid of its *grandeur*. Other office developments include projects like the Meraas HQ (2014, 14,144 m^2), a complex of low-rise buildings connected by courtyards and shaded paths surrounded by water, and the Dubai WTC Office Buildings C1-C5 (2017, 224,000 m^2), an ensemble of 9-to-13-storey buildings with retail at the ground floor connected with an abundance of atria and green roofs, both designed by Hopkins, and RMJM's Innovation Hub (2014–18, 110,000 m^2 office + 90,000 m^2 hotel) and the Dubai IFC Precinct Buildings (2005–17, 100,000 m^2).

In other regions, workplace design has not kept international firms busy as much as in China and the Middle East, and projects can be counted in the dozens rather than the hundreds. In South-East Asia, Jakarta is where foreign firms have added more office space. Since the early 2000s, Denton, Corker, Marshall completed several office buildings, albeit data on GFA is not available, and so have also done Arquitectonica (over 1.9 million m^2), KPF (around 300,000 m^2), and others. Being most of these projects of high-rise typology, we have already commented on them in Sect. 5.4.

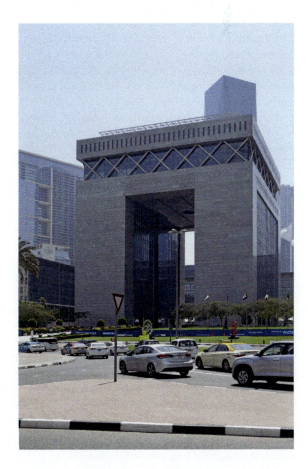

Fig. 9.6 The Gate by Gensler in the Dubai International Financial Centre. Photograph by Giaime Botti, distributed under a CC BY 4.0

The same applies to other cities in the region, from Kuala Lumpur to Hanoi, where most office buildings follow the typology of the tower. In this panorama, notable exceptions are Gensler's Viettel Group Headquarters (23,710 m^2) in Hanoi, a sloping oval building with an elliptical central courtyard, and two projects by GMP. The most impressive one is the Vietnamese Ministry of the Interior complex (2006–11, 180,000 m^2) in Hanoi, composed of two parallel comb-shaped volumes on which rests a transversal block, thus defining a monumental gate.[4] The second project is the Deutsches Haus (2013–17, 52,700 m^2) in Ho Chi Minh City, a two-volume prismatic building containing the offices of the German consulate, trade and cultural institutions, and companies.

Moving to India, the protagonists are overall the same, with perhaps a notable exception in Mario Botta. The Swiss architect was, in fact, called at the end of the 1990s by Tata Consultancy, part of the large conglomerate Tata Group, for its New Delhi (1996–2002, 11,300 m^2) and Hyderabad (1999–2003, 30,000 m^2) offices. The first project comprises a long 4-storey volume for the software developers connected to a cylindrical one hosting the administrative section for an overall precise geometric composition typical of Botta's works. The Hyderabad building, also clad in red Agra stone, features a similar sensibility, with a clear cylindrical volume from which a triangular piazza was carved in the middle as a wedge. At that time, Tata also commissioned Kevin Roche and John Dinkeloo for a factory building in Jamshedpur (Tata Cumnis, 1995). More recently, Cannon Design elaborated the project for a more anonymous two-slab Software Development Campus (2017, 195,000 m^2) in Kolkata for the same company. This very anonymity and genericity characterise most of the projects we recorded in India, from Callison RTKL's Piramal Agastya, a low-rise three-building office complex, to KPF's glazed box for the First International Finance Centre Citigroup India (54,600 m^2), or SOM's Godrej BKC (2015, 111,000 m^2, LEED Platinum), all in Mumbai.

On the other hand, Pei, Cobb, Freed & Partners' design for the headquarter of a US financial company (2011–19, 251,000 m^2, LEED Platinum) in Bangalore cannot be blamed for anything in terms of architectural quality. Its three parallel glazed blocks connected by courtyards provide an orderly configuration; fine finishing and detailing satisfy the eye; the variety of facilities, indoor and outdoor space for relaxation, and the landscape design create a pleasant workplace. As discussed on other occasions, criticism becomes a challenging activity in front of this and many other similar projects. Evidently, the traditional system of values applied to architectural judgement based on more artistic considerations is useless. Indeed, one possible criticism could be the genericity of the proposed solution, as this campus could have been designed in Texas or Southern China. Frequently, the attempt to formally contextualise a project can result in a clumsy design, as is the case of Chapman Taylor's lotus-flower-shaped Bestech HQ (13,500 m^2) in Gurgaon.

In Russia, both Moscow and Saint Petersburg have seen the construction of several office projects delivered by overseas firms, particularly American, British,

[4] For the Vietnamese Government, GMP also designed the National Assembly (2007–14, 36,000 m^2) after winning an international design competition.

9.1 Global Cities and Multinational Companies: The Office is Dead; Long ... 393

and German ones, while in Kazakhstan, cases are far more limited. In the Russian capital, many office towers have been developed in the Moscow International Business Centre (Sect. 5.5), and not much else deserves our attention, as buildings like Aukett Swanke's Arcus II in Moscow (2015, 48,397 m^2) with its coloured façade, or Saraiva + Associados' Forte Bank HQ (2016, 18,400 m^2) in Nur-Sultan with it staggered volumes, do not call for any comment. Equally unremarkable are projects like NBBJ's K2 Business Park (2014, 92,000 m^2) and Silver City (2007, 44,500 m^2), the latter in collaboration with Italian firm Archest, both in Moscow. Notable only in terms of scale is Sberbank City (2018–21, 207,700 m^2) in Moscow by Austrian firm ATP Architects and Engineers, while slightly more interesting are PLP Architecture's Trinity Place (35,000 m^2) and the Bank St. Petersburg by Tschoban Voss, both in Saint Petersburg. A valuable exception is Foster + Partners' RCC Headquarters (2012–21, 18,450 m^2) in Yekaterinburg, the first project completed by the Pritzker-winner's firm in Russia. This 15-floor tower features a two-storey module containing two offices, one on top of the other, that organises the interior space and configures the façade; overall, the building boasts a lavish and elegant design.

US firms have also completed several office buildings in Latin America, although Spanish and Portuguese ones also had a more significant presence than in other regions. Again, several examples of office towers, primarily located in Mexico City, São Paulo, and Rio de Janeiro, have already been highlighted in Sect. 5.6, together with the role of firms like SOM, KPF, Pelli Clarke Pelli, or Arquitectonica. In addition to these, other projects deserve attention. Some of them might be classified as towers but given their limited height—usually below 100 m—they are treated in this section; others are low-rise buildings. In Rio de Janeiro, the Porto Maravilha redevelopment promoted the construction of new office buildings like KPF's Vista Mauá (2016, 30,000 m^2, LEED Gold) and Foster + Partners' AQWA Corporate (2012–18, 223,000 m^2, LEED ASHRAE Gold). Considering the magnificent architectural legacy of downtown Rio de Janeiro, spanning from lavish eclectic buildings to modernist masterpieces like the Ministry of Health and Education designed by Lucio Costa, Oscar Niemeyer, and others, these projects add very little to the city's architectural heritage. Indeed, in other South American projects, Foster has proven more extraordinary ability in dialoguing with architectural legacies. For instance, the Buenos Aires Government House (2010–15, 45,000 m^2) provided a contemporary reinterpretation of Amancio Williams's concrete 'umbrellas'. In the affluent neighbourhood of Leblon in Rio de Janeiro, we also find a small office block (2011–16, 7,030 m^2) by Richard Meier, designed according to the architect's well-known white minimalist aesthetic and extensive use of *brise-soleil* in line with the Brazilian modernist tradition. Arquitectonica designed the BG Group Global Technology Centre (5,000 m^2) with a diagonal grid of perforated aluminium fins on all the façades and, in Brasilia, another more anonymous office building. Firms like Perkins & Will and Gensler also completed several projects of office interiors in Brazil and Mexico, mainly for US multinational companies. Gensler, for instance, designed the interiors for Facebook in São Paulo and Mexico City, IBM in Guadalajara, and BP in Mexico City. In addition to a few expansive office towers (Sect. 5.6), some interesting low-rise office buildings have been recently completed in other

Mexican cities. In Guadalajara, SOM-designed Bio-Esfera (2018, 39,248 m^2) stands out with its two parallel blocks wrapped by vertical concrete fins that protect from excessive solar radiation. In the same city, Spanish studio OAB Ferrater completed the Torre Hipódromo (2012–18), an irregular prismatic 15-storey building dense with architectural memories, from other projects of Ferrater himself like the Mediapro in Barcelona to the Brazilian tradition of the *muxarabi*, to which the rigid grid articulating the façade is inspired (Montaner 2020). Another Spanish firm, Estudio Lamela, completed the Santander Bank Contact Centre (2005–08, 93,600 m^2) in Querétaro, a heavy and enclosed building inspired by traditional Mexican architecture topped by a lighter and more transparent elliptical volume. Finally, in Bogotá, Saraiva + Associados designed two distinct office buildings, the well proportioned cube of the Savile Building (2016, 4,900 m^2) and the larger Bog Americas (2017, 66,733 m^2).

Finally, the involvement of foreign firms in designing office buildings in our sample of African countries is minimal, and the very few projects completed usually have at most 20–30,000 m^2 of GFA. In terms of size, exceptions are the Total E&P Angola (2013, 37,200 m^2) and the 18-storey Torres Atlántico, both designed by EDI International, and a three-building business complex (2013–15, 95,400 m^2) by Portuguese firm CVDB also in Luanda, Angola. Other anonymous office buildings are RMJM's SCB Headquarters (2,000 m^2) in Nairobi and the Basil Read Corporate Head Office (2009, 3,500 m^2) in Boksburg, South Africa. Indeed, the whole sample of projects is small and architecturally unremarkable, with one exception. One Airport Square (2015, 17,000 m^2) in Accra, designed by Mario Cucinella Architects, is a building that features a commercial ground floor and nine storeys of office space and exhibits an irregular diagonal concrete structure with deep cantilevering slabs to shade the interiors. In terms of formal and structural complexity, this project is remarkable and unique compared to the other works mapped across Africa.

9.2 The Typology of the Office Building and the New City: Low-Versus High-Rise, Monofunctional Versus Mixed-Use

What has been described should already have brought several issues to the reader's attention. Quantitatively, we have seen a disproportionate number of projects with an overall larger size built in China compared to all the other regions. In addition, we have recognised certain firms' role in delivering hundreds of thousands of square metres of GFA. In general, such projects feature high design efficiency and sustainability standards, with many buildings achieving environmental certifications with the best possible ratings, like Gold and Platinum LEED. Many of them, however, also feature an equally high level of monotony when not banality. Notwithstanding, some projects stand out and significantly contribute to the current debate in the discipline; some have already been featured, and others will be discussed shortly. But before doing so, we will delve more into some typological issues.

9.2 The Typology of the Office Building and the New City: Low-Versus …

First, it is interesting to note how the typology of the commercial office building is generally intended as a high-rise building. Indeed, the birth of the office building is intimately connected with the advent of the skyscraper in late-nineteenth-century Chicago and New York. Despite its limited height, William Le Baron Jenney's Home Insurance Building (1884–85, 42 m) in Chicago is unanimously considered the first skyscraper. Not by chance, Sullivan (1924, 310–311) freely used the words "tall commercial building" and "tall office building" in his *The Autobiography of An Idea*. Of course, all the first iconic skyscrapers of Manhattan—the Flatiron Building (1901–02, 86 m) by Daniel Burnham and Frederick P. Dinkelberg, the Metropolitan Life Insurance Company Tower (1905–09, 210 m) by Napoleon LeBrun & Sons, the Woolworth Building (1910–12, 241 m) by Cass Gilbert—were corporate towers housing their headquarters. In a way, the office building, after this heroic period in which its history overlaps with that of the skyscraper, granting it a deeper coverage by architectural historiography, almost disappears from narratives (but not from reality, of course). We then usually find exceptions like Mies van der Rohe's Seagram Building (1954–57) and SOM's Lever House (1949–52) in New York, and later Norman Foster's HSBC HQ (1979–86) in Hong Kong, or Richard Rogers' Lloyds Building (1978–86) in London. For low-rise office typology, on the other hand, notable cases generally included are Frank Lloyd Wright's Larkin Administration Building (Buffalo, NY, 1903–06) and the Johnson Wax HQ (Racine, WI, 1936–39 and 1945–50 for the office tower), and some works of Eero Saarinen, Louis Kahn, and Paul Rudolph, for example. This is to name a few examples and architects we could find browsing a general architectural history (for example, Curtis 2006; Frampton 2020). Still, office buildings, especially in their high-rise version, represented in the last decades, and also before, one of the main typologies that kept architects at work.

Considering the emerging markets investigated in this book, office buildings designed by foreign firms have been primarily of high-rise typology, generally clustered within brand-new dense CBDs like in Beijing, Shenzhen, Dubai, Riyadh, and Moscow, or along specific corridors like in Abu Dhabi or Mexico City (Chap. 5). Multinational corporations, and especially banks and insurance companies, have generally relied on the expertise of a few architectural and engineering firms for their headquarters. Similarly, developers have commissioned these same firms to design multi-tenant towers, whose interiors were sometimes furbished according to projects elaborated by the same bunch of architects as separate works. Still, despite the dominance of the high-rise typology for corporate offices, some companies have preferred to develop low-rise solutions in the form of isolated iconic buildings or multi-building campus-like complexes. Such a trend has been certainly boosted by the attitude of the tech giants of Silicon Valley, whose usually suburban headquarters mark a striking difference from the tradition of corporate America's architecture embodied by Manhattan skyscrapers like the ones previously mentioned or others like the modernist Pan-Am Building (1959–63) of Pietro Belluschi, Richard Roth, and Walter Gropius, the postmodernist AT&T (198–84) of Philip Johnson and John Burgee, or the delicately high-tech New York Times HQ (2003–07) of Renzo Piano. In Silicon Valley's suburban landscape, tech companies like Apple or Facebook have located their headquarters in low-rise, iconic buildings. More precisely, Steve Jobs

chose Foster + Partners to develop the ring-shaped Apple Park (2009–18, LEED Platinum) for 12,000 employees in Cupertino, while Facebook commissioned Frank O. Gehry its 40,000-square-metre Campus completed in 2018 as a fragmented horizontal volume topped by an expansive, 450-m-long roof garden. In the meantime, BIG has been busy with multiple projects for Google scattered between Sunnyvale and Mountain View, California, and London. These and other buildings, thus, promote a different headquarters architecture, suburban, iconic, green, and high-tech, but not high-rise; an architecture that also encourages a different approach for the office interior, conceived as more casual, informal, and collaborative workplaces compared to traditional offices to foster ideas' exchange and innovation (Roney 2013).

After having observed several examples of high-rise office buildings in Sect. 8.3, we can now look at some low-rise examples. In China, two projects of this type deserve particular attention. They both stand in a flat, suburban industrial landscape and were designed by Pritzker-winner architects. Morphosis' Giant Interactive Group HQ (2005–10, 24,000 m^2) in the suburban district of Songjiang, Shanghai, accommodates the office and recreational space for the company's employees under an undulating green-roof folding and unfolding along an artificial water body. As Brendan McGetrick (2011) commented, the building is "impressively coherent" and "indisputably Morphosis," "formally complex and futuristic." It attempts to introduce forms of office organisation typical of "Californian corporate horizontality" and represents a valid "counterpoint" to the "big, blatant expression of power" that characterise Chinese cities and, we may add, corporate architecture. The second project is the office building designed by Álvaro Siza and Carlos Castanheira for the Shihlien Chemical Industrial Jiangsu Co (2009–14, 11,000 m^2), also known as the "building in the water," in Huai'an City. It rises above the artificial basin water needed by the nearby New Salt Industrial Park plant for the production of soda ash and ammonium chloride. It consists of a long and narrow white-concrete body that curls like a horseshoe. This figure meant "a classic, poetic design," representing an essential stage in the creation of Siza's "personal brand; a mythology" (Williams 2015). This project, widely published, marked the arrival of Siza in mainland China after he had met the client for the first time in Taiwan. Since then, the Portuguese master has completed a few more projects, mostly museums (Sect. 6.1). In addition to these two, we can point out a couple more examples. Indeed, while Siza's design more or less explicitly (he denied it) recalled a dragon resting on the waters, Zaha Hadid Architects' Infinitus Plaza (2016–20, 185,643 m^2, LEED Gold) in Guangzhou evoked another symbol dear to Chinese culture, the infinite. The two eight-storey blocks (eight is the number of the infinite) are connected by two sky bridges creating a loop that also recalls the symbol of the infinite. The buildings, whose design began the year of Hadid's death, also feature an external skin that emphasises horizontal continuity while also operating as a shading system to reduce solar heat gain. Changing of location, even greater attention to sustainability is showcased in the design of the headquarters for the waste management company Bee'ha (2013–22, 9,000 m^2, LEED Platinum) in Sharjah, UAE. This small building emerges from the desertic wasteland like a double artificial dune with a bright, futuristic interior in Zaha Hadid's fashion and the possibility of operating with minimal energy consumption.

9.2 The Typology of the Office Building and the New City: Low-Versus ...

Back in China, more projects are worthy a mention. One, OMA's Tencent Beijing HQ, has already been discussed. Another one, on a smaller scale, is the Hongqiao Flower Building (2015, 15,000 m^2) by MVRD, a four-storey, flower-shaped office building with a central piazza completed as part of the Hongqiao CBD that the Dutch firm master-planned. All in all, this project appears to reflect the strategy of the 'randomly-placed-object-in-the-void', making other proposals characterised by a more rigorous approach of more interest. Urban pieces like Adrian Smith + Gordon Gill's Chemsunny Plaza (2008, 132,000 m^2) in Beijing, a massive, elongated, glazed block formed by several L-shaped volumes interlocked like in a Tetris game, or Schmidt Hammer Lassen's Ningbo Daily Newspaper Group HQ (2019, 123,000 m^2; Fig. 9.7) in Ningbo, are better examples. The latter is composed of two elongated volumes parallelly laid down and transversally interconnected, culminating in both extremes with massive cantilevering bodies. Still, the most radical design of the new century's first decade was Steven Holl's Horizontal Skyscraper (2009, 120,400 m^2) in Shenzhen. One of the first LEED Platinum-certified buildings in China, its hybrid programme and typology contributed to the definition of a new paradigm for mixed-use buildings in such a bold way, unseen since El Lissitzky's Wolkenbügel project of the 1920s. Spreading over 300 m in length, the Horizontal Skyscraper integrated the headquarters of the real estate giant Vanke with a hotel, a conference centre, and serviced apartments floating on top of a lush tropical garden. As the *New York Times*' architecture critic Ouroussoff (2011) has written, the project materialised new ideas that have remained on the shelves for years, proving how China, where architects are "free to explore," can become their "incubator".

As discussed (Sect. 8.6), mixed-use developments often produce some of the most interesting urban spaces. We highlighted the innovative role of SOHO China in the local real estate market embodied in mixed-use projects like Jianwai SOHO. Now,

Fig. 9.7 The Ningbo Daily Newspaper Group HQ by Schmidt Hammer Lassen in Ningbo Eastern New City, Ningbo. Photograph by Giaime Botti, distributed under a CC BY 4.0

Fig. 9.8 The SOHO Fuxing Lu by GMP, Shanghai. Photograph by Giaime Botti, distributed under a CC BY 4.0

we can look at other operations of mixed-use developments primarily composed of office space (and generally devoid of residential) commissioned by this developer to high-profile international architects. In Beijing, where most of SOHO China's first projects were built, the developer relied on Kengo Kuma for the Sanlitun Village (2010, 465,000 m^2), a popular retail- and leisure-oriented development completed with office towers, and for the nearby Hongkou SOHO (2011–15, 95,000 m^2), an office tower with a commercial podium marked by a pleated aluminium mesh façade. In the capital, other projects included LAB Architecture's SOHO Shangdu (2004–07, 170,000 m^2), which recalls Melbourne Federation Square (2002) in terms of volumes and texture, and Iroje Architects & Planners' Chaowai SOHO (2007, 150,000 m^2). SOHO China also appointed GMP for the deluxe SOHO "Beijing Chateau" residences (2003–8, 69,000 m^2) and three office developments. The first one was SOHO Guanghua 2 in Beijing (2009–15, 103,000 m^2), which complemented the first phase of the development (by MADA s.p.a.m.) with a dense urban block composed of five irregularly shaped and interconnected glazed volumes protected by thin vertical louvres. The other two projects of GMP, instead, are located in Shanghai. SOHO

Fuxing Lu (2015, 130,000 m^2; Fig. 9.8) is composed of a tower and nine low and elongated volumes with sloping roofs that dialogue with the historical typology of the *lilong* characteristic of the former French Concession, creating a low-rise, human-scale urban outdoor. Lastly, along the Huangpu River, Bund SOHO (2016, 189,500 m^2; Fig. 9.9) emerges as a sculptural ensemble of six buildings, including four office towers, with a rich system of lanes and plazas. Indeed, the list of 'signature' SOHO projects is long, and, despite the developer's relationship with several top international architects, one has gained a prominent position: Zaha Hadid.

In Beijing, since the end of the 2000s, her firm has designed multiple projects, all characterised by similar fluid and streamlined forms. Wangjing SOHO (2009–14, 521,200 m^2; Fig. 9.10) featured three towers (200, 127, 118 m), which in the architects' view, were shaped as "mountains" immersed in a new 60,000 m^2 park. The three buildings provided flexible office space to the many small and medium companies and professionals that sought the advantage of being located in a dynamic sector of the Chinese capital, where several multinational companies have offices. The more iconic Galaxy SOHO (2009–12, 332,000 m^2; Fig. 9.11) was also completed in the same years. The complex consisted of several buildings interconnected by sky bridges and sunken courtyards and unified by continuous horizontal white strips of balconies. These first two projects were followed by the multi-tenant office building

Fig. 9.9 The Bund SOHO by GMP, Shanghai. Photograph by Giaime Botti, distributed under a CC BY 4.0

Leeza SOHO (2015–19, 172,800 m^2, 199 m, LEED Gold), made of two rotating vertical volumes connected by sky bridges and wrapped by a single envelope that creates a stunning 194.5-m-tall atrium. Lastly, but this time in Shanghai, we find the SOHO Sky Bridges (2010–14, 342,500 m^2; Fig. 9.12): four slightly bent parallel slabs of streamlined appearance linked by a continuous commercial podium and a few sky bridges.

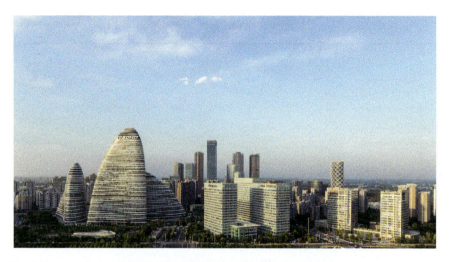

Fig. 9.10 A view of the Wanjing subdistrict (Chaoyang District) area with the Wanjing SOHO (on the left) by Zaha Hadid Architects, Beijing. Photograph by Beijingstory

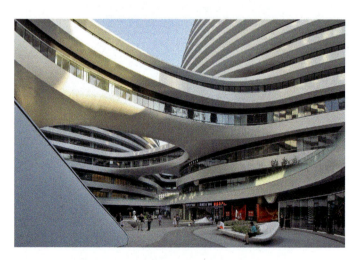

Fig. 9.11 The Galaxy SOHO by Zaha Hadid Architects in Chaoyang, Beijing. Photograph by Giaime Botti, distributed under a CC BY 4.0

9.2 The Typology of the Office Building and the New City: Low-Versus … 401

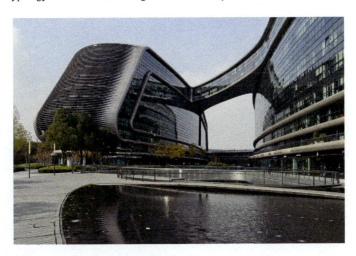

Fig. 9.12 The SOHO Sky Bridges by Zaha Hadid Architects in Hongqiao, Shanghai. Photograph by Giaime Botti, distributed under a CC BY 4.0

Fig. 9.13 The SOHO Tianshan Plaza by KPF, Shanghai. Photograph by Giaime Botti, distributed under a CC BY 4.0

Mixed-use developments are currently on the rise across all main Chinese cities, but some more projects in Shanghai deserve a comment. To close our mapping on SOHO, we must add KPF's SOHO Tianshan Plaza (102,000 m^2; Fig. 9.13), an elegant mixed-use complex made of several regular volumes, and the SOHO Gubei (2019, 160,000 m^2; Fig. 9.14), a zigzagging 38-storey office tower, also located in Hongqiao

Fig. 9.14 The SOHO Gubei by KPF, Shanghai

District. Still, the most convincing project by KPF for a mixed-used development was the massive Kerry Centre (2013–16, 360,000 m^2; Fig. 9.15) in the Jing'an Temple area of Shanghai. It consisted of two main towers, the tallest one occupied by the Shangri-La Hotel, and a double commercial podium with upscale shopping malls, and includes a preserved ancient house where Chairman Mao Zedong lived. The buildings are neat, prismatic glass boxes with tidy, slightly aseptic gardens between them that create an overwhelming outdoor space for pedestrians. In this regard, more mixed-use developments with a predominance of office space can be found. Among them, one stands out for its quality: Foster + Partners' Bund Finance Centre (2010–17, 420,000 m^2; Fig. 9.16), designed in collaboration with Heatherwick Studio just beside the Shanghai Bund Riverside (2012–20, 124,360 m^2), a three-towers office complex by Foster, too. Finely designed with unusual care for the detailing of the stone and metalwork of facades, the Bund Finance Centre ensemble consists of two main towers (180 m) plus several lower volumes, carefully arranged to dialogue with the Huangpu River on one side, and the historical area East of the Yu Garden, on the other. Regretfully, this low-rise, dense fabric, one of the last traces of the old Shanghai,

9.2 The Typology of the Office Building and the New City: Low-Versus … 403

Fig. 9.15 The Kerry Centre by KPF in Jing'an, Shanghai

is doomed to be demolished. Thus, even if ex post any interest in contextualising the building might seem unnecessary given the upcoming demolition, at least the scheme defined a quiet urban space to complement the shopping experience at the ground level with pleasant outdoor locations for eating avocado toast or Italian *gelato*, or even enjoying some cultural activities in the Fosun exhibition space designed by Heatherwick Studio with a kinetic façade of golden bamboos. Overall, the Bund Finance Centre is late capitalist architecture at the nth power but very well designed. As we have introduced the theme of the human scale in the public space, we also have to remind the reader about the size of these projects. As noted in the 1990s, the average dimension of a project in Asia was generally higher than anywhere else:

> A podium of three to seven stories devoted primarily to retailing, with one or more other uses, such as offices, hotels, or apartments, placed above. Where such mixed-use developments have been built in the U.S., they have contained 1.3–2.5 million square feet [120,000–230,000 m^2]. In Asia, they swell to 2–4 million square feet [185,000–371,000 m^2], according to David Brotman, vice chairman of RTKL (Langdon 1995, 44).

Fig. 9.16 The Bund Finance Centre by Foster + Partners, Shanghai

Fig. 9.17 The OōEli Art Park by RPBW, Hangzhou. Photograph by Giaime Botti, distributed under a CC BY 4.0

As a matter of fact, any of these mixed-used developments could compete with unique projects representing the largest developments in Europe, like Potsdamer Platz in Berlin (above 500,000 m^2) during the 1990s or Porta Nuova in Milano (above 200,000 m^2) during the 2010s. Working on projects of such a scale also allowed firms like KPF to build up the expertise needed for even larger and more expansive works like Hudson Yard (1.2 million m^2) in New York (KPF 2022a).

Another example deserving of comment is the OōEli Art Park (2013–20, 230,000 m^2; Fig. 9.17) in Hangzhou, the first project in China completed by Renzo Piano's

Fig. 9.18 The Henderson CIFI Tiandi by Atelier Jean Nouvel, Shanghai. Photograph by Giaime Botti, distributed under a CC BY 4.0

firm. The OōEli is a mixed-use office park consisting in a well-scaled and permeable complex whose multiple buildings enclose a central public space and define the perimeter of a large city block. On the ground floor, the buildings accommodate shops and F&B, art galleries and a small museum, with the rest occupied by a hotel and, above all, office space, including the headquarters of Chinese fashion firm JNBY and the design firm GOA-Group of Architects, which acted as local architect for the project. Overall, the composition is refined, with volumes diagonally cut to enhance views through the block, a varied but tidy massing, and an overall impression of order and consistency thanks to the uniform curtain wall in anodised aluminium used for the façades. The smooth concrete surface of fine quality requested the involvement of the Italian Dottor Group, while the landscaped area composed of sunken gardens, ground greeneries and reflective pools was elaborated by Paul Kephart, the American landscape designer who curated the "living roof" of Renzo Piano's California Academy of Sciences (2000–08). On a smaller scale, another office project where the concern for the quality of the urban space has emerged is Jean Nouvel's Henderson CIFI Tiandi in the French Concession area of Shanghai. Here,

two parallel office buildings create an internal, two-level *passage* full of restaurants and shops protected by a glazed roof. With this project, Nouvel reinterpreted the nineteenth-century shopping arcade, making it an appealing and distinctive piece of the new Shanghai through the treatment of the façades, filled with rows of flowerpots and painted in a vivid red-tone palette (Fig. 9.18).

9.3 New Islands of Knowledge Production: Science and Technology Parks

If mixed-use developments produced a new porous, walkable, and lively urban space in cities across both the developed and developing world that are often dominated by mono-functional and enclosed urban spaces, other typologies of productive spaces retain some of these characteristics. Today, in our knowledge-based economy, we find more and more areas dedicated to specialised programmes related to knowledge production. As studies show, incubating and developing new ideas into viable economic outputs requires a complex ecosystem as well as a suitable space. Such ecosystems depend on the synergies between different actors—the so-called triple helix of university, industry, and government (Etzkowitz and Leydesdorff 1998)—in a precise spatial location. In other words, despite globalisation, the place still matters (Florida 2012, 183–202). And if place matters, design matters, too. In this light, the present section presents some projects of science and technology parks designed by overseas firms in emerging markets.

Although several definitions exist, a science and technology park (STP), or a technopole, can be described as "an organisation managed by specialised professionals, whose main aim is to increase the wealth of its community by promoting the culture of innovation and the competitiveness of its associated businesses and knowledge-based institutions," by stimulating "the flow of knowledge and technology amongst universities, R&D institutions, companies and markets" and facilitating "the creation and growth of innovation-based companies through incubation and spin-off processes" within "high quality space and facilities" (IASP 2017). STPs have evolved since the first generation of the 1950s, which followed the example of the Stanford University Research Park in Palo Alto, California. The underlying model was based on the concept of "science push," in which a university establishes a park to transform scientific ideas into commercial uses. On the other hand, the second generation of technopoles involves a "market pull" approach, further expanding the business beyond the simple income generation for the university and reaching a significant autonomy in its management. Finally, third-generation STPs rely on synergies between different players and long-term public–private partnerships (Annerstedt 2006). Hence, STP's primary functions are technology transfer, knowledge creation, and incubation. Despite their success and proliferation, however, their effectiveness has been questioned (Capello and Morrison 2009).

9.3 New Islands of Knowledge Production: Science and Technology Parks

As a result, due to the generic definition of an STP and the significant number of parks built or under development, it is difficult to map the phenomenon comprehensively. Indeed, the interest here is in highlighting trends related to the involvement of foreign architecture firms in emerging markets (where they gave an important but perhaps not vital contribution) and discussing some remarkable cases. Once again, in terms of quantity and quality, China stands out. Since the opening of the first science and technology industrial park in 1988, Beijing Zhongguancun, their number has grown in the hundred, with companies located within these precincts able to enjoy favourable fiscal and customs policies (Zhang and Sonobe 2011). In Zhongguancun, we find some buildings already mentioned, like the Microsoft R&D Headquarters designed by NBBJ, the IBM Office and Research Centre by Next Architects, Lenovo HQ by Callison RTKL, and the new Tencent HQ by OMA, as well as the offices of many Chinese and international tech companies, including a 110,000-square-metre office tower (2007) designed by KPF, and even the Beijing campus of the CEIBS business school designed by Spanish megafirm IDOM. When lucky enough to get the commission, overseas firms are commissioned the design of a whole master plan and its main buildings. For such schemes, it became common to arrange several standardised buildings surrounded by generous green space around a central lake, like, for example, in Richard Rogers' Chiswick Park (1996–2016, 185,000 m^2) in London. That is the case for the 1.5-million-square-metre Beijing Science City Innovation Park designed by Perkins Eastman. The same can be said for the two large R&D campuses of the Chinese telecom giant Huawei, currently the second-largest smartphone manufacturer in the world. Both the campus in Wuhan (2017, 525,900 m^2), designed by Ennead, and in Hangzhou (2013, 225,000 m^2), by Henn, feature a similar scheme. The German firm, which can boast solid expertise in industrial and research buildings,[5] also completed the denser and more urban Nanopolis (2013, 400,000 m^2) in Suzhou. In the same city, celebrated for its historical gardens, GMP designed the refined Yangcheng R&D Industrial Park (2018–21, 372,000 m^2) within a large green area that responded to the "sponge city" policy requirements and was inspired by the famous Humble Administrator's Garden. The most varied project by GMP, however, is the China Mobile South Base (2006–2019, 176,000 m^2) in Guangzhou, a campus developed in phases where we find office buildings with green roofs, villas blocks, and the recent Display Centre, a landmark building shaped as a half-hyperboloid with a diameter growing from 35 to 80 m from the bottom up.

The smaller Jinqiao Technolgy Park (2008, 41,300 m^2) in Shanghai, designed by AS Architecture Studio, also featured a scheme of scattered buildings around a central lake. In the area of this park, AS also completed two office buildings, one shaped like a sloping crescent (2010, 26,955 m^2) and the other one like a massive wall interrupted by gaps to connect with the backyard garden (2019, 464,700 m^2). B+H, which designed an office building for General Motors, also completed the Shanghai General Motors & PATAC Jinqiao R&D Campus, a complex that includes an office

[5] Indeed, another project of uncertain status is China Life R&D Park (2018) in Beijing, while also HPP had delivered design proposals for the Alibaba Cloud Valley Park in Hangzhou and Nanshan Science & Technology Innovation Centre in Shenzhen.

block, a staff canteen, the design centre, a Cadillac showroom, and an aero wind tunnel lab, organised as to keep the most secure facilities at the centre of the campus. However, in terms of design quality, there is nothing here comparable to older GM facilities like those in Warren, Michigan, designed by Eero Saarinen in the 1950s, or more recent projects for other car manufacturers like Foster + Partners' McLaren Technology Centre (1998–2004, 63,000 m^2) in Woking, another example, after the Willis-Faber (1971–75) in Ipswich, of what Frampton (2020, 337), borrowing a term from Max Bill, called a *Produktform*, a building where "all the emphasis has been placed on the elegance of the production itself."

A different proposal, but also a different scale, was that of AS+P for the Zhang Jiang Hi-Tech Park (2000–01) in Shanghai Pudong. The German firm won the competition for the 2,500-hectare area and later completed an anonymous L-shaped Administration Centre (2003–04, 35,000 m^2) tower to mark the park entrance. With this example, we want to emphasise how the dimension of these parks is sometimes comparable to that of a small town and, therefore, the result of the work of multiple architects. In Shanghai, the most important STP is the Zhangjiang Hi-Tech Park, established in 1992 with the same privileges as the Special Economic Zones. It now hosts more than three thousand companies employing over 100,000 people. Inside the area, multiple works have been completed by international firms surveyed in this book: AS Architecture Studio has delivered the Wison Chemical HQ and Laboratories building (2003, 20,000 m^2) and the new HQ (2012, 139,800 m^2), LRS Architects some office buildings (2012, 102,193 m^2, LEED Platinum), and RMJM the already mentioned Dow Corning China R&D HQ. Inside Zhangjiang, we also find the Novartis Campus, developed following the example of the main Novartis Campus in Basel: gathering top overseas architects for an exhibition of iconic pieces. The Swiss pharmaceutical, in fact, commissioned Atelier FCJZ, a well-known Chinese firm, for the master plan and the laboratory. At the same time, it appointed Kengo Kuma for a small multifunction building (2016, 960 m^2), Chilean Pritzker architect Alejandro Aravena for an office building, and West 8 (2012–16) for the landscape design. Further to the South of Shanghai, the Zizhu Science-based Industrial Park also hosts several multinationals, including Coca-Cola, Microsoft, for which B+H designed the already mentioned Microsoft Zizhu Campus, and ExxonMobil, for which Arup completed the Asia Pacific R&D Centre (26,600 m^2, LEED Silver) and Mossessian Architecture the Technology Centre (2010, 31,000 m^2).

And this is not all, as more parks are currently under development, although it is not always easy to understand the actual status of these projects. For sure, the Yuqiao Science Park in Shanghai (367,000 m^2), designed by Benoy, and the Shenshan Robotics Technology Campus (247,840 m2) in Shenzhen by Retail Design Collaborative are currently under construction. Among other things, these master plans seem to provide a more urban character and a more varied programme, perhaps following a global trend of re-urbanisation, after decades of suburbanisation, for these parks and their employees, the "creative class" (Florida 2012, viii). More importantly, STPs may offer today a blueprint for sustainable urbanism and urban ecological innovations (Zouain and Plonski 2015; Yang et al. 2022). In this regard, one last case to be mentioned is the Xin Wei Yi Technology Park in Nanjing, designed by

9.3 New Islands of Knowledge Production: Science and Technology Parks 409

NBBJ. Spanning over an area of 13.4 hectares, this so-called Eco High-Tech Island, located relatively close to Nanjing downtown, features a mixed-used programme of R&D offices ($62{,}000$ m^2) and residences ($34{,}000$ m^2) and an Exhibition Hall ($24{,}000$ m^2) immersed in the green. All buildings display a wide array of strategies for environmental sustainability in terms of reducing energy consumption, saving and harvesting water, and fostering biodiversity, while the Exhibition Hall stands out for its design, especially for the extended roof with "peaks" and "valleys" channelling the natural light to the floors below.

Outside of China and within the countries surveyed, technopole projects remain limited. Before looking at some interesting cases in the Middle East, it may be worth mentioning a few more examples, but more for the sake of completeness than for any architectural merit. To attract an extensive array of multinationals, from Nokia to Amazon, from Google to Samsung, Indian Bagmane Capital is currently developing several business parks in Bengaluru, with some of the most recent buildings designed by Broadway Malyan (Kyoto Bagmane, $74{,}500$ m^2, Rio Bagmane $145{,}000$ m^2); in Kolkata, RMJM has completed the Infospace IT Park Corporate Park Campus (2014, $198{,}295$ m^2). In Vietnam, on the other hand, neither Arup's Hoa Lac National Innovation Centre in Hanoi nor a few more business and IT parks projects have broken ground yet. In this architecturally unremarkable panorama, the main exception is the Skolkovo Technopark/Innovation Centre on the outskirts of Moscow, also known as the Russian Silicon Valley. Launched in 2009 by the Russian government, it hosts the Skolkovo Institute of Science and Technology (Skoltech), a private university established in partnership with the Massachusetts Institute of Technology, and several companies to promote synergies along five clusters of research. The competition finalised in 2011 saw the participation of renowned names like Mecanoo, OMA, and AREP, with the latter winning. The area was later subdivided into different districts, with projects of SANAA, Stefano Boeri, OMA, Valode & Pistre, and Herzog & De Meuron. In the end, only the last two were brought to completion. Valode & Pistre master-planned the Technopark and designed some laboratory buildings (2016, $145{,}000$ m^2), while the Swiss Pritzker-duo completed the Skoltech building (2013–18, $133{,}979$ m^2) in District 3, which they previously master-planned. The structure is organised in plan within a 280-m diameter ring, encompassing two smaller circles, which serve as connections and for some academic facilities. This system is intersected by a series of parallel rectangular volumes arranged in a chessboard pattern. The result is highly original, with these simple, repeated volumes reminding of an industrial complex, although its continuous, curved front wrapped in wood announces a cosier interior. Less than two kilometres away, by 2010 was already completed another circular building, the Skolkovo Moscow School of Management ($42{,}890$ m^2; Fig. 9.19). A work by Ghanaian-British architect David Adjaye, it stands out for its daring volumetric composition inspired by suprematist paintings and constructivist architecture, with a 150-m-wide circular glazed platform sandwiched between the two slabs and four prismatic sculptural volumes on top, two of which, long and narrow, impressively cantilevering out of the circular base. Nearby, and we do not mention it for any architectural quality but rather to show the degree of involvement of international firms in such flagship developments, is also under construction

Fig. 9.19 The Skolkovo Moscow School of Management by David Adjaye in Skolkovo Technopark, Moscow. Photograph by AShkanov

Skolkovo Park, a business district of 270,000 m^2 of office and retail space designed by Scott Brownrigg.

To conclude this section, it is time to turn our gaze towards the Middle East. Here, the push towards economic diversification from oil and gas has enormously boosted new research, educational, and industrial facilities, often clustered in parks as ambitious as to become real cities. In addition to the Qatar Education City (Sect. 9.4) and Masdar City in Abu Dhabi (Sect. 8.7), which are discussed elsewhere, here we will look at the King Abdulaziz City for Science and Technology (KACST) and the King Abdullah Petroleum Studies and Research Centre (KAPSARC) in Riyadh. Founded in the 1970s as an independent scientific organisation, the KACST has occupied a new campus (over 800,000 m^2) in the north-western periphery of Riyadh, near King Saud Medical City. The campus was master-planned by Australian-German firm LAVA in 2011 as a dense and sustainable mini-city, conceived to reduce heat loads in outdoor areas through shading elements and other passive cooling strategies. At the centre of the campus, LAVA also designed the KACST HQ (2017, 51,420 m^2), a compact office tower dominating the whole area. The core space of the building is constituted by a vertical sequence of stacked atria bringing natural light inside. At the same time, the exterior is conceived as a solid block getting more and more open in a kind of pixelated effect towards the central part corresponding to the atria. Panels repeat the same gradient with small, glazed square openings of different sizes that reiterate the pixelated image. The second relevant work is the KAPSARC, an advisory think-tank research centre established in 2007 and focused on energy. Located north of Princess Nora bint Abdul Rahman University, in Riyadh's northern periphery, the campus is composed of the main research facility (2019–17, 70,000 m^2, LEED Platinum) designed by Zaha Hadid Architects and its residential community (2014, 190,240 m^2) by HOK. The former is composed of five buildings shaped according to a deformed hexagonal honeycomb grid and connected by a canopy following the

Fig. 9.20 The canopy of the main research facility of the KAPSARC by Zaha Hadid Architects, Riyadh. Photograph by Fahad Abdualhameid, distributed under a CC0 1.0 Public Domain, available at https://commons.wikimedia.org/wiki/File:DSC04791kapsarkrequest.jpg

same geometry that protects the outdoor spaces and *de facto* creates a single unified building (Fig. 9.20). As for the community, it includes three apartment buildings and 200 single-family houses, retail space, and several amenities and cultural facilities. Thus, HOK's project configured a small mixed-use neighbourhood for almost two thousand people, with a central piazza shaded by umbrella-shaped canopies and a mosque (950 m^2). This last building consists of a glazed cube with irregular diagonal mullions and thick diagonal elements that filter the light and recreate the effect of a kind of over-scaled *mashrabiya*, the traditional Arab latticework screen. As one of the largest LEED Neighbourhood Development in the Middle East, the campus is powered by a photovoltaic field planned by HOK in its proximity.

9.4 A New City of Knowledge: Qatar Education City

Many of the projects we have seen so far exemplify the growing relevance of a new typology of production place in the form of citadels devoted to research and education that sometimes assume the dimension and the features of a real mixed-use neighbourhood. Especially in the Middle East, in most cases, their development involves top overseas firms, they present at least one iconic piece of architecture, boast high environmental performances (recognised by certifications like LEED Platinum and Gold), and settle within carefully landscaped sites. In this regard, one of the most ambitious projects developed in the region has been the Qatar Education City (QEC) in Al Rayyan. It was established by the Qatar Foundation in 1997 when the Virginia Commonwealth University opened its branch campus, and was inaugurated in 2003.

The master plan was drawn in the early 2000s by Arata Isozaki, who envisioned a central green spine culminating in the north with the Qatar National Convention Centre and in the south with the Ceremonial Court. The Convention Centre (2004–11, LEED Gold; Fig. 9.21) was shaped by the Japanese architect as an extended glass box containing the auditoriums and protected by a wide roof supported by giant tree-like columns. Although praised as "one of the most extraordinary attempts at synthesising international modernism and Qatari identity" because of the inspiration from the Sidra tree (Adam 2013), very similar organic columns supporting a large canopy were the most significant elements in Isozaki's entry for the Florence High-Speed Railways Station competition of 2002, making it just one of the many stories of design and story-telling recycling.

After almost two decades of development, QEC hosts today the campuses of several US and European universities, a science and technology park, and other cultural and sports infrastructure, some of which deserve further attention. The first project to comment on is certainly OMA's Qatar Foundation HQ (2017; Fig. 9.22), rising on one side of the central spine. This office building is a simple rectangular cuboid with a white precast concrete façade characterised by a pixelated effect resulting from the regular and repetitive grid of tiny square openings on all its four sides. In such a minimalist composition, the only exception is represented by the cut of a continuous terrace at two-thirds of the height of the building, providing the effect of a floating upper volume detached from the lower part, also thanks to the lack of columns along the envelope. In a way, it might be said that the Qatar Foundation HQ materialised that quest for "simplicity" that Rem Koolhaas and Reinier de Graaf had pursued with the "Simplicity Manifesto" and explicitly claimed with the high-rise, unbuilt project Dubai Renaissance (2006): "The ambition of this project is

Fig. 9.21 The Convention Centre by Arata Isozaki in the Qatar Education City, Al Rayyan. Photograph by Giaime Botti, distributed under a CC BY 4.0

9.4 A New City of Knowledge: Qatar Education City

to end the current phase of architectural idolatry—the age of the icon—where obsession with individual genius far exceeds commitment to the collective effort that is needed to construct the city…" (Koolhaas et al. 2006). The Dubai Renaissance's aim (Sect. 5.7), understandable by comparing that high-rise thin slab characterised by a homogenous grid façade with the surrounding towers exhibiting the more disparate shapes, was precisely to stand out for rigour and monotony rather than for extravagance. Similarly, the QF HQ emerges in its simple perfection within a context of 'signature' buildings relying on a certain formal complexity to call for the spectators' attention. Just in front of this building, rising from the same stone-tiled floor platform, OMA also designed the QF Strategy Study Centre (Fig. 9.22), a low horizontal white volume expansively cantilevering from its base, and two blocks away, its main work, the Qatar National Library (Sect. 6.4).

Within the Education City, architectural surprises do not end here. Between 2002 and 2008, RMJM completed several buildings, including a Library (30,000 m^2), and in collaboration with Mexican firm Legorreta Arquitectos, the Texas A&M

Fig. 9.22 The Qatar Foundation HQ (in the background) and QF Strategy Study Centre by OMA in the Qatar Education City, Al Rayyan. Photograph by Giaime Botti, distributed under a CC BY 4.0

School of Engineering (53,000 m^2; Fig. 9.23) and the Carnegie Mellon University at Qatar (43,000 m^2). The Mexican firm, established by the modernist master Eduardo Legorreta in the 1960s, also designed the Georgetown University School of Foreign Services (2011, 50,000 m^2). All these buildings bring the signature of Legorreta, visible in their solid and monumental volumetry inspired by Louis Kahn, in the selective use of colours like blue, red, and yellow, in the abundance of internal patios, often enriched by geometric water features and greenery, and in the equally geometric decorative patterns, whose inspiration could have come as much from the Islamic tradition, of which Legorreta was himself an admirer, as from the pre-Columbian Mesoamerican one. Of a very different appearance, on the other hand, is the Qatar Faculty of Islamic Studies and the annexed Mosque (2015), designed by the British-Spanish firm Mangera Yvars Architects (not included in our survey) with a fluid geometry in line with the parametric paradigm of the late Zaha Hadid and Patrick Schumacher. At the north of the Convention Centre, we also find the Qatar Science and Technology Park, a free-trade zone hosting companies like EADS, ExxonMobil, Microsoft, and Shell. The QSTP was completed in 2012 according to a project of Woods Bagot over an area of 120 hectares defined by the presence of the Incubator Building, aligned with the central axis of the Education City (Fig. 9.24). The complex thus counts on a lifted volume covered by a large undulating roof reaching other buildings on its two sides, creating a shady area that animates outdoor activities and the pedestrian movement between buildings. Finally, additional contributions from our sample of firms include the overall landscape proposal—about 100 hectares—assigned to AECOM and the seventeen new tram stations designed by Nicholas Grimshaw (2019) as open-air stops protected by a cable net structure.

Fig. 9.23 The Texas A&M School of Engineering by RMJM and Legorreta Arquitectos in the Qatar Education City, Al Rayyan. Photograph by Giaime Botti, distributed under a CC BY 4.0

Fig. 9.24 The Incubator Building by Woods Bagot in the Qatar Science and Technology Park just north of the Qatar Education City, Al Rayyan. Photograph by Giaime Botti, distributed under a CC BY 4.0

9.5 From Nation-Building to Market-Competition: The Architecture of Higher Education

The construction of new university campuses (often called 'university cities') has represented during the twentieth century a great enterprise of nation-building for many countries. In Latin America, new university cities rose between the 1930–50s in Concepción, Bogotá, La Paz, Quito, Mexico City and Caracas, generally giving visible form to broader political and economic reforms that also involved the educational realm. From the 1950s, several Asian and African newly independent countries relied on foreign professionals for the design of new universities as explored in Sect. 3.3. The University of Baghdad (1957 onwards) by The Architects' Collaborative, the Indian Institute of Management (1962–74) in Ahmedabad by Louis Kahn, and Oscar Niemeyer's works in Algeria were just some of the most relevant cases. By the 1970s, then, a new wave of projects involved the Middle East (Sect. 3.4). During the last few decades, international architects have continued to work on higher education projects in emerging markets, where we mapped several designs. The framework in which they have worked, however, has sensibly changed. Rather than large public operations, most of the interventions were limited to smaller campuses or just flagship buildings for private institutions. Such a shift simply reflected the growing privatisation of the higher education sector, which today accounts for about 32% of global enrolments, with a strong concentration in developing countries (Levy 2018).

China is one of the leading countries for enrolments in private higher education (although lower than India, USA, and Brazil) and a country in which the activity of overseas design firms has been hectic. In Hong Kong, since 2000, several educational

facilities designed by top firms have been completed after fierce design competitions. The list includes Daniel Libeskind's Creative Media Building (2011) at the City University of Hong Kong, Coldefy & Associés' Hong Kong Design Institute Building (2010), and Zaha Hadid's Jockey Club Innovation Tower (2013; Fig. 9.25) for the Polytechnic University (Xue 2016), while regrettably, one of the most interesting projects, OMA's Chu Hai College, was never built. In the same period, a new wave of educational projects, sometimes integrated within larger science and technology parks, have been completed in mainland China, where several international firms have been busy with multiple commissions at a time for the renewal and expansion of Chinese universities' campuses and the establishment of foreign institutions, sometimes in the form of partnerships between Western and Chinese universities.

A new campus of the prestigious Fudan University was developed between 2003 and 2005 according to a master plan of AS+P, which was also responsible for the project of the faculty buildings of Computing Science and Microelectronics (72,300 m^2). This simple and repetitive design, immersed in a Chinese-like garden, does contrast with the approach of EMBT for the Campus of Fudan School of Management (70,000 m^2), where buildings are dynamically organised in a denser and more interconnected volumetric scheme, in which a yellow roof with irregular skylights stands out as iconic element. Italian firm Archea, more simply, refurbished the Tongji University Youchou Building (2015–17, 5,580 m^2) with a better-looking new façade in GRC panels and weathering steel details. The result also improved the overall energy performance to make the building a prototype for sustainable refurbishments. In Shenzhen, KPF completed the Peking University School of Transnational Law building (2019, 9,000 m^2), Foster + Partners the Xiao Jing Wan University (2011–16,

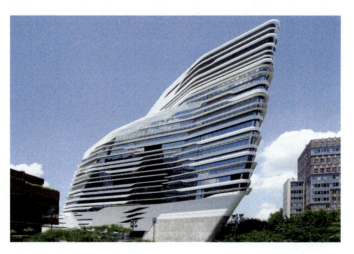

Fig. 9.25 The Jockey Club Innovation Tower by Zaha Hadid Architects in the Polytechnic University, Hong Kong. Photograph by Sebastian Wallroth, distributed under a CC BY 3.0, available at https://commons.wikimedia.org/wiki/File:Wikimania_2013_04404.JPG

55,000 m^2) for the state-owned conglomerate China Resources, and AS—Architecture Studio the Faculty of Human Sciences of the South China University of Technology (2020, 27,300 m^2), a composition well-integrated in the hilly landscape and shaped as a modern reinterpretation of the traditional *Lingnan* (Cantonese) architecture. A similar approach, but at a more imposing scale, was followed by BDP for the Faculty of Medicine of the Nanjing Medical University (2014, 70,000 m^2), while GMP re-proposed a scheme already seen in the Yangcheng R&D Industrial Park for the Jiangsu Industrial Technology Research Institute (2017–21, 100,900 m^2): a rigid master plan with simple and austere rectangular buildings within a park with water bodies complying with the local "sponge city" policy. For the sake of completeness, other projects of minimal interest include the Xiamen National Accounting Institute (2004) by B+H, the China Pharmaceutical University Jiangning Laboratory Building (80,000 m^2) in Nanjing by the HDR, the Shanghai Second Polytechnic University (2012–16, 24,000 m^2) by VMX Architects, the Luxun Academy of Fine Arts Campus (2014) in Dalian by Auer Weber.

More importantly, overseas architects have designed whole campuses or single buildings of foreign and Chinese-Western joint universities. One of the first significant examples of this kind was the China–Europe International Business School, established in the 1990s through an agreement between China and the European Commission. The campus was designed by Pei, Cobb, Freed & Partners (1995–2004, 34,000 m^2) in the Pudong New Area. The master plan organised the buildings on a regular grid, creating an introverted scheme, with the library, the most iconic element, located at the site's core, surrounded by a garden enclosed by the arcades of the perimetral buildings. Indeed, water pools, courtyards and vernacular details defined a contemporary but Chinese image of the complex, comparable to what Pei experimented with at the Fragrant Hill Hotel (Sect. 10.2), although Pei himself did not lead the project. Ten years later, the firm completed the expansion of the CEIBS campus (2009–14) in Shanghai in a very similar fashion, while, as seen in a previous section, IDOM designed the CEIBS Beijing campus. In Shanghai, KPF took over the project of a building already under construction to transform it into a space for the New York University (53,800 m^2). At the same time, it also designed the new NYU Shanghai building (under construction, 114,922 m^2), an interesting urban block composed of staggered volumes. More recently, the US megafirm completed the new campus of the Hong Kong University of Science and Technology in Guangzhou, a one million square metres complex, with 550,000 m^2 corresponding to the first phase already opened in 2022 just three years after its design thanks to the work of more than seventy architects from KPF's New York, Shanghai, Hong Kong, and Singapore offices. The campus aims at achieving carbon neutrality by 2060 (KPF 2022b).

In the East China provinces of Zhejiang and Jiangsu, four more campuses have been built or are currently under development. The University of Nottingham Ningbo China, established in 2004, boasts a campus with extended green areas and water bodies in a region rich in water canals. While its principal buildings are rather unremarkable—one even poorly mimics the iconic 1928 Trent building in Nottingham—two are more attractive. One is the recently completed UNNC Incubator (2021,

Fig. 9.26 The UNNC Incubator by Broadway Malyan in the University of Nottingham Ningbo China campus, Ningbo. Photograph by Giaime Botti, distributed under a CC BY 4.0

15,000 m^2; Fig. 9.26) by Broadway Malyan, and the other is the Centre for Sustainable Energy Technologies. The latter, designed by the office of the Italian architect Mario Cucinella (2006–08, 1,200 m^2; Fig. 9.27), was the first zero-energy building in China. At the time of its construction, Cucinella, one of the most committed professionals to sustainable architecture in Italy, had just completed the Sino-Italian Ecological and Energy Efficient Building (2003–06, 20,000 m^2) at Tsinghua University in Beijing, as the result of a joint effort between the Italian and Chinese governments to promote education and research on energy efficiency. Like the CSET in Ningbo, the building itself was intended as a built manifesto for the next generation of sustainable architecture in China. In Wenzhou, a further two hundred kilometres southwards of Ningbo, New Jersey's Kean University opened in 2012 a campus masterplanned by Michael Graves in a frankly conservative fashion, where no significant architectural pieces were built, despite a 2015 competition for the library building awarded to Schmidt Hammer Lassen. Nonetheless, for educational architecture, the real masterpiece of Zhejiang province is the decade-long project of the Xiangshan Campus of the Chinese Academy of Art in Hangzhou, designed by Wang Shu and

9.5 From Nation-Building to Market-Competition: The Architecture … 419

Fig. 9.27 The Centre for Sustainable Energy Technologies by Mario Cucinella Architects in the University of Nottingham Ningbo China campus, Ningbo. Photograph by Giaime Botti, distributed under a CC BY 4.0

Lu Wenyu's Amateur Studio (Frampton 2020, 491–492; Fig. 9.28; also Sect. 6.1 for Kengo Kuma's and Álvaro Siza's museums).

In Jiangsu, not far from Shanghai, two more universities resulting from partnerships between Western and Chinese institutions compete to attract students. The Xi'an Jiaotong-Liverpool University (XJTLU) occupies more than 25 hectares in Suzhou Industrial Park, a strategic area 12 kms east of the city and well connected with Shanghai, home to several multinational companies and a few Chinese universities. In 2013, the North Campus, master-planned by Perkins & Will, opened its door. The US firm designed a four-wing building (41,800 m^2) with accessible green roofs and courtyards that provides generous space for socialisation (Coulson et al. 2015), an overall example of well-integrated green infrastructure within an accessible, permeable campus devoid of perimetral walls and controlled gates, something rather exceptional in China (Mell 2016, 167–168). This first phase of the development also included the Central Building, an iconic piece of architecture by AEDAS (not included in our survey): a large cube carved with organic-shaped voids that reveal its interior. After 2013, the South Campus of XJTLU was developed in the adjacent

Fig. 9.28 A part of the Wa Shan Guesthouse by Amateur Studio in the Xiangshan Campus of the Chinese Academy of Art, Hangzhou. Photograph by Giaime Botti, distributed under a CC BY 4.0

block according to a master plan and an architectural project by BDP. This new area presents a long crescent building for the International Business School (30,000 m^2), and a few others arranged in a circle around a small lake. At the same time, Greenberg Farrow completed the South Campus Sports Complex (2019, 13,935 m^2) and the School of Film and Television Arts (3,195 m^2). And today, the university is further expanding with a new campus in the Taicang High-Tech Development Zone. The 470,000 m^2 project currently under construction has been produced by HPP, which won an international competition in which also Perkins & Will participated. The latter firm, however, was luckier with the project for the new campus of the Duke Kunshan University, which is currently under construction (153,182 m^2), to expand the first phase developed by Gensler, responsible for the master plan and the project of five buildings, one of which features a modern "big roof" as a regionalist element. Considering all these projects, we notice a general adherence to a minimalist international language, sometimes steering towards the high-tech, with limited attempts to regionalise it through the reference to the tradition of the Chinese garden for the landscape, like in many science and technology parks.

9.5 From Nation-Building to Market-Competition: The Architecture ... 421

To complete this overview, several more education projects deserve some attention. In the early 2000s, Foster + Partners completed the Petronas University of Technology (1998–2004, 240,000 m^2) in Seri Iskandar, Malaysia. Immersed in luxuriant vegetation, the campus is organised along three crescent-shaped canopies that connect different buildings and allow students and staff to circulate, protected from the equatorial sun and rain. In Malaysia, we also find campuses of foreign universities, including the University of Nottingham and the University of Reading (2015, 30,000 m^2), the latter one based in a multi-building compact complex unified by a large roof that creates a central atrium provided with green and rich in informal social spaces. Scott Brownrigg designed the project in the UK, and the construction stage was followed by its Singapore office branch. Just one block away lies the Newcastle University Medicine Malaysia, whose small Medical Clinic (2018, 650 m^2) was also designed by Scott Brownrigg. The British firm the same year completed another small-scale interior design project for the same client, the Newcastle Research and Innovation Institute (1,010 m^2) in Singapore. In Indonesia, Denton Corker Marshall, an Australian firm with a consolidated presence in the country since the 1990s, in a short time delivered the University of Indonesia Central Library (2009–11, 28,900 m^2), a sculptural building composed of different sharp volumes rising for a sort of mound, the Alam Sutera Campus of the Binus University (2009–14) in Tangerang, which includes a landmark tower made of irregularly-stacked volumes, and the University of Multimedia Nusantara (2010–13) in Jakarta. Glossier works can be found in the Middle East, like B+H's Arab Centre for Research and Policy Studies (2016, 56,000 m^2) and Woods Bagot's The College of the North Atlantic (2005, 75,000 m^2) in Doha, or HOK-designed King Abdullah University of Science and Technology in Thuwal, Saudi Arabia. The latter deserves a few words. The campus counts 27 interconnected buildings for over 500,000 m^2 of GFA that create a compact structure to face the harshness of the climate. The result was one of the largest LEED Platinum-certified buildings, which not only incorporates but also monumentalises the architectural elements needed to achieve such a standard, from large canopies and shading devices inspired by the *mashrabiya* to solar-powered wind towers. Its pioneering character is also reinforced by hosting the first mixed-gender educational institution in Saudi Arabia.

In India, John Portman Architects collaborated with Vikram Lall for the campus of the Indian School of Business (2001, 74,322 m^2) in Hyderabad, a monumental complex not casually reminding of Louis Kahn's work. Later, RMJM elaborated a master plan for the future development of the campus. The university, the highest-ranked private institution in the country for MBAs, has also opened a new branch (2010–12, 7,432 m^2) in Mohali with buildings designed by Perkins Eastman. The complex aims to achieve a LEED Gold certification through the extensive use of passive and active strategies. A simpler and less-expansive architecture characterises the Indian Institute of Technology in Mandi (2013–18), in the Himalayan state of Himachal Pradesh. The institution is now hosted in a 230-hectare campus designed by BDP on the slopes of a dramatic mountainous landscape. The IIT features a village-like structure and simple, vernacular-inspired buildings rather than generic modernist boxes. Still, one of the most interesting projects can be found in Angola: the campus

for the Universidade Agostinho Neto (2008–11, 30,650 m^2) in Benguela by Perkins & Will. This complex, the result of public investments made possible by oil revenues, is located in the desertic landscape of the city's outskirts and consists of four teaching buildings covered by extended mental canopies and a sunken central plaza dominated by a daring, L-shaped library tower (the only air-conditioned space). Buildings rely on carefully studied passive strategies, as they are orientated to maximise shadow and capture prevailing winds, and they feature roofs designed to act as airfoils, reducing indoor air pressure and thus removing hot air (Bernstein 2012). The result is utterly modern, simple, almost austere, but effective, both aesthetically and environmentally. Another remarkable project currently under construction is The Leadership Centre of the College of Insurance in Nairobi, a bold design by White Arkitekter and Kenyan firm MMI. Aimed at achieving a LEED Gold certification, it consists of a long horizontal block raised above the sloping volume of the conference centre. Not included in our survey, the Botswana Innovation Hub (46,450 m^2) by SHoP Architects is a project displaying advanced design, modelling, and construction techniques implemented by overseas firms in Africa. Like The Leadership Centre, this incubator and research centre features strong attention to the environment and the quality of indoor and outdoor spaces, especially visible in the shaded and greened courtyards, and a respectful setting in the landscape, thanks to its colours, horizontal lines, and green roofs.

Compared to other regions, the involvement of overseas architects in university facilities has remained relatively limited in Latin America. As pointed out on other occasions, this can result from various reasons, although two seem to be the most convincing. On the one hand, investments in R&D in Brazil, Colombia, or Mexico are lower than in China, both in absolute terms and in the percentage of the GDP. On the other hand, the active architectural scene of Latin America makes the environment for foreign architects far more complex. Moreover, as previously mentioned, this book does not map cross-border work within the region, and, for example, the activity of a Brazilian architect in Mexico would not be mapped. In the end, and this is particularly true for educational buildings, contemporary Latin American architects rest on the shoulders of giants, as several university buildings of the 1950s and 1960s have gained a well-deserved space in every text of architectural history, even the most Eurocentric ones. Undisputed masterpieces of the 1950s are the University City of Mexico, master-planned by Mario Pani and Enrique del Moral with buildings by Juan O'Gorman and Félix Candela, and Carlos Raúl Villanueva' Universidad Central de Venezuela in Caracas. The 1960s, then, were the time of João Batista Vilanova Artigas' School of Architecture and Urbanism (1966–69) at the University of São Paulo. And today, we find that the most iconic new additions to university campuses are usually the result of the work of local architects. The Bogotá campus of the National University of Colombia, an early modernist collective work of the late 1930s, features high-quality additions like the Building for Postgraduate Studies in Humanities (Edificio de Posgrado de Ciencias Humanas, 1995–2000) designed by Colombian architectural master Rogelio Salmona, and the more recent Faculty of Nursing (2016, 7,100 m^2) by Leonardo Álvarez Yepes. On the other hand, a winning scheme for the Doctoral Building designed by Steven Holl in 2010 (8,825 m^2) for

the same university was never built. The nearby Pontificia Universidad Javeriana has also recently added two bold architectural pieces to its Bogotá campus, both designed by local firms: the Faculty of Arts (2015, 17,725 m^2) by La Rotta Arquitectos, and the Jorge Hoyos Vásquez Building (2016, 11,300 m^2) by +UdeB Arquitectos. This highlights how such projects in Latin America tend to remain in the hands of local professionals, who produce broadly published and awarded pieces of architecture.

In this context, from our survey, just a few projects emerge, not casually all from private universities. One is the Faculty of Medicine at the Universidade Anhembi Morumbi (2016–17, 5,300 m^2) in São José dos Campos, Brazil, a severe project by KAAN Architecten in the shape of a monolith wrapped with sun-shading vertical concrete fins. Another is the Centro Roberto Garza Sada de Arte Arquitectura y Diseño (2007–12) of the University of Monterrey, Mexico, by Tadao Ando: a solid concrete block cut in the middle by a triangular void appearing as the result of a twisting of the volume from below. However, the principal academic client in the country has been the fast-growing Monterrey Institute of Technology. For this leading private institution, Sasaki has developed an overall strategy for campus design, and master-planned and updated Puebla City's and Santiago de Querétaro's campuses and the area around the Monterrey campus. Then, the firm completed two buildings in Monterrey: the light and minimalist La Carreta Pavilion (2017, 1,376 m^2) and the new Main Library (2017, 17,000 m^2, LEED Gold). The latter is an elegant rectangular glass prism with an internal courtyard crossed by sky bridges, an inviting entrance under a wide cantilever, and a terrace with expansive views of Monterrey's surrounding mountains carved from one corner of the top floor. In other words, well-executed piece of international design.

As this section has shown, with few exceptions, especially in the Middle East, public institutions are no longer providing the ground for large projects shaping the higher education infrastructure of a whole country. Indeed, private universities compete to attract students with shiny and iconic facilities. In many ways, this is nothing new considering the involvement of architects like Alvar Aalto, Mies van der Rohe, Louis Khan, or Paul Rudolph—the archistars of that time—in several US universities during the 1950–60s. In many emerging markets, university buildings are mostly designed by overseas architects, although conditions change from region to region. In Latin America and China, for instance, some of the best and more acknowledged works were authored by local architects. Still, despite an overall good design and some peaks, none of the projects mapped in this chapter stands out for its groundbreaking character. None is comparable to modernist masterpieces of the 1940–60s nor to more recent works like the controversial and expansive OMA's Milstein Hall (2006–11, 4,370 m^2) at Cornell University in Ithaca, Dominique Perrault's Ewha Womens University (2004–08, 70,000 m^2) in Seoul, or Grafton Architects' Bocconi University (2008, 45,000 m^2) in Milan.

9.6 Between Private Demand and Good Intentions: School Architecture

Beyond university buildings, the education sector has offered further opportunities to architects. In many countries, private international schools have grown to satisfy the demand of expats, local elites, and a growing middle class to enrol their kids in international schools. As these schools generally require tuition fees almost comparable to those for higher education, they need to project a specific image and rely on fancy facilities, making international architects once again privileged providers of design services. In this regard, the case of China is exemplary. Until the crackdown of 2021, which made almost illegal after-school activities and signalled a shift in the attitude towards private and foreign education providers (Davidson 2021), China has seen the development of the largest market for K-12 education (kindergarten to 12th grade according to the US education classification): 150 million K12 students, with over 300,000 of which enrolled in private schools in 2020, more than triple than the 96,000 of 2010 (International Trade Administration 2020a). These growing numbers, and the solid business they originated, fostered the demand for new school buildings. In 1998–2000, GMP designed the German School and Apartment House in the Diplomatic District N. 3 of Beijing to serve the small local community of diplomats and expats. But since then, the needs have changed, and in the last ten years, a significant number of new projects have been developed, reflecting the growth of a middle-class willing and able to invest substantial financial resources in children's education. Table 9.1 helps us understand the varied type of architectural companies active in this market, and the geographical concentration of international schools in first, before, and, more recently, second-tier cities. In this context, an exception is represented by Whittle School in Shenzhen, not least because it is the only one involving the firm of a Pritzker architect, Renzo Piano. It was his second built project in China and reflected the ambitions of the Whittle School & Studios. This US educational company unsuccessfully attempted to establish a multi-country campus system for students between Washington, DC, and Shenzhen. The outbreak of the COVID-19 pandemic did not help the business.

Outside China, in our surveyed sample of countries, there are a few more school projects scattered across different regions. HOK designed an International School in Kuala Lumpur, LAVA an Eco Kindergarten (2019, 6,300 m^2) of playful appearance in Vinh, Vietnam. In Indonesia, C. F. Møller completed a Montessori School in Bali (2013–17, 6,900 m^2), a facility designed in a modernised Balinese fashion and thought to satisfy the needs of the local expat community, while Denton Corker Marshall had previously completed the Binus Kindergarten and Primary School (2099–11) in Serpong. Indeed, while these projects were conceived to satisfy the ambitions of local elites and emerging middle classes and respond to the request of expat communities by for-profit educational companies, there are some architects, including famed ones, whose work has addressed the requests coming from governments and NGOs to provide, often in a *pro bono* fashion, school buildings to communities in need.

9.6 Between Private Demand and Good Intentions: School Architecture

Table 9.1 Private schools (built projects) in China designed by overseas firms (surveyed sample)

Firm	Project	City	Year	GFA (m²)
B+H	Canadian International School	Kunshan	N.A.	118,000
Broadway Malyan	Jiading School	Shanghai	2003	43,400
	Dulwich College Puxi	Shanghai	2013–16	39,100
	Nanwai King's College School	Wuxi	2014–18	145,820
	Academy of ASTEM	Shanghai	2017	N.A.
	Overseas Chinese Academy of Chiway	Suzhou	2015–18	44,986
	Dipont King's College School	Hangzhou	2015–18	117,944
	Chengdu Westminster	Chengdu	2020	100,000
Diller Scofidio + Renfro	The Tianjin Juillard School	Tianjin	2017–20	36,200
DLR Group	Huili School	Shanghai	2018	7,900
Ferrier Marchetti	International French School	Beijing	2016	19,000
GMP	German School and Apartment House	Beijing	1998–2000	9,658
	Extension of the German School	Beijing	2003–N.A.	26,500
HLW	Wellington College International	Shanghai	2014	N.A.
PBK	Hainan iSchool Elementary School	Haikou	N.A.	3,064
	Beijing Yuying Middle School	Beijing	N.A.	28,000
Perkins Eastman	Concordia International School	Shanghai	2010	20,000
	Wuhan International Education Centre	Wuhan	2016	30,000
Progetto CMR	Dulwich College	Beijing	N.A.	6,000
RAMSA	Schwarzman College	Beijing	2016	N.A.
RPBW	Whittle School	Shenzhen	2016–19	5,800
Schneider + Schumacher	Teda High School	Tianjin	2012–17	62,000
Scott Brownrigg	LEH Foshan	Foshan	2017	47,000

We can call such works the 'architecture of good intentions,' somewhat different from the many vanity projects we have seen so far in this book. The design and construction of rural schools have always represented a primary product of international cooperation and development aids, as also seen in Sect. 3.3. And more recently, looking at our samples of firms and countries, we can find examples scattered across different regions, from the three rural schools in the César Department of Colombia

by Zyscovich Architects to one in Indonesia by JY-Architects. In China, after the 2008 Great Sichuan earthquake that left over 80,000 people dead and U$150 billion in damages, the Chinese government launched a massive and successful reconstruction effort. With some controversies, it included the transformation of the small town of Yingxiu, the closest to the epicentre, into an AAAA-grade tourist destination and a museum of anti-seismic architecture (Sorace 2018). As a result, it now hosts a fascinating Earthquake Museum (2013) designed by Chinese architects Cai Yongjie and Cao Ye hidden in the ground of an artificial sloping landscape cut by sunken paths within CorTen-clad walls, and an Academic Exchange Centre in name, but a hotel in reality, designed by Paul Andreu, at that time one of the most successful foreign architects in China. After that earthquake, Shigeru Ban designed the Hualin Temporary Elementary School in Chengdu, made of paper tubes and assembled by Japanese and Chinese architecture students. And after the 2013 Ya'an earthquake, also in Sichuan Province, the Paper Nursery School was erected with a similar structure and the help of many of the same volunteers involved in the previous project. With Corporate Social Responsibility becoming more relevant for design firms, the Japanese megapractice Nikken Sekkei offered its expertise to design the Matizhai Hope Primary School (2013) in the impoverished mountainous area of Yunnan Province.

In Africa, it is common to find high-quality, low-budget projects designed by European, Australian, and Japanese architects for local and international NGOs. Indeed, in 2012, an article in *Architectural Record* pointed out the overlooked potentialities of Africa for Western architects and highlighted the role of not-for-profit organisations and governmental agencies for civic and educational buildings (Syrkett 2012). Some recent examples (outside our sample) include the InsideOut School by Andrea Tabocchini & Francesca Vittorini (2017, budget €12,000) and the Framed Escape Library (2017, 164 m², budget €9,000) by Maude Cannat and Rachel Méau in Ghana, the Eco Moyo Education Centre (2019) by Arkitekter Uten Grenser, Architectopia and Jan Kazimierz Godzimirski in Kenya, and the TERAKOYA Primary School (2020, 896 m²) by Terrain Architecture in Uganda. Included in our survey, instead, is Studio Anna Heringer's Tatale Campus in Ghana, a project built in rammed earth and timber by the community, and above all, a couple of projects by the 2022 Pritzker winner Diébédo Francis Kéré. The Burkinabé-German architect, whose work has reached several African countries, has completed in Kenya the Startup Lions Campus (2019– 21, 1,416 m²), while his design for the Obama Legacy Campus has not materialised. A closer look at the Startup Lions Campus, thus, helps us understand some key facts. On the one hand, we see the role of NGOs as clients for foreign architects; in this case, it is Learning Lion, a non-profit organisation for digital empowerment, that commissioned Kéré Architecture for the work. On the other, there is perhaps no better example in the contemporary scene of an architect able to produce a high-quality design with a limited budget, community involvement, and environmentally sustainable solutions. The result is a well-fitted ensemble overlooking the beautiful savannah landscape around Lake Turkana, with interiors naturally cooled thanks to the stack effect of the termite mounds-inspired ventilation towers that provide the project with its unique morphology. As the Pritzker Prize Jury Citation states, Kéré's

work "shows us the power of materiality rooted in place. His buildings, for and with communities, are directly of those communities—in their making, their materials, their programs and their unique characters. They are tied to the ground on which they sit and to the people who sit within them" (Aravena et al. 2022). To conclude this section, one more small educational project also distant from the logic of the fancy school facilities designed by international architects is the School for disabled students (2018, 1,550 m^2) in Barka, Oman, an exciting project carried out by VMX Architects, a simple one-storey building with classrooms of different sizes, with external arcades with a coloured background contrasting with the white volume of the school.

9.7 Room for Machines: Data Centres and Factory Plants

Knowledge and information are today stored in very different ways compared to the past, and architecture, unlike what we have just seen, not always responds to the needs of a community. Sometimes, architecture must neglect people and accommodate something else; this is not new. For instance, any monumental burial site, whether the Egyptian pyramids or the Halicarnassus Mausoleum, was not conceived to accommodate any person, at least alive. Since the Industrial Revolution, then, buildings have increasingly been occupied by machines together with people. Accordingly, this section will delve into factory plants designed by overseas firms. Before doing so, however, we will look at another typology on the rise, the data centres. By the twentieth century, machines have generally gone through a process of miniaturisation, of which the most outstanding example has been the personal computer. Nonetheless, while a laptop barely occupies a few square centimetres on our desk, some computers still require hundreds of square metres, plenty of electric energy, and clean and cool air. This is why data centres are needed.

Given their strict security requirements, such structures are some kind of modern-day castles, enclosed buildings, not least because they are populated mainly by computers rather than people and because computers do not need natural light. In addition, data centres require a large amount of energy and water to function. It has been calculated that in 2018, for instance, they consumed about 1% of the global electricity output; 1.8% in the USA, where they are also responsible for approximately 0.5% of the greenhouse national emission (Siddik et al. 2021). Additionally, they highly benefit from a cooler climate, which helps reduce energy consumption for cooling (Caulfield 2018). Not by chance, countries like Iceland or Ireland enjoy a growing interest as locations for these centres. And this does not come without problems, as new investments in the sector face increasing scrutiny, primarily because of the high consumption associated with their operations (Adalbjornssonarchive 2019; Fox 2022). Data centres are, therefore, highly concentrated in a few countries, with the USA leading by far, with about a third (over 2,600) of the world total, primarily located in California and Dallas, TX. The UK follows at a distance, with 5.7%, trailed by Germany (5.5%) and China (5.2%). About 77% of the infrastructure is

located in OECD countries and 64% in NATO countries (Daigle 2021). Looking at our sample of architectural firms, we find a group that is very active in designing this typology of buildings. Indeed, the data centre represents a growing and highly specialised submarket in the hands of a few megafirms. Figures on US firms show the importance of these projects, which granted over U$49 million in revenues to Corgan in 2017, 25 to Gensler, 18 to HDR and AECOM, and 14 to Page, just to name the top five (BD+C 2018).

Gensler has designed at least 21 data centres, 17 of which are in the USA. In the countries object of our survey, it completed the China Pacific Insurance Company Data Centre (188,200 m^2) in Chengdu, and a second one in an undisclosed location in China, while in Guadalajara, Mexico, it has refurbished an existing warehouse into an IBM Data Centre (900 m^2). China's growing data processing power is visible in the increasing number of data centres designed by Western architects, even though they still represent a minimal number of the total. AREP completed two data centres in Shanghai in 2007 and one in Chengdu in 2008, Corgan the Cloudsite Data Centre in Tianjin, while Henn one of such buildings within the already mentioned Huawei R&D Park of Hangzhou. Another German firm, Schneider + Schumacher, has even proposed the first high-rise data centre, the Qianhai Information Building in Shenzhen (Mecanoo received the second prize in the competition). Whether it will be built remains to be seen, but perhaps a more striking example of *produktform* is Benthem Crouwel Architects' Equinix AM3/AM4 Data Centre (2012 and 2017, 18,750 + 24,000 m^2) in Amsterdam. Thus, while we wait for more projects of significant design value, we can notice two facts: the limited participation of boutique firms—with exceptions like the naturally cooling Gak Chuncheon in South Korea by Kengo Uma and DMP—and the ongoing efforts in greening this energy-intensive typology. Arup, for example, designed at least a dozen of these buildings worldwide, including one for Citibank in Frankfurt, which was the first LEED Platinum-certified data centre, and the IXcellerate Moscow One Data Centre (2,500 m^2), the largest one in Russia.

Looking at the other typology on which this section focuses, factory buildings, we see that foreign firms have designed several plants across all our surveyed regions. Their work follows some recognisable patterns. Firstly, we can notice the market dominance of a bunch of firms, usually large AEC companies, with only a few exceptions. A 'signature' factory plant with a strong, iconic character is not the rule in a sector where efficiency, cost control, and other technical performances are far more important than aesthetics. In the second place, we recognise stable architects-companies networks often based on shared nationality. Finally, firms from manufacturing countries like Japan and Germany have delivered the highest number of these projects. In contrast, a surprisingly low number of projects by US firms have been identified. This could be due to the surveyed sample, which does not include Engineering & Construction firms and other engineering consultancies that can be more involved in the design of factory plants, as well as to the fact that these projects often remain under the radar as they are not displayed on websites, whether for confidentiality issues or because of their minimal aesthetic qualities.

9.7 Room for Machines: Data Centres and Factory Plants

Among the examined sample, one of the firms most involved in the design of industrial plants is Takenaka Corporation, one of Japan's largest contractors. In addition to the many plants it designed in Japan and other countries worldwide, Takenaka Corporation delivered projects for seven factories in China (for a total of over 280,000 m^2), three in India, and three in Indonesia (Table 9.2). Its network, not surprisingly, involves Japanese manufacturers like Mitsubishi, Honda, Toyota, and Daikin in three different countries. Indeed, such connections are visible in other firms' work, too. Danish consulting engineering Ramboll, for instance, delivered completed projects as the general planner (from geotechnical surveys to technical installations) for several Danish companies. It thus designed two plants for Grundfos in Suzhou (2005 and 2008, 28,500 and 20,300 m^2), one for Coloplast in Zhuhai (2007, 21,000 m^2), a refurbishment for Novo Nordisk in Tianjin (2012, 600 m^2), and a plant for Haldor Topsoe (2014, 15,500 m^2) in Tianjin, too. Another Danish firm, C.F. Møller Architects, designed one plant for Grundfos in Saudi Arabia and a few others in countries not included in our research, like Denmark, the Czech Republic, Japan, the UK, and the USA. Swiss firm Concept Consult completed a plant for Nestlé in Samalkha, India, while two more projects, one in the United Arab Emirates and one in Mexico, were probably not built. Italian firm Archest completed a factory building for the Italian meat processing company Cremonini (2009, 26,000 m^2) in Odintsovo. At that time, Archest has been active in Russia since the mid-1990s, completing the Domodedovo Airport Cargo Warehouse in 1996, three more factories for a total of more than 60,000 m^2, and three office buildings.

Of course, not always links between architectural firms and companies consistently follow national patterns. French cosmetic giant L'Oréal chose Arte Charpentier for its China R&D Centre in Shanghai (2008–13, 150,000 m^2), but Perkins & Will and RAF Arquitetura for the Rio de Janeiro R&D Centre (2013, 13,935 m^2, LEED Gold). Built on one of the branches of the artificial Fundão Island, where the University City and its annexed Technology Park are located, this elongated building faces the polluted waters of Guanabara Bay, which it filters and releases once depurated.

Table 9.2 Industrial plants designed by Takenaka Corporation in surveyed countries

Project	City (country)	Year	GFA (m^2)
Daikin Air Conditioning New Factory	Suzhou (China)	2012	128,939
Kubota Construction Machinery Co. Ltd. Wuxi Factory	Wuxi (China)	2012	38,068
Amada Shanghai facility	Shanghai (China)	2013	29,214
Toyota Motor Engineering & Manufacturing Phase 1 and 2	N.A. (China)	2013	55,225
Guangzhou Yakult The Second Factory	Guangzhou (China)	2014	14,898
Nabtesco Changzhou Factory	Changzhou (China)	2015	14,300
Honda5 Motor Technology Centre	N.A. (China)	2015	48,168
Mitsubishi Elevator India New Factory	N.A. (India)	2016	25,200

(continued)

Table 9.2 (continued)

Project	City (country)	Year	GFA (m^2)
FCC Gujarat New Factory	N.A. (India)	2018	9,165
Sanko Gosei Gujarat New Factory	N.A. (India)	2018	11,874
Honda Prospect Motor 2nd Factory	N.A. (Indonesia)	2013	153,200
Yakult Surabaya (Mojokerto) Factory	Surabaya (Indonesia)	2014	12,641
Mitsubishi Motors Indonesia New Factory	N.A. (Indonesia)	2016	177,981

The volume follows the curving line of the shore with an inclined, fully glazed front that reveals its interior while protecting it from the sun. Valode & Pistre designed several plants for the French automotive supplier Valeo in China, the Czech Republic, Hungary, Mexico, Morocco, and Poland. In Mexico, plants are located in San Luis de Potosí, where Davis Brody Bond designed the Valeo Electrical System plant (18,200 m^2). This elegant industrial building features a system of tension cables to sustain the roof to minimise the need for internal vertical support. In Brazil, Davis Brody Bond, who also unsuccessfully participated in the competition for the Rio de Janeiro L'Oréal R&D Centre and another project for the same company in the USA, completed a manufacturing and laboratory for Valeo Security System (19,200 m^2) in São Paulo, organised in four parallel bands along a slope. To complete the picture, Davis Brody Bond also unsuccessfully designed a plant for Valeo in the USA and finished another in Mexico for Procter & Gamble Gilette (104,980 m^2).

Factory buildings sometimes become real showcases of the company, with Peter Behrens' AEG Turbinenfabrik in Berlin (1908–09) as the best-known example. More recently, the Vitra Campus in Weil am Rhein certainly established a difficult-to-equal benchmark, with factory buildings designed by Nicholas Grimshaw, Álvaro Siza, and SANAA, in addition to several more buildings signed by other renowned architects. In this light, but at another scale, we can look at Henn's Brilliance/BMW Plant (2013, 220,000 m^2 + second and third phase of unknown size; Fig. 9.29) in Shenyang, the manufacturing hub of north-eastern China chosen by the German company for its local production. The most interesting aspect of Henn's project is the visual integration of the production line in the main office building, which is crossed by a conveyor belt. As in other cases, Henn could already rely on a successful track record of industrial projects in Germany, especially for the automotive sector, including the famous VW AutoTürme in Wolfsburg, the two iconic glazed towers used to store newly produced cars temporarily. The project in Shenyang, then, apparently opened the way for further involvement with BMW, as the more recent projects of the BMW FIZ master plan and the Hybrid Building in Munich show. Swedish electric car manufacturer Polestar, on the other hand, chose Norwegian firm Snøhetta for the project of its plant in Chengdu (2016–19), a building characterised by a curved front, where glass and a black steel cladding fold and unfold, and a quiet courtyard for the relax of the employees.

This exploration continues with more cases of interest scattered in different countries. In China, the choice of the Shanghai Lingang Huaping Economic Development

9.7 Room for Machines: Data Centres and Factory Plants 431

Fig. 9.29 A satellite picture of the Brilliance/BMW production plant by Henn, Shenyang. © Maxar Technologies from Google Earth Pro

Group in favour of GMP for several factory buildings in Lingang/Nanhui New City, a new town master-planned by the German firm, is remarkable for showing how GMP worked to propose simple and standardised solutions to create a visual identity for large industrial and logistic parks. In the High Tech Park—Heavy Industry Zone (2015–17, 196,000 m^2), warehouses feature façades dominated by a blue horizontal strip, while in another industrial field ("Barcode Halls", 2008–09, 18,300 m^2), the buildings display barcode-like façades. For two more industrial parks, covering over 348,000 m^2, GMP developed corrugated aluminium façades with rounded corners that once again define the visual identity of the park. Such projects, to which we should add at least a further one hundred thousand square metres designed by GMP of similar destination, show the interest of this state-owned developer (Shanghai Lingang Huaping Economic Development Group) in relying on international architectural firms to define the image of the industrial area on a generic base, as the future users were not identified yet, but with a higher-than-usual standard. A façade problem, in a way, was also tackled in Playze's Glass Factory Campus (2007–10, 47,570 m^2) in Kunshan. In this multi-building industrial complex, the German firm exploited inexpensive materials like corrugated metal sheets and simple formal strategies like undulating and folding the façade and roof to create a recognisable but low-cost product. This time in Malaysia, one last example suggests the possibility of 'greener' alternatives for industrial plants' envelopes. Designed by Ryuichi Ashizawa Architects, the JST Malaysia Factory extension (2013, 25,141 m^2) in Johor Bahru consists of a factory building, which necessarily follows a regular geometry, covered by a green 'carpet' folding down along the lateral façades, and a low elliptical office tower, shrouded in climbing vegetation to emphasise the sustainable character of the

Fig. 9.30 The CopenHill by BIG, Copenhagen. Photograph by News Oresund, distributed under a CC BY 2.0, available at https://commons.wikimedia.org/wiki/File:2019-11-27_Amager_Bakke_Copenhagen_Hill_(49141383237).png

intervention, which relies on several strategies to minimise carbon emissions and improve the environmental quality of the workspace.

Finally, a 'dirty' typology increasingly aestheticised by architects is that of waste treatment plants and waste-to-energy plants. Their design has long remained the preserve of engineering firms, but today is becoming more and more an activity for which architects are required, signalling the growing importance of better integrating these infrastructures with the city and the landscape. In this regard, BIG's CopenHill (2011–19; Fig. 9.30) in Copenhagen has overtly shown the way, manifesting the architectural potential of infrastructures as crucial today as traditionally hidden or disguised. With its ski slope on top, this waste-to-energy plant became a public monument to sustainability, a new icon of the Danish capital, and a recreational facility for the public. Thus, while in Northern Europe these infrastructures are becoming an object of interest for architects (Parkes 2021), a few projects have been produced by foreign firms in our surveyed regions. Cases and figures are limited, but it seems they might be signalling a trend for the future, for example, in China, where the governmental "Beautiful China Initiative" established the framework for the country's achievement of the United Nations' 2030 Agenda for Sustainable Development's goals (Martinelli 2018; Fang et al. 2020). French firm AIA Life Designer has a portfolio of at least six waste treatment plants completed or under construction across China. Schmidt Hammer Lassen/Perkins & Will designed a waste-to-energy plant in Shenzhen set to become the largest in the world. Its compact, circular volume, immersed in a landscaped park, will also make it a unique, iconic presence and likely a model in China for more plants to be built and exhibited rather than hidden.

9.8 Healthy and Long Lives: The High-Tech Hospital

Before concluding this chapter, a few more special typologies of buildings need to be mentioned because the choice of overseas design firms for such projects reflects the will to rely on specialised expertise. Hospitals and clinics are one example of a highly specialised workplace, where the space needed for patients' treatment and stay is often combined with advanced research laboratories and other facilities. As a result, healthcare architecture requires design capabilities and technical know-how that not all firms can provide. Considering our sample of emerging countries, China alone has represented the largest market for international architects. To investigate this specific sub-market, we will not look analytically at every region but rather highlight a small number of firms' roles in delivering a high number of projects. In this regard, a small warning is required. Figures referred to these projects are less precise because the actual status of many of these works is more difficult to track. As mentioned for other typologies, this can be explained for two reasons. First, hospitals and clinics receive much more limited media coverage than iconic cultural buildings, housing projects, or skyscrapers. Secondly, our sample may not encompass many AEC firms highly specialised in this typology.

That said, the history of building healthcare facilities overseas for Western architecture and engineering firms is long, and some cases—the work of TAC and The Architects Co-Partnership in Saudi Arabia in the 1970–80s, for instance—have already been mentioned in Sect. 3.4. In the history of China, too, the construction of modern hospitals at the beginning of the Reform Era represents an interesting case. One of the first international projects involving Japanese firms and Chinese design institutes during the 1980s (Sect. 3.4) was the China-Japan Friendship Hospital (1984), designed by Nikken Sekkei with KJTO Architects & Engineers and the Second Research & Design Institute of Nuclear Industry (Xue et al. 2021). Since then, China's healthcare infrastructure has undergone a significant process of modernisation and expansion. In 2019, the country counted about 6.8 million beds (International Trade Administration 2020b) in over 34,000 hospitals, compared to 20,000 in 2010 (National Bureau of Statistics of China 2021, Chap. 22.1). Such growth reflected the increasing demand for healthcare services from an ageing and more affluent population.

Given these numbers, the work of foreign firms in the sector appears nothing more than a drop in the ocean in China and relatively limited across the other surveyed regions, too. As visible from Table 9.3, in China, HKS, AIA Life Designers, and Nickl & Partners have been significant players considering the number of projects and built GFA, although some single works have been as large as the sum of a few. For instance, Payette has designed a massive 520,000-square-metre hospital now under construction in Changsha. Overall, the table shows that US firms hold the lion's share in this sector, although competition is fierce from both Chinese and third-party architects, as highlighted by the market intelligence unit of the US International Trade Administration (2020b). In any case, the strength of US firms in this sector may result from more developed ties between design firms and private

Table 9.3 Overseas firms (surveyed sample) with built hospital and clinic projects in Chinese cities

Firm	Cities	Year of completion (oldest)	Total GFA (m^2)
AIA Life Designer (FR)	Beijing, Guangzhou, Nanjing, Shanghai, Suzhou, Wuhan, Zhuhai	2005	426,332
AREP (FR)	Beijing	2006	225,000
B+H (CA)	Jiaxing	2019	1,400
Callison RTKL (USA)	Beijing, Tianjin	N.A.	222,000
GBBN (USA)	Kunming, Suzhou	N.A.	132,340
GMP (DE)	Shanghai, Wuzhen	2015	101,500
Gresham, Smith and Partners (USA)	Shanghai	N.A.	88,072
HDR (USA)	Suzhou	N.A.	27,900
HKS (USA)	Beijing, Chengdu, Hefei, Shanghai, Suzhou, Wuhan	2014	693,400
HMC Architects (USA)	Shunde	2017	225,000
HPP (DE)	Shanghai	2017	603
NBBJ (USA)	Shanghai	2017	142,300
Nickl & Partners (DE)	Dalian, Qingdao, Shenyang, Yingkou	2008	477,000
Nihon Sekkei (JP)	Taizhou	2014	201,300
Payette (USA)	Changsha	2020	520,200
Smith Group (USA)	Shanghai (×2), Tianjin,	2017	104,158
Stantec (CA)	Hefei	2020	23,225

international healthcare providers, which have a growing importance in the Chinese market. The Hefei BOE Hospital designed by HKS stemmed from a partnership with the US healthcare provider Dignity Health, while two more hospitals—the ParkwayHealth Gleneagles Shanghai International Hospital and the ParkwayHealth Gleneagles Chengdu Hospital (this one designed within a former shopping mall)—were developed by the Singaporean private healthcare company Parkway.

Another market of similar relevance is the Middle East. From Table 9.4, we can notice that the main players are the same, but also that the average dimension of the structures is more limited than in China. Among these cases, one deserving a few words is the impressive Cleveland Clinic in Abu Dhabi by HDR (Fig. 9.31). This LEED Gold, state-of-the-art hospital is composed of several volumes, some glazed and with a visible diagrid inside, other opaques, orthogonally stacked one upon the other. The more elongated ones create deep cantilevers, while the top one, which is a taller slab, rests on this dynamic volumetric composition. Avoiding a case-by-case analysis, we conclude by showing how, according to available data, most of the US firms seen here also represent the major player in such a sector. Rankings

9.8 Healthy and Long Lives: The High-Tech Hospital

Table 9.4 Overseas firms (surveyed sample) with built hospital and clinic projects in Middle Eastern cities (surveyed countries)

Firm	Cities	Year of completion (oldest)	Total GFA (m^2)
AECOM (USA)	Abu Dhabi	2009	N.A.
Cuningham Group Architecture (USA)	Doha	N.A.	26,940
General Planning (IT)	Ajman, Sharjah	2013	54,050
HDR (USA)	Abu Dhabi	2015	213,600
HKS (USA)	Abu Dhabi	2010	44,695
IBI group (CA)	Dubai	2018	16,000
Leo A Daily (USA)	Abu Dhabi (×2)	N.A.	18,527
Nickl & Partner (DE)	Mecca	2009	2,100
Pelli Clarke Pelli Architects (USA)	Doha	2018	139,000
Perkins & Will (USA)	Doha	2019	N.A.
Perkins Eastman (USA)	Ras Al Khaimah	2014	65,000
Stantec (CA)	Abu Dhabi (×3), Dubai	N.A.	387,400

on North America (BD+C 2021) put HDR, with U$309 million in revenues from healthcare design, in the first position, followed by HKS (U$205 million), which has also completed two hospitals in India (over 14,000 m^2) and two in Mexico (23,038 m^2). Perkins & Will (U$175 million) is ranked third. Cannon Design (U$137 million), which completed the Tata Medical Centre (2019) in Kolkata, follows. The ranking continues with Stantec in fifth position, Perkins Eastman (7th), NBBJ (8th), and Smith Group (9th), just to display how most of the firms we see at work in these countries are at the top of North American ranking in the healthcare design sector. According to our mapping, a few more projects were built in other regions: one in Malaysia by Scott Brownrigg (650 m^2), one in Vietnam by Heerim Architects and Planners (150,450 m^2), one in Malaysia by B+H (103,064 m^2), two in Russia by Nickl & Partners (>20,000 m^2), and one in Brazil by Albert Kahn Associates. In addition, Safdie Architects completed the first phase (42,900 m^2) of a larger teaching hospital complex in Cartagena de Indias, Colombia.

To conclude this section, two different projects in Ghana deserve a mention. The Greater Accra Regional Hospital at Ridge (2017, 43,200 m^2) by Perkins & Will features a contemporary international aesthetic with some local hints and is based on a low-tech approach to achieving high performance. It heavily relies on passive strategies, including passive cooling and natural ventilation, with systems for rain-water harvesting and solar water heating, while a walkable outdoor ramp allows patients' movement without the need for elevators which are affected by frequent power outages. As a result, the building first achieved a LEED Silver certification

Fig. 9.31 The Cleveland Clinic by HDR, Abu Dhabi. Photograph by Giaime Botti, distributed under CC BY 4.0

for healthcare architecture in Africa. Together with this multi-million dollar flagship project for the region, however, the Ghana Ministry of Health sought more straightforward and cheaper solutions, appointing British firm TP Bennet to design the Korle-Bu Children's Hospital and one showcase hospital to serve as a model for six more constructions across the country. In this case, the building is based on simple one-storey modules not to require elevators and costly concrete structures and provides a flexible and adaptable scheme with a generous provision of waiting zones, outdoor gardens, and workers' accommodations.

9.9 Conclusions

In this chapter, we have focused on a wide range of projects whose programmatic diversity did not hinder the possibility of categorising them under the umbrella of workplace architecture. We have examined the relevance that the office building still has today in the architecture market, despite cyclical claims of its demise, which the COVID-19 pandemic boosted again. In this regard, the role of megafirms in emerging markets, where the demand is still strong, especially in emerging global centres, has been fundamental in delivering dozens of projects that are usually relatively standardised but of overall high quality and well-performing from an environmental standpoint. In addition, innovative and unique designs have materialised in both high and low-rise office buildings with signature projects by internationally awarded architects. Indeed, the theme of the office and, more in general, of the architecture of the workplace also touches on the scale of the city. On the one hand, office towers tend to concentrate on specific city sectors, the CBDs, which perpetuates

all the problems that monofunctional zoning has created since its full embracement in the CIAM's Athens Charter. On the other, we do recognise a trend in which monofunctional office skyscrapers are replaced by mixed-use ones (Sect. 5.1), and office buildings are more and more located within mixed-use developments that, although they generally do not include housing, do include retail, leisure space, and hospitality programmes. Projects like the OōEli Art Park by RPBW in Hangzhou define a positive counterpoint to many CBDs dominated by large blocks, high-rises, and vehicular traffic, making them potential blueprints for a functionally diverse, pedestrianised, and more human-in-scale urban space.

While such developments propose a more porous urban space, especially in China, where gated communities dominate the residential areas, and fences surround many workplaces, other typologies of productive spaces remain enclosed. Data centres are emerging as the new factories of the information age, requiring for their design specialised know-how that only some design firms have. In some cases, they also strive to acquire some aesthetic quality beyond a purely functional expression. Similarly, factories and warehouses were designed by overseas architects across different regions. However, given the nature of the typology (extremely functional, peripherally located), it appears clear that such commissions come only when the project demands the expression of some cutting-edge corporate identity or, in the case of established collaborations between industrial groups and design firms (usually large AEC). Less secretive, but often not accessible to the general public, are the science and technology parks built across China, India, and the Middle East. Overall, they tend to repropose the modernist configuration of loosely connected buildings in a more or less green void. In general, buildings feature a high-tech aesthetic and high energy and environmental performances in a very international language, without too much concern for regionalising it (if not for the presence of large, overhanging roofs in China or latticework screens in the Middle East). In terms of general layout and landscaping, we can note in China the presence of extended green areas and diffuse attention towards their design with an eye on traditional gardens. On the contrary, in the Middle East, for climatic reasons, buildings are more densely clustered and connected by shading canopies. At the same time, the outdoors, including water features, have a more rigid and geometric design.

University campuses also feature similar schemes and similar differences across regions. Buildings tend to be aesthetically appealing, rich in informal spaces for gatherings and sociality, and manifestly eco-friendly. They need to be state-of-the-art and iconic facilities to project an adequate image for institutions charging students several thousand dollars per year in tuition fees and embody values of innovation and sustainability through high-tech design. We thus find 'manifesto buildings' like Cucinella projects in China a decade ago and a growing number of constructions and overall master plans that primarily address this problem. From this trend, no region is excluded, as demonstrated by one of the most interesting projects mapped in this chapter: the campus for the Universidade Agostinho Neto in Benguela by Perkins & Will. Finally, some individual buildings of formal and typological value include Adjaye's and Herzog & De Meuron's projects in Skolkovo, and Legorreta's works in the Qatar Education City, which display the scope of one of the very few

Latin American contemporary firms with a strong international projection. The QAE, in addition, leads us to some final reflections on the agency of foreign architects in emerging markets. In size, scope, and meaning, it could be well compared to major public enterprises of the 1940–60s, generally carried out by local architects in Latin America and overseas ones in Asia and Africa. The whole project thus displays some contemporary trends along different lines. In terms of development and financing, we see a typical mix of public and private actors, with the additional complexity given by the local system in which state-led capitalism overlaps with the activities of the ruling families (the Qatar Foundation itself is a not-for-profit state-led organisation). This is visible in the institutions occupying the area, which include private foreign universities and QF's facilities. The mix of programmes represents an evolution from older university cities towards a more diverse set of functions reflecting the growing complexity of today's education and research ecosystem, although it clearly remains a mono-functionally zoned area with no residential space. Neither a piece of the city nor a 'city' despite its name. Finally, the actors involved—some of the most renowned architects and megafirms, including two Pritzker winners—prove once again the reliance on overseas designers for flagship projects in the region and, from the opposite perspective, the importance of this market for European, US, Japanese, and Australian firms.

References

Adalbjornsson, Tryggvi. 2019. Iceland's data centers are booming—Here's why that's a problem. *MIT Technology Review*, June 18. https://www.technologyreview.com/2019/06/18/134902/ice lands-data-centers-are-booming-heres-why-thats-a-problem/. Accessed 16 Mar 2022.

Adam, Robert. 2013. Doha, Qatar. In *Architecture and Globalisation in the Persian Gulf Region*, ed. Murray Fraser and Nasser Golzari, 105–127. Farnham: Ashgate.

Annerstedt, Jan. 2006. Science parks and high-tech clustering. In *International Handbook on Industrial Policy*, ed. Patrizio Bianchi and Sandrine Labory, 279–297. Cheltenham: Edward Elgar.

Aravena, Alejandro, Barry Bergdoll, Deborah Berke, Stephen Breyer, André Aranha Corrêa do Lago, Kazuyo Sejima, Shu Wang, Benedetta Tagliabue, and Manuela Lucá-Dazio. 2022. *Jury citation*. The Pritzker Architecture Prize, Mar 15. https://www.pritzkerprize.com/laureates/ diebedo-francis-kere#:~:text=Chicago%2C%20IL%20(March%2015%2C,internationally% 20as%20architecture's%20highest%20honor. Accessed 25 June 2022.

BD+C. 2018. *Top 40 data center architecture + AE firms [2018 Giants 300 Report]*. Building Design+Construction, Sept 4. https://www.bdcnetwork.com/top-40-data-center-architecture-ae-firms-2018-giants-300-report. Accessed 15 Mar 2022.

BD+C. 2021. *2021 healthcare sector giants: Top architecture, engineering, and construction firms in the U.S. healthcare facilities sector*. Building Design+Construction, Aug 27. https://www.bdcnetwork.com/2021-healthcare-sector-giants-top-architecture-engineering-and-construction-firms-us-healthcare. Accessed 20 May 2022.

Bernstein, Fred A. 2012. Under African Skyes. Universidade Agostinho Neto. *Architectural Record* 200 (8): 76–81.

Brown, Dominic. 2022. The resilient office in Asia Pacific. *The Edge Magazine (cushman & Wakefield)* 7: 18–22.

References

Capello, Roberta, and Andrea Morrison. 2009. Science parks and local knowledge creation: A conceptual approach and an empirical analysis in two Italian realities. In *New Directions in Regional Economic Development*, ed. Charlie Karlsson, Ake E. Andersson, Paul C. Cheshire, and Roger R. Stough, 221–245. Berlin: Springer.

Caulfield, John. 2018. *Data centers keep cool while staying hot-hot-hot*. Building Design + Construction, July 25. https://www.bdcnetwork.com/data-centers-keep-cool-while-staying-hot-hot-hot. Accessed 10 Mar 2022.

CBRE. 2022. *U.S. office leasing activity slows in march but tenant interest grows CBRE Pulse of U.S. office demand*. CBRE, Apr 20. https://www.cbre.com/insights/briefs/pulse-of-us-office-demand-us-office-leasing-activity-slows-in-march-but-tenant-interest-grows. Accessed 30 June 2022.

Cohen, Arianne. 2022. *Why commercial landlords will give you months of free office rent*. Bloomberg. April 15. https://www.bloomberg.com/news/articles/2022-04-12/office-space-lease-bidding-wars-breaking-out. Accessed 25 June 2022.

Coulson, Jonathan, Paul Roberts, and Isabelle Taylor. 2015. *University Trends: Contemporary Campus Design*. Abingdon: Routledge.

Curtis, William J.R. 2006. *Modern Architecture Since 1900*. London: Phaidon.

Cushman & Wakefield. 2021. *Predicting the Return to the Office*. Cushman & Wakefield.

Daigle, Brian. 2021. *Data centers around the world: A quick look*. United States International Trade Commission.

Davidson, Helen. 2021. China's crackdown on tutoring leaves parents with new problems. *The Guardian*, Aug 3. https://www.theguardian.com/world/2021/aug/03/chinas-crackdown-on-tutoring-leaves-parents-with-new-problems. Accessed 15 Nov 2022.

Dua, André, Kweilin Ellingrud, Phil Kirschner, Adrian Kwok, Ryan Luby, Rob Palter, and Sarah Pemberton. 2022. Americans are embracing flexible work—And they want more of it. McKinsey & Company, June 23. https://www.mckinsey.com/industries/real-estate/our-insights/americans-are-embracing-flexible-work-and-they-want-more-of-it. Accessed 10 Oct 2022.

Etzkowitz, Henry, and Loet Leydesdorff. 1998. A triple helix of university–industry–government relations: introduction. *Industry and Higher Education* 12 (4): 197–201.

European Commission—Joint Research Centre. 2020. Telework in the EU before and after the COVID-19: Where we were, where we head to. Policy brief, European Union. https://joint-research-centre.ec.europa.eu/system/files/2021-06/jrc120945_policy_brief_-_covid_and_telework_final.pdf.

Fang, Chuanglin, Zhenbo Wang, and Haimeng Liu. 2020. Beautiful China initiative: Human-nature harmony theory, evaluation index system and application. *Journal of Geographical Sciences* 30: 691–704.

Florida, Richard L. 2012. *The Rise of the Creative Class: Revisited*. New York, NY: Basic Books.

Fox, Kara. 2022. *Ireland's data centers are an economic lifeline. environmentalists say they're wrecking the planet*. CNN, Jan 23. https://edition.cnn.com/2022/01/23/tech/ireland-data-centers-climate-intl-cmd/index.html. Accessed 16 Mar 2022.

Frampton, Kenneth. 2020. *Modern Architecture: A Critical History*, 5th ed. London: Thames & Hudson.

IASP. June 2017. *Definitions*. International Association of Science Parks and Areas of Innovation. https://www.iasp.ws/our-industry/definitions. Accessed 10 Mar 2022.

International Trade Administration. 2020a. *China education design and construction*. International Trade Administration. United States of America. Department of Trade, Aug 12. https://www.trade.gov/market-intelligence/china-education-design-and-construction. Accessed 20 June 2022.

International Trade Administration. 2020b. *China healthcare facility construction*. International Trade Administration. United States of America. Department of Trade, July 13. https://www.trade.gov/market-intelligence/china-healthcare-facility-construction. Accessed 20 May 2022.

Jain, Anshul. 2022. Indian real estate in the post-covid-19 era. *Corporate Real Estate Journal* 11 (3): 266–279. https://www.cushmanwakefield.com/en/india/news/2022/05/indian-real-est ate-in-the-post-covid-19-era.

Kahn, Sobia. 2021. Economic recovery to bring back office leasing momentum to pre-pandemic levels. *The Economic Times*, Oct 8. https://economictimes.indiatimes.com/industry/services/ property-/-cstruction/economic-recovery-to-bring-back-office-leasing-momentum-to-pre-pan demic-levels/articleshow/86859936.cms?from=mdr. Accessed 26 June 2022.

Koolhaas, Rem. 1995. The generic city. In *S, M, L, XL*, ed. Office for Metropolitan Architecture, Rem Koolhaas and Bruce Mau, 1238–1267. New York, NY: The Monacelli Press.

Koolhaas, Rem, Reinier de Graaf, and OMA. 2006. Dubai renaissance. *OMA*. https://www.oma. com/projects/dubai-renaissance. Accessed 20 Mar 2022.

KPF. 2022a. Cutting edge, sustainable new campus for Hong Kong University of Science and Technology opens in Guangzhou. *KPF*, Aug 9. https://www.kpf.com/news/cutting-edge-sustai nable-new-campus-for-hong-kong-university-of-science-and-technology-opens-in-guangzhou. Accessed 15 Oct 2022a.

KPF. 2022b. Under one roof. The evolution of the mixed-use building. *KPF*, July 21. https://www. kpf.com/story/mixed-use. Accessed 5 Sept 2022b.

Langdon, Philip. 1995. Asia bound: What are American architects' responsibilities in developing countries? *Progressive Architecture* 76 (3): 43–51.

Levy, Daniel C. 2018. Global private higher education: An empirical profile of its size and geographical shape. *Higher Education* 76 (4): 701–715.

Martinelli, Maurizio. 2018. How to build a 'beautiful china' in the anthropocene. The political discourse and the intellectual debate on ecological civilization. *Journal of Chinese Political Science* 23: 365–386.

McGetrick, Brendan. 2011. The giant interactive group campus. *Domus*, Jan 20. https://www.dom usweb.it/en/architecture/2011/01/10/the-giant-interactive-group-campus.html. Accessed 15 Apr 2022.

McKinsey Global Institute, Susan Lund, Anu Madgavkar, James Manyika, and Sven Smit. 2020. *What's next for remote work: an analysis of 2,000 tasks, 800 Jobs, and Nine countries*. McKinsey Global Institute, Nov 23. https://www.mckinsey.com/featured-insights/future-of-work/whats-next-for-remote-work-an-analysis-of-2000-tasks-800-jobs-and-nine-countries. Accessed 25 June 2022.

Mell, Ian. 2016. *Global Green Infrastructure: Lessons for Successful Policy-Making, Investment and Management*. Abingdon: Routledge.

Montaner, Josep Maria. 2020. Torre Hipódromo: Carlos Ferrater. *Summa* + (179): 32–41.

National Bureau of Statistics of China. 2020. *China City Statistical Yearbook 2020*. Beijing: National Bureau of Statistics of China.

National Bureau of Statistics of China. 2021. *China Statistical Yearbook 2021*. Beijing: China Statistics Press.

Ouroussoff, Nicolai. 2011. Turning design on its side. *The New York Times*, June 27.

Parkes, James. 2021. Eight power plants that combine innovative architecture and energy solu- tions. *Dezeen*, Aug 31. https://www.dezeen.com/2021/08/31/power-plant-architecture-energy/. Accessed May 25, 2022.

Press Trust of India. 2021. Gross leasing of office space down 22% across 6 cities in Jan-June. *Busi- ness Standard*, July 18. https://www.business-standard.com/article/economy-policy/gross-lea sing-of-office-space-down-22-across-6-cities-in-jan-june-121071800426_1.html. Accessed 25 June 2022.

Robinson, Bryan. 2022. Remote work is here to stay and will increase into 2023, Experts Say. *Forbes*, Feb 1. https://www.forbes.com/sites/bryanrobinson/2022/02/01/remote-work-is-here-to-stay-and-will-increase-into-2023-experts-say/. Accessed 18 June 2022.

Roney, Win. 2013. Flexible collaboration: Silicon valley's influence on the workplace. *Work Design Magazine*. https://www.workdesign.com/2013/01/flexible-collaboration-silicon-valleys-influe nce-on-the-workplace/. Accessed 25 July 2022.

References

Sassen, Sakia. 2006. *Territory, Authority, Rights: From Medieval to Global Assemblages*. Princeton, NJ: Princeton University Press.

Siddik, Md. Abu Bakar, Arman Shehabi, and Landon Marston. 2021. The environmental footprint of data centers in the United States. Environmental Research Letters 16: 064017.

Sorace, Christian P. 2018. *Shaken Authority: China's Communist Party and the 2008 Sichuan Earthquake*. Ithaca, NY: Cornell University Press.

Sullivan, Louis. 1924. *The Autobiography of An Idea*. New York, NY: Press of the American Institute of Architects.

Syrkett, Asad. 2012. Forward thinking. *Architectural Record* 200 (8): 61–64.

Tisch, Andrew. 2020. Why the death of the office is greatly exaggerated. *Forbes*, Sept 20. https://www.forbes.com/sites/andrewtisch/2020/09/10/why-the-death-of-the-office-is-greatly-exaggerated/. Accessed 25 June 2022.

Williams, Austin. 2015. Chemical analysis. *The Architectural Review* 237 (2): 30–43.

Xue, Charlie Q. 2016. *Hong Kong Architecture 1945–2015: From Colonial to Global*. Singapore: Springer.

Xue, Charlie Q.L., Guanghui Ding, and Yingting Chen. 2021. Overseas Architectural Design in China: A Review of 40 Years. *Architectural Practice* (29): 8–21.

Yang, Siying, Wei Liu, and Zhe Zhang. 2022. The dynamic value of China's high-tech zones: Direct and indirect influence on urban ecological innovation. *Land* 11 (1).

Zhang, Haiyang, and Tetsushi Sonobe. 2011. Development of science and technology parks in China, 1988–2008. *Economics: The Open-Access, Open-Assessment EJournal* 5 (6): 1–25.

Zouain, Desiree Moraes, and Guilherme Ary Plonski. 2015. Science and technology parks: Laboratories of innovation for urban development—An approach from Brazil. *Triple Helix* 2 (7).

Chapter 10
Architecture for Leisure: Living the "Generic City"

Before the COVID-19 pandemic broke out, tourism accounted for about 10% of the global GDP and occupied a similar share of the workforce, according to the UN World Tourism Organisation. It accounted for 12–14% of the GDP in a country like Spain, or 10% in Italy, while places like the Maldives or Macau relied on it for more than half of their GDP. In its broader definition, tourism includes all those temporary displacements—longer than 24 h and shorter than 365 days—motivated by pleasure, business, and other reasons (including medical care or visiting relatives). Moved by the quest for an "authentic" experience, the tourist is nowadays the representative of a new "leisure class" (MacCannell 1976), no longer restricted to Veblen's (1899) upper segments of the society but overlapping with the whole middle and working class. And while Dean MacCannell writing in the 1970s had a Western focus, data on international tourism reveal the globality of the phenomenon, with emerging middle classes from all over the Global South now travelling as never before. While several buildings, especially museums, have been conceived precisely to attract tourists, and megaevents have also played a role in providing international visibility to countries and cities with the aim (and the hope) of boosting tourism, it is in this last chapter that we discuss the architecture more connected to this multi-faceted activity and the broader concept of leisure and consumption. In many ways, we can say that this chapter touches on the architecture of the fourth function of the CIAM's Athens Charters: recreation.

In this light, we begin the present chapter discussing the architecture of new city gates: airports and, in the case of China, high-speed railway stations designed by international architects. Airports represent a short circuit of globalisation, a "concentrate of both the hyper-local and hyper-global" in terms of iconography and performance, Koolhaas (1995, 1251) wrote, and architecture, we add. In their design, a small group of firms have played a fundamental role across all the emerging markets after having gained expertise in their home countries. After that, three central sections will focus on hospitality architecture, firstly by investigating the link between globalisation, local identities, and design in the context of economies involved in processes of international opening or diversification; secondly, by examining hotel architecture

© The Author(s), under exclusive license to Springer Nature Singapore Pte Ltd. 2023
G. Botti, *Designing Emerging Markets*,
https://doi.org/10.1007/978-981-99-1552-1_10

443

in the emerging markets and identifying the main architectural trends while also highlighting the role and the engagement of certain firms; finally, by exploring the booming (pre-Covid-19) hospitality sector of China and the involvement of international firms in the design of several hotels for major global chains. Then, the chapter continues by focusing on shopping malls and other venues devoted to shopping and entertainment, again analysing the role of overseas architects in designing the fanciest malls. While the typology underwent changes that transformed them into real "leisure centres," architecturally speaking, they remain standalone boxes often wrapped by aesthetically captivating skins. In many cases, however, they are also integrated within larger mixed-use developments (Sect. 8.6), for which they act as commercial anchors in the form of big boxes, extended podiums, or pedestrianised shopping villages. To all this, we add a variety of other entertainment typologies starting from theme parks and ending with attractions like those parts of the city that Koolhaas (1995, 1256) called the "Lipservice" quarter, "where a minimum of the past is preserved." Finally, the closing section of this chapter deals with business-oriented tourism, allowing us to focus on two interrelated typologies for which international architects have produced several remarkable projects, not least in terms of scale.

As the reader might have already understood, Koolhaas' "The Generic City" is, in many ways, a guide to follow along this chapter. The architecture of transportation, hospitality, leisure and consumption is, in many cases, barely entering the 'high' debate and remains unfeatured by historiography. Contemporary airports and stations are considered functional buildings reflecting complex technical requirements with a very standardised typological scheme and an architectural expression limited to its skin and roof; hotels and resorts have always deserved little attention and their publication is generally considered more adapt to 'coffee table' books on interior design than to scholarly textbooks; shopping malls and similar, then, has never been considered worthy of discussion beyond a systematic (and certainly not unfounded) criticism, with some exception like Koolhaas-led studies within the "Project on the City" programme at Harvard University (Chung et al. 2001). Indeed, we can begin this chapter with a question: "Is the contemporary city like the contemporary airport—'all the same'?" (Koolhaas 1995, 1248).

10.1 City Gates in Search of Place: Airports and Railway Stations

For various reasons, airports have represented a typology at the forefront of architectural globalisation (Fig. 10.1). They are both symbolic and actual gates to countries and cities, thus deserving an up-to-date, sometimes even futuristic, image. They are also complex machines for which specific know-how and a capacity to coordinate multiple consultants are necessary, making emerging markets particularly dependent on foreign architects. Not surprisingly, during the 1970–80s, as seen in Sect. 3.4, the new airports built in Saudi Arabia were designed by US firms like HOK, Minoru

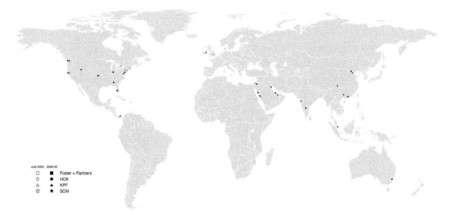

Fig. 10.1 A map of airport projects (built) by Foster + Partners, HOK, KPF, and SOM before and after 2005. Copyright Giaime Botti

Yamasaki, and SOM. Similarly, Paul Andreu, the architect and engineer head of Aéroports de Paris Ingénierie (ADPI) and designer of multiple terminals in the French capital, led the projects of large new airports in Dar-Es-Salaam (1977–84), Jakarta (1977–85, and 1991 phase 2), Cairo (1977–86), and Abu Dhabi (1982, 52,500 m^2). In the meantime, RMJM completed the airport of Kota Kinabalu in Malaysia (1985). In the 1990s, the growth of South-East Asia pushed for new *grand* transportation infrastructures, both in aspiring global cities and tourist destinations. We then find some Japanese and US firms leading in the sector and Paul Andreu with ADPI.

Kisho Kurokawa designed the new Kuala Lumpur International Airport (1992–98, 405,930 m^2) based on a flexible grid pattern conceived to ease potential expansions and display a mix of Islamic tradition and modern technology (ambitions seen in Sect. 5.4 for the Petronas Towers) through its hyperbolic shell domes. Japanese megafirm Takenaka Corporation designed in the same period the Satellite Building (1998) of Kuala Lumpur airport, as well as Bali International T1 (1992). In the meantime, China was opening its doors to the world, and airports were among the first typologies for which foreign architects' expertise was sought. Again, Paul Andreu completed the Sanya Phoenix Airport (1991–94) and the larger Shanghai Pudong (1996–99, 220,000 m^2), while less successful were his proposals for Ningbo Dongshe Airport and Guangzhou Baiyun in 1998. Canadian megafirm B+H Architects, after winning the competition for Xiamen Gaoqi International Airport (1992–1996, 111,4880 m^2), set up an office in Shanghai and developed the projects for the Beijing International T2 (completed 1999, 216,000 m^2) and Haikou Meilan Airport (completed 1999, 89,000 m^2) in Hainan. British firm Llewelyn-Davis International (not included in our survey) in 2000 completed the Domestic Terminal (60,000 m^2) of Shenzhen Airport, and then the terminal for Beihai Airport (40,000 m^2) and one for Chongqing (65,000 m^2) both in 2005.

In the early 2000s, the most outstanding airport project in the region was the new airport of Beijing, inaugurated in time for the 2008 Olympic Games (Sect. 7.1).

Drawing on the experience of Hong Kong Chek Lap Kok, Foster + Partners' Beijing Capital (2003–08, 1,300,000 m^2) represented a record-breaking building for its size, and an advanced machine able to reduce energy consumption while improving indoor comfort through multiple passive strategies. In addition, it was a perfect gateway for the new Beijing, ready for one of the most important international events, a symbol of modernity not devoid of references to Chinese millennial traditions: the overall layout recalling the shape of a dragon, the chromatic palette inspired by traditional architecture and changing from red to yellow along the building to help orient the passengers moving through it. In this same decade, the competition for Shenzhen Bao'an T3 (2008–13, 500,000 m^2; Fig. 10.2) was won by Italian firm Fuksas & Associati, which quite surprisingly has been able to deliver (considering that airport design is almost a monopoly of few megafirms) a magnificent project fully wrapped by a honeycomb-shaped double skin that creates a fluid continuity between primary and secondary volumes and a bright, sometimes psychedelic interior.

Then, in the 2010s, airport projects multiplied in China, with various designs successfully carried out (Table 10.1) and several more unsuccessful (or of unknown status), involving firms like Corgan, Pascall + Watson, PES Architects, and RSH+P. Still, the decade closed with another record-breaking building, Zaha Hadid Architects' (in collaboration with ADPI) Beijing Daxing International Airport (2014–19, 1,430,000 m^2; Fig. 10.3). As Koolhaas (1995, 1252) joked, the race to increase airports' dimensions is because they "come in two sizes: too big and too small." We do not know if Beijing Daxing will be too big or too small, but for sure it is, once again, one the largest in the world, with a capacity of 72 million passengers per year. It features an original centralised star-shape, whose 'arms' maximise docking space for aeroplanes. At the same time, its compact form reduces distances from the core, creating a less time-consuming circulation. Needless to say, it relies on several sustainable passive features to increase natural daylight and decrease energy

Fig. 10.2 Shenzhen Bao'an International Airport T3 by Fuksas & Associati, Shenzhen. Photograph by 準建築人手札網站 Forgemind ArchiMedia, distributed under a CC BY 2.0, available at https://commons.wikimedia.org/wiki/File:Shenzhen_Bao%27an_Airport.jpg

10.1 City Gates in Search of Place: Airports and Railway Stations

Table 10.1 Airports in China designed (built/under construction) by overseas firms (surveyed sample), 2010–2020

Designer	City	Project	Year	GFA (m²)
Atkins	Yinchuan	Yinchuan International Airport	2008–11	33,000
	Taiyuan	Taiyuan Wusu International Airport	2011–N.A.	N.A.
B+H Architects	Ordos	New Ordos Airport	2013	50,000
KPF	Chengdu	Chengdu new Airport	N.A.	N.A.
	Nanning	Nanning Airport	N.A–2017	189,200
Next Architects	Shanghe	Shanghe Airport	2019–u.c	4000,000
PLP Architects + KPF	Tianjin	Tianjin Binhai International Airport	N.A.	N.A.

consumption, as well as active strategies to produce at least 10 MW of energy per day through photovoltaic panels and to collect and purify rainwater.

During the last two decades, several airport projects have been also launched in India and Russia, with the usual bunch of firms involved. In the sub-continent, Nordic completed the Rajiv Gandhi Airport (2004–08, 108,000 m²) of Hyderabad, RMJM the NSCB International Airport (2008–13, 120,000 m²) of Kolkata, and SOM the Chhatrapati Shivaji International Airport Terminal 2 (2014, 450,000 m², LEED Gold) of Mumbai, whilst also HOK was involved in the design consultancy (we did not include these projects in our survey) for the expansion of the T1 of Kempegowda International Airport in Bengaluru, and for the Air Traffic Control Tower at New Delhi Indira Gandhi International. Among all these, SOM's design is certainly the most intriguing one. An X-shaped mega-building with four concourses for aeroplanes' docking, it boasts a coffered roof supported by distanced and monumental mushroom-shaped columns, in which the coffers deform in a dynamic geometry that seems to represent the flowing of the loads from the roof to the ground. However, Mumbai will have another brand-new airport, as soon as Zaha Hadid Architects' Navi Mumbai will be completed possibly in 2032. In the last decade, then, more airport projects were launched in Russia. Many were not carried out, as several projects by AREP of unknown status seem to suggest, but others have been built or are currently under construction. RMJM has recently completed the Sheremetyevo Terminal C1 (2020, 12, 375 m²) in Moscow, while Terminal B2 (55,850 m²) together with its connecting station (4,500 m²), and the Moscow Domodedovo Airport (252,000 m²) are currently under construction. Ramboll, Pascall + Watson, and Grimshaw have completed the Pulkovo Airport (2014) in Saint Petersburg, while Fuksas & Associati won the competition for the Gelendzhik Airport in 2018, designing a small and compact building with an organic shape, which is now almost operational. In the region, it must also be mentioned Kisho Kurokawa's Astana Airport (2000–05, 23,892 m²), which was built at a moment in which the Japanese architect was very active in Kazakhstan (Sect. 7.3).

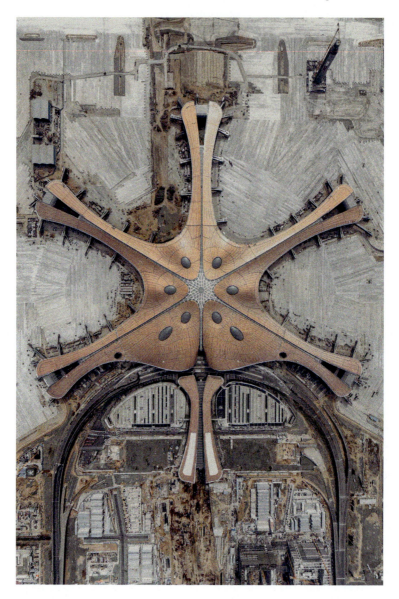

Fig. 10.3 Aerial view of Beijing Daxing International Airport by Zaha Hadid Architects, Beijing. Photograph by KILOVISION

While in South-East Asia, we have yet to record built airport projects designed by our sample of firms in these three decades, there are today multiple ongoing projects in Malaysia, Indonesia, and Vietnam, some of which may soon be implemented. In addition, Safdie Architects' completed in Singapore the Jewel Changi (2018, 135,700 m^2), a shopping mall with a spectacular indoor garden within a glazed torus-shaped

10.1 City Gates in Search of Place: Airports and Railway Stations

volume acting as a connector between the terminals and the bus station. In Africa, we recorded the completion of the Kotoka International Airport (44,833 m^2) in Accra, Ghana, by ARUP, and the ongoing project of Scott Brownrigg for Abuja Airport, Nigeria, whilst more projects of uncertain status by Pascall + Watson have been recorded in Ghana, Kenya, Nigeria, and South Africa. However, of all the unsuccessful designs, the most relevant one, for scale and political implications, was in Latin America. The New International Airport of Mexico City (2014, 743,000 m^2), designed by Foster + Partners with Fernando Romero and NACO, was supposed to become one of the largest airports in the region, and one of the more sustainable buildings (targeting LEED platinum). Nonetheless, the immense cost (estimated at U$147 billion) for the building in a context of widespread corruption, and the proximity to a natural reserve, made the project contested since the beginning, with current Mexican president Andrés Manuel López Obrador promising during his successful presidential campaign to halt it and find different solutions eventually. Indeed, after winning the elections, López Obrador called a referendum that cancelled the project, which was already under construction (Gibson 2018). The alternative found was the expansion of an existing military airport, with all the design and construction phases assigned to the Mexican Army's engineers, for what has been seen by the press as the airport of "austerity" (Pérez 2022). This case is emblematic of how, in different contexts, the dreams of (costly) modernisation of the political elite may find popular opposition and political figures willing to exploit it.

Just to mention a significant case, we can consider the continued political and legal fight about Heathrow's expansion in the UK (Edgington 2020). But for sure, this is not what happened in China, South-East Asia, or the Middle East. In the latter region, after the extensive works of the 1970–80s, international firms were again strongly involved in the last decade. HOK designed the Hamad International Airport (HIA; completed 2014, 600,000 m^2; Fig. 10.4) in Doha—often ranked as one of the best in the world, if not the best one, by passengers—within a larger area named HIA City, master-planned by OMA since 2013. Dubai International Airport, which opened in 2008, resulted from a collaboration between ADPI and Dar Al-Handasah. In the meantime, the KPF-designed new Abu Dhabi International Airport Midfield Terminal (launched in 2017, 735,000 m^2) is under construction. On the contrary, OMA's new airport for Mecca, a ring-shaped structure wrapped by a perforated skin conceived as a gateway able to accommodate the hundreds of thousands of pilgrims reaching the city for the *Hajj*, was never carried out.

Airports represent the gate *par excellence* of contemporary cities at the global scale; in the past century, railways stations have performed the same role, at least at the national scale. Today, however, most emerging markets do not count on extended and modern railway networks, except for China. As known, the country now boasts the most extended high-speed network in the world, with more than 40,000 km, against the 4,000 km of Spain, the second-ranked country, and France, the third one, with about 1,800 km. High-speed railway stations represent in China key urban elements, monumental infrastructural nodes located at the apex of kilometre-long urban axes, gateways to cities and incredible accelerators of urbanisation. In their proximity, new cores of the city develop into new CBDs and dense mixed-used areas,

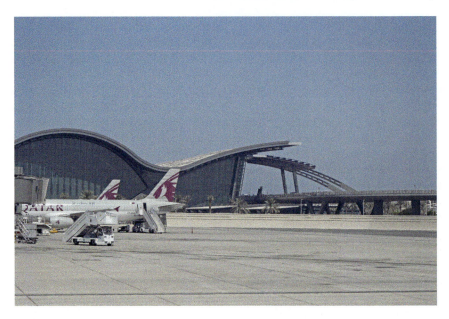

Fig. 10.4 Hamad International Airport by HOK, Doha. Photograph by Giaime Botti, distributed under a CC BY 4.0

like in Shanghai Hongqiao (where we also find the second airport). In secondary cities that are lucky enough to be touched, even at a distance of ten or twenty kilometres, by this network, dense agglomerations grow up, sometimes in the form of New Towns. People familiar with China also know that railway stations are generally of two types. The very large ones feature a long main hall, transversal to the railway platforms located at the lower level. The main hall has restaurants and shops on the upper level of the two longer sides, while from the central part, two gates per platform lead to the lower level. From the platform level, arrival passengers are guided downstairs, where they find more restaurants and public transportation connections. Stations in minor cities, instead, present an elevated building (because the tracks run on viaducts) at the same level as the platforms. This system, common all over China, makes railway stations easily navigable and quite standardised, with the only formal variations visible in the roof design. Big roofs, in fact, can assume a more modern, streamlined appearance like in Ningbo or Urumqi, or more traditional forms like in Suzhou (Fig. 10.5), or, with more efforts to make it a modern interpretation of the past, like in Xi'an.

Most of these stations have been designed by Chinese design institutes and AEC firms and are anonymous projects rigidly based on the model described above. However, some were assigned via international competitions in the early 2000s. Still, being the typology so clearly defined, variations have been once again just in the overall shape and type of roof. Farrells have completed the Guangzhou South

10.1 City Gates in Search of Place: Airports and Railway Stations 451

Fig. 10.5 Suzhou Railways Station. Photograph by song songroov, distributed under a CC BY 3.0, available at https://commons.wikimedia.org/wiki/File:Gusu,_Suzhou,_Jiangsu,_China_-_pan oramio_(202).jpg.Modified by Giaime Botti

Railway Station (2003–10, 486,000 m^2) and Beijing South Railway Station (2005–08, 225,000 m^2). The former features a kind of vaulted skylight along the main axis and transversal vaults above the platforms; the latter, which is formed by a central oval roof covering the main hall, and a double, undulated curved roof on the two sides, recalls both the *grand* tradition of railways stations and the circular forms of the Temple of Heaven in Beijing. On the other hand, GMP's Tianjin West Railway Station (2007–11, 179,000 m^2; Fig. 10.6) presents a rigorous geometric front, almost a classical and stylised colonnade, and a monumental 400-m-long barrel vault of glass and diamond-shaped steel diagrid. Of great elegance is also the Hangzhou Southern Railway Station (2011–18, 90,000 m^2), which the German megafirm designed as a classical and light building standing on a podium upon which a steel roof folds at right angles to cover the main hall and the platforms. French megafirm AREP, which is a subsidiary of SNCF Gares & Connexions established in 1997 by Jean-Marie Duthilleul and Étienne Tricaud, exploited the expertise gained with several projects of the late 1990s and played an essential role in modernising China's stations. In the early 2000s, it designed the Shanghai South Railway Station (2001–06, 47,000 m^2), a quite unique one given the immense circular roof of 255-m in diameter that filters the natural light in the hall and centralises the space, and the Station of Wuhan (2004–09, 120,000 m^2), featuring an undulated roof with a higher 'wave' in correspondence with the central entrance. In the following decades, AREP designed other stations, some quite impressive, like the one of Qingdao (2013, 70,000 m^2; Fig. 10.7), and others more ordinary, like Jinan East (2018, 75,000 m^2; Fig. 10.8) and Qinghe (2016–19, 148,000 m^2) in Beijing. Finally, in 2011, Nikken Sekkei complemented the Wuxi Central Station with a mixed-used development of 381,00 m^2, while SOM

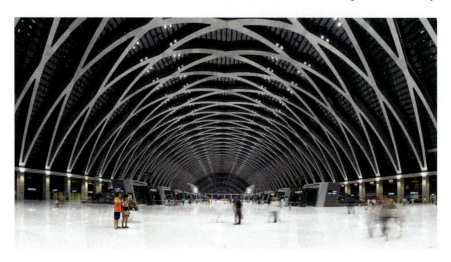

Fig. 10.6 The main hall of Tianjin West Railway Station by GMP, Tianjin. Photograph by kele_jb1984, distributed under a CC BY 2.0, available at https://commons.wikimedia.org/wiki/File:%E7%82%AB%E5%BD%A9%E6%B4%A5%E9%97%A8121%E5%A4%A9%E6%B4%A5%E8%A5%BF%E7%AB%99%E5%80%99%E8%BD%A6%E5%A4%A7%E5%8E%85Waiting_Room_of_Tianjin_West_Railway_Station.jpg

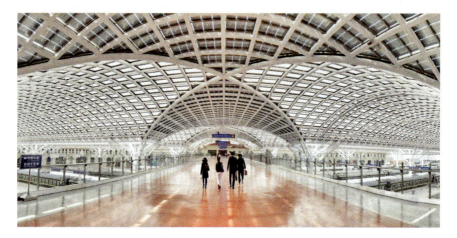

Fig. 10.7 The main hall of Qingdao Railway Station by AREP, Qingdao. Photograph by Dan Nevill, distributed under a CC BY 2.0, available at https://commons.wikimedia.org/wiki/File:Qingdao_Train_Station_(31424817708).jpg

with ARUP finalised the underground Tianjin Binhai (formerly Yujiapu) Railways Station (2009–12, 100,000 m^2), visible from the city thanks to a parabolic glass dome emerging in the middle of a green area.

Considering transportation infrastructures, there is a growing number of mass rapid transit systems that are currently under study or construction, especially in

10.1 City Gates in Search of Place: Airports and Railway Stations

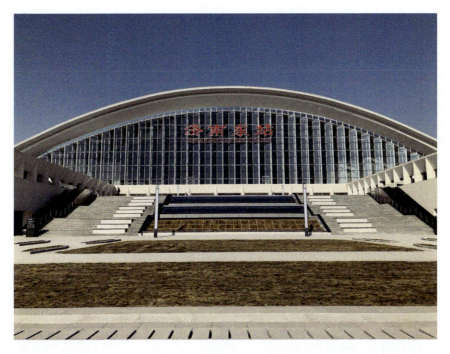

Fig. 10.8 Jinan East Railway Station by AREP, Jinan. Photograph by Stang, distributed under a CC BY 4.0, available at https://commons.wikimedia.org/wiki/File:201901_Jinandong_Station_Outdoor_Scene.jpg

several Middle Eastern cities, to promote more sustainable mobility. In Doha and Dubai, two metro lines are currently under construction following a project by AREP. Gerber Architekten designed the Olaya Metro Station in Riyadh (2014-u.c., 92,700) with a large roof garden on top. Another station was designed by Snøhetta, which is also engaged in the ongoing project of Mecca's new metro line C. In the meantime, Italian firm Cremonesi CREW has completed the Hamad International Airport Metro Station (2016–19) in Doha, and with OneWorks has ongoing projects for metro stations in Riyadh, whose overall design is coordinated by Spanish megafirm IDOM. A new metro is also under construction in Hyderabad, India, based on a project by RMJM. Lastly, we need to mention the Gautrain in South Africa, an 80-km commuter train line linking Johannesburg, Pretoria, and the O.R. Tambo International Airport, which was inaugurated in 2010 in time for the commencement of the FIFA World Cup (Sect. 7.4). Three of its stations have been designed by Farrells (2006–09, 31,071 m^2 overall).

10.2 Hotel Design and Globalisation: Opening, Diversifying, and Crafting Identities

Hospitality design has represented a powerful architectural sub-market for boosting the globalisation of the architectural practice since the Cold War when the architecture of the Hilton hotels built in Europe and the Middle East by US architects was intended as a showcase of American lifestyle, wealth, and openness (Wharton 2001). As the following three sections will show, since the 2000s, the number of hotels designed by international architects has exploded, especially in China and the Persian Gulf states. Looking from the perspective of Western architects, we recognise a typical pattern of expansion, already seen in other sectors: a growing presence of foreign architects in South-East Asia in the 1980s and the first landmark projects in China, where numbers started significantly increasing in the 1990s to balloon after the 2000s. Scattered hotel projects were also developed in the Persian Gulf since the 1970s to boom in the 2000s, when cities like Dubai and Abu Dhabi emerged as new global destinations for business and leisure tourism. The recent opening of Saudi Arabia will also create more opportunities in the near future. Again, and this has been demonstrated in Sect. 4.3, figures show that the first decade of the twenty-first century marked an unprecedented turn in the global scope of the architectural profession. Before delving into our findings, we can look at the exemplary case of a firm not included in our survey: Hirsch Bedner Associates (HBA). Established in 1965 in Santa Monica, California, and now headquartered in Singapore, HBA is today one of the largest firms in the hospitality sector, a giant with 24 offices scattered worldwide with completed projects in 80 countries. However, by the end of the 1990s, it was still operating locally. In its portfolio of over 2,000 works, for instance, the firm can boast 74 completed projects in China, Hong Kong, Macau, and Taiwan, all of them developed after 2006. Among our sample of practices, in any case, we find other firms with a strong specialisation in hotel design, like BBGM Architects, WATG and Wilson Associates, and several megafirms with big earnings from the hospitality sector, like Gensler, HKS, or Stantec, to name a few. They will be among the protagonists of the next sections, starting from WATG, a world-leading hotel design firm originally established in Honolulu, Hawaii, in 1945[1] and grown up to a size of 500 employees spread over seven offices around the globe.

The history of the hospitality sector in China is deeply entangled with the very history of the economic reforms that transformed the country in the last four decades. And in this, architecture and foreign architects did play an important role, too. After Deng Xiaoping's Reforms at the end of the 1970s, some foreign architects, mostly US and Japanese, delivered the first projects of modern hotels with international standards. By that moment, hotels had become essential for China's modernisation and hospitality represented the first sector opened to receive foreign direct investments (Roskam 2015, 2021). In 1978–79, WATG was invited to tour China, identify sites

[1] WATG was established in 1971, when George Whisenand, Jerry Allison, Gregory Tong and Don Goo joined George Wimberly, who had been working with Howard L. Cook in Honolulu since 1945.

for hotel developments, and design two hotels, one in Shanghai and one in Guilin. Although they were never built, it is interesting to read what WATG's Vice President, Gregory M. B. Tong, wrote at the time to explain these projects. His words depicted a precise picture of the challenges foreign architects would face in the following years, both in terms of cultural differences and technological limitations. For example, unlike a Western hotel, a Chinese one needed on-site housing for the whole staff, but due to the fact the elevators were a luxury, dormitories had to be accommodated in mid-rise blocks; instead of a large car park, an extended bicycle parking was more important; an underground air-raid shelter was also requested. More interestingly, Tong recounted how the project was developed in secrecy before the USA and China re-established their diplomatic relations and explained the role of Hong Kong, where the firm was already active (Tong 1979). The Shanghai Huashan project already made evident two important design issues, too. By mixing a modern high-rise block and an extended platform characterised by the presence of Chinese "big-roofs," it questioned the possibility of regionalising international architecture in modern high-rise buildings. In the second place, it foreran the process of verticalisation of Chinese cities, which will eventually find in the hotel building of the 1990s some of their first high-rises. Some more hospitality projects developed since the 1980s will help us understand more about these problems.

In 1982, the first Sino-American hotel opened its door in Beijing. Designed by Chinese-American architect Clement Chen Jr., the Jianguo Hotel offered amenities and technological features unseen before in the country, and the first French restaurant in the capital, within a low-rise compound inaccessible to ordinary Beijingers. As recognised by local architectural critics, it was also the first "glass-walled building," an enclave of capitalism but also something galvanising the debate among architects (Roskam 2015). The same year, I. M. Pei, who had initially refused to design high-rise hotels in central Beijing to preserve its historic skyline, completed the Fragrant Hill Hotel (1979–82, 35,000 m^2; Fig. 10.9) on the outskirts of the city. Resulting from the cooperation of Hong Kong-based YTT Tourism, the US Turner Construction, and Hyatt International Corporation, the hotel not only reflected ongoing policies of careful and balanced opening towards foreign investors and capitals like the other projects, but it was also a catalyser for the architectural debate in the country. Pei's building, not exempts from shortcomings as well as expansive solutions (criticised as decadent and eccentric), established a direct link with the Chinese past, although an idealised one, as a language based on South-Eastern Chinese vernacular (Xue 2006, 19–20) could be all but contextual in the proximity of Beijing. Postmodernist ideas and the pursuit of a "national form" to feed the growing tourism industry thus found an answer in the Fragrant Hill Hotel and in the Queli Hotel (1985) in Qufu designed by the Chinese architect and Deputy Minister of Construction Dai Nianchi. Indeed, both buildings were locally appreciated as attempts to create a "distinctive Chinese architecture" in which "tradition can be incorporated in modern buildings" (Xue 2006, 19–21).

Two years later, the Great Wall Hotel, designed by US firm Welton Becket Associates, marked another significant moment. Following the model of the Dallas Hyatt, the hotel featured three mirror-glazed 22-storey wings linked to a central core, topped

Fig. 10.9 The Fragrant Hill Hotel by I.M. Pei, Beijing. Photograph by Gisling, distributed under a CC BY 3.0, available at https://commons.wikimedia.org/wiki/File:Fragrant_Hill_Hotel.jpg

by the octagonal volume of the restaurant. Although Becket abandoned the project because of the impossibility of meeting technical and construction standards by local contractors (Roskam 2015), at its completion, the Great Wall Hotel did materialise, with its vertical development and profusion of mirror-glass, that vision of the modern Western hotel already foreseen in WATG's Huashan project. Indeed, the typology of the high-rise hotel will become predominant since the 1990s in urban China, once again, thanks to the work of a US architect: John Portman. Active in Singapore in the 1980s—where he designed The Regent (1982, 37,000 m^2) and the Mandarin Oriental (1987)—, Portman had already opened an office in Hong Kong in 1979, but only in 1990 his first project in mainland China will be completed: the Shanghai Centre (1985–1990, 181,000 m^2). Following the tri-tower model of his Renaissance Centre (1976) in Detroit, the project blended traditional Chinese architecture and Western elements, well visible in its four-storey impressive atrium (Xue and Li 2008). The overall scheme—in the architect's words, inspired by Chinese traditional symmetrical disposition along a north–south axis (Roskam 2015)—featured a central, taller tower hosting The Ritz-Carlton Hotel, and two flanking towers hosting serviced apartments, the first of the kind in China. It even needed a dedicated energy substation, as it represented the most voracious consumer in the district. Its exclusive amenities and services allowed foreign families to live in the city for longer, embodying a new form of residence "within China yet not in China" (Roskam 2015). Thus, although

several projects will be discussed in the next section, many more have been implicitly presented in Chap. 5. Hotels represent one of the main programmes of mixed-use skyscrapers: supertalls like the Guangzhou IFC by WilkinsonEyre, or the Shanghai Tower by Gensler, just to name two cases, feature luxury hotels on their upper floors. In other cases, skyscrapers are fully occupied by hotel space and eventually serviced apartments, but usually not the supertall ones.

While sleek high-rise architecture of international appearance represents the global standard for hotel buildings in major cities, hotels have also taken forms more related to their context through more or less convincing reinterpretations of the past. Since the 1970s, the architecture of luxury resorts in South-East Asia has produced a varied stream of works with a consistent orientation towards a refined vernacular generally named "Bali Style" (Scriver and Srivastava 2019). Such a trend emerged in the late 1960s from the confluence of different factors and actors, starting from the work of the Australian artist Donald Friend and the local antique dealer and former architect Wija Wawuoruntu. The duo transformed a guest house into a boutique hotel (the Tandjug Sari) filled with local antiquities. With the success of this operation, they secured a larger estate and, in 1972, invited Sri Lankan architect Jeffrey Bawa (a talented exponent of "vernacular modernism" according to Frampton 2020, 864) to design the master plan and fifteen garden villas of a new resort. The story continued with the involvement of Australian architect Peter Muller in the 1970s, who became particularly influential after being hired by the Oberoi hotel chain. Thus, the work of both Bawa and Muller became the point of departure for another Australian professional, Kerry Hill, who moved to Bali as the site architect of Palmer & Turner to work on the project of the Bali Hyatt in the early 1970s. With the tourist boom of the 1980s, more works arrived for architects like Muller, Hill, and American but Paris-based Ed Tuttle, not only in Bali but also across the whole of South-East Asia, especially in Thailand.

The "Bali Style" thus consolidated as a transnational aesthetic for luxury hotels and villas in the tropics; not really (and philologically) Balinese, it is, however, certainly "Asian." But above all, it should be understood as something going beyond the purely aesthetic, as it is the "outcome of a global condition" in which local economic actors "exercised direct agency in the global flows of capital and architectural services" (Scriver and Srivastava 2019, 86). Looking at our sample of firms, we see this reflected, for example, in early overseas works of US firms like WATG, that in 1981 completed the Tanjong Jara Resort in Kuala Terengganu, Malaysia, in a refined vernacular (Fig. 10.10). The theme of identity, thus, returns. In the age of globalisation, the expression of local/national identities has emerged as a central problem, especially for developing countries. Highly visible and symbolic buildings like, for instance, the Petronas Towers in Malaysia, have been previously discussed under this point of view (Sect. 5.4). How the project of Fragrant Hill Hotel fostered the architectural debate in regard to the problem of Chinese architecture has just been pointed out. With these problems in mind, we can now explore hospitality architecture throughout our mapped emerging markets.

Fig. 10.10 The Tanjong Jara Resort by WATG, Kuala Terengganu. Photograph by Peter Gronemann, distributed under a CC BY 2.0, available at https://commons.wikimedia.org/wiki/File:Tanjong_Jara_(4281298322).jpg

10.3 Hospitality Design and its Firms: When the Hyper-Local is Hyper-Global

Exactly like airports concentrate "the hyper-local and hyper-global" (Koolhaas 1995, 1251), hotels embody a similar contradiction. Hotels are in many cases part of global multi-brand chains, accommodated in buildings and interiors designed by a bunch of international firms, and subject to international quality standards. At the same time, they must reflect local qualities sought after by their guests, who want to be constantly reminded of not being at home. Exploring what and where has been built by some of the firms we surveyed will help us understand the variety of trends and responses to common issues while we also examine the agency of these architects across different regions.

Looking at today's hotel scene in Dubai, it may seem that way more than a century had passed since 1960 when John Harris designed the first master plan of Dubai, and 1978 when his project of the Hilton Hotel was completed. Soaring in the middle of the desert, besides the new Dubai World Trade Centre tower and the World Trade Centre Apartments, the Hilton was a 5-storey block characterised by a concrete blinding screen in front of the windows to protect the interior from direct sunlight, but also almost completely hindering the view towards the exterior. Still, John Harris' modernism adapted traditional principles and elements with modern ones, like precast concrete and free plan (García Rubio 2019), quite unlike what we

tend to see today in an urban landscape dominated by anonymous glass surfaces and cheap formal extravagances. In 1981, the Inter-Continental Abu Dhabi was also completed according to a design by Boston-based Benjamin Thompson and Associates. Initially conceived for 450 rooms, the project was then almost doubled to 750 upon request of Sheikh Zayed and then built at 60% due to the economic slowdown of the late 1970s. According to the architect, to satisfy the demand of the Royal Family, the hotel should have been "an example of synthesis of contemporary form, purpose, and materials with Islamic values, finding spatial and sensual expression through reinterpretation of timeless themes and traditional language" (Thompson 1987). To achieve this, the American architect incorporated a chromatic palette of "traditional colours with symbolic values," materials like tiles and stones from the broader region, geometric ornamental patterns, and elements like wooden *mashrabiya*.

By the 1990s, however, the milestone hospitality project of the region that somehow displayed Dubai as a new international touristic destination provided with the most exclusive and spectacular hotels was unquestionably 'international' in its (exterior) design. The Burj Al Arab (120,000 m^2, 321 m; Fig. 10.11), likely the city's first globally recognised landmark, is a tower shaped like a sail unfurled in the wind and rising from the waters of the Persian Gulf. Designed by Tom Wright at Atkins in 1993, it opened in 1999 to become one of the most luxurious hotels in the world. It also paved the way for the development of Dubai's shores, helping transform the image of this fast-growing city as a touristic coastal destination. In front of the tower, which stands on an artificial platform one hundred metres from the shoreline, in 1997 had already opened the Jumeirah Beach Hotel, also designed by Atkins, in the shape of two curved triangles reminding of a sail. And this was just the beginning, as in 2001, the construction of the artificial, palm-shaped island of Palm Jumeirah commenced. The island is now occupied by private villas in its branches, apartment buildings, and 28 hotels scattered in its 'trunk' and along the external ring that protects the internal lagoon. On the island, we find the RMJM-designed W Hotel & Alef Residences (2019, 100,000 m^2), a complex of curving low-rise slabs with a streamlined marine aesthetic, and the real landmark of this reclaimed piece of land: Atlantis—The Palm (2008, 209,563 m^2; Fig. 10.12). A project by WATG with interiors designed by Wilson Associates, it displays a Disney-like phantasy of Aladdinesque characters blended with echoes of the Atlantis myth.

Indeed, eclecticism has not died, and architectural language for hospitality design remains variegated and typological solutions multiple. As a matter of fact, most of Dubai's upscale hotels occupy tall buildings, but, before looking at some of them, the new Atlantis The Royal provides a first counterpoint (193,600 m^2). Designed by KPF and still under construction, it is situated at a little distance from the original Atlantis—The Palm, along the same artificial ring that surrounds the palm-shaped island. The building comprises two stepped towers composed of horizontal blocks scattered in a staggered disposition with multiple voids in-between and connected by a central block creating a long sky bridge (Fig. 10.13).

Although such configurations are increasingly popular (see, for instance, Büro Ole Scheeren's Sanya Horizon project), it is nonetheless a project defying standard typological solutions of both slabs and tower buildings and, for this reason, worthy of

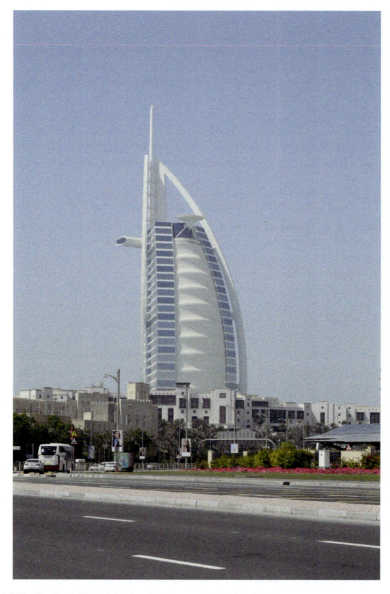

Fig. 10.11 The Burj Al Arab by Tom Wright at Atkins in Jumeirah Beach, Dubai. Photograph by Giaime Botti, distributed under a CC BY 4.0

10.3 Hospitality Design and its Firms: When the Hyper-Local is Hyper-Global 461

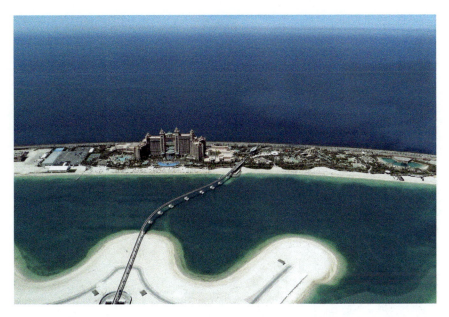

Fig. 10.12 The Atlantis—The Palm Hotel by WATG on the artificial island of Palm Jumeirah, Dubai. Photograph by Giggel, distributed under a CC BY 3.0, available at https://upload.wikimedia.org/wikipedia/commons/c/c3/Vereinigte_Arabische_Emirate_-_Atlantis_on_Palm_Jumeirah_-_%D8%A3%D8%AA%D9%84%D8%A7%D9%86%D8%AA%D9%8A%D8%B3_%D9%81%D9%8A_%D9%86%D8%AE%D9%84%D8%A9_%D8%AC%D9%85%D9%8A%D8%B1%D8%A7_-_panoramio.jpg.Modified by Giaime Botti

discussion. Along Dubai's beaches, on the other hand, resorts usually propose similar schemes with concave layouts of mid-rise two-wing buildings facing the sea and beachfront and garden villas. WATG's Four Seasons Dubai Jumeriah beach (40,000 m^2) features a concave scheme of mid-rise blocks of Andalusian style encompassing the central swimming pools area, while the nearby One & Only Royal Mirage is inspired by Arabic architecture and presents a similar configuration but with lower, detached buildings. A minimalist elegance, instead, characterises the Bulgari Hotel & Resort designed by Citterio-Viel (2017, 123,000 m^2), a complex with a marina and yacht club, the hotel block, and villas in a small artificial island in front of Jumeirah Beach that also includes several apartment buildings. The work of Citterio-Viel with Bulgari, for which they also designed hotels in Milan, Paris, London, Beijing, and Shanghai, displays the creation of niches in the hotel market that are occupied by firms that, in spite of their undeniable good financial performance, are certainly not giants: Citterio-Viel, which ranked second in Italy in 2019, had about 20 million Euros in revenues that year, WATG over 50 (Norsa 2020; Tether 2020). Another Italian firm with a strong connection with the realm of interior and industrial design, Lissoni Associati (€10 million in revenues in 2019), designed the Oberoi Al Zorah, in the nearby Emirate of Ajman, according to a similar minimalist fashion, with a remarkable design of the landscape (Fig. 10.14).

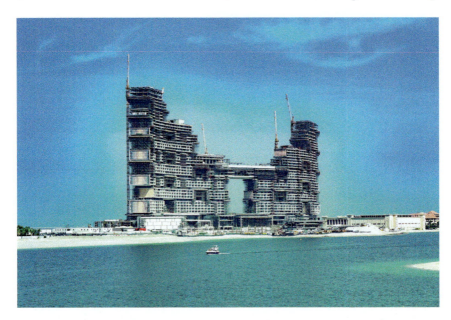

Fig. 10.13 The Atlantis The Royal by KPF under construction on the artificial island of Palm Jumeirah, Dubai. Photograph by kanzilyou. Modified by Giaime Botti

Fig. 10.14 The Oberoi Al Zorah resort by Lissoni Associati in Al Zorah, Ajman. Photograph by Giaime Botti, distributed under a CC BY 4.0

10.3 Hospitality Design and its Firms: When the Hyper-Local is Hyper-Global

Back in Dubai, in and around the Palm Jumeirah islands, several high-rise buildings are also fully or partially occupied by hotels. At the centre of the Palm's 'trunk' stands The Palm Tower (2015–20), designed by Gensler in collaboration with Singaporean firm RSP. This 231-m banal skyscraper hosting apartments and the St. Regis Hotel culminates with a slight enlargement—as a kind of capital in the column—to create a 360-degree infinite pool and observation deck with views of all the artificial islands. Named the tallest 360-degree infinite pool, since its opening, it had to face the challenge of the nearby The Address Beach Resort (2020), a building made of two connected towers creating a 301-m-tall gate-like structure featuring a swimming pool at 293 m by Killa Design, the Dubai-based firm co-founded by Shaun Killa, former Director of Architecture at Atkins. Moving toward the centre of Dubai, a discussion about the high-rise hotel typology must include the most famous and the tallest of the tall buildings, the Burj Khalifa (Sect. 5.3). In its lowest part, in fact, is located the Armani Hotel (2010, 464,515 m^2), the first one of the Italian fashion brand; it boasts a "minimalist opulence" very distant from the—literally—golden-coated interiors of the Burj Al Arab. Thus, the whole work, designed by Wilson Associates but constantly overseen by Giorgio Armani himself, displayed furniture and fabrics by Armani Home in a kind of *gesamtkunstwerk* (total work of art) fashion (Stephens 2010, 86). Just in front of it, The Address Downtown by Atkins, and The Address Boulevard (2012–17, 370 m) by Atkins and NORR host serviced apartments and hotels in non-memorable skyscrapers (Sect. 5.3).

Along Sheikh Zayed Road, NORR designed the Shangri-La Hotel (Fig. 10.15) in a double tower clad in granite and glass inspired by 1920s Manhattan architecture. While the works for the construction of the Ciel Tower, the first hotel supertall (365 m), are currently underway in Dubai Marina, the Canadian multinational has already completed some more hotel projects in high-rise buildings: Habtoor Grand Resort & Spa (2004), Hotel Indigo, and The First Collection at Jumeirah Village Circle (2016–21, 172 m), a glazed prismatic tower with interesting volumetric shifts which simply add formal complexity. Just a few hundred meters from it, we find the Five Jumeirah Village designed by Atkins: a cylindrical hotel and apartment tower with openings and balconies arranged to suggest a continuous, rotating upward movement to the eye. Another relevant player that we have already encountered on many occasions is RMJM, which completed the simple but well-designed blocks of the Jumeirah Creekside Hotel (2012, 60,000 m^2) and the Holiday Inn & Staybridge Suites (2005–2020, 43,000 m^2), and the less interesting The H Hotel & Office Tower (2017, 484,512 m^2). Finally, we can name Smallwood, Reynolds, Stewart, Stewart for the banal and a bit too classical Ramada Jumeirah (31,085 m^2) and The Ritz-Carlton Dubai (extension and renovation, 27,016 m^2), and Gensler for The Ritz-Carlton Hotel & Residences Dubai IFC, a monumental block targeting the business clientele of the International Financial Centre.

As a matter of fact, Dubai has been able to become a top-touristic destination in the region, with about 15 million visitors per year before the pandemic, dwarfing the rest of the cities of the Persian Gulf. A quick search on Booking.com shows that it boasts slightly less than 600 operating hotels and resorts, an approximate number corroborated by official statistics, which counted 526 hotels and 186 hotel

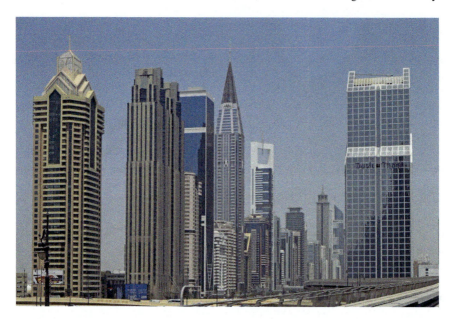

Fig. 10.15 The Shangri-La Hotel (the second from the left) by NORR along Sheikh Zayed Road, Dubai. Photograph by Giaime Botti, distributed under a CC BY 4.0

apartment buildings (Dubai Statistics Center 2021). The same search revealed much lower numbers for Abu Dhabi (120) and Doha (less than 100). Still, the two cities are trying to catch up, with the former working to increase its cultural offer through a rich museum scene (Sect. 6.2) and the latter doing the same while also counting on sports events, not least the 2022 FIFA World Cup (Sect. 7.4). Projects like Aukett Swanke's Radisson Blu & Park Inn Hotels (2009, 30,000 m^2), or Atkins' Hilton Capital Grand Abu Dhabi (2011) in Abu Dhabi fit well into the category of the generic modernism. A beachfront resort like Perkins Eastman's Park Hyatt Abu Dhabi Hotel and Villas (2013, 45,000 m^2; Fig. 10.16) follows the usual concave scheme of a two-wing complex facing the sea, all in a somewhat minimalist fashion in terms of building forms and volumes but contextualised with light sand-pastel tones. Similar schemes, but different stylistic interpretations, are adopted by other resorts along Saadiyat Island, one of Abu Dhabi's main areas of touristic development. Along these shores, DBI's Jumeirah at Saadiyat Island Resort (2008–19, 42,265 m^2) features an abstract and modern appearance, with white, streamlined volumes and a complex and organic general layout. WATG's Rixos Saadiyat Island, on the contrary, displays a more rigid, palatial solution with multiple gardens and courtyards axially organised, all in a Moorish-Andalusian fashion. Then, the two most iconic hospitality projects in the Emirates capital show an opposite approach. On the one side, we find the Yas Marina and Hotel (2010, 85,000 m^2; Fig. 10.17) designed by US firm Asymptote Architecture within the Formula One racetrack. It consists of two elongated, elliptical buildings with a streamlined aesthetic—well-suited in

10.3 Hospitality Design and its Firms: When the Hyper-Local is Hyper-Global 465

Fig. 10.16 The main pool area of the Park Hyatt Abu Dhabi Hotel and Villas by Perkins Eastman on Saadiyat Island, Abu Dhabi. Photograph by slava296

this context—connected by a steel and glass double-curvature wrapping canopy at night illuminated with colourful LEDs. On the very opposite side, the opulence of Abu Dhabi is reflected by WATG-designed Emirates Palace (2001–05, 243,000 m^2; Fig. 10.18), a monumental building inspired by traditional architecture. This real palace, composed of a central volume and two large symmetrical wings, raises on a podium at the end of a central boulevard flanked with palm trees and fountains and provided with a monumental staircase. Its interiors, with domes decorated with geometric patterns in the Islamic tradition, marble columns, and lavish ornaments, made it one the most expansive hotels ever built: U$3.9 billion (Young 2016). It has been defined as the "high-end expression, slightly more crafted expression" of an otherwise trivial "fairy tale tendency," based on the showcase of "an inaccurate and artificial localized style, if not indeed a kitsch version of refined traditional Arabic architecture" (Duncan and Tomic 2013, 145–146). Such monumentality and classical inspiration display the need to balance between the hypermodern and international, on the one hand, and classical and traditional, on the other, when it comes to crafting the image of Abu Dhabi through its modern monuments. In this regard, the most significant project has been the Sheikh Zayed Grand Mosque (1996–2007), a white-marble lavish building with over one thousand columns and roofed with 82 domes inspired by a mix of Islamic architectural traditions.

466 10 Architecture for Leisure: Living the "Generic City"

Fig. 10.17 The Yas Marina and Hotel (W Abu Dhabi) by Asymptote in Yas Island, Abu Dhabi. Photograph by eli_asenova

Fig. 10.18 A view of the Emirates Palace complex by WATG, Abu Dhabi. Photograph by Chris Down, distributed under a CC BY 4.0, available at https://commons.wikimedia.org/wiki/File:Emirates_Palace.jpg

10.3 Hospitality Design and its Firms: When the Hyper-Local is Hyper-Global

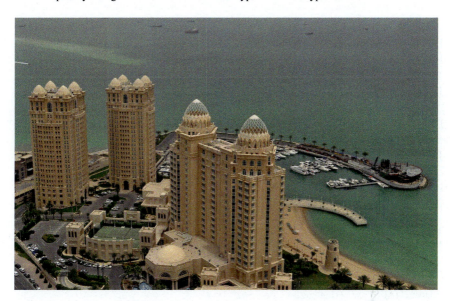

Fig. 10.19 The Four Seasons Hotel (on the right) and two residential towers (on the left) by Smallwood, Reynolds, Stewart, Stewart in West Bay, Doha. Photograph by Ahmad Dalloul, distributed under a CC BY 2.0, available at https://commons.wikimedia.org/wiki/File:Aerial_view_of_The_Four_Seasons_Hotel_in_Doha.jpg. Modified by Giaime Botti

During the last decade, Qatar has experienced significant growth in the number of hotel rooms, which has almost tripled since 2010, despite a decrease in international arrivals after 2016 (UNWTO 2020). Still, the hotel scene in terms of architectural quality does not seem to change as fast as the figures do. The involvement of international firms has also stagnated, while in many cases, their work has been of little interest. The overall quality seems poor, oscillating between an anonymous modernism and an eclectic pseudo-historicism lacking the opulence seen in the UAE. In the former category, albeit regionalised through a geometric pattern applied to the glazed envelope, falls the Shaza Kempinski Hotel, designed by Pascall + Watson. In the latter one, fall instead works like Smallwood, Reynolds, Stewart, Stewart's Four Seasons Hotel (36,565 m^2; Fig. 10.19) in West Bay, and the Kempinski Marsa Malaz Hotel (2014, 46,113 m^2) by Arab Engineering Bureau (AEB), which, as we have seen in Sect. 8.6, features a mixture of Arab and Venetian style. With advertisements presenting it as "traditional Qatari and Islamic architecture in a striking contemporary way," The Pearl embodies "the very dilemma that underlies all development in Doha since the early-1950" (Adam 2013, 126). In the end, such a flagship project reinforces the idea of the predominance of a generally conservative, sometimes Las Vegas-like, pastiche architecture in Doha, with the exception of the new hotels built following the aesthetic guidelines of Msheireb Downtown (Sect. 8.6). Still, this last example can also serve to shed light on the vital role of Qatari and regional design practices. As discussed in Sect. 5.3, most of the high-rise buildings in the city, some of which are hotel towers, have not been designed by any US or European architects

468 10 Architecture for Leisure: Living the "Generic City"

but by regional firms. AEB, a Qatari firm established in the 1960s, also designed the Kempinski Residences and Suites (2009, 253 m) and the new Majlis Grand Mercure Hotel. Diwan Al Emara, another local firm, designed the Hilton Double Tree Sinyar Tower (2016, 230 m), while Egyptian practice Engineering Consultancy Group the JW Marriott Hotel and apartments West Bay (215 m).

In South-East Asia (Indonesia, Malaysia, Vietnam), the four top players have been Denton Corker Marshall, Richez Associés, Smallwood, Reynolds, Stewart, Stewart, and WATG (Table 10.2). The Australian firm has been active in Indonesia since the 1990s (Sect. 9.5) and, from the early 2000s, has designed several hospitality projects, but not upscale hotels for international chains. In Indonesia, such hotels are usually in Jakarta and Bali; in Malaysia, in Kuala Lumpur and nearby Putrajaya. If located in

Table 10.2 Hotels in South–East Asia designed by the four most involved overseas firms (surveyed sample), 1990–2020

Designer	City (Country)	Project	Year	GFA (m^2)
Denton Corker Marshall (AUS)	Ubud (Indonesia)	Maya Ubud Resort + Spa	1998–2001	N.A.
	Palembang (Indonesia)	Novotel Palembang	2000–04	N.A.
	Jakarta (Indonesia)	Alila	2001–02	N.A.
		Manhattan Hotel	2000–06	20,000
	Bandung (Indonesia)	Sensa Hotel	2006–09	N.A.
	Lampung (Indonesia)	Novotel Lampung	2006–10	N.A.
	Bali Island (Indonesia)	Anantara Uluwatu	2009–11	N.A.
		Maya Sanur Hotel Resort + Spa	2010–14	N.A.
	Solo (Indonesia)	Alila	2011–15	N.A.
	Bali Island (Indonesia)	Kempinski Nusa Dua	2014–19	N.A.
Richez Associés (FR)	Putrajaya (Malaysia)	Shangri-La Hotel Putrajaya	2003	20,000
		Alam Warisan Hotel	N.A.	48,550
	Kuala Lumpur (Malaysia)	Le Méridien KL	N.A.	N.A.
Smallwood, Reynolds, Stewart, Stewart (USA)	Jakarta (Indonesia)	The Ritz-Carlton Jakarta, Pacific Place	2005	N.A.
		The Langham [interior design]	2019	N.A.
	Ha Long Bay (Vietnam)	Vinpearl Resort [interior design]	N.A.	12,000

(continued)

Table 10.2 (continued)

Designer	City (Country)	Project	Year	GFA (m^2)
WATG (USA)	Bali Island (Indonesia)	Conrad Bali	N.A.	N.A.
		Sofitel Bali Nusa Dua	N.A.	N.A.
		The Ritz-Carlton	N.A.	N.A.
	Flores Island (Indonesia)	Ayana Komodo Resort	N.A.	N.A.
	Kuala Lumpur (Malaysia)	Grand Hyatt	N.A.	N.A.
		Mandarin Oriental	N.A.	N.A.
		Palace of the Golden Horses	N.A.	N.A.

an urban context, they usually take the form of medium-to-high-rise blocks; on the contrary, in seaside locations, they are generally resorts composed of multiple low-rise pavilions, including independent or semi-independent villas. In the cities, the architectural language tends to remain that of international modernism; on the coasts, we typically find an elegant, modernised tropical vernacular, or "Bali Style". WATG's projects, for instance, integrate local craftsmanship in the detailing within a triumph of tropical greenery, infinity pools, and shading canopies. However, in certain cases, the result is heavy and monumental rather than light and vernacular, like in the Nusa Dua Sofitel in Bali. Another project, the Bali Esperanza Villa Uluwatu (2019, 795 m^2) by Jun Mitsui & Associates, features a more modern and minimalist inflexion, while OMA's Potato Head Studios, also in Bali, defies the standard typology of the seafront hotel as an enclosed compound. Lifted from the ground, it leaves an unobstructed space leading to the beach and a publicly accessible roof. On the other hand, WATG's Ayana Komodo Resort in Labuan Bajo is nothing more than a curved block covered by a generic Asian-looking roof to contextualise its presence weakly. Sometimes, even forms of colonial architecture reappear (see also the next section), like in Smallwood, Reynolds, Stewart, Stewart's Vinepearl Resort in Ha Long Bay, Vietnam, a mix of Palladianism (using the architect's words) and Asian roofs. Or, to mention another extreme case, very much in line with an a-historical eclectic architectural proposal just seen, for example, in the Emirates Palaces and The Atlantis—The Palm, we can point out the Palace of the Golden Horses, also by WATG, in Kuala Lumpur. Wilson, one of the global top-player in hospitality architecture, has completed the Four Seasons Kuala Lumpur Hotel & Residences, and Pelli, Clark, Pelli the Four Seasons Hotel in Jakarta, inside the Capital Place complex (Sect. 5.4). On the other hand, to see how smaller firms have found their niches, we can look at the Italian Area-17 that designed four resorts in Bali in the second half of the 2010s. Still, to put things in perspective, the total GFA was about 9,000 m^2.

Considering another country examined in this book, India, we can notice that the main actors remain overall the same (Table 10.3), while also here the question of identity—a complex problem involving both brand and local identity—emerges as a crucial one. Upscale hotels are often housed in eclectic palatial architectures inspired

Table 10.3 Hotels in India designed by the four most involved overseas firms (surveyed sample), 1990–2020

Designer	City	Project	Year	GFA (m^2)
Chapman Taylor	Lucknow	Renaissance and Marriott	2015	17,500
	Karjat	Radisson Blu 5* Hotel & Spa	2016	15,000
	Mohali	Radisson Red Hotel	2020	15,000
Smallwood, Reynolds, Stewart, Stewart	New Delhi	Leela Palace New Delhi	2011	42,300
		JW Marriott New Delhi Aerocity	N.A.	59,238
	Chandigarh	JW Marriott Chandigarh	N.A.	18,575
	Chennai	Park Hyatt Chennai	N.A.	41,700
		ITC Grand Chola	N.A.	N.A.
	Bangalore	Conrad Bengaluru	N.A.	40,000
WATG	Bangalore	The Ritz-Carlton Bangalore	N.A.	N.A.
		Leela Palace Kempinski	N.A.	N.A.
	Goa	Leela Kempinski	1990s	N.A.
	Hyderabad	Taj Falaknuma Palace Hotel	2010	N.A.
Wight & Company with Lohan Associates	Mumbai	Grand Hyatt	2013	N.A.
		Four Seasons	N.A.	N.A.
	Pune	Hyatt Regency	N.A.	N.A.

by different periods of Indian history. For instance, Smallwood's ITC Grand Chola Chennai was inspired by Chola architecture, while the Leela Palace New Delhi was by Lutyens' colonial classicism. WATG-designed Leela Palace Kempinski in Bangalore, perhaps the most monumental of all these projects, was drawn with the eclectic tradition of Mysuru as a reference. WATG, in the early 1990s, also designed the eclectic Leela Kempinski in Goa, a resort with villas located around a central lake and inspired by a mix of Mediterranean, Portuguese colonial, and Indian architecture, and renovated the impressive Taj Falaknuma Palace in Hyderabad, a late-nineteenth-century classical building designed by British architect William Ward Marret. Less understandable, instead, is Chapman Taylor's Balinese-Thai potpourri in the Radisson Blu in Karja. These considerations lead us to what was previously discussed about the eyes of the tourists that will be enjoying the view of the swimming pools no matter how philologically correct the architect's stylistic solution is. Ultimately, architectural proposals do not need to be univocal, and they change according to location and brand without a discernible pattern. To complete our mapping of projects in India, we can then add several more works of anonymous appearance, usually inclined towards the modern-monumental, like Goettsch Partners's Grand Hyatt Mumbai (111,480 m^2), Portman Architects' Park Hyatt Hyderabad (2012,

55,700 m^2), Smallwood's Park Hyatt Chennai and Conrad Bengaluru, and WATG's The Ritz-Carlton Bangalore. On the contrary, in a pure hyper-modern fashion is SOM-designed The Park (2010, 49,400 m^2, LEED Gold) in Hyderabad, a regular block carved to create an elevated courtyard and wrapped by a perforated metal skin stretched in correspondence with the entrance and the long horizontal openings.

Russia and Kazakhstan and surveyed African countries, on the contrary of what seen so far, appear minimally significant for our sample of firms—and thus we dare to say for the global profession until this moment—when it comes to hospitality projects.[2] For major hotel chains, WATG designed the Astana St. Regis in Kazakhstan, while Valode & Pistre the Hyatt Regency of Ekaterinenburg (2009, 35,000 m^2) and Sochi (2013) in Russia, where Aukett Swanke also completed the Azimut Hotel in 2014, just in time for the Winter Olympics (Sect. 7.4), while Steelman Partners later converted the Olympic Media Centre into a Casino and Resort (2016–17, 35,000 m^2). German firm Batek Architekten designed seven more hotels for the Russian chain Azimut between 2013 and 2017. In Africa, Wilson Associates designed the Fairmont Mount Kenya Safari Club and the Fairmont Mara Safari Club in Kenya, and the Intercontinental Hotel of Johannesburg OR Tambo Airport in South Africa. Here, Steelman Partners completed the Caesar's Gauteng casino and hotel, while in Rustenburg, we find the Palace of the Lost City, another example of upscale palatial pastiche by WATG with annexed golf course, this time located in a beautiful scenario at the edges of an extinct volcano now part of the Pilanesberg National Park. Lastly, just for the sake of completeness, Broadway Malyan refurbished the Hotel Trópico in Luanda, Angola.

Casting our gaze on Latin America, we do not recognise significant differences in terms of market concentration. Three US firms—BBGM Architects, HKS, and WATG (Table 10.4)—delivered more than half of the hospitality projects mapped in the region. They are all located in Mexico, where we find upscale urban hotels and beach resorts, especially in Cancún and Cabo San Lucas. In the Mexican capital, in addition to what we see in Table 10.4, we find Wilson Associates' refurbishment of Sofitel Mexico City Reforma (2019) and Pelli Clarke Pelli Architects' Torre Libertad St. Regis (Sect. 5.6), both located along the Paseo de la Reforma, and Callison RTKL's JW Marriott (2011) in Polanco neighbourhood. Overall, these projects tend to be more sleekly modern and international, even in the case of seaside resorts, with WATG's Nobu Hotel Los Cabos as one of the finest. And in examples like HKS' Las Ventanas Al Paraiso and The Waldorf Astoria Los Cabos Pedregal, the architectural proposal also tends to rely on a nuanced colonial-Californian language. Considering Brazil and Colombia, then, we mapped the work of Goettsch Partners, which designed the Grand Hyatt of São Paulo (2003, 55,000 m^2, with Wight &

[2] For sure, we need to recognise how, for example, the sample of African countries is small and does not include important touristic destinations, especially coastal ones, like Zanzibar in Tanzania, Capo Verde, or the Red Sea coast of Egypt, where we could have certainly identified several resorts designed by international firms. In addition, our sample does not include, for instance, the Maldives and the Seychelles archipelagos, nor, in America, any Caribbean island (except for Colombia's San Andrés and Providencia), another region in which firms specialised in hospitality design find an active market.

Table 10.4 Hotels in Latin America designed by the three most involved overseas firms (surveyed sample), 1990–2020

Designer	City	Project	Year	GFA (m^2)
BBGM Architects	Mexico City	Four Seasons Hotel	N.A.	N.A.
	Monterrey	Crowne Plaza	N.A.	N.A.
	Playa del Carmen	Rosewood Mayakoba	N.A.	N.A.
	Mérida	Merida Boutique	N.A.	N.A.
	Mexico City	JW Marriott Mexico City [interior design]	N.A.	N.A.
HKS	Cabos San Lucas	Las Ventanas Al Paraiso, A Rosewood Resort	N.A.	26,000
	Cabos San Lucas	The Waldorf Astoria Los Cabos Pedregal	N.A.	23,783
	Cabos San Lucas	Esperanza, An Auberge Resort [renovation, interior design]	N.A.	N.A.
	Huatulco	Celeste Beach Residence & Spa	N.A.	11,824
WATG	Mexico City	Four Seasons Mexico City	1994	33,237
	Cabo San Lucas	Nobu Hotel Los Cabos	2019	N.A.
	Punta Mita	Four Seasons Punta Mita	N.A.	N.A.
	Puebla	Rosewood Puebla	N.A.	N.A.

Company) and Bogotá (2019, 76,500 m^2), and Philippe Starck in collaboration with Jean Nouvel for the interiors of the Rosewood São Paulo, inside the old Matarazzo Hospital. Starck had also previously completed the renovation of the Fasano Hotel (2007) in Rio de Janeiro. Finally, two refined hotel projects, the Txai Resort Itacaré in Bahía (2008) and the Nova Lima House (2013) in Minas Gerais, were designed by Portuguese architects Saraiva + Associados.

The conclusions of these two sections focused on hotel projects touch on several entangled aspects. Firstly, we have seen how a bunch of design firms, mainly from the US, dominate the market of hospitality design worldwide, especially for hotels of the leading international conglomerates (with their sub-brands): Hilton Hotels & Resorts, Hyatt Hotels & Resorts, InterContinental Hotels Group, and Marriott International. At the same time, some boutique firms have been able to carve market niches, whether regional or in terms of design service (interiors only) and client networks. Had we investigated more firms specialised in hospitality and interior design, we would probably have identified more key actors. Some F&B interior projects we mapped but did not discuss in these pages also suggest so. Secondly, we can now understand the role of design, or better, of good design. Howard Wolff, senior vice-president and marketing director at WATG, for example, has highlighted the importance of good design in creating value, citing a Design Quality Indicator (DQI) experimented by Hyatt that found a positive correlation between DQI scores

and guests' and employees' satisfactions. In addition, Wolff also argued that effective design, which for him means one embodying WATG's principles, adds value, reduces operating and maintenance costs, increases productivity, and improves the overall guests' experience (Dev 2012, 19). Indeed, what is good design sounds like a million-dollar question. As Wolff claims, it reflects and emphasises expectations towards a brand (Dev 2012, 19).

To this, we can also add that good design should be functional, internally consistent, exceptionally beautiful, environmentally sustainable, and socially equitable. In other words, it should be ethical. And here comes the difficult part. Can a design pastiche, even well-executed, be good from the point of view of contemporary architectural values? Certainly, it could have been in the middle of the eighteenth century, but after modernism, we believed that the rejection of the pseudo-historical—the quest for morality elevated by Giedion (1949, "The Demand for Morality in Architecture", Part IV)—was too strong. However, we may find out that this is not a problem today among common observers and users like hotel guests. But neglecting aesthetic issues, other concerns are more pressing: is the consumption of hundreds of cubic metres of water for multiple swimming pools in the desert sustainable? Is a fully "air-conditioned" life within air-tight glazed envelopes sustainable? And what about the enclosed life in a walled resort surrounded by misery? How much the presence of a resort benefits the economy of small communities living in the surroundings? A study by the collective Supersudaca on tourism in the Caribbean pointed out how cruises and all-inclusive resorts impact the coastal territory. The latter, in particular, often creates along the coast an "All-Inclusive Resort Strip" that is "programmatically homogenous," combining the "logic of the American suburb" with "spatial segregation" (Supersudaca 2009). In the end, the debate about all-inclusive tourism and its impact is open, with many critical issues pointed out (Tourism Concern 2014) but also some voices (usually from the operators) defending it as a more sustainable form of mass tourism (Buckley 2019).

As seen, hospitality architecture dramatically varies in its aesthetic proposal, with the hyper-modern and the monumental with historical undertones that sometimes become blatant "fairy tale" pastiche, while in more natural settings, a tropicalised and more or less modernised vernacular emerges as the dominant trend. The success of the "Bali Style", then, also lies in its tropical versatility, being "Asian" first of all (Scriver and Srivastava 2019, 86), and thus suitable in a territory spanning from the Philippines to the Maldives. Indeed, it is here, for example, that we also find some of the most exclusive and dreamlike hotels, with vernacular water bungalows and sleekly minimalist water villas, some even provided with underwater bedrooms as in The Muraka at the Conrad Maldives Rangali Island resort. This stunning hotel was designed by local architect Ahmed Saleem with New York-based firm Yuji Yamazaki (not included in our survey). The same firm has recently completed the Kudadoo Maldives Private Island, an eco-resort with the main building roofed with well-visible photovoltaic panels that suggest a shift in the approach from concealment to display of these elements even in luxury resorts on idyllic islands. In this light, we can expect a stronger integration and open exhibition of passive and active bioclimatic devices in hospitality design as sustainability increasingly becomes a must for travellers.

Turning an eye to the agency of international design firms, and especially of the ones we surveyed, we notice their active presence in emerging markets, although we do recognise that many more have been the significant actors involved in the delivery of high-end hospitality projects. In this regard, in the next section, we will go deeper into the relationship between some design firms and major international hotel chains, especially in China.

10.4 International Chains, International Architects: China's Booming Hotel Market

Many of the firms mentioned in the previous section as market leaders in the design of hotels and resorts have effectively delivered a large number of projects in mainland China, whose hotel market has boomed in the last few decades. Between 1984 and 1988, the number of hotel rooms almost tripled, from 76,900 to more than 220,000, and by 1990, China counted 1,987 hotels (Roskam 2015, 103). By 2014, star hotels exceeded 13,200, with a growing number of five-star facilities despite a general slow-down after 2009. Five multi-national hotel chains alone—IHG, Marriott, Hilton, Windham, and Accor—had 741 new hotels in the pipeline between 2014 and 2019 (Chan et al. 2016). These figures help us understand the role of China in the hospitality design sector. What happened during the 1980s, with the first hotel projects designed by foreign architects, and the importance of this sector in the first phases of the process of Chinese economic opening has already been discussed, making us now able to look at significant hotel projects. To do so, we initially proceed through a geographical overview of three popular locations, and then we explore the role of the major architectural players in this sector. The three locations are Beijing, which can count on at least 636 bookable hotels on the Chinese platform CTrip, Shanghai, which has 1,139, and Sanya, the main seaside resort city of Southern China, with 276.

In Beijing, after the construction of the Jianguo, the Fragrant Hill, and The Great Wall Hotel, The Palace was inaugurated in 1989. This building, designed by Cheung Kong-Yeung Architects from Hong Kong, featured a stereotyped hip-and-gable roof over a massive 14-storey volume. It was, however, in the early 2000s that the hotel scene completely changed. On the one hand, with the Commune by Great Wall developed by SOHO China, the typology of the villa hotel was introduced, together with new marketing and branding strategies connecting real estate developments to the international art and architecture system (Ren 2011, 74–75). SOHO China then called twelve well-known Asian architects to design just as many luxurious villas immersed in the mountains around Badaling. In the pool of architects, the names of Young Ho Chang (Atelier FCJZ), Rocco Yim, Cu Kai, Kengo Kuma, Shigeru Ban, and Antonio Ochoa Picardo stood out. The latter one, a Venezuelan architect operating in China since the early days of the opening, had by then become the chief architect at SOHO and was the only non-Asian involved in the Commune

operation. As for Kuma and Ban, each of them designed one of the villas using bamboo as the main material, the former by erecting a linear building conceived as an inhabitable wall wrapped by a bamboo screen, the latter by developing prefabricated panels of laminated bamboo to create a kind of modular house. In addition, South Korean firm Iroje Architects & Planners designed the clubhouse and, in 2005, completed a 20,000-square-metre extension comprehensive of ten two-storey villas, a spa, and the Weekend House for SOHO founders. Such a development paved the way for other similar, more or less successful projects across China, where it is very common, especially in hilly and mountainous areas, the typology of the hotel in the form of a village of scattered villas. Among them, the most important case, involving several high-profile international architects, has been the already mentioned Sifang Art Museum and the Contemporary International Practical Exhibition of Architecture (Sect. 6.1). Then, with the second half of the 2000s and the preparation for the 2008 Summer Olympic Games (Sect. 7.1), the involvement of foreign firms grew in general, and for the design of hotels, too. Not by chance, as visible in Table 10.5, many high-end hotels in Beijing opened during those years, and the trend has continued since then.

Table 10.5 Hotels in Beijing designed by overseas firms (surveyed sample), 1990–2020

Designer	Project	Year	GFA (m^2)
Adrian Smith + Gordon Gill	Waldorf Astoria Beijing	2015	36,397
Benoy	EAST Hotel	2012	49,000
Callison RTKL	W Beijing Chang'An	N.A.	N.A.
Citterio-Viel	Beijing Bulgari Hotel	2017	27,000
GMP	Chao Hotel	2012–16	31,300
GRAFT	The Emperor Hotel	2008	4,800
	Gallery Hotel	2009	N.A.
Kengo Kuma	The Opposite House	2008	14,000
KPF	WF Central, Mandarin Oriental Wangfujing	2019	102,000
RBTA	Shangri-La Hotel	2008	N.A.
RMJM	InterContinental Beichen Hotel	2008	40,000
SOM	The Ritz-Carlton Beijing Financial Street	2006	40,000
Stantec	Marriott Beijing	N.A.	4,180
	Renaissance Wangfujing Beijing Hotel	N.A.	44,036
Urban Design System	Muji Hotel	2018	4,000
WATG	The Ritz-Carlton & JW Marriott Beijing	N.A.	N.A.

(continued)

Table 10.5 (continued)

Designer	Project	Year	GFA (m^2)
Wilson Associates	Hilton Beijing Wangfujing [interior design]	2008	N.A.
	China World Hotel—Shangri-La [interior design]	N.A.	N.A.
	Westin Beijing Financial Street [interior design]	N.A.	N.A.

While the construction of new hotels represented a formidable occasion for debate in the Beijing of the 1980s, by the 1990s, Shanghai was emerging as the top business destination in China. Its hospitality sector took off at the end of the first decade of the 2000s, at least for what concerns the work of foreign architects (Table 10.6).

Table 10.6 Hotels in Shanghai designed by overseas firms (surveyed sample), 1990–2020

Designer	Project	Year	GFA (m^2)
Arquitectonica	Longemont Hotel and Office Tower	2005	86,800
Atkins	InterContinental Shanghai Wonderland Hotel (The Quarry Hotel)	2011–13	49,400
B\|H	You You Grand Sheraton International Plaza	2007	20,000
	The Ritz-Carlton Hotel Shanghai [interior design]	2010	43,000
	Shanghai Wanda Reign Hotel [landscape]	2016	9,000
Citterio-Viel	Shanghai Bulgari Hotel [interior design]	2018	25,000
Dox Interiors	Nan Quiao Hotel [interior design]	N.A.	N.A.
	Quiantan 29 [interior design]	N.A.	N.A.
Gensler	Portman Ritz-Carlton [renovation]	N.A.	N.A.
HOK	Four Seasons	2002	N.A.
	The Peninsula Shanghai	2010	56,000
KPF	The Langham & Andaz Xintiandi	2011	61,800
	Pudong Shangri-La Hotel	N.A.	45,000
	Shangri-La Qiantan	2014–20	N.A.
	Hyatt Place Changning (SOHO Tianshan Plaza)	N.A.	N.A.

(continued)

10.4 International Chains, International Architects: China's Booming Hotel ... 477

Table 10.6 (continued)

Designer	Project	Year	GFA (m^2)
Lissoni Associati	The Middle House	2012–18	13,912
Mario Botta	Hotel Twelve	2006–12	51,100
Mitsubishi Jisho Sekkei	Crowne Plaza Shanghai	2008	15,800
MG2	Crowne Plaza Shanghai Fudan	2005	36,431
Pierre-Yves Rochon	The Peninsula Shanghai [interior design]	2010	N.A.
Portman Architects	Shanghai Centre—The Ritz-Carlton	1985–1990	181,000
	Tomorrow Square—Marriott	1996–2003	93,000
	Jian Ye Li	2007	18,000
	Waldorf Astoria Shanghai on The Bund	2011	60,600
Smallwood, Reynolds, Stewart, Stewart	Sofitel Shanghai Sheshan	2015	76,000
SOM	Shanghai JW Marriott	2017	119,600
Stantec	Renaissance Shanghai Putuo Hotel	N.A.	23,200
WATG	Bellagio Shanghai	2016	N.A.
Wilson Associates	Four Seasons Shanghai at Pudong	2012	N.A.
	Crowne Plaza Shanghai Pujiang	2017	N.A.

Even before the construction of Portman's Shanghai Centre (Sect. 5.2), containing The Ritz-Carlton, the Hilton Hotel, designed by Hong Kong architects Andrew Li and Alex Lui, and the Garden Hotel by the Japanese firm Obayashi Corporation had already opened in the city (Xue and Li 2008). Still, the work of Portman was particularly relevant in shaping the skyline of pre-2000 Shanghai as much as that of the subsequent years. The iconic Tomorrow Square—Marriott tower soared with its unique profile, resulting from the extrusion of a square plan, hosting 36 floors of executive apartments, that then rotates 45 degrees to signal the beginning of the Marriott Hotel. To complete its unmistakable silhouette, the tower ends with four sharp converging triangles enclosing a sort of light-sphere. On the opposite of the spectrum, in terms of typological possibilities, Portman Architects also renovated the Jian Ye Li complex into an upscale residential and hospitality destination, the Capella Hotel. Built during the 1920s by French architects within the French Concession as workers' residences, the Jian Ye Li is especially relevant as it represents one of the few typical lane houses (*lilong*) estates preserved in the city. Indeed, this experience followed another successful project of adaptive reuse and heritage preservation of the old *lilong*, Xintiandi (1998–2002), by US architects Wood & Zapata (Lin 2011). And the work of Portman Architects did not stop there. The firm also renovated the Waldorf Astoria Shanghai on the Bund with a double intervention: on the one hand,

they renovated the old Shanghai Club, a landmark of colonial Shanghai built in 1910 along the Bund; on the other, they designed a new 20-storey tower in the rear of the old building. Such a project allows us to discuss one key aspect of hospitality architecture in Shanghai, somehow related to the question of identity enunciated in the previous section.

As already noted, Shanghai has represented for more than two decades the ultimate Chinese metropolis, the most convincing symbol of the new international status of China as a modern country first of all visible in its ever-growing skyline (Sect. 5.2). And hotels often occupy parts of the tallest and hyper-modern skyscrapers of the city: the upper floors of the 632-m Shanghai Tower are occupied by the J Hotel, those of Shanghai World Financial Centre by the Park Hyatt, and those of the Jin Mao by the Grand Hyatt. However, Shanghai also boasts a significant and partly preserved architectural heritage corresponding to its first period of modernisation: the late nineteenth century. The neoclassical and eclectic buildings of the colonial era, mainly concentrated along and behind the Bund, are today reminders of that period and an obvious reference for foreign architects. As a matter of fact, Art Deco architecture, of which the Park Hotel designed by László Hudec and completed in 1934 represented one of the best examples (and the tallest building in the city until the 1960s), is often mentioned as the stylistic reference in hotel design. A modernised Art Deco, in fact, is the architectural language of WATG's Bellagio Shanghai Bund, both in its volume and interiors, but also of Gensler's refurbishment of the interiors of the (now) Portman Ritz-Carlton. And The Peninsula Hotel, designed by HOK, presents a volumetry rich in setbacks explicitly referring to colonial Art Deco architecture, while its sumptuous interiors by Pierre-Yves Rochon also reinterpret such a legacy. In the end, this trend, while certainly consistent with the identity of upscale hotels of US chains, also emerges as a clear sign of the architects' attempt to contextualise their work.

When it comes to the irrefutably modern, on the other hand, hotels are often located in high-rise buildings, whether mono-functional or mixed-use. Arquitectonica's Longemont Hotel occupies a bold, sculptural tower, which also includes office space, while KPF's The Langham & Andaz Xintiandi is housed in two curved buildings with similar-but-different façade patterns (Fig. 10.20). KPF also designed the rather monumental Shangri-La Pudong (Sect. 5, Fig. 5.10) and the Shangri-La Qiantan, a 110-m-tall slab counterpointing the 280-m Qiantan Centre tower. However, more hotel projects are generally part of mixed-use developments: the Jing An Kerry Centre (Sect. 9.2, Fig. 9.16) contains a Shangri-La Hotel in its central tower, while the Hyatt Place Changning is located within the SOHO Tianshan Plaza. Our overview would not be completed, however, without considering the categories of the extravagant, which in hotel architecture certainly plays an important role, and the work of some boutique firms, especially active in interior design. In the former, the most outstanding example is Atkins' InterContinental Wonderland, a luxury hotel located in an abandoned quarry in the metropolitan area of Shanghai. The hotel leans against the rock cliff and overlooks the artificial lake and an equally artificial waterfall, while some rooms even boast an underwater view. Pity that the place is not in the sea of Maldives, and, in fact, the window is actually looking at an aquarium.

Fig. 10.20 The Andaz Xintiandi by KPF, Shanghai. Photograph by Giaime Botti, distributed under a CC BY 4.0

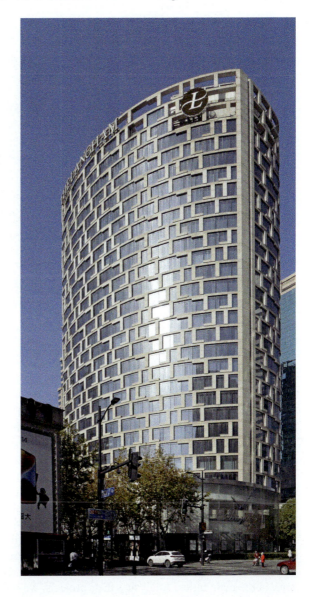

Among signature hotels, instead, one project worthy a mention is Mario Botta's Twelve Hotel (Fig. 10.21). Coated in *terracotta* tiles, it occupies a regular prism carved by a concave entrance and a central elliptical courtyard with a small garden. Other firms with relevant experience in luxury hospitality interiors are Citterio-Viel, responsible for the interior design of the Bulgari Hotel in Shanghai and Beijing, Lissoni Associati for The Middle House, and Pierre-Yves Rochon for The Peninsula Shanghai. Nonetheless, it would be unfair to discuss hospitality architecture and interior design without mentioning local firms, especially Neri & Hu. Established in

Fig. 10.21 The Twelve Hotel by Mario Botta, Shanghai. Photograph by Giaime Botti, distributed under a CC BY 4.0

Shanghai in 2004 by Lyndon Neri and Rossana Hu, it has emerged as a leading global boutique firm, with projects scattered around the world and with a visible touch in Shanghai's most glamour locations, whether a French Michelin-starred restaurant like Jean-Georges at Three on the Bund or a whole fancy hotel like The Edition.

A third key touristic destination of China, with the best seaside spots in the country, is the southern tropical island of Hainan, and especially the city of Sanya with the nearby area of Yalong Bay. Here, several upscale hotels and resorts have popped up in the last two decades (Table 10.7). The island began its touristic development in the 1990s to exploit its mild climate, sandy beaches surrounded by palm trees, and pristine waters. Already in 1994, a new airport designed by Paul Andreu and ADP Ingénierie was inaugurated. Still, it was not until the end of the first decade of the twenty-first century that the real boom in the construction of major hotels began, attracting that same array of international firms that we have already seen at work in the main cities. Analysing their projects, we notice that many beach-front hotels feature a similar scheme with a central body looking at multiple swimming pools and amenities in the lush tropical green in the middle, and two more or less symmetrical wings, diagonally facing the sea to increase the number of rooms with an unobstructed view. This scheme is repeated with a few variations, mostly in terms of architectural language. WATG's MGM Grand Sanya presents two wings with simple lines, while The Ritz-Carlton Sanya and the Hilton Sanya Yalong Bay Resort & Spa feature a modernised vernacular Chinese language adapted to multi-storey slabs. A similar but more nuanced approach is followed by B+H for the Pullman Oceanview

10.4 International Chains, International Architects: China's Booming Hotel ... 481

Sanya Bay Resort, hosted in quite neutral, tall blocks, where only a few elements, like the main entrance's canopy, display a generic Asian character. Smallwood, Reynolds, Stewart, Stewart master-planned the Haitang Bay Sigma Resort, consisting of two resorts with an overall sinuous scheme resulting from two similar complexes, each of them composed of a central volume with two wings in a concave configuration that allows the positioning in the middle of the swimming pools and some villas. The architecture of these two resorts, namely the JW Marriott (former The Royal Begonia) and the Sheraton, feature a Mediterranean-inspired language, while another one, the Marriott Yalong Bay Resort & Spa, a modernised and generic Chinese vernacular.

Again, we also find hotels whose architectural language stands on the opposite side of the spectrum. An utterly contemporary project is, for instance, HOK-designed Sanya Atlantis, composed of a thin tower described by HOK architects as two juxtaposed fins and a sinuous, extended podium that incorporates a multiplicity of water features (swimming pools, dolphinarium, and internal aquariums) branded as one of the selling points of the Atlantis chain. This project was developed after a competition in which Jean Nouvel presented a "radical"—we use this adjective to echo Italian 1960s radical architecture—solution: a 170-m-tall, 400-m-long, thin slab containing all the rooms and the amenities standing as a Chinese screen with marine motives. Another project on the same line is the Rosewood Sanya and Sanya Forum (it includes

Table 10.7 Hotels in Sanya designed by overseas firms (surveyed sample), 1990–2020

Designer	Project	Year	GFA (m^2)
B+H	Pullman Oceanview Sanya Bay Resort	2010	78,000
	Greenland Primus Resort & Apartments [interior design]	2019	39,477
Goettsch Partners	Rosewood Sanya and Sanya Forum	2014–17	151,500
HOK	MGM Grand Sanya [renovation, interior design]	2012	94,000
	Atlantis Sanya	2018	237,000
	The St. Regis Sanya Yalong Bay Resort	N.A.	86,000
Nihon Sekkei	Sanya Poly Phoenix	2015	35,500
Smallwood, Reynolds, Stewart, Stewart	Sanya Marriott Yalong Bay Resort & Spa	N.A.	37,900
	JW Marriott Sanya Haitang Bay (former The Royal Begonia)	N.A.	22,300
	Sheraton Sanya Haitang Bay	N.A.	69,000
WATG	MGM Grand Sanya	N.A.	94,000
	Hilton Sanya Yalong Bay Resort & Spa	N.A.	N.A.
	The Ritz-Carlton Sanya	N.A.	N.A.

a large conference centre) designed by Goettsch Partners. It consists of a sinuous slab for the hotel connected to an apartment tower on top of it by the continuous horizontal lines of the balconies. Following other successful examples, the hotel boasts a popular rooftop swimming pool in the like of Marina Bay in Singapore or the new The Address Beach Resort in Dubai. A comparable architectural proposal, in terms of language, is provided by MAD Architects, one of the most successful and internationally acclaimed Chinese firms, with Phoenix Island (2013). The development, master-planned by US firm Leisure Quest (not included in our survey), consisted of a long artificial island in front of Sanya, where MAD designed a complex of over 500,000 m^2 of hotel and residential towers, shopping streets, and a marina. As of today, the tallest tower for a 7-star hotel has been built, while five residential towers of a typical contemporary nautical aesthetics emerge like big sails on the horizon (Fig. 10.22).

As a result of thirty years of solid and uninterrupted economic growth, the construction of hotels has boomed all over China, from provincial capitals and prefecture-level cities to provide accommodation to the rising number of business and cultural tourists, to resort areas in the mountains, countryside, or around lakes. A complete overview would be impossible, and for this reason, in the last part of this section, we will focus on some selected projects while showing the presence of

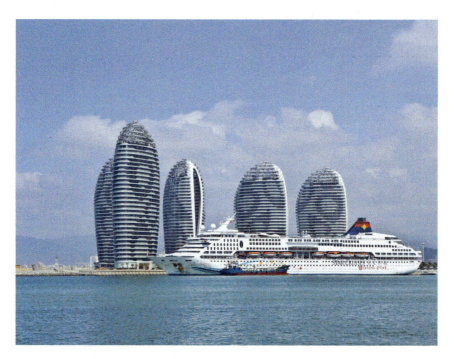

Fig. 10.22 Phoenix Island by MAD Architects, Sanya. Photograph by Anna Frodesiak, distributed under a CC0 BY 1.0, available at https://commons.wikimedia.org/wiki/File:Phoenix_Island,_Sanya_Bay_-_02.jpg

a limited number of international firms and their strong ties with major hotel chains. These brands have relied on a constellation of firms, mainly from the USA, for their projects in China (and elsewhere, too). Given the number of hotels built in the last decade, however, the limits of this mapping must be recognised, as some architecture firms specialised in hospitality design have certainly remained outside of our survey, while other projects could have been delivered by Chinese firms, above all in second and third-tier cities and in case of 4-star hotels and below.

A broader outlook on the major actors involved in hospitality projects in China allows us to highlight the activity of US megafirms and of few other actors (Table 10.8).[3] In terms of outcomes, once again, the picture is complex but can be simplified with a few considerations. Foreign architects are usually involved in projects of large hotels (60–80,000 m^2) in urban locations, generally in the form of tall buildings, sometimes part of mixed-use developments, in some cases, within mixed-use towers. These buildings usually feature a generic modern appearance, but there are exceptions leaning towards different forms and degrees of eclecticism. One example is Smallwood, Reynolds, Stewart, Stewart's Hilton Zhengzhou, a 150-m-tall tower inspired by New York Art Deco located within a Manhattan-themed district. In other cases, especially in locations of historical value, a modernised vernacular takes over while buildings' heights diminish and pavilions replace towers. In Xi'an, the ancient capital of the Tang dynasty (618–907 AD) and the city of the famous *terracotta* army, Callison RTKL designed the Hyatt Regency in a language meant to homage Tang architecture and respect the adjacent royal garden. At the same time, in the fast-growing business district of the city, at a small distance from SOM's 498-m Greenland Centre (Sect. 5.2), the Maike Business Centre (215,000 m^2), also designed by Callison RTKL consists of two towers connected via a sky bridge, one hosting offices, the other the Grand Hyatt. In this case, no concession is made to history in terms of architectural language.

Lakes are beloved destinations in China, and expansive resorts have popped up around their shores, whether in urban or rural locations. In Hangzhou, a series of upscale hotels of limited height due to regulations aimed at safeguarding its landscape occupies the West Lake waterfront. They include the unremarkable Grand Hyatt (2005, 32,341 m^2), a monumental crescent designed by Portman Architects. More delicate projects in non-urban locations have been created by WATG. The InterContinental One Thousand Island Lake Resort is organised in two low blocks with simple modern lines with a touch of generic Chineseness in a large circular opening and curved roof profiles. More interestingly, the Jinshuo Hotel and Resort in Sichuan features an articulated sequence of pavilions and small buildings within an intricate landscape enriched by water and plants and enclosed by walls. Stone and rammed earth contribute to this elegant blend of traditional and contemporary design. In Dongqian Lake, a popular resort near Ningbo, just beside the Huamao Museum designed by Álvaro Siza (Sect. 6.1), stands the Hilton Dongqian (2009–17) designed

[3] Another important actor we mentioned several times, Wilson Associates, delivered at least ten interior design projects for hotels in mainland China, but having its involvement limited to the interiors, it has not been included in the Table.

Table 10.8 Hotels in China by selected overseas firms (surveyed sample), 1990–2020

Designer	City	Project	Year	GFA (m^2)
Callison RTKL (USA)	Changsha	InterContinental Changsha	N.A.	N.A.
	Dongguan	Vanke Dongguan Aloft Hotel	N.A.	N.A.
	Fuzhou	Kempinski Hotel & Tahoe Headquarters [mixed-use development]	N.A.	N.A.
	Shanxi province	Wutai Mountain Marriott Hotel	N.A.	N.A.
	Shenzhen	Grand Hyatt Shenzhen	N.A.	N.A.
	Xi'an	Hyatt Regency Xi'an	N.A.	N.A.
		Grand Hyatt at Maike Business Centre [mixed-use development]	2013–17	N.A.
David Chipperfield	Jingdezhen	Hyatt Place Hotel and Taoxichuan Hotel (Ceramic Art Avenue Taoxichuan)	2018–22	265,000 (including museum, grand theatre, and shops)
Denton Corker Marshall (AUS)	Nanning	Gold Diamond International Hotel	2005–08	N.A.
	Liuzhou	Radisson Blu Hotel	2007–12	N.A.
	Qingyuan	Qingyuan Clubhouse	2012	N.A.
Goettsch Partners (USA)	Chengdu	Chicony Square—Grand Hyatt	2005–11	185,810
	Shenzhen	Hotel Kapok Shenzhen Bay	2012	27,000
	Guangzhou	R&F Yingkai Square—Park Hyatt [mixed-use tower]	2008–14	N.A.
	Dalian	Grand Hyatt Dalian	2009–14	81,200
	Guangzhou	Poly 335 Financial Centre—Tower 2 [mixed-use development]	2017-UC	31,000
	Hangzhou	Marriott Hotel Qianjiang	N.A.	93,400
GMP (DE)	Ningbo	Marriott Hotel, Binjiang Plaza	2011	86,630

(continued)

10.4 International Chains, International Architects: China's Booming Hotel … 485

Table 10.8 (continued)

Designer	City	Project	Year	GFA (m^2)
	Hangzhou	Thousand Island Lake Reception Building	2010–14	18,200
	Hangzhou	Xiantiandi HZ Business Centre und Hotel	2011–19	49,100
	Jinxian	Jinxian Bay	N.A.	105,850
	Xiamen	Longyan Hotel	2012	N.A.
HOK (USA)	Xiamen	Xiamen Tefang Seven Star Bay Resort	2018	92,500
	Hangzhou	Le Méridien Hangzhou	N.A.	60,000
	Lanzhou	Hilton Lanzhou Hotel [interior design]	N.A.	70,000
Smallwood, Reynolds, Stewart, Stewart (USA)	Suzhou	InterContinental Suzhou	2010s	N.A.
	Changzhou	Sheraton Changzhou Wujin Hotel	2010s	N.A.
	Zhengzhou	Hilton Zhengzhou	2010s	76,300
	Haikou	The Langham	N.A.	N.A.
	Suzhou	Le Méridien Wujiang	N.A.	40,000
WATG (USA)	Guangzhou	The Ritz-Carlton Guangzhou	2007	N.A.
	Hangzhou	InterContinental One Thousand Island Lake Resort	N.A.	N.A.
	Ningbo	Park Hyatt Ningbo Resort and Spa	N.A.	68,353
	Shenzhen	Hilton Shenzhen Marina Hotel	N.A.	43,800
	Tianjin	Renaissance Tianjin Teda	N.A.	N.A.
	Xi'an	The Ritz-Carlton Xi'an Luxury Hotel + Retail	N.A.	N.A.
	Sichuan province	Jinshuo Hotel + Resort	N.A.	N.A.

by Chinese firm Tanghua Architects & Associates in a finely modernist fashion with a Chinese flavour in its landscaping, while the nearby Park Hyatt (68,353 m^2) of WATG re-proposes the forms, in a pretty direct way, of a traditional village. In this regard, but also recalling the use of local materials and techniques, it is fair to mention that the most compelling project of a village-like structure with a blend of traditional and modern design is Amateur Studio's Wencun, not far from Hangzhou. To be clear, this project is not a hotel and is, in fact, an integral renovation of a village, where Wang Shu and Lu Wenyu have shown the n-fold possibilities of what Frampton (2020, 492) called a "*répétition différente*" (Fig. 10.23) in the reconstruction and repair of these buildings while maintaining the "continuity and the rhythm of the original linear form of the village," whose future—and this is why it has been mentioned in this occasion—lies in transforming itself into a slow-tourism destination according to a model of dispersed hospitality (the Italian *albergo diffuso*).

Across China, the variety of solutions is staggering, spanning from in-style pastiche to the ultramodern, from the low-tech to the adaptive reuse. The Xiamen Tefang Seven Star Bay Resort, designed by HOK, for instance, features a Renaissance French style selected by the developer exactly as clients did for their residences and palaces in the mid-nineteenth century. The result is a complex of oversized buildings that differ just in their size from the many McMansions in French style built across China, like, for example, the Palais de Fortune gated community in Beijing. And it does not indeed represent a unique case as even more pompous hotels include the Bavarian-looking The Castle Hotel in Dalian, managed by Starwood Hotels &

Fig. 10.23 Wencun renovated by Amateur Studio in Zhejiang Province. Photograph by Giaime Botti, distributed under a CC BY 4.0

Resorts, with its interiors designed HBA, or Jilong Castle Country Club Resort in Guizhou province. On the opposite side of the spectrum, we find ultramodern works like Coop Himmelb(l)au's Nefertiti Tower—Langham Place (2013–18, 60,000 m^2), or MAD Architects' Sheraton Huzhou Hot Spring Resort (2009–12, 59,686 m^2). The former one is a sculptural tower inspired in its shape by the Nefertiti Bust—luckily in a very abstract fashion—connected to a streamlined podium and adjacent to a yet-to-be-built theme park and hotel, the Ice World, also designed by Coop Himmelb(l)au in a quarry in the non-idyllic Dawang Mountain, in the periphery of Changsha. The latter is the famous curved arch or half-doughnut hotel soaring from the waters of Tai Lake. Indeed, while these works required complex construction technologies, others relied on more traditional techniques and materials. Hannah Heringer's Three Hotels (2013–16) in Baoxi village, Zhejiang, consists of three small circular buildings constructed with solid cores in stone or rammed earth and a sculptural envelope in bamboo, making these prototypical buildings sort of big lanterns at night. Their construction was part of the larger Bamboo Biennale hosted by the village, in which a few renowned architects participated, including Li Xiadong, Vo Trong Nghia, and Kengo Kuma, who designed the small Contemporary Celadon Ceramic Museum. More importantly for the economy of this chapter, the Japanese architect had also designed the Yunfeng Spa Resort (2008, 59,000 m^2), a real village on the slopes of the mountains outside the city of Tengchong, Yunnan, all built with local stones used to create a mosaic appearance. Finally, in the category of adaptive reuse in the beautiful agricultural and hilly landscape of Yangshuo, near Guilin, Chinese firm Vector Architects transformed an old sugar mill into a minimalist but expansive and instagrammable hotel (Alila Yangshuo), integrating new, rough-concrete buildings with the abandoned structures of the mill. Nearby, AECOM was in charge of the landscape design of the Guangxi Yangshuo Banyan Tree Resort, an upscale resort conceived as a traditional enclosed village with a palatial magnificence in its axial layout.

10.5 Spending Time and Money: From the Shopping Mall to the Leisure Centre

As Rem Koolhaas has often pointed out, shopping is increasingly becoming an omnipresent activity now pervading every typology of building, from museums to airports. Indeed, transportation hubs are becoming more and more like shopping malls, while shopping malls are changing, too. In their essence, malls are idealised worlds, clean and rather calm, untouched by outdoor weather conditions (Lepik and Bader 2016). Since their invention in the 1950s, commonly attributed to American-based Austrian architect Victor Gruen, they have continuously evolved. Once, at least in the USA, an anti-urban typology, today they may even construct parts of the city fabric. Even the Las Vegas strip, from a continuous space conceived for the automobile as mapped by Denise Scott-Brown, Robert Venturi, and Charles Izenour in the

1970s evolved into something "configured for collective forms of movement, with moving sidewalks, monorails, sidewalks, and skywalks connecting all the casinos into a continuous, smooth experience" (Chung et al. 2001, 604). The case of central Hong Kong is even more explicative, with the city readable as a continuous shopping mall connected by underground and indoor passages, escalators, and sky bridges, whereas the street level is no longer conceived as the key public space (Frampton et al. 2012). In the meantime, not only are shopping malls evolving into something richer and more complex in terms of programmes and offer (Callison RTKL n.d.)—making them known today as "lifestyle centres" (Bhatnagar 2005)—but they are being more and more considered as equivalents to public spaces in the contemporary city. As UN Studio's co-founder Ben van Berkel stated, "shopping malls are the public spaces of Chinese cities. These retail complexes are not simply shopping places; they are all-in-one destinations for outings and social gatherings. They are also places where culture and commerce merge and where architecture can express this expansive condition" (UN Studio 2021). Indeed, similar views have been strongly contested. Many authors have emphasised how shopping malls represent one of the main causes (Voyce 2006) of an ongoing and broader process of privatisation of public space (Sorkin 1992; Kohn 2004).

Still, anybody familiar with China (and many other places, too) would find van Berkel's words quite convincing. As a matter of fact, UN Studio's architects know the Chinese market very well and delivered several mall projects. For such a typology, however, a few more overseas firms have been very active, too, making it impossible (and useless) to map and discuss them thoroughly. In addition, our impression is that many of these projects remain undetected, as they are usually not considered worthy of publication on websites, not to mention how little interest they trigger among architectural magazines' editors. It is, therefore, very likely that they are many more than those mapped. That said, the first thing to note about China, as well as other emerging markets, is that here, unlike in Europe and the USA, shopping malls tend to be urban rather than suburban. They are usually either large boxes occupying one superblock in residential areas or integrated within mixed-use developments. In this case, they can be isolated, autonomous boxes or be a more integral part of the overall design, occupying, for example, the podium(s) of a high-rise complex. Overall, the former type tends to be more anonymous and of little architectural interest, while the second one, being part of a broader design proposal, may have higher quality as well as more chances to be designed by a trendier architectural firm.

Isolated shopping malls can be single large anonymous containers like the SunArt Plaza (2012–14, 78,000 m^2) in Ningbo by Broadway Malyan and Gansam's Project 3 Department Store (2016, 103,300 m^2) in Shenyang, or more futuristic ones like those designed by UN Studio, including Lane 189 (2013–017, 38,800 m^2) in Shanghai, which stands out for its complex, parametrically design façade, and the Hanjie Wanda Square (2011–13, 22,600 m^2) in Wuhan, another mall with white streamlined interiors and an external skin through which the Dutch firm perhaps tried to replicate the success of Birmingham's Selfridges by Future Systems. A very instagrammable mall has been recently completed in Shanghai by Heatherwick Studio. Known as the '1000 Trees' (2011–21, 300,000 m^2; Fig. 10.24), it is a nine-storey building with a

10.5 Spending Time and Money: From the Shopping Mall to the Leisure Centre

Fig. 10.24 The '1000 Trees' shopping mall by Heatherwick Studio, Shanghai. Photograph by Giaime Botti, distributed under a CC BY 4.0

terraced front facing the Suzhou Creek where concrete columns topped with planters accommodate about 1,000 trees and thousands of plants. In some cases, rather than autonomous boxes, we find malls conceived with more urban sensibility, like in Benoy's Parc Central (2016, 110,000 m^2; Fig. 10.25) in Guangzhou. Located in the northern extremity of the Tianhe axis (Sect. 5.2), the mall is formed by two connected low-rise buildings creating a sunken central plaza and a heavily formalised public space, which, however, maintains a certain permeability to strengthen the conceptual idea of the green, pedestrian urban axis. Another interesting project by Benoy is the massive Suzhou Joy Breeze (2012, 330,000 m^2), which features a complex volumetry with several stacked rectangular boxes of different sizes and textures, providing an overall bold and contemporary image. Such an image appears even stronger compared to projects like those by Callison RTKL, which seems to indulge with (late) postmodern details and textures and an hyper-commercial appearance like in the Vanke Songhu Plaza in Dongguan, a real leisure district with multiple low-rise buildings along a street-and-square configuration. However, the best example of a mall designed with the same architectural coherence as a theme park is Chapman Taylor's Jiangnan Global Harbour (2016; 500,000 m^2 to be expanded to 800,000) in Changzhou. A real city of leisure extended over a large superblock, it features a total pastiche of colonnades, domes, and pyramids, including an observation wheel on the roof of one of the buildings.

Still, most urban malls in China are part of mixed-use developments occupying a large city block, of which they constitute one of the visible anchors. The Hangzhou

Fig. 10.25 The Parc Central by Benoy in Zhujiang New Town (Tianhe CBD), Guangzhou. Photograph by Giaime Botti, distributed under a CC BY 4.0

Joy City (2018, 460,000 m^2) by Benoy includes a multi-storey box partially wrapped by a large LED media wall for the retail and an office tower, while Callison RTKL's Grand Gateway 66 (306,500 m^2) in Shanghai, initially designed in the mid-1990s by Callison and completed only in 2005, presents two glazed towers on a postmodern commercial podium. Other examples by Callison RTKL are The MixC in Shenyang, with a large, boxy mall, two glazed office towers, and several residential high-rises to complete the block, and the Kunming Shuncheng Retail Centre, a pedestrian-friendly block with piazzas and streets in between commercial volumes that constitute the base for residential and office towers. Benoy has also completed several of these mixed-use developments with shopping mall anchors. The LCM (HKLand and CIFI Plaza) in Shanghai (2019, 197,000 m^2) includes a mall and separated office towers; the Lilacs International Commercial Centre (2018, 140,000 m^2) features a four-storey retail podium with two office towers connected. The recent Wenzhou INCITY Mega (250,000 m^2) is definitely dominated by leisure and commercial programmes but also includes elevated blocks for offices. Like the Suzhou Joy Breeze, this commercial complex presents a bold image resulting from the sequence of massive, stacked boxes connected by red-painted galleries, bridges, and escalators along two sides of a residential superblock. Other complexes of this kind are the Shanghai Jiuguang Centre (2014–21, 350,000 m^2) by UN Studio and Nihon Sekkei, consisting of a large multi-storey mall formed by different stacked volumes around a central courtyard, and two office towers completing the scheme, or UN Studio's Raffles City in Hangzhou (Sect. 5.2). Still, the most ambitious project, today in a state of decay

10.5 Spending Time and Money: From the Shopping Mall to the Leisure Centre 491

Fig. 10.26 The Himalayas Centre by Arata Isozaki in Pudong District, Shanghai. Photograph by Giaime Botti, distributed under a CC BY 4.0

and abandonment, was Arata Isozaki's Himalayas Centre (2003–15, 150,000 m^2; Fig. 10.26). Located near Pudong's Century Park, it consists of a rectangular city block composed of a tall podium below a wide tower on the northern tip accommodating two hotels, and smaller volumes for office in the southern. The lower part, which houses the DaGuan Theatre (a project by French firm AS), an Art Museum, and a shopping mall, is partly wrapped by a geometric latticework and partly designed to recall a system of organically shaped caves.

Considering the shopping mall sub-market, we recognise the dominance of some firms. Callison RTKL and Benoy are among them. The US megafirm has completed at least fifteen shopping malls (well over 1.3 million square metres, but available data are partial), some other commercial interiors, and, above all, several mixed-used developments composed of office or residential towers (usually two), and a shopping mall anchor. For Benoy, we mapped at least 1.9 million square metres of purely shopping malls, all but one completed after 2010, plus additional commercial space in the mixed-use developments like the ones we have already mentioned. Other firms which have been active and successful include Chapman Taylor, with five malls (835,000 m^2); B+H Architects, with at least six (over 550,000 m^2); and Broadway Malyan, with four (519,000 m^2). Some Australian firms have become important players in this market, too, starting from Denton Corker Marshall, which completed the Dazhongsi International Plaza (2003–10) and InTime Lotte Shopping Centre (2004–10, 50,000 m^2) in Beijing by 2010. Most of the projects, however, were erected in the second decade of the new century. Buchan Group, an Australian

Fig. 10.27 The Raffles City Changning with the shopping mall by Buchan Group and the office towers by P&T, Shanghai. Photograph by Giaime Botti, distributed under a CC BY 4.0

megafirm specialised in commercial architecture, completed at least eight shopping malls (for a total GFA well above 400,000 m^2, with data available for only half of the projects), including the shopping mall at the base of the iconic Raffles City Chongqing designed by Moshe Safdie (Sect. 5.7), in the Raffles City Chengdu by Steven Holl (Sect. 8.6), and in Raffles City Changning in Shanghai (Fig. 10.27) by P&T. In addition, Woods Bagot successfully delivered three shopping mall projects (446,500 m^2), and Hassel one (88,000 m^2).

If we look at cities like Abu Dhabi and Dubai in the Persian Gulf, we also find several shopping malls and other commercial leisure spaces, clusters of F&B activities usually designed by firms like Benoy (for commercial and leisure projects for about 160,520 m^2 between UAE and Saudi Arabia) and Chapman Taylor (with five cinemas in Dubai). In these cities, generally of difficult walkability due to climate, distances and planning choices, shopping malls are experienced as the most common and more attractive form of (privately owned) and air-conditioned public space. Generally, such malls are large amorphous urban containers, like the most famous and crowded one in Dubai: designed by Singaporean firm DP Architects, Dubai Mall is one of the largest in the world with over 500,000 m^2. It faces the Bazar-style Time Out Market and emerges as the anchor of a cluster of shopping and leisure spaces located along the boardwalk that leads to the Burj Khalifa (Sect. 5.3) and the Dubai Opera (Sect. 6.3) along a light-blue artificial basin that resembles a swimming pool. The fact that the mall also contains an aquarium, cinemas, a VR park, and other attractions explains how the mall's concept has changed from a space primarily

10.5 Spending Time and Money: From the Shopping Mall to the Leisure Centre

oriented towards shopping to one where leisure dominates. The other well-known mall of Dubai is the Mall of the Emirates, designed by F+A Architects (not included in our survey), a US firm with several of these projects in its portfolio. This relatively unremarkable massive container directly connects to two hotels, and, above all, accommodates the largest indoor skiing facility in the world.

Although difficult walkability—of course, coupled with an unfriendly torrid climate—hinders the enjoyment of outdoor life in many of these cities, today we do find projects that try to address the lack of proper outdoor public space, proposing commercial and F&B areas formed by multiple low-rise buildings connected by pedestrian streets and piazzas rather than inside big containers. This is, for example, the case of Callison RTKL's retail, dining, and entertainment area in the artificial Bluewaters Island in Dubai, or of Benoy's The Beach (2010, 31,400 m²) and City Walk (2017, 81,000 m²), both in Dubai, and Aidan Walk (2019, 15,120) and Tahlia Street (11,630 m²) respectively in Al Khobar and Riyadh, Saudi Arabia. Unlike the outlets we have seen before, these projects feature a cleaner, more minimalist design, with attention to shading devices, water features, and vegetation. The more human scale of their outdoor space contrasts with the one dominating most of these cities, making them among the few possibilities to escape the traffic, dust, and heat of standard sidewalks without entering an indoor mall. As sometimes architects explicitly refer to these projects with expressions like "civic heart" (Benoy n.d.), we cannot avoid remarking that Gruen and other CIAM architects in the 1950s championed the idea of the urban mall as a civic centre. The mall was at that time envisioned as one of those "gathering places" able to re-centralise urban life, as wished by Josep Lluís Sert, and satisfy human needs and aspirations as a civic centre should do (Zuccaro Marchi, 2018, 74–78). In this light, we can momentarily get back to China to discuss a noteworthy project: Liu Jiakun's West Village (2015) in Chengdu. This 42,000-square-metre complex extends over a whole urban block with a continuous 5-storey perimetral building interrupted only on one of its four sides by long ramps supported by a forest of *pilotis* leading to the rooftop, where the promenade continues as a loop around the whole block. Commercial space occupies the whole building as well as part of the central void, where we also find some football fields, a playground, and some green space. The result is a "gentle urban megastructure capable of building a socio-spatial community" (Bologna 2019, 69), or, in other words, a real civic centre for the neighbourhood, proving itself a valid alternative to the indoor conditioned space of shopping malls as a public gathering space.

In South-East Asia and India, on the other hand, malls tend to remain enclosed, air-conditioned boxes, perhaps also due to the presence of seasons of abundant rain. And while their role in urban life appears similar to what we see in Chinese cities, overseas design firms' involvement in the most upscale projects characterises these markets, too. Since the end of the 1980s, Denton Corker Marshall has been designing shopping malls in the region, starting with the Atrium Shopping Centre (1989–92) in Jakarta, and the Ampang Point Plaza (1992–93) in Kuala Lumpur, followed by the Entertainment X'nter (2001–04) also in the Indonesian capital, and the Ciwalk (2006–09) in Bandung. However, in the last decade, we find a growing number of malls designed by the same group of firms that we have seen in other areas. Takenaka

Corporation completed the Aeon Mall (2017, 165,000 m^2) in Jakarta, while B+H the Quill City Mall (2015, 92,903 m^2) in Kuala Lumpur, where Buchan Group's Merdeka @118 (145,000 m^2) is currently under construction. In India, we mapped Smallwood, Reynolds, Stewart, Stewart's Inorbit Mall (31,500 m^2) in Bangalore, and Broadway Malyan's Phoenix Market City in Mumbai, although the key market leader as much in India as in South-East Asia has been Benoy. The British firm completed eight malls in India for over 500,000 m^2 of GFA between 2012 and 2016. In Jakarta, it designed the Season City (2013), while across the region, it also completed the retail area of the Jewel Changi Airport (137,000 m^2), Westgate (91,700 m^2), and the ION Orchard (126,000 m^2), one of the fanciest and most iconic malls of Singapore, and the massive ICONSIAM mixed-use development (725,000 m^2) in Bangkok.

Moving to more suburban locations, a specific typology of malls that encounters growing success is the factory outlet, an extended shopping centre where customers find mono-brand stores of apparel, shoes, and some other products. They are usually suburban, organised in a town-like pattern of streets, piazzas, and continuous low-rise buildings (no more than two storeys), sometimes with arcades. Their overall aesthetic often reminds of a small, relaxed, old town. This is particularly true for the many projects successfully designed by Italian firm Hydea, which completed five upscale outlets in China (262,500 m^2) accommodating shops of top luxury brands, and three more in Russia (103,700 m^2), all inaugurated after 2010. Hydea, which had previously completed some outlets in Italy, had then developed expertise in the design of the outdoor space and of historical-looking details to craft that typical atmosphere of Italianate inspiration sought after for these projects, well visible in its first Chinese outlet, the Florentia Village of Tianjin (2009–18, 41,000 m^2), which features sights inspired by Venice, Verona, and Florence. In our mapping, another firm stands out for its multiple outlet projects: California-based Architects Orange delivered four projects in China (316,190 m^2), two in Malaysia (55,600 m^2), and one in Mexico (35,000 m^2), with a less Italian and more generic and postmodern aesthetic.

10.6 The City of Leisure and History: Theme Parks and Disneyfied Heritage

While the typology of the shopping mall has evolved into something with a more programmatic variety than simple shopping, a wide range of destinations for leisure and entertainment have been crafted by architects and planners across our sample of emerging markets. We are talking of different types of theme parks, marinas and regenerated (or brand new) waterfronts, and even heritage sites, often of industrial character. The common feature of all these typologies is their commercial nature and their targeting of both tourists and other city users. Such buildings and larger developments would barely appear in any history of architecture because of their uncertain typology and the difficulty in evaluating them based on current categories.

Can indeed architectural aesthetic canons be applied to judge Cinderella Castle at Disney resorts (and all its hundreds of copies in the world)? Therefore, here our interest lies primarily in investigating how overseas design firms have contributed to the development of tourism and the leisure economy by shaping leisure spaces worldwide.

Theme parks represent one of these touristic destinations that we find scattered all over the world, although with a strong concentration in the USA, China, and Japan, where 14 of the 20 most visited attractions are located. Before COVID-19, parks like Magic Kingdom at Walt Disney Resort in Florida or Disneyland Park in California attracted 20.9 and 18.6 million visitors in a year (TEA and AECOM 2021). The overall market was worth U$47.2 billion in 2018 and was expected to grow at a CAGR of 6% to achieve U$74.7 billion by 2026 (Nitesh et al. 2019). Most of them were conceived and designed by firms with an extreme specialisation in this sector, which, consequently, remained excluded from our survey. It is the case of companies like Walt Disney Imagineering and Universal Creative, which are the development and planning divisions of their respective multi-media conglomerates, or others considered 'experience design companies' like Thinkwell Group, Jack Rouse Associates, and Falcon's Creative Group. In our survey, the only firms we included with solid expertise in the sector are Huitt Zollars and Cuningham Group Architecture. As a result, it is clear that the projects mapped represent just a fraction of the total. Moreover, their architecture does not contribute to the global conversation on the discipline.

In the UAE, Benoy designed one of the most famous iconic new theme parks: the Ferrari World Abu Dhabi (2010, 176,000 m^2). The first and only park for the Italian luxury cars brand, it consists of a large sinuous Y-shaped building with all the attractions located under a big Ferrari-red metal roof. One of the three arms of the building stretches towards one of the curves of the racetrack where the Abu Dhabi Formula One Gran Prix has been held since 2009 (with the Marina and hotel inside designed by Asymptote), while in front of its entrance, we find several malls, the SeaWorld Abu Dhabi on the east, and the Yas Waterworld on its west, a water park designed by Atkins and inaugurated in 2013. In Dubai, instead, we find another car circuit, the Dubai Autodrome and Business Park (2004), designed by Populous, which has planned the Formula Ona circuits of Mumbai, Buenos Aires, and Silverstone, too. However, this less-successful racetrack (it does not host major competition like Formula One or Moto GP) lies isolated in an area of residential development rather than within a leisure-oriented district like Yas Island in Abu Dhabi.

While the concentration of upscale entertainment attractions in Abu Dhabi is remarkable, and we have only focused on the most important ones and those designed by the firms we surveyed, the number of such venues is undoubtfully higher in China. And it is growing and expected to grow more, as in the country, the number of world-class theme parks per 100 million inhabitants is still 0.2, compared to 2.5 and 3.1 in the US and Japan, respectively (Daxue Consulting 2020). The world's most famous franchise of theme parks, Disneyland, opened in China in 2016. The Disney Resort in Shanghai Pudong includes an entertainment district, hotels, and the very Disneyland Park, which contains seven themed parks. One of them, Tomorrowland (2016,

645,840 m^2), was designed by Grimshaw, with particular care for the landscape, the use of sustainable climate-control strategies, including the iconic sinuous steel canopy filled with ETFE pillows that protect paths and attractions like the roller-coaster. In Shenzhen, one of the major entertainment districts, ranked in TripAdvisor's top-ten in the city, is the Shekou Sea World Plaza, an area master-planned by Callison RTKL that includes restaurants, retail shops, and several leisure activities around a water basin where an old ocean liner has been converted into a hotel. In the south of the district is also located the new Shenzhen Sea World Culture and Arts Centre (2017, 73,918 m^2), a museum and theatre complex designed by Fumiko Maki. In another area of the megacity, in addition, the Shenzhen Xiaomeisha Area New Ocean World (131,400 m^2), a tourist complex composed of an aquarium and a hotel, is currently under construction, according to a project of the Japanese firm AXS Satow. All over China, more theme parks can be found. Arquitectonica completed a large indoor water park, the Sea World Tianjin Aquatic Park and Community (155,400 m^2), within an oval dome container reminding of Paul Andreu's National Grand Theatre of Beijing. In Hainan, the Global 100 by Chapman Taylor recently opened; it consists of a 400-hectare theme park with districts inspired by six countries and their famous movies. On the other hand, the Japanese firm Urban Design System has completed a small, fully indoor educational theme park for children in Beijing, the Blue Sky City EE City (2010, 18,600 m^2). Other surveyed firms that have elaborated unsuccessful proposals (as far as we know) for theme parks in China are Carrier Johnson + Culture and Cuningham Group Architecture. Among our surveyed firms, on the other hand, we also find the small Garuda Wisnu Kencana Cultural Park in Bali, for which AECOM provided landscape and design services, and Dream Island (2020) in Moscow, a fully indoor theme park whose design involved Chapman Taylor.

As shopping, entertainment, and cultural programmes mix more and more within specialised districts, we could provocatively add the theme of heritage preservation to the present discussion. In China, such a mix becomes particularly common when it touches industrial heritage. The most well-known and the most emblematic case in displaying the logic entangling globalisation, tourism, cultural and leisure economy, heritage preservation, and gentrification phenomena is the 798 Art Zone in Beijing. During the late 1990s, several artists started renting abandoned factories in the northeast of the Chaoyang district at low cost, transforming them into work-shops and galleries. Quickly, these old factories became the epicentre of the Chinese contemporary art scene. With rising land values, however, the area was meant to be demolished, and only a mix of factors—including the international reputation of the artists, the campaign launched to preserve the old buildings and save the galleries, the upcoming Olympic Games, and the growing importance given to the cultural and creative industries by the Chinese government—saved the 798, which was trans-formed into an official art district (Currier 2008; Ren and Sun 2012). In 2004, Bernard Tschumi proposed a grid of horizontal buildings hovering above the old factories to both fulfil mass housing needs and preserve the industrial fabric and its art galleries. More realistically, in 2006, the vision plan for the area was assigned to Sasaki, whose master plan contributed to making 798 Art Zone into one of the most visited attrac-tions of the city, although, as Xuefei Ren reminds, its success also meant the loss

of the original artist colony and its replacement by tourist-oriented activities and more international galleries and shops (Ren and Sun 2012). In the following years, the 798 Art Zone became a flagship of the link between cultural/creative industries and industrial heritage in China. What was initially a spontaneous, bottom-up phenomenon was soon institutionalised in top-down policies that promoted the regeneration of former industrial sites into art districts and places of production for cultural and creative industries, sometimes successful, sometimes not, very often extremely commercialised and anonymous. In Beijing (Bonino and de Pieri 2015), notable cases included the N. 2 Textile Factory, which was transformed by Kengo Kuma (but then disowned by the Japanese architect) into the Legend Town cultural and creative cluster, and Xinhua 1949 by Ideal Design and Construction. In Shanghai, one of the first cases was the M50 or 50 Moganshan Road, a former textile mill converted into a space with artist studios and galleries in the early 2000s. A more recent work by a firm we surveyed, Playze, is Xingfuli (2018, 14,000 m^2), a former industrial site transformed into a creative park with retail and F&B on the ground floor and small office spaces on the upper floors within low and mid-rise renovated buildings displaying a strikingly contemporary image and defining a pleasant urban space at human scale. On the other hand, many more industrial areas along the Huangpu River and the Suzhou Creek have been cleared and redeveloped with residential and mixed-used neighbourhoods or partly preserved and transformed into cultural areas like, for example, along Xuhui Waterfront (Sect. 6.1). Cases across China would be too many to map, and the transformation of these areas usually involves local rather than foreign architects, unless the site requires a high-profile intervention. In this regard, one unsuccessful project was entrusted to OMA in Taiyuan, where the Dutch firm elaborated a study in 2014 for the regeneration (revitalisation and transformation) of a 200-hectare abandoned industrial site.

Different foreign firms have been involved in heritage projects in China and in other emerging markets, at scales spanning from the intervention on a single building to territorial master-planning. Cases are many more than those mapped in this book, not least because there are highly specialised architectural and planning consultancies and, therefore, not included in our survey. Still, some cases can be highlighted and trends discussed, starting once again from China. In Beijing, we can mention the restoration of ancient buildings like the Jianfu Palace (2005) in the Forbidden City by Pei Architect and the Republican-era Quanyechang (2012–14, 7,400 m^2) by AREP, which was involved in the renovation of the whole Dashilan area (2012, 138,000 m^2). In Shanghai, along the Bund, several majestic historical buildings of the colonial time were renovated in the last two decades, many being transformed into upscale hotels, like the former Shanghai Club converted into the Waldorf Astoria (2011, 60,600 m^2) by John Portman, or the Bund 27, now an upscale F&B venue after the renovation led by Callison RTKL. And just north of the Bund, along Yuanmingyuan Road, David Chipperfield has recently completed a long intervention that included the restoration of eleven historical buildings (2006–21, 35,000 m^2) and the design of the new Rockbund Art Museum (Sect. 6.1). Industrial plants were also transformed into fancy work and leisure spaces, like the Shanghai Fashion Centre (2009–12, 150,000 m^2), a 1920s textile factory renovated by Arte Charpentier, or the Bailian

Fashion Centre Yanqingli (2018, 6,200 m^2) and 501 Jiujiang Road (2015, 2,600 m^2) by Stefano Boeri Architects. Along the Huangpu River, Kengo Kuma transformed a 1970s shipyard warehouse (Shipyard 1862, 2017, 31,600 m^2; Fig. 10.28) into a fancy complex with restaurants, bars, shops, an exhibition space, and a theatre. Still, we cannot neglect projects by Chinese architects like the 1933 Old Millfun, an exposed-concreted Piranesian Art Deco structure built as a slaughterhouse and now accommodating mostly shops and studios after Chongxin Zhao renovated it. Another Chinese firm with a very interesting portfolio of cultural projects on former industrial sites in Atelier Deshaus, which, for example, transformed the Wharf Silos in Shanghai into a museum space. Other silos, this time in Ningbo, were converted by German firm Winking Froh Architekten into a new office complex with cultural facilities and a large bookstore, Ningbo Book City (2010, 65,000 m^2).

Looking at the larger scale, the history of one of the most successful and popular entertainment areas of central Shanghai, Xintiandi, is a perfect example of how the built heritage, restored and reconstructed, has become one of the favourite entertainment and consumption spots for tourists and locals. As He and Wu (2005, 10–11) explained, it represented a successful attempt "to grasp the opportunities for rediscovering historical and cultural values and turning them into economic outcomes through the strategies of image changing and property development." As a matter of fact, property-led redevelopments like Xintiandi materialised the desire of local government and real estate developers to "rebuild Shanghai as an international metropolis," and, above all, were effective in "raising the area's reputation [and surrounding

Fig. 10.28 The Shipyard 1862 by Kengo Kuma, Shanghai. Photograph by Giaime Botti, distributed under a CC BY 4.0

10.6 The City of Leisure and History: Theme Parks and Disneyfied Heritage

land's values] and changing its image through physical and functional transformation of the area" (He and Wu 2005). Located at the heart of the French Concession, Xintiandi featured the typical Shanghainese *shikumen* ("stone gate") houses organised in a dense *lilong* pattern (low-rise houses, attached side-by-side and provided with narrow lanes on the front and the back). The first master plan by SOM recognised the importance of the site, where, among other things, the First National Congress of the Communist Party of China was held in 1921. Still, its survival was not assured until the developer, Shui On Group, hired US architect Ben Wood (not included in our survey), who transformed the area into a car-free commercial district full of shops, restaurants, and bars; a pleasant, although crowded oasis of low-rise buildings, narrow streets and small squares filled with tables, with a historical image. The project, indeed, promoted a touristic rather than heritage-based "notion of authenticity," with an "uneven" degree of conservation in the area with "visual criteria" in terms of "verisimilitude" privileged over authenticity (González Martínez 2021). A similar commercial approach, but even more extreme in terms of disregard for the material authenticity of the fabric, characterises several leisure districts scattered across many Chinese cities, where pedestrian areas full of shops and restaurants are accommodated within low-rise historical-looking buildings, more often than not built anew. That is the case of the popular Sino-Ocean Taikoo Li (2015) in Chengdu, master-planned by the multinational firm The Oval Partnership (not included in our survey), where we also find an elegant multi-storey hotel designed by Make Architects composed of two L-shaped blocks enclosing a Qing Dynasty building (35,000 m^2) used as hotel entrance. Cases of such kind are countless, from Nanluoguxiang in Beijing to Nantong Road in Ningbo, with a different degree of authenticity (or, shifting perspective, of 'fakeness') and changing architectural quality.

While these projects usually extend over one or more large city blocks or, in some cases, involve the linear space of the so-called "old streets," we also find plans for heritage conservation and touristic development of larger territories. Italian firm Hydea, for example, had developed a few in China during the 2010s—Confucius and Mencius Cultural Heritage Conservation & Development Project for Qufu and the Gansu Cultural and Natural Heritage Protection and Development Project—as well as India, Saudi Arabia, UAE, and other countries not included in this survey. Indeed, already in the 1980s, Arte Charpentier had assisted the Cambodian Government with the listing of Angkor Wat as a UNESCO World Heritage site, while in these same decades, we have already seen how foreign expertise was sought after in Saudi Arabia and Kuwait (Sect. 3.4). In the early 2000s, although in a rather theoretical fashion, OMA/AMO investigated possible preservation strategies for Beijing urban fabric based on different forms of sampling the city with expiration dates. While such a study did not lead to any concrete outcome in terms of preservation plans in China, it was instrumental to further reflections on heritage and preservation carried on by OMA/AMO and presented in the *Cronocaos* exhibition at the Venice Biennale of 2010 (Koolhaas 2011). In the exhibition, some provocative statements about demolition were made through a 'revision' of the *UNESCO Convention Concerning the Protection of the World Cultural and Natural Heritage* modified to become the *Convention Concerning the Demolition of World Cultural Junk*. Beyond

the evident provocation, Rem Koolhaas and his firm were questioning several relevant themes, starting from questioning a reality in which an overall fast-developing world constantly clashes with growing portions of territory (and sea) subject to a regime of immutability due to different forms of conservation policies.

Such themes, in many ways, go beyond the scope of this book. At the same time, we certainly need to emphasise how the worldwide extension of the Western concept of heritage and the outreach of supernational regulatory frameworks to preserve it through institutions like UNESCO are one of the most powerful examples of what globalisation is. A World Heritage site "is premised on locality," but at the same time, its title "subjects these localities to a global regime. Humanity in its entirety is assumed to acquire rights as well as duties over these sites" (Brumann and Berliner 2018, 2). Tourists, along with scholars, journalists, and politicians, visit these sites and "can also have an influence from a distance" on them (Brumann and Berliner 2018, 2). The cross-border work of design firms also touches on broader themes of architectural and urban heritage. That said, our mapping has been limited in this regard, as a more targeted choice of firms to survey would be needed to better grasp the involvement of foreign expertise in this field. More important for the scope of this book, however, is highlighting the involvement of some of them in projects, which, by restoring, renovating, or reusing buildings and urban areas of historical value, have contributed to fostering tourism and consumption in several cities across the emerging markets. And this, again, has been both an indicator of the global scope of the architects' profession and the global ambitions of governments and developers relying on these firms.

10.7 Megaboxes Since 1851: Conference and Fair Centres

While cities compete to attract leisure tourism, they also do so to invite a more business-oriented type of travellers who rest in high-end hotels and enjoy the local cultural, commercial, and dining scene. Such tourists are often drawn by international fairs, exhibitions, and congresses mostly organised within two main typologies of buildings: conference centres and exhibition centres. The formers are generally large, isolated auditoriums, or in many cases, small-to-medium size ones integrated into a hotel complex and located on the podium, in the underground, or in separate volumes. Fair and exhibition centres tend to be large single or multiple buildings, usually in peripheral but well-connected urban locations. They are mainly flexible halls spanning dozens of thousands of square metres complemented with ancillary spaces, from meeting rooms and auditoriums to restaurant facilities. They are flexible containers conceived to accommodate hundreds of thousands of visitors and contain goods and boots assembled and disassembled several times per year. The history of such megaboxes or megacontainers is connected to the first world's fairs.

In terms of architectural archetypes, indeed, two projects can be taken as a reference for these two typologies. Conference centres evolved from the typology of

the theatre/auditorium, an indoor hall with stalls and tribunes. However, more flexible containers have been envisioned in modern times, with Mies van der Rohe's unbuilt proposal for a convention hall (1954) in Chicago as the archetype of this big, column-free, open interior space for events where thousands of people can gather. In Mies' mind, such typology should allow the maximum flexibility of use thanks to a large span roof supported by trusses resting on a perimetral structure; something then worked out at a smaller scale with the S. R. Crown Hall (1956) at the Illinois Institute of Technology. This flexible container can also be understood as an archetype for a generic large-scale exhibition space (like Mies' Neue Nationalgalerie) as requested for commercial exhibition venues. In this case, however, we can move further backwards in history to the architecture of the nineteenth-century world's fairs, especially the first ones. The Great Exhibition of the Works of Industry of All Nations of 1851 was housed in a single, history-making building: the Crystal Palace, conceived by Joseph Paxton. Two decades later, the 1873 Vienna World's Fair was mainly centralised in a single building, the *Rotunde*. Then, by the end of the century, the pavilion configuration was gaining ground, not hindering, however, the development of large exhibition halls like Ferdinand Dutert and Victor Contamin's Palais des machines at the Exposition Universelle of 1889 in Paris.

While these buildings have gained a place in every history of modern architecture, more recent conference and exhibition centres have generally been neglected, although there are some notable works of the 1990s. OMA's Congrexpo (1990–94) in Lille, combining a 5,000 seats concert hall, three auditoriums, and 20,000 m² of exhibition space, is a megabox that Rem Koolhaas viewed as the only possible element to deal with the "Extra Large" dimension entailed by the programme and its link with the Euralille master-plan, also elaborated by OMA, which aimed at transforming the area of Lille's high-speed railway station into one of the new European transportation hubs. While Koolhaas understood the problem at the territorial scale and proposed an architectural piece "scandalously simple" (OMA n.d.) exactly because, as the whole *S, M, L, XL* declared, at that scale, traditional architectural tools and strategies become obsolete, Peter Eisenman proceeded in the opposite direction with the Greater Columbus Convention Centre (1990–93). The conventional homogenous box was deconstructed by Eisenman into a sequence of parallel strips creating an identifiable, postmodern, fragmented urban front. In the same years in Germany, GPM completed some exhibition halls notable for their size and long-span roofs, like the Hannover Hall 5 (1994–96, 35,650 m²), covered by a light roof spanning 122 m, and the New Trade Fair of Leipzig (1992–95, 273,000 m²), featuring a column-free central hall 80-m-wide and 240-m-long. A few years later, in Italy was also completed the New Milan Trade Fair (2002–05, 1,000,000 m²) designed by Fuksas & Associati. The fair was organised in a set of standardised types of exhibition pavilions, auditoriums, and other programmes repeated along a central two-level circulation spine covered with a glazed canopy with a changing three-dimensional geometry.

Since the early 2000s, several new conference and exhibition centres have been popping up across China, while, more recently, a second wave of construction has come to completion. In the first wave, we find the anonymous Shanghai International Exhibition Centre (2001, 50,000 m²) by Murphy/Jahn and the Guangzhou

International Convention and Exhibition Centre (2002, 367,700 m^2) by AXS Satow, a mega-container protected by a large waving roof sustained by an undulated arched-like structure. By 2005, the Nanning International Convention and Exhibition Centre (1999–2005, 130,000 m^2) and the Shenzhen Convention & Exhibition Centre (2001–05, 256,000 m^2) were inaugurated, both designed by GMP. The former is organised with a circular multi-purpose hall, covered with a blossoming flower-shaped membrane dome, and a more standard rectangular exhibition hall covered with metal vaults. The latter one, located in a prominent urban position of Shenzhen at the southern end of Futian CBD (Sect. 5.2), stands out more for its impressive dimensions than for its inner architectural qualities, being a relatively anonymous box of 280 by 540 m (Fig. 10.29). Yet, despite its size, this building has been recently replaced in the hierarchy by the new Shenzhen Exhibition Park (2019, 70,000 m^2) designed by French firm Valode & Pistre. Not of any special interest for its design, the venue nonetheless will cover over 850,000 m^2 at its completion, making it larger than Hannover Exhibition Centre. In 2005, Kisho Kurokawa's Zhengzhou International Conference and Exhibition Centre (2003–05, 226,800 m^2) was built, a non-impressive complex located at the core of Zhengdong New Town, a new settlement entirely planned by the Japanese architect. Just a few years later, in the north of Guangzhou, close to Baiyun Airport, Belgian firm B2A1 completed in a very short time the 272,000-square-metre Baiyun International Convention Centre (2005–07), a conference venue conceived as a system of sculptural volumes anchored to the landscape rather than as single anonymous boxes.

Fig. 10.29 The Shenzhen Convention & Exhibition Centre by GMP in Futian CBD, Shenzhen. On the right is visible the Shenzhen Energy HQ by BIG. Photograph by bingfengwu

Such a concentration of projects can be easily understood in the historical moment of the early-2000s, with China becoming a WTO member and a new economic superpower with a global projection. The Bo'ao Forum for Asia, a high-level international meeting following the model of the World Economic Forum (WFE) of Davos, was launched in 2001 by China with twenty-four other Asian countries plus Australia. Its permanent meeting venue, Bo'ao in Hainan, was then equipped with a 100,000-square-metre conference centre and a hotel commissioned in 2003 to Australian firm DBI, with the Beijing Institute of Architectural Design taking over after the conceptual design phase. Architecturally speaking, the result is not of any interest, unfortunately. By 2003 it was also ready the Bo'ao Canal Village (200,203, 66,000 m^2), a 100-villa complex to host the forum guests designed by Iroje Architects & Planners for SOHO China. Another major international event marking the new global position of China and requiring a new and iconic facility was the summer meeting of the WEF. For this event, Coop Himmelb(l)au designed the Dalian Conference Centre (2008–12, 117,650 m^2; Fig. 10.30), a 1,600 plus 2,500-seat venue shaped in the typical streamlined and futuristic aesthetic of the Austrian firm.

In the decade, other projects were concluded, including SOM's Zhongshan Expo Centre (2008, 123,000 m^2) in Zhongshan, characterised by a continuous roof that extends over the frontal plaza as a canopy, Nihon Sekkei's Xiamen Straits Exchange Centre and International Conference Centre (2010), and NBBJ's Qingdao Aoshan Bay International Exhibition Centre (260,000 m^2). Completed around 2011, it

Fig. 10.30 The Dalian Conference Centre by Coop Himmelb(l)au, Dalian. Photograph by 準建築人手札網站 Forgemind ArchiMedia, distributed under a CC BY 2.0, available at https://commons.wikimedia.org/wiki/File:Dalian_International_Conference_Center.jpg

featured a continuous red canopy protecting the entrance to the exhibition halls and visually connecting them. NBBJ has also finalised a smaller Expo Centre in Karamay (79,000 m^2) and, more recently, an elegant conference centre within the Nanjing Eco Hi-Tech Island, Xin Wei Yi Technology Park (Sect. 9.3). In the meantime, a second wave of buildings, usually launched in the early 2010s, is now getting to completion, showing in certain cases a higher design quality. Once again, GMP stood out for its work, both quantitatively and qualitatively. Compared to the projects of the previous decade, those developed during the 2010s boasted a more sophisticated aesthetic proposal. The Qujiang International Conference Centre/Xi'an Exhibition Centre (2008–12, 76,153 m^2) and the more recent Silk Road International Conference Centre (2017–20, 128,000 m^2) in Xi'an feature a refined formal approach, well visible in the latter building, a square-plan glazed box elevated on and slightly detached from the podium, with a projecting convex floor and a concave roof connected by thin columns. A rather classical building, Western and Chinese at the same time, and entirely contemporary. Recent completions by GMP also include the Hongdao International Conference & Exhibition Centre (2015–20,488,000m^2) in Qingdao— an H-shaped complex composed of a central glazed hall roofed by curved membrane roof and fourteen halls of exhibition space on two sides—, and the National Convention and Exhibition Centre (2012–21, 550,000 m^2) in Tianjin, an enormous complex composed of two identical elements formed by a central entrance hall and two lateral exhibitions halls, which in turn consist of four volumes each. The main formal characteristic of the central hall is the support system, shaped with columns expanding into an inverted pyramid reminding of an abstract version of traditional *dougong* elements (the interlocking wooden brackets comparable to capitals in Western classical architecture). Other recent deliveries include SOM's crescent-shaped Greenland Exhibition Centre (2016 252,000 m^2) in Nanchang, and Christian de Portzamparc's new China National Convention Centre (2017–21, 750,000 m^2) in Beijing, a building formally in continuity with the adjacent project with the same name designed by RMJM for the 2008 Summer Olympic Games (Sect. 7.1). To this long list, we can finally add a few hotels with annexed conference spaces as well as smaller auditoriums. They include appealing designs like the previously mentioned Rosewood Sanya and Sanya Forum by Goettsch Partners, Zaha Hadid Architects' Nanjing International Youth Centre, and Morphosis' Nanjing Conference Centre (2019–21, 180,000 m^2), a well-balanced composition of a slightly undulated thin tower facing the river and a deconstructivist podium for the conference venue.

To a lesser extent, in other emerging markets, too, we find a growing number of such building complexes. In Vietnam, it was first completed the National Conference Centre (2004–06, 65,000 m^2) of Hanoi designed by GMP with a 'weaving' roof, and then the Saigon Exhibition and Convention Centre Hall A (2008, 31,239 m^2) in Ho Chi Minh City by Nikken Sekkei. In India, on the other hand, different projects by Populous and one from IDOM have not been built, while in Kazakhstan, we mapped the Palace of Peace and Reconciliation, which is, in fact, a conference centre by Foster + Partners, and the Astana Congress Centre by Adrian Smith + Gordon Gill, completed in time for the 2017 Expo (Sect. 7.3), and in Russia, Tchoban Voss Architekten's Expoforum (2008–16, 100,000 m^2) in Saint Petersburg. In Brazil,

Wilmotte & Associés completed the Imigrantes Exhibition and Congress Centre (2013–16, 99,000 m²) in São Paulo, a large venue with a long façade articulated by thin columns supporting a projecting white roof. Regretfully, its elevated position from the street level hinders spatial and visual continuity. In addition, such a project would carry the burden of a comparison with another exhibition centre, the Parque Ibirapuera (1951–54), designed by Oscar Niemeyer. Built for the celebration of the four hundred years of the city, the park accommodated several sculptural buildings used for temporary exhibitions and the auditorium, all connected by a sinuous canopy.

With economic growth and touristic development, several business-oriented conference facilities paired with exhibition halls were also built in the Middle East during the last two decades. In Qatar, Arata Isozaki's Qatar National Convention Centre (2004–11), located in the Education City (Sect. 9.4), was expanded by Populous with 89,650 additional square metres in 2011 (LEED Gold), while Murphy/Jahn designed, in Doha West Bay, the Doha Exhibition and Convention Centre (2005–15, 219,361 m²; Fig. 10.31), a quite standard big box featuring wide overhangs for shading the glazed walls and circular skylights along the whole roof for natural lighting. Unimpressive are also RMJM-designed Dubai International Convention and Exhibition Centre (2004, 92,700 m²) as well as the Sharjah Exhibition (2013, 20,000 m²) by Hopkins Architects, while the Oman Convention & Exhibition Centre and JW Marriott (2007–15) by WATG stands out for its more luxurious and refined interiors. On the contrary, SOM's KAFD Conference Centre in Riyadh (2017; 13,000

Fig. 10.31 The Doha Exhibition and Convention Centre by Murphy/Jahn in West Bay, Doha. Photograph by Giaime Botti, distributed under a CC BY 4.0

m^2; also Sect. 5.2) emerges for its complex faceted steel megaroof, reminding of a large tent wrapping and protecting everything beneath it.

10.8 Conclusions

The economy of leisure in less than a century transformed from the one aimed at satisfying the desires of a small elite, as analysed by Thorstein Veblen (1899), to the one involving the Western middle-class, first, and a growing global middle-class, later, with the attribute "mass" becoming the prefix of any of these activities, from mass-tourism to mass-entertainment. With more and more people travelling for leisure or business, transportation infrastructure was developed in the Global South with the involvement of overseas design firms with a solid experience in the sector. Hospitality architecture boomed across different regions, with architects working on tourist developments, resorts, and hotel blocks and towers. If hotels became "the generic accommodation of the Generic City, its most common building block…" (Koolhaas, 1995, 1260), they also strived to define some kind of generic local identity through a regionalised (often tropicalised) modernism inside cities and vernacular modernism outside of them, while hotel architecture has also swung from the triviality of the "fairy tale" Disneyfied design to the hypermodern. In all this, architects have to hang the balance between (hotel) brand identity and place identity. On a different scale, airport design already challenged architects to transform an efficient machine (with the need to make it less and less energy-intensive) into a 'situated' one, in which architecture is able to recall elements of the local identity within a hypermodern structure. A structure that "has become ornamental," where "small, shiny, space frames support nominal loads, or huge beams deliver cyclopic burdens to unsuspecting destinations…" (Koolhaas 2004, 163).

Thus, with the new century, it seems that "Bigness" has been replaced by "Junkspace." Like most of the architecture seen in this chapter, for Koolhaas (2004), "Junkspace is sealed, held together not by structure, but by skin, like a bubble." It is an "endless building" made possible by air conditioning (162). It is, therefore, the airport (which has become a shopping mall), the shopping mall, the conference and exhibition centre. For the design of all these typologies in emerging markets, the work of overseas firms has been fundamental. They have shaped the city gates to the world and the shopping hubs, often directly connected to these gates. "Public life" is replaced by "Public Space™" (168), which, as we have seen, is an increasingly privatised space contained within shopping malls, or multi-level shopping and F&B village-like urban configurations that emerge as the only walkable spaces in many cities. Not even part of the built heritage escaped this logic of commercialisation and Disneyfication. That said, it would be a mistake to consider these problems as limited to emerging markets.

Indeed, all this created a relevant market for the global architecture profession. As seen, for each of these typologies, there were some firms able to work across continents, transferring and deploying their know-how from one place to the other,

using the weight of their experience and previous success—their brand, indeed—to secure further work. Projects of airports, railway stations, shopping malls, and conference and exhibition centres show the leadership of some megafirms, while boutique architects and the upper tier of the star system receive a call only for special occasions. For hotel design, on the other hand, there are some differences. The separation between the envelope/structure and interiors is stronger. There are both large and medium-sized firms that carved their niche for the interior design of fancy hotels contained within large mixed-use projects designed by megafirms, while smaller-scale hospitality projects are still designed by boutique architects. Ultimately, a large swath of the architecture seen in this chapter does not enter any history of architecture but still represents a growing component of our built environment, whether we see it as "Junkspace," or, to say it with French sociologist Marc Augé (1995), the "non-places of supermodernity" that are codified by "instructions for use" (96) where people lose their identity and assume "the role of passenger, customer or driver" (103).

References

Adam, Robert. 2013. Doha, Qatar. In *Architecture and Globalisation in the Persian Gulf Region*, ed. Murray Fraser and Nasser Golzari, 105–127. Farnham: Ashgate.

Augé, Marc. 1995. *Non-places: Introduction to an Anthropology of Supermodernity*. London: Verso.

Benoy. n.d. *City walk Dubai, UAE*. Benoy. https://www.benoy.com/projects/city-walk/. Accessed 13 Aug 2022.

Bhatnagar, Parija. 2005. *Not a mall, it's a lifestyle center. Developers are embracing these cozy, high-end urban centers in lieu of traditional big box formats*. CNN, Jan 12. https://money.cnn.com/2005/01/11/news/fortune500/retail_lifestylecenter/. Accessed 18 Sept 2022.

Bologna, Alberto. 2019. *Chinese Brutalism Today: Concrete and Avant-Garde Architecture*. San Francisco, CA: ORO Editions.

Bonino, Michele, and Filippo de Pieri. 2015. *Beijing Danwei: Industrial Heritage in the Contemporary City*. Berlin: Jovis.

Brumann, Christoph, and David Berliner. 2018. Introduction. UNESCO world heritage—Grounded? In *World Heritage on the Ground. Ethnographic Perspectives*, ed. Christoph Brumann and David Berliner, 1–34. New York, NY; Oxford: Berghahn Books.

Buckley, Julia. 2019. *The future of sustainable tourism may lie with all-inclusive resorts*. CNN, Nov 9. https://edition.cnn.com/travel/article/all-inclusive-resorts-sustainable-travel/index.html. Accessed 10 July 2022.

Callison RTKL. n.d. Retail of the Future. Callison RTKL. https://www.callisonrtkl.com/mall-of-the-future/. Accessed 18 Sept 2022.

Dubai Statistics Center. 2021. *Hotels & hotel apartments 2021*. Dubai Statistics Center.

Chan, David, Tian Ye, and Honggang Xu. 2016. Localization of senior managers of international luxury hotels in China: The current situation and influencing factors. *Journal of China Tourism Research* 12 (1): 126–143.

Chung, Chuihua Judy, Jeffrey Inaba, Rem Koolhaas, and Sze Tsung Leong. 2001. *Project on the City II: The Harvard Guide to Shopping*. Berlin: Taschen.

Currier, Jennifer. 2008. Art and power in the New China: An exploration of Beijing's 798 art district and its implications for contemporary urbanism. *Town Planning Review* 79 (2–3): 87–114.

Daxue Consulting. 2020. *New amusement parks in China open as tourism turns to domestic destinations.* Daxue Consulting, Dec 29. https://daxueconsulting.com/china-worlds-largest-amusement-park-industry/. Accessed 12 Sept 2022.

Dev, Chekitan Singh. 2012. *Hospitality Branding.* Ithaca, NY: Cornell University Press.

Duncan, Olivia, and Sonny Tomic. 2013. Abu Dhabi, UAE. In *Architecture and Globalisation in the Persian Gulf Region*, ed. Murray Fraser and Nasser Golzari, 129–153. Farnham: Ashgate.

Edgington, Tom. 2020. *Heathrow expansion: What is the third runway plan?* BBC, Dec 16. https://www.bbc.com/news/explainers-51646562. Accessed 20 May 2022.

Frampton, Adam, Clara Wong, and Jonathan D. Solomon. 2012. *Cities Without Ground: A Hong Kong Guidebook.* Berkely, CA: ORO editions.

Frampton, Kenneth. 2020. *Modern Architecture: A Critical History*, 5th ed. London: Thames & Hudson.

García Rubio, Rubén. 2019. "Building Dubai. The Legacy of John Harris". *Ananke. Quadrimestrale Di Cultura, Storia e Tecniche Della Conservazione per Il Progetto* 86: 109–112.

Gibson, Eleanor. 2018. *Foster's $13 Billion mexico city airport scrapped after public vote.* Dezeen, Oct 30. https://www.dezeen.com/2018/10/30/foster-partners-fernando-romero-mexico-city-airport-nixed-public-vote/. Accessed 10 May 2022.

Giedion, Sigfried. 1949. *Space, Time and Architecture: The Growth of a New Tradition.* Cambridge, MA: Harvard University Press.

González Martínez, Plácido. 2021. Curating the selective memory of gentrification: The Wulixiang Shikumen Museum in Xintiandi, Shanghai. *International Journal of Heritage Studies* 27 (6): 537–553.

He, Shenjing, and Fulong Wu. 2005. Property-led redevelopment in post-reform China: A case study of Xintiandi redevelopment project in Shanghai. *Journal of Urban Affairs* 27 (1): 1–23.

Kohn, Margaret. 2004. *Brave New Neighbourhoods: The Privatization of Public Space.* London; New York, NY: Routledge.

Koolhaas, Rem. 1995. The generic city. In *S, M, L, XL*, ed. Office for Metropolitan Architecture, Rem Koolhaas and Bruce Mau, 1238–1267. New York, NY: The Monacelli Press.

Koolhaas, Rem. 2004. Junkspace. In *Content*, ed. Rem Koolhaas, Brendan McGetrick and Simon Brown, 162–171. Cologne: Taschen.

Koolhaas, Rem. 2011. Cronocaos. *The Log* 21: 119–123.

Lepik, Andres, and Vera Simone Bader. 2016. *World of Malls: Architectures of Consumption.* Berlin: Hatje Cantz.

Lin, Nancy P. 2011. Imagining "Shanghai" Xintiandi and the Construction of Shanghai Identity. BSc diss., Harvard University.

MacCannell, Dean. 1976. *The Tourist: A New Theory of the Leisure Class.* New York, NY: Schocken Books.

Marcial Pérez, David. 2022. López Obrador y el aeropuerto de la austeridad. *El País*, Mar 21. https://elpais.com/mexico/2022-03-20/lopez-obrador-y-el-aeropuerto-de-la-austeridad.html. Accessed 26 Aug 2022.

Nitesh, C., V. Himanshu, and D. Roshan. 2019. *Theme Park Vacation Market by Type.* Allied Market Research.

Norsa, Aldo. 2020. *Report 2020 on the Italian Construction, Architecture and Engineering Industry.* Guamari.

OMA. n.d. *Congrexpo.* OMA. https://www.oma.com/projects/congrexpo. Accessed 10 May 2022.

Ren, Xuefei. 2011. *Building Globalization: Transnational Architecture Production in Urban China.* Chicago, IL: The University of Chicago Press.

Ren, Xuefei, and Meng Sun. 2012. Artistic urbanization: Creative industries and creative control in Beijing. *International Journal of Urban and Regional Research* 36 (3): 504–521.

Roskam, Cole. 2015. The international hotel in postrevolutionary China, 1974–1990. *Grey Room* 58: 84–111.

Roskam, Cole. 2021. *Designing Reform: Architecture in the People's Republic of China, 1970–1992.* New Haven, CT: Yale University Press.

References

Scriver, Peter, and Amit Srivastava. 2019. Cultivating Bali style: A story of Asian becoming in the late twentieth century. In *Southeast Asia's Modern Architecture: Questions of Translation, Epistemology, and Power*, ed. Jiat Hwee Chang and Imran bin Tajudeen, 85–111. Singapore: NUS Press.

Shannon, Kelly. 2014. Beyond tropical regionalism: The architecture of Southeast Asia. In *A Critical History of Contemporary Architecture: 1960–2010*, ed. Elie G. Haddad and David Rifkind, 359–377. Surrey: Ashgate.

Sorkin, Michael, ed. 1992. *Variations on a Theme Park: The New American Cities and the End of Public Space*. New York, NY: Hill and Wang.

Stephens, Suzanne. 2010. Armani hotel Dubai. A world within a world. *Architectural Record* 198 (8): 86–87.

Supersudaca. 2009. Turismos Caribe. Supersudaca.

TEA, and AECOM. 2021. *Theme index and museum index: The global attractions attendance report.* Themed Entertainment Association.

Tether, Bruce. 2020. AJ100 2020: Can architects recover the optimism they had in our pre-coronavirus survey? *Architect's Journal*, June 1. https://www.architectsjournal.co.uk/news/aj100-2020-can-architects-recover-the-optimism-they-had-in-our-pre-coronavirus-survey. Accessed 28 Apr 2022.

Thompson, Benjamin. 1987. Abu Dhabi inter-continental hotel. *Mimar* 25: 40–45.

Tong, Gregory M.B.. 1979. Designing hotels for the People's Republic of China. *Cornell Hotel and Restaurant Administration Quarterly* 20 (1): 33–40.

Tourism Concern. 2014. *The Impacts of All-Inclusive Hotels on Working Conditions and Labour Rights in Barbados, Kenya & Tenerife.* Tourism Concern.

UN Studio. 2021. Shanghai Jiuguang Center. UN Studio. https://www.unstudio.com/en/page/15899/shanghai-jiuguang-center. Accessed 18 Sept 2022.

UNWTO. 2020. *Qatar. Country Fact Sheet.* United Nations World Tourism Organization.

Veblen, Thorstein. 1899. *The Theory of the Leisure Class: An Economic Study of Institutions.* New York, NY: Macmillan Company.

Voyce, Malcolm. 2006. Shopping malls in Australia: the end of public space and the rise of 'consumerist citizenship'? *Journal of Sociology* 42 (3): 269–286.

Wharton, Annabel Jane. 2001. *Building the Cold War: Hilton International Hotels and Modern Architecture.* Chicago, IL: University of Chicago Press.

Xue, Charlie Q.L. 2006. *Building a Revolution. Chinese Architecture Since 1980.* Hong Kong: Hong Kong University Press.

Xue, Charlie Q.L.., and Yingchun Li. 2008. Importing American architecture to China: The practice of John Portman & associates in Shanghai. *The Journal of Architecture* 13 (3): 317–333.

Young, Alice. 2016. *The 10 most expensive buildings in the world.* Construction, June 10. https://constructiondigital.com/top10/10-most-expensive-buildings-world. Accessed 28 Apr 2022.

Zuccaro Marchi, Leonardo. 2018. *The Heart of the City. Legacy and Complexity of a Modern Design Idea.* London; New York, NY: Routledge.

Appendix A
Emerging Markets: Surveyed Regions

China (mainland)

Population (2018 in million): 1,393|GDP (2018 in trillion U$): 13.895.
 Number of surveyed firms with unbuilt/built projects: 358/238.
 Total number of projects/built projects in the country by surveyed firms: 3,040/1,484 (Fig. A.1).

India

Population (2018 in million): 1,353|GDP (2018 in trillion U$): 2.701.
 Number of surveyed firms with unbuilt/built projects: 112/60.
 Total number of projects/built projects in the country by surveyed firms: 318/145 (Fig. A.2).

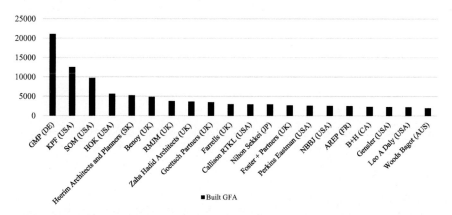

Fig. A.1 Top twenty firms in the country by built GFA (thousand m^2).[1] Copyright Giaime Botti

[1] Data on GFA by Denton Corker Marshall are not available but the firm is a key actor for number of projects.

© The Editor(s) (if applicable) and The Author(s), under exclusive license to Springer Nature Singapore Pte Ltd. 2023
G. Botti, *Designing Emerging Markets*,
https://doi.org/10.1007/978-981-99-1552-1

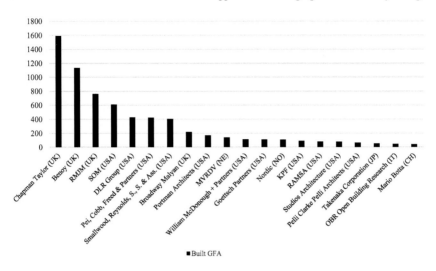

Fig. A.2 Top twenty firms in the country by built GFA (thousand m^2). Copyright Giaime Botti

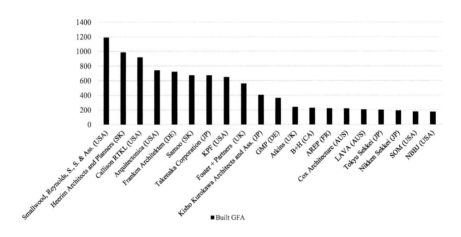

Fig. A.3 Top twenty firms in the region by built GFA (thousand m^2). Copyright Giaime Botti

South-East Asia

Indonesia–Malaysia–Vietnam.

Aggregate population (2018 in million): 394.7|Aggregate GDP (2018 in trillion U$): 1.645.

Number of surveyed firms with unbuilt/built projects: 132/74.

Total number of projects/built projects in the region by surveyed firms: 477/197 (Fig. A.3).

Appendix A: Emerging Markets: Surveyed Regions

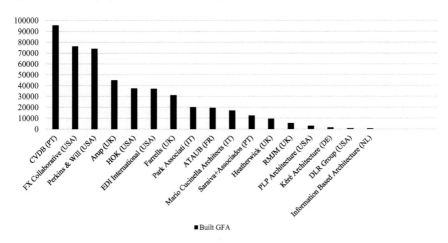

Fig. A.4 Top seventeen firms in the region by built GFA (m^2). Copyright Giaime Botti

Sub-Saharan Africa

Angola–Ghana–Ivory Coast–Kenya–Nigeria–South Africa.

Aggregate population (2018 in million): 390.7|Aggregate GDP (2018 in trillion U$): 1.076.

Number of surveyed firms with unbuilt/built projects: 67/35.

Total number of projects/built projects in the region by surveyed firms: 116/48 (Fig. A.4).

Middle East

Kingdom of Saudi Arabia–Oman–Qatar–United Arab Emirates.

Aggregate population (2018 in million): 50.9|Aggregate GDP (2018 in trillion U$): 1.47.

Number of surveyed firms with unbuilt/built projects: 250/128.

Total number of projects/built projects in the region by surveyed firms: 1,153/449 (Fig. A.5).

Eurasia

Russian Federation–Kazakhstan.

Aggregate population (2018 in million): 162.7|Aggregate GDP (2018 in trillion U$): 1.836.

Number of surveyed firms with unbuilt/built projects: 150/64.

Total number of projects/built projects in the region by surveyed firms: 469/164 (Fig. A.6).

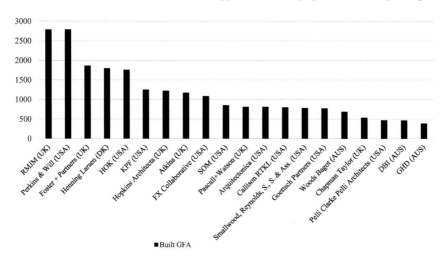

Fig. A.5 Top twenty firms in the region by built GFA (thousand m^2).[2] Copyright Giaime Botti

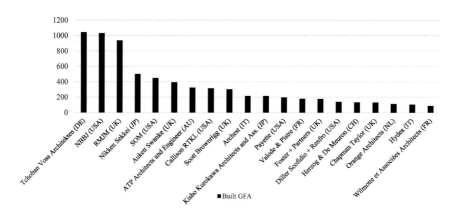

Fig. A.6 Top twenty firms in the region by built GFA (thousand m^2). Copyright Giaime Botti

Latin America

Brazil–Colombia–Mexico.

Aggregate population (2018 in million): 385.3|Aggregate GDP (2018 in trillion U$): 3.473.

Number of surveyed firms with unbuilt/built projects: 142/87.

Total number of projects/built projects in the region by surveyed firms: 380/182 (Fig. A.7).

[2] Data on GFA by Atkins and NORR are not available but the firms are key actors for number of projects.

Appendix A: Emerging Markets: Surveyed Regions

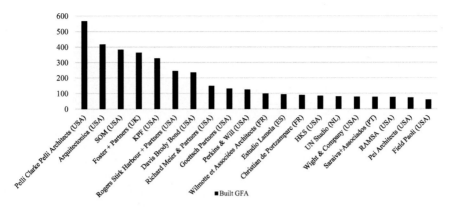

Fig. A.7 Top twenty firms in the region by built GFA (thousand m^2). Copyright Giaime Botti

Appendix B
Surveyed Firms by Country

Australia

Population (2018): 24,982,688|GDP (2018 in trillion U$): 1.43.

N. of registered architects: 13,567|Architects/Population ratio: 0.54|N. of surveyed firms: 25.

Surveyed firms (branch offices in emerging markets): Austin Maynard Architects; BKK Architects; Buchan Group (Shanghai); Candalepas Associates; Chenchow Little Architects; Cox Architecture*; DBI (Abu Dhabi); Denton Corker Marshall (Jakarta); FJMT Studio; GHD* (Abu Dhabi, Beijing, Doha, Dubai, Manila, Port Moresby); Glenn Murcutt**; Hames Sharley*; Hassell* (Hong Kong, Shanghai); Hayball; Iredale Pedersen Hook; John Wardle Architects; Koichi Takada Architects; LAB Architecture (New Delhi, Shanghai); LAVA (China unknown city, Ho Chi Minh City); MCK Architecture & Interiors; MVS Architects Minifie van Schaik; Plus Architecture; Thomson Adsett Architects* (Hong Kong); Wood Marsh Architecture; Woods Bagot* (Beijing, Hong Kong, Shanghai). [*Global top hundred 2013; **Pritzker Prize].

Total n. of projects: 335|Total n. of built projects: 129|Total built GFA (m^2): 5,265,916 (Figs. B.1 and B.2).

Austria

Population (2018): 8,840,521|GDP (2018 in billion U$): 455.17.

N. of registered architects: 5,400|Architects/Population ratio: 0.6|N. of surveyed firms: 14.

Surveyed firms (branch offices in emerging markets): ATP Architects and Engineer* (Moscow); Baumschlager Eberle Architekten (Hanoi, Hong Kong); BEHF Architects; Berger Parkkinen; Coop Himmelb(l)au (Beijing, Hong Kong); Delugan Meissl; Dietrich Untertrifaller; Hans Hollein**; Heri&Salli; LP Architekten; Querkraft; Riepl Riepl; Schenker Salvi Weber; Solid Architecture [*Global top hundred 2013; **Pritzker Prize].

© The Editor(s) (if applicable) and The Author(s), under exclusive license
to Springer Nature Singapore Pte Ltd. 2023
G. Botti, *Designing Emerging Markets*,
https://doi.org/10.1007/978-981-99-1552-1

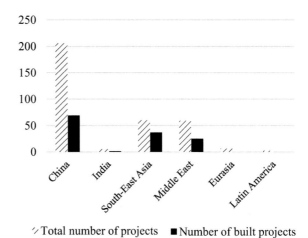

Fig. B.1 Number of projects by surveyed Australian firms in emerging markets (hereafter, a country/region with no projects is not included in the graph). Copyright Giaime Botti

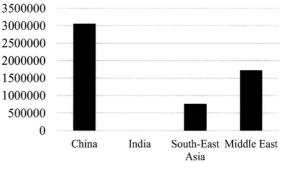

Fig. B.2 Built GFA (m²) by surveyed Australian firms in emerging markets (hereafter, a country/region with no built projects is not included in the graph; if values are equal to 0, it means that data on GFA are not available). Copyright Giaime Botti

Total n. of projects: 54|Total n. of built projects: 23|Total built GFA (m²): 1,288,805 (Figs. B.3 and B.4).

Belgium

Population (2018): 11,427,054|GDP (2018 in billion U$): 543.35.

N. of registered architects: 14,800|Architects/Population ratio: 1.28|N. of surveyed firms: 19.

Surveyed firms (branch offices in emerging markets): B2Ai; Binst Architects; Conix RDBM; Creneau International (Dubai); David Driesen Tom Verschueren DDTV; De Jaeghere Architectuuratelier; Govaert&Vanhoutte; HUB; Jasper-Eyers Architecture*; Kersten Geers David Van Severen; Klaarchitectuur; Label Architecture; Lens Ass Architecten; Samyn and Partners; SKOPE; Studio Farris Architects; Vincent van Duysen; We-s Architecten; Xaveer de Geyter Architects XDGA [*Global top hundred 2013].

Appendix B: Surveyed Firms by Country

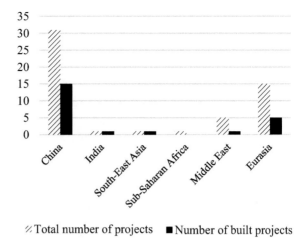

Fig. B.3 Number of projects by surveyed Austrian firms in emerging markets. Copyright Giaime Botti

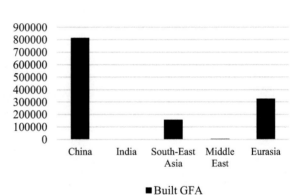

Fig. B.4 Built GFA (m^2) by surveyed Austrian firms in emerging markets. Copyright Giaime Botti

Total n. of projects: 39|Total n. of built projects: 25|Total built GFA (m^2): 346,322 (Figs. B.5 and B.6).

Canada

Population (2018): 37,065,084|GDP (2018 in trillion U$): 1.73.

N. of registered architects: 15,000|Architects/Population ratio: 0.4|N. of surveyed firms: 38.

Surveyed firms (branch offices in emerging markets): 5468796 Architecture; Angela Tsementzis Architect; Architect Microclimat; Architecture49; Atelier Barda; Atelier Général; B+H* (Hong Kong, Shanghai); Batay-Csorba Architects; D'Arcy Jones Architecture; Diamond Schmitt*; Gow Hastings Architects; Hapa Collaborative; IBI Group* (Hong Kong, Bengaluru, Hyderabad, Mumbai, New Delhi, Riyadh, Abu Dhabi, Dubai, Mexico City, Trinidad); INPHO Architectures Physiques et d'Information; JA Architecture Studio; Jean Verville Architects; La SHED; Lebel + Bouliane; Lemay; MA+HG Studio; Menkes Shooner Dagenais Letourneux Architectes; Montgomery Sisam Architects; Naturehumaine; NORR* (Abu Dhabi, Dubai);

Fig. B.5 Number of projects by surveyed Belgian firms in emerging markets. Copyright Giaime Botti

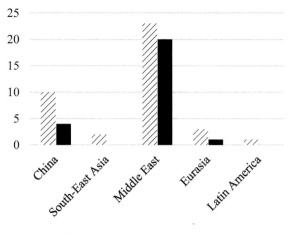

Fig. B.6 Built GFA (m^2) by surveyed Belgian firms in emerging markets. Copyright Giaime Botti

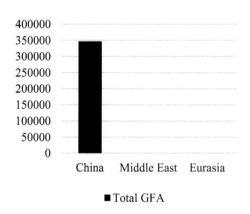

Office of Adrian Phiffer; Office OU; Omar Gandhi; Partisans; Paul Bernier Architect; Polymétis; Public City Architecture; Public Work; Stantec* (Shanghai, Doha, Dubai); Studio AC; Studio North; Taylor Architecture Group; UUfie; Woodford Sheppard Architecture [*Global top hundred 2013].

Total n. of projects: 164|Total n. of built projects: 90|Total built GFA (m^2): 3,219,324 (Figs. B.7 and B.8).

Denmark

Population (2018): 5,793,636|GDP (2018 in billion U$): 356.84.

N. of registered architects: 10,300|Architects/Population ratio: 1.8|N. of surveyed firms: 10.

Surveyed firms (branch offices in emerging markets): 3XN [also GXN]; BIG; C.F. Møller*; CEBRA (Abu Dhabi); Effekt; Henning Larsen* (Hong Kong, Riyadh);

Appendix B: Surveyed Firms by Country 521

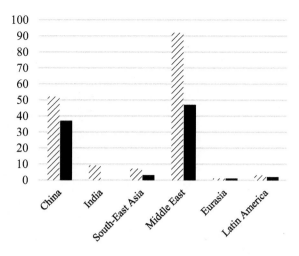

Fig. B.7 Number of projects by surveyed Canadian firms in emerging markets. Copyright Giaime Botti

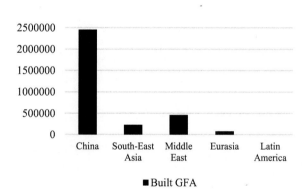

Fig. B.8 Built GFA (m^2) by surveyed Canadian firms in emerging markets. Copyright Giaime Botti

JDS—Julien de Smedt (Shanghai); Lundgaard & Tranberg; Ramboll* (Beijing, Hong Kong, Shanghai); Schmidt Hammer Lassen (Shanghai) [*Global top hundred 2013].

Total n. of projects: 93|Total n. of built projects: 42|Total built GFA (m^2): 3,407,001 (Figs. B.9 and B.10).

Finland

Population (2018): 5,515,525|GDP (2018 in billion U$): 275.72.

N. of registered architects: 3,600|Architects/Population ratio: 0.65|N. of surveyed firms: 9

Surveyed firms (branch offices in emerging markets): ALA Architects; Avanto Architects; JKMM; K2S; OOPEAA; PES Architects (Shanghai); Playa Architects; Sigge Architects; Verstas Architects.

Total n. of projects: 40|Total n. of built projects: 10|Total built GFA (m^2): 243,067 (Figs. B.11 and B.12).

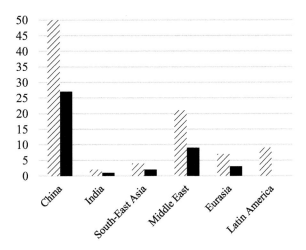

Fig. B.9 Number of projects by surveyed Danish firms in emerging markets. Copyright Giaime Botti

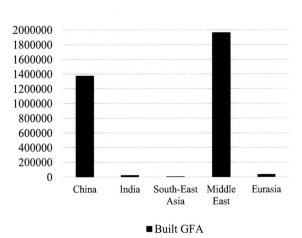

Fig. B.10 Built GFA (m^2) by surveyed Danish firms in emerging markets. Copyright Giaime Botti

France

Population (2018): 67,101,930|GDP (2018 in trillion U$): 2.79.

N. of registered architects: 30,000|Architects/Population ratio: 0.46|N. of surveyed firms: 74.

Surveyed firms (branch offices in emerging markets): 4BI et Associés Bruno Moinard; Atelier 2/3/4 (Shanghai); A26 Architecture (Beijing, Shanghai, Kuwait City); AA Group; AEA Architectes; AIA Life Designers* (Shanghai); ANMA (Beijing); APlus Architectures; Architectures Anne Démians; AREP (Beijing, Shanghai, Hanoi); Art and Build; Arte Charpentier Architectes (Shanghai); Artefact; ARUA Architectes; AS Architecture Studio* (Shanghai); ATAUB; Ateliers 115 Architectes; Atelier Jean Nouvel**; Atelier O-S; BFV Architectes; Blezat;

Appendix B: Surveyed Firms by Country 523

Fig. B.11 Number of projects by surveyed Finnish firms in emerging markets. Copyright Giaime Botti

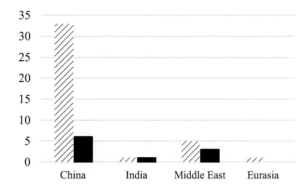

Fig. B.12 Built GFA (m^2) by surveyed Finnish firms in emerging markets. Copyright Giaime Botti

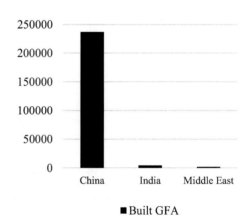

Brunet Saunier Architecture; CalQ; Chabanne; Chaix & Morel et associés; Christian de Potzamparc**; Coldefy & Associates (Hong Kong, Shanghai); Corinne Vezzoni et Associés; CRR Architecture; DGM; Dominique Perrault Architecture; DTACC; ERTIM Architectes; Ferrier Marchetti Studio (Shanghai); Frédéric Borel Architect; Group 6; IPA Igancio Prego Architectures; Jakob + MacFarlane; JAP; Kardham Architecture; Lacaton & Vassal**; LAN Local Architecture Network; Leclercq Associés; Lemoal Lemoal Architectes; Lobjoy-Bouvier-Boisseau Architecture; Majorelle; Manuelle Gautrand Architecture; Michel Beauvais Associés; Patriarche Architecture; Patrick Berger Architect; Paul Andreu—ADP Ingénierie (-2003) + Paul Andreu, Agence (2004–2009); Periferique; Philippe Starck; Pierre-Yves Rochon; RDAI; Reichen Robert & Associés; Richard Scoffier Architect; Richez Associés + Paul Andreu 2009–18 (Kuala Lumpur); Rudy Ricciotti Architecte; SCAU; SRA Architectes; Studio Jacques Garcia; Studio Odil Decq; Sud Architectes (Hong Kong, Shanghai); Taillandier Architectes Associés; Tangram Architectes; Tectoniques Architectes; TLR Architectes Associés; Tracks Architectes; Valode &

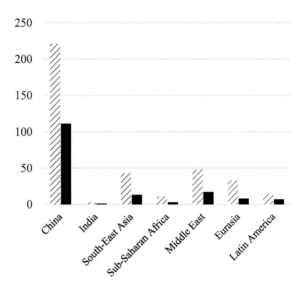

Fig. B.13 Number of projects by surveyed French firms in emerging markets. Copyright Giaime Botti

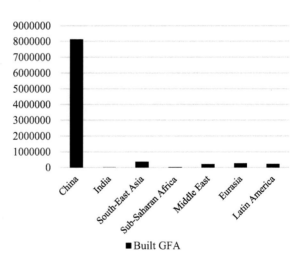

Fig. B.14 Built GFA (m^2) by surveyed French firms in emerging markets. Copyright Giaime Botti

Pistre* (Beijing, Shanghai, Moscow, Dubai); Viguier (Casablanca); Wilmotte et Associées Architects*; XTU; ZUO Zestful Urban Office (Abidjan) [*Global top hundred 2013; **Pritzker Prize].

Total n. of projects: 373|Total n. of built projects: 160|Total built GFA (m^2): 9,226,189 (Figs. B.13 and B.14).

Appendix B: Surveyed Firms by Country

Germany

Population (2018): 82,905,782|GDP (2018 in trillion U$): 3.98.

N. of registered architects: 111,200|Architects/Population ratio: 1.33|N. of surveyed firms: 91.

Surveyed firms (branch offices in emerging markets): 4A Architekten; A24 Landschaft; ACMS Architekten; AFF Architekten; Allmann Sattler Wappner; AS+P—Albert Speer + Partners (Shanghai); Atelier Loidl; Auer Weber; Bär Stadelmann Stöcker Architekten und Stadtplaner; Barkow Leibinger; Batek Architekten; Behnisch Architekten; Bez & Kock Architekten; Blauram; Bogevischs Buro; Böhm Architekten; Bolles + Wilson; Brenne Architekten; Bruno Fioretti Marquez Architekten; Dominikus Stark Architekten; Eike Becker Architekten; Ferdinand Heide Architekt; Florian Nagler Architekten; Franken Architekten; Georg Redelbach Architekten; Gerber Architekten (Shanghai, Riyadh); Gernot Schulz: Architektur; GMP—Gerkan, Marg and Partners* (Beijing, Shanghai, Shenzhen, Hanoi); GRAFT (Beijing); H4Architekten; Haas Cook Zemmrich Studio2050 (Shanghai); Harris + Kurrle; Hascher Jehle Architektur; Heinle, Wischer und Partner; Heinrich Böll; Henchion Reuter Architekten; Henn Architekten* (Beijing); Hild und K Architekten; HPP (Beijing, Shanghai, Shenzhen); Ingenhoven; J. Mayer H.; JSWD; Kadawittfeld Architektur; Kaden + Lager; Kéré Architecture**; Kister Scheithauer Gross; Kleihues + Kleihues; Knerer und Lang; Koeber Landschaftsarchitektur; KSP Jürgen Engel Architekten (Beijing, Shenzhen); Kuhen Malvezzi; Kuhn und Lehmann; Lederer Ragnarsdóttir Oei; Limbrock Tubbesing; Magma Architecture; Max Dudler; Meck Architekten; Meixner Schluter Wendt; Mono Architekten; Muck Petzet Architekten; Nickl & Partner (Beijing, Jakarta); NKBAK; Numrich Albrecht Klumpp Architekten; O&O Baukunst; PFP Architekten; Playze (Shanghai); Pool Leber Arch; Praeger Richter; Richter Musikowski; RKW Architektur; Robert Neun; Sauerbruch Hutton; Schneider + Schumacher (Shenzhen, Tianjin); Schulz und Schulz; Sinai Gesellschaft von Landschaftsarchitekten; SL Rasch; Staab Architekten; Steidle Architekten; Steimle Architekten; Störmer Murphy and Partners; Studio Anna Heringer; Studio Other Spaces; Tchoban Voss Architekten; Waechter + Waechter; Wandel Lorch Architekten; Wiewiorra Studio; Winking Froh Architekten (Hangzhou); Wörner Traxler Richter; Wulf Architekten; Zanderroth architekten; Zvi Hecker [*Global top hundred 2013; **Pritzker Prize].

Total n. of projects: 468|Total n. of built projects: 279|Total built GFA (m²): 27,524,169 (Figs. B.15 and B.16).

Italy

Population (2018): 60,421,760|GDP (2018 in trillion U$): 2.09.

N. of Architects: 160,000|Architects/Population ratio: 2.64|N. of surveyed firms: 72.

Surveyed firms (branch offices in emerging markets): ABDR Architetti Associati; AEGIS; Alberto Izzo & Partners; Archea (Beijing); Archest; Archilinea; Area 17 (Beijing, Hong Kong, Shanghai, Cuenca); ASA Studio Albanese; Asti Architetti; Atelier(s) Alfonso Femia AF517; ATI Projects; Beretta Associati; Binini

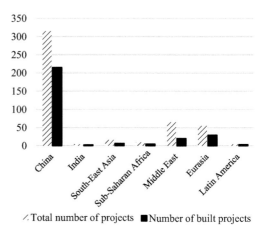

Fig. B.15 Number of projects by surveyed German firms in emerging markets. Copyright Giaime Botti

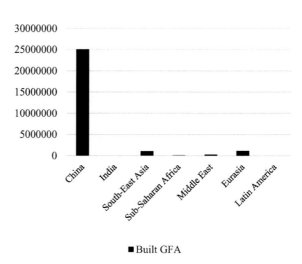

Fig. B.16 Built GFA (m^2) by surveyed German firms in emerging markets. Copyright Giaime Botti

Partners; Bioedil Progetti; Cairepro; Caputo Partnership; Carlo Ratti Associati; Citterio Viel—ACPV; Cremonesi CREW; CZA Cino Zucchi Architetti; Domus Ing & Arch; Dordoni Architetti; DVision Architettura; Fortebis; Fuksas & Associati (Shenzhen, Dubai); Garretti Associati; GBPA Architects; General Planning; Genius Loci Architettura; Gio Forma Studio Associato; Giugiaro Architettura; Global Planning Architecture GPA; Gnosis Progetti; Goring & Straja Studio; Gregotti Associati; H&H Associati (Shanghai); Hydea (Beijing, Shanghai); Il Prisma Architettura; Insite Studio Architettura e Ingegneria; Iosa Ghini Associati; Ipostudio Architetti; J+S Architecture Engineering; Joseph Di Pasquale Architects; LAND Italia; Leonardo Progetti; Lissoni Associati; Lombardini 22; MADE Associati; Mario Cucinella Architects; Matteo Thun; Michele De Lucchi; OBR Open Building Research; OneWorks; Open Project; Park Associati; Patricia Urquiola; Piuarch; Polis; Polistudio; Progettisti Associati Tecnarc; Progetto CMR* (Beijing, Tianjin,

Appendix B: Surveyed Firms by Country

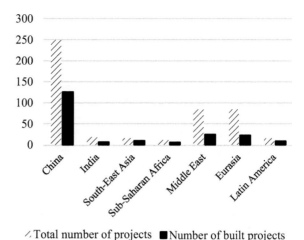

Fig. B.17 Number of projects by surveyed Italian firms in emerging markets. Copyright Giaime Botti

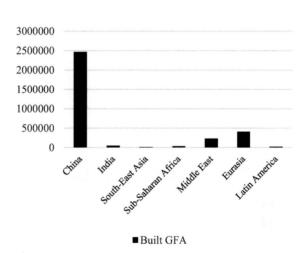

Fig. B.18 Built GFA (m^2) by surveyed Italian firms in emerging markets. Copyright Giaime Botti

Hanoi, Jakarta, Moscow, Istanbul); RPBW Renzo Piano Building Workshop**; Schiattarelli Associati; Starching; Stefano Boeri Architetti (Shanghai); Studio Amati; Studio Italo Rota; Studio Marco Piva; Studio Muzi e Associati; Tectoo; Vudafieri Saverino Partners (Shanghai); WIP [*Global top hundred 2013; **Pritzker Prize].

Total n. of projects: 476|Total n. of built projects: 209|Total built GFA (m^2): 3,219,596 (Figs. B.17 and B.18).

Japan

Population (2018): 126,811,000|GDP (2018 in trillion U$): 5.04.

N. of Architects: 300,000|Architects/Population ratio: 2.37|N. of surveyed firms: 120.

528 Appendix B: Surveyed Firms by Country

Surveyed firms (branch offices in emerging markets): 24d Studio; AA & Sun Associates; AAt + Makoto Yokomizu Architects; AHA Aki Hamada Architects; AIDA Atelier; Akasaka Shinichiro Atelier; Akihiro Kondo; Albert Abut Architecture (Hong Kong); ALPHAville architects; ALTS Design Office; ALX Sampei Junichi; Amorphe Takeyama & Associate; AND Aoyama Nomura Design; Aoki Jun; APOLLO Architects; Arata Isozaki**; Arbol Design; Archisan; Architects Teehouse; Artechnic Architects; Assistant—Megumi Matsubara, Hiroi Ariyama, Motohiro Sunouchi; Atelier Bow-wow; Atelier Hitoshi Abe; Atelier Ichiku; Atelier Ryo Abe AARA; Atelier Tekuto; AXS Satow* (Beijing); Bakoko; Bond Design Studio; Chiba Manabu Architects; Dox Interiors; Florian Busch Architects; FOBA; FT Architects; Fumio Toki Associates; Go Hasegawa; HAO Akihisa Hirata Architecture Office; Hata Tomohiro; Himematsu; Hiroshi Naito Architect & Associates; Hiroshi Nakamura; Hiroyuki Ito Architect; Ishimoto Architectural & Engineering Firm*; Itsuko Hasegawa Atelier; James Lambiasi Architect; Jun Igarashi Architects; Jun Mitsui & Associates; Junya Ishigami + Associates; K Associates Waro Kishi; Katsuhiro Miyamoto & Associates; Katsutoshi Sasaki + Associates; Kazuya Morita; Keiji Ashizawa Design; Kengo Kuma; Kisho Kurokawa Architects and Associates (Astana); Klein Dytham Architecture; Kochi Architect's Studio; Kubo Tsushima Architects; Kuno Hiroshi; KWAS; Maki and Associates**; Makoto Sei Watanabe; Makoto Yamaguchi Design; Masuda + Katasuhisa Shingo Otsubo; MHS Planners, Architects and Engineers; Michiya Tsukano; Milligram Architectural Studio; Mitsubishi Jisho Sekkei*; Miyahara Architects Office; Mount Fuji Architects Studio; Move Design; Nendo; Nihon Sekkei* (Shanghai, Jakarta); Nikken Sekkei* (Beijing, Chengdu, Dalian, Shanghai, Bangkok, Hanoi, Ho Chi Minh City, Singapore, Seoul, Moscow, Dubai, Riyadh); Noriaki Okabe Architecture Network; ON Design & Partner; Paramodern Shuhei Endo; Riken Yamamoto (Beijing); Ryuichi Ashizawa Architects; Ryumei Fujiki + Fujiki Studio FADS; SANAA—Kazuyo Sejima and Ryue Nishizawa**; Satoh Hirotaka Architects; Satoshi Okada Architects; Schemata Architects; Shigeru Ban**; Shin Takamatsu (Taipei); Shinichi Ogawa & Architects; Showa Sekkei* (Shanghai); SO & CO Teruuchi; Sou Fujimoto; Studio On Site; Studio Velocity; Tadao Ando**; Taiji Kawano Architects; Takahashi Ippei; Takao Shiotsuka Atelier; Takashi Yamaguchi & Associates (Hong Kong, Shanghai); Takashi Yonezawa Architects; Takashige Yamashita; Takenaka Corporation; Takeshi Hosaka Architects; Tange Associates** (Shanghai, Taipei, Jakarta, Singapore); Terada Design Architect; Terrain Architects; Terunobu Fujimori; Tezuka Architects; Tokujin Yoshioka; Tokyu Sekkei; Tomoaki Uno; Tomohiro Hata; Torafu Architects; Toru Shimokawa; Toyo Ito**; Urban Design System (Shanghai); wAtelier; Yamazaki Kentaro Design Workshop; Yu Momoeda Architecture; Yuji Tanabe Architects; Yuki Ishiguro architect; Yuko Nagayama & Associates [*Global top hundred 2013; **Pritzker Prize].

Total n. of projects: 340|Total n. of built projects: 198|Total built GFA (m^2): 12,905,806 (Figs. B.19 and B.20).

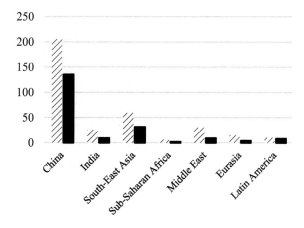

Fig. B.19 Number of projects by surveyed Japanese firms in emerging markets. Copyright Giaime Botti

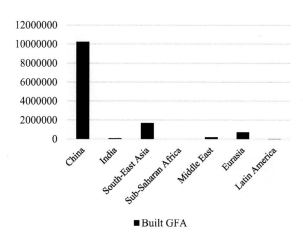

Fig. B.20 Built GFA (m^2) by surveyed Japanese firms in emerging markets. Copyright Giaime Botti

The Netherlands

Population (2018): 17,231,624|GDP (2018 in billion U$): 914.04.

N. of Architects: 10,600|Architects/Population ratio: 0.61|N. of surveyed firms: 26.

Surveyed firms (branch offices in emerging markets): Atelier Kempe Thill; Bedaux de Brouwer Architecten; Benthem Crouwel; Cepezed; Concrete Amsterdam; Hans van der Heijden Architect; HofmanDujardin; HOH Architecten; i29 Interior Architects; Information Based Architecture (Guangzhou); KAAN (São Paulo); KCAP (Shanghai); Mecanoo (Kaohsiung); Mei Architects and Planners; MVRDV (Shanghai); Neutelings Riedijk Architects; Next Architects (Beijing); NL Architects; OMA** (Beijing, Hong Kong, Doha, Dubai); Orange Architects; Powerhouse Company (Beijing); Studioninedots; UN Studio* (Hong Kong, Shanghai); VMX

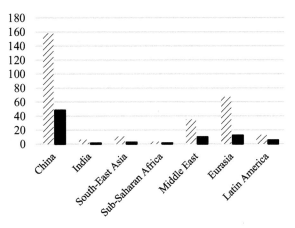

Fig. B.21 Number of projects by surveyed Dutch firms in emerging markets. Copyright Giaime Botti

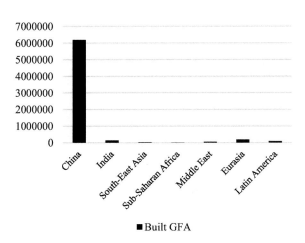

Fig. B.22 Built GFA (m^2) by surveyed Dutch firms in emerging markets. Copyright Giaime Botti

Architects (Muscat); West8; Wiel Arets Architects [*Global top hundred 2013; **Pritzker Prize].

Total n. of projects: 293|Total n. of built projects: 79|Total built GFA (m^2): 6,668,108 (Figs. B.21 and B.22).

New Zealand

Population (2018): 4,900,600|GDP (2018 in billion U$): 188.84.

N. of Architects: 2,111|Architects/Population ratio: 0.43|N. of surveyed firms: 8

Surveyed firms (branch offices in emerging markets): Athfield Architects; Bossley Architects; CAAHT Studio; Crosson Architects; DAA Dorrington Atcheson Architects; Daniel Marshall Architects; Fearon Hay Architects; Young Architects.

Total n. of projects: 2|Total n. of built projects: 0|Total built GFA (m^2): 0

Appendix B: Surveyed Firms by Country

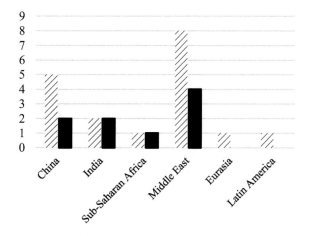

Fig. B.23 Number of projects by surveyed Norwegian firms in emerging markets. Copyright Giaime Botti

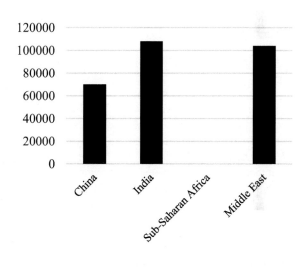

Fig. B.24 Built GFA (m^2) by surveyed Norwegian firms in emerging markets. Copyright Giaime Botti

Norway

Population (2018): 5,311,916|GDP (2018 in billion U$): 437.

N. of Architects: 3,825|Architects/Population ratio: 0.70|N. of surveyed firms: 8

Surveyed firms (branch offices in emerging markets): Helen & Hard; JVA; Link Arkitektur*; Lund + Slaatto; Nordic; R21 Arkitekter; Rintala Eggertsson Architects; Snøhetta (Hong Kong) [*Global top hundred 2013].

Total n. of projects: 18|Total n. of built projects: 9|Total built GFA (m^2): 282,000 (Figs. B.23 and B.24).

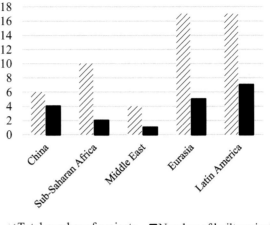

Fig. B.25 Number of projects by surveyed Portuguese firms in emerging markets. Copyright Giaime Botti

Portugal

Population (2018): 10,283,822|GDP (2018 in billion U$): 242.31.

N. of Architects: 23,000|Architects/Population ratio: 2.87|N. of surveyed firms: 17.

Surveyed firms (branch offices in emerging markets): Aires Mateus; Alvaro Siza**; Bak Grodon Arquitectos; Carvalho Araújo; Correia Ragazzi Arquitectos; CVDB; Eduardo Souto de Moura**; Global, Arquitectura Paisagista; Goncalo Byrne; João Tiago Aguiar; José Luis Carrilho da Graca; M Arquitectos; Menos é Mais Arquitectos; OODA Oporto Office for Design and Architecture; Pedra Silva Arquitectos; Pitagoras Group (Accra, Maputo, Cabo de Santo Agostinho, Medellín); Saraiva + Associados (Ho Chi Minh City, Kuala Lumpur, Singapore, Malabo, Oran, Astana, Bogotá, Mexico City, São Paulo) [**Pritzker Prize].

Total n. of projects: 54|Total n. of built projects: 19|Total built GFA (m^2): 245,427 (Figs. B.25 and B.26).

South Korea

Population (2018): 51,085,058|GDP (2018 in trillion U$): 1.72.

N. of Architects: N.A.|Architects/Population ratio: N.A.|N. of surveyed firms: 52.

Surveyed firms (branch offices in emerging markets): 2M2 Architects; AI Architects; AOA Architects; Architecture Studio Hand; Archium; Archiworkshop; Atelier Jun; BCHO Architects; Beyond Space—Ryu Choon-soo; Chae Pereira Architects; Choon Choi Architect; D-Lim Architects; DIA Architecture; Doojin Hwang Architects; Farming Architecture; Ga.a Architects; Gansam* (Hanoi, Ho Chi Minh City); Guga Urban Architecture; Heerim Architects and Planners* (Beijing, Dhaka, Hanoi, Ho Chi Min City, Phnom Penh, Astana, Tashkent, Baku, Doha, Dubai, Erbil); Hyunjoon Yoo Architects; Iroje KHM; Iroje Architects & Planners; Ison Architects; ITM Yoo Ehwa Architects; Jegong Architects; JMY Architects; Joho Architecture;

Appendix B: Surveyed Firms by Country 533

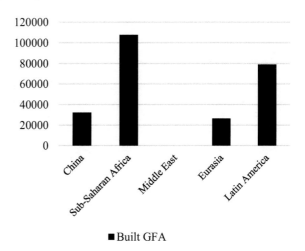

Fig. B.26 Built GFA (m^2) by surveyed Portuguese firms in emerging markets. Copyright Giaime Botti

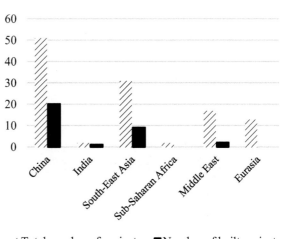

Fig. B.27 Number of projects by surveyed South Korean firms in emerging markets. Copyright Giaime Botti

JY-Architects; K.O.M.A. Korea Office of Modern Architecture—Lee Eun Seok; KUNWON Architects, Planners, Engineers*; KYWC Architects; Leehong Kim; Mass Studies; Moon Hoon; Motoelastico; MPART Architects; Nameless Architecture; OBBA; One O One Architects; PWFerretto; Samoo* (Xi'an, New Delhi, Hanoi, Kuala Lumpur); Shin Architects; Simplex Architecture; Snow Aide; SSD Architecture; Tectonics Lab; The Plus Partners; The System Lab; Typstudio; Unsangdong Architects Cooperation; WISE Architecture; Wonder Architects [*Global top hundred 2013].

Total n. of projects: 116|Total n. of built projects: 32|Total built GFA (m^2): 7,907,676 (Figs. B.27 and B.28).

Fig. B.28 Built GFA (m^2) by surveyed South Korean firms in emerging markets. Copyright Giaime Botti

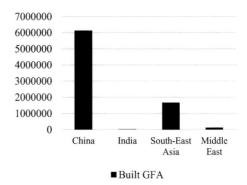

Spain

Population (2018): 46,797,754|GDP (2018 in trillion U$): 1.42.

N. of Architects: 55,700|Architects/Population ratio: 1.19|N. of surveyed firms: 56.

Surveyed firms (branch offices in emerging markets): A-Cero; AF6 Arquitectura; Alberto Campo Baeza; AS + Abalos + Sentkiewicz (Shanghai); AZPML (+FOA); B720 Fermin Vazquez; Baas Arquitectura; Barozzi Veiga; Batlle i Roig; BETA.Ø architecture office; Blanca Lleó; CaSa Colombo and Serboli; Cruz y Ortiz; Ecosistema Urbano; EMBT Miralles Tagliabue (Shanghai); Enric Ruiz Geli; Ensamble Studio; Estudio Cordero y Viñas; Estudio Lamela (Mexico City); Fenwick Iribarren; Fran Silvestre Arquitectos (Bogotá, Mexico City); Francisco Mangado; FRPO Rodriguez & Oriol Arquitectos; GAC3000; GarciaGerman Arquitectos; Guallart Architects; Harquitectes; HCP; IDOM* (New Delhi, Kuala Belait, Kuala Lumpur, Manila, Singapore, Algers, Addis Abeba, Casablanca, Dakar, Abu Dhabi, Ankara, Dubai, Riyadh, Asunción, Buenos Aires, Bogotá, Lima, Medellín, Mexico City, Panama City, San José, Santiago de Chile, São Paulo); Josep Llinas; Juan Navarro Baldeweg; L35 (Casablanca, Dubai, Istanbul, Bogotá, Mexico City, Santiago de Chile, São Paulo); Lacol Arquitectura; Linazasoro & Sánchez; Luis Vidal + Architects (Santiago de Chile, Santo Domingo); Mansilla + Tuñón; Marià Castellò; Mias Architects; Nieto Sobejano; Nomad Arquitectos; Nook Architects; OAB-Ferrater; Pinearq (Lima, Panama City); Rafael de la Hoz (Beijing, Morocco unknown city, Iraq unknown city, Saudi Arabia unknown city, Colombia unknown city); Rafael Moneo**; RBTA—Ricardo Bofill; RCR Arquitectes**; Ruiz Larrea & Asociados; Sancho + Madridejos; SHARE—Sendarrubias & Hernández, Architecture and Engineering (Algers); Soma; Studio Gronda; Ted A Arquitectes; Touza Arquitectos; Vasquez Consuegra; Viar Estudio [*Global top hundred 2013; **Pritzker Prize].

Total n. of projects: 202|Total n. of built projects: 49|Total built GFA (m^2): 1,052,220 (Figs. B.29 and B.30).

Appendix B: Surveyed Firms by Country 535

Fig. B.29 Number of projects by surveyed Spanish firms in emerging markets. Copyright Giaime Botti

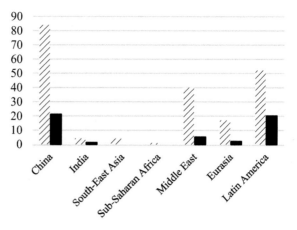

Fig. B.30 Built GFA (m^2) by surveyed Spanish firms in emerging markets. Copyright Giaime Botti

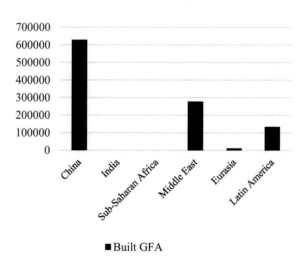

Sweden

Population (2018): 10,175,214|GDP (2018 in billion U$): 555.46.

N. of Architects: 6,750|Architects/Population ratio: 0.67|N. of surveyed firms: 15.

Surveyed firms (branch offices in emerging markets): AIX Arkitekter; Arrhov Frick Arkitektkontor; Blasberg Andréasson Arkitekter; Elding Oscarson; FOJAB; General Architecture; Nyréns Arkitektkontor; Petra Gipp Arkitektur; Sweco*; Tengbom*; Tham & Videgård; Unit Arkitektur; White Arkitekter*; Wingårdh Arkitektkontor; YAJ Arkitekter [*Global top hundred 2013].

Total n. of projects: 17|Total n. of built projects: 5|Total built GFA (m^2): N.a (Fig. B.31).

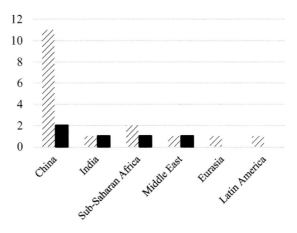

Fig. B.31 Number of projects by surveyed Swedish firms in emerging markets. Copyright Giaime Botti

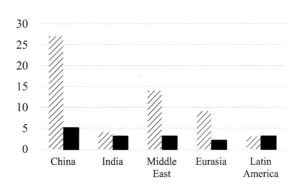

Fig. B.32 Number of projects by surveyed Swiss firms in emerging markets. Copyright Giaime Botti

Switzerland

Population (2018): 8,514,329|GDP (2018 in billion U$): 735.54.

N. of Architects: 7,400|Architects/Population ratio: 0.86|N. of surveyed firms: 14|.

Surveyed firms (branch offices in emerging markets): AFGH; Bearth & Deplazes; Burckhardt + Partner; Christian Kerez; Concept Consult; Diener & Diener Architekten; Durisch + Nolli; Herzog & De Meuron**; HHF; Mario Botta; Peter Zumthor**; Santiago Calatrava; Studio Vacchini; Valerio Olgiati [**Pritzker Prize].

Total n. of projects: 72|Total n. of built projects: 16|Total built GFA (m^2): 558,683 (Figs. B.32 and B.33).

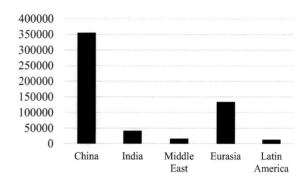

Fig. B.33 Built GFA (m²) by surveyed Swiss firms in emerging markets. Copyright Giaime Botti

United Kingdom

Population (2018): 66,460,344|GDP (2018 in trillion U$): 2.9.

N. of Architects: 41,000|Architects/Population ratio: 0.6|N. of surveyed firms: 79.

Surveyed firms (branch offices in emerging markets): 3144 Architects; 3DReid*; Adjaye Associates (Accra); ADP Architecture (New Delhi); AFL Architects For Life; AHR (Almaty, Moscow); aLL Design—Will Alsop (Chongqing, Doha); Allford Hall Monaghan Morris; Allies and Morrison* (Doha); Arup* (Beijing, Chongqing, Guangzhou, Hong Kong, Macau, Shenzhen, Wuhan, Taipei, Hyderabad, Mumbai, Bandar Seri Begawan, Ho Chi Minh City, Jakarta, Kuala Lumpur, Manila, Penang, Phnom Penh, Sabah, Singapore, Cape Town, Durban, Johannesburg, Harare, Lagos, Abu Dhabi, Dubai, Bogotá); Atkins* (Beijing, Chengdu, Hong Kong, Macau, Shanghai, Shenzhen, Bengaluru, Gurugram, Kuala Lumpur, Ho Chi Minh City, Singapore, Dar Es Salaam, Nairobi, Abu Dhabi, Dubai, Doha, Jeddah, Manama, Muscat, Kuwait City, Riyadh, Trinidad); Aukett Swanke* (Moscow, Abu Dhabi, Dubai, Istanbul); AWW; BDP* (Shanghai, New Delhi, Singapore, Abu Dhabi); Benoy* (Beijing, Hong Kong, Shanghai, Shenzhen, Mumbai, Singapore, Dubai); Bond Bryan; BPTW; Brisac Gonzalez; Broadway Malyan* (Shanghai, Shenzhen, Mumbai, Jakarta, Singapore, Abu Dhabi, Dubai, São Paulo); Bryden Wood Technology; Buckley Gray Yeoman; Caruso St John Architects; Chapman Taylor* (Shanghai, New Delhi, Bangkok, Moscow, Abu Dhabi, Dubai); Child Graddon Lewis; Corstorphine + Wright; Darling Associates; DarntonB3 Architecture; David Chipperfield Architects (Shanghai); Donald Insall Associates; ECE Architecture; EPR Architects; Eric Parry Architects (Singapore); Farrells (Hong Kong, Shanghai); FaulknerBrowns; Feilden Clegg Bradley Studios; Fletcher Priest Architects; Foster + Partners*/** (Beijing, Hong Kong, Shanghai, Shenzhen, Bangkok, Singapore, Abu Dhabi, Dubai, Buenos Aires); Glenn Howells Architects; Grid Architects; Grimshaw (Dubai); Hawkins Brown; Haworth Tompkins; Heatherwick; HLM Architects; Holder Mathias Architects; Hopkins Architects (Shanghai, Dubai); Jestico + Whiles; JMArchitects; JTP Architects; Levitt Bernstein; Lewis & Hickey (Mumbai); LSI Architects; Make Architects (Hong Kong); Mossessian Architecture; P+HS

Fig. B.34 Number of projects by surveyed British firms in emerging markets. Copyright Giaime Botti

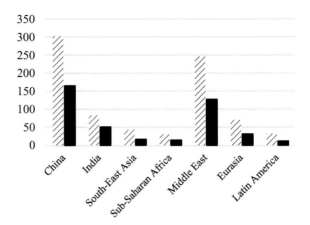

Architects; Pascall + Watson (Abu Dhabi); Penoyre & Prasad; Peter Barber Architects; Pick Everard; PLP Architecture (Beijing, Shanghai); PRP Architects*; PRS Architects Capita Symonds*; Purcell (Hong Kong); RH Partnership Architects; RMJM (Hong Kong, Shanghai, Shenzhen, Pakistan unknown city, Kuala Lumpur, Singapore, Dar Es Salaam, Gaborone, Kampala, Mombasa, Nairobi, Pretoria, Dubai, Teheran, Saudi Arabia unknown city, Curitiba, São Paulo); RSH+P—Rogers Stirk Harbour + Partners** (Shanghai); Ryder Architects (Hong Kong); Scott Brownrigg (Hong Kong, Singapore); Sheppard Robson*; SimpsonHaugh; Squire and Partners; Stephen George + Partners; Stockwool; Stride Treglown (Abu Dhabi); TP Bennett* (Hong Kong, Shanghai); Universal Architecture & Interior Design; Weston Williamson + Partners; WilkinsonEyre (Hong Kong); Zaha Hadid Architects*/** (Beijing) [*Global top hundred 2013; **Pritzker Prize].

Total n. of projects: 807|Total n. of built projects: 408|Total built GFA (m^2): 42,159,817 (Figs. B.34 and B.35).

United States of America

Population (2018): 326,838,199|GDP (2018 in trillion U$): 20.53.

N. of Architects: 141,700|Architects/Population ratio: 0.43|N. of surveyed firms: 278.

Surveyed firms (branch offices in emerging markets): 4240 Architecture; ACAI Associates; Adrian Smith + Gordon Gill Architecture (Beijing); AE Works Limited; AECOM* (Hong Kong, Singapore, Gurugram, Abu Dhabi); AHL Architect Hawaii Limited; Albert Kahn Associates; Alliiance; ALSC Architects; Architects Orange; Architecture Incorporated; Aria Group Architects; Arquitectonica (Hong Kong, Shanghai, Manila, Lima, São Paulo); Array Architects; Ashley McGraw Architects; Asymptote; Ayers Saint Gross; Ballinger; Barge Design Solutions; Barker Rinker Seacat Architecture; Baskervill; Base4; BBGM Architects; BBS Architects & Engineers; Beck Group (Mexico City, Monterrey); Becker Morgan Group;

Appendix B: Surveyed Firms by Country

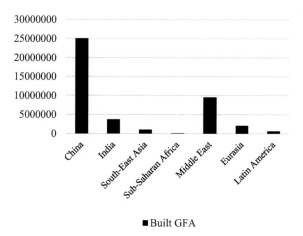

Fig. B.35 Built GFA (m^2) by surveyed British firms in emerging markets. Copyright Giaime Botti

Ben Herzog Architect; Bermello Ajamil & Partners; Bernard Tschumi Architect; Bernardon; Beyer Blinder Belle; BHDP Architecture; Blair + Mui Dowd Architects; BLDD Architects; Bohlin Cywinski Jackson; Boarman Kroos Vogel Group BKV; Bostwick Design Partnership; Boulder Architects; Brownstone; BSB Design; Butler, Rosenbury & Partners BRP; BWBR; Caldwell Associates Architects; Callison RTKL* (Beijing, Hong Kong, Shanghai, Manila, Abu Dhabi, Dubai, Mexico City); Cambridge Seven; Cannon Design* (Mumbai); Carrier Johnson + Culture; CASCO + R5; CBRE Heery; CBT Architects (Abu Dhabi); Centerbrook Architects & Planners; CESO; Champlin Architecture; Clark Nexsen; CM Architects; CO Architects; Cooper Carry; Cordogan Clark & Associates; Corgan; CSArch; CTA Architects; Cuhaci & Peterson; Cuningham Group Architecture (Beijing, Doha); Curtis + Ginsberg Architects; CWB Architects; Dattner Architects; Davis Architects; Davis Brody Bond; Design Resources Group Architects; DIGroupArchitecture; Diller Scofidio + Renfro; DLR Group* (Shnaghai, Dubai); DLZ Architects; EDI International; Elkus Manfredi Architects; Emersion Design; Ennead Architects (Shanghai); Eppstein Uhen Architects; Epstein Global; Eric Owen Moss; EYP; EwingCole; Fanning/Howey Associates; Fentress Architects; FGM Architects; Field Paoli; Finegold Alexander Architects; Fitzgerald Associates; Flad Architects; Fogarty Finger Architecture; Francis Cauffman; FSB; FX Collaborative; G70 Design; Garmann Miller & Associates; GBBN (Beijing); Gehry Partners**; Gensler* (Beijing, Hong Kong, Shanghai, Bengaluru, Mumbai, Bangkok, Singapore, Abu Dhabi, Dubai, Bogotá, Mexico City, San José, São Paulo); GFF Architects; GGLO Design; Glavé & Holmes Architecture; Godden|Sudik Architects; Goettsch Partners (Shanghai, Abu Dhabi); Goodwyn Mills Cawood; Gould Turner Group; GreenbergFarrow (Hong Kong, Shanghai, Phnom Penh, Mexico City); Gresham, Smith and Partners; Grimm + Parker Architects; GSB Architects; GWWO Architects; H. Hendy Associates; Harvard Jolly Architecture; Hastings + Chivetta Architects; HBG Design; HDR* (Beijing, Shanghai, Mumbai, Singapore, Abu Dhabi, Doha, Dubai, King Abdullah Economic City); HGA Architects and Engineers; Highland

Associates; Hixson Architecture, Engineering, Interiors; HKS* (Shanghai, New Delhi, Singapore, Dubai, Mexico City); HLW International; HMC Architects; HMFH Architects; HNTB Corp; Hoefer Wysocki Architecture; Hoffmann Architects; HOK (Beijing, Hong Kong, Shanghai, Mumbai, Dubai); Holst Architecture; Hord Coplan Macht; Huckabee; Huitt-Zollars; Humphreys & Partners Architects (Chennai, Hanoi, Ho Chi Min City, Montevideo); Hunton Brady Architects; Huntsman Architectural Group; Inventure Design; Jacobs* (Hong Kong, Shanghai, Bengaluru, Gurugram, Hyderabad, Kolkata, Navi, New Delhi, Mumbai, Pune, Vadodara, Jakarta, Johor Bahru, Kuala Lumpur, Casablanca, Nairobi, Abu Dhabi, Doha, Dubai, Muscat, Sharjah, Riyadh, Al-Khobar, Jubail Industrial City, Trinidad and Tobago); Jahn; JAM; JCJ Architecture; JLC Architects; Jonathan Nehmer + Associates; JRS Architects; Kahler Slater (Singapore); Kevin Roche John Dinkeloo and Associates; KCBA Architects; Kirksey Architects; Kostow Greenwood Architects; KPF- Kohn Pedersen Fox* (Hong Kong, Shanghai, Singapore. Abu Dhabi); KSQ Design; KSS; KTGY Architecture + Planning; KZF Design; LaBella Associates; Langdon Wilson International* (Kuwait City); Larson Design Group; Lawrence Group; Legat Architects; Leo A Daly* (Abu Dhabi); Little; LK Architecture; LMN Architects; Lord Aeck Sargent; LRK Looney Ricks Kiss; LRS Architects; LS3P; M+A Architects; Macgregor Associates Architects; Margulies Perruzzi; Marlon Blackwell Architects; Mascari Warner Dinh Architects; Massa Multimedia Architecture; MBH Architects (Bengaluru, Mumbai); MEIS Architects; MESH; Method Architecture; Michael Graves Architecture & Design; MG2 (Shanghai); Michael Baker Intl; Miller Dunwiddie; Miller Hull Partnership; Mitchell Giurgola; Mithun; Moody Nolan; Morphosis—Thom Mayne**; Moseley Architects; MSA Design; NAC Architecture (Shanghai); NBBJ* (Hong Kong, Shanghai, Pune); Nelson Worldwide; Niles Bolton Associates; NMR Architects + Engineers; NSPJ Architects; O'Connell Robertson; Orcutt|Winslow; OZ Architecture; Page Southerland Page* (Dubai, Mexico City); Parkhill, Smith & Cooper; Payette; PBK (Beijing, Shenzhen); Pei Architects; Pei, Cobb, Freed & Partners**; Pelli Clarke Pelli Architects (Shanghai, Shenzhen, Abu Dhabi); Perkins Eastman* (Shanghai, Mumbai, Dubai, Samborondón); Perkins & Will* (Shanghai, Monterrey, São Paulo); PF&A Design; PGAL; Populous* (Beijing, New Delhi, Singapore, Dubai); Portman Architects (Hong Kong, Shanghai); Progressive AE; Quattrocchi Kwok Architects; Quinn Evans Architects; RAMSA Robert A.M. Stern Architects*; Randall-Paulson Architects; RATIO HPA; RATIO SMDP (Shanghai, Kuala Lumpur); RBB Architects Los Angeles; RB+B Architects; RDG Planning & Design; REES Associates (Mexico City); Retail Design Collaborative; REX; Richard Meier & Partners; RKTB Architects; RMW architecture & interiors; RSP Architects (Bengaluru); Rule Joy Trammell + Rubio; RUR Reiser Umemoto; Safdie Architects (Shanghai, Singapore, Jerusalem); Salus Architecture; Sasaki (Shanghai); SCB Solomon Cordwell Buenz; SchenkelShultz Architecture; Schradergroup; SEI Design Group; Shepley Bulfinch; Sizeler Thompson Brown Architects; SLCE Architects; Smallwood, Reynolds, Stewart, Stewart & Associates (Singapore); Smith Group* (Shanghai); SO-IL; SOM—Skidmore, Owings & Merrill*/** (Hong Kong, Shanghai, Dubai); Steelman Partners (Macau, Zhuhai, Ho Chi Min City, Phnom Penh); Steinberg Hart (Shanghai); Steven Holl (Beijing); Stevens & Wilkinson;

Appendix B: Surveyed Firms by Country

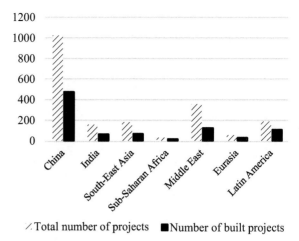

Fig. B.36 Number of projects by surveyed US firms in emerging markets. Copyright Giaime Botti

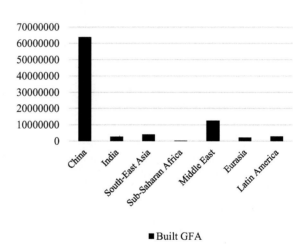

Fig. B.37 Built GFA (m^2) by surveyed US firms in emerging markets. Copyright Giaime Botti

STR Partners; Studio Gang; Studio Libeskind; Studio One Eleven; Studios Architecture; SWBR; Taylor Design; Ted Moudis Associates; TEG Architects; Teter; Then-Design Architecture; The SLAM Collaborative; Tigerman McCurry; TreanorHL; Tricarico Architecture and Design; Trinity: Planning, Design, Architecture; Tsoi Kobus Design; Urbahn Architects; Urban Pioneering; VLK Architects; Vocon; Ware Malcomb (Mexico City); WATG (Shanghai, New Delhi, Singapore, Dubai, Istanbul, Cairo); WDG Architects; Weber Thompson; Wight & Company; William McDonough + Partners; Wilson Associates* (Shanghai, Singapore, Dubai); Wilson Butler Architects; Wright Heerema Architects; WRNS Studio; ZGF Architects*; Ziegler Cooper Architects; Zyscovich Architects (Bogotá) [*Global top hundred 2013; **Pritzker Prize].

Total n. of projects: 1,989|Total n. of built projects: 886|Total built GFA (m^2): 88,296,967 (Figs. B.36 and B.37).